Portable Edition | Book 1

Fifth Edition

ART HISTORY

Ancient Art

MARILYN STOKSTAD

Judith Harris Murphy Distinguished Professor of Art History Emerita The University of Kansas

MICHAEL W. COTHREN

Scheuer Family Professor of Humanities Department of Art, Swarthmore College

PEARSON

Boston Columbus Indianapolis New York San Francisco Upper Saddle River

Amsterdam Cape Town Dubai London Madrid Milan Munich Paris Montréal Toronto

Delhi Mexico City São Paulo Sydney Hong Kong Seoul Singapore Taipei Tokyo

Editorial Director: Craig Campanella Editor in Chief: Sarah Touborg

Senior Sponsoring Editor: Helen Ronan Editorial Assistant: Victoria Engros

Vice-President, Director of Marketing: Brandy Dawson

Executive Marketing Manager: Kate Mitchell

Marketing Assistant: Paige Patunas Managing Editor: Melissa Feimer

Project Managers: Barbara Cappuccio and Marlene Gassler

Senior Operations Supervisor: Mary Fischer

Operations Specialist: Diane Peirano Media Director: Brian Hyland Senior Media Editor: David Alick Media Project Manager: Rich Barnes Pearson Imaging Center: Corin Skidds Printer/Binder: Courier / Kendallville

Cover Printer: Lehigh-Phoenix Color / Hagerstown

This book was designed by Laurence King Publishing Ltd, London www.laurenceking.com

Editorial Manager: Kara Hattersley-Smith

Senior Editor: Clare Double Production Manager: Simon Walsh

Page Design: Nick Newton Cover Design: Jo Fernandes Picture Researcher: Evi Peroulaki Copy Editor: Jennifer Speake

Indexer: Vicki Robinson

Cover image: Stele of Amenemhat, from Assasif. Late Eleventh Dynasty, c. 2000 BCE. Painted limestone, 110" × 150" (30 × 50 cm). Egyptian Museum, Cairo. Photo: Jürgen Liepe.

Credits and acknowledgments borrowed from other sources and reproduced, with permission, in this textbook appear on the appropriate page within text or on the credit pages in the back of this book.

Copyright © 2014, 2011, 2008 by Pearson Education, Inc.

All rights reserved. Printed in the United States of America. This publication is protected by Copyright and permission should be obtained from the publisher prior to any prohibited reproduction, storage in a retrieval system, or transmission in any form or by any means, electronic, mechanical, photocopying, recording, or likewise. To obtain permission(s) to use material from this work, please submit a written request to Pearson Education, Inc., Permissions Department, One Lake Street, Upper Saddle River, New Jersey 07458 or you may fax your request to 201–236–3290.

Library of Congress Cataloging-in-Publication Data

Stokstad, Marilyn

Art history / Marilyn Stokstad, Judith Harris Murphy Distinguished Professor of Art History Emerita, The University of Kansas, Michael W. Cothren, Scheuer Family Professor of Humanities, Department of Art, Swarthmore College. -- Fifth edition.

pages cm

Includes bibliographical references and index. ISBN-13: 978-0-205-87347-0 (hardcover) ISBN-10: 0-205-87347-2 (hardcover)

1. Art--History--Textbooks. I. Cothren, Michael Watt. II. Title.

N5300.S923 2013 709--dc23

2012027450

10 9 8 7 6 5 4 3

Prentice Hall is an imprint of

ISBN 10: 0-205-87376-6 ISBN 13: 978-0-205-87376-0

Contents

Letter from the Author vi • What's New vii • MyArtsLab viii • Pearson Choices x • Acknowledgments and Gratitude xi • Use Notes xiii • Starter Kit xiv • Introduction xviii

Prehistoric Art 1

THE STONE AGE 2

THE PALEOLITHIC PERIOD 2

Shelter or Architecture? 4 Artifacts or Works of Art? 5 Cave Painting 8 Cave Sculptures 11

THE NEOLITHIC PERIOD 12

Architecture 13 Sculpture and Ceramics 20

NEW METALLURGY, ENDURING STONE 23

The Bronze Age 23 Rock Carvings 24

BOXES

ART AND ITS CONTEXTS

The Power of Naming 6 Intentional House Burning 16

A BROADER LOOK

Prehistoric Woman and Man 22

A CLOSER LOOK

A House in Çatalhöyük 15

■ ELEMENTS OF ARCHITECTURE

Early Construction Methods 19

■ TECHNIQUE

Prehistoric Wall Painting 8 Pottery and Ceramics 20

■ RECOVERING THE PAST

How Early Art is Dated 12

Art of the Ancient Near East 26

THE FERTILE CRESCENT AND MESOPOTAMIA 28

Sumer 28 Akkad 35 Ur and Lagash 37 Babylon 37

THE HITTITES OF ANATOLIA 37

ASSYRIA 38

Kalhu 38 Dur Sharrukin 41 Nineveh 42

NEO-BABYLONIA 44

PERSIA 44

BOXES

ART AND ITS CONTEXTS

Art as Spoils of War—Protection or Theft? 34 The Code of Hammurabi 39

A BROADER LOOK

A Lyre from a Royal Tomb in Ur 32

A CLOSER LOOK

Enemies Crossing the Euphrates to Escape Assyrian Archers 42

■ TECHNIQUE

Cuneiform Writing 30

Art of Ancient Egypt 48

THE GIFT OF THE NILE 50

EARLY DYNASTIC EGYPT, c. 2950-2575 BCE 50

The God-Kings 50 Artistic Conventions 51 Funerary Architecture 53

THE OLD KINGDOM, c. 2575-2150 BCE 56

The Great Pyramids at Giza 56 Sculpture 58 Pictorial Relief in Tombs 61

THE MIDDLE KINGDOM, C. 1975-C. 1640 BCE 62

Portraits of Senusret III 62 Rock-Cut Tombs 62 Funerary Stelai 63 Town Planning 65

THE NEW KINGDOM, c. 1539-1075 BCE 65

The Great Temple Complexes 65 Hatshepsut 67 The Tomb of Ramose 69 Akhenaten and the Art of the Amarna Period 70 The Return to Tradition: Tutankhamun and Ramses II 73 The Books of the Dead 77

THE THIRD INTERMEDIATE PERIOD, C. 1075-715 BCE 77

LATE EGYPTIAN ART, c. 715-332 BCE 78

BOXES

- ART AND ITS CONTEXTS
 - Egyptian Symbols 51
- A BROADER LOOK

The Temples of Ramses II at Abu Simbel 74

A CLOSER LOOK

The Palette of Narmer 52

■ ELEMENTS OF ARCHITECTURE

Mastaba to Pyramid 55

■ TECHNIQUE

Preserving the Dead 53 Egyptian Pictorial Relief 64 Glassmaking 76

RECOVERING THE PAST

How Early Art is Dated 79

THE BRONZE AGE IN THE AEGEAN 82 THE CYCLADIC ISLANDS 82

THE MINOAN CIVILIZATION ON CRETE 84

The Old Palace Period, C. 1900-1700 BCE 84 The New Palace Period, C. 1700-1450 BCE 85

The Spread of Minoan Culture 90

THE MYCENAEAN (HELLADIC) CULTURE 92

Helladic Architecture 92 Mycenaean Tombs 97 Ceramic Arts 99

BOXES

A BROADER LOOK

The Lion Gate 95

A CLOSER LOOK

The "Flotilla Fresco" from Akrotiri 92

■ TECHNIQUE

Aegean Metalwork 90

■ RECOVERING THE PAST

Pioneers of Aegean Archaeology 85 The "Mask of Agamemnon" 97

IV

THE EMERGENCE OF GREEK CIVILIZATION 102

Historical Background 102

Religious Beliefs and Sacred Places 102

GREEK ART c. 900-c. 600 BCE 102

The Geometric Period 102 The Orientalizing Period 105

THE ARCHAIC PERIOD, c. 600-480 BCE 105

The Sanctuary at Delphi 107 Temples 108 Free-standing Sculpture 114

Painted Pots 117

THE EARLY CLASSICAL PERIOD, c. 480-450 BCE 120

Marble Sculpture 120 Bronze Sculpture 120 Ceramic Painting 126

THE HIGH CLASSICAL PERIOD, c. 450-400 BCE 127

The Akropolis 128 The Parthenon 129 The Propylaia and the Erechtheion 135 The Temple of Athena Nike The Athenian Agora 137 City Plans 138 Stele Sculpture 139

Painting 140

THE LATE CLASSICAL PERIOD, c. 400-323 BCE 141

Sculpture 142 The Art of the Goldsmith 145 Painting and Mosaics 145

THE HELLENISTIC PERIOD, 323-31/30 BCE 147

The Corinthian Order in Hellenistic Architecture 147 Sculpture 149

BOXES

ART AND ITS CONTEXTS

Greek and Roman Deities 104 Classic and Classical 120 Who Owns the Art? The Elgin Marbles and the Euphronios Krater 133 Women at a Fountain House 139 Greek Theaters 148 The Celts 150

A BROADER LOOK

The Tomb of the Diver 124

A CLOSER LOOK

The Death of Sarpedon 119

ELEMENTS OF ARCHITECTURE

The Greek Orders 110

■ TECHNIQUE

Color in Greek Sculpture 113 Black-Figure and Red-Figure 118 "The Canon" of Polykleitos 134

RECOVERING THE PAST

The Riace Warriors 127

THE ETRUSCANS 158

Etruscan Architecture 158 Etruscan Temples 158 Tomb Chambers 160 Works in Bronze 164

THE ROMANS 166

THE REPUBLIC, 509-27 BCE 166

Portrait Sculpture 167 Roman Temples 171

THE EARLY EMPIRE, 27 BCE-96 CE 171

Art in the Age of Augustus 172 The Julio-Claudians 172 Roman Cities and the Roman Home 176 Wall Painting 179 The Flavians 184

THE HIGH IMPERIAL ART OF TRAJAN AND HADRIAN 190

Imperial Architecture 190 Imperial Portraits 200

THE LATE EMPIRE, THIRD AND FOURTH CENTURIES CE 202

The Severan Dynasty 203 The Soldier Emperors 205 Constantine the Great 207 Roman Art after Constantine 211

BOXES

ART AND ITS CONTEXTS

Roman Writers on Art 167 Roman Portraiture 168 August Mau's Four Styles of Pompeian Painting 182 A Painter at Work 183

A BROADER LOOK

The Ara Pacis Augustae 174

A CLOSER LOOK

Sarcophagus with the Indian Triumph of Dionysus 202

ELEMENTS OF ARCHITECTURE

Roman Architectural Orders 161 The Roman Arch 170 Roman Vaulting 187 Concrete 194

TECHNIQUE

Roman Mosaics 199

RECOVERING THE PAST

The Capitoline She-Wolf 165 The Mildenhall Treasure 212

Map 214 • Glossary 215 • Bibliography 224 Credits 227 Index 228

Letter from the Author

Dear Colleagues

Energized by an enthusiasm that was fueled by conviction, I taught my first introductory art history survey course in the late 1970s, soon after the dawn of a period of crisis and creativity in the discipline of art history that challenged the fundamental assumptions behind the survey and questioned the canon of works that had long served as its foundation. Some

professors and programs abandoned the survey altogether; others made it more expansive and inclusive. We all rethought what we were doing, and the soul searching this required made many of us better teachers—more honest and relevant, more passionate and convincing. It was for the subsequent generation of students and teachers, ready to reap the benefits of this refined notion of art history, that Marilyn Stokstad conceived and created her new survey textbook during the 1990s, tailored for students whose lives would unfold in the twenty-first century. It is a humbling honor to have become part of this historic project.

Reconsidering and refining what we do as professors and students of art history, however, did not cease at the turn of the century. The process continues. Like art, our teaching and learning changes as we and our culture change, responding to new expectations and new understandings. Opportunities for growth sometimes emerge in unexpected situations. Recently, while I was inching through sluggish suburban traffic with my daughter Emma—a gifted fifth-grade teacher—I confessed my disappointment in my survey students' dismal performance on the identification portion of their recent exam, lamenting their seeming inability to master basic information about the set of works I expected them to know. "Why," I asked rhetorically, "was it so difficult for them to learn these facts?" Emma's unexpected answer, rooted in her exploration of Grant Wiggins and Jay McTigue's Understanding by Design during a graduate course on curriculum development, shifted the question and reframed the discussion. "Dad," she said, "you are focusing on the wrong aspect of your teaching. What are you trying to accomplish by asking your students to learn those facts for identification on the exam? Question and explore your objectives first, then determine whether your assessment is actually the best way to encourage its accomplishment."

Emma's question, posed while I was planning this fifth edition of Art History, inspired me to pause and reflect more broadly on what it is that we seek to accomplish in art history survey courses. I initiated a series of conversations with professors across the country to take me beyond my own experience and into a national classroom. Many of you provided illuminating feedback, sharing goals and strategies, searching with me for a way of characterizing a shared set of learning outcomes that underlie the survey courses we teach as a way of introducing our students in the present to the study of art from the past. Talking with you helped me formulate language for the essential ideas we want our students to grasp, and characterize succinctly the kinds of knowledge and skills that are required to master them. From these conversations and your feedback, I developed a set of four fundamental outcomes envisioned for the book as a whole, outcomes that would be reflected within each chapter in four coordinated learning objectives at the beginning, and four assessment questions at the end. These overall learning outcomes aim to encompass the goals we share as we introduce the history of art to beginners. Thinking about them has already helped me refocus on what it is I am trying to accomplish in my own classroom. It certainly has alleviated the frustration I shared with Emma about my students' performance on slide IDs. I am now working on new ways to assess their engagement in relation to two fundamental goals—the "big ideas" that are embodied in these learning outcomes: building a knowledge base to anchor cultural understanding, and encouraging the extended examination of works of art, what I call "slow looking."

I hope these ideas, goals, and outcomes resonate as much with you as they have with me, that they will invite you to continue to think with me about the reasons why we believe the study of art history is meaningful and important for our students. After all, our discipline originated in dialogue, and it is rooted in the desire—maybe even the need—to talk with each other about why works of art matter and why they affect us so deeply. I would love to hear from you—mcothre1@swarthmore.edu.

Warm regards,

Michael Cothren

WHY USE THIS NEW EDITION?

Art history—what a wonderful, fascinating, and fluid discipline that evolves as the latest research becomes available for debate and consideration. The fifth edition of *Art History* has been revised to reflect these new discoveries, recent research and fresh interpretive perspectives, and also to address the changing needs of the audience—both students and educators. With these goals in mind, and by incorporating feedback from our many users and reviewers, we have sought to make this fifth edition an improvement over its earlier incarnations in sensitivity, readability, and accessibility without losing anything in comprehensiveness, in scholarly precision, or in its ability to engage readers.

To facilitate student learning and understanding of art history, the fifth edition is centered on four key Learning Outcomes. These overarching outcomes helped steer and shape this revision with their emphasis on the fundamental reasons we teach art history to undergraduates:

LEARNING OUTCOMES FOR ART HISTORY

Explore and understand the developing traditions and cultural exchanges represented by major monuments of world art by

- 1. Identifying the hallmarks of regional and period styles in relation to their technical, formal, and expressive character;
- 2. Understanding the principal themes, subjects, and symbols in the art of a variety of cultures, periods, and locations;
- 3. Probing the relationship of works of art to human history by exploring their cultural, economic, political, social, spiritual, moral, and intellectual contexts, and
- 4. Recognizing and applying the critical thinking, creative inquiry, and disciplined reasoning that stand behind art-historical interpretation, as well as the vocabulary and concepts used to describe and characterize works of art with clarity and power.

Each chapter opens with **Learn About It** objectives to help students focus on the upcoming chapter material and ends with corresponding **Think About It** assessment questions. These tools are rooted in the four learning outcomes stated above and help students think through, apply the chapter material, and synthesize their own viewpoints.

OTHER HIGHLIGHTS OF THE NEW EDITION INCLUDE THE FOLLOWING:

- The chapters are coordinated with significantly expanded MyArtsLab resources that enrich and reinforce student learning (see p. xvi).
- Crosscurrent Questions at the end of each chapter encourage students to compare works from different chapters and probe the relationship of recurrent themes across cultures, times, and places.
- Enriched Recovering the Past boxes document the discovery, re-evaluation, restoration, or conservation of works of art, such as the bronze She-Wolf that was once considered Etruscan and has recently been interpreted as medieval.
- Closer Look features appear in each chapter, guiding students in their exploration of details within a single work of art and helping students to understand issues of usage, iconography, and style. Each Closer Look is expanded and narrated within MyArtsLab to explore technique, style, subject matter, and cultural context.
- Broader Look boxes in each chapter offer an in-depth contextual treatment of a single work of art.
- Global coverage has been deepened with the addition of new works of art and revised discussions that incorporate new scholarship, especially in the area of South and Southeast Asia, whose chapters have been expanded.
- Throughout, images have been updated whenever new and improved images were available or works of art have been cleaned or restored.
- New works have been added to the discussion in many chapters to enhance and enrich what is said in the text. For example, the Disk of Enheduanna, Sphinx of Taharqo, garden mural from Livia's villa at Primaporta, and monastery of St. Catherine's on Mount Sinai. In addition, the following artists are now discussed through new, and more representative, works: Bihzad, Giovanni Pisano, Duccio, Verrocchio, Giambologna, Bronzino, Gentileschi, Hals, Steen, Rubens, Sharaku, Turner, Friedrich, Monet, Degas, Gauguin, Cézanne, and Warhol.
- New artists have been added, notably, Sultan Muhammad, Joan Mitchell, Diane Arbus, and Ed Ruscha.
- The language used to characterize works of art—especially those that attempt to capture the lifelike appearance of the natural world—has been **refined and clarified** to bring greater precision and nuance.
- In response to readers' requests, discussion of many major monuments has been revised and expanded.
- **Byzantine art** has been separated from the treatment of Jewish and Early Christian art for expanded treatment in a new chapter (8) of its own.

MyArtsLab lets your students experience and interact with art

This program will provide a better teaching and learning experience for you and your students. Here's how:

The new MyArtsLab delivers proven results in helping individual students succeed. Its automatically graded assessments, personalized study plan, and interactive eText provide engaging experiences that personalize, stimulate, and measure learning for each student.

- ► The Pearson eText lets students access their textbook anytime, anywhere, and any way they want—including downloading to an iPad or listening to chapter audio read by Michael Cothren and Brian Seymour. Includes a unique scale feature showing students the size of a work in relation to the human figure.
- Personalized study plan for each student promotes critical-thinking skills. Assessment tied to videos, applications, and chapters enables both instructors and students to track progress and get immediate feedback.

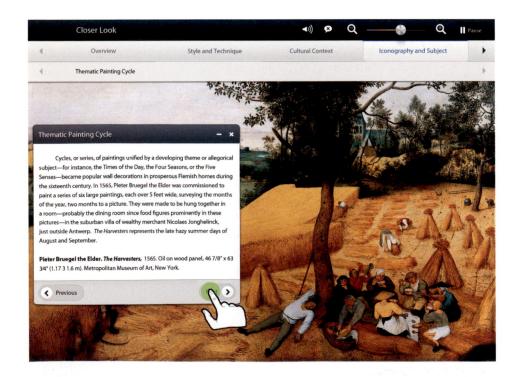

- New: Henry Sayre's Writing About Art 6th edition is now available online in its entirety as an eText within MyArtsLab.
- New and expanded: Closer Look tours—interactive walkthroughs featuring expert audio—offer in-depth looks at key works of art. Now optimized for mobile.
- **New and expanded:** Over 75 in total, 360-degree architectural panoramas and simulations of major monuments help students understand buildings—inside and out. *Now optimized for mobile.*

▶ New: Students on Site videos—over 75 in total, produced and edited by students for students, these 2–3 minute videos provide "you are there" impressions of major monuments, reviewed and approved by art historians. To learn more about how your students can participate, please visit www.pearsonfreeagent.com

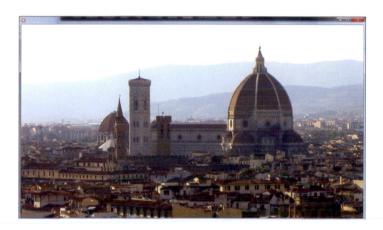

BREAK THROUGH TO A NEW WORLD OF LEARNING

MyArtsLab consistently and positively impacts the quality of learning in the classroom. When educators require and integrate MyArtsLab in their course, students and instructors experience success. Join our ever-growing community of 50,000 users across the country giving their students access to the high quality rich media and assessment on MyArtsLab.

- "Students who use MyArtsLab perform better on their exams than students who do not."
- —Cynthia Kristan-Graham, Auburn University
- "MyArtsLab also makes students more active learners. They are more engaged with the material."
- -Maya Jiménez, Kingsborough Community College
- "MyArtsLab keeps students connected in another way to the course material. A student could be immersed for hours!"
- —Cindy B. Damschroder, University of Cincinnati
- "I really enjoy using MyArtsLab. At the end of the quarter, I ask students to write a paragraph about their experience with MyArtsLab and 97% of them are positive."
- -Rebecca Trittel, Savannah College of Art and Design

Join the conversation!

www.facebook.com/stokstadcothren

Give Your Students Choices

ORDERING OPTIONS

Pearson arts titles are available in the following formats to give you and your students more choices—and more ways to save.

MyArtsLab with eText: the Pearson eText lets students access their textbook anytime, anywhere, and any way they want, including listening online or downloading to an iPad.

MyArtsLab with eText Combined: 0-205-88736-8 MyArtsLab with eText Volume I: 0-205-94839-1 MyArtsLab with eText Volume II: 0-205-94846-4

Build your own Pearson Custom e-course material. Pearson offers the first eBook-building platform that empowers educators with the freedom to search, choose, and seamlessly integrate multimedia. *Contact your Pearson representative to get started.*

The Books à la Carte edition offers a convenient, three-hole-punched, loose-leaf version of the traditional text at a discounted price—allowing students to take only what they need to class. Books à la Carte editions are available both with and without access to MyArtsLab.

Books à la Carte edition Volume I: 0-205-93840-X Books à la Carte edition Volume I plus MyArtsLab: 0-205-93847-7 Books à la Carte edition Volume II: 0-205-93844-2 Books à la Carte edition Volume II plus MyArtsLab: 0-205-93846-9

The CourseSmart eTextbook offers the same content as the printed text in a convenient online format—with highlighting, online search, and printing capabilities. www.coursesmart.com

Art History Portable edition has all of the same content as the comprehensive text in six slim volumes. If your survey course is Western, the Portable Edition is available in value-package combinations to suit Western-focused courses (Books 1, 2, 4, and 6). Portable Edition volumes are also available individually for period or region specific courses.

Book 1 - Ancient Art (Chapters 1-6): 978-0-205-87376-0

Book 2 – Medieval Art (Chapters 7–9, 15–18):

978-0-205-87377-7

Book 3 – A View of the World, Part One (Chapters 9–14): 978-0-205-87378-4

Book 4 – Fourteenth to Seventeenth Century Art (Chapters 18–23): 978–0–205–87379–1

Book 5 – A View of the World, Part Two (Chapters 24–29): 978-0-205-87380-7

Book 6 – Eighteenth to Twenty-first Century Art (Chapters 30–33): 978-0-205-87756-0

INSTRUCTOR RESOURCES

All of our instructor resources are found on MyArtsLab and are available to faculty who adopt *Art History*. These resources include:

PowerPoints featuring nearly every image in the book, with captions and without captions.

Teaching with MyArtsLab PowerPoints help instructors make their lectures come alive. These slides allow instructors to display the very best rich media from MyArtsLab in the classroom—quickly and easily.

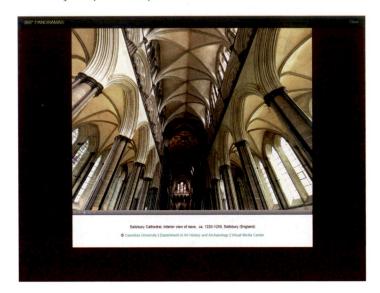

Instructor's Manual and Test Item File

This is an invaluable professional resource and reference for new and experienced faculty.

The Class Preparation Tool collects these and other presentation resources in one convenient online destination.

Acknowledgments and Gratitude

Art History, which was first published in 1995 by Harry N. Abrams, Inc. and Prentice Hall, Inc., continues to rely, each time it is revised, on the work of many colleagues and friends who contributed to the original texts and subsequent editions. Their work is reflected here, and we extend to them our enduring gratitude.

In preparing this fifth edition, we worked closely with two gifted and dedicated editors at Pearson/Prentice Hall, Sarah Touborg and Helen Ronan, whose almost daily support in so many ways was at the center of our work and created the foundation of what we have done. We are continually bolstered by the warm and dedicated support of Yolanda de Rooy, Pearson's President of the Social Sciences and the Arts, and Craig Campanella, Editorial Director. Also at Pearson, Barbara Cappuccio, Marlene Gassler, Melissa Feimer, Cory Skidds, Brian Mackey, David Nitti, and Carla Worner supported us in our work. At Laurence King Publishing, Clare Double, Kara Hattersley-Smith, Julia Ruxton, and Simon Walsh oversaw the production of this new edition. For layout design we thank Nick Newton and for photo research we thank Evi Peroulaki. Much appreciation also goes to Brandy Dawson, Director of Marketing, and Kate Stewart Mitchell, Marketing Manager extraordinaire, as well as the entire Social Sciences and Arts team at Pearson.

FROM MARILYN STOKSTAD: The fifth edition of *Art History* represents the cumulative efforts of a distinguished group of scholars and educators. Over four editions, the work done in the 1990s by Stephen Addiss, Chutsing Li, Marylin M. Rhie, and Christopher D. Roy for the original book has been updated and expanded by David Binkley and Patricia Darish (Africa); Claudia Brown and Robert Mowry (China and Korea); Patricia Graham (Japan); Rick Asher (South and Southeast Asia); D. Fairchild Ruggles (Islamic); Claudia Brittenham (Americas); Sara Orel and Carol Ivory (Pacific Cultures); and Bradford R. Collins, David Cateforis, Patrick Frank, and Joy Sperling (Modern). For this fifth edition, Robert DeCaroli reworked the chapters on South and Southeast Asia.

In addition, I want to thank University of Kansas colleagues Sally Cornelison, Susan Craig, Susan Earle, Charles Eldredge, Kris Ercums, Sherry Fowler, Stephen Goddard, Saralyn Reece Hardy, Marsha Haufler, Marni Kessler, Amy McNair, John Pulz, Linda Stone Ferrier, and John Younger for their help and advice. My thanks also to my friends Katherine Giele and Katherine Stannard, William Crowe, David Bergeron, and Geraldo de Sousa for their sympathy and encouragement. Of course, my very special thanks go to my sister, Karen Leider, and my niece, Anna Leider.

FROM MICHAEL COTHREN: Words are barely adequate to express my gratitude to Marilyn Stokstad for welcoming me with such trust, enthusiasm, and warmth into the collaborative adventure of revising this historic textbook, conceived and written for students in a new century. Working alongside her—and our extraordinary editors Sarah Touborg and Helen Ronan—has been delightful and rewarding, enriching, and challenging. I look forward to continuing the partnership.

My work was greatly facilitated by the research assistance and creative ideas of Moses Hanson-Harding, and I continued to draw on the

work of Fletcher Coleman and Andrew Finegold, who helped with research on the previous edition. I also have been supported by a host of colleagues at Swarthmore College. Generations of students challenged me to hone my pedagogical skills and steady my focus on what is at stake in telling the history of art. My colleagues in the Art Department—especially Stacy Bomento, June Cianfrana, Randall Exon, Laura Holzman, Constance Cain Hungerford, Patricia Reilly, and Tomoko Sakomura—have answered all sorts of questions, shared innumerable insights on works in their areas of expertise, and offered unending encouragement and support. I am so lucky to work with them.

Many art historians have provided assistance, often at a moment's notice, and I am especially grateful to Betina Bergman, Claudia Brown, Elizabeth A.R. Brown, Brigitte Buettner, David Cateforis, Madeline Harrison Caviness, Sarah Costello, Cynthia Kristan-Graham, Joyce de Vries, Cheri Falkenstien-Doyle, Sharon Gerstel, Kevin Glowaki, Ed Gyllenhaal, Julie Hochstrasser, Vida J. Hull, Penny Jolly, Barbara Kellum, Alison Kettering, Benton Kidd, Ann Kuttner, Anne Leader, Steven A. LeBlanc, Cary Liu, Elizabeth Marlowe, Thomas Morton, Kathleen Nolan, David Shapiro, Mary Shepard, Larry Silver, David Simon, Donna Sadler, Jeffrey Chipps Smith, and Mark Tucker.

I was fortunate to have the support of many friends. John Brendler, David Eldridge, Stephen Lehmann, Mary Marissen, Denis Ott, and Bruce and Carolyn Stephens, patiently listened and truly relished my enjoyment of this work.

My preparation for this work runs deep. My parents, Mildred and Wat Cothren, believed in me from the day I was born and made significant sacrifices to support my education from pre-school through graduate school. From an early age, Sara Shymanski, my elementary school librarian, gave me courage through her example and loving encouragement to pursue unexpected passions for history, art, and the search to make them meaningful in both past and present. Françoise Celly, my painting professor during a semester abroad in Provence, by sending me to study the Romanesque sculpture of Autun, began my journey toward art history. At Vanderbilt, Ljubica Popovich fostered this new interest by teaching me about Byzantine art. My extraordinary daughters Emma and Nora remain a constant inspiration. I am so grateful for their delight in my passion for art's history, and for their dedication to keeping me from taking myself too seriously. My deepest gratitude is reserved for Susan Lowry, my wife and soul-mate, who brings joy to every facet of my life. She is not only patient and supportive during the long distractions of my work on this book; she has provided help in so very many ways. The greatest accomplishment of my life in art history occurred on the day I met her at Columbia in 1973.

If the arts are ultimately an expression of human faith and integrity as well as human thought and creativity, then writing and producing books that introduce new viewers to the wonders of art's history, and to the courage and visions of the artists and art historians that stand behind it—remains a noble undertaking. We feel honored to be a part of such a worthy project.

Marilyn Stokstad Lawrence, KS Spring 2012 Michael W. Cothren Swarthmore, PA IN GRATITUDE: As its predecessors did, this fifth edition of Art History benefited from the reflections and assessments of a distinguished team of scholars and educators. The authors and Pearson are grateful to the following academic reviewers for their numerous insights and suggestions for improvement: Kirk Ambrose, University of Colorado, Boulder; Lisa Aronson, Skidmore College; Mary Brantl, St. Edward's University; Denise Budd, Bergen Community College; Anne Chapin, Brevard College; Sheila Dillon, Duke University; William Ganis, Wells College; Sharon Gerstel, University of California, Los Angeles; Kevin Glowacki, Texas A&M University; Amy Golahny, Lycoming College; Steve Goldberg, Hamilton College; Bertha Gutman, Delaware County Community College; Deborah Haynes, University of Colorado, Boulder; Eva Hoffman, Tufts University; Mary Jo Watson, University of Oklahoma; Kimberly Jones, University of Texas, Austin; Barbara Kellum, Smith College; Sarah Kielt Costello, University of Houston; Cynthia Kristan-Graham, Auburn University; Paul Lavy, University of Hawaii at Manoa; Henry Luttikhuizen, Calvin College; Elizabeth Mansfield, New York University; Michelle Moseley Christian, Virginia Tech; Eleanor Moseman, Colorado State University; Sheila Muller, University of Utah; Elizabeth Olton, University of Texas at San Antonio; David Parrish, Purdue University; Tomoko Sakomura, Swarthmore College; Erika Schneider, Framingham State University; David Shapiro; Richard Sundt, University of Oregon; Tilottama Tharoor, New York University; Sarah Thompson, Rochester Institute of Technology; Rebecca Turner, Savannah College of Art and Design; Linda Woodward, LSC Montgomery.

This edition has continued to benefit from the assistance and advice of scores of other teachers and scholars who generously answered questions, gave recommendations on organization and priorities, and provided specialized critiques during the course of work on previous editions.

We are grateful for the detailed critiques from the following readers across the country who were of invaluable assistance during work on the third and fourth editions: Craig Adcock, University of Iowa; Charles M. Adelman, University of Northern Iowa; Fred C. Albertson, University of Memphis; Kimberly Allen-Kattus, Northern Kentucky University; Frances Altvater, College of William and Mary; Michael Amy, Rochester Institute of Technology; Susan Jane Baker, University of Houston; Jennifer L. Ball, Brooklyn College, CUNY; Samantha Baskind, Cleveland State University; Tracey Boswell, Johnson County Community College; Jane H. Brown, University of Arkansas at Little Rock; Stephen Caffey, Texas A&M University; Charlotte Lowry Collins, Southeastern Louisiana University; Roger J. Crum, University of Dayton; Brian A. Curran, Penn State University; Cindy B. Damschroder, University of Cincinnati; Michael T. Davis, Mount Holyoke College; Juilee Decker, Georgetown College; Laurinda Dixon, Syracuse University; Rachael Z. DeLue, Princeton University; Anne Derbes, Hood College; Caroline Downing, State University of New York at Potsdam; Laura Dufresne, Winthrop University; Suzanne Eberle, Kendall College of Art & Design of Ferris State University; April Eisman, Iowa State University; Dan Ewing, Barry University; Allen Farber, State University of New York at Oneonta; Arne Flaten, Coastal Carolina University; John Garton, Cleveland Institute of Art; Richard Gay, University of North Carolina, Pembroke; Regina Gee, Montana State University; Rosi Gilday, University of Wisconsin, Oshkosh; Mimi Hellman, Skidmore College; Julie Hochstrasser, University of Iowa; Eunice D. Howe, University of Southern California; Phillip Jacks, George Washington University; Evelyn Kain, Ripon College; Nancy Kelker, Middle Tennessee State University; Patricia Kennedy, Ocean County College; Jennie Klein, Ohio University; Katie Kresser, Seattle Pacific University; Cynthia Kristan-Graham, Auburn University; Barbara Platten Lash, Northern Virginia Community College; William R. Levin, Centre College; Susan Libby, Rollins College; Henry Luttikhuizen, Calvin College; Lynn Mackenzie, College of DuPage; Elisa C. Mandell, California State University, Fullerton; Pamela Margerm, Kean University; Elizabeth Marlowe, Colgate University; Marguerite Mayhall, Kean University; Katherine A. McIver, University of Alabama at Birmingham; Dennis McNamara, Triton College; Gustav Medicus, Kent State University; Lynn Metcalf, St. Cloud State University; Janine Mileaf, Swarthmore College; Jo-Ann Morgan, Coastal Carolina University; Johanna D. Movassat, San Jose State University; Beth A. Mulvaney, Meredith College; Dorothy Munger, Delaware Community College; Jacqueline Marie Musacchio, Wellesley College; Bonnie Noble, University of North Carolina at Charlotte; Leisha O'Quinn, Oklahoma State University; Lynn Ostling, Santa Rosa Junior College; Willow Partington, Hudson Valley Community College; Martin Patrick, Illinois State University; Ariel Plotek, Clemson University; Patricia V. Podzorski, University of Memphis; Albert Reischuck, Kent State University; Margaret Richardson, George Mason University; James Rubin, Stony Brook University; Jeffrey Ruda,

University of California, Davis; Donna Sandrock, Santa Ana College; Michael Schwartz, Augusta State University; Diane Scillia, Kent State University; Joshua A. Shannon, University of Maryland; Karen Shelby, Baruch College; Susan Sidlauskas, Rutgers University; Jeffrey Chipps Smith, University of Texas, Austin; Royce W. Smith, Wichita State University; Stephanie Smith, Youngstown State University; Stephen Smithers, Indiana State University; Janet Snyder, West Virginia University; Laurie Sylwester, Columbia College (Sonora); Carolyn Tate, Texas Tech University; Rita Tekippe, University of West Georgia; James Terry, Stephens College; Michael Tinkler, Hobart and William Smith Colleges; Amelia Trevelyan, University of North Carolina at Pembroke; Julie Tysver, Greenville Technical College; Jeryln Woodard, University of Houston; Reid Wood, Lorain County Community College. Our thanks also to additional expert readers including: Susan Cahan, Yale University; David Craven, University of New Mexico; Marian Feldman, University of California, Berkeley; Dorothy Johnson, University of Iowa; Genevra Kornbluth, University of Maryland; Patricia Mainardi, City University of New York; Clemente Marconi, Columbia University; Tod Marder, Rutgers University; Mary Miller, Yale University; Elizabeth Penton, Durham Technical Community College; Catherine B. Scallen, Case Western University; Kim Shelton, University of California, Berkeley.

Many people reviewed the original edition of Art History and have continued to assist with its revision. Every chapter was read by one or more specialists. For work on the original book and assistance with subsequent editions thanks goes to: Barbara Abou-el-Haj, SUNY Binghamton; Roger Aiken, Creighton University; Molly Aitken; Anthony Alofsin, University of Texas, Austin; Christiane Andersson, Bucknell University; Kathryn Arnold; Julie Aronson, Cincinnati Art Museum; Michael Auerbach, Vanderbilt University; Larry Beck; Evelyn Bell, San Jose State University; Janetta Rebold Benton, Pace University; Janet Berlo, University of Rochester; Sarah Blick, Kenyon College; Jonathan Bloom, Boston College; Suzaan Boettger; Judith Bookbinder, Boston College; Marta Braun, Ryerson University; Elizabeth Broun, Smithsonian American Art Museum; Glen R. Brown, Kansas State University; Maria Elena Buszek, Kansas City Art Institute; Robert G. Calkins; Annmarie Weyl Carr; April Clagget, Keene State College; William W. Clark, Queens College, CUNY; John Clarke, University of Texas, Austin; Jaqueline Clipsham; Ralph T. Coe; Robert Cohon, The Nelson-Atkins Museum of Art; Alessandra Comini; James D'Emilio, University of South Florida; Walter Denny, University of Massachusetts, Amherst; Jerrilyn Dodds, City College, CUNY; Lois Drewer, Index of Christian Art; Joseph Dye, Virginia Museum of Art; James Farmer, Virginia Commonwealth University; Grace Flam, Salt Lake City Community College; Mary D. Garrard; Paula Gerson, Florida State University; Walter S. Gibson; Dorothy Glass; Oleg Grabar; Randall Griffey, Amherst College; Cynthia Hahn, Florida State University; Sharon Hill, Virginia Commonwealth University; John Hoopes, University of Kansas; Reinhild Janzen, Washburn University; Wendy Kindred, University of Maine at Fort Kent; Alan T. Kohl, Minneapolis College of Art; Ruth Kolarik, Colorado College; Carol H. Krinsky, New York University; Aileen Laing, Sweet Briar College; Janet LeBlanc, Clemson University; Charles Little, The Metropolitan Museum of Art; Laureen Reu Liu, McHenry County College; Loretta Lorance; Brian Madigan, Wayne State University; Janice Mann, Bucknell University; Judith Mann, St. Louis Art Museum; Richard Mann, San Francisco State University; James Martin; Elizabeth Parker McLachlan; Tamara Mikailova, St. Petersburg, Russia, and Macalester College; Anta Montet-White; Anne E. Morganstern, Ohio State University; Winslow Myers, Bancroft School; Lawrence Nees, University of Delaware; Amy Ogata, Cleveland Institute of Art; Judith Oliver, Colgate University; Edward Olszewski, Case Western Reserve University; Sara Jane Pearman; John G. Pedley, University of Michigan; Michael Plante, Tulane University; Eloise Quiñones-Keber, Baruch College and the Graduate Center, CUNY; Virginia Raguin, College of the Holy Cross; Nancy H. Ramage, Ithaca College; Ann M. Roberts, Lake Forest College; Lisa Robertson, The Cleveland Museum of Art; Barry Rubin; Charles Sack, Parsons, Kansas; Jan Schall, The Nelson-Atkins Museum of Art; Tom Shaw, Kean College; Pamela Sheingorn, Baruch College, CUNY; Raechell Smith, Kansas City Art Institute; Lauren Soth; Anne R. Stanton, University of Missouri, Columbia; Michael Stoughton; Thomas Sullivan, OSB, Benedictine College (Conception Abbey); Pamela Trimpe, University of Iowa; Richard Turnbull, Fashion Institute of Technology; Elizabeth Valdez del Alamo, Montclair State College; Lisa Vergara; Monica Visoná, University of Kentucky; Roger Ward, Norton Museum of Art; Mark Weil, St. Louis; David Wilkins; Marcilene Wittmer, University of Miami.

Use Notes

The various features of this book reinforce each other, helping the reader to become comfortable with terminology and concepts that are specific to art history.

Starter Kit and Introduction The Starter Kit is a highly concise primer of basic concepts and tools. The Introduction explores the way they are used to come to an understanding of the history of art.

Captions There are two kinds of captions in this book: short and long. Short captions identify information specific to the work of art or architecture illustrated:

artist (when known)
title or descriptive name of work
date
original location (if moved to a museum or other site)
material or materials a work is made of
size (height before width) in feet and inches, with meters and
centimeters in parentheses
present location

The order of these elements varies, depending on the type of work illustrated. Dimensions are not given for architecture, for most wall paintings, or for most architectural sculpture. Some captions have one or more lines of small print below the identification section of the caption that gives museum or collection information. This is rarely required reading; its inclusion is often a requirement for gaining permission to reproduce the work.

Longer, discursive captions contain information that complements the narrative of the main text.

Definitions of Terms You will encounter the basic terms of art history in three places:

In the Text, where words appearing in boldface type are defined, or glossed, at their first use.

In Boxed Features, on technique and other subjects, where labeled drawings and diagrams visually reinforce the use of terms.

In the Glossary, at the end of the volume (p. 215), which contains all the words in boldface type in the text and boxes.

Maps At the beginning of each chapter you will find a map with all the places mentioned in the chapter.

Boxes Special material that complements, enhances, explains, or extends the narrative text is set off in six types of tinted boxes.

Art and Its Contexts and A Broader Look boxes expand on selected works or issues related to the text. A Closer Look boxes use leader-line captions to focus attention on specific aspects of important works. Elements of Architecture boxes clarify specifically architectural features, often explaining engineering principles or building technology. Technique boxes outline the techniques and processes by which certain types of art are created. Recovering the Past boxes highlight the work of archaeologists who uncover and conservators who assure the preservation and clear presentation of art.

Bibliography The bibliography at the end of this book beginning on page 224 contains books in English, organized by general works and

by chapter, that are basic to the study of art history today, as well as works cited in the text.

Learn About It Placed at the beginning of each chapter, this feature captures in bulleted form the key learning objectives, or outcomes, of the chapter. They point to what will have been accomplished upon its completion.

Think About It These critical thinking questions appear at the end of each chapter and help students assess their mastery of the learning objectives (Learn About It) by asking them to think through and apply what they have learned.

MyArtsLab prompts These notations are found throughout the chapter and are keyed to MyArtsLab resources that enrich and reinforce student learning.

Dates, Abbreviations, and Other Conventions This book uses the designations BCE and CE, abbreviations for "Before the Common Era" and "Common Era," instead of BC ("Before Christ") and AD ("Anno Domini," "the year of our Lord"). The first century BCE is the period from 99 BCE to 1 BCE; the first century CE is from the year 1 CE to 99 CE. Similarly, the second century CE is the period from 199 BCE to 100 BCE; the second century CE extends from 100 CE to 199 CE.

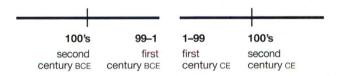

Circa ("about") is used with approximate dates, spelled out in the text and abbreviated to "c." in the captions. This indicates that an exact date is not yet verified.

An illustration is called a "figure," or "fig." Thus, figure 6–7 is the seventh numbered illustration in Chapter 6, and fig. Intro-3 is the third figure in the Introduction. There are two types of figures: photographs of artworks or of models, and line drawings. Drawings are used when a work cannot be photographed or when a diagram or simple drawing is the clearest way to illustrate an object or a place.

When introducing artists, we use the words *active* and *documented* with dates, in addition to "b." (for "born") and "d." (for "died"). "Active" means that an artist worked during the years given. "Documented" means that documents link the person to that date.

Accents are used for words in French, German, Italian, and Spanish only. With few exceptions, names of cultural institutions in Western European countries are given in the form used in that country.

Titles of Works of Art It was only over the last 500 years that paintings and works of sculpture created in Europe and North America were given formal titles, either by the artist or by critics and art historians. Such formal titles are printed in italics. In other traditions and cultures, a single title is not important or even recognized.

In this book we use formal descriptive titles of artworks where titles are not established. If a work is best known by its non-English title, such as Manet's *Le Déjeuner sur l'Herbe (The Luncheon on the Grass)*, the original language precedes the translation.

Starter Kit

Art history focuses on the visual arts—painting, drawing, sculpture, prints, photography, ceramics, metalwork, architecture, and more. This Starter Kit contains basic information and addresses concepts that underlie and support the study of art history. It provides a quick reference guide to the vocabulary used to classify and describe art objects. Understanding these terms is indispensable because you will encounter them again and again in reading, talking, and writing about art.

Let us begin with the basic properties of art. A work of art is a material object having both form and content. It is often described and categorized according to its *style* and *medium*.

FORM

Referring to purely visual aspects of art and architecture, the term form encompasses qualities of line, shape, color, light, texture, space, mass, volume, and composition. These qualities are known as formal elements. When art historians use the term formal, they mean "relating to form."

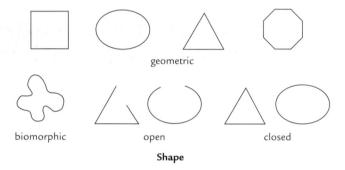

Line and shape are attributes of form. Line is an element—usually drawn or painted—the length of which is so much greater than the width that we perceive it as having only length. Line can be actual, as when the line is visible, or it can be implied, as when the movement of the viewer's eyes over the surface of a work follows a path determined by the artist. Shape, on the other hand, is the two-dimensional, or flat, area defined by the borders of an enclosing *outline* or *contour*. Shape can be *geometric*, *biomorphic* (suggesting living things; sometimes called *organic*), *closed*, or *open*. The *outline* or *contour* of a three-dimensional object can also be perceived as line.

Color has several attributes. These include hue, value, and saturation.

Hue is what we think of when we hear the word color, and the terms are interchangeable. We perceive hues as the result of differing wavelengths of electromagnetic energy. The visible spectrum, which can be seen in a rainbow, runs from red through violet. When the ends of the spectrum are connected through the hue red-violet, the result may be diagrammed as a color wheel. The primary hues (numbered 1) are red, yellow, and blue. They are known as primaries because all other colors are made by combining these hues. Orange, green, and violet result from the mixture of two primaries and are known as secondary hues (numbered 2). Intermediate hues, or tertiaries (numbered 3), result from the mixture of a primary and a secondary. Complementary colors are the two colors directly opposite one

another on the color wheel, such as red and green. Red, orange, and yellow are regarded as warm colors and appear to advance toward us. Blue, green, and violet, which seem to recede, are called cool colors. Black and white are not considered colors but neutrals; in terms of light, black is understood as the absence of color and white as the mixture of all colors.

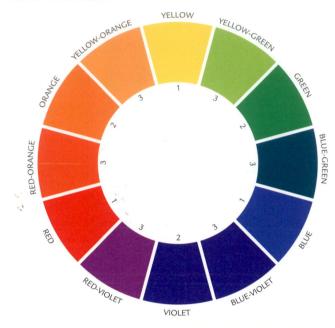

Value is the relative degree of lightness or darkness of a given color and is created by the amount of light reflected from an object's surface. A dark green has a deeper value than a light green, for example. In black-and-white reproductions of colored objects, you see only value, and some artworks—for example, a drawing made with black ink—possess only value, not hue or saturation.

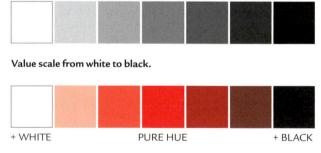

Value variation in red.

Saturation, also sometimes referred to as *intensity*, is a color's quality of brightness or dullness. A color described as highly saturated looks vivid and pure; a hue of low saturation may look a little muddy or grayed.

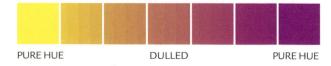

Intensity scale from bright to dull.

Texture, another attribute of form, is the tactile (or touch-perceived) quality of a surface. It is described by words such as *smooth*, *polished*, *rough*, *prickly*, *grainy*, or *oily*. Texture takes two forms: the texture of the actual surface of the work of art and the implied (illusionistically described) surface of objects represented in the work of art.

Space is what contains forms. It may be actual and three-dimensional, as it is with sculpture and architecture, or it may be fictional, represented illusionistically in two dimensions, as when artists represent recession into the distance on a flat surface—such as a wall or a canvas—by using various systems of perspective.

Mass and volume are properties of three-dimensional things. Mass is solid matter—whether sculpture or architecture—that takes up space. Volume is enclosed or defined space, and may be either solid or hollow. Like space, mass and volume may be illusionistically represented on a two-dimensional surface, such as in a painting or a photograph.

Composition is the organization, or arrangement, of forms in a work of art. Shapes and colors may be repeated or varied, balanced symmetrically or asymmetrically; they may be stable or dynamic. The possibilities are nearly endless and artistic choice depends both on the

time and place where the work was created as well as the objectives of individual artists. Pictorial depth (spatial recession) is a specialized aspect of composition in which the three-dimensional world is represented on a flat surface, or *picture plane*. The area "behind" the picture plane is called the *picture space* and conventionally contains three "zones": *foreground*, *middle ground*, and *background*.

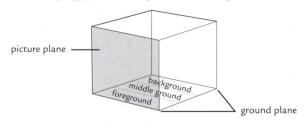

Various techniques for conveying a sense of pictorial depth have been devised by artists in different cultures and at different times. A number of them are diagrammed here. In some European art, the use of various systems of *perspective* has sought to create highly convincing illusions of recession into space. At other times and in other cultures, indications of recession are actually suppressed or avoided to emphasize surface rather than space.

TECHNIQUE | Pictorial Devices for Depicting Recession in Space

overlapping

In overlapping, partially covered elements are meant to be seen as located behind those covering them.

diminution

In diminution of scale, successively smaller elements are perceived as being progressively farther away than the largest ones.

vertical perspective

Vertical perspective stacks elements, with the higher ones intended to be perceived as deeper in space.

atmospheric perspective

Through atmospheric perspective, objects in the far distance (often in bluish-gray hues) have less clarity than nearer objects. The sky becomes paler as it approaches the horizon.

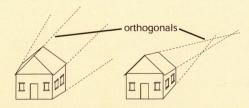

divergent perspective

In divergent or reverse perspective, forms widen slightly and imaginary lines called orthogonals diverge as they recede in space.

intuitive perspective

Intuitive perspective takes the opposite approach from divergent perspective. Forms become narrower and orthogonals converge the farther they are from the viewer, approximating the optical experience of spatial recession.

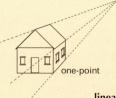

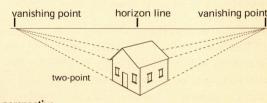

linear perspective

Linear perspective (also called scientific, mathematical, one-point and Renaissance perspective) is a rationalization or standardization of intuitive perspective that was developed in fifteenth-century Italy. It uses mathematical formulas to construct images in which all elements are shaped by, or arranged along, orthogonals that converge in one or more vanishing points on a horizon line.

CONTENT

Content includes subject matter, but not all works of art have subject matter. Many buildings, paintings, sculptures, and other art objects include no recognizable references to things in nature nor to any story or historical situation, focusing instead on lines, colors, masses, volumes, and other formal elements. However, all works of art—even those without recognizable subject matter—have content, or meaning, insofar as they seek to communicate ideas, convey feelings, or affirm the beliefs and values of their makers, their patrons, and usually the people who originally viewed or used them.

Content may derive from the social, political, religious, and economic *contexts* in which a work was created, the *intention* of the artist, and the *reception* of the work by beholders (the audience). Art historians, applying different methods of *interpretation*, often arrive at different conclusions regarding the content of a work of art, and single works of art can contain more than one meaning because they are occasionally directed at more than one audience.

The study of subject matter is called *iconography* (literally, "the writing of images") and includes the identification of *symbols*—images that take on meaning through association, resemblance, or convention.

STYLE

Expressed very broadly, *style* is the combination of form and composition that makes a work distinctive. *Stylistic analysis* is one of art history's most developed practices, because it is how art historians recognize the work of an individual artist or the characteristic manner of groups of artists working in a particular time or place. Some of the most commonly used terms to discuss *artistic styles* include *period style*, *regional style*, *representational style*, *abstract style*, *linear style*, and *painterly style*.

Period style refers to the common traits detectable in works of art and architecture from a particular historical era. It is good practice not to use the words "style" and "period" interchangeably. Style is the sum of many influences and characteristics, including the period of its creation. An example of proper usage is "an American house from the Colonial period built in the Georgian style."

Regional style refers to stylistic traits that persist in a geographic region. An art historian whose specialty is medieval art can recognize Spanish style through many successive medieval periods and can distinguish individual objects created in medieval Spain from other medieval objects that were created in, for example, Italy.

Representational styles are those that describe the appearance of recognizable subject matter in ways that make it seem lifelike.

Realism and Naturalism are terms that some people used interchangeably to characterize artists' attempts to represent the observable world in a manner that appears to describe its visual appearance accurately. When capitalized, Realism refers to a specific period style discussed in Chapter 31.

Idealization strives to create images of physical perfection according to the prevailing values or tastes of a culture. The artist may work in a representational style and idealize it to capture an underlying value or expressive effect.

Illusionism refers to a highly detailed style that seeks to create a convincing illusion of physical reality by describing its visual appearance meticulously.

Abstract styles depart from mimicking lifelike appearance to capture the essence of a form. An abstract artist may work from nature or from a memory image of nature's forms and colors, which are simplified, stylized, perfected, distorted, elaborated, or otherwise transformed to achieve a desired expressive effect.

Nonrepresentational (or Nonobjective) Art is a term often used for works of art that do not aim to produce recognizable natural imagery.

Expressionism refers to styles in which the artist exaggerates aspects of form to draw out the beholder's subjective response or to project the artist's own subjective feelings.

Linear describes both styles and techniques. In linear styles artists use line as the primary means of definition. But linear paintings can also incorporate *modeling*—creating an illusion of three-dimensional substance through shading, usually executed so that brush-strokes nearly disappear.

Painterly describes a style of representation in which vigorous, evident brushstrokes dominate, and outlines, shadows, and highlights are brushed in freely.

MEDIUM AND TECHNIQUE

Medium (plural, *media*) refers to the material or materials from which a work of art is made. Today, literally anything can be used to make a work of art, including not only traditional materials like paint, ink, and stone, but also rubbish, food, and the earth itself.

Technique is the process that transforms media into a work of art. Various techniques are explained throughout this book in Technique boxes. Two-dimensional media and techniques include painting, drawing, prints, and photography. Three-dimensional media and techniques are sculpture (for example, using stone, wood, clay or cast metal), architecture, and many small-scale arts (such as jewelry, containers, or vessels) in media such as ceramics, metal, or wood.

Painting includes wall painting and fresco, illumination (the decoration of books with paintings), panel painting (painting on wood panels), painting on canvas, and handscroll and hanging scroll painting. The paint in these examples is pigment mixed with a liquid vehicle, or binder. Some art historians also consider pictorial media such as mosaic and stained glass—where the pigment is arranged in solid form—as a type of painting.

Graphic arts are those that involve the application of lines and strokes to a two-dimensional surface or support, most often paper. Drawing is a graphic art, as are the various forms of printmaking. Drawings may be sketches (quick visual notes, often made in preparation for larger drawings or paintings); studies (more carefully drawn analyses of details or entire compositions); cartoons (full-scale drawings made in preparation for work in another medium, such as fresco, stained glass, or tapestry); or complete artworks in themselves. Drawings can be made with ink, charcoal, crayon, or pencil. Prints, unlike drawings,

are made in multiple copies. The various forms of printmaking include woodcut, the intaglio processes (engraving, etching, drypoint), and lithography.

Photography (literally, "light writing") is a medium that involves the rendering of optical images on light-sensitive surfaces. Photographic images are typically recorded by a camera.

Sculpture is three-dimensional art that is *carved*, *modeled*, *cast*, or *assembled*. Carved sculpture is subtractive in the sense that the image is created by taking away material. Wood, stone, and ivory are common materials used to create carved sculptures. Modeled sculpture is considered additive, meaning that the object is built up from a material, such as clay, that is soft enough to be molded and shaped. Metal sculpture is usually cast or is assembled by welding or a similar means of permanent joining.

Sculpture is either free-standing (that is, surrounded by space) or in pictorial relief. Relief sculpture projects from the background surface of the same piece of material. High-relief sculpture projects far from its background; low-relief sculpture is only slightly raised; and sunken relief, found mainly in ancient Egyptian art, is carved into the surface, with the highest part of the relief being the flat surface.

Ephemeral arts include processions, ceremonies, or ritual dances (often with décor, costumes, or masks); performance art; earthworks; cinema and video art; and some forms of digital or computer art. All impose a temporal limitation—the artwork is viewable for a finite period of time and then disappears forever, is in a constant state of change, or must be replayed to be experienced again.

Architecture creates enclosures for human activity or habitation. It is three-dimensional, highly spatial, functional, and closely bound with developments in technology and materials. Since it is difficult to capture in a photograph, several types of schematic drawings are commonly used to enable the visualization of a building:

Plans depict a structure's masses and voids, presenting a view from above of the building's footprint or as if it had been sliced horizontally at about waist height.

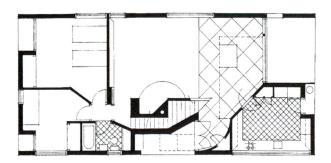

Plan: Philadelphia, Vanna Venturi House

Sections reveal the interior of a building as if it had been cut vertically from top to bottom.

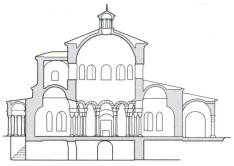

Section: Rome, Sta. Costanza

Isometric drawings show buildings from oblique angles either seen from above ("bird's-eye view") to reveal their basic three-dimensional forms (often cut away so we can peek inside) or from below ("worm's-eye view") to represent the arrangement of interior spaces and the upward projection of structural elements.

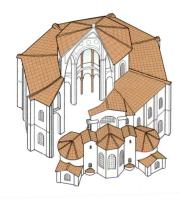

Isometric cutaway from above: Ravenna, San Vitale

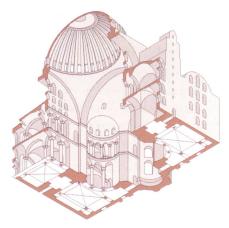

Isometric projection from below: Istanbul, Hagia Sophia

Introduction

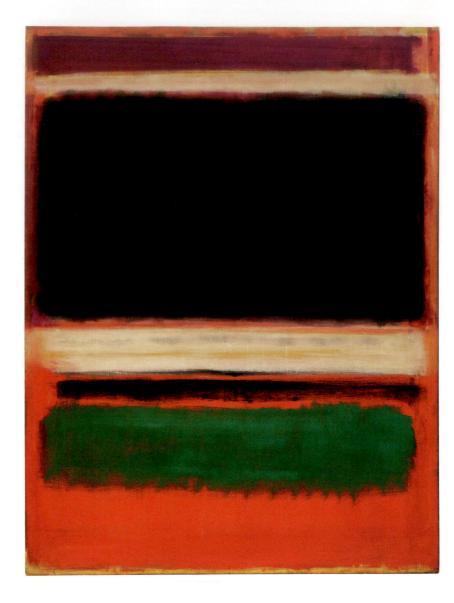

Intro-1 • Mark Rothko MAGENTA, BLACK, GREEN, ON ORANGE (NO. 3/NO. 13)
1949. Oil on canvas, 7'1%" × 5'5" (2.165 × 1.648 m). Museum of Modern Art, New York.

The title of this book seems clear. It defines a field of academic study and scholarly research that has achieved a secure place in college and university curricula across North America. But *Art History* couples two words—even two worlds—that are less well focused when separated. What is art? In what sense does it have a history? Students of art and its history should pause and engage, even if briefly, with these large questions before beginning the journey surveyed in the following chapters.

WHAT IS ART?

Artists, critics, art historians, and the general public all grapple with this thorny question. The *Random House Dictionary* defines "art" as "the quality, production, expression, or realm of what is beautiful, or of more than ordinary significance." Others have characterized "art" as something human-made that combines creative imagination and technical skill, and satisfies an innate desire for order and harmony—perhaps a human hunger for the beautiful. This seems

LEARN ABOUT IT

- **1.1** Explore the methods and objectives of visual analysis.
- 1.2 Assess the way art historians identify conventional subject matter and symbols in the process called iconography.
- I.3 Survey the methods used by art historians to analyze works of art and interpret their meaning within their original cultural contexts.
- **1.4** Trace the process of art-historical interpretation in a case study.

((•• Listen to the chapter audio on myartslab.com

relatively straightforward until we start to look at modern and contemporary art, where there has been a heated and extended debate concerning "What is Art?" The focus is often far from questions of transcendent beauty, ordered design, or technical skill, and centers instead on the conceptual meaning of a work for an elite target audience or the attempt to pose challenging questions or unsettle deep-seated cultural ideas.

The works of art discussed in this book represent a privileged subset of artifacts produced by past and present cultures. They were usually meant to be preserved, and they are currently considered worthy of conservation and display. The determination of which artifacts are exceptional—which are works of art—evolves through the actions, opinions, and selections of artists, patrons, governments, collectors, archaeologists, museums, art historians, and others. Labeling objects as art is usually meant to signal that they transcended or now transcend in some profound way their practical function, often embodying cherished cultural ideas or asserting foundational values. Sometimes it can also mean they are considered beautiful, well designed, and made with loving care, but this is not always the case. We will discover that at various times and places, the complex notion of what is art has little to do with standards of skill or beauty. Some critics and historians argue broadly that works of art are tendentious embodiments of power and privilege, hardly sublime expressions of beauty or truth. After all, art can be unsettling as well as soothing, challenging as well as reassuring, whether made in the present or surviving from the past.

Increasingly, we are realizing that our judgments about what constitutes art—as well as what constitutes beauty—are conditioned by our own education and experience. Whether acquired at home, in classrooms, in museums, at the movies, or on the Internet, our responses to art are learned behaviors, influenced by class, gender, race, geography, and economic status as well as education. Even art historians find that their definitions of what constitutes art—and what constitutes artistic quality—evolve with additional research and understanding. Exploring works by twentieth–century painter Mark Rothko and nineteenth–century quilt–makers Martha Knowles and Henrietta Thomas demonstrates how definitions of art and artistic value are subject to change over time.

Rothko's painting, MAGENTA, BLACK, GREEN, ON ORANGE (NO. 3/NO. 13) (FIG. Intro-1), is a well-known example of the sort of abstract painting that was considered the epitome of artistic sophistication by the mid-twentieth-century New York art establishment. It was created by an artist who meant it to be a work of art. It was acquired by the Museum of Modern Art in New York, and its position on the walls of that museum is a sure sign of its acceptance as art by a powerful cultural institution. However, beyond the context of the American artists, dealers, critics, and collectors who made up Rothko's art world, such paintings were often received with skepticism. They were seen by many as incomprehensible—lacking both technical skill and recognizable subject matter, two criteria that were part of the general public's

definition of art at the time. Abstract paintings soon inspired a popular retort: "That's not art; my child could do it!" Interestingly enough, Rothko saw in the childlike character of his own paintings one of the qualities that made them works of art. Children, he said, "put forms, figures, and views into pictorial arrangements, employing out of necessity most of the rules of optical **perspective** and geometry but without the knowledge that they are employing them." He characterized his own art as childlike, as "an attempt to recapture the freshness and naiveté of childish vision." In part because they are carefully crafted by an established artist who provided these kinds of intellectual justifications for their character and appearance, Rothko's abstract paintings are broadly considered works of art and are treasured possessions of major museums across the globe.

Works of art, however, do not always have to be created by individuals who perceive themselves as artists. Nor are all works produced for an art market surrounded by critics and collectors ready to explain, exhibit, and disperse them, ideally to prestigious museums. Such is the case with this quilt (FIG. Intro-2), made by Martha Knowles and Henrietta Thomas a century before Rothko's painting. Their work is similarly composed of blocks of color, and like Rothko, they produced their visual effect by arranging these flat chromatic shapes carefully and regularly on a rectangular field. But this quilt was not meant to hang on the wall of an art museum. It is the social product of a friendship, intended as an intimate gift, presented to a loved one for use in her home. An inscription on the quilt itself makes this clear—"From M.A. Knowles to her

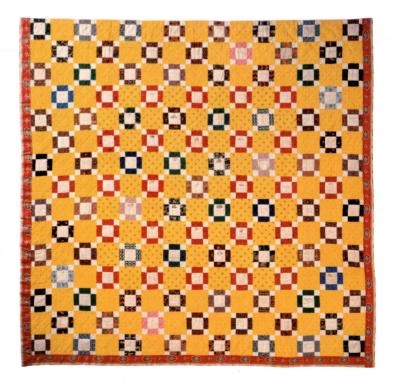

Intro-2 • Martha Knowles and Henrietta Thomas MY SWEET SISTER EMMA

1843. Cotton quilt, $8'11''\times 9'1''$ (2.72 \times 2.77 m). International Quilt Studies Center, University of Nebraska, Lincoln, Nebraska.

ART AND ITS CONTEXTS | Art and Architecture

This book contains much more than paintings and textiles. Within these pages you will also encounter sculpture, vessels, books, jewelry, tombs, chairs, photographs, architecture, and more. But as with Rothko's *Magenta, Black, Green, on Orange (No. 3/No. 13)* (see Fig. Intro–1) and Knowles and Thomas's *My Sweet Sister Emma* (see Fig. Intro–2), criteria have been used to determine which works are selected for inclusion in a book titled *Art History*. Architecture presents an interesting case.

Buildings meet functional human needs by enclosing human habitation or activity. Many works of architecture, however, are considered "exceptional" because they transcend functional demands by manifesting distinguished architectural design or because they embody in important ways the values and goals of the culture that built them. Such buildings are usually produced by architects influenced, like painters, by great works and traditions from the past. In some cases they harmonize with, or react to, their natural or urban surroundings. For such reasons, they are discussed in books on the history of art.

Typical of such buildings is the church of Nôtre-Dame-du-Haut in Ronchamp, France, designed and constructed between 1950 and 1955

by Swiss architect Charles-Edouard Jeanneret, better known by his pseudonym, Le Corbusier. This building is the product of a significant historical moment, rich in international cultural meaning. A pilgrimage church on this site had been destroyed during World War II, and the creation here of a new church symbolized the end of a devastating war, embodying hopes for a brighter global future. Le Corbusier's design—drawing on sources that ranged from Algerian mosques to imperial Roman villas, from crab shells to airplane wings—is sculptural as well as architectural. It soars at the crest of a hill toward the sky but at the same time seems solidly anchored in the earth. And its coordination with the curves of the natural landscape complement the creation of an outdoor setting for religious ceremonies (to the right in the figure) to supplement the church interior that Le Corbusier characterized as a "container for intense concentration." In fact, this building is so renowned today as a monument of modern architecture, that the bus-loads of pilgrims who arrive at the site are mainly architects and devotees of architectural history.

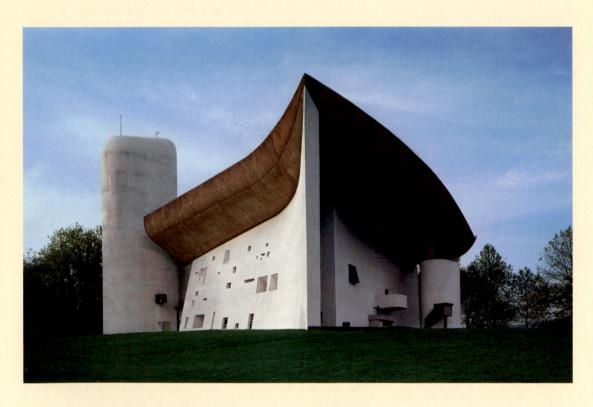

Intro-3 • Le Corbusier NÔTRE-DAME-DU-HAUT Ronchamp, France. 1950– 1955.

Sweet Sister Emma, 1843." Thousands of such friendship quilts were made by women during the middle years of the nineteenth century for use on beds, either to provide warmth or as a covering spread. Whereas quilts were sometimes displayed to a broad and enthusiastic audience of producers and admirers at competitions held at state and county fairs, they were not collected by art museums or revered by artists until relatively recently.

In 1971, at the Whitney Museum in New York—an establishment bastion of the art world in which Rothko moved and

worked—art historians Jonathan Holstein and Gail van der Hoof mounted an exhibition entitled "Abstract Design in American Quilts," demonstrating the artistic affinity we have already noted in comparing the way Knowles and Thomas, like Rothko, create abstract patterns with fields of color. Quilts were later accepted—or perhaps "appropriated"—as works of art and hung on the walls of a New York art museum because of their visual similarities with the avant-garde, abstract works of art created by establishment, New York artists.

Art historian Patricia Mainardi took the case for quilts one significant step further in a pioneering article of 1973 published in The Feminist Art Journal. Entitled, "Quilts: The Great American Art," her argument was rooted not only in the aesthetic affinity of quilts with the esteemed work of contemporary abstract painters, but also in a political conviction that the definition of art had to be broadened. What was at stake here was historical veracity. Mainardi began, "Women have always made art. But for most women, the arts highest valued by male society have been closed to them for just that reason. They have put their creativity instead into the needlework arts, which exist in fantastic variety wherever there are women, and which in fact are a universal female art, transcending race, class, and national borders." She argued for the inclusion of quilts within the history of art to give deserved attention to the work of women artists who had been excluded from discussion because they created textiles and because they worked outside the male-dominated professional structures of the art world—because they were women. Quilts now hang as works of art on the walls of museums and appear with regularity in books that survey the history of art.

As these two examples demonstrate, definitions of art are rooted in cultural systems of value that are subject to change. And as they change, the list of works considered by art historians is periodically revised. Determining what to study is a persistent part of the art historian's task.

WHAT IS ART HISTORY?

There are many ways to study or appreciate works of art. Art history represents one specific approach, with its own goals and its own methods of assessment and interpretation. Simply put, art historians seek to understand the meaning of art from the past within its original cultural contexts, both from the point of view of its producers—artists, architects, and patrons—as well as from the point of view of its consumers—those who formed its original audience. Coming to an understanding of the cultural meaning of a work of art requires detailed and patient investigation on many levels, especially with art that was produced long ago and in societies distinct from our own. This is a scholarly rather than an intuitive exercise. In art history, the work of art is seen as an embodiment of the values, goals, and aspirations of its time and place of origin. It is a part of culture.

Art historians use a variety of theoretical perspectives and a host of interpretive strategies to come to an understanding of works of art within their cultural contexts. But as a place to begin, the work of art historians can be divided into four types of investigation:

- 1. assessment of physical properties,
- 2. analysis of visual or formal structure,
- 3. identification of subject matter or conventional symbolism, and
- 4. integration within cultural context.

ASSESSING PHYSICAL PROPERTIES

Of the methods used by art historians to study works of art, this is the most objective, but it requires close access to the work itself. Physical properties include shape, size, materials, and technique. For instance, many pictures are rectangular (e.g., see FIG. Intro-1), but some are round (see page xxiii, FIG. C). Paintings as large as Rothko's require us to stand back if we want to take in the whole image, whereas some paintings (see page xxii, FIG. A) are so small that we are drawn up close to examine their detail. Rothko's painting and Knowles and Thomas's quilt are both rectangles of similar size, but they are distinguished by the materials from which they are made—oil paint on canvas versus cotton fabric joined by stitching. In art history books, most physical properties can only be understood from descriptions in captions, but when we are in the presence of the work of art itself, size and shape may be the first thing we notice. To fully understand medium and technique, however, it may be necessary to employ methods of scientific analysis or documentary research to elucidate the practices of artists at the time when and place where the work was created.

ANALYZING FORMAL STRUCTURE

Art historians explore the visual character that artists bring to their works—using the materials and the techniques chosen to create them—in a process called **formal analysis**. On the most basic level, it is divided into two parts:

- assessing the individual visual elements or formal vocabulary that constitute pictorial or sculptural communication, and
- discovering the overall arrangement, organization, or structure of an image, a design system that art historians often refer to as composition.

THE ELEMENTS OF VISUAL EXPRESSION Artists control and vary the visual character of works of art to give their subjects and ideas meaning and expression, vibrancy and persuasion, challenge or delight (see "A Closer Look," page xxii). For example, the motifs, objects, figures, and environments within paintings can be sharply defined by line (see FIGS. Intro-2, Intro-4), or they can be suggested by a sketchier definition (see FIGS. Intro-1, Intro-5). Painters can simulate the appearance of three-dimensional form through modeling or shading (see FIG. Intro-4 and page xxiii, FIG. C), that is, by describing the way light from a single source will highlight one side of a solid while leaving the other side in shadow. Alternatively, artists can avoid any strong sense of threedimensionality by emphasizing patterns on a surface rather than forms in space (see Fig. Intro-1 and page xxii, Fig. A). In addition to revealing the solid substance of forms through modeling, dramatic lighting can also guide viewers to specific areas of a picture (see page xxii, FIG. B), or it can be lavished on every aspect of a picture to reveal all its detail and highlight the vibrancy of its color (see page xxiii, FIG. D). Color itself can be muted or intensified, depending on the mood artists want to create or the tastes and expectations of their audiences.

A CLOSER LOOK | Visual Elements of Pictorial Expression: Line, Light, Form, and Color

LINE

A. Carpet Page from the Lindisfarne Gospels From Lindisfarne, England. c. 715–720. Ink and tempera on vellum, 13% × 9%6" (34 × 24 cm). British Library, London. Cotton MS Nero D.IV fol. 26v

Every element in this complicated painting is sharply outlined by abrupt barriers between light and dark or between one color and another; there are no gradual or shaded transitions. Since the picture was created in part with pen and ink, the linearity is a logical extension of medium and technique. And although line itself is a "flattening" or two-dimensionalizing element in pictures, a complex and consistent system of overlapping gives the linear animal forms a sense of shallow but carefully worked-out three-dimensional relationships to one another.

LIGHT

B. Georges de la Tour The Education of the Virgin c. 1650. Oil on canvas, $33'' \times 391/2''$ (83.8×100.4 cm). The Frick Collection, New York.

The source of illumination is a candle depicted within the painting. The young girl's upraised right hand shields its flame, allowing the artist to demonstrate his virtuosity in painting the translucency of human flesh.

Since the candle's flame is partially concealed, its luminous intensity is not allowed to distract from those aspects of the painting most brilliantly illuminated by it—the face of the girl and the book she is reading.

 $\overline{ extbf{View}}$ the Closer Look for visual elements of pictorial expression: line, light, form, and color on myartslab.com

FORM

C. Michelangelo The Holy Family (Doni Tondo) c. 1503. Oil and

tempera on panel, diameter 3'111/4" (1.2 m). Galleria degli Uffizi, Florence.

The complex overlapping of their highly three-dimensionalized bodies conveys the somewhat contorted spatial positioning and relationship of these three figures.

Through the use of modeling or shading—a gradual transition from lights to darks—Michelangelo imitates the way solid forms are illuminated from a single light source—the side closest to the light source is bright while the other side is cast in shadow—and gives a sense of three-dimensional form to his figures.

In a technique called **foreshortening**, the carefully calculated angle of the Virgin's elbow makes it seem to project out toward the viewer.

The actual three-dimensional projection of the sculpted heads in medallions around the frame—designed for this painting by Michelangelo himself—heightens the effect of fictive three-dimensionality in the figures painted on its flat surface.

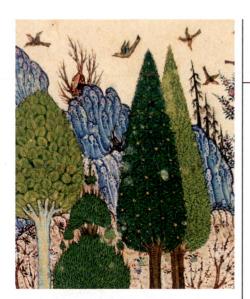

Junayd chose to flood every aspect of his painting with light, as if everything in it were illuminated from all sides at once. As a result, the emphasis here is on jewel-like color. The vibrant tonalities and dazzling detail of the dreamy landscape are not only more important than the simulation of three-dimensional forms distributed within a consistently described space; they actually upstage the human drama taking place against a patterned, tipped-up ground in the lower third of the picture.

COLOR

D. Junayd *Humay and Humayun*, from a manuscript of the *Divan* of Kwaju Kirmani

Made in Baghdad, Iraq. 1396. Color, ink, and gold on paper, $12\frac{5}{8}$ " \times $9\frac{7}{16}$ " (32 \times 24 cm). British Library, London. MS Add. 18113, fol. 31r

Thus, artists communicate with their viewers by making choices in the way they use and emphasize the elements of visual expression, and art-historical analysis seeks to reveal how artists' decisions bring meaning to a work of art. For example, in two paintings of women with children (see FIGS. Intro-4, Intro-5), Raphael and Renoir work with the same visual elements of line, form, light, and color in the creation of their images, but they employ these shared elements to differing expressive ends. Raphael concentrates on line to clearly differentiate each element of his picture as a separate form. Careful modeling describes these outlined forms as substantial solids surrounded by space. This gives his subjects a sense of clarity, stability, and grandeur. Renoir, on the other hand, foregrounds the flickering of light and the play of color as he downplays the sense of three-dimensionality in individual forms. This gives his image a more ephemeral, casual sense. Art historians pay close attention to such variations in the use of

visual elements—the building blocks of artistic expression—and use visual analysis to characterize the expressive effect of a particular work, a particular artist, or a general period defined by place and date.

COMPOSITION When art historians analyze composition, they focus not on the individual elements of visual expression but on the overall arrangement and organizing design or structure of a work of art. In Raphael's **MADONNA OF THE GOLDFINCH** (**FIG. Intro-4**), for example, the group of figures has been arranged in a triangular shape and placed at the center of the picture. Raphael emphasized this central weighting by opening the clouds to reveal a

patch of blue in the middle of the sky, and by flanking the figural group with lacelike trees. Since the Madonna is at the center and since the two boys are divided between the two sides of the triangular shape, roughly—though not precisely—equidistant from the center of the painting, this is a bilaterally symmetrical composition: on either side of an implied vertical line at the center of the picture, there are equivalent forms on left and right, matched and balanced in a mirrored correspondence. Art historians refer to such an implied line—around which the elements of a picture are organized—as an axis. Raphael's painting has not only a vertical, but also a horizontal axis, indicated by a line of demarcation between light and dark—as well as between degrees of color saturation—in the terrain of the landscape. The belt of the Madonna's dress is aligned with this horizontal axis, and this correspondence, taken with the coordination of her head with the blue patch in the sky, relates her harmoniously to the natural world in which

Intro-4 • Raphael MADONNA OF THE GOLDFINCH (MADONNA DEL CARDELLINO)

1506. Oil on panel, 42" \times 29½" (106.7 \times 74.9 cm). Galleria degli Uffizi, Florence.

The vibrant colors of this important work were revealed in the course of a careful, ten-year restoration, completed only in 2008.

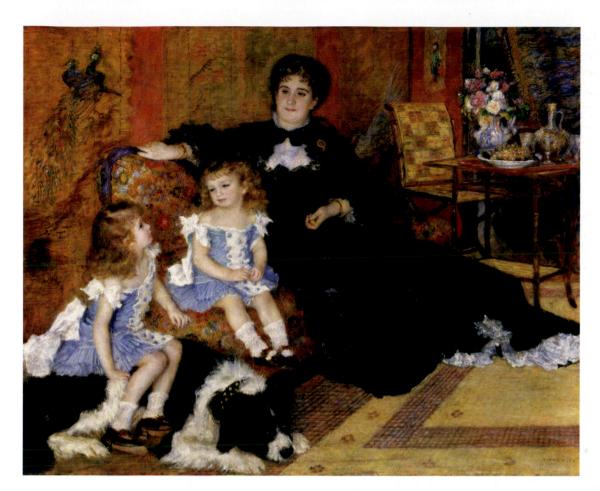

Intro-5 • Auguste Renoir MME. CHARPENTIER AND HER CHILDREN 1878. Oil on canvas, 601/2" × 747/8" (153.7 × 190.2 cm). Metropolitan Museum of Art, New York.

she sits, lending a sense of stability, order, and balance to the picture as a whole.

The main axis in Renoir's painting of MME. CHARPEN-TIER AND HER CHILDREN (FIG. Intro-5) is neither vertical, nor horizontal, but diagonal, running from the upper right to the lower left corner of the painting. All major elements of the composition are aligned along this axis-dog, children, mother, and the table and chair that represent the most complex and detailed aspect of the setting. The upper left and lower right corners of the painting balance each other on either side of the diagonal axis as relatively simple fields of neutral tone, setting off and framing the main subjects between them. The resulting arrangement is not bilaterally symmetrical, but blatantly asymmetrical, with the large figural mass pushed into the left side of the picture. And unlike Raphael's composition, where the spatial relationship of the figures and their environment is mapped by the measured placement of elements that become increasingly smaller in scale and fuzzier in definition as they recede into the background, the relationship of Renoir's figures to their spatial environment is less clearly defined as they recede into the background along the dramatic diagonal axis. Nothing distracts us from the bold informality of this family gathering.

Both Raphael and Renoir arrange their figures carefully and purposefully, but they follow distinctive compositional systems that communicate different notions of the way these figures interact with each other and the world around them. Art historians pay special attention to how pictures are arranged because composition is one of the principal ways artists charge their paintings with expressive meaning.

IDENTIFYING SUBJECT MATTER

Art historians have traditionally sought subject matter and meaning in works of art with a system of analysis that was outlined by Erwin Panofsky (1892–1968), an influential German scholar who was expelled from his academic position by the Nazis in 1933 and spent the rest of his career of research and teaching in the United States. Panofsky proposed that when we seek to understand the subject of a work of art, we derive meaning initially in two ways:

- First we perceive what he called "natural subject matter" by recognizing forms and situations that we know from our own experience.
- Then we use what he called "iconography" to identify the conventional meanings associated with forms and figures as bearers of narrative or symbolic content, often specific to a particular time and place.

Some paintings, like Rothko's abstractions and Knowles and Thomas's quilt, do not contain subjects drawn from the world around us, from stories, or from conventional symbolism, but Panofsky's scheme remains a standard method of investigating

A CLOSER LOOK | Iconography

The study and identification of conventional themes, motifs, and symbols to elucidate the subject matter of works of art.

These grapes sit on an imported, Italian silver *tazza*, a luxury object that may commemorate northern European prosperity and trade. This particular object recurs in several of Peeters's other still lifes.

An image of the artist herself appears on the reflective surface of this pewter tankard, one of the ways that she signed her paintings and promoted her career.

Luscious fruits and flowers celebrate the abundance of nature, but because these fruits of the earth will eventually fade, even rot, they could be moralizing references to the transience of earthly existence.

Detailed renderings of insects showcased Peeters's virtuosity as a painter, but they also may have symbolized the vulnerability of the worldly beauty of flowers and fruit to destruction and decay.

These coins, including one minted in 1608–1609, help focus the dating of this painting. The highlighting of money within a still life could reference the wealth of the owner—or it could subtly allude to the value the artist has crafted here in paint.

This knife—which appears in several of Peeters's still lifes—is of a type that is associated with wedding gifts.

A. Clara Peeters Still Life with Fruit and Flowers

c. 1612. Oil on copper, $251/5'' \times 35''$ (64 \times 89 cm). Ashmolean Museum, Oxford.

Quince is an unusual subject in Chinese painting, but the fruit seems to have carried personal significance for Zhu Da. One of his friends was known as the Daoist of Quince Mountain, a site in Hunan Province that was also the subject of a work by one of his favorite authors, Tang poet Li Bai.

The artist's signature reads "Bada Shanren painted this," using a familiar pseudonym in a formula and calligraphic style that the artist ceased using in 1695.

This red block is a seal with an inscription drawn from a Confucian text: "Teaching is half of learning." This was imprinted on the work by the artist as an aspect of his signature, a symbol of his identity within the picture, just as the reflection and inscribed knife identify Clara Peeters as the painter of her still life.

B. Zhu Da (Bada Shanren) *Quince (Mugua)* 1690. Album leaf mounted as a hanging scroll; ink and colors on paper, $7\%'' \times 5\%'''$ (20 × 14.6 cm). Princeton University Art Museum.

View the Closer Look for iconography on myartslab.com

meaning in works of art that present narrative subjects, portray specific people or places, or embody cultural values with iconic imagery or allegory.

NATURAL SUBJECT MATTER We recognize some things in works of visual art simply by virtue of living in a world similar to that represented by the artist. For example, in the two paintings by Raphael and Renoir just examined (see FIGS. Intro-4, Intro-5), we immediately recognize the principal human figures in both as a woman and two children, boys in the case of Raphael's painting, girls in Renoir's. We can also make a general identification of the animals: a bird in the hand of Raphael's boys, and a pet dog under one of Renoir's girls. And natural subject matter can extend from an identification of figures to an understanding of the expressive significance of their postures and facial features. We might see in the boy who snuggles between the knees of the woman in Raphael's painting, placing his own foot on top of hers, an anxious child seeking the security of physical contact with a trusted caretaker—perhaps his mother—in response to fear of the bird he reaches out to touch. Many of us have seen insecure children take this very pose in response to potentially unsettling encounters.

The closer the work of art is in both time and place to our own situation temporally and geographically, the easier it sometimes is to identify what is represented. But although Renoir painted his picture over 125 years ago in France, the furniture in the background still looks familiar, as does the book in the hand of Raphael's Madonna, painted five centuries before our time. But the object hanging from the belt of the scantily clad boy at the left in this painting will require identification for most of us. Iconographic investigation is necessary to understand the function of this form.

ICONOGRAPHY Some subjects are associated with conventional meanings established at a specific time or place; some of the human figures portrayed in works of art have specific identities; and some of the objects or forms have symbolic or allegorical meanings in addition to their natural subject matter. Discovering these conventional meanings of art's subject matter is called iconography. (See "A Closer Look," opposite.)

For example, the woman accompanied in the outdoors by two boys in Raphael's *Madonna of the Goldfinch* (see FIG. Intro-4) would have been immediately recognized by members of its intended early sixteenth-century Florentine audience as the Virgin Mary. Viewers would have identified the naked boy standing between her knees as her son Jesus, and the boy holding the bird as Jesus' cousin John the Baptist, sheathed in the animal skin garment that he would wear in the wilderness and equipped with a shallow cup attached to his belt, ready to be used in baptisms. Such attributes of clothing and equipment are often critical in making iconographic identifications. The goldfinch in the Baptist's hand was at this time and place a symbol of Christ's death on the cross, an allegorical implication that makes the Christ Child's retreat

into secure contact with his mother—already noted on the level of natural subject matter—understandable in relation to a specific story. The comprehension of conventional meanings in this painting would have been almost automatic among those for whom it was painted, but for us, separated by time and place, some research is necessary to recover associations that are no longer part of our everyday world.

Although it may not initially seem as unfamiliar, the subject matter of Renoir's 1878 portrait of Mme. Charpentier and her Children (see FIG. Intro-5) is in fact even more obscure. There are those in twenty-first-century American culture for whom the figures and symbols in Raphael's painting are still recognizable and meaningful, but Marguérite-Louise Charpentier died in 1904, and no one living today would be able to identify her based on the likeness Renoir presumably gave to her face in this family portrait commissioned by her husband, the wealthy and influential publisher Georges Charpentier. We need the painting's title to make that identification. And Mme. Charpentier is outfitted here in a gown created by English designer Charles Frederick Worth, the dominant figure in late nineteenth-century Parisian high fashion. Her clothing was a clear attribute of her wealth for those who recognized its source; most of us need to investigate to uncover its meaning. But a greater surprise awaits the student who pursues further research on her children. Although they clearly seem to our eyes to represent two daughters, the child closest to Mme. Charpentier is actually her son Paul, who at age 3, following standard Parisian bourgeois practice, has not yet had his first haircut and still wears clothing comparable to that of his older sister Georgette, perched on the family dog. It is not unusual in art history to encounter situations where our initial conclusions on the level of natural subject matter will need to be revised after some iconographic research.

INTEGRATION WITHIN CULTURAL CONTEXT

Natural subject matter and iconography were only two of three steps proposed by Panofsky for coming to an understanding of the meaning of works of art. The third step he labeled "iconology," and its aim is to interpret the work of art as an embodiment of its cultural situation, to place it within broad social, political, religious, and intellectual contexts. Such integration into history requires more than identifying subject matter or conventional symbols; it requires a deep understanding of the beliefs and principles or goals and values that underlie a work of art's cultural situation as well as the position of an artist and patron within it.

In "A Closer Look" (opposite), the subject matter of two **still life** paintings (pictures of inanimate objects and fruits or flowers taken out of their natural contexts) is identified and elucidated, but to truly understand these two works as bearers of cultural meaning, more knowledge of the broader context and specific goals of artists and audiences is required. For example, the fact that Zhu Da (1626–1705) became a painter was rooted more in the political than the artistic history of China at the middle of the seventeenth century. As a member of the imperial family of the Ming dynasty,

his life of privilege was disrupted when the Ming were overthrown during the Manchu conquest of China in 1644. Fleeing for his life, he sought refuge in a Buddhist monastery, where he wrote poetry and painted. Almost 40 years later, in the aftermath of a nervous breakdown (that could have been staged to avoid retribution for his family background), Zhu Da abandoned his monastic life and developed a career as a professional painter, adopting a series of descriptive pseudonyms—most notably Bada Shanren ("mountain man of eight greatnesses") by which he is most often known today. His paintings are at times saturated with veiled political commentary; at times they seek to accommodate the expectations of collectors to assure their marketability; and in paintings like the one illustrated here (see page xxvi, FIG. B), the artist seems to hark back to the contemplative, abstract, and spontaneous paintings associated with great Zen masters such as Muqi (c. 1201-after 1269), whose calligraphic pictures of isolated fruits seem almost like acts of devotion or detached contemplations on natural forms, rather than the works of a professional painter.

Clara Peeters's still life (see page xxvi, FIG. A), on the other hand, fits into a developing Northern European painting tradition within which she was an established and successful professional, specializing in portrayals of food and flowers, fruit and reflective objects. Still-life paintings in this tradition could be jubilant celebrations of the abundance of the natural world and the wealth of luxury objects available in the prosperous mercantile society of the Netherlands. Or they could be moralizing "vanitas" paintings, warning of the ephemeral meaning of those worldly possessions, even of life itself. But this painting has also been interpreted in a more personal way. Because the type of knife that sits in the foreground near the edge of the table was a popular wedding gift, and since it is inscribed with the artist's own name, some have suggested that this still life could have celebrated Peeters's marriage. Or this could simply be a witty way to sign her picture. It certainly could be personal and at the same time participate in the broader cultural meaning of still-life paintings. Mixtures of private and public meanings have been proposed for Zhu Da's paintings as well. Some have seen the picture of quince illustrated here (see page xxvi, FIG. B) as part of a series of allegorical "self-portraits" that extend across his career as a painter. Art historians frequently reveal multiple meanings when interpreting single works. Art often represents complex cultural and personal situations.

A CASE STUDY: ROGIER VAN DER WEYDEN'S PHILADELPHIA CRUCIFIXION

The basic, four-part method of art historical investigation and interpretation just outlined and explored may become clearer when its extended use is traced in relation to one specific work of art. A particularly revealing subject for such a case study is a

seminal and somewhat perplexing painting now in the Philadelphia Museum of Art—the CRUCIFIXION WITH THE VIRGIN AND ST. JOHN THE EVANGELIST (FIG. Intro-6) by Rogier van der Weyden (c. 1400–1464), a Flemish artist who will be featured in Chapter 19. Each of the four levels of art-historical inquiry reveals important information about this painting, information that has been used by art historians to reconstruct its relationship to its artist, its audience, and its broader cultural setting. The resulting interpretation is rich, but also complex. An investigation this extensive will not be possible for all the works of art in the following chapters, where the text will focus only on one or two facets of more expansive research. Because of the amount and complexity of information involved in a thorough art-historical interpretation, it is sometimes only in a second reading that we can follow the subtleties of its argument, after the first reading has provided a basic familiarity with the work of art, its conventional subjects, and its general context.

PHYSICAL PROPERTIES

Perhaps the most striking aspect of this painting's physical appearance is its division into two separate tall rectangular panels, joined by a frame to form a coherent, almost square composition. These are oak panels, prepared with chalk to form a smooth surface on which to paint with mineral pigments suspended in oil. A technical investigation of the painting in 1981 used infrared reflectography to reveal a very sketchy under-drawing beneath the surface of the paint, proving to the investigators that this painting is almost entirely the work of Rogier van der Weyden himself. Famous and prosperous artists of this time and place employed many assistants to work in large production workshops, and they would make detailed under-drawings to ensure that assistants replicated the style of the master. But in cases where the masters themselves intended to execute the work, only summary compositional outlines were needed. Modern technical investigation of Rogier's painting also used dendrochronology (the dating of wood based on the patterns of the growth rings) to date the oak panels and consequently the painting itself, now securely situated near the end of the artist's career, c. 1460.

The most recent restoration of the painting—during the early 1990s by Mark Tucker, Senior Conservator at the Philadelphia Museum of Art—returned it, as close as possible, to current views of its original fifteenth-century appearance (see "De-restoring and Restoring Rogier van der Weyden's *Crucifixion*," page xxx). This project included extensive technical analysis of almost every aspect of the picture, during which a critical clue emerged, one that may lead to a sharper understanding of its original use. X-rays revealed dowel holes and plugs running in a horizontal line about one-fourth of the way up from the bottom across the entire expanse of the two-panel painting. Tucker's convincing research suggests that the dowels would have attached these two panels to the backs of wooden boxes that contained sculptures in a complex work of art that hung over the altar in a fifteenth-century church.

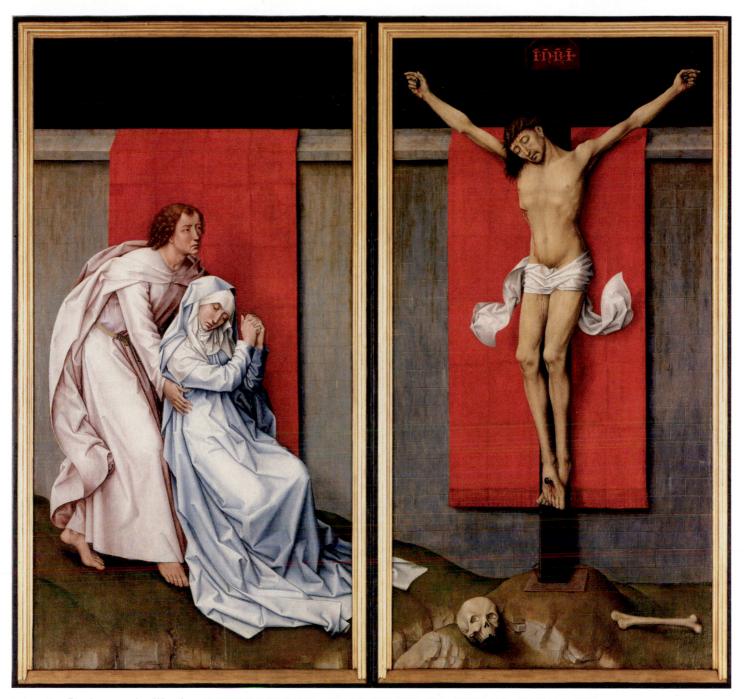

Intro-6 • Rogier van der Weyden CRUCIFIXION WITH THE VIRGIN AND ST. JOHN THE EVANGELIST c. 1460. Oil on oak panels, $71'' \times 73''$ (1.8 \times 1.85 m). John G. Johnson Collection, Philadelphia Museum of Art.

FORMAL STRUCTURE

The visual organization of this two-part painting emphasizes both connection and separation. It is at the same time one painting and two. Continuing across both panels is the strip of midnight blue sky and the stone wall that constricts space within the picture to a shallow corridor, pushing the figures into the foreground and close to the viewer. The shallow strip of mossy ground under the two-figure group in the left panel continues its sloping descent into the right panel, as does the hem of the Virgin's ice-blue garment. We look into this scene as if through a window with a mullion down

the middle and assume that the world on the left continues behind this central strip of frame into the right side.

On the other hand, strong visual forces isolate the figures within their respective panels, setting up a system of "compare and contrast" that seems to be at the heart of the painting's design. The striking red cloths that hang over the wall are centered directly behind the figures on each side, forming internal frames that highlight them as separate groups and focus our attention back and forth between them rather than on the pictorial elements that unite their environments. As we begin to compare the two sides,

RECOVERING THE PAST | De-restoring and Restoring Rogier van der Weyden's Crucifixion

Ever since Rogier van der Weyden's strikingly asymmetrical, twopanel rendering of the Crucifixion (see FIG. Intro-6) was purchased by Philadelphia lawyer John G. Johnson in 1906 for his spectacular collection of European paintings, it has been recognized not only as one of the greatest works by this master of fifteenth-century Flemish painting, but as one of the most important European paintings in North America. Soon after the Johnson Collection became part of the Philadelphia Museum of Art in 1933, however, this painting's visual character was significantly transformed. In 1941, the museum employed freelance restorer David Rosen to work on the painting. Deciding that Rogier's work was seriously marred by later overpainting and disfigured by the discoloration of old varnish, he subjected the painting to a thorough cleaning. He also removed the strip of dark blue paint forming the sky above the wall at the top-identifying it as an eighteenth-century restoration—and replaced it with gold leaf to conform with remnants of gold in this area that he assessed as surviving fragments of the original background. Rosen's restoration of Rogier's painting was uncritically accepted for almost half a century, and the gold background became a major factor in the interpretations of art historians as distinguished as Erwin Panofsky and Meyer Schapiro.

In 1990, in preparation for a new installation of the work, Rogier's painting received a thorough technical analysis by Mark Tucker, the museum's Senior Conservator. There were two startling discoveries:

- The dark blue strip that had run across the top of the picture before Rosen's intervention was actually original to the painting. Remnants of paint left behind in 1941 proved to be the same azurite blue that also appears in the clothing of the Virgin, and in no instance did the traces of gold discovered in 1941 run under aspects of the original paint surface. Rosen had removed Rogier's original midnight blue sky.
- What Rosen had interpreted as disfiguring varnish streaking the
 wall and darkening the brilliant cloths of honor hanging over it
 were actually Rogier's careful painting of lichens and water stains
 on the stone and his overpainting on the fabric that had originally
 transformed a vermillion undercoat into deep crimson cloth.

In meticulous work during 1992–1993, Tucker cautiously restored the painting based on the evidence he had uncovered. Neither the lost lichens and water stains nor the toning crimson overpainting of the hangings were replaced, but a coat of blue-black paint was laid over Rosen's gold leaf at the top of the panels, taking care to apply the new layer in such a way that should a later generation decide to return to the gold leaf sky, the midnight tonalities could be easily removed. That seems an unlikely prospect. The painting as exhibited today comes as close as possible to the original appearance of Rogier's *Crucifixion*. At least we think so.

it becomes increasingly clear that the relationship between figures and environment is quite distinct on each side of the divide.

The dead figure of Christ on the cross, elevated to the very top of the picture, is strictly centered within his panel, as well as against the cloth that hangs directly behind him. The grid of masonry blocks and creases in the cloth emphasizes his rectilinear integration into a system of balanced, rigid regularity. His head is aligned with the cap of the wall, his flesh largely contained within the area defined by the cloth. His elbows mark the juncture of the wall with the edge of the hanging, and his feet extend just to the end of the cloth, where his toes substitute for the border of fringe they overlap. The environment is almost as balanced. The strip of dark sky at the top is equivalent in size to the strip of mossy earth at the bottom of the picture, and both are visually bisected by centered horizontals—the cross bar at the top and the alignment of bone and skull at the bottom. A few disruptions to this stable, rectilinear, symmetrical order draw the viewers' attention to the panel at the left: the downward fall of the head of Christ, the visual weight of the skull, the downturn of the fluttering loin cloth, and the tip of the Virgin's gown that transgresses over the barrier to move in from the other side.

John and Mary merge on the left into a single figural mass that could be inscribed into a half-circle. Although set against a rectilinear grid background comparable to that behind Jesus, they contrast with, rather than conform to, the regular sense of order. Their curving outlines offer unsettling unsteadiness, as if they are toppling to the ground, jutting into the other side of the frame. This instability is reinforced by their postures. The projection of Mary's knee in relation to the angle of her torso reveals that she is collapsing into a curve, and the crumpled mass of drapery circling underneath her only underlines her lack of support. John reaches out to catch her, but he has not yet made contact with her body. He strikes a stance of strident instability without even touching the ground, and he looks blankly out into space with an unfocused expression, distracted from, rather than concentrating on, the task at hand. Perhaps he will come to his senses and grab her. But will he be able to catch her in time, and even then support her, given his unstable posture? The moment is tense; the outcome is unclear. But we are moving into the realm of natural subject matter. The poignancy of this concentrated portrayal seems to demand it.

ICONOGRAPHY

The subject of this painting is among the most familiar themes in the history of European art. The dead Jesus has been crucified on the cross, and two of his closest associates—his mother and John, one of his disciples—mourn his loss. Although easily recognizable, the austere and asymmetrical presentation is unexpected. More usual is an earlier painting of this subject by the same artist, **CRUCIFIXION TRIPTYCH WITH DONORS AND SAINTS** (FIG. Intro-7), where he situates the crucified Christ at the center

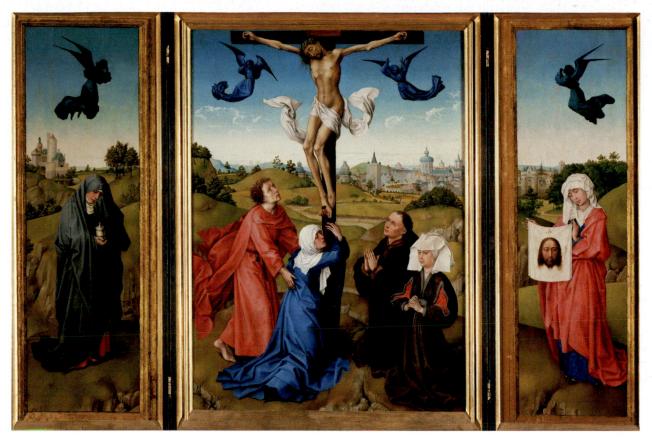

Intro-7 • Rogier van der Weyden CRUCIFIXION TRIPTYCH WITH DONORS AND SAINTS c. 1440. Oil on wooden panels, $393\%'' \times 55''$ (101 × 140 cm). Kunsthistorisches Museum, Vienna.

of a symmetrical arrangement, the undisputed axial focus of the composition. The scene unfolds here within an expansive land-scape, populated with a wider cast of participants, each of whom takes a place with symmetrical decorum on either side of the cross. Because most crucifixions follow some variation on this pattern, Rogier's two-panel portrayal (see FIG. Intro-6) in which the cross is asymmetrically displaced to one side, with a spare cast of attendants relegated to a separately framed space, severely restricted by a stark stone wall, requires some explanation. As does the mysterious dark world beyond the wall, and the artificial backdrop of the textile hangings.

This scene is not only austere and subdued; it is sharply focused, and the focus relates it to the specific moment in the story that Rogier decided to represent. The Christian Bible contains four accounts of Jesus' crucifixion, one in each of the four Gospels. Rogier took two verses in John's account as his painting's text (John 19:26–27), cited here in the Douai-Reims literal English translation (1582, 1609) of the Latin Vulgate Bible that was used by Western European Christians during the fifteenth century:

When Jesus therefore had seen his mother and the disciple standing whom he loved, he saith to his mother: Woman, behold thy son. After that, he saith to the disciple: Behold thy mother. And from that hour, the disciple took her to his own.

Even the textual source uses conventions that need explanation, specifically the way the disciple John is consistently referred to in this Gospel as "the disciple whom Jesus loved." Rogier's painting, therefore, seems to focus on Jesus' call for a newly expanded relationship between his mother and a beloved follower. More specifically, he has projected us slightly forward in time to the moment when John needs to respond to that call—Jesus has died; John is now in charge.

There are, however, other conventional iconographic associations with the crucifixion that Rogier has folded into this spare portrayal. Fifteenth-century viewers would have understood the skull and femur that lie on the mound at the base of the cross as the bones of Adam—the first man in the Hebrew Bible account of creation—on whose grave Jesus' crucifixion was believed to have taken place. This juxtaposition embodied the Christian belief that Christ's sacrifice on the cross redeemed believers from the death that Adam's original sin had brought to human existence.

Mary's swoon and presumed loss of consciousness would have evoked another theological idea, the *co-passio*, in which Mary's anguish while witnessing Jesus' suffering and death was seen as a parallel passion of mother with son, both critical for human salvation. Their connection in this painting is underlined visually by the similar bending of their knees, inclination of their heads, and closing of their eyes. They even seem to resemble each other in facial likeness, especially when compared to John.

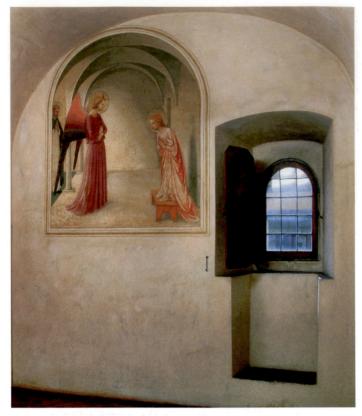

Intro-8 • VIEW OF A MONK'S CELL IN THE MONASTERY OF SAN MARCO, FLORENCE

Including Fra Angelico's fresco of the Annunciation. c. 1438-1445.

CULTURAL CONTEXT

In 1981 art historian Penny Howell Jolly published an interpretation of Rogier's Philadelphia *Crucifixion* as the product of a broad personal and cultural context. In addition to building on the work of earlier art historians, she pursued two productive lines of investigation to explain the rationale for this unusually austere presentation:

- the prospect that Rogier was influenced by the work of another artist, and
- the possibility that the painting was produced for an institutional context that called for a special mode of visual presentation and a particular iconographic focus.

FRA ANGELICO AT SAN MARCO We know very little about the life of Rogier van der Weyden, but we do know that in 1450, when he was already established as one of the principal painters in northern Europe, he made a pilgrimage to Rome. Either on his way to Rome, or during his return journey home, he stopped off in Florence and saw the **altarpiece**, and presumably also the frescos, that Fra Angelico (c. 1400–1455) and his workshop had painted during the 1440s at the monastery of San Marco. The evidence of Rogier's contact with Fra Angelico's work is found in a work Rogier painted after he returned home, based on a panel of the San Marco altarpiece. For the Philadelphia *Crucifixion*,

however, it was Fra Angelico's devotional frescos on the walls of the monks' individual rooms (or cells) that seem to have had the greatest impact (FIG. Intro-8). Jolly compared the Philadelphia Crucifixion with a scene of the Mocking of Christ at San Marco to demonstrate the connection (FIG. Intro-9). Fra Angelico presented the sacred figures with a quiet austerity that recalls Rogier's unusual composition. More specific parallels are the use of an expansive stone wall to restrict narrative space to a shallow foreground corridor, the description of the world beyond that wall as a dark sky that contrasts with the brilliantly illuminated foreground, and the use of a draped cloth of honor to draw attention to a narrative vignette from the life of Jesus, to separate it out as an object of devotion.

THE CARTHUSIANS Having established a possible connection between Rogier's unusual late painting of the crucifixion and frescos by Fra Angelico that he likely saw during his pilgrimage to Rome in 1450, Jolly reconstructed a specific context of patronage and meaning within Rogier's own world in Flanders that could explain why the paintings of Fra Angelico would have had such an impact on him at this particular moment in his career.

During the years around 1450, Rogier developed a personal and professional relationship with the monastic order of

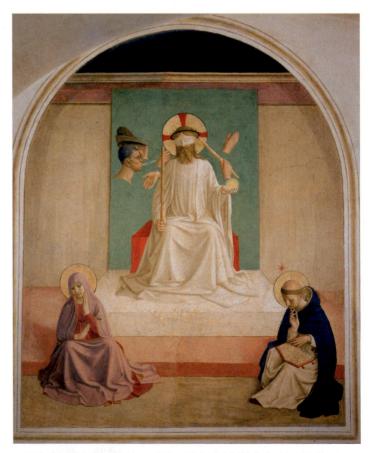

Intro-9 • Fra Angelico MOCKING OF CHRIST WITH THE VIRGIN MARY AND ST. DOMINIC

Monastery of San Marco, Florence. c. 1441-1445.

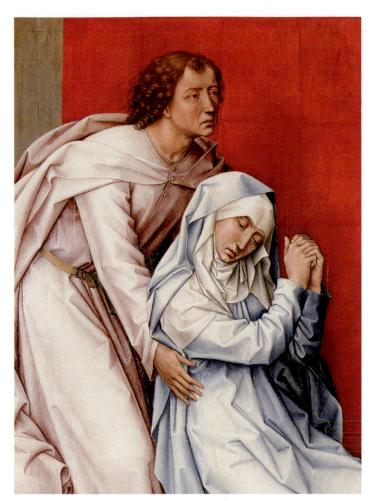

Intro-10 • DETAIL OF FIG. Intro-6 SHOWING PART OF THE LEFT WING

the Carthusians, and especially with the Belgian Charterhouse (or Carthusian monastery) of Hérrines, where his oldest son was invested as a monk in 1450. Rogier gave money to Hérrines, and texts document his donation of a painting to its chapel of St. Catherine. Jolly suggested that the Philadelphia *Crucifixion* could be that painting. Its subdued colors and narrative austerity are consistent with Carthusian aesthetic attitudes, and the walled setting of the scene recalls the enclosed gardens that were attached to the

individual dormitory rooms of Carthusian monks. The reference in this painting to the *co-passio* of the Virgin provides supporting evidence since this theological idea was central to Carthusian thought and devotion. The *co-passio* was even reflected in the monks' own initiation rites, during which they re-enacted and sought identification with both Christ's sacrifice on the cross and the Virgin's parallel suffering.

In Jolly's interpretation, the religious framework of a Carthusian setting for the painting emerges as a personal framework for the artist himself, since this *Crucifixion* seems to be associated with important moments in his own life—his religious pilgrimage to Rome in 1450 and the initiation of his oldest son as a Carthusian monk at about the same time. Is it possible that the sense of loss and separation that Rogier evoked in his portrayal of a poignant moment in the life of St. John (FIG. Intro-10) could have been especially meaningful to the artist himself at the time this work was painted?

A CONTINUING PROJECT The final word has not been spoken in the interpretation of this painting. Mark Tucker's recent work on the physical evidence revealed by x-ray analysis points toward seeing these two panels as part of a large sculptured altarpiece. Even if this did preclude the prospect that it is the panel painting Rogier donated to the chapel of St. Catherine at Hérrines, it does not negate the relationship Jolly drew with Fra Angelico, nor the Carthusian context she outlined for the work's original situation. It simply reminds us that our historical understanding of works such as this will evolve when new evidence about them emerges.

As the history of art unfolds in the ensuing chapters of this book, it will be important to keep two things in mind as you read the characterizations of individual works of art and the larger story of their integration into the broader cultural contexts of those who made them and those for whom they were initially made. Arthistorical interpretations are built on extended research comparable to that we have just summarily surveyed for Rogier van der Weyden's Philadelphia *Crucifixion*. But the work of interpretation is never complete. Art history is a continuing project, a work perpetually in progress.

THINK ABOUT IT

- I.1 Analyze the composition of one painting illustrated in this Introduction.
- 1.2 Characterize the difference between natural subject matter and iconography, focusing your discussion on a specific work of art.
- I.3 What are the four separate steps proposed here for characterizing the methods used by art historians to interpret works of art? Characterize the cultural analysis in step four by showing
- the way it expands our understanding of one of the still lifes in the Closer Look.
- I.4 What aspect of the case study of Rogier van der Weyden's Philadelphia Crucifixion was especially interesting to you? Why? How did it broaden your understanding of what you will learn in this course?

Study and review on myartslab.com

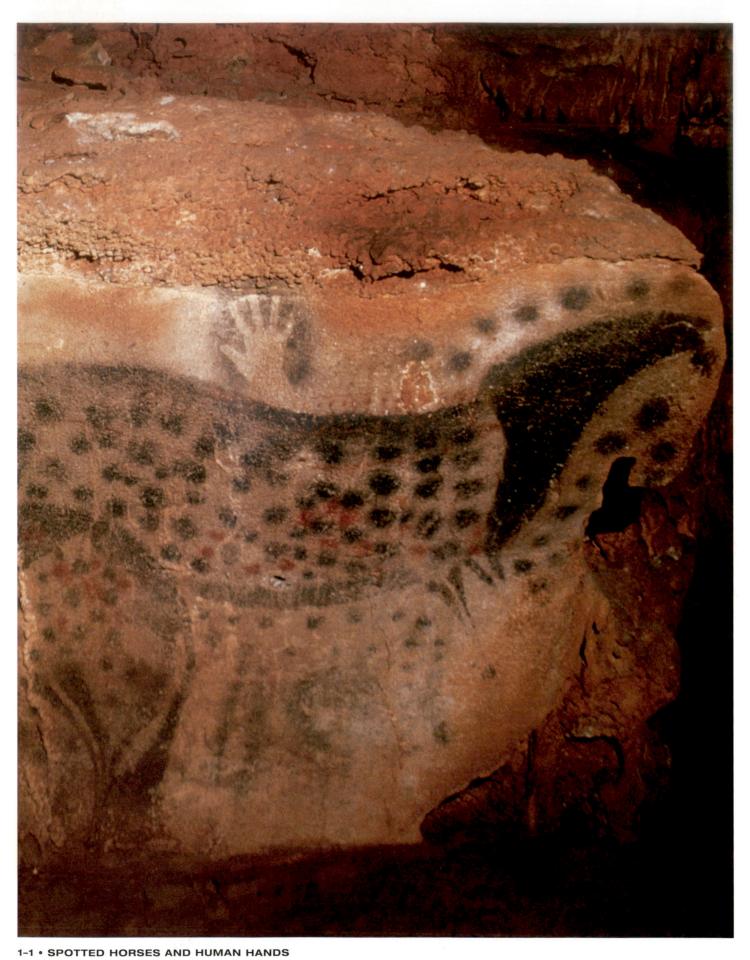

Pech-Merle Cave. Dordogne, France. Horses 25,000–24,000 BCE; hands c. 15,000 BCE. Paint on limestone, individual horses over 5' (1.5 m) in length.

Prehistoric Art

The detail shown at left features one of two horses, positioned back to back on the wall of a chamber within the Pech-Merle Cave, located in the Dordogne region of modern France (FIG. 1-1). The tapering head of this horse follows the natural shape of the rock. Black dots surround portions of its contours and fill most of its body, a striking feature that was once believed to be decorative, until DNA analysis of the remains of prehistoric horses, published in 2011, proved that one species flourishing at this time actually was spotted. In this instance, at least, prehistoric painters were painting what they saw. At a later date, a large fish (58 inches long and very difficult to see) was painted in red on top of the spots. Yet the painters left more than images of horses and fish; they left their own handprints in various places around the animals. These images, and many others hidden in chambers at the ends of long, narrow passages within the cave, connect us to an almost unimaginably ancient world of 25,000 BCE.

Prehistory includes all of human existence before the emergence of writing, and long before that people were carving objects, painting images, and creating shelters and other structures. Thirty thousand years ago our ancestors were not making "works of art" and there were no "artists" as we use the term today. They were flaking, chipping, and polishing flints into spear points, knives, and scrapers, not into sculptures, even if we find these artifacts pleasing to the

eye and to the touch. And wall paintings must have seemed equally important as these tools to their prehistoric makers, in terms of everyday survival, not visual delight.

For art historians, archaeologists, and anthropologists, prehistoric "art" provides a significant clue—along with fossils, pollen, and other artifacts—to help us understand early human life and culture. Specialists continue to discover more about when and how these works were created. In 2012, for instance, an international team of scientists used a refined dating technology known as the uranium-thorium method (see "How Early Art is Dated," page 12) to prove that some paintings in a Spanish cave known as El Castillo are at least 40,000 years old—probably much older—raising the possibility that they could have been painted by Neanderthals rather than *Homo sapiens*.

We may never know exactly why these prehistoric paintings were made. In fact, there may be no single meaning or use for any one image on a cave wall; cave art probably meant different things to the different people who saw it, depending on their age, their experience, or their specific needs and desires. And the sculpture, paintings, and structures that survive are but a tiny fraction of what must have been created over a very long time span. The conclusions and interpretations we draw from them are only hypotheses, making prehistoric art one of the most speculative, but dynamic and exciting, areas of art history.

LEARN ABOUT IT

- 1.1 Explore the variety of styles, techniques, and traditions represented by what remains of prehistoric art and architecture, and probe its technical, formal, and expressive character.
- **1.2** Survey the principal themes, subjects, and symbols in prehistoric painting, sculpture, and objects.
- 1.3 Investigate how art historians and anthropologists have speculated on the cultural meanings of works for which there is no written record to provide historical context.
- **1.4** Grasp the concepts and vocabulary used to describe and characterize prehistoric art and architecture.

THE STONE AGE

How and when modern humans evolved is the subject of ongoing debate, but anthropologists now agree that the species called *Homo sapiens* appeared about 400,000 years ago, and that the subspecies to which we belong, *Homo sapiens sapiens* (usually referred to as modern humans), evolved as early as 120,000 years ago. Based on archaeological evidence, it is now clear that modern humans spread from Africa across Asia, into Europe, and finally to Australia and the Americas. This vast movement of people took place between 100,000 and 35,000 years ago.

Scholars began the systematic study of prehistory only about 200 years ago. Nineteenth-century archaeologists, struck by the wealth of stone tools, weapons, and figures found at ancient sites, named the whole period of early human development the Stone Age. Today, researchers divide the Stone Age into two parts: Paleolithic (from the Greek *paleo-*, "old," and *lithos*, "stone") and Neolithic (from the Greek *neo-*, "new"). They divide the Paleolithic period itself into three phases reflecting the relative position of objects found in the layers of excavation: Lower (the oldest), Middle, and Upper (the most recent). In some places archaeologists

1-2 • RAINBOW SERPENT ROCK Western Arnhem Land, Australia.

Appearing in Australia as early as 6000 BCE, images of the Rainbow Serpent play a role in rituals and legends of the creation of human beings, the generation of rains, storms, and floods, and the reproductive power of nature and people.

can identify a transitional, or Mesolithic (from the Greek *meso-*, "middle") period.

The dates for the transition from Paleolithic to Neolithic vary with geography and with local environmental and social circumstances. For some of the places discussed in this chapter, such as Western Europe, the Neolithic way of living did not emerge until 3000 BCE; in others, such as the Near East, it appeared as early as 8000 BCE. Archaeologists mark time in so many years ago, or BP ("before present"). However, to ensure consistent style throughout the book, which reflects the usage of art historians, this chapter uses BCE (before the Common Era) and CE (the Common Era) to mark time.

Much is yet to be discovered about prehistoric art. In Australia, some of the world's very oldest images have been dated to between 50,000 and 40,000 years ago, and the tradition of transient communities who marked the land in complex, yet stunningly beautiful ways continues into historical time. In western Arnhem Land (Fig. 1-2), rock art images of the Rainbow Serpent have their origins in prehistory, and were perhaps first created during times of substantial changes in the environment. Africa, as well, is home to ancient rock art in both its northern and southern regions. In all cases, archaeologists associate the arrival of modern humans in these regions with the advent of image making.

Indeed, it is the cognitive capability to create and recognize symbols and imagery that sets us as modern humans apart from all our predecessors and from all our contemporary animal relatives. We are defined as a species by our abilities to make and understand art. This chapter focuses primarily on the rich traditions of prehistoric European art from the Paleolithic and Neolithic periods and into the Bronze Age (MAP 1-1). Later chapters consider the prehistoric art of other continents and cultures, such as China (Chapter 11) and sub-Saharan Africa (Chapter 14).

THE PALEOLITHIC PERIOD

Human beings made tools long before they made what today we call "art." Art, in the sense of image making, is the hallmark of the Upper Paleolithic period and the emergence of our subspecies, Homo sapiens sapiens. Representational images appear in the archaeological record beginning about 38,000 BCE in Australia, Africa, and Europe. Before that time, during the Lower Paleolithic period in Africa, early humans made tools by flaking and chipping (knapping) flint pebbles into blades and scrapers with sharp edges. Dating to 2.5 million years ago, the earliest objects made by our human ancestors were simple stone tools, some with sharp edges, that were used to cut animal skin and meat and bash open bones to reveal the marrow, and also to cut wood and soft plant materials. These first tools have been found at sites such as Olduvai Gorge in Tanzania. Although not art, they document a critical development in our evolution: humans' ability to transform the world around them into specific tools and objects that could be used to complete a task.

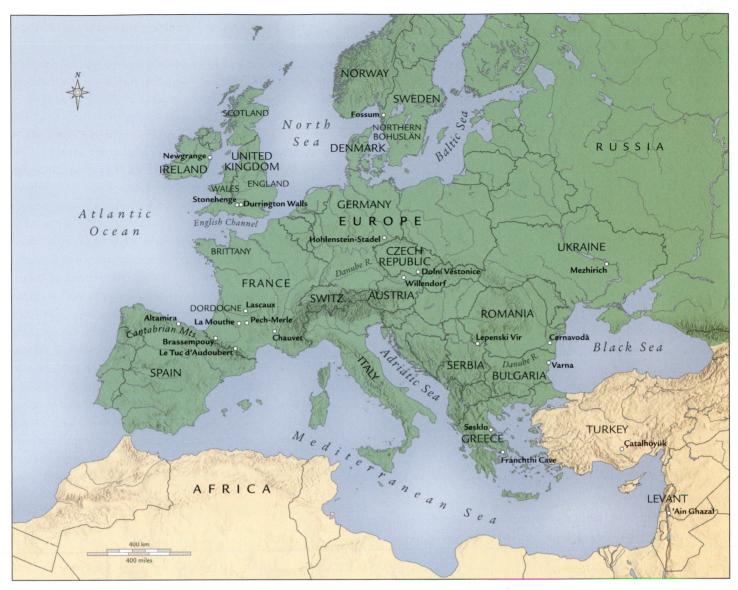

MAP 1-1 • PREHISTORIC EUROPE

As the Ice Age glaciers receded, Paleolithic, Neolithic, Bronze Age, and Iron Age settlements increased from south to north.

By 1.65 million years ago, significant changes in our ancestors' cognitive abilities and manual dexterity can be seen in sophisticated stone tools, such as the teardrop-shaped hand-axes (**FIG. 1-3**) that have been found at sites across Eurasia. These extraordinary objects, symmetrical in form and produced by a complex multistep process, were long thought of as nothing more than tools (or perhaps even as weapons), but the most recent analysis suggests that they had a social function as well. Some sites (as at Olorgesailie in Kenya) contain hundreds of hand-axes, far more than would have been needed in functional terms, suggesting that they served to announce an individual's skills, status, and standing in his or her community. Although these ancient hand-axes are clearly not art in the representational sense, it is important to see them in terms of performance and process. These concepts, so central to modern Western art, have deep prehistoric roots.

Evolutionary changes took place over time and by 400,000 years ago, during the late Middle Paleolithic period, a *Homo sapiens* subspecies called Neanderthal inhabited Europe. Its members used a wider range of stone tools and may have carefully buried their dead with funerary offerings. Neanderthals survived for thousands of years and overlapped with modern humans. *Homo sapiens sapiens*, which had evolved and spread out of Africa some 300,000 years after the Neanderthals, eventually replaced them, probably between 38,000 and 33,000 BCE.

Critical cognitive abilities set modern humans apart from all their predecessors; indeed *Homo sapiens sapiens*, as a species, outlasted Neanderthals precisely because they had the mental capacity to solve problems of human survival. The new cognitive abilities included improvements in recognizing and benefiting from variations in the natural environment, and in managing

1-3 • PALEOLITHIC HAND-AXEFrom Isimila Korongo, Tanzania. 60,000 years ago. Stone, height 10" (25.4 cm).

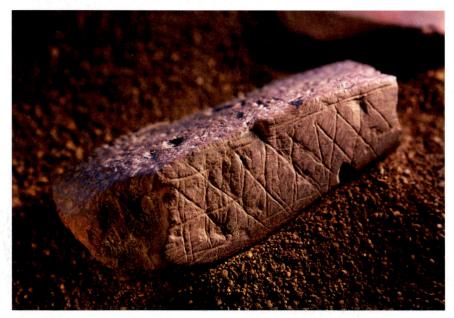

1-4 • DECORATED OCHERFrom Blombos Cave, southern Cape coast, South Africa. 75,000 years ago.

social networking and alliance making—skills that enabled organized hunting. The most important new ability, however, was the capacity to think symbolically: to create representational analogies between one person, animal, or object, and another, and to recognize and remember those analogies. This cognitive development marks the evolutionary origin of what we call art.

The world's earliest examples of art come from South Africa: two 77,000-year-old, engraved blocks of red ocher (probably used as crayons) found in the Blombos Cave (FIG. 1-4). Both blocks are engraved in an identical way with cross-hatched lines on their sides. Archaeologists argue that the similarity of the engraved patterns means these two pieces were intentionally made and decorated following a common pattern. Thousands of fragments of ocher have been discovered at Blombos and there is little doubt that people were using it to draw patterns and images, the remains of which have long since disappeared. Although it is impossible to prove, it is highly likely that the ocher was used to decorate peoples' bodies as well as to color objects such as tools or shell ornaments. Indeed, in an earlier layer on the same site, archaeologists uncovered more than 36 shells, each of which had been perforated so that it could be hung from a string or thong, or attached to clothing or a person's hair; these shells would have been used to decorate the body. An ostrich eggshell bead came from the same site and would have served the same purpose. The Blombos finds are enormously important. Here our early ancestors, probably modern humans but possibly even their predecessors, used the earth's raw materials to decorate themselves with jewelry (made of shells) and body art (using the ocher).

SHELTER OR ARCHITECTURE?

"Architecture" usually refers to the enclosure of spaces with some aesthetic intent. People may object to its use in connection with

prehistoric improvisations, but building even a simple shelter requires a degree of imagination and planning deserving of the name "architecture." In the Upper Paleolithic period, humans in some regions used great ingenuity to build shelters that were far from simple. In woodlands, evidence of floors indicates that our ancestors built circular or oval huts of light branches and hides that measured as much as 15–20 feet in diameter. (Modern tents to accommodate six people vary from 10– by 11–foot ovals to 14– by 7–foot rooms.)

In the treeless grasslands of Upper Paleolithic Russia and Ukraine, builders created settlements of up to ten houses using the bones of the now extinct woolly mammoth, whose long, curving tusks made excellent roof supports and arched door openings (FIG. 1–5). This bone framework was probably covered with animal hides and turf. Most activities centered around the inside fire

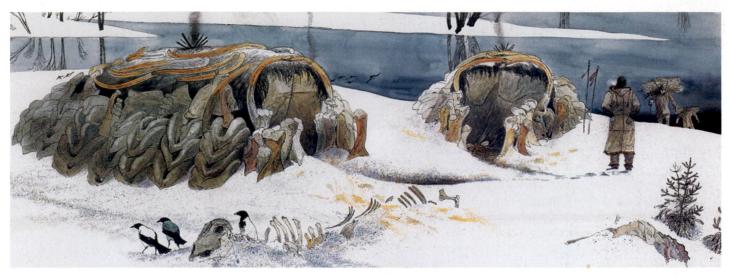

1-5 • RECONSTRUCTION DRAWING OF MAMMOTH-BONE HOUSES Ukraine. c. 16,000–10,000 BCE.

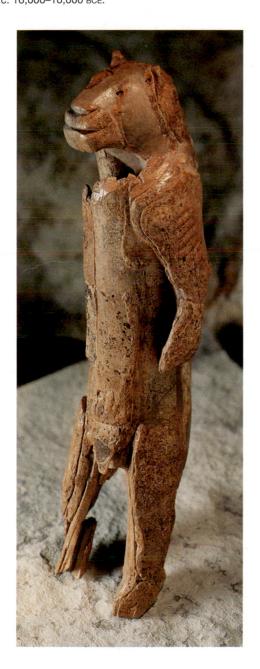

pit, or hearth, where food was prepared and tools were fashioned. Larger houses might have had more than one hearth, and spaces were set aside for specific uses—working stone, making clothing, sleeping, and dumping refuse. Inside the largest dwelling on a site in Mezhirich, Ukraine, archaeologists found 15 small hearths that still contained ashes and charred bones left by the last occupants. Some people also colored their floors with powdered ocher in shades that ranged from yellow to red to brown. These Upper Paleolithic structures are important because of their early date: The widespread appearance of durable architecture concentrated in village communities did not occur until the beginning of the Neolithic period in the Near East and southeastern Europe.

ARTIFACTS OR WORKS OF ART?

As early as 30,000 BCE small figures, or figurines, of people and animals made of bone, ivory, stone, and clay appeared in Europe and Asia. Today we interpret such self-contained, three-dimensional pieces as examples of **sculpture in the round**. Prehistoric carvers also produced relief sculpture in stone, bone, and ivory. In **relief sculpture**, the surrounding material is carved away to form a background that sets off the projecting figure.

THE LION-HUMAN An early and puzzling example of a sculpture in the round is a human figure—probably male—with a feline head (**FIG. 1-6**), made about 30,000–26,000 BCE. Archaeologists excavating at Hohlenstein-Stadel, Germany, found broken pieces of ivory (from a mammoth tusk) that they realized were parts of an entire figure. Nearly a foot tall, this remarkable statue surpasses most early figurines in size and complexity. Instead of copying

1-6 • LION-HUMAN

From Hohlenstein-Stadel, Germany. c. 30,000–26,000 BCE. Mammoth ivory, height 115/8" (29.6 cm). Ulmer Museum, Ulm, Germany.

ART AND ITS CONTEXTS | The Power of Naming

Words are only symbols for ideas, and it is no coincidence that the origins of language and of art are often linked in human evolutionary development. But the very words we invent—or our ancestors invented—reveal a certain view of the world and can shape our thinking. Today, we exert the power of naming when we select a name for a baby or call a friend by a nickname. Our ideas about art can also be affected by names, even the ones used for captions in a book. Before the twentieth century, artists usually did not name, or title, their works. Names were eventually supplied by the works' owners or by art historians writing about them, and thus often express the cultural prejudices of the labelers or of the times in which they lived.

An excellent example of such distortion is the naming of the hundreds of small prehistoric statues of women that have been found. Earlier scholars called them by the Roman name Venus. For example,

the sculpture in FIGURE 1–7 was once called the *Venus of Willendorf* after the place where it was found. Using the name of the Roman goddess of love and beauty sent a message that this figure was associated with religious belief, that it represented an ideal of womanhood, and that it was one of a long line of images of "classical" feminine beauty. In a short time, most similar works of sculpture from the Upper Paleolithic period came to be known as Venus figures. The name was repeated so often that even experts began to assume that the statues had to be fertility figures and Mother Goddesses, although there is no proof that this was so.

Our ability to understand and interpret works of art responsibly and creatively is easily compromised by distracting labels. Calling a prehistoric figure a woman instead of Venus encourages us to think about the sculpture in new and different ways.

what he or she saw in nature, the carver created a unique creature, part human and part beast. Was the figure intended to represent a person wearing a ritual lion mask? Or has the man taken on

1-7 • WOMAN FROM WILLENDORFAustria. c. 24,000 BCE. Limestone, height 43/8" (11 cm).
Naturhistorisches Museum, Vienna.

the appearance of an animal? Archaeologists now think that the people who lived at this time held very different ideas (from our twenty-first-century ones) about what it meant to be a human and how humans were distinct from animals; it is quite possible that they thought of animals and humans as parts of one common group of beings who shared the world. What is absolutely clear is that the Lion-Human shows highly complex thinking and creative imagination: the uniquely human ability to conceive and represent a creature never seen in nature.

FEMALE FIGURES While a number of figurines representing men have been found recently, most human figures from the Upper Paleolithic period are female. The most famous of these, the **WOMAN FROM WILLENDORF** (**FIG. 1-7**), Austria, dates from about 24,000 BCE (see "The Power of Naming," above). Carved from limestone and originally colored with red ocher, the statuette's swelling, rounded forms make it seem much larger than its actual 4%-inch height. The sculptor exaggerated the figure's female attributes by giving it pendulous breasts, a big belly with a deep navel (a natural indentation in the stone), wide hips, dimpled knees and buttocks, and solid thighs. By carving a woman with a well-nourished body, the artist may have been expressing health and fertility, which could ensure the ability to produce strong children, thus guaranteeing the survival of the clan.

The most recent analysis of the Paleolithic female sculptures, however, has replaced the traditional emphasis on fertility with more nuanced understandings of how and why the human figure is represented in this way, and who may have had these kinds of objects made. According to archaeologist Clive Gamble, these little sculptures were subtle forms of nonverbal communication among small isolated groups of Paleolithic people spread out across vast regions. Gamble noted the tremendous (and unusual) similarity in the shapes of figures, even those found in widely distant parts of Europe. He suggested that when groups of Paleolithic

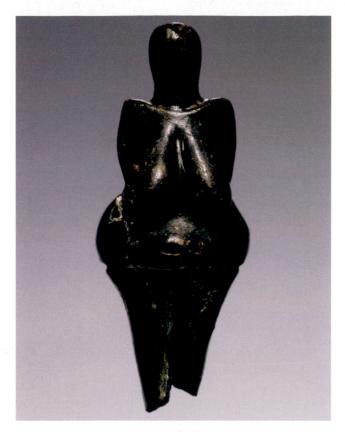

1-8 • WOMAN FROM DOLNÍ VĚSTONICE Moravia, Czech Republic. 23,000 BCE. Fired clay, $41/4'' \times 17/10''$ (11 \times 4.3 cm). Moravske Museum, Brno, Czech Republic.

hunter-gatherers did occasionally meet up and interact, the female statues may have been among several signature objects that signaled whether a group was friendly and acceptable for interaction and, probably, for mating. As symbols, these figures would have provided reassurance of shared values about the body, and their size would have demanded engagement at a close personal level. It is not a coincidence, then, that the largest production of these types of Paleolithic figurine occurred during a period when climatic conditions were at their worst and the need for interaction and alliance building would have been at its greatest.

Another figure, found in the Czech Republic, the **WOMAN FROM DOLNÍ VĚSTONICE** (**FIG. 1-8**), takes our understanding of these objects further still. The site of Dolní Věstonice is important because it marks a very early date (23,000 BCE) for the use of fire to make durable objects out of mixtures of water and soil. What makes the figures from this site and those from other sites in the region (Pavlov and Prědmosti) unusual is their method of manufacture. By mixing the soil with water—to a very particular recipe—and then placing the wet figures in a hot kiln to bake, the makers were not intending to create durable, well-fired statues. On the contrary, the recipe used and the firing procedure followed indicate that the intention was to make the figures explode in the kilns before the firing process was complete, and before a "successful" figure could be produced. Indeed, the finds at these sites support this interpretation: There are very few complete figures,

but numerous fragments that bear the traces of explosions at high temperatures. The Dolní Věstonice fragments are records of performance and process art in their rawest and earliest forms.

Another remarkable female image, discovered in the Grotte du Pape in Brassempouy, France, is the tiny ivory head known as the WOMAN FROM BRASSEMPOUY (FIG. 1-9). Though the finders did not record its archaeological context, recent studies prove it to be authentic and date it as early as 30,000 BCE. The carver captured the essence of a head, or what psychologists call the memory image—those generalized elements that reside in our standard memory of a human head. An egg shape rests on a long neck. A wide nose and strongly defined browline suggest deep-set eyes, and an engraved square patterning may be hair or a headdress. The image is an abstraction (what has come to be known as abstract art): the reduction of shapes and appearances to basic yet recognizable forms that are not intended to be exact replications of nature. The result in this case looks uncannily modern to contemporary viewers. Today, when such a piece is isolated in a museum case or as a book illustration we enjoy it as an aesthetic object, but we lose its original cultural context.

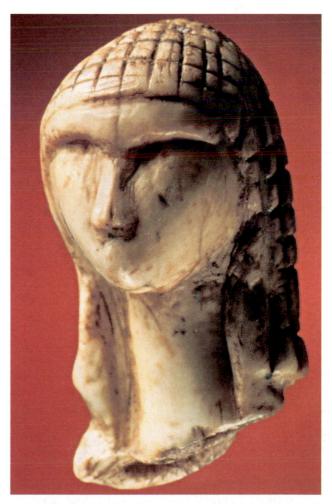

1-9 • WOMAN FROM BRASSEMPOUY
Grotte du Pape, Brassempouy, Landes, France. Probably
c. 30,000 BCE. Ivory, height 11/4" (3.6 cm). Musée des Antiquités
Nationales, Saint-Germain-en-Laye, France.

TECHNIQUE | Prehistoric Wall Painting

In a dark cave, working by the light of an animal-fat lamp, artists chew a piece of charcoal to dilute it with saliva and water. Then they blow out the mixture on the surface of a wall, using their hands as stencils. This drawing demonstrates how cave archaeologist Michel Lorblanchet and his assistant used the step-by-step process of the original makers of a cave painting at Pech-Merle (see Fig. 1–1) in France to create a complex design of spotted horses.

By turning himself into a human spray can, Lorblanchet produced clear lines on the rough stone surface much more easily than he could with a brush. To create the line of a horse's back, with its clean upper edge and blurry lower one, he blows pigment below his hand. To capture its angular rump, he places his hand vertically against the wall, holding it slightly curved. To produce the sharpest lines, such as those of the upper hind leg and tail, he places his hands side by side and blows between them. To create the forelegs and the hair on the horses' bellies, he fingerpaints. A hole punched in a piece of leather serves as a stencil for the horses' spots. It took Lorblanchet only 32 hours to reproduce the Pech-Merle painting of spotted horses, his speed suggesting that a single artist created the original (perhaps with the help of an assistant to mix pigments and tend the lamp).

Homo sapiens sapiens artists used three painting techniques: the spraying demonstrated by Lorblanchet; drawing with fingers or blocks of ocher; and daubing with a paintbrush made of hair or moss. In some places in prehistoric caves three stages of image creation can be seen: engraved lines using flakes of flint, followed by a color wash of ocher and manganese, and a final engraving to emphasize shapes and details.

CAVE PAINTING

Art in Europe entered a rich and sophisticated phase well before 40,000 years ago, when images began to be painted on the walls of caves in central and southern France and northern Spain. No one knew of the existence of prehistoric cave paintings until one day in 1879, when a young girl, exploring with her father in Altamira in northern Spain, crawled through a small opening in the ground and found herself in a chamber whose ceiling was covered with painted animals (see FIG. 1-13). Her father, a lawyer and amateur archaeologist, searched the rest of the cave, told authorities about the remarkable find, and published his discovery the following year. Few people believed that these amazing works could have been made by "primitive" people, and the scientific community declared the paintings a hoax. They were accepted as authentic only in 1902, after many other cave paintings, drawings, and engravings had been discovered at other places in northern Spain and in France.

THE MEANING OF CAVE PAINTINGS What caused people to paint such dramatic imagery on the walls of caves? The idea that human beings have an inherent desire to decorate themselves and their surroundings—that an aesthetic sense is somehow innate to the human species—found ready acceptance in the nineteenth century. Many believed that people create art for the sheer love of beauty. Scientists now agree that human beings have an aesthetic impulse, but the effort required to accomplish the great cave paintings suggests their creators were motivated by more than simple visual pleasure (see "Prehistoric Wall Painting," above). Since the discovery at Altamira, anthropologists and art

historians have devised several hypotheses to explain the existence of cave art. Like the search for the meaning of prehistoric female figurines, these explanations depend on the cultural views of those who advance them.

In the early twentieth century, scholars believed that art has a social function and that aesthetics are culturally relative. They proposed that the cave paintings might be products both of rites to strengthen clan bonds and of ceremonies to enhance the fertility of animals used for food. In 1903, French archaeologist Salomon Reinach suggested that cave paintings were expressions of sympathetic magic: the idea, for instance, that a picture of a reclining bison would ensure that hunters found their prey asleep. Abbé Henri Breuil took these ideas further and concluded that caves were used as places of worship and were the settings for initiation rites. During the second half of the twentieth century, scholars rejected these ideas and rooted their interpretations in rigorous scientific methods and current social theory. André Leroi-Gourhan and Annette Laming-Emperaire, for example, dismissed the sympathetic magic theory because statistical analysis of debris from human settlements revealed that the animals used most frequently for food were not the ones traditionally portrayed in caves.

Researchers continue to discover new cave images and to correct earlier errors of fact or interpretation. A study of the Altamira Cave in the 1980s led anthropologist Leslie G. Freeman to conclude that the artists had faithfully represented a herd of bison during the mating season. Instead of being dead, asleep, or disabled—as earlier observers had thought—the animals were dust-wallowing, common behavior during the mating season. Similar thinking has led to a more recent interpretation of cave art by archaeologist

Steve Mithen. In his detailed study of the motifs of the art and its placement within caves, Mithen argued that hoofprints, patterns of animal feces, and hide colorings were recorded and used as a "text" to teach novice hunters within a group about the seasonal appearance and behavior of the animals they hunted. The fact that so much cave art is hidden deep in almost inaccessible parts of caves—indeed, the fact that it is placed within caves at all—suggested to Mithen that this knowledge was intended for a privileged group and that certain individuals or groups were excluded from acquiring that knowledge.

South African rock-art expert David Lewis-Williams has suggested a different interpretation. Using a deep comparative knowledge of art made by hunter-gatherer communities that are still in existence, Lewis-Williams argued that Upper Paleolithic cave art is best understood in terms of shamanism: the belief that certain people (shamans) can travel outside of their bodies in order to mediate between the worlds of the living and the spirits. Traveling under the ground as a spirit, particularly within caves, or conceptually within the stone walls of the cave, Upper Paleolithic shamans would have participated in ceremonies that involved hallucinations. Images conceived during this trancelike state would likely combine recognizable (the animals) and abstract (the nonrepresentational) symbols. In addition, Lewis-Williams interprets the stenciled human handprints found on the cave walls (see FIG. 1-1) as traces of the nonshaman participants in the ritual reaching toward and connecting with the shaman spirits traveling within the rock.

Although the hypotheses that seek to explain cave art have changed and evolved over time, there has always been agreement that decorated caves must have had a special meaning because people returned to them time after time over many generations, in some cases over thousands of years. Perhaps Upper Paleolithic cave art was the product of rituals intended to gain the favor of the supernatural. Perhaps because much of the art was made deep inside the caves and nearly inaccessible, its significance may have had less to do with the finished painting than with the very act of creation. Artifacts and footprints (such as those found at Chauvet, below, and Le Tuc d'Audoubert, see FIG. 1-14) suggest that the subterranean galleries, which were far from living quarters, had a religious or magical function. Perhaps the experience of exploring the cave may have been significant to the image-makers. Musical instruments, such as bone flutes, have been found in the caves, implying that even acoustical properties may have had a role to play.

CHAUVET One of the earliest known sites of prehistoric cave paintings, discovered in December 1994, is the Chauvet Cave (called after one of the persons who found it) near Vallon-Pont-d'Arc in southeastern France. It is a tantalizing trove of hundreds of paintings (**FIG. 1-10**). The most dramatic of the images depict grazing, running, or resting animals, including wild horses, bison, mammoths, bears, panthers, owls, deer, aurochs, woolly rhinoceroses, and wild goats (or ibex). Also included are occasional humans, both male and female, many handprints, and hundreds

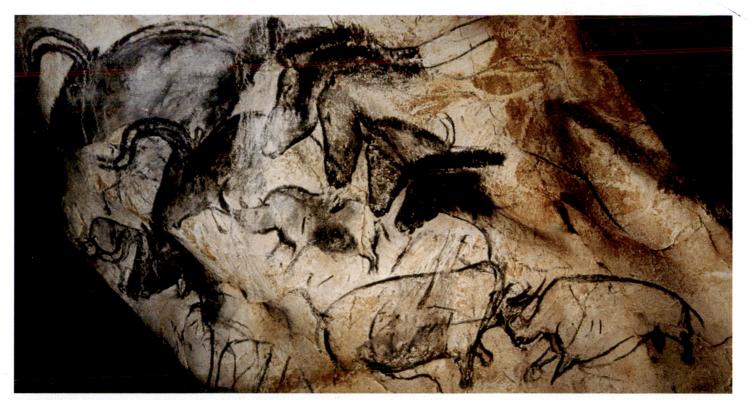

1-10 • WALL PAINTING WITH HORSES, RHINOCEROSES, AND AUROCHS
Chauvet Cave. Vallon-Pont-d'Arc, Ardèche Gorge, France. c. 32,000–30,000 BCE. Paint on limestone.

Watch a video about cave painting on myartslab.com

of geometric markings such as grids, circles, and dots. Footprints in the Chauvet Cave, left in soft clay by a child, go to a "room" containing bear skulls. The charcoal used to draw the rhinos has been radiocarbon-dated to 32,410 years old (+/- 720 years).

LASCAUX The best-known cave paintings are those found in 1940 at Lascaux, in the Dordogne region of southern France (see Figs. 1-11, 1-12). They have been dated to about 15,000 BCE. Opened to the public after World War II, the prehistoric "museum" at Lascaux soon became one of the most popular tourist sites in France. Too popular, because the visitors brought heat, humidity, exhaled carbon dioxide, and other contaminants. The cave was closed to the public in 1963 so that conservators could battle an aggressive fungus. Eventually they won, but instead of reopening the site, the authorities created a facsimile of it. Visitors at what is called Lascaux II may now view copies of the paintings without harming the precious originals.

The scenes they view are truly remarkable. Lascaux has about 600 paintings and 1,500 engravings. In the **HALL OF BULLS** (**FIG. 1–11**), the Lascaux painters depicted cows, bulls, horses, and deer along the natural ledges of the rock, where the smooth white limestone of the ceiling and upper wall meets a rougher surface below. They also utilized the curving wall to suggest space. The animals appear singly, in rows, face to face, tail to tail, and even painted on top of one another. Their most characteristic features

have been emphasized. Horns, eyes, and hooves are shown as seen from the front, yet heads and bodies are rendered in profile in a system known as a **composite pose**. The animals are full of life and energy, and the accuracy in the drawing of their silhouettes, or outlines, is remarkable.

Painters worked not only in large caverns, but also far back in the smallest chambers and recesses, many of which are almost inaccessible today. Small stone lamps found in such caves—over 100 lamps have been found at Lascaux—indicate that the artists worked in flickering light obtained from burning animal fat. Although 1 pound of fat would burn for 24 hours and produce no soot, the light would not have been as strong as that created by a candle.

One scene at Lascaux was discovered in a remote setting on a wall at the bottom of a 16-foot shaft that contained a stone lamp and spears. The scene is unusual because it is the only painting in the cave complex that seems to tell a story (FIG. 1-12), and it is stylistically different from the other paintings at Lascaux. A figure who could be a hunter, greatly simplified in form but recognizably male and with the head of a bird or wearing a bird's-head mask, appears to be lying on the ground. A great bison looms above him. Below him lie a staff, or baton, and a spear-thrower (atlatl)—a device that allowed hunters to throw farther and with greater force—the outer end of which has been carved in the shape of a bird. The long, diagonal line slanting across the bison's hindquarters may be

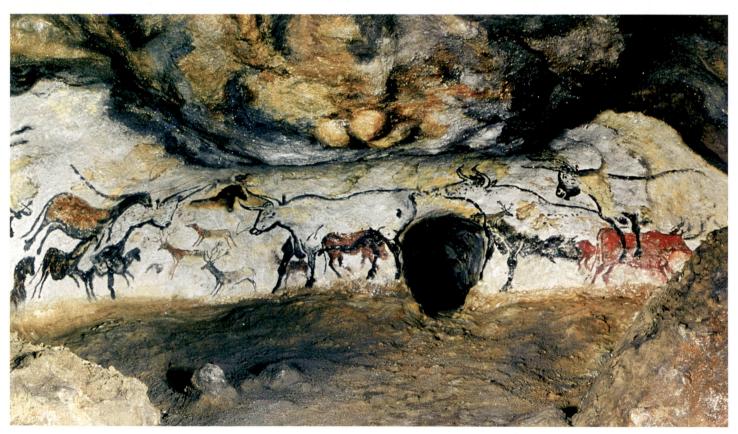

1-11 • HALL OF BULLS
Lascaux Cave. Dordogne, France. c. 15,000 BCE. Paint on limestone, length of largest auroch (bull) 18' (5.50 m).

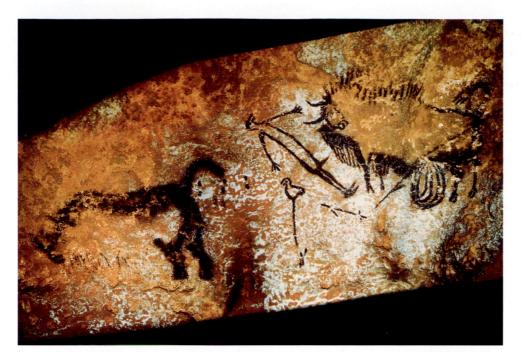

1-12 • BIRD-HEADED MAN WITH BISON
Shaft scene in Lascaux Cave. c. 15,000 BCE. Paint on limestone, length approx. 9' (2.75 m).

a spear. The bison has been disemboweled and will soon die. To the left of the cleft in the wall a woolly rhinoceros seems to run off. Why did the artist portray the man as only a sticklike figure when the bison was rendered with such accurate detail? Does the painting illustrate a story or a myth regarding the death of a hero? Is it a record of an actual event? Or does it depict the vision of a shaman?

ALTAMIRA The cave paintings at Altamira, near Santander in the Cantabrian Mountains in Spain—the first to be discovered and attributed to the Upper Paleolithic period have been recently dated to about 12,500 BCE (see "How Early Art is Dated," page 12). The Altamira artists created sculptural effects by painting over and around natural irregularities in the cave walls and ceilings. To produce the herd of bison on the ceiling of the main cavern (FIG. 1-13), they used rich red and brown ocher to paint the large areas of the animals' shoulders, backs, and flanks, then sharpened the contours of the rocks and added the details of the legs, tails, heads, and horns in black and brown. They mixed yellow and brown from iron-based ocher to make the red tones, and they derived black from manganese or charcoal.

CAVE SCULPTURES

Caves were sometimes adorned with relief sculpture as well as paintings. At Altamira, an artist simply heightened the resemblance of a natural projecting rock to a similar and familiar animal form. Other reliefs were created by modeling, or shaping, the damp clay of the cave's floor. An excellent example of such work in clay (dating to 13,000 BCE) is preserved at Le Tuc d'Audoubert, south of the Dordogne region of France. Here the sculptor created two bison leaning against a ridge of rock (FIG. 1-14). Although the beasts are modeled in very high relief (they extend well forward from the background), they display the same conventions as in earlier painted ones, with emphasis on the broad masses of the meat-bearing flanks and

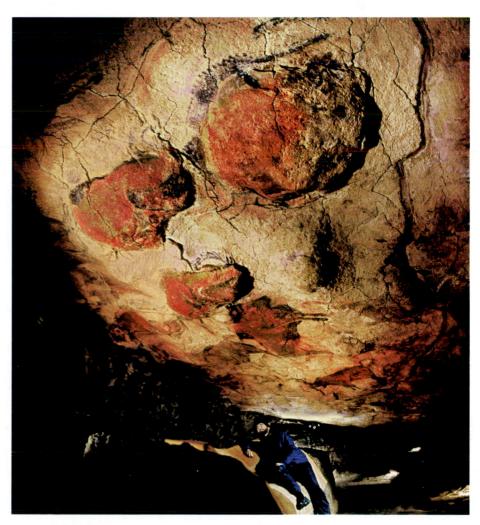

1-13 • BISONCeiling of a cave at Altamira, Spain. c. 12,500 BCE. Paint on limestone, length approx. 8'3" (2.5 m).

RECOVERING THE PAST | How Early Art is Dated

Since the first discoveries at Altamira, archaeologists have developed increasingly sophisticated ways of dating cave paintings and other excavated objects. Today, they primarily use two approaches to determine an artifact's age. Relative dating relies on the chronological relationships among objects in a single excavation or among several sites. If archaeologists have determined, for example, that pottery types A, B, and C follow each other chronologically at one site, they can apply that knowledge to another site. Even if type B is the only pottery present, it can still be assigned a relative date. Absolute dating, on the other hand, aims to determine a precise span of calendar years in which an artifact was created.

The most accurate method of absolute dating is radiometric dating, which measures the degree to which radioactive materials have disintegrated over time. Used for dating organic (plant or animal) materials—including some pigments used in cave paintings—one radiometric method measures a carbon isotope called radiocarbon, or carbon-14, which is constantly replenished in a living organism. When an organism dies, it stops absorbing carbon-14 and starts to lose its store of the isotope at a predictable rate. Under the right circumstances, the amount of carbon-14 remaining in organic material can tell us how long ago an organism died.

This method has serious drawbacks for dating works of art. Using carbon-14 dating on a carved antler or wood sculpture shows only when the animal died or when the tree was cut down, not when the artist created the work using those materials. Also, some part of the object must be destroyed in order to conduct this kind of test-something that is never desirable in relation to works of art. For this reason, researchers frequently test organic materials found in the same context as the work of art rather than sacrificing part of the work itself. Radiocarbon dating is most accurate for materials no more than 30,000 to 40,000 years old.

Potassium-argon dating, which measures the decay of a radioactive potassium isotope into a stable isotope of argon, an inert gas, is most reliable with materials over a million years old. Uranium-thorium dating measures the decay of uranium into thorium in the deposits of calcium carbonate that cover the surfaces of cave walls, to determine the minimum age of paintings under the crust. Thermo-luminescence dating measures the irradiation of the crystal structure of a material subjected to fire, such as pottery, and the soil in which it is found, determined by the luminescence produced when a sample is heated. Electron spin resonance techniques involve using a magnetic field and microwave irradiation to date a material such as tooth enamel and the soil around it.

Recent experiments have helped to date cave paintings with increasing precision. Radiocarbon analysis has determined, for example, that the animal images at Lascaux are 17,000 years old-to be more precise, 17,070 years, plus or minus 130 years.

shoulders. To make the animals even more lifelike, their creator engraved short parallel lines below their necks to represent their shaggy coats. Numerous small footprints found in the clay floor of this cave suggest that important group rites took place here.

1-14 • BISON Le Tuc d'Audoubert, France. c. 13,000 BCE. Unbaked clay, length 25" (63.5 cm) and 24" (60.9 cm).

THE NEOLITHIC PERIOD

Today, advances in technology, medicine, transportation, and electronic communication change human experience in a generation. Many thousands of years ago, change took place much more

> slowly. In the tenth millennium BCE the world had already entered the present interglacial period, and our modern climate was taking shape. The world was warming up, and this affected the distribution, density, and stability of plant and animal life as well as marine and aquatic resources. However, the Ice Age ended so gradually and unevenly among regions that people could not have known what was happening.

> One of the fundamental changes that took place in our prehistoric past was in the relationship people had with their environment. After millennia of established interactions between people and wild plants and animalsranging from opportunistic foraging to well-scheduled gathering and collecting-people gradually started to exert increasing control over the land and its resources. Seen from the modern

perspective, this change in economy (archaeologists use "economy" to refer to the ways people gathered or produced food) seems abrupt and complete. Different communities adopted and adapted new sets of technologies, skills, and plant and animal species that allowed them to produce food. This was the origin of plant and animal domestication. Wheat and barley were cultivated; sheep, goats, cattle, and pigs were bred. This new economy appeared at different rates and to varying degrees of completeness in different parts of the Near East and Europe, and no community relied exclusively on the cultivation of plants or on breeding animals. Instead they balanced hunting, gathering, farming, and animal breeding in order to maintain a steady food supply.

ARCHITECTURE

At the same time as these new food technologies and species appeared, people began to establish stronger, more lasting connections to particular places in the landscape. The beginnings of architecture in Europe are marked by the building of human social environments made up of simple but durable structures constructed of clay, mud, dung, and straw interwoven among wooden posts. While some of these buildings were simple huts, used for no more than a season at a time, others were much more substantial, with foundations made of stone, set into trenches, and supporting walls of large timbers. Some were constructed from simple bricks made of clay, mud, and straw, shaped in rectangular molds and then dried in the sun. Regardless of the technique used, the result was the same: people developed a new attachment to the land, and with settlement came a new kind of social life.

At the site of Lepenski Vir, on the Serbian bank of the Danube River, rows of trapezoidal buildings made of wooden posts, branches, mud, and clay—set on stone foundations and with stone-faced hearths—face the river from which the inhabitants took large fish (FIG. 1-15). Although this site dates to between 6300 and 5500 BCE, there is little evidence for the domestication of plants and animals that might be expected at this time in association with

an architectural settlement. Archaeologists found human burials under the floors of these structures, as well as in the spaces between individual buildings. In some houses extraordinary art was found, made of carefully pecked and shaped river boulders (FIG. 1-16). Some of the boulders appear to represent human forms. Others look more like fish. A few seem to consist of mixtures of human and fish features. Here we have a site with a confusing combination of architecture with a nondomesticated economy, very distinctive art, and many burials. Archaeologists interpret such sites as temporary habitations where people carried out special rites and activities linked to death and to the natural and wild worlds. In such settlements, art played a role.

In some places early architecture was dramatic and longlasting, with the repeated building—sometimes over 1,000 years or more—of house upon house in successive architectural generations, resulting in the gradual rise of great mounds of villages referred to as tells or mound settlements. A particularly spectacular example is Çatalhöyük (Chatal Huyuk) in the Konya Plain in central Turkey where the first traces of a village date to 7400 BCE in the early Neolithic period. The oldest part of the site consists of many densely clustered houses separated by areas of rubbish. They were made of rectangular mud bricks held together with mortar; walls, floors, and ceilings were covered with plaster and lime-based paint and were frequently replastered and repainted (see "A Closer Look," page 15). The site was large and was home to as many as 3,000 people at any one time. Beyond the early date of the site and its size and population, the settlement at Çatalhöyük is important to the history of art for two reasons: the picture it provides of the use of early architecture and the sensational art that has been found within its buildings.

Archaeologists and anthropologists often assume that the decision to create buildings such as the houses at Neolithic sites came from a universal need for shelter from the elements. However, as suggested by the special nature of the activities at Lepenski Vir, recent work at Çatalhöyük also shows clearly that while structures

did provide shelter, early houses had much more significant functions for the communities of people who lived in them. For the Neolithic people of Çatalhöyük, their houses were the key component of their worldview. Most importantly, they became an emblem of the spirit and history of a community. The building of house upon house created a historical continuity that outlasted any human lifetime; indeed, some house-rebuilding sequences lasted many hundreds of years. And the seasonal replastering and repainting of walls and floors only enhanced the sense of long-term continuity that made these buildings

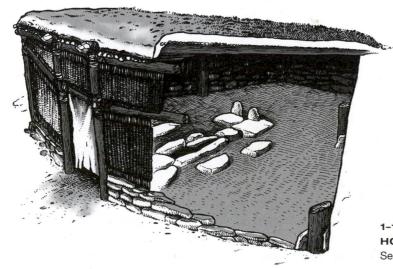

1-15 • RECONSTRUCTION DRAWING OF LEPENSKI VIR HOUSE/SHRINE

Serbia. 6000 BCE.

1-16 • HUMAN-FISH SCULPTUREFrom Lepenski Vir, Serbia. c. 6300–5500 BCE.

history-makers. In fact, Ian Hodder, the director of excavations at Çatalhöyük, and his colleagues call some of them "history houses" and have found no evidence to suggest that they were shrines or temples as earlier interpreters had mistakenly concluded.

As at Lepenski Vir, the dead were buried under the floors of many of the buildings at Çatalhöyük, so the site connected the community's past, present, and future. While there were no burials in some houses, a few contained between 30 and 60 bodies (the average is about six per house), and one had 62 burials, including people who had lived their lives in other parts of the village. Periodically, perhaps to mark special community events and ceremonies, people dug down into the floors of their houses and removed the heads of the long-deceased, then buried the skulls in new graves under the floors. Skulls were also placed in the foundations of new houses as they were built and rebuilt, and in other special deposits around the settlement. In one extraordinary burial, a deceased woman holds in her arms a man's skull that had been plastered and painted. Perhaps it, too, had been removed from an earlier underfloor grave.

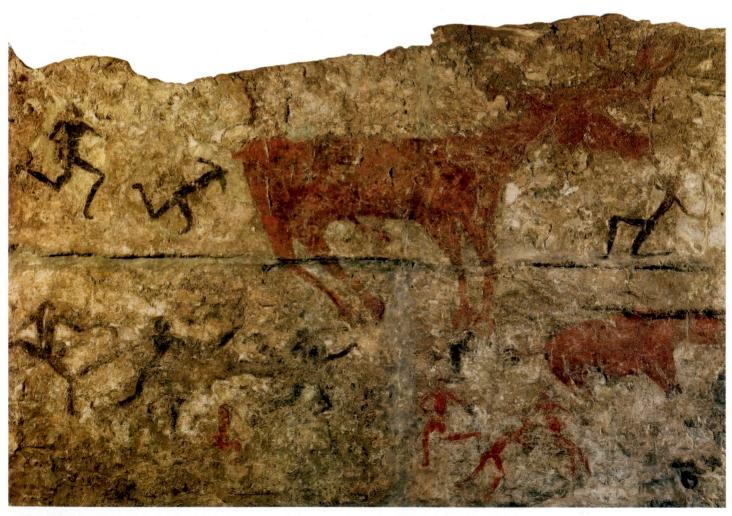

1-17 • MEN TAUNTING A DEER (?)
Detail of a wall painting from Çatalhöyük, Turkey. c. 6000 BCE. Museum of Anatolian Civilization, Ankara, Turkey.

A CLOSER LOOK | A House in Çatalhöyük

Reconstruction drawing. Turkey. 7400-6200 BCE.

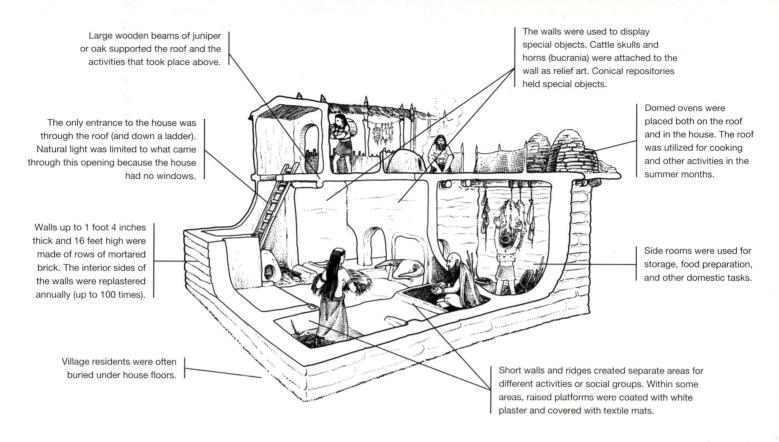

View the Closer Look for the house in Çatalhöyük on myartslab.com

The houses of Çatalhöyük were powerful places not only because of the (literal) depths of their histories, but also because of the extraordinary art that decorated their interiors. Painted on the walls of some of the houses are violent and wild scenes. In some, humans are represented without heads as if they had been decapitated. Vultures or other birds of prey appear huge next to them, and narratives seem to highlight dangerous interactions between people and animals. In one painting (FIG. 1-17), a huge, horned wild animal (probably a deer) is surrounded by small humans who are jumping or running; one of them is pulling on something sticking out of the deer's mouth, perhaps its tongue. There is an emphasis on maleness: some of the human figures are bearded and the deer has an erect penis. Archaeologists have interpreted this scene as a dangerous game or ritual of baiting and taunting a wild animal. In other paintings, people hunt or tease boars or bulls. Conservation of the wall paintings is highly complex, and since many of the most dramatic examples were excavated before modern preservation techniques existed, we must rely on the archaeologist's narrative descriptions or quick field sketches.

Other representations of wild animals are modeled in relief on the interior walls, most frequently the heads and horns of bulls. In some houses, people placed boar tusks, vulture skulls, and fox and weasel teeth under the floors; in at least one case, they dug into previous house generations to retrieve the plastered and painted heads of bulls.

Sites such as Lepenski Vir and Çatalhöyük have forced archaeologists to think in new ways about the role of architecture and art in prehistoric communities (see "Intentional House Burning," page 16). Critically, the mixture of shelter, architecture, art, spirit, ritual, and ceremony at these and many other Neolithic settlements makes us realize that we cannot easily distinguish between "domestic" and "sacred" architecture. This point re-emerges from the recent work at Stonehenge in England (see page 17). In addition, the clear and repeated emphasis on death, violence, wild animals, and male body parts at Çatalhöyük has challenged traditional interpretations of the Neolithic worldview that concentrated on representations of the female body, human fertility, and cults of the Mother Goddess.

Most Neolithic architectural sites were not as visually sensational as Çatalhöyük. At the site of Sesklo in northern Greece, dated to 6500 BCE, people built stone-based, long-lasting structures (**FIG. 1-18**) in one part of a village and less substantial mud, clay,

ART AND ITS CONTEXTS | Intentional House Burning

While much research has focused on the origins and construction technology of the earliest architecture—as at Çatalhöyük, Lepenski Vir, and other sites—some of the most exciting new work has come from studies of how Neolithic houses were destroyed. Excavations of settlements dating to the end of the Neolithic period in eastern and central Europe commonly reveal a level of ash and other evidence for great fires that burned down houses at these sites. The common interpretation had been that invaders, coming on horseback from Ukraine and Russia, had attacked these villages and burned the settlements.

In one of the most innovative recent studies, Mira Stevanović and Ruth Tringham employed the methods of modern forensic science and meticulously reconstructed the patterns of Neolithic house conflagrations. The results proved that the fires were not part of village-wide destructions, but were individual events, confined to particular houses. Most significantly, they showed that each fire had been deliberately set. In fact, in order to get the fires to consume the houses completely, buildings had been stuffed with combustibles before they were set alight. Repeated tests by experimental archaeologists have supported these conclusions. Each intentional, house-destroying fire was part of a ritual killing of the house and a rupture of the historical and social entity that the house had represented for the community. Critically, even in their destruction, prehistoric buildings played important and complex roles in relation to the ways that individuals and communities created (and destroyed) social identities and continuities.

and wood buildings in another part. The stone-based buildings may have had a special function within the community—whether ritual, crafts-based, or political is difficult to determine. Since they were rebuilt again and again over a long period of time, the part of the village where they were located "grew" vertically into a mound or tell. Some buildings had easily recognizable functions, such as a place for making ceramic vessels. The distinction between the area of the longer-lasting, often rebuilt buildings and the more temporary structures is clear in the style of architecture as well as in the quality of artifacts found. Finer, decorated pottery is more abundant in the former.

In different regions of Europe, people created architecture in different ways. The crowded buildings of Çatalhöyük differed from the structures at Sesklo, and these differed from the trapezoidal

1-18 • SESKLO STONE-FOUNDATION HOUSE Sesklo, northern Greece. 6500 BCE.

huts at Lepenski Vir. To the northwest, in Germany and central Europe, Neolithic villages typically consisted of three or four long timber buildings, each up to 150 feet long, housing 45 to 50 people. The structures were rectangular, with a row of posts down the center supporting a ridgepole, a long horizontal beam against which the slanting roof poles were braced (see example 4 in "Early Construction Methods," page 19). The walls were probably made of wattle and daub (see example 5 in "Early Construction Methods") and roofed with thatch, plant material such as reeds or straw tied over a framework of poles. These houses also included large granaries, or storage spaces for the harvest; some buildings contain sections for animals and for people. Around 4000 BCE, Neolithic settlers began to locate their communities at defensible sites—near rivers, on plateaus, or in swamps. For additional protection, they also frequently surrounded their settlements with wooden walls, earth embankments, and ditches.

CEREMONIAL AND TOMB ARCHITECTURE In western and northern Europe, people erected huge stones to build ceremonial structures and tombs. In some cases, they had to transport these great stones over long distances. The monuments thus created are examples of what is known as **megalithic** architecture, the descriptive term derived from the Greek words for "large" (*mega-*) and "stone" (*lithos*).

Archaeologists disagree about the nature of the societies that created these monuments. Some believe they reflect complex, stratified societies in which powerful religious or political leaders dictated the design of these monuments and inspired (and coerced) large numbers of people to contribute their labor to such engineering projects. Skilled "engineers" would have devised the methods for shaping, transporting, and aligning the stones. Other interpreters argue that these massive monuments are clear evidence for shared collaboration within and between groups, with people working together on a common project, the successful completion of which fueled social cohesion in the absence of a powerful individual.

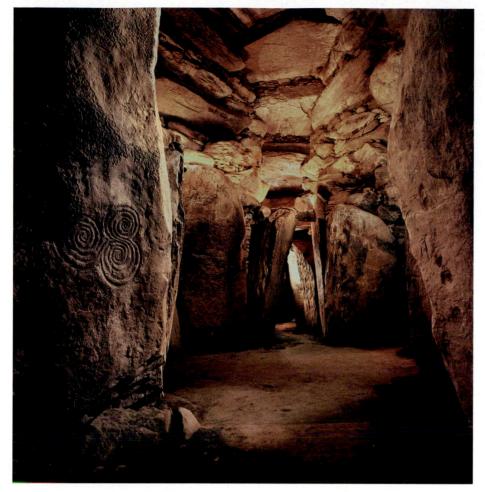

1-19 • TOMB INTERIOR WITH CORBELING AND ENGRAVED STONES Newgrange, Ireland. c. 3000-2500 BCE.

Many of these megalithic structures are associated with death. Most recent interpretations stress the role of death and burial as fundamental, public performances in which individual and group identity, cohesion, and dispute were played out. In this reasoning, death and its rituals are viewed as theater, with the deceased as well as grave goods perceived as props, the monument as a stage, the celebrants and mourners as actors, and the entire event proceeding in terms of an (unwritten) script with narrative and plot.

Elaborate megalithic tombs first appeared in the Neolithic period. Some were built for single burials; others consisted of multiple burial chambers. The simplest type was the **dolmen**, built on the post-and-lintel principle (see examples 1 and 2 in "Early Construction Methods," page 19). The tomb chamber was formed of huge upright stones supporting one or more tablelike rocks, or **capstones**. The structure was then mounded over with smaller rocks and dirt to form a **cairn** or artificial hill. A more imposing type of structure was the **passage grave**, in which narrow, stonelined passageways led into a large room at the center.

At Newgrange, in Ireland, the mound of an elaborate passage grave (**FIG. 1–19**) originally stood 44 feet high and measured about 280 feet in diameter. The mound was built of sod and river pebbles and was set off by a circle of engraved standing stones around its

perimeter. Its passageway, 62 feet long and lined with standing stones, leads into a three-part chamber with a corbel vault (an arched structure that spans an interior space) rising to a height of 19 feet (see example 3 in "Early Construction Methods," page 19). Some of the stones are engraved with linear designs, mainly rings, spirals, and diamond shapes. These patterns may have been marked out using strings or compasses, then carved by picking at the rock surface with tools made of antlers. Recent detailed analysis of the art engraved on passage graves like Newgrange, but also at Knowth in Ireland, suggest that the images are entoptic (meaning that their significance and function relate to the particularities of perception by the eye), and that we should understand them in terms of the neuropsychological effect they would have had on people visiting the tomb. These effects may have included hallucinations. Archaeologists argue that key entoptic motifs were positioned at entrances and other important thresholds inside the tomb, and that they played important roles in ritual or political ceremonies that centered

around death, burial, and the commemoration and visitation of the deceased by the living.

STONEHENGE Of all the megalithic monuments in Europe, the one that has stirred the imagination of the public most strongly is **STONEHENGE**, on Salisbury Plain in southern England (**FIGS. 1–20, 1–21**). A **henge** is a circle of stones or posts, often surrounded by a ditch with built-up embankments. Laying out such circles with accuracy would have posed no particular problem. Architects likely relied on the human compass, a simple but effective surveying method that persisted well into modern times. All that is required is a length of cord either cut or knotted to mark the desired radius of the circle. A person holding one end of the cord is stationed in the center; a coworker, holding the other end and keeping the cord taut, steps off the circle's circumference. By the time of Stonehenge's construction, cords and ropes were readily available.

Stonehenge is not the largest such circle from the Neolithic period, but it is one of the most complex, with eight different phases of construction and activity starting in 3000 BCE during the Neolithic period, and stretching over a millennium and a half through the Bronze Age. The site started as a cemetery of cremation burials

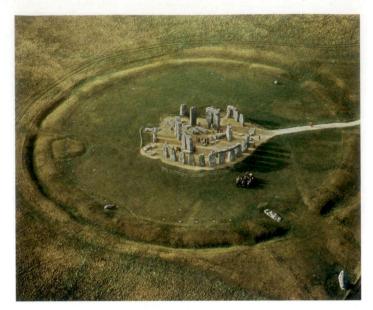

1-20 • STONEHENGE FROM THE AIR Salisbury Plain, Wiltshire, England. c. 2900–1500 BCE.

View the Closer Look for Stonehenge on myartslab.com

marked by a circle of bluestones. Through numerous sequences of alterations and rebuildings, it continued to function as a domain of the dead. Between 2900 and 2600 BCE, the bluestones were rearranged into an arc. Around 2500 BCE, a circle of sarsen stones was used to create the famous appearance of the site—sarsen is a gray sandstone—and the bluestones were rearranged within the sarsens. The center of the site was now dominated by a horseshoe-shaped

arrangement of five sandstone trilithons, or pairs of upright stones topped by **lintels**. The one at the middle stood considerably taller than the rest, rising to a height of 24 feet, and its lintel was more than 15 feet long and 3 feet thick. This group was surrounded by the so-called sarsen circle, a ring of sandstone uprights weighing up to 26 tons each and averaging 13 feet 6 inches tall. This circle, 106 feet in diameter, was capped by a continuous lintel. The uprights taper slightly toward the top, and the gently curved lintel sections were secured by **mortise-and-tenon** joints, that is, joints made by a conical projection at the top of each upright that fits like a peg into a hole in the lintel. Over the next thousand years people continued to alter the arrangement of the bluestones and cremation burials continued in pits at the site.

The differences in the types of stone used in the different phases of construction are significant. The use of bluestone in the early phases (and maintained and rearranged through the sequence) is particularly important. Unlike the sarsen stone, bluestone was not locally available and would have been transported over 150 miles from the west, where it had been quarried in the mountains of west Wales. The means of transporting the bluestones such distances remains a source of great debate. Some argue that they were floated around the coast on great barges; others hold that they traveled over land on wooden rollers. Regardless of the means of transport, the use of this distant material tells us that the people who first transformed the Stonehenge landscape into a ceremonial site probably also had their ancestral origins in the west. By bringing the bluestones and using them in the early Stonehenge cemetery, these migrants made a powerful connection with their homelands.

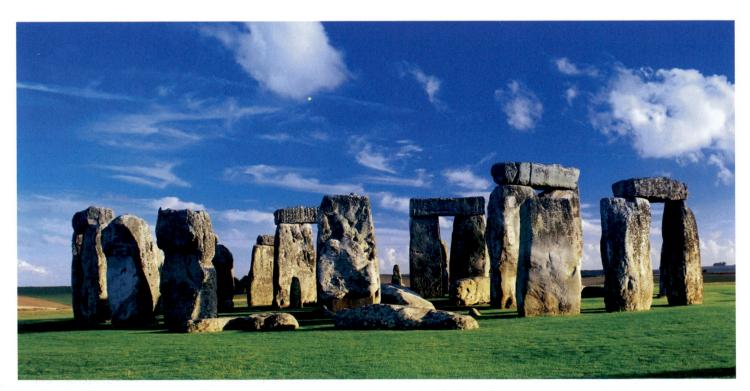

1-21 • STONEHENGE FROM THE GROUND

ELEMENTS OF ARCHITECTURE | Early Construction Methods

Of all the methods for spanning space, **post-and-lintel** construction is the simplest. At its most basic, two uprights (posts) support a horizontal element (lintel). There are countless variations, from the wood structures, dolmens, and other underground burial chambers of prehistory, to Egyptian and Greek stone construction, to medieval timber-frame buildings, and even to cast-iron and steel construction. Its limitation as a space spanner is the degree of tensile strength of the lintel material: the more flexible, the greater the span possible. Another early method for

creating openings in walls and covering space is **corbeling**, in which rows or layers of stone are laid with the end of each row projecting beyond the row beneath, progressing until opposing layers almost meet and can then be capped with a stone that rests across the tops of both layers. The walls of early buildings were often created by the stones or posts used to support the covering, but they could be made of what is known as wattle and daub—branches woven in a basketlike pattern, then covered with mud or clay.

1. Post and lintel

2. Cross section of post-and-lintel underground burial chamber

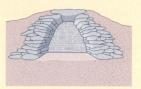

3. Cross section of corbeled underground burial chamber

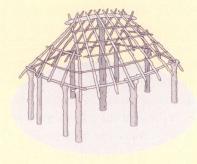

4. Wood-post framing of prehistoric structure

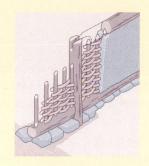

Neolithic wattle-and-daub walls,
 Thessaly, Greece, c. 6000 BCE

6. Granite post-and-lintel construction, Valley Temple of Khafre, Giza, Egypt, c. 2500 BCE

Watch an architectural simulation about post-and-lintel construction on myartslab.com

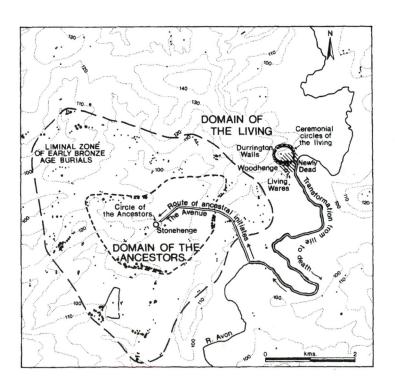

Through the ages, many theories have been advanced to explain Stonehenge. In the Middle Ages, people thought that Merlin, the legendary magician of King Arthur, had built it. Later, the site was erroneously associated with the rituals of the Celtic druids (priests). Because it is oriented in relation to the movement of the sun, some people have argued that it may have been an observatory or that it had special importance as a calendar for regulating early agricultural schedules. Today, none of these ideas is supported by archaeologists and the current evidence.

We now believe that Stonehenge was the site of ceremonies linked to death and burial. This theory has been constructed from evidence that looks not only at the stone circles but also at the nearby sites dating from the periods when Stonehenge was in use (FIG. 1-22). A new generation of archaeologists, led by Mike Parker Pearson, has pioneered this contextual approach to the puzzle of Stonehenge.

1-22 • PLAN OF STONEHENGE AND ITS SURROUNDING SETTLEMENTS

TECHNIQUE | Pottery and Ceramics

The terms pottery and ceramics may be used interchangeably—and often are. Because it covers all baked-clay wares, **ceramics** is technically a more inclusive term than pottery. Pottery includes all baked-clay wares except **porcelain**, which is the most refined product of ceramic technology.

Pottery vessels can be formed in several ways. It is possible, though difficult, to raise up the sides from a ball of raw clay. Another method is to coil long rolls of soft, raw clay, stack them on top of each other to form a container, and then smooth them by hand. A third possibility is simply to press the clay over an existing form, a dried gourd for example. By about 4000 BCE, Egyptian potters had developed the potter's wheel, a round, spinning platform on which a lump of clay is placed and then formed with the fingers while rotating, making it relatively simple to produce a uniformly shaped vessel in a very short time. The potter's wheel appeared in the ancient Near East about 3250 BCE and in China about 3000 BCE.

After forming, a pot is allowed to dry completely before it is fired. Special ovens for firing pottery, called **kilns**, have been discovered at prehistoric sites in Europe dating from as early as 26,000 BCE (as at Dolní Věstonice). For proper firing, the temperature must be maintained at a relatively uniform level. Raw clay becomes porous pottery when heated to at least 500° Centigrade. It then holds its shape permanently and will not disintegrate in water. Fired at 800° Centigrade, pottery is technically known as **earthenware**. When subjected to temperatures between 1,200° and 1,400° Centigrade, certain stone elements in the clay vitrify, or become glassy, and the result is a stronger type of ceramic called **stoneware**.

Pottery is relatively fragile, and new vessels were constantly in demand to replace broken ones, so fragments of low-fired ceramics—fired at the hearth, rather than the higher-temperature kiln—are the most common artifacts found in excavations of prehistoric settlements. Pottery fragments, or **potsherds**, serve as a major key in dating sites and reconstructing human living and trading patterns.

The settlements built near Stonehenge follow circular layouts, connecting them in plan to the ceremonial site (FIG. 1-23). Unlike the more famous monument, however, these habitations were built of wood, in particular large posts and tree trunks. A mile from Stonehenge is Durrington Walls, which was a large inhabited settlement (almost 1,500 feet across) surrounded by a ditch. Inside are a number of circles—made not from stone but from wood—and

many circular houses constructed with wooden posts. The rubbish left behind at this and similar sites provides archaeologists with insights into the lives of the inhabitants. Chemical analysis of animal bone debris, for example, indicates that the animals consumed came from great distances before they were slaughtered, and therefore that the people who stayed here had come from regions far removed from the site.

Significantly, both Stonehenge and Durrington Walls are connected to the Avon River by banked avenues. These connected the worlds of the living (the wood settlement) with the domain of the dead (the stone circle). Neolithic people would have moved between these worlds as they walked the avenues, sometimes bringing the deceased to be buried or cremated, other times approaching the stone circle for ceremonies and rituals dedicated to the memories of the deceased and the very ancient ancestors. The meaning of Stonehenge therefore rests within an understanding of the larger landscape that contained not only other ritual sites but also sites of habitation.

1-23 • RECONSTRUCTION DRAWING OF DURRINGTON WALLS
The settlement at Durrington Walls, near Stonehenge, southern England. 2600 BCE.

SCULPTURE AND CERAMICS

In addition to domestic and ceremonial architecture and a food-producing economy, the other critical component of the Neolithic way of life was the ability to make ceramic vessels (see "Pottery and Ceramics." opposite). This "pot revolution" marked a shift from a complete reliance on skin, textile, and wooden containers to the use of pots made by firing clay. Pottery provided a new medium of extraordinary potential for shaping and decorating durable objects. Ceramic technology emerged independently, at different times, across the globe, with the earliest examples being produced by the Jomon culture of hunter-gatherers in Japan in 12,000 BCE (FIG. 1-24). It is extremely difficult to determine with certainty why pottery was first invented or why subsequent cultures adopted it. The idea that pottery would only emerge out of farming settlements is confounded by the example of the Jomon. Rather, it seems that there was no one set of social, economic, or environmental circumstances that led to the invention of ceramics.

It is likely that the technology for producing ceramics evolved in stages. Archaeologist Karen Vitelli's detailed studies of the early Neolithic site of Franchthi Cave in Greece have shown that pottery making at this site started with an experimental stage during which nonspecialist potters produced a small number of pots. These early pots were used in ceremonies, especially those where medicinal or narcotic plants were consumed (FIG. 1-25). Only later did specialist potters share manufacturing recipes to produce enough pots for standard activities such as cooking and eating. A similar pattern may have occurred in other early potting communities.

In addition to firing clay to make pots, cups, pitchers, and large storage containers, Neolithic people made thousands of miniature figures of humans. While it was once thought that these figurines

1-24 • EARLY POTTERY FROM JAPAN'S JOMON **CULTURE** 12,000 BCE.

1-25 • EARLY POTTERY FROM THE FRANCHTHI CAVE. GREECE

6500 BCE.

refer to fertility cults and matriarchal societies, archaeologists now agree that they had many different functions—for example, as toys, portraits, votives. More importantly, specialists have shown that there are great degrees of similarity in figurine shape and decoration within distinct cultural regions. Such regional similarities, and the huge numbers of Neolithic figurines that would have been in circulation at any one place and time, have convinced experts that the critical significance of these objects is that they mark the emergence of the human body as the core location of human identity. Thus, the central role the body has played in the politics, philosophy, and art, of historical and modern times began over 8,000 years ago with Neolithic figurines.

Neolithic figures of humans were most numerous and diverse in central and eastern Europe (see "Prehistoric Woman and Man," page 22), but in the Near Eastern site of 'Ain Ghazal in modern Jordan, archaeologist Gary Rollefson found 32 extraordinary HUMAN FIGURES (FIG. 1-27). Dated to 6500 BCE and constructed by covering bundled-twig cores with layers of plaster, the statues were found in two pits. One contained 12 busts and 13 full figures, and in the other were two full figures, two fragmental busts, and three figures with two heads. These statues, each about 3 feet tall, are disturbing for many modern viewers, especially the startlingly stylized faces. The eyes-made with cowrie shells outlined with bitumen (a natural asphalt), also used to represent pupils—are wide open, giving the figures a lifelike appearance. Nostrils are also clearly defined, even exaggerated, but the mouths are discreet and tight-lipped. Clothes and other features were painted on the bodies. The powerful legs and feet are clearly modeled independently with plaster, but the strangely spindly arms and tiny, tapering hands cling closely to the body, as if inert. The impression is of living, breathing individuals who are unable (or unwilling) to gesture or speak.

A BROADER LOOK | Prehistoric Woman and Man

For all we know, the person who created these figurines at around 4500 BCE (FIG. 1-26) had nothing particular in mind—people had been modeling clay figures in southeastern Europe for a long time. Perhaps a woman who was making cooking and storage pots out of clay amused herself by fashioning images of the people she saw around her. But because these figures were found in the same grave in Cernavodă, Romania, they suggest to us an otherworldly message.

The woman, spread-hipped and big-bellied, sits directly on the ground, expressive of the mundane world. She exudes stability and fecundity. Her ample hips and thighs seem

to ensure the continuity of her family. But in a lively, even elegant, gesture, she joins her hands coquettishly on one raised knee, curls up her toes, and tilts her head upward. Though earthbound, is she a spiritual figure communing with heaven? Her upwardly tilted head could suggest that she is watching the smoke rising from the hearth, or worrying about holes in the roof, or admiring hanging containers of laboriously gathered drying berries, or gazing adoringly at her partner. The man is rather slim, with massive legs and shoulders. He rests his head on his hands in a brooding, pensive pose, evoking thoughtfulness. Or is it weariness, boredom, or sorrow?

We can interpret the Cernavodă woman and man in many ways, but we cannot know what they meant to their makers or owners. Depending on how they are displayed, we spin out different stories about them, broadening the potential fields of meaning. When they are set facing each other, or side by side as they are here, we tend to think of them as a couple—a woman and man in a relationship. In fact, we do not know whether the artist conceived of them in this way, or even made them at the same time. For all their visual eloquence, their secrets remain hidden from us, but it is difficult not to speculate.

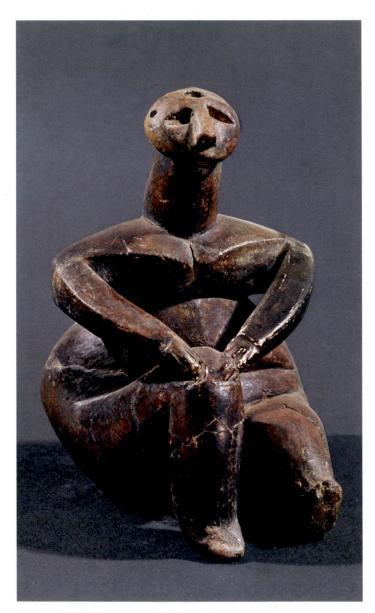

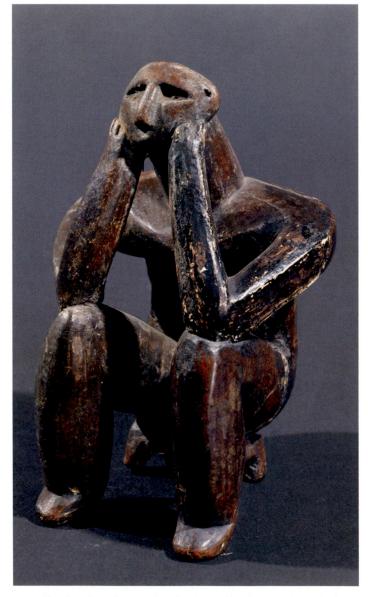

1-26 • FIGURES OF A WOMAN AND A MAN

From Cernavodă, Romania. c. 4500 BCE. Ceramic, height 41/2" (11.5 cm). National History Museum, Bucharest.

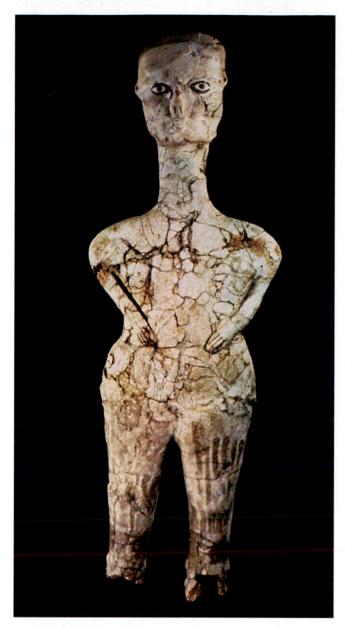

1-27 • HUMAN FIGUREFrom 'Ain Ghazal, Jordan. 6500 BCE. Fired lime plaster with cowrie shell, bitumen, and paint, height approx. 35" (90 cm). National Museum, Amman, Jordan.

Scholars have searched for clues about the function of these figures. The people who lived in 'Ain Ghazal built and rebuilt their houses, replastered walls, and buried their dead under house floors—they even dug down through the floors to retrieve the skulls of long-deceased relatives—just like the inhabitants of Çatalhöyük. They used the same plaster to coat the walls of their houses and to make the human figures. The site also contains buildings that may have served special, potentially ceremonial functions, and some suggest that the figures are linked to these rites. In addition to the figures' lifelike appearance, the similarity between the burial of bodies under house floors and the burial of the plaster figures in pits is striking. At the same time, however, there are significant differences: the statues are buried in groups while the human

bodies are not; the statues are buried in pits, not in houses; and the eyes of the statues are open, as if they are alive and awake. In the current state of research, it is difficult to know with certainty how the figures of 'Ain Ghazal were used and what they meant to the people who made them.

NEW METALLURGY, ENDURING STONE

The technology of metallurgy is closely allied to that of ceramics. Although Neolithic culture persisted in northern Europe until about 2000 BCE (and indeed all of its key contributions to human evolution—farming, architecture, and pottery—continue through present times), the age of metals made its appearance in much of Europe about 3000 BCE. In central and southern Europe, and in the Aegean region, copper, gold, and tin had been mined, worked, and traded even earlier. Smelted and cast copper beads and ornaments dated to 4000 BCE have been discovered in Poland.

Metals were first used for ornamentation. Gold was one of the first metals to be used in prehistory, used to make jewelry (ear, lip, and nose rings) or to ornament clothing (appliqués sewn onto fabric). Toward the end of the Neolithic, people shaped simple beads by cold-hammering malachite, a green-colored, copper carbonate mineral that can be found on the surface of the ground in many regions.

Over time, the objects made from gold and copper became more complicated and technologies of extraction (the mining of copper in Bulgaria) and of metalworking (casting copper) improved. Ivan Ivanov discovered some of the most sensational (and earliest) prehistoric gold and copper objects in the late Neolithic cemetery at Varna on Bulgaria's Black Sea coast. While the cemetery consisted of several hundred graves of men, women, and children, a few special burials contained gold and copper artifacts (FIGS. 1-28, 1-29). Objects such as gold-covered scepters, bracelets, beads, arm rings, lip-plugs, and copper axes and chisels distinguish the graves of a small number of adult males, and in a very few of them, no skeleton was present. Instead, the body was represented by a clay mask richly decorated with gold adornments (see FIG. 1-28) and the grave contained extraordinary concentrations of metal and special marine-shell ornaments. As in other prehistoric contexts, death and its attendant ceremonies were the focus for large and visually expressive displays of status and authority.

THE BRONZE AGE

The period that followed the introduction of metalworking is commonly called the Bronze Age. Although copper is relatively abundant in central Europe and in Spain, objects fashioned from it are too soft to be functional and therefore usually have a ceremonial or representational use and value. However, bronze—an **alloy**, or mixture, of tin and copper—is a stronger, harder substance with a wide variety of uses.

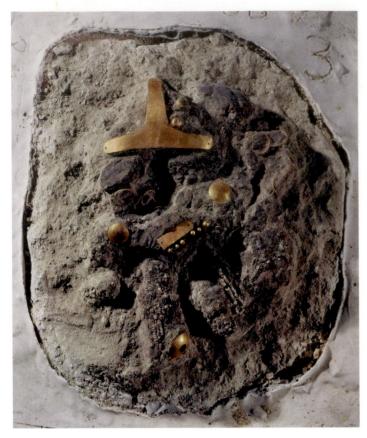

1–28 • GOLD-ADORNED FACE MASKFrom Tomb 3, Varna I, Bulgaria. Neolithic, 3800 BCE. Terra cotta and gold. Archaeological Museum, Plovdiv, Bulgaria.

The development of bronze, especially for weapons such as daggers and short swords, changed the peoples of Europe in fundamental ways. While copper ore was widely available across Europe, either as surface outcrops or easily mined, the tin that was required to make bronze had a much more limited natural distribution and

often required extraction by mining. Power bases shifted within communities as the resources needed to make bronze were not widely available to all. Trade and intergroup contacts across the continent and into the Near East increased, and bronze objects circulated as prized goods.

ROCK CARVINGS

Bronze Age artistry is not limited to metalworking; indeed, some of the most exciting imagery of the period is found in the rock art of northern Europe. For a thousand years starting around 1500 BCE people created designs by scratching outlines and pecking and grinding the surface of exposed rock faces using stone hammers and sometimes grains of sand as an abrasive. The Swedish region of northern Bohuslän is especially rich in rock carvings dating to this period; archaeologists have recorded over 40,000 individual images from more than 1,500 sites. The range of motifs is wide, including boats, animals (bulls, elk, horses, a few snakes, birds, and fish), people (mostly sexless, some with horned helmets, but also men with erect penises), wheeled vehicles and ploughs (and unassociated disks, circles, and wheels), and weapons (swords, shields, and helmets). Within this range, however, the majority of images are boats (FIG. 1-30), not just in Sweden but across northern Europe. Interestingly, the boat images are unlike the boats that archaeologists have excavated. The rock-engraved images do not have masts, nor are they the dugouts or log boats that are known from this period. Instead they represent boats made from wooden planks or with animal skins.

What is the meaning of these boat images? Most agree that the location of the majority of the rock art near current or past shorelines is the critical clue to their meaning. Archaeologist Richard Bradley suggests that rock art connects sky, earth, and sea, perhaps visualizing the community's view of the three-part nature of the universe. Others suggest that the art is intentionally located

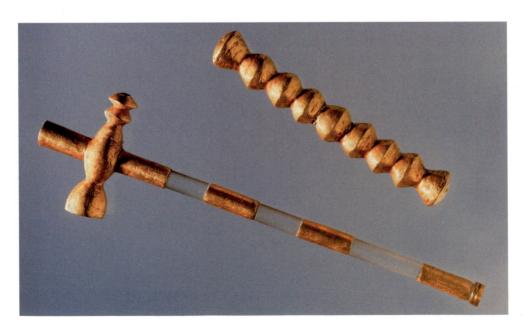

1-29 • GOLD SCEPTERSFrom Varna, Bulgaria. 3800 BCE. National Museum of History, Sofia, Bulgaria.

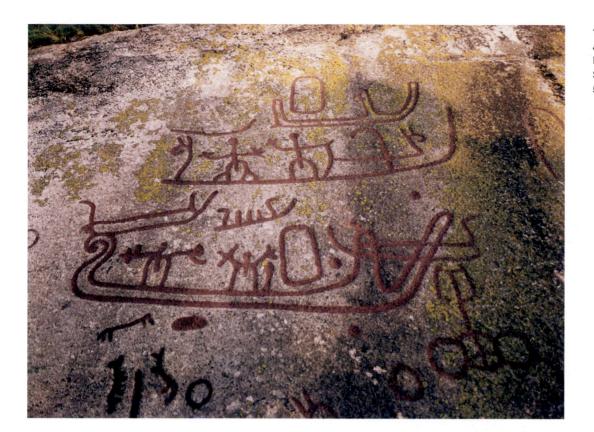

1-30 • ROCK ART: BOAT AND SEA BATTLE Fossum, northern Bohuslän, Sweden. Bronze Age, c. 1500– 500 BCE.

between water and earth to mark a boundary between the world of the living and the world of spirits. In this view, the permanent character of the rock, grounded deep in the earth, provided a means of communication and connection between distant and distinct worlds.

For people of the prehistoric era, representational and abstract art had critical symbolic importance, justifying the labor required to paint in the deep recesses of caves, move enormous stones great distances, or create elaborately ornamented masks. Prehistoric art and architecture connected the earthly with the spiritual, established social power hierarchies, and perhaps helped people learn and remember information about the natural world that was critical for their survival. This art represents one of the fundamental elements of our development as a human species.

THINK ABOUT IT

- 1.1 Prehistoric artists created representations of human figures using a variety of media, styles, and techniques. Compare two examples drawn from different times and places by discussing the relationship between style or technique and expressive character.
- 1.2 What are the common motifs found in cave paintings such as those at Lascaux and Altamira? Summarize the current theories about their original meaning and purpose.
- 1.3 Many examples of prehistoric art and architecture express relationships between the living and the dead. Discuss how this theme is evoked in one work of architecture and one example of sculpture discussed in this chapter. Why do you think this theme was so important?
- 1.4 How did the emergence of ceramics and metallurgy transform art making in the Neolithic era? Select and analyze a work discussed in the chapter that was made in one of these new media and discuss the unique properties of the medium.

CROSSCURRENTS

FIG. 1-11

FIG. 1-21

Although we have limited information about the meanings prehistoric people associated with sacred spaces, art historians and archaeologists have linked these two famous sites with specific social practices and rituals. Discuss and compare current interpretations of Lascaux and Stonehenge, evidence as well as conclusions.

Study and review on myartslab.com

2-1 • STELE OF NARAM-SINFrom Sippar; found at Susa (present-day Shush, Iran). Naram-Sin r. 2254–2218 BCE. Limestone, height 6'6" (1.98 m). Musée du Louvre, Paris.

Art of the Ancient Near East

In public works such as this stone **stele** (upright stone slab), the artists of Mesopotamia developed a suave and sophisticated symbolic visual language—a kind of conceptual art—that both celebrated and communicated the political stratification that gave order and security to their world. Akkadian ruler Naram-Sin (ruled 2254-2218 BCE) is pictured proudly here (FIG. 2-1). His preeminence is signaled directly by size: he is by far the largest person in this scene of military triumph, conforming to an artistic practice we call hierarchic scale, where relative size indicates relative importance. He is also elevated well above the other figures, boldly silhouetted against blank ground. Even the shape of the stone slab is an active part of the composition. Its tapering top perfectly accommodates the carved mountain within it, and Naram-Sin is posed to reflect the profile of both, increasing his own sense of grandeur by association. He clasps a veritable arsenal of weaponry—spear, battleaxe, bow and arrow—and the grand helmet that crowns his head sprouts horns, an attribute heretofore reserved for gods. By wearing it here, he is claiming divinity for himself. Art historian Irene Winter has gone even further, pointing to the eroticized pose and presentation of Naram-Sin, to the alluring display of a well-formed male body. In ancient Mesopotamian culture, male potency and vigor were directly related to mythical heroism and powerful kingship. Thus every aspect of the representation of this ruler speaks to his sacred and political authority as leader of the state.

This stele is more than an emblem of Naram-Sin's divine right to rule, however. It also tells the story of one of his important military victories. The ruler stands above a crowded scene enacted by smaller figures. Those to the left, dressed and posed in a fashion similar to their ruler, represent his army, marching in diagonal bands up the hillside into battle. The artist has included identifiable native trees along the mountain pathway to heighten the sense that this portrays an actual event rather than a generic battle scene. Before Naram-Sin, both along the right side of the stele and smashed under his forward striding leg, are representations of the enemy, in this case the Lullubi people from eastern Mesopotamia (modern Iran). One diminutive adversary has taken a fatal spear to the neck, while companions behind and below him beg for mercy.

Taller than most people who stand in front of it, and carved of eye-catching pink stone, this sumptuous work of ancient art maintains the power to communicate with us forcefully and directly even across over four millennia of historical distance. We will discover in this chapter that powerful symbolism and dynamic story-telling are not unique to this one stele; they are signal characteristics of royal art in the ancient Near East.

LEARN ABOUT IT

- 2.1 Investigate a series of conventions for the portrayal of human figures through the history of the ancient Near East.
- **2.2** Explore the development of visual narrative to tell stories of gods, heroes, and rulers in sculpted reliefs.
- 2.3 Survey the various ways rulers in the ancient Near East expressed their power in portraits, historical narrative, and great palace complexes.
- 2.4 Evaluate the way modern archaeologists have laid the groundwork for the art-historical interpretation of the ancient cultures of the Near East.

THE FERTILE CRESCENT AND MESOPOTAMIA

Well before farming communities appeared in Europe, people in Asia Minor and the ancient Near East were already domesticating grains in an area known today as the Fertile Crescent (MAP 2-1). In the sixth or fifth millennium BCE, agriculture developed in the alluvial plains between the Tigris and Euphrates rivers, which the Greeks called *Mesopotamia*, meaning the "land between the rivers," now in present-day Iraq. Because of problems with periodic flooding as well as drought, there was a need for large-scale systems to control the water supply. Meeting this need may have contributed to the development of the first cities.

Between 4000 and 3000 BCE, a major cultural shift seems to have taken place. Agricultural villages evolved into cities simultaneously and independently in both northern and southern Mesopotamia. These prosperous cities joined with their surrounding territories to create what are known as city-states, each with its own gods and government. Social hierarchies—rulers and workers—emerged with the development of specialized skills beyond those needed for agricultural work. To grain mills and ovens were added brick and pottery kilns and textile and metal workshops. With extra goods and even modest affluence came increased trade and contact with other cultures.

Organized religion played an important role, and the people who controlled rituals and the sacred sites eventually became full-time priests. The people of the ancient Near East worshiped numerous gods and goddesses. (The names of comparable deities varied over time and place—for example, Inanna, the Sumerian goddess of fertility, love, and war, was equivalent to the Babylonians' Ishtar.) Every city had its special protective deity, and the fate of the city was seen as dependent on the power of that deity. Large architectural complexes—clusters of religious, administrative, and service buildings—developed in each city as centers of ritual and worship and also of government.

Although the stone-free alluvial plain of southern Mesopotamia was prone to floods and droughts, it was a fertile bed for agriculture and successive, interlinked societies. But its wealth and agricultural resources, as well as its few natural defenses, made Mesopotamia vulnerable to political upheaval. Over the centuries, the balance of power shifted between north and south and between local powers and outside invaders. First the Sumerians controlled the south, filling their independent city-states with the fruits of new technology, developed literacy, and impressive art and architecture. Then they were eclipsed by the Akkadians, their neighbors to the north. When invaders from farther north in turn conquered the Akkadians, the Sumerians regained power locally. During this period the city-states of Ur and Lagash thrived under strong leaders. The Amorites were next to dominate the south. Under them and their king, Hammurabi, a new, unified society arose with its capital in the city of Babylon.

SUMER

The cities and city-states that developed along the rivers of southern Mesopotamia between about 3500 and 2340 BCE are known collectively as Sumer. The Sumerians are credited with important technological and cultural advances. They may have invented the wagon wheel and the plow. But perhaps their greatest contribution to later civilizations was the invention in 3400–3200 BCE of the first form of written script.

WRITING Sumerians pressed cuneiform ("wedge-shaped") symbols into clay tablets with a stylus, a pointed writing instrument, to keep business records (see "Cuneiform Writing," page 30). Thousands of surviving Sumerian tablets have allowed scholars to trace the gradual evolution of writing and arithmetic, another tool of commerce, as well as an organized system of justice. The world's first literary epic is Sumerian in origin, although the fullest surviving version of this tale is written in Akkadian, the language of Sumer's neighbors to the north. The Epic of Gilgamesh records the adventures of a legendary Sumerian king of Uruk and his companion Enkidu. When Enkidu dies, a despondent King Gilgamesh sets out to find the secret of eternal life from the only man and woman who had survived a great flood sent by the gods to destroy the world, because the gods had granted them immortality. Gilgamesh ultimately accepts his own mortality, abandons his quest, and returns to Uruk, recognizing the majestic city as his lasting accomplishment.

THE ZIGGURAT The Sumerians' most impressive surviving archaeological remains are **ziggurats**, huge stepped structures with a temple or shrine on top. The first ziggurats may have developed from the practice of repeated rebuilding at a sacred site, with rubble from one structure serving as the foundation for the next. Elevating the buildings also protected the shrines from flooding.

Whatever the origin of their design, ziggurats towering above the flat plain proclaimed the wealth, prestige, and stability of a city's rulers and glorified its gods. Ziggurats functioned symbolically too, as lofty bridges between the earth and the heavens—a meeting place for humans and their gods. They were given names such as "House of the Mountain" and "Bond between Heaven and Earth."

URUK Two large temple complexes in the 1,000-acre city at Uruk (present-day Warka, Iraq) mark the first independent Sumerian city-state. One was dedicated to Inanna, the goddess of love and war, while the other complex belonged to the sky god Anu. The temple platform of Anu, built up in stages over the centuries, ultimately rose to a height of about 40 feet. Around 3100 BCE, a whitewashed mud-brick temple that modern archaeologists refer to as the White Temple was erected on top of the platform (**FIG. 2-2**). This now-ruined structure was a simple rectangle with an off-center doorway that led into a

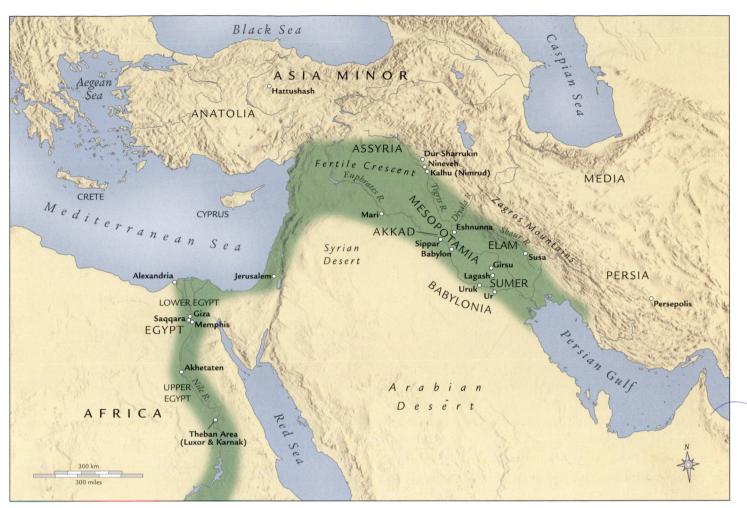

MAP 2-1 • THE ANCIENT NEAR EAST

The green areas represent fertile land that could support early agriculture, notably the area between the Tigris and Euphrates rivers and the strips of land on either side of the Nile in Egypt.

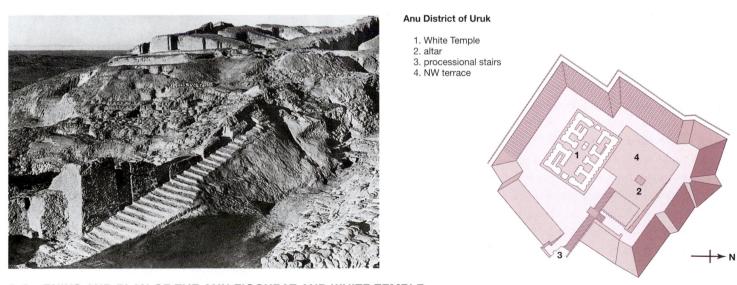

2-2 • RUINS AND PLAN OF THE ANU ZIGGURAT AND WHITE TEMPLE

Uruk (present-day Warka, Iraq). c. 3400-3200 BCE.

Many ancient Near Eastern cities still lie undiscovered. In most cases an archaeological site in the region is signaled by a large mound—known locally as a *tell*, *tepe*, or *huyuk*—that represents the accumulated debris of generations of human habitation. When properly excavated, such mounds yield evidence about the people who inhabited the site.

TECHNIQUE | Cuneiform Writing

Sumerians invented writing around 3400–3200 BCE, apparently as an accounting system for goods traded at Uruk. The symbols were pictographs, simple pictures cut into moist clay slabs with a pointed tool. By the fourth millennium BCE, the symbols had begun to evolve from pictures into phonograms—representations of syllable sounds—thus becoming a writing system as we know it. By 3000–2900, scribes adopted a stylus, or writing tool, with one triangular end and one pointed end that could be pressed easily and rapidly into a wet clay tablet to produce cuneiform writing.

These drawings demonstrate the shift from pictographs to cuneiform. The c. 3100 BCE drawing of a bowl (which means "bread" or "food") was reduced to a four-stroke sign by about 2400 BCE, and by about 700 BCE to a highly abstract arrangement of vertical marks. By combining the pictographs and, later, cuneiform signs, writers created composite signs; for example, a combination of the signs for "head" and "food" meant "to eat."

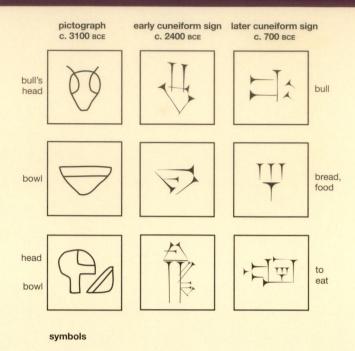

View the Closer Look for cuneiform writing in Sumeria on myartslab.com

large chamber containing an altar, and smaller spaces opened to each side.

Statues of gods and donors were placed in Sumerian temples. A striking life-size marble face from Uruk (FIG. 2-3) may represent a temple goddess. It could have been attached to a wooden head on a full-size wooden body. Now stripped of its original paint, wig, and the **inlay** set in for brows and eyes, it appears as a stark white mask. Shells may have been used for the whites of the eyes and lapis lazuli for the pupils, and the hair may have been gold.

A tall vessel of carved alabaster (a fine, white stone) found in the temple complex of Inanna at Uruk (FIG. 2-4) shows how early Mesopotamian sculptors told stories in stone with great clarity and verve. The visual narrative is organized into three registers, or horizontal bands, and the story condensed to its essential elements. The lowest register shows in a lower strip the sources of life in the natural world, beginning with water and plants (variously identified as date palm and barley, wheat and flax) and continuing in a superimposed upper strip, where alternating rams and ewes march single file along a solid ground-line. In the middle register naked men carry baskets of foodstuffs, and in the top register, the goddess Inanna accepts an offering from two standing figures. Inanna stands in front of the gate to her richly filled shrine and storehouse, identified by two reed door poles hung with banners. The two men who face her are thought to be first a naked priest or acolyte presenting an offering-filled basket, followed by a partially preserved, ceremonially dressed figure of the priest-king (not visible in FIGURE 2-4). The scene may represent a re-enactment of the ritual

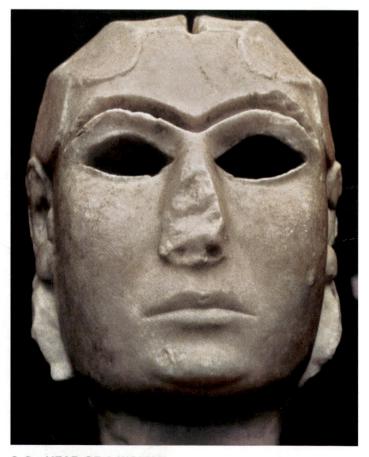

2-3 • HEAD OF A WOMAN
From Uruk (present-day Warka, Iraq).

From Uruk (present-day Warka, Iraq). c. 3300–3000 BCE. Marble, height approx. 8" (20.3 cm). Iraq Museum, Baghdad.

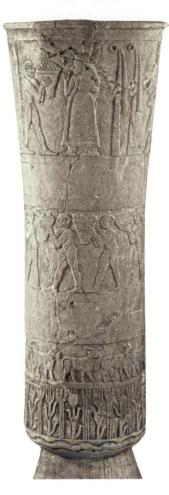

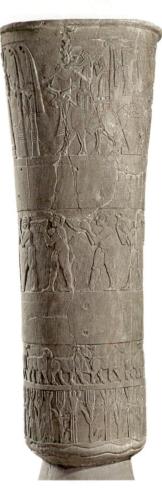

2-4 • CARVED VESSEL
From Uruk (present-day Warka, Iraq). c. 3300–3000 BCE. Alabaster, height 36" (91 cm). Iraq Museum, Baghdad.

marriage between the goddess and Dumuzi, her consort—a role taken by the priest-king—that took place during the New Year's festival to ensure the fertility of crops, animals, and people, and thus the continued survival of Uruk.

VOTIVE FIGURES Limestone statues dated to about 2900–2600 BCE from the Square Temple in Eshnunna (**FIG. 2-5**), excavated in 1932–1933, reveal another aspect of Sumerian religious art. These **votive figures** of men and women—images dedicated to the gods—are directly related to an ancient Near Eastern devotional practice in which individual worshipers could set up images of themselves in a shrine before a larger, more elaborate image of a god. A simple inscription might identify the figure as "One who offers prayers." Longer inscriptions might recount in detail all the things the donor had accomplished in the god's honor. Each sculpture served as a stand-in for the donor, locked in eye-contact with the god, caught perpetually in the act of worship.

The sculptors of these votive statues followed **conventions** (traditional ways of representing forms) that were important in Sumerian art. Figures have stylized faces and bodies, dressed in clothing that emphasizes pure cylindrical shapes. They stand solemnly, hands clasped in respect, perhaps a posture expected in devotional contexts. The bold, staring eyes may be related to statements in contemporary Sumerian texts that advise worshipers to approach their gods with an attentive gaze. As with the face of the woman from Uruk, arched brows were inlaid with dark shell, stone, or bitumen that once emphasized the huge, wide-open eyes.

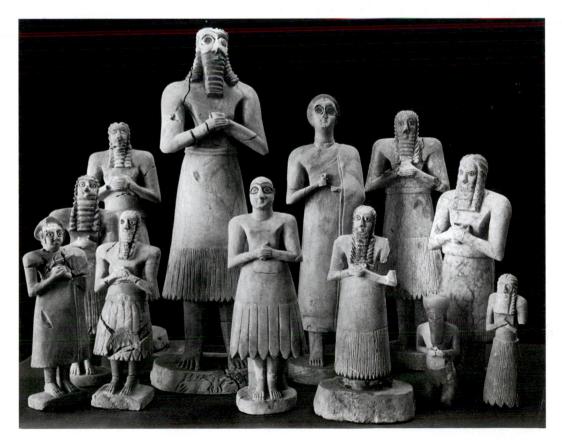

2-5 • TWELVE VOTIVE FIGURES

From the Square Temple, Eshnunna (present-day Tell Asmar, Iraq). c. 2900–2600 BCE. Limestone, alabaster, and gypsum, height of largest figure approx. 30" (76.3 cm). The Oriental Institute Museum, University of Chicago.

A BROADER LOOK | A Lyre from a Royal Tomb in Ur

Sir Leonard Woolley's excavations at Ur during the 1920s initially garnered international attention because of the association of this ancient Mesopotamian city with the biblical patriarch Abraham. It was not long, however, before the exciting discoveries themselves moved to center stage, especially 16 royal burials that yielded spectacular objects crafted of gold and lurid evidence of the human sacrifices associated with Sumerian royal burial practices, when retainers were seemingly buried with the rulers they served.

Woolley's work at Ur was a joint venture of the University of Pennsylvania Museum in Philadelphia and the British Museum in London, and in conformance with Iraq's Antiquities Law of 1922, the uncovered artifacts were divided between the sponsoring institutions and Iraq itself. Although Woolley worked with a large team of laborers and

assistants during 12 seasons of digging at Ur, he and his wife Katherine reserved for themselves the painstakingly delicate process of uncovering the most important finds (FIG. 2-6). Woolley's own account of work within one tomb outlines the practice-"Most of the workmen were sent away ... so that the final work with knives and brushes could be done by my wife and myself in comparative peace. For ten days the two of us spent most of the time from sunrise to sunset lying on our tummies brushing and blowing and threading beads in their order as they lay.... You might suppose that to find three-score women all richly bedecked with jewelry could be a very thrilling experience, and so it is, in retrospect, but I'm afraid that at the moment one is much more conscious of the toil than of the thrill" (quoted in Zettler and Horne, p. 31).

(FIG. 2-7). Like nine other lyres Woolley found at Ur, the wooden sound box of this one had long since deteriorated and disappeared, but an exquisitely crafted bull's-head finial of gold and lapis lazuli survived, along with a plaque of carved shell inlaid with bitumen, depicting at the top a heroic image of a man interlocked with and in control of two bulls, and below them three scenes of animals mimicking the activities of humans (FIG. 2-8). On one register, a seated donkey plucks the strings of a bull lyre—similar to the instrument on which this set of images originally appeared stabilized by a standing bear, while a fox accompanies him with a rattle. On the register above, upright animals bring food and drink for a feast. A hyena to the left—assuming the role of a butcher with a knife in his belt-carries a table piled high with meat. A lion follows, toting a large jar and pouring vessel. The top and bottom registers are particularly intriguing in relation to the Epic of Gilgamesh, a 3,000-line poem that is Sumer's great contribution to world literature. Rich in descriptions of heroic feats and fabulous creatures, Gilgamesh's story probes the question of immortality and expresses the heroic aim to understand hostile surroundings and to find meaning in human existence. the one pictured in the lowest register,

One of the most spectacular discoveries in

the royal burials at Ur was an elaborate lyre,

had presumably played it during the funeral

ceremony for the royal figure buried nearby

which rested over the body of the woman who

Gilgamesh encounters scorpion-men, like the one pictured in the lowest register, and it is easy to see the hero himself in the commanding but unprotected bearded figure centered in the top register, naked except for a wide belt, masterfully controlling in his grasp the two powerfully rearing human-headed bulls that flank him. Because the poem was first written down 700 years after this lyre was created, this plaque may document a very long oral tradition.

On another level, because we know lyres were used in funeral rites, could this imagery depict a heroic image of the deceased in the

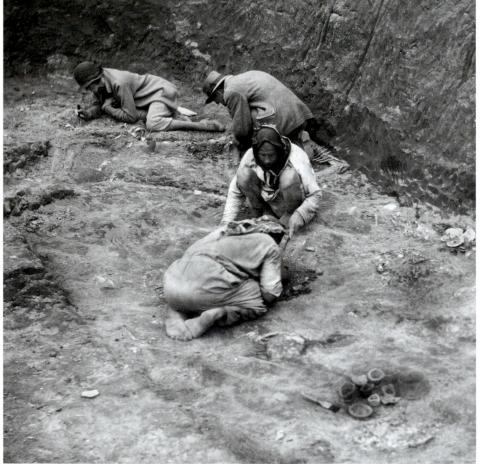

2-6 • KATHERINE AND LEONARD WOOLLEY (ABOVE) EXCAVATING AT UR IN 1937, BESIDE TWO ARCHAEOLOGICAL ASSISTANTS IN ONE OF THE ROYAL BURIALS

Archives of the University of Pennsylvania Museum, Philadelphia.

top register, and a funeral banquet in the realm of the dead at the bottom? Cuneiform tablets preserve songs of mourning, perhaps chanted by priests accompanied by lyres at funerals. One begins, "Oh, lady, the harp of mourning is placed on the ground," a particularly poignant statement considering that the lyres of Ur may have been buried on top of the sacrificed bodies of the women who originally played them.

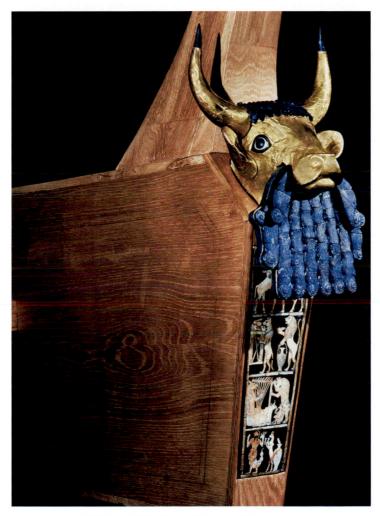

2-7 • THE GREAT LYRE WITH BULL'S HEAD

From Royal Tomb (PG 789), Ur (present-day Muqaiyir, Iraq). c. 2600–2500 BCE. Wood with gold, silver, lapis lazuli, bitumen, and shell, reassembled in modern wood support; height of head 14" (35.6 cm); height of front panel 13" (33 cm); maximum length of lyre $55\frac{1}{2}$ " (140 cm); height of upright back arm $46\frac{1}{2}$ " (117 cm). University of Pennsylvania Museum of Archaeology and Anthropology, Philadelphia.

2-8 • FRONT PANEL, THE SOUND BOX OF THE GREAT LYRE

From Ur (present-day Muqaiyir, Iraq). Wood with shell inlaid in bitumen, height $13'' \times 4^{1}\!/\!_{2}''$ (33×11 cm). University of Pennsylvania Museum of Archaeology and Anthropology, Philadelphia.

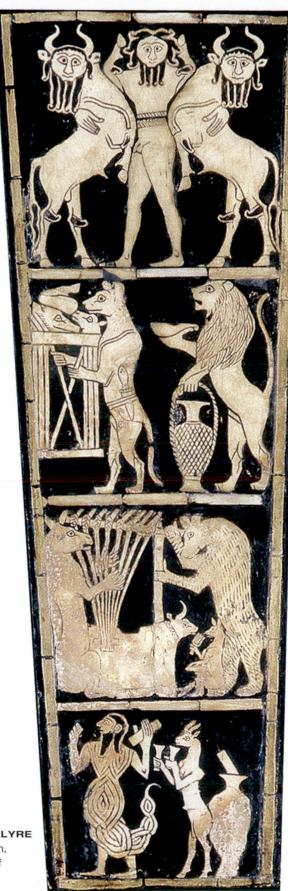

ART AND ITS CONTEXTS | Art as Spoils of War—Protection or Theft?

Art has always been a casualty in times of social unrest. One of the most recent examples is the looting of the unguarded Iraq National Museum after the fall of Baghdad to U.S.-led coalition forces in April 2003. Among the many thousands of treasures that were stolen is a precious marble head of a woman from Warka, over 5,000 years old (see Fig. 2–3). Fortunately it was later recovered. Also looted was a carved Sumerian vessel (see Fig. 2–4), eventually returned to the museum two months later, shattered into 14 pieces. The museum itself managed to reopen in 2009, but thousands of its antiquities are still missing.

Some of the most bitter resentment spawned by war has involved the taking by the victors of art objects that held great value for the conquered population. Two historically priceless objects unearthed in Elamite Susa, for example—the Akkadian stele of Naram-Sin (see Fig. 2–1) and the Babylonian stele of Hammurabi (see Fig. 2–15)—were not Elamite at all, but Mesopotamian. Both had been brought there as military booty by an Elamite king, who added an inscription to the stele of Naram-Sin claiming it for himself and his gods. Uncovered in Susa during excavations organized by French archaeologist Jacques de Morgan, both works were taken back to Paris at the turn of the twentieth century and are now displayed in the Louvre. Museums around the world contain such works, either snatched by invading armies or acquired as a result of conquest.

The Rosetta Stone, the key to deciphering Egyptian hieroglyphs, was discovered in Egypt by French troops in 1799, fell into British hands when they forced the French from Egypt, and ultimately ended up in the British Museum in London (see Fig. 3–38). In the early nineteenth century, the Briton Lord Elgin purchased and removed classical Greek sculpture from the Parthenon in Athens with the permission of the Ottoman authorities who governed Greece at the time (see "Who Owns the Art?" page 133). Although his actions may indeed have protected these treasures from neglect and damage in later wars, they have remained installed in the British Museum, despite continuing protests from Greece. Many German collections include works that were similarly "protected" at the end of World War II and are surfacing now. In the United States, Native Americans are increasingly vocal in their demands that artifacts and human remains collected by anthropologists and archaeologists be returned to them.

"To the victor," it is said, "belong the spoils." But passionate and continuous debate surrounds the question of whether this notion remains valid in our own time, especially in the case of revered cultural artifacts.

2-9 • FACE OF A WOMAN, KNOWN AS THE WARKA HEAD Displayed by Iraqi authorities on its recovery in 2003 by the Iraq Museum in Baghdad. The head is from Uruk (present-day Warka, Iraq). c. 3300–3000 BCE. Marble, height approx. 8" (20.3 cm).

The male figures, bare-chested and dressed in what appear to be sheepskin skirts, are stocky and muscular, with heavy legs, large feet, big shoulders, and cylindrical bodies. The female figures are as massive as the men. Their long sheepskin skirts reveal sturdy legs and feet.

Sumerian artisans worked in various precious metals, and in bronze, often combining them with other materials. Many of these creations were decorated with—or were in the shape of—animals or composite animal-human-bird creatures. A superb example of their skill is a lyre—a kind of harp—from the city of Ur (present-day Muqaiyir, Iraq), to the south of Uruk. This combines wood, gold, lapis lazuli, and shell (see FIGS. 2-7, 2-8). Projecting from the base is a wood-sculpted head of a bearded bull overlaid with gold,

intensely lifelike despite the decoratively patterned blue beard created from the semiprecious gemstone, lapis lazuli. Since lapis lazuli had to be imported from Afghanistan, the work documents widespread trade in the region at this time.

CYLINDER SEALS About the time written records appeared, Sumerians developed seals for identifying documents and establishing property ownership. By 3300–3100 BCE, record keepers redesigned the stamp seal as a cylinder. Rolled across documents on clay tablets or over the soft clay applied to a closure that needed sealing—a jar lid, the knot securing a bundle, or the door to a room—the cylinders left a raised mirror image of the design incised (cut) into their surface. Such sealing attested to the

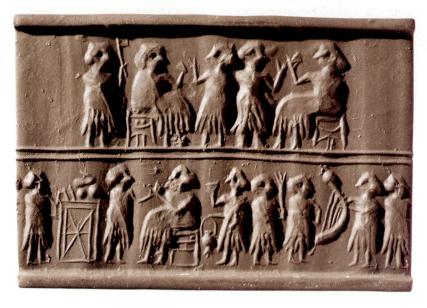

2-10 • CYLINDER SEAL AND ITS MODERN IMPRESSION

From the tomb of Queen Puabi (PG 800), Ur (present-day Muqaiyir, Iraq). c. 2600–2500 BCE. Lapis lazuli, height 1%6" (4 cm), diameter 25/32" (2 cm). University of Pennsylvania Museum of Archaeology and Anthropology, Philadelphia.

authenticity or accuracy of a text or ensured that no unauthorized person could gain access to a room or container. Sumerian **cylinder seals**, usually less than 2 inches high, were generally made of a hard stone so that the tiny but intricate incised scenes would not wear away during repeated use. Individuals often acquired seals as signs of status or on appointment to a high administrative position, and the seals were buried with them, along with other important possessions.

The lapis lazuli **CYLINDER .SEAL** in **FIGURE 2-10** is one of over 400 that were found in excavations of the royal burials at Ur. It comes from the tomb of a powerful royal woman known as Puabi, and was found leaning against the right arm of her body. The modern clay impression of its incised design shows two registers of a convivial banquet at which all the guests may be women, with fringed skirts and long hair gathered up in buns behind their necks. Two seated figures in the upper register raise their glasses, accompanied by standing servants, one of whom, at far left, holds a fan. The single seated figure in the lower register sits in front of a table piled with food, while a figure behind her offers a cup of drink, presumably drawn from the jar she carries in her other hand, reminiscent of the container held by the lion on the lyre plaque (see FIG. 2–8). Musical entertainment is provided by four women standing to the far right.

AKKAD

A people known as the Akkadians inhabited an area north of Uruk. During the Sumerian period, they adopted Sumerian culture, but unlike the Sumerians, the Akkadians spoke a Semitic language (the same family of languages that includes Arabic and Hebrew). Under the powerful military and political figure Sargon I (ruled c. 2332–2279 BCE), they conquered most of Mesopotamia. For more than half a century, Sargon, "King of the Four Quarters of the World," ruled this empire from his capital at Akkad, the actual site of which is yet to be discovered.

DISK OF ENHEDUANNA A partially preserved circular relief sculpture in alabaster, excavated at Ur in 1927 by British archaeologist Leonard Woolley (see "A Lyre from a Royal Tomb in Ur," page 32), is one of the most extraordinary surviving works of ancient Near Eastern art (**FIG. 2-11**). An inscription on the back identifies the centrally highlighted figure on the front—slightly larger than her companions and wearing a flounced, fleeced wool garment and the headgear of a high priestess—as Enheduanna,

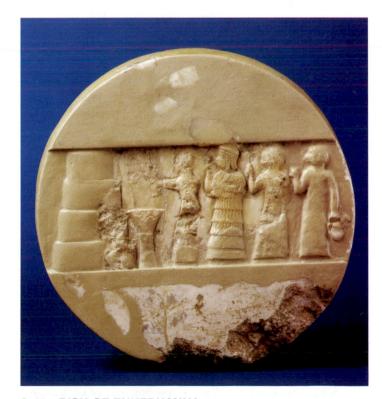

2-11 • DISK OF ENHEDUANNA
From Ur (present-day Muqaiyir, Iraq). c. 2300–2275 BCE. Alabaster, diameter 10" (25.6 cm). University of Pennsylvania Museum of Archaeology and Anthropology, Philadelphia.

daughter of Sargon I and high priestess of the moon god Nanna at his temple in Ur. Enheduanna's name also appears in other surviving Akkadian inscriptions and most notably in association with a series of poems and hymns dedicated to the gods Nanna and Inanna. Hers is the earliest recorded name of an author in human history.

The procession portrayed on the front of the disk commemorates the dedication of Enheduanna's donation of a dais (raised platform) to the temple of Inanna in Ur. The naked man in front of her pours a ritual libation in front of a ziggurat, while Enheduanna and her two followers—probably female attendants—raise their right hands before their faces in a common gesture of pious greeting (e.g., see Fig. 2–14). Sargon's appointment of his daughter

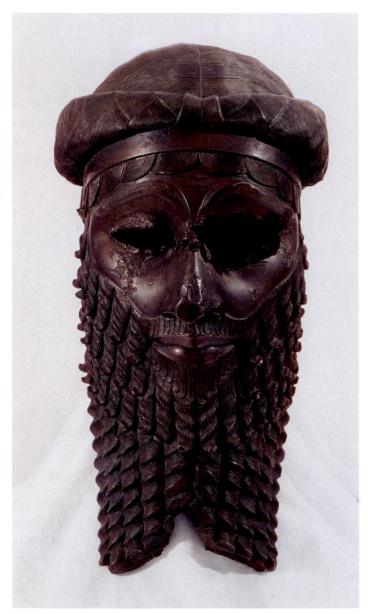

2-12 • HEAD OF A MAN (KNOWN AS AN AKKADIAN RULER)

From Nineveh (present-day Ninua, Iraq). c. 2300–2200 BCE. Copper alloy, height 143% (36.5 cm). Iraq Museum, Baghdad.

to this important religious office followed an established tradition, but it may also have been the ruler's attempt to bolster his support and assert dynastic control in the southern part of his domain, largely populated by Sumerians.

HEAD OF A RULER A life-size bronze head (**FIG. 2-12**)—found in the northern city of Nineveh (present-day Ninua, Iraq) and thought to date from the time of Sargon—is the earliest known work of hollow-cast sculpture using the **lost-wax casting** process (see "Lost-Wax Casting," page 418). Its artistic and technical sophistication is nothing short of spectacular.

The facial features and hairstyle may reflect a generalized ideal more than the unique likeness of a specific individual, although the sculpture was once identified as Sargon himself. The enormous curling beard and elaborately braided hair (circling the head and ending in a knot at the back) indicate both royalty and ideal male appearance. The deliberate damage to the left side of the face and eye suggests that the head was symbolically mutilated at a later date to destroy its power. Specifically, the ears and the inlaid eyes appear to have been removed to deprive the head of its ability to hear and see.

THE STELE OF NARAM-SIN The concept of imperial authority was literally carved in stone by Sargon's grandson Naram-Sin (see Fig. 2-1). This 6½-foot-high stele (probably only ¾ its original height) memorializes one of his military victories, and is one of the first works of art created to celebrate a specific achievement of an individual ruler. The original inscription—framed in a rectangular box just above the ruler's head—states that the stele commemorates Naram-Sin's victory over the Lullubi people of the Zagros Mountains. Watched over by solar deities (symbolized by the rayed suns at the top of the stele) and wearing the horned helmet-crown heretofore associated only with gods, the hierarchically scaled king stands proudly above his soldiers and his fallen foes, boldly silhouetted against the sky next to the smooth surface of a mountain.

This expression of physical prowess and political power was erected by Naram-Sin in the courtyard of the temple of the sun god Shamash in Sippar, but it did not stay there permanently. During the twelfth century BCE—over a thousand years after the end of Akkadian rule—Elamite king Shutruk-Nahhunte conquered Sippar and transported the stele of Naram-Sin back to his own capital in Susa, where he rededicated it to an Elamite god. He also added a new explanatory inscription—in a diagonal band on the mountain in front of Naram-Sin—recounting his own victory and claiming this monument—which is identified specifically with Naram-Sin—as a statement of his own military and political prowess. The stele remained in Susa until the end of the nineteenth century, when it was excavated by a French archaeologist and traveled once more, this time appropriated for exhibition in Paris at the Louvre.

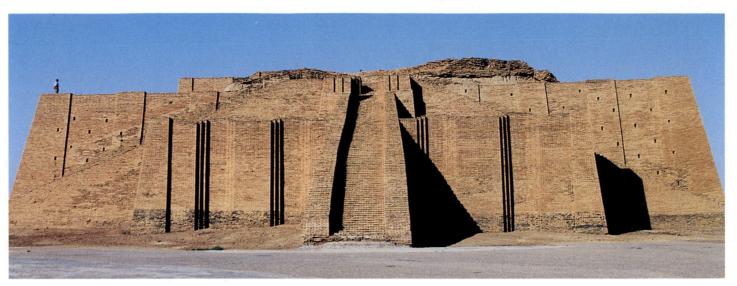

2-13 • NANNA ZIGGURAT
Ur (present-day Muqaiyir, Iraq). c. 2100–2050 BCE.

UR AND LAGASH

The Akkadian Empire fell around 2180 BCE to the Guti, a mountain people from the northeast. For a brief time, the Guti controlled most of the Mesopotamian plain, but ultimately Sumerian people regained control of the region and expelled the Guti in 2112 BCE, under the leadership of King Urnammu of Ur. He sponsored magnificent building campaigns, notably a ziggurat dedicated to the moon god Nanna, also called Sin (FIG. 2-13). Although located on the site of an earlier temple, this imposing structure—mud-brick faced with kiln-dried brick set with bitumen—was not the accidental result of successive rebuilding. Its base is a rectangle 205 by 141 feet, with three sets of stairs converging at an imposing entrance gate atop the first of what were three platforms. Each platform's walls slope outward from top to base, probably to prevent rainwater from forming puddles and eroding the mud-brick pavement below. The first two levels of the ziggurat and their retaining walls are recent reconstructions.

One large Sumerian city-state remained independent throughout this period: Lagash, whose capital was Girsu (present-day Telloh, Iraq), on the Tigris River. Gudea, the ruler, built and restored many temples, and within them, following a venerable Mesopotamian tradition, he placed votive statues representing himself as governor and embodiment of just rule. The statues are made of diorite, a very hard stone, and the difficulty of carving it may have prompted sculptors to use compact, simplified forms for the portraits. Or perhaps it was the desire for powerful, stylized images that inspired the choice of this imported stone for this series of statues. Twenty of them survive, making Gudea a familiar figure in the study of ancient Near Eastern art.

Images of Gudea present him as a strong, peaceful, pious ruler worthy of divine favor (**FIG. 2–14**). Whether he is shown sitting or standing, he wears a long garment, which provides ample, smooth space for long cuneiform inscriptions. In this imposing statue, only

2½ feet tall, his right shoulder is bare, and he wears a cap with a wide brim carved with a pattern to represent fleece. He holds a vessel in front of him, from which life-giving water flows in two streams, each filled with leaping fish. The text on his garment states that he dedicated himself, the statue, and its temple to the goddess Geshtinanna, the divine poet and interpreter of dreams. The sculptor has emphasized the power centers of the human body: the eyes, head, and smoothly muscled arms. Gudea's face is youthful and serene, and his eyes—oversized and wide open—perpetually confront the gaze of the deity with intense concentration.

BABYLON

For more than 300 years, periods of political turmoil alternated with periods of stable government in Mesopotamia, until the Amorites (a Semitic-speaking people from the Syrian desert, to the west) reunited the region under Hammurabi (ruled 1792–1750 BCE). Hammurabi's capital city was Babylon and his subjects were called Babylonians. Among Hammurabi's achievements was a written legal code that detailed the laws of his realm and the penalties for breaking them (see "The Code of Hammurabi," page 39).

THE HITTITES OF ANATOLIA

Outside Mesopotamia, other cultures developed and flourished in the ancient Near East. Anatolia (present-day Turkey) was home to several independent cultures that had resisted Mesopotamian domination, but the Hittites—whose founders had moved into the mountains and plateaus of central Anatolia from the east—were the most powerful among them.

The Hittites established their capital at Hattusha (near present-day Boghazkoy, Turkey) about 1600 BCE, and the city thrived until its destruction about 1200 BCE. Through trade and conquest, the Hittites created an empire that stretched along the coast of the

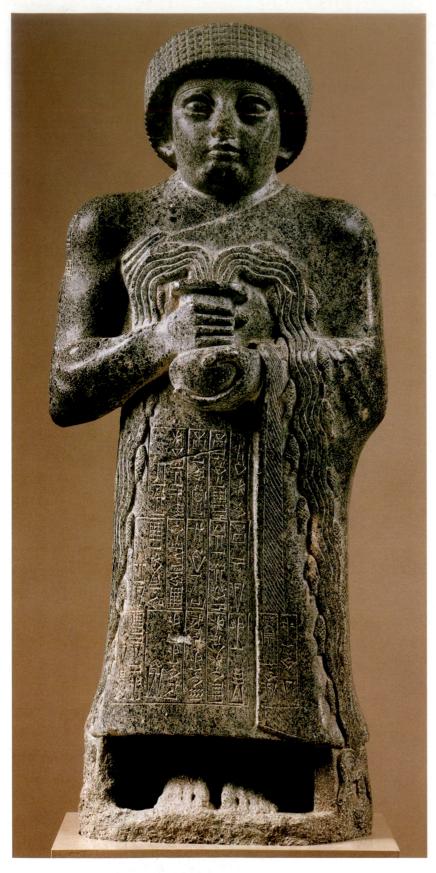

2-14 • VOTIVE STATUE OF GUDEA

From Girsu (present-day Telloh, Iraq). c. 2090 BCE. Diorite, height 29" (73.7 cm). Musée du Louvre, Paris.

Read the document related to the statue of Gudea on myartslab.com

Mediterranean Sea in the area of present-day Syria and Lebanon, bringing them into conflict with the Egyptian Empire, which was expanding into the same region (see Chapter 3). The Hittites also made incursions into Mesopotamia, and their influence was felt throughout the region.

The Hittites may have been the first people to work in iron, which they used for war-chariot fittings, weapons, chisels, and hammers. They are noted for the artistry of their fine metalwork and for their imposing palace citadels with double walls and fortified gateways, that survive today only in the ruins of archaeological sites. One of the most monumental of these sites consists of the foundations and base walls of the Hittite stronghold at Hattusha, which date to about 1400–1300 BCE. Local quarries supplied stone for the lower walls, and the upper walls, stairways, and walkways were finished in brick.

The blocks of stone used to frame doorways at Hattusha were decorated in high relief with a variety of guardian figures—some of them 7 feet tall. Some were half-human, half-animal creatures; others were more naturalistically rendered animals like the lions at the **LION GATE** (FIG. 2-16). Carved from the building stones and consistent with the colossal scale of the wall itself, the lions seem to emerge from the gigantic boulders that form the gate. Despite extreme weathering, the lions have endured over the millennia and maintain their sense of both vigor and permanence.

ASSYRIA

About 1400 BCE, a people called the Assyrians rose to dominance in northern Mesopotamia. After about 1000 BCE, they began to conquer neighboring regions. By the end of the ninth century BCE, the Assyrians controlled most of Mesopotamia, and by the early seventh century BCE they had extended their influence as far west as Egypt. Soon afterward they succumbed to internal weakness and external enemies, and by 600 BCE their empire had collapsed.

Assyrian rulers built huge palaces atop high platforms inside a series of fortified cities that served at one time or another as Assyrian capitals. They decorated these palaces with shallow stone reliefs of battle and hunting scenes, of Assyrian victories, of presentations of tribute to the king, and of religious imagery.

KALHU

During his reign (883–859 BCE), Assurnasirpal II established his capital at Kalhu (present-day Nimrud, Iraq), on the east bank of the Tigris River, and

ART AND ITS CONTEXTS | The Code of Hammurabi

Babylonian ruler Hammurabi's systematic codification of his people's rights, duties, and punishments for wrongdoing was engraved on a black basalt slab known as the **STELE OF HAMMURABI** (FIG. 2–15). This imposing artifact, therefore, is both a work of art that depicts a legendary event and a precious historical document that records a conversation about justice between god and man.

At the top of the stele, we see Hammurabi standing in an attitude of prayer before Shamash, the sun god and god of justice. Rays rise from Shamash's shoulders as he sits, crowned by a conical horned cap, on a backless throne, holding additional symbols of his power—the measuring rod and the rope circle. Shamash gives the law to the king, his intermediary, and the codes of justice flow forth underneath them in horizontal bands of exquisitely engraved cuneiform signs. The idea of god-given laws engraved on stone tablets will have a long tradition in the ancient Near East. About 500 years later, Moses, the lawgiver of Israel, received two stone tablets containing the Ten Commandments from God on Mount Sinai (Exodus 32:19).

A prologue on the front of the stele lists the temples Hammurabi has restored, and an epilogue on the back glorifies him as a peacemaker, but most of the stele "publishes" the laws themselves, guaranteeing uniform treatment of people throughout his kingdom. Within the inscription, Hammurabi declares that he intends "to cause justice to prevail in the land and to destroy the wicked and the evil, that the strong might not oppress the weak nor the weak the strong." Most of the 300 or so entries that follow deal with commercial and property matters. Only 68 relate to domestic problems, and a mere 20 deal with physical assault.

Punishments are based on the wealth, class, and gender of the parties—the rights of the wealthy are favored over the poor, citizens over slaves, men over women. Most famous are instances when punishments are specifically tailored to fit crimes—an eye for an eye, a tooth for a tooth, a broken bone for a broken bone. The death penalty is decreed for crimes such as stealing from a temple or palace, helping a slave to escape, or insubordination in the army. Trial by water and fire could also be imposed, as when an adulterous woman and her lover were to be thrown into the water; if they did not drown, they were deemed innocent. Although some of the punishments may seem excessive today, Hammurabi was breaking new ground by regulating laws and punishments rather than leaving them to the whims of rulers or officials.

2-15 • STELE OF HAMMURABI

Probably from Sippar; found at Susa (present-day Shush, Iran). c. 1792–1750 BCE. Basalt, height of stele approx. 7'4" (2.25 m); height of figural relief 28" (71.1 cm). Musée du Louvre, Paris.

Read the document related to the code of Hammurabi on myartslab.com

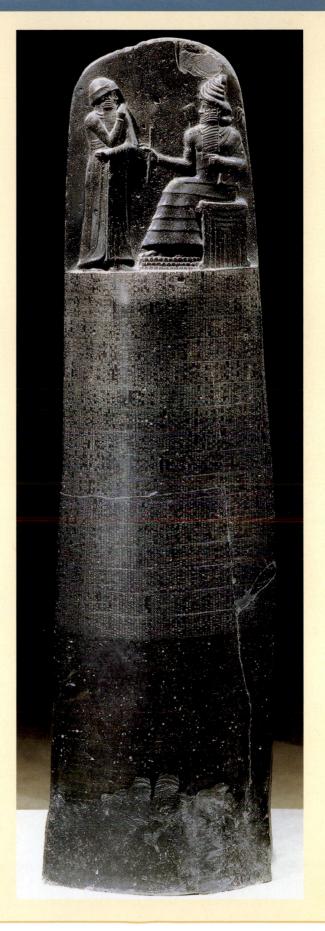

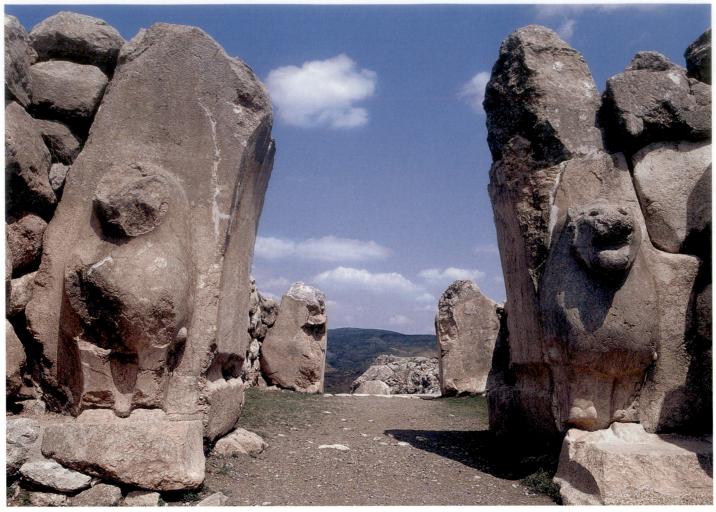

2-16 • LION GATE

Hattusha (near present-day Boghazkoy, Turkey). c. 1400 BCE. Limestone.

undertook an ambitious building program. His architects fortified the city with mud-brick walls 5 miles long and 42 feet high, and his engineers constructed a canal that irrigated fields and provided water for the expanded population of the city. According to an inscription commemorating the event, Assurnasirpal gave a banquet for 69,574 people to celebrate the dedication of the new capital in 863 BCE.

Most of the buildings in Kalhu were made from mud bricks, but limestone and alabaster—more impressive and durable—were used to veneer walls with architectural decoration. Colossal guardian figures flanked the major **portals** (grand entrances, often decorated), and panels covered the walls with scenes in **low relief** (sculpted relief with figures that project only slightly from a recessed background) of the king participating in religious rituals, war campaigns, and hunting expeditions.

THE LION HUNT In a vivid lion-hunting scene (**FIG. 2-17**), Assurnasirpal II stands in a chariot pulled by galloping horses and draws his bow against an attacking lion, advancing from the rear with arrows already protruding from its body. Another expiring

beast collapses on the ground under the horses. This was probably a ceremonial hunt, in which the king, protected by men with swords and shields, rode back and forth killing animals as they were released one by one into an enclosed area. The immediacy of this image marks a shift in Mesopotamian art, away from a sense of timeless solemnity, and toward a more dramatic, even emotional, involvement with the event portrayed.

ASSYRIAN ARCHERS In another palace relief, the scene shifts from royal ceremony to the heat of battle, set within a detailed landscape (see "A Closer Look," page 42). Three of the Assyrians' enemies—two using flotation devices made of inflated animal skins—swim across a raging river, retreating from a vanguard of Assyrian archers who kneel at its banks to launch their assault. The scene evokes a specific event from 878 BCE described in the annals of Assurnasirpal. As the Assyrian king overtook the army of an enemy leader named Kudurru near the modern town of Anu, both leader and soldiers escaped into the Euphrates River in an attempt to save their lives.

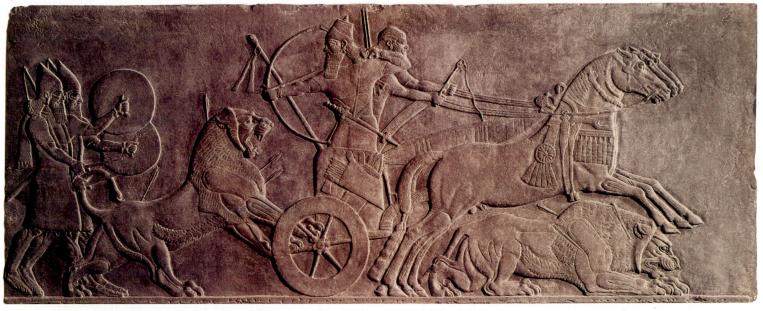

2-17 • ASSURNASIRPAL II KILLING LIONS

From the palace complex of Assurnasirpal II, Kalhu (present-day Nimrud, Iraq). c. 875–860 BCE. Alabaster, height approx. 39" (99.1 cm). British Museum, London.

DUR SHARRUKIN

Sargon II (ruled 721–706 BCE) built a new Assyrian capital at Dur Sharrukin (present-day Khorsabad, Iraq). On the northwest side of the capital, a walled citadel, or fortress, straddled the city wall

(FIG. 2-18). Within the citadel, Sargon's palace complex (the group of buildings where the ruler governed and resided) stood on a raised, fortified platform about 40 feet high—demonstrating the use of art as political propaganda.

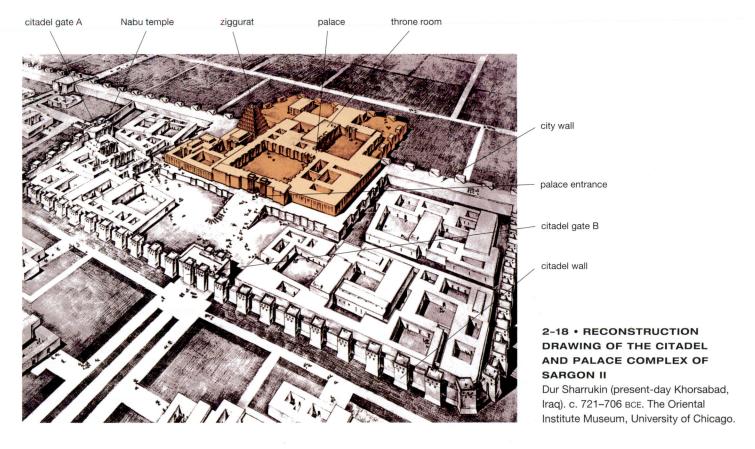

A CLOSER LOOK | Enemies Crossing the Euphrates to Escape Assyrian Archers

Palace complex of Assurnasirpal II, Kalhu (present-day Nimrud, Iraq). c. 875–860 BCE. Alabaster, height approx. 39" (99.1 cm). British Museum, London.

These Assyrian archers are outfitted in typical fashion, with protective boots, short "kilts," pointed helmets, and swords, as well as bows and quivers of arrows. Their smaller scale conveys a sense of depth and spatial positioning in this relief, reinforced by the size and placement of the trees.

The detailed landscape setting documents the swirling water of the river, its rocky banks, and the airy environment of the trees, one of which is clearly described as a palm.

The oblique line of the river bank and the overlapping of the swimmers convey a sense of depth receding from the picture plane into pictorial space. If this is the ruler of the enemy citadel, he seems shocked into powerlessness by the Assyrian invasion. Note the contrast between his lax weapon and those deployed by the archers of the Assyrian vanguard.

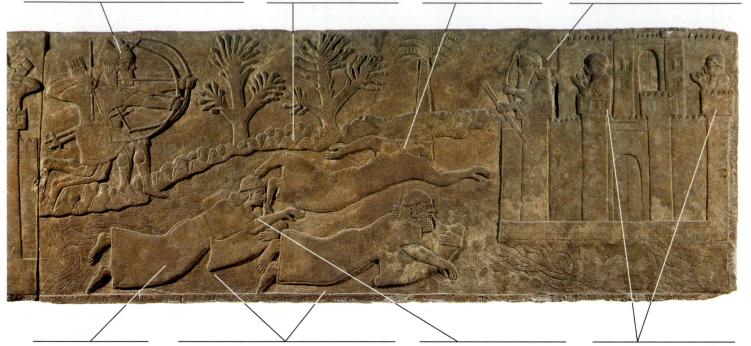

The long robes of the three enemy swimmers signal their high status. They are not ordinary foot soldiers. The two lower swimmers were clearly taken by surprise. Already engaged in their watery retreat, they are still blowing through "tubes" to inflate their flotation devices, made from sewn animal skins.

This beardless swimmer is probably a eunuch, many of whom served as high officials in ancient Near Eastern courts.

Two figures raising their hands in despair react to the bleak fate of their arrow-riddled comrades attempting to swim to safety.

View the Closer Look for Enemies Crossing the Euphrates to Escape Assyrian Archers on myartslab.com

Guarded by two towers, the palace complex was accessible only by a wide ramp leading up from an open square, around which the residences of important government and religious officials were clustered. Beyond the ramp was the main courtyard, with service buildings on the right and temples on the left. The heart of the palace, protected by a reinforced wall with only two small, off-center doors, lay past the main courtyard. Within the inner compound was a second courtyard lined with narrative relief panels showing tribute bearers. Visitors would have waited to see the king in this courtyard that functioned as an open-air audience hall; once granted access to the royal throne room, they would have passed through a stone gate flanked, like the other gates of citadel and palace (FIG. 2-19), by awesome guardian figures. These colossal beings, known as lamassus, combined the bearded head of a

man, the powerful body of a lion or bull, the wings of an eagle, and the horned headdress of a god.

In an open space between the palace complex and temple complex at Dur Sharrukin rose a ziggurat declaring the might of Assyria's kings and symbolizing their claim to empire. It probably had seven levels, each about 18 feet high and painted a different color (see FIG. 2–18). The four levels still remaining were once white, black, blue, and red. Instead of separate flights of stairs between the levels, a single, squared-off spiral ramp rose continuously around the exterior from the base.

NINEVEH

Assurbanipal (ruled 669–c. 627 BCE), king of the Assyrians three generations after Sargon II, maintained his capital at Nineveh.

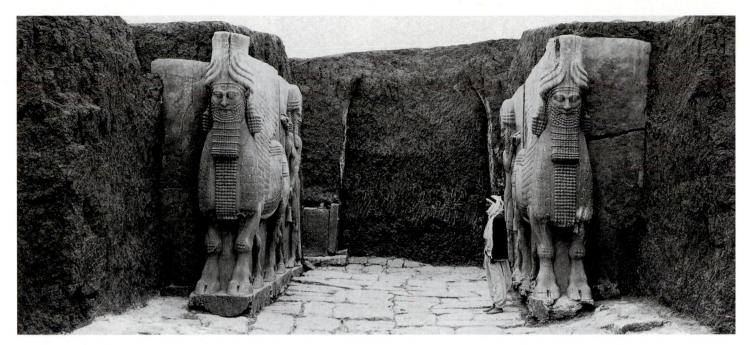

2-19 • GUARDIAN FIGURES AT GATE A OF THE CITADEL OF SARGON II DURING ITS EXCAVATION IN THE 1840S

Dur Sharrukin (present-day Khorsabad, Iraq). c. 721-706 BCE.

Like that of Assurnasirpal II two centuries earlier, his palace was decorated with alabaster panels carved with pictorial narratives in low relief. Most show Assurbanipal and his subjects in battle or hunting, but there are occasional scenes of palace life.

An unusually peaceful example shows the king and queen relaxing in a pleasure garden (FIG. 2-20). The king reclines on a couch, and the queen sits in a chair at his feet, while a musician at far left plays diverting music. Three servants arrive from the left

with trays of food, while others wave whisks to protect the royal couple from insects. The king has taken off his rich necklace and hung it on his couch, and he has laid aside his weapons—sword, bow, and quiver of arrows—on the table behind him, but this apparently tranquil domestic scene is actually a victory celebration. A grisly trophy, the severed head of his vanquished enemy, hangs upside down from a tree at the far left.

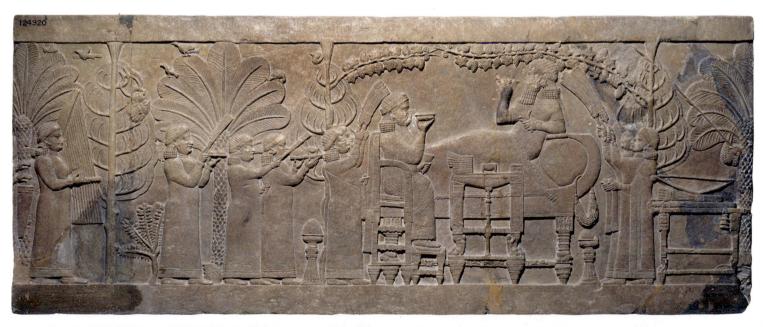

2-20 • ASSURBANIPAL AND HIS QUEEN IN THE GARDEN

From the palace at Nineveh (present-day Ninua, Iraq). c. 647 BCE. Alabaster, height approx. 21" (53.3 cm). British Museum, London.

NEO-BABYLONIA

At the end of the seventh century BCE, Assyria was invaded by the Medes, a people from western Iran who were allied with the Babylonians and the Scythians, a nomadic people from northern Asia (present-day Russia and Ukraine). In 612 BCE, the Medes' army captured Nineveh. When the dust had settled, Assyria was no more and the Neo-Babylonians—so named because they recaptured the splendor that had marked Babylon 12 centuries earlier under Hammurabi-controlled a region that stretched from modern Turkey to northern Arabia and from Mesopotamia to the Mediterranean Sea.

The most famous Neo-Babylonian ruler was Nebuchadnezzar II (ruled 605-562 BCE), notorious today for his suppression of the Jews, as recorded in the book of Daniel in the Hebrew Bible, where he may have been confused with the final Neo-Babylonian ruler, Nabonidus. A great patron of architecture, Nebuchadnezzar II built temples dedicated to the Babylonian gods throughout his realm, and transformed Babylon—the cultural, political, and economic hub of his empire—into one of the most splendid cities

Babylon straddled the Euphrates River, its two sections joined by a bridge. The older, eastern sector was traversed by the Processional Way, the route taken by religious processions honoring the city's patron god, Marduk (FIG. 2-21). This street, paved with large stone slabs set in a bed of bitumen, was up to 66 feet wide at some points. It ran from the Euphrates bridge, through the temple district and palaces, and finally through the Ishtar Gate, the ceremonial entrance to the city. The Ishtar Gate's four crenellated towers (crenellations are notched walls for military defense) symbolized Babylonian power (FIG. 2-22). Beyond the Ishtar Gate, walls on either side of the route—like the gate itself—were faced with dark blue glazed bricks. The glazed bricks consisted of a film of colored glass adhering to the surface of the bricks after firing, a process used since about 1600 BCE. Against that blue background, specially molded turquoise, blue, and gold-colored bricks formed images of striding lions, mascots of the goddess Ishtar as well as the dragons that were associated with Marduk.

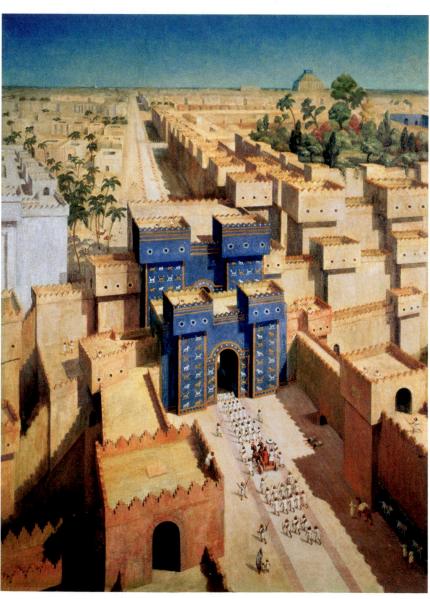

PERSIA

In the sixth century BCE, the Persians, a formerly nomadic, Indo-European-speaking people, began to seize power in Mesopotamia. From the region of Parsa, or Persis (present-day Fars, Iran), they established a vast empire. The rulers of this new empire traced their ancestry to a semilegendary Persian king named Achaemenes, and consequently they are known as the Achaemenids.

The dramatic expansion of the Achaemenids began in 559 BCE with the ascension of a remarkable leader, Cyrus II (Cyrus the Great, ruled 559-530 BCE). By the time of his death, the Persian Empire included Babylonia, Media (which stretched across present-day northern Iran through Anatolia), and some of the Aegean islands far to the west. Only the Greeks stood fast against them (see Chapter 5). When Darius I (ruled 521–486 BCE) took the throne, he could

2-21 • RECONSTRUCTION DRAWING OF BABYLON IN THE 6TH CENTURY BCE

The Oriental Institute Museum, University of Chicago.

The palace of Nebuchadnezzar II, with its famous Hanging Gardens, can be seen just behind and to the right of the Ishtar Gate, west of the Processional Way. The Marduk Ziggurat looms in the far distance on the east bank of the Euphrates.

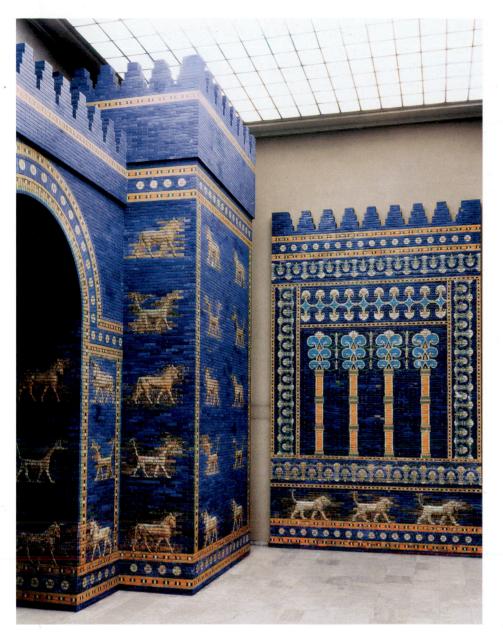

proclaim: "I am Darius, great King, King of Kings, King of countries, King of this earth."

An able administrator, Darius organized the Persian lands into 20 tribute-paying areas under Persian governors. He often left local rulers in place beneath the governors. This practice, along with a tolerance for diverse native customs and religions, won the Persians the loyalty of large numbers of their subjects. Like many powerful rulers, Darius created palaces and citadels as visible symbols of his authority. He made Susa his first capital and commissioned a 32-acre administrative compound to be built there.

In about 515 BCE, Darius began construction of Parsa, a new capital in the Persian homeland, today known by its Greek name: **PERSEPOLIS**. It is one of the best-preserved and most impressive ancient sites in the Near East (**FIG. 2-23**). Darius imported materials, workers, and artists from all over his empire. He even ordered work to be executed in Egypt and transported to his capital. The

2-22 • ISHTAR GATE AND THRONE ROOM WALL

Reconstruction; originally from Babylon (present-day Babil, Iraq). c. 575 BCE. Glazed brick, height of gate originally 40' (12.2 m) with towers rising 100' (30.5 m). Vorderasiatisches Museum, Staatliche Museen zu Berlin, Preussischer Kulturbesitz.

The Ishtar Gate is decorated with tiers of dragons (with the head and body of a snake, the forelegs of a lion, and the hind legs of a bird of prey) that were sacred to Marduk, with bulls associated with Adad, the storm god, and with lions associated with Ishtar. Now reconstructed in a Berlin museum, it is installed next to a panel from the throne room in Nebuchadnezzar's nearby palace, in which lions walk beneath stylized palm trees.

result was a new multicultural style of art that combined many different traditions— Persian, Median, Mesopotamian, Egyptian, and Greek.

In Assyrian fashion, the imperial complex at Persepolis was set on a raised platform, 40 feet high and measuring 1,500 by 900 feet, accessible only via a single approach made of wide, shallow steps that could be ascended on horseback. Like Egyptian and Greek cities, it was laid out on a rectangular grid. Darius lived to see the completion only of a treasury, the Apadana (audience hall), and a very small palace for himself. The **APADANA**, set above the rest of the complex on a second terrace (**FIG. 2-24**), had open porches on three sides and

a square hall large enough to hold several thousand people. Darius's son Xerxes I (ruled 485–465 BCE) added a sprawling palace complex for himself, enlarged the treasury building, and began a vast new public reception space, the Hall of 100 Columns.

The central stair of Darius's Apadana displays reliefs of animal combat, tiered ranks of royal guards (the "10,000 Immortals"), and delegations of tribute-bearers. Here, lions attack bulls on either side of the Persian generals. Such animal combats (a theme found throughout the Near East) emphasize the ferocity of the leaders and their men. Ranks of warriors cover the walls with repeated patterns and seem ready to defend the palace. The elegant drawing, balanced composition, and sleek modeling of figures reflect the Persians' knowledge of Greek art and perhaps the use of Greek artists. Other reliefs throughout Persepolis depict displays of allegiance or economic prosperity. In one example, once the centerpiece, Darius holds an audience while his son and heir, Xerxes,

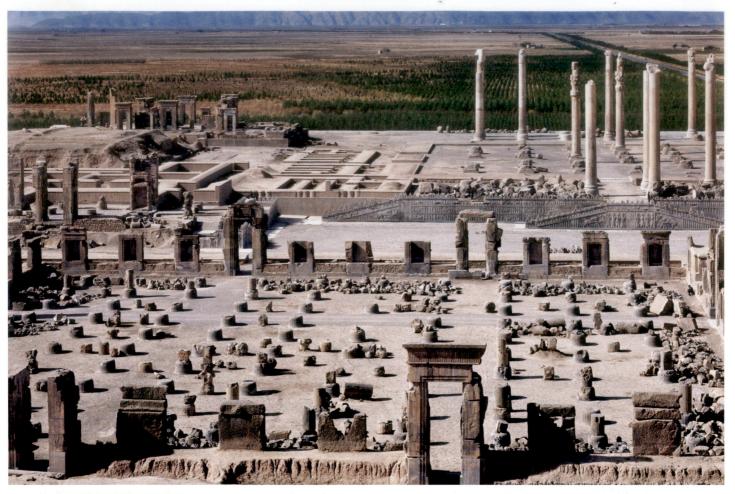

2-23 • AERIAL VIEW OF THE CEREMONIAL COMPLEX, PERSEPOLIS Iran. 518-c. 460 BCE.

• Watch a video about Persepolis on myartslab.com

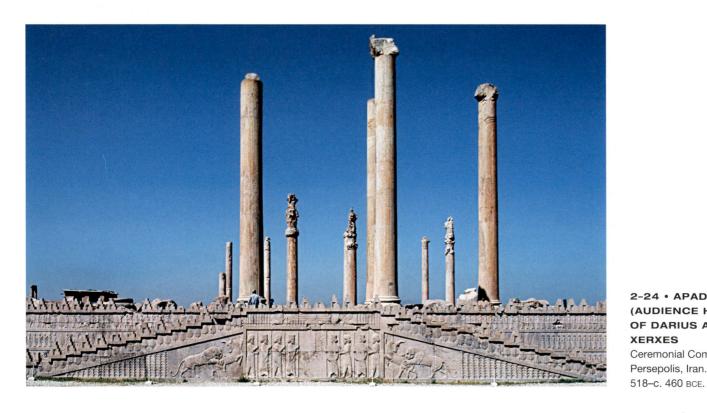

2-24 • APADANA (AUDIENCE HALL) OF DARIUS AND **XERXES** Ceremonial Complex, Persepolis, Iran.

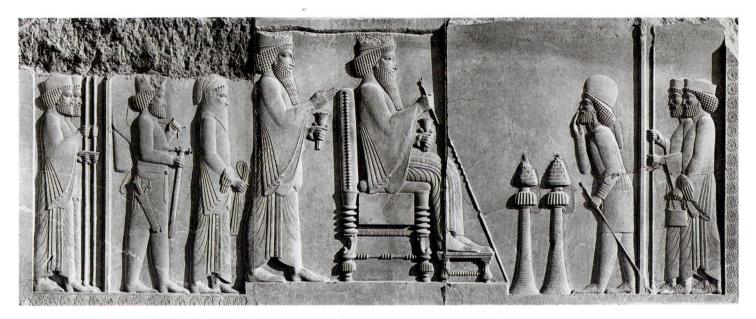

2-25 • DARIUS AND XERXES RECEIVING TRIBUTE

Detail of a relief from the stairway leading to the Apadana, Persepolis, Iran. 491–486 BCE. Limestone, height 8'4" (2.54 m). Courtesy the Oriental Institute of the University of Chicago.

Watch a video about the process of sculpting in relief on myartslab.com

listens from behind the throne (FIG. 2-25). Such panels would have looked quite different when they were freshly painted in bright colors, with metal objects such as Darius's crown and necklace covered in **gold leaf** (sheets of hammered gold).

At its height, the Persian Empire extended from Africa to India. From Persepolis, Darius in 490 BCE and Xerxes in 480 BCE sent their armies west to conquer Greece, but mainland Greeks successfully resisted the armies of the Achaemenids, preventing

them from advancing into Europe. Indeed, it was a Greek who ultimately put an end to their empire. In 334 BCE, Alexander the Great of Macedonia (d. 323 BCE) crossed into Anatolia and swept through Mesopotamia, defeating Darius III and nearly destroying Persepolis in 330 BCE. Although the Achaemenid Empire was at an end, Persia eventually revived, and the Persian style in art continued to influence Greek artists (see Chapter 5) and ultimately became one of the foundations of Islamic art (see Chapter 9).

THINK ABOUT IT

- 2.1 Describe and characterize the way human figures are represented in the Sumerian votive figures of Eshnunna. What are the potential relationships between style and function?
- 2.2 Discuss the development of relief sculpture in the ancient Near East. Choose two specific examples, one from the Sumerian period and one from the Assyrian period, and explain how symbols and stories are combined to express ideas that were important to these two cultures.
- 2.3 Select two rulers discussed in this chapter and explain how each preserved his legacy through commissioned works of art and/or architecture.
- 2.4 How did the excavations of Sir Leonard Woolley contribute to our understanding of the art of the ancient Near East?

CROSSCURRENTS

FIG. 2–10

FIG. 2-20

Both of these works depict a social gathering involving food and drink, but they are vastly different in scale, materials, and physical context. How do the factors of scale and materials contribute to the visual appearance of the scenes? How does physical context and audience affect the meaning of what is portrayed?

Study and review on myartslab.com

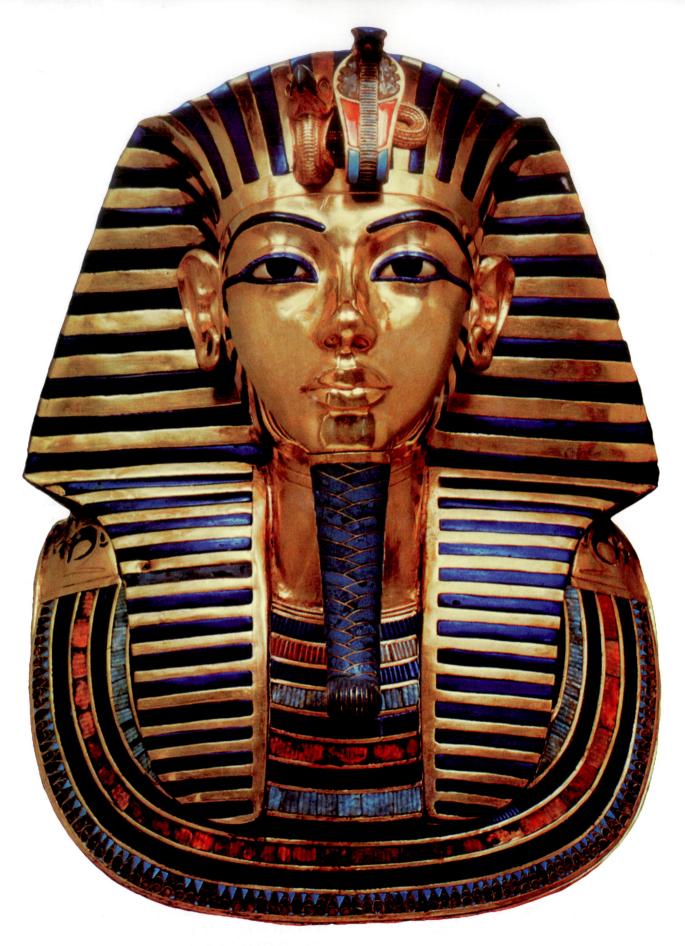

3-1 • FUNERARY MASK OF TUTANKHAMUN

From the tomb of Tutankhamun, Valley of the Kings. Eighteenth Dynasty (Tutankhamun, r. c. 1332–1322 BCE), c. 1327 BCE. Gold inlaid with glass and semiprecious stones, height 211/4" (54.5 cm), weight 24 pounds (11 kg). Egyptian Museum, Cairo. (JE 60672)

Art of Ancient Egypt

On February 16, 1923, The Times of London cabled the New York Times with dramatic news of a discovery: "This has been, perhaps, the most extraordinary day in the whole history of Egyptian excavation The entrance today was made into the sealed chamber of [Tutankhamun's] tomb ... and yet another door opened beyond that. No eyes have seen the King, but to practical certainty we know that he lies there close at hand in all his original state, undisturbed." And indeed he did. A collar of dried flowers and beads covered the chest, and a linen shroud was draped around the head. A gold FUNERARY MASK (FIG. 3-1) had been placed over the head and shoulders of his mummified body, which was enclosed in three nested coffins, the innermost made of gold (see FIG. 3-29, and page 73). The coffins were placed in a yellow quartzite sarcophagus (stone coffin) that was itself encased within gilt wooden shrines nested inside one another.

The discoverer of this treasure, the English archaeologist Howard Carter, had worked in Egypt for more than 20 years before he undertook a last expedition, sponsored by the wealthy British amateur Egyptologist Lord Carnarvon. Carter was convinced that the tomb of Tutankhamun, one of the last Eighteenth–Dynasty royal burial places still unidentified, lay hidden in the Valley of the Kings. After 15 years of

digging, on November 4, 1922, he unearthed the entrance to Tutankhamun's tomb and found unbelievable treasures in the antechamber: jewelry, textiles, gold-covered furniture, a carved and inlaid throne, four gold chariots. In February 1923, Carter pierced the wall separating the anteroom from the actual burial chamber and found the greatest treasure of all, Tutankhamun himself.

Since ancient times, tombs have tempted looters; more recently, they also have attracted archaeologists and historians. The first large-scale "archaeological" expedition in history landed in Egypt with the armies of Napoleon in 1798. The French commander must have realized that he would find great wonders there, for he took French scholars with him to study ancient sites. The military adventure ended in failure, but the scholars eventually published richly illustrated volumes of their findings, unleashing a craze for all things Egyptian that has not dimmed since. In 1976, the first blockbuster museum exhibition was born when treasures from the tomb of Tutankhamun began a tour of the United States and attracted over 8 million visitors. Most recently, in 2006, Otto Schaden excavated a tomb containing seven coffins in the Valley of the Kings, the first tomb to be found there since Tutankhamun's in 1922.

LEARN ABOUT IT

- 3.1 Explore the pictorial conventions for representing the human figure in ancient Egyptian art, established early on and maintained for millennia.
- **3.2** Analyze how religious beliefs were reflected in the funerary art and architecture of ancient Egypt.
- 3.3 Examine the relationship of royal ancient Egyptian art to the fortunes and aspirations of the rulers who commissioned it.
- **3.4** Understand and characterize the major transformation of ancient Egyptian art and convention under the revolutionary rule of Akhenaten.

THE GIFT OF THE NILE

The Greek traveler and historian Herodotus, writing in the fifth century BCE, remarked, "Egypt is the gift of the Nile." This great river, the longest in the world, winds northward from equatorial Africa and flows through Egypt in a relatively straight line to the Mediterranean (MAP 3-1). There it forms a broad delta before emptying into the sea. Before it was dammed in 1970 by the Aswan High Dam, the lower (northern) Nile, swollen with the runoff of heavy seasonal rains in the south, overflowed its banks for several months each year. Every time the floodwaters receded, they left behind a new layer of rich silt, making the valley and delta a continually fertile and attractive habitat.

By about 8000 BCE, the valley's inhabitants had become relatively sedentary, living off the abundant fish, game, and wild plants. Not until about 5000 BCE did they adopt the agricultural village life associated with Neolithic culture (see Chapter 1). At that time, the climate of north Africa grew increasingly dry. To ensure adequate resources for agriculture, the farmers along the Nile began to manage flood waters in a system called basin irrigation.

The Predynastic period, from roughly 5000 to 2950 BCE, was a time of significant social and political transition that preceded the unification of Egypt under a single ruler. (After unification, Egypt was ruled by a series of family dynasties and is therefore characterized as "dynastic.") Rudimentary federations emerged and began conquering and absorbing weaker communities. By about 3500 BCE, there were several larger states, or chiefdoms, in the lower Nile Valley and a centralized form of leadership had emerged. Rulers were expected to protect their subjects, not only from outside aggression, but also from natural catastrophes such as droughts and insect plagues.

The surviving art of the Predynastic period consists chiefly of ceramic figurines, decorated pottery, and reliefs carved on stone plaques and pieces of ivory. A few examples of wall painting—lively scenes filled with small figures of people and animals—were found in a tomb at Hierakonpolis, in Upper Egypt, a Predynastic town of mud-brick houses that was once home to as many as 10,000 people.

EARLY DYNASTIC EGYPT, c. 2950–2575 BCE

Around 3000 BCE, Egypt became a consolidated state. According to legend, the country had previously evolved into two major kingdoms—the Two Lands—Upper Egypt in the south (upstream on the Nile) and Lower Egypt in the north (downstream). But a powerful ruler from Upper Egypt conquered Lower Egypt and unified the two kingdoms. In the art of the subsequent Early Dynastic period we see the development of fundamental and enduring ideas about kingship and the cosmic order. Since the works of art and architecture that survive from ancient Egypt come mainly from

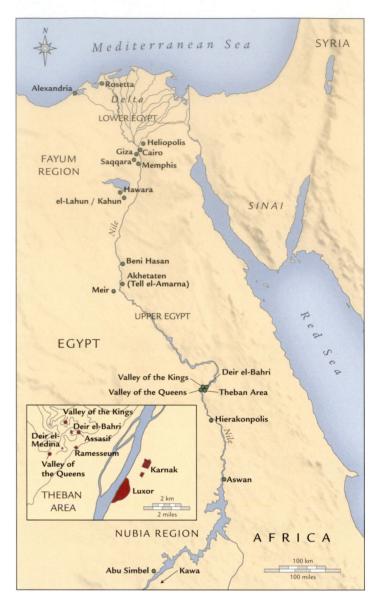

MAP 3-1 • ANCIENT EGYPT

Upper Egypt is below Lower Egypt on this map because the designations "upper" and "lower" refer to the directional flow of the Nile, not to our conventions for south and north in drawing maps. The two kingdoms were united c. 3000 BCE, just before the Early Dynastic period.

tombs and temples—the majority of which were located in secure places and built with the most durable materials—most of what we now know about the ancient art of Egypt is rooted in religious beliefs and practices.

THE GOD-KINGS

The Greek historian Herodotus thought the Egyptians were the most religious people he had ever encountered. In their world-view, the movements of heavenly bodies, the workings of gods, and the humblest of human activities were all believed to be part of a balanced and harmonious grand design. Death was to be feared only by those who lived in such a way as to disrupt that harmony. Upright souls could be confident that their spirits would live on eternally.

ART AND ITS CONTEXTS | Egyptian Symbols

Three crowns symbolize kingship in early Egyptian art: the tall, clublike white crown of Upper Egypt (sometimes adorned with two plumes); the flat or scooped red cap with projecting spiral of Lower Egypt; and the double crown representing unified Egypt.

A striped gold and blue linen head cloth, known as the **nemes headdress**, having a cobra and a vulture at the center front, was also commonly used as royal headgear. The upright form of the cobra, known as the *uraeus*, represents the goddess Wadjet of Lower Egypt and is often included in king's crowns as well (see Fig. 3–1). The

queen's crown included the feathered skin of the vulture goddess Nekhbet of Upper Egypt.

The god Horus, king of the earth and a force for good, is represented as a falcon or falcon-headed man. His eyes symbolize the sun and moon; the solar eye is called the *wedjat*. The looped cross, called the **ankh**, is symbolic of everlasting life. The **scarab** beetle (*khepri*, meaning "he who created himself") was associated with creation, resurrection, and the rising sun.

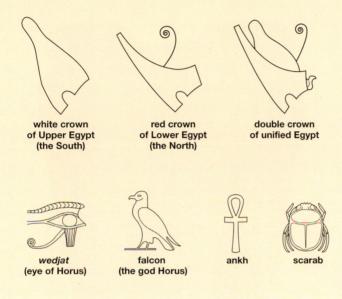

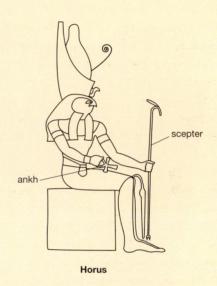

By the Early Dynastic period, Egypt's kings were revered as gods in human form. A royal jubilee, the *heb sed* or *sed* festival, held in the thirtieth year of the living king's reign, renewed and reaffirmed his divine power, and when they died, kings rejoined their father, the sun god Ra, and rode with him in the solar boat as it made its daily journey across the sky.

In order to please the gods and ensure their continuing good-will toward the state, kings built splendid temples and provided priests to maintain them. The priests saw to it that statues of the gods, placed deep in the innermost rooms of the temples, were never without fresh food and clothing. Egyptian gods and goddesses were depicted in various forms, some as human beings, others as animals, and still others as humans with animal heads. For example, Osiris, the overseer of the realm of the dead, regularly appears in human form wrapped in linen as a mummy. His son, the sky god Horus, is usually depicted as a falcon or falcon-headed man (see "Egyptian Symbols," above).

Over the course of ancient Egyptian history, Amun (chief god of Thebes, represented as blue and wearing a plumed crown), Ra (of Heliopolis), and Ptah (of Memphis) became the primary national gods. Other gods and their manifestations included Thoth (ibis), god of writing, science, and law; Ma'at (feather), goddess

of truth, order, and justice; Anubis (jackal), god of embalming and cemeteries; and Bastet (cat), daughter of Ra.

ARTISTIC CONVENTIONS

Conventions in art are established ways of representing things, widely accepted by artists and patrons at a particular time and place. Egyptian artists followed a set of fairly strict conventions, often based on conceptual principles rather than on the observation of the natural world with an eye to rendering it in lifelike fashion. Eventually a system of mathematical formulas was developed to determine design and proportions (see "Egyptian Pictorial Relief," page 64). The underlying conventions that govern ancient Egyptian art appear early, however, and are maintained, with subtle but significant variations, over almost three millennia of its history.

THE NARMER PALETTE This historically and artistically significant work of art (see "A Closer Look," page 52) dates from the Early Dynastic period and was found in the temple of Horus at Hierakonpolis. It is commonly interpreted as representing the unification of Egypt and the beginning of the country's growth as a powerful nation-state. It employs many of the

A CLOSER LOOK | The Palette of Narmer

From Hierakonpolis. Early Dynastic period, c. 2950 BCE. Green schist, height 25" (64 cm). Egyptian Museum, Cairo. (JE 32169 = CG 14716)

This figure, named by hieroglyphic inscription and standing on his own ground-line, holds the king's sandals. Narmer is barefoot because he is standing on sacred ground, performing sacred acts. The same sandal-bearer, likewise labeled, follows Narmer on the other side of the palette.

Phonetic hieroglyphs centered at the top of each side of the palette name the king: a horizontal fish (nar) above a vertical chisel (mer). A depiction of the royal palace—seen simultaneously from above, as a groundplan, and frontally, as a façade (front wall of a building)—surrounds Narmer's name to signify that he is king.

Narmer here wears the red crown of Lower Egypt and is identified by the hieroglyph label next to his head, as well by as his larger size in relation to the other figures (hierarchic scale).

The royal procession inspects two rows of decapitated enemies, their heads neatly tucked between their feet.

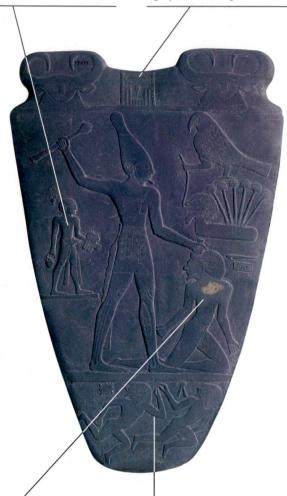

Narmer attacks a figure of comparable size, also identified by a hieroglyphic label, indicating that he is an enemy of real importance, likely the ruler of Lower Egypt.

Next to the heads of these two defeated enemies are, on the left, an aerial depiction of a fortified city, and on the right, a gazelle trap, perhaps emblems of Narmer's dominion over both city and countryside.

A bull symbolizing the might of the king-he wears a bull's tail on both sides of the palettetramples another enemy in front of a fortified city.

Palettes were tablets with circular depressions where eye makeup was ground and prepared. Although this example was undoubtedly ceremonial rather than functional, a mixing saucer is framed by the elongated, intertwined necks of lions, perhaps signifying the union of Upper and Lower Egypt.

\times View the Closer Look for the Palette of Narmer on myartslab.com

representational conventions that would dominate royal Egyptian art from this point on.

On the reverse side of the palette, as in the stele of Naram-Sin (see FIG. 2-1), hierarchic scale signals the importance of Narmer by

showing him overwhelmingly larger than the other human figures around him. He is also boldly silhouetted against a blank ground, just like Naram-Sin, distancing details of setting and story so they will not distract from his pre-eminence. He wears the white crown

TECHNIQUE | Preserving the Dead

Egyptians developed mummification techniques to ensure that the ka, soul or life force, could live on in the body in the afterlife. No recipes for preserving the dead have been found, but the basic process seems clear enough from images found in tombs, the descriptions of later Greek writers such as Herodotus and Plutarch, scientific analysis of mummies, and modern experiments.

By the time of the New Kingdom, the routine was roughly as follows: The body was taken to a mortuary, a special structure used exclusively for embalming. Under the supervision of a priest, workers removed the brains, generally through the nose, and emptied the body cavity—except for the heart—through an incision in the left side. They then covered the body with dry natron, a naturally occurring salt, and placed it on a

sloping surface to allow liquids to drain. This preservative caused the skin to blacken, so workers often used paint or powdered makeup to restore some color, using red ocher for a man, yellow ocher for a woman. They then packed the body cavity with clean linen soaked in various herbs and ointments, provided by the family of the deceased. The major organs were wrapped in separate packets and stored in special containers called **canopic jars**, to be placed in the tomb chamber.

Workers next wound the trunk and each of the limbs separately with cloth strips, before wrapping the whole body in additional layers of cloth to produce the familiar mummy shape. The workers often inserted charms and other smaller objects among the wrappings.

of Upper Egypt while striking the enemy who kneels before him with a mace. Above this foe, the god Horus—depicted as a falcon with a human hand—holds a rope tied around the neck of a man whose head is attached to a block sprouting stylized papyrus, a plant that grew in profusion along the Nile and symbolized Lower Egypt. This combination of symbols made the central message clear: Narmer, as ruler of Upper Egypt, is in firm control of Lower Egypt.

Many of the figures on the palette are shown in composite poses, so that each part of the body is portrayed from its most characteristic viewpoint. Heads are shown in profile, to capture most clearly the nose, forehead, and chin, while eyes are rendered frontally, from their most recognizable and expressive viewpoint. Hips, legs, and feet are drawn in profile, and the figure is usually striding, to reveal both legs. The torso, however, is fully frontal. This artistic convention for representing the human figure as a conceptualized composite of multiple viewpoints was to be followed for millennia in Egypt when depicting royalty and other dignitaries. Persons of lesser social rank engaged in active tasks (compare the figure of Narmer with those of his standard-bearers) tend to be represented in ways that seem to us more lifelike.

FUNERARY ARCHITECTURE

Ancient Egyptians believed that an essential part of every human personality is its life force, or soul, called the ka, which lived on after the death of the body, forever engaged in the activities it had enjoyed in its former existence. But the ka needed a body to live in, either the mummified body of the deceased or, as a substitute, a sculpted likeness in the form of a statue. The Egyptians developed elaborate funerary practices to ensure that their deceased moved safely and effectively into the afterlife.

It was especially important to provide a comfortable home for the ka of a departed king, so that even in the afterlife he would continue to ensure the well-being of Egypt. Egyptians preserved the bodies of the royal dead with care and placed them in burial chambers filled with sculpted body substitutes and all the supplies and furnishings the *ka* might require throughout eternity (see "Preserving the Dead," above).

MASTABA AND NECROPOLIS In Early Dynastic Egypt, the most common tomb structure—used by the upper level of society, the king's family and relatives—was the **mastaba**, a flattopped, one-story building with slanted walls erected above an underground burial chamber (see "Mastaba to Pyramid," page 55). Mastabas were at first constructed of mud brick, but toward the end of the Third Dynasty (c. 2650–2575 BCE), many incorporated cut stone, at least as an exterior facing.

In its simplest form, the mastaba contained a **serdab**, a small, sealed room housing the *ka* statue of the deceased, and a chapel designed to receive mourning relatives and offerings. A vertical shaft dropped from the top of the mastaba down to the actual burial chamber, where the remains of the deceased reposed in a coffin—at times placed within a larger stone sarcophagus—surrounded by appropriate grave goods. This chamber was sealed off after interment. Mastabas might have numerous underground burial chambers to accommodate whole families, and mastaba burial remained the standard for Egyptian elites for centuries.

Mastabas tended to be grouped together in a **necropolis**—literally, a "city of the dead"—at the edge of the desert on the west bank of the Nile, for the land of the dead was believed to be in the direction of the setting sun. Two of the most extensive of these early necropolises are at Saqqara and Giza, just outside modern Cairo.

DJOSER'S COMPLEX AT SAQQARA For his tomb complex at Saqqara, the Third-Dynasty King Djoser (c. 2650–2631 BCE) commissioned the earliest-known monumental architecture in Egypt (**FIG. 3-2**). The designer of the complex was Imhotep, who served as Djoser's prime minister. Imhotep is the first architect in history to be identified; his name is inscribed together with Djoser's on the base of a statue of the king found near the Step Pyramid.

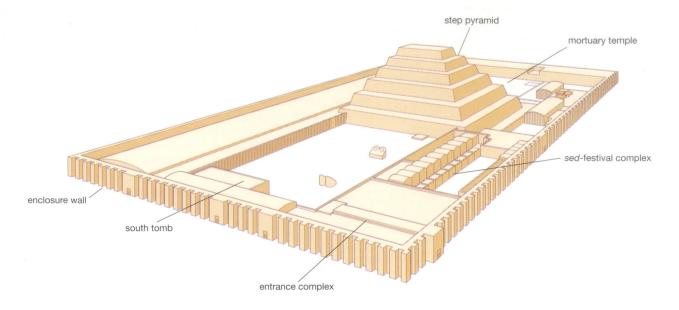

3-2 • RECONSTRUCTION DRAWING OF DJOSER'S FUNERARY COMPLEX, SAQQARA

Third Dynasty, c. 2630–2575 BCE. Situated on a level terrace, this huge commemorative complex—some 1,800′ (544 m) long by 900′ (277 m) wide—was designed as a replica in stone of the wood, brick, and reed buildings used in rituals associated with kingship. Inside the wall, the step pyramid dominated the complex.

It appears that Imhotep first planned Djoser's tomb as a single-story mastaba, only later deciding to enlarge upon the concept. The final structure is a step pyramid formed by six mastaba-like elements of decreasing size stacked on top of each other (**FIG. 3-3**). Although the step pyramid resembles the ziggurats of Mesopotamia, it differs in both meaning (signifying a stairway to the sun god

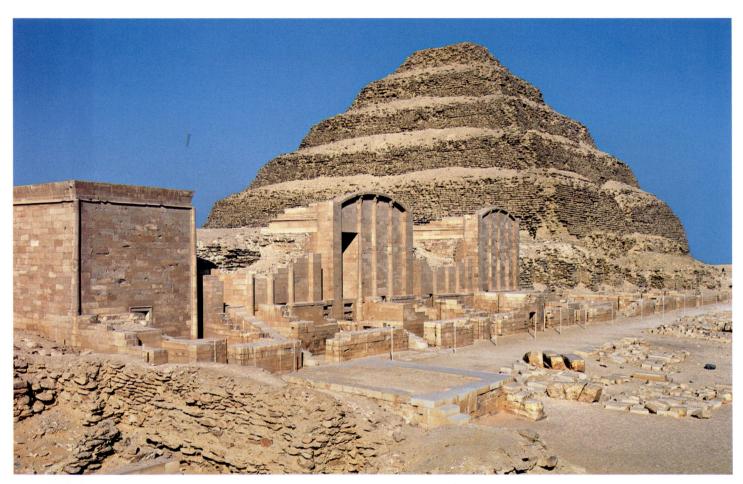

3-3 • THE STEP PYRAMID AND SHAM BUILDINGS, FUNERARY COMPLEX OF DJOSER Limestone, height of pyramid 204′ (62 m).

ELEMENTS OF ARCHITECTURE | Mastaba to Pyramid

As the gateway to the afterlife for Egyptian kings and members of the royal court, the Egyptian burial structure began as a low, solid, rectangular mastaba with an external niche that served as the focus of offerings. Later mastabas had either an internal *serdab* (the room where the *ka* statue was placed) and chapel (as in the drawing) or an attached chapel and *serdab* (not shown). Eventually, mastaba forms of decreasing

size were stacked over an underground burial chamber to form the step pyramid. The culmination of this development is the pyramid, in which the actual burial site may be within the pyramid—not below ground—with false chambers, false doors, and confusing passageways to foil potential tomb robbers.

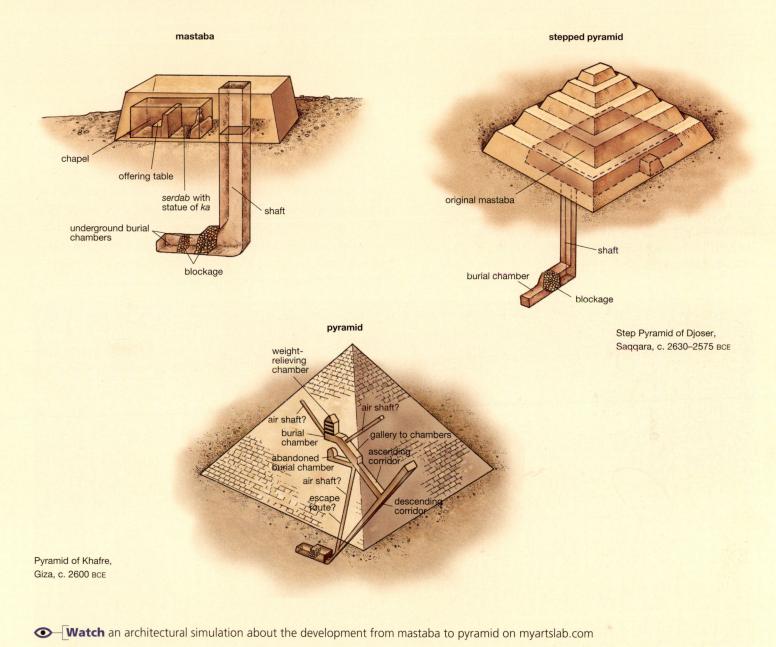

Ra) and purpose (protecting a tomb). A 92-foot shaft descended from the original mastaba enclosed within the pyramid. A descending corridor at the base of the step pyramid provided an entrance from outside to a granite-lined burial vault.

The adjacent funerary temple, where priests performed rituals before placing the king's mummified body in its tomb, was used for continuing worship of the dead king. In the form of his *ka* statue, Djoser intended to observe these devotions through two peepholes in the wall between the *serdab* and the funerary chapel. To the east of the pyramid, buildings filled with debris represent actual structures in which the spirit of the dead king could continue to observe the *sed* rituals that had ensured his long reign.

THE OLD KINGDOM, c. 2575–2150 BCE

The Old Kingdom was a time of social and political stability, despite increasingly common military excursions to defend the borders. The growing wealth of ruling families of the period is reflected in the enormous and elaborate tomb complexes they commissioned for themselves. Kings were not the only patrons of the arts, however. Upper-level government officials also could afford tombs decorated with elaborate carvings.

THE GREAT PYRAMIDS AT GIZA

The architectural form most closely identified with Egypt is the true pyramid with a square base and four sloping triangular faces, first erected in the Fourth Dynasty (2575–2450 BCE). The angled sides may have been meant to represent the slanting rays of the sun, for inscriptions on the walls of pyramid tombs built in the Fifth and Sixth Dynasties tell of deceased kings climbing up the rays to join the sun god Ra.

Although not the first pyramids, the most famous are the three great pyramid tombs at Giza (**FIGS. 3-4, 3-5**). These were built by three successive Fourth-Dynasty kings: Khufu (r. c. 2551–2528 BCE), Khafre (r. 2520–2494 BCE), and Menkaure (r. c. 2490–

2472 BCE). The oldest and largest pyramid at Giza is that of Khufu, which covers 13 acres at its base. It was originally finished with a thick veneer of polished limestone that lifted its apex to almost 481 feet, some 30 feet above the present summit. The pyramid of Khafre is slightly smaller than Khufu's, and Menkaure's is considerably smaller.

The site was carefully planned to follow the sun's east-west path. Next to each of the pyramids was a funerary temple connected by a causeway—an elevated and enclosed pathway or corridor—to a valley temple on the bank of the Nile (see FIG. 3-5). When a king died, his body was embalmed and ferried west across the Nile from the royal palace to his valley temple, where it was received with elaborate ceremonies. It was then carried up the causeway to his funerary temple and placed in its chapel, where family members presented offerings of food and drink, and priests performed rites in which the deceased's spirit consumed a meal. These rites were to be performed at the chapel in perpetuity. Finally, the body was entombed in a vault deep within the pyramid, at the end of a long, narrow, and steeply rising passageway. This tomb chamber was sealed off after the burial with a 50-ton stone block. To further protect the king from intruders, three false passageways obscured the location of the tomb.

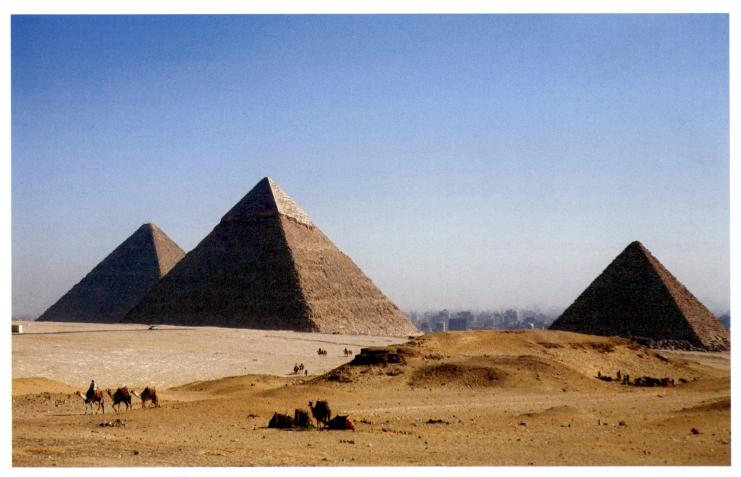

3-4 • GREAT PYRAMIDS, GIZA

Fourth Dynasty, c. 2575–2450 BCE. Erected by (from the left) Menkaure, Khafre, and Khufu. Limestone and granite, height of pyramid of Khufu, 450′ (137 m).

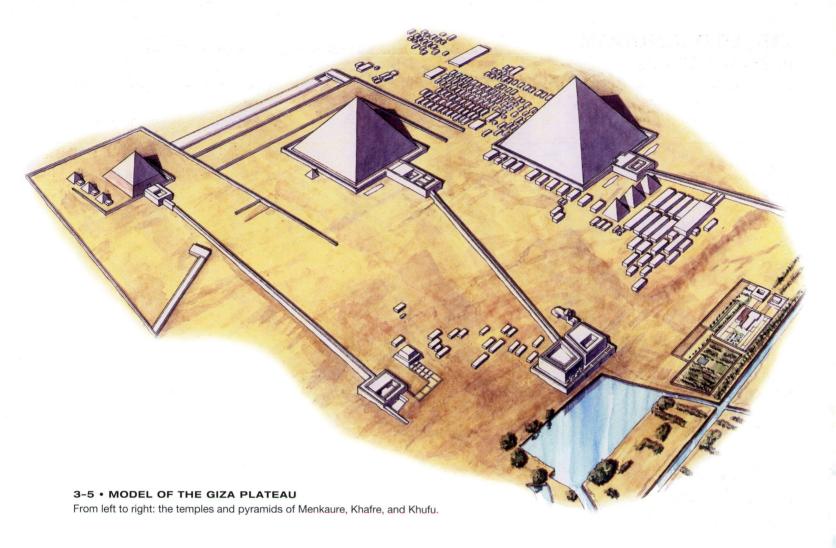

CONSTRUCTING THE PYRAMIDS Building a pyramid was a formidable undertaking. A large workers' burial ground discovered at Giza attests to the huge labor force that had to be assembled, housed, and fed. Most of the cut stone blocks—each weighing an average of 2.5 tons—used in building the Giza complex were quarried either on the site or nearby. Teams of workers transported them by sheer muscle power, employing small logs as rollers or pouring water on mud to create a slippery surface over which they could drag the blocks on sleds.

Scholars and engineers have various theories about how the pyramids were raised. Some ideas have been tested in computerized projections and a few models on a small but representative scale have been constructed. The most efficient means of getting the stones into position might have been to build a temporary, gently sloping ramp around the body of the pyramid as it grew higher. The ramp could then be dismantled as the stones were smoothed out or slabs of veneer were laid.

The designers who oversaw the building of such massive structures were capable of the most sophisticated mathematical calculations. They oriented the pyramids to the points of the compass and may have incorporated other symbolic astronomical calculations as well. There was no room for trial and error. The huge foundation layer had to be absolutely level and the angle of each of

the slanting sides had to remain constant so that the stones would meet precisely in the center at the top.

KHAFRE'S COMPLEX Khafre's funerary complex is the best preserved. Its pyramid is the only one of the three to have maintained some of its veneer facing at the top. But the complex is most famous for the **GREAT SPHINX** that sits just behind Khafre's valley temple. This colossal portrait of the king—65 feet tall—combines his head with the long body of a crouching lion, seemingly merging notions of human intelligence with animal strength (**FIG. 3-6**).

In the adjacent **VALLEY TEMPLE**, massive blocks of red granite form walls and piers supporting a flat roof (**FIG. 3-7**). (See "Early Construction Methods," page 19.) A **clerestory** (a row of tall, narrow windows in the upper walls, not visible in the figure), lets in light that reflects off the polished Egyptian alabaster floor. Within the temple were a series of over-life-size statues, portraying **KHAFRE** as an enthroned king (**FIG. 3-8**). The falcon god Horus perches on the back of the throne, protectively enfolding the king's head with his wings. Lions—symbols of regal authority—form the throne's legs, and the intertwined lotus and papyrus plants beneath the seat symbolize the king's power over Upper (lotus) and Lower (papyrus) Egypt.

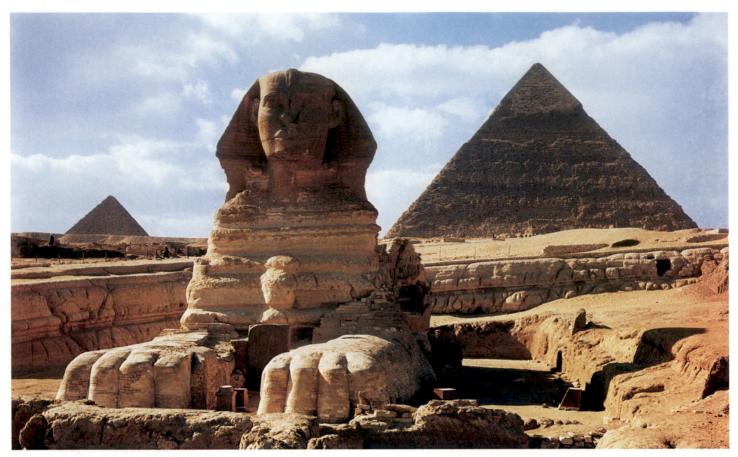

3-6 • GREAT SPHINX, FUNERARY COMPLEX OF KHAFRE Giza. Old Kingdom, c. 2520–2494 BCE. Limestone, height approx. 65′ (19.8 m).

Khafre wears the traditional royal costume—a short, pleated kilt, a linen headdress, and a false beard symbolic of royalty. He exudes a strong sense of dignity, calm, and above all permanence. In his right hand, he holds a cylinder, probably a rolled piece of cloth. His arms are pressed tightly within the contours of his body, which is firmly anchored in the confines of the stone block from which it was carved. The statue was created from an unusual stone, a type of gneiss (related to diorite), imported from Nubia, that produces a rare optical effect. When illuminated by sunlight entering through the temple's clerestory, it glows a deep blue, the celestial color of Horus, filling the space with a blue radiance.

SCULPTURE

As the surviving statues of Khafre's valley temple demonstrate, Egyptian sculptors were adept at creating lifelike three-dimensional figures that also express a feeling of strength and permanence consistent with the unusually hard stones from which they were carved.

3-7 • VALLEY TEMPLE OF KHAFRE

Giza. Old Kingdom, c. 2520-2494 BCE. Limestone and red granite.

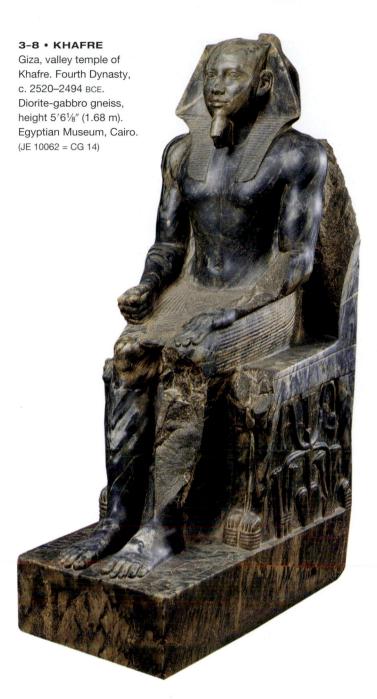

youthful queen, taking a smaller step forward, echoes his striding pose. Her sheer, close-fitting garment reveals the soft curves of her gently swelling body, a foil for the tight muscularity of the king. The time-consuming task of polishing this double statue was never completed, suggesting that the work may have been undertaken only a few years before Menkaure's death in about 2472 BCE. Traces of red paint remain on the king's face, ears, and neck (male figures were traditionally painted red), as do traces of black on the queen's hair.

MENKAURE AND A QUEEN Dignity, calm, and permanence also characterize a sleek double portrait of Khafre's heir King Menkaure and a queen, probably Khamerernebty II, discovered in Menkaure's valley temple (**FIG. 3-9**). The couple's separate figures, close in size, are joined by the stone from which they emerge, forming a single unit. They are further united by the queen's symbolic gesture of embrace. Her right hand comes from behind to clasp his torso, and her left hand rests gently, if stiffly, over his upper arm.

The king—depicted in accordance with Egyptian ideals as an athletic, youthful figure, nude to the waist and wearing the royal kilt and headcloth—stands in a conventional, balanced pose, striding with the left foot forward, his arms straight at his sides, and his fists clenched over cylindrical objects. His equally

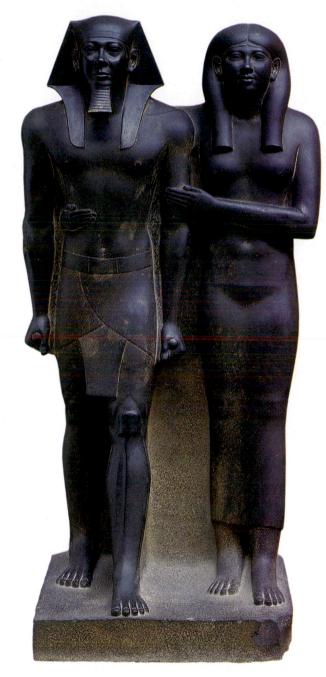

3-9 • MENKAURE AND A QUEEN, PROBABLY KHAMERERNEBTY II

From Giza. Fourth Dynasty, 2490–2472 BCE. Graywacke with traces of red and black paint, height 54½" (142.3 cm). Museum of Fine Arts, Boston. Harvard University—Museum of Fine Arts Expedition. (11.1738)

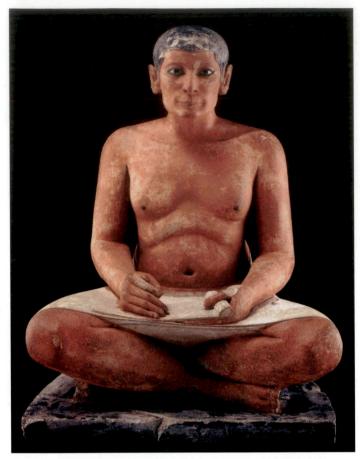

3-10 • SEATED SCRIBEFound near the tomb of Kai, Saqqara. Fifth Dynasty, c. 2450–2325 BCE.
Painted limestone with inlaid eyes of rock crystal, calcite, and magnesite mounted in copper, height 21" (53 cm). Musée du Louvre, Paris. (N 2290 = E 3023)

High-ranking scribes could hope to be appointed to one of several "houses of life," where they would copy, compile, study, and repair valuable sacred and scientific texts.

SEATED SCRIBE Old Kingdom sculptors also produced statues of less prominent people, rendered in a more relaxed, lifelike fashion. A more lively and less formal mode is employed in the statue of a **SEATED SCRIBE** from early in the Fifth Dynasty (**FIG. 3-10**)—with round head, alert expression, and cap of closecropped hair—that was discovered near the tomb of a government official named Kai. It could be a portrait of Kai himself. The irregular contours of his engaging face project a sense of individual likeness and human presence.

The scribe's sedentary vocation has made his sagging body slightly flabby, his condition advertising a life free from hard physical labor. As an ancient Egyptian inscription advises—"Become a scribe so that your limbs remain smooth and your hands soft and you can wear white and walk like a man of standing whom [even] courtiers will greet" (cited in Strouhal, p. 216). This scribe sits holding a papyrus scroll partially unrolled on his lap, his right hand clasping a now-lost reed brush used in writing. The alert expression on his face reveals more than a lively intelligence. Because the

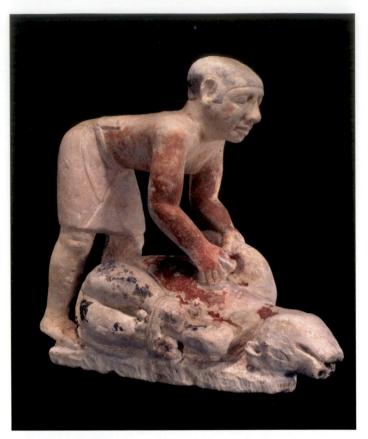

3-11 • BUTCHER

Perhaps from the tomb of the official Ni-kau-inpu and his wife Hemet-re, Giza? Fifth Dynasty, c. 2450–2325 BCE. Painted limestone (knife restored), height 145%" (37 cm). The Oriental Institute Museum, University of Chicago. (10626)

Although statues such as this have been assumed to represent the deceased's servants, it has recently been proposed that instead they depict relatives and friends of the deceased in the role of servants, allowing these loved ones to accompany the deceased into the next life.

pupils are slightly off-center in the irises, the eyes give the illusion of being in motion, as if they were seeking contact, and the reflective quality of the polished crystal inlay reproduces with eerie fidelity the contrast between the moist surface of eyes and the surrounding soft flesh in a living human face.

STATUETTES OF SERVANTS Even more lifelike than the scribe were smaller figures of servants at work that were made for inclusion in Old Kingdom tombs so that the deceased could be provided for in the next world. Poses are neither formal nor reflective, but rooted directly in the labor these figures were expected to perform throughout eternity. A painted limestone statuette from the Fifth Dynasty (**FIG. 3-11**) captures a butcher, raised up on the balls of his feet to bend down and lean forward, poised, knife in hand, over the throat of an ox that he has just slaughtered. Having accomplished his work, he looks up to acknowledge us, an action that only enhances his sense of lifelike presence. The emphasis on involved poses and engagement with

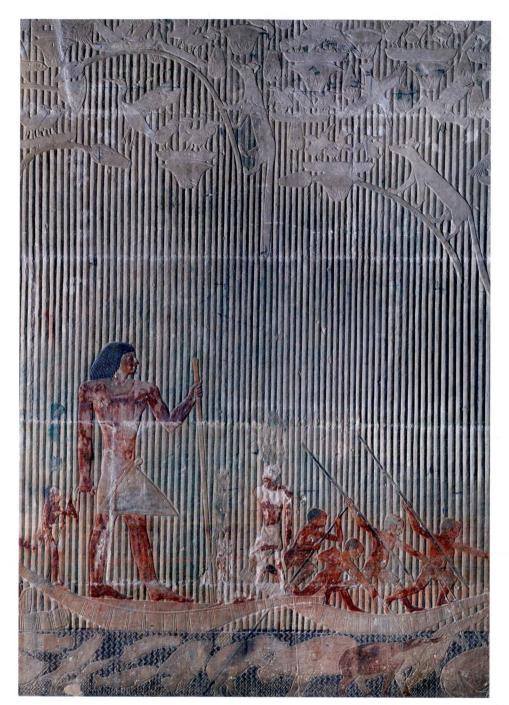

the viewer may have been an attempt to underscore the ability of such figures to perform their assigned tasks, or perhaps it was meant to indicate their lower social status by showing them involved in physical labor. Both may be signified here. The contrast between the detached stylization of upper-class figures and the engaging lifelikeness of laborers can be seen in Old Kingdom pictorial relief works as well.

PICTORIAL RELIEF IN TOMBS

To provide the ka with the most pleasant possible living quarters for eternity, wealthy families often had the interior walls and ceilings of their tombs decorated with paintings and reliefs. This

3-12 • TI WATCHING A HIPPOPOTAMUS HUNT

Tomb of Ti, Saqqara. Fifth Dynasty, c. 2450–2325 BCE. Painted limestone relief, height approx. 45" (114.3 cm).

decoration carried religious meaning, but it could also evoke the deceased's everyday life or depict ceremonial events that proclaimed the deceased's importance. Tombs therefore provide a wealth of information about ancient Egyptian culture.

THE TOMB OF TI On the walls of the large mastaba of a wealthy Fifth-Dynasty government official named Ti, a painted relief shows him watching a hippopotamus hunt—an official duty of royal courtiers (**FIG. 3-12**). It was believed that Seth, the god of chaos, disguised himself as a hippo. Hippos were also destructive since they wandered into fields, damaging crops. Tomb depictions of such hunts therefore proclaimed the valor of the deceased and the triumph of good over evil, or at least order over destructiveness.

The artists who created this picture in painted limestone relief used a number of established Egyptian representational conventions. The river is conceived as if seen from above, rendered as a band of parallel wavy lines below the boats. The creatures in this river, however—fish, a crocodile, and hippopotamuses—are shown in profile for easy identification. The shallow boats carrying Ti and his men by skimming along the surface of the water are shown straight on in relation to the viewers' vantage point, and the papyrus stalks that

choke the marshy edges of the river are disciplined into a regular pattern of projecting, linear, parallel, vertical forms that highlight the contrastingly crisp and smooth contour of Ti's stylized body. At the top of the papyrus grove, however, this patterning relaxes while enthusiastic animals of prey—perhaps foxes—stalk birds among the leaves and flowers. The hierarchically scaled and sleekly stylized figure of Ti, rendered in the conventional composite pose, looms over all. In a separate boat ahead of him, the actual hunters, being of lesser rank and engaged in more strenuous activities, are rendered in a more lifelike and lively fashion than their master. They are captured at the charged moment of closing in on the hunted prey, spears positioned at the ready, legs extended for the critical lunge forward.

THE MIDDLE KINGDOM, c. 1975–c. 1640 BCE

The collapse of the Old Kingdom, with its long succession of powerful kings, was followed by roughly 150 years of political turmoil, fragmentation, and warfare, traditionally referred to as the First Intermediate period (c. 2125–1975 BCE). About 2010 BCE, a series of kings named Mentuhotep (Eleventh Dynasty, c. 2010–c. 1938 BCE) gained power in Thebes, and the country was reunited under Nebhepetre Mentuhotep, who reasserted royal power and founded the Middle Kingdom.

The Middle Kingdom was another high point in Egyptian history. Arts and writing flourished in the Twelfth Dynasty (1938–1756 BCE), while reflecting a burgeoning awareness of the political upheaval from which the country had just emerged. Using a strengthened military, Middle Kingdom rulers expanded and patrolled the borders, especially in lower Nubia, south of present-day Aswan (see MAP 3-1, page 50). By the Thirteenth Dynasty (c. 1755–1630 BCE), however, central control by the government was weakened by a series of short-lived kings and an influx of foreigners, especially in the delta.

PORTRAITS OF SENUSRET III

Some royal portraits from the Middle Kingdom appear to express an unexpected awareness of the hardship and fragility of human existence. Statues of Senusret III, a king of the Twelfth Dynasty, who ruled from c. 1836 to 1818 BCE, reflects this new sensibility. Old Kingdom rulers such as Khafre (see Fig. 3–8) gaze into eternity confident and serene, toned and unflinching, whereas the portrait of **SENUSRET III** seems to capture a monarch preoccupied and emotionally drained (**Fig. 3–13**). Creases line his sagging cheeks, his eyes are sunken, his eyelids droop, his forehead is flexed, and his jaw is sternly set—a bold image of a resolute ruler, tested but unbowed.

Senusret was a dynamic king and successful general who led four military expeditions into Nubia, overhauled the Egyptian central administration, and was effective in regaining control over the country's increasingly independent nobles. To modern viewers, his portrait raises questions of interpretation. Are we looking at the face of a man wise in the ways of the world but lonely, saddened, and burdened by the weight of his responsibilities? Or are we looking at a reassuring statement that in spite of troubled times—that have clearly left their mark on the face of the ruler himself—royal rule endures in Egypt? Given what we know about Egyptian history at this time, it is difficult to be sure.

ROCK-CUT TOMBS

During the Eleventh and Twelfth Dynasties, members of the nobility and high-level officials commissioned tombs hollowed out of the face of a cliff. A typical rock-cut tomb included an entrance **portico** (projecting porch), a main hall, and a shrine with a burial chamber under the offering chapel. The chambers of these tombs,

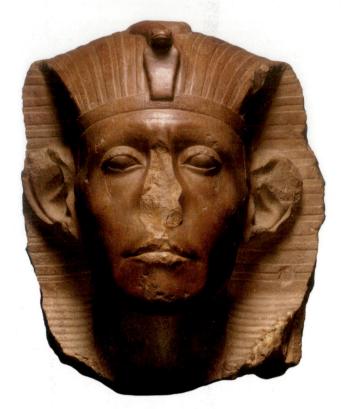

3-13 • HEAD OF SENUSRET III

Twelfth Dynasty, c. 1836–1818 BCE. Yellow quartzite, height $17^3\!\!/\!_{4}'' \times 13^1\!\!/\!_{2}'' \times 17''$ (45.1 \times 34.3 \times 43.2 cm). The Nelson-Atkins Museum of Art, Kansas City, Missouri. Purchase: William Rockhill Nelson Trust (62-11)

as well as their ornamental columns, lintels, false doors, and niches, were all carved into the solid rock. An impressive necropolis was created in the cliffs at **BENI HASAN** on the east bank of the Nile (**FIG. 3–14**). Painted scenes cover the interior walls of many tombs. Among the best preserved are those in the Twelfth-Dynasty tomb

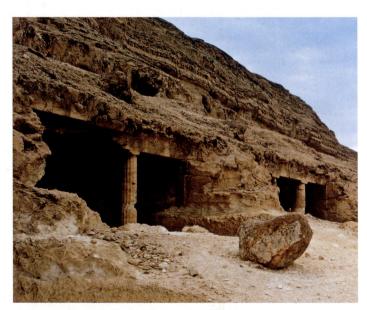

3-14 • ROCK-CUT TOMBS, BENI HASAN

Twelfth Dynasty, 1938–1756 BCE. At the left is the entrance to the tomb of a provincial governor and the commander-in-chief Amenemhat.

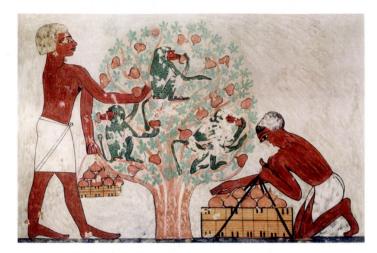

3-15 • PICKING FIGSWall painting from the tomb of Khnumhotep, Beni Hasan. Twelfth Dynasty, c. 1890 BCE. Tempera facsimile by Nina de Garis.

of local noble Khnumhotep, some of which portray vivid vignettes of farm work on his estates. In one painting two men harvest figs, rushing to compete with three baboons who relish the ripe fruit from their perches within the trees (**FIG. 3–15**). One man reaches

for a fig to add to the ordered stack in his basket, while his companion carefully arranges the harvest in a larger box for transport. Like the energetic hunters on the much earlier painted relief in the tomb of Ti (see FIG. 3–12), the upper torsos of these farm workers take a more lifelike profile posture, deviating from the strict frontality of the royal composite pose.

FUNERARY STELAI

Only the wealthiest and noblest of ancient Egyptians could afford elaborately decorated mastabas or rock-cut tombs. Prosperous people, however, could still commission funerary stelai depicting themselves, their family, and offerings of food. These personal monuments—meant to preserve the memory of the deceased and inspire the living to make offerings to them—contain compelling works of ancient Egyptian pictorial art. An unfinished stele made for the tomb of the **SCULPTOR USERWER** (**FIG. 3-16**) presents three levels of decoration: one large upper block with five bands of hieroglyphs, beneath which are two registers with figures, each identified by inscription.

The text is addressed to the living, imploring them to make offerings to Userwer: "O living ones who are on the earth who pass by this tomb, as your deities love and favor you, may you say:

3-16 • STELE OF THE SCULPTOR USERWER

Twelfth Dynasty, c. 1850 BCE. Limestone, red and black ink, $20\% ''\times 19''$ (52 \times 48 cm). British Museum London. (EA 579)

TECHNIQUE | Egyptian Pictorial Relief

Painting usually relies on color and line for its effect, while relief sculpture usually depends on the play of light and shadow alone, but in Egypt, relief sculpture was also painted (see Fig. 3–17). The walls and closely spaced columns of Egyptian tombs and temples were almost completely covered with colorful scenes and hieroglyphic texts. Until the Eighteenth Dynasty (c. 1539–1292 BCE), the only colors used were black, white, red, yellow, blue, and green. Modeling might be indicated by overpainting lines in a contrasting color, although the sense of three-dimensionality was conveyed primarily by the carved forms and incised inscriptions underneath the paint. The crisp outlines created by such carving assured the primacy of line in Egyptian pictorial relief.

With very few exceptions, figures, scenes, and texts were composed in bands, or registers. The scenes were first laid out with inked lines, using a squared grid to guide the designer in proportioning the human figures. The sculptor who executed the carving followed

these drawings, and it may have been another person who smoothed the carved surfaces of the relief and eventually covered them with paint.

The lower left corner of the unfinished Twelfth-Dynasty stele of Userwer shown here still maintains its preliminary underdrawings. In some figures there are also the tentative beginnings of the relief carving. The figures are delineated with black ink and the grid lines are rendered in red. Every body part had its designated place on the grid. For example, figures are designed 18 squares tall, measuring from the soles of their feet to their hairline; the tops of their knees conform with the sixth square up from the ground-line. Their shoulders align with the top of square 16 and are six squares wide. Slight deviations exist within this structured design format, but this canon of proportions represents an ideal system that was standard in pictorial relief throughout the Middle Kingdom.

DETAIL OF THE STELE OF THE SCULPTOR USERWER IN FIG. 3-16

'A thousand of bread and beer, a thousand of cattle and birds, a thousand of alabaster [vessels] and clothes, a thousand of offerings and provisions that go forth before Osiris'" (Robins, p. 103).

At left, on the register immediately below this inscription, Userwer sits before a table piled with offerings of food. Behind him is his wife Satdepetnetjer, and facing him on the other side of the offering table is Satameni, a standing woman also identified as his wife. Userwer could have had more than one wife, but one of these women might also be the sculptor's deceased first wife. At the other side of the stele on this same register but facing in the opposite direction sits another couple before another table heaped with food. They are identified as Userwer's parents, and the figure

on the other side of their offering table is his son, Sneferuweser. In the lowest register are representations of other family members (probably Userwer's children) and his grandparents.

One of the most striking features of the lowest register of this stele is its unfinished state. The two leftmost figures were left uncarved, but the stone surface still maintains the preparatory ink drawing meant to guide the sculptor, preserving striking evidence of a system of canonical figure proportions that was established in the Middle Kingdom (see "Egyptian Pictorial Relief," above). The unfinished state of this stele has led to the suggestion that Userwer might have been in the process of carving it for himself when his sudden death left it incomplete.

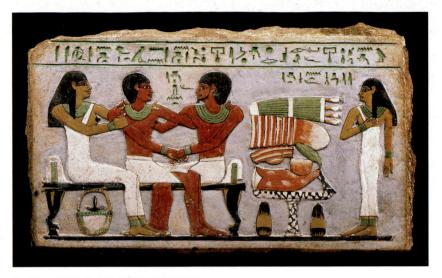

3-17 • STELE OF AMENEMHAT From Assasif. Late Eleventh Dynasty, c. 2000 BCE. Painted limestone, $11'' \times 15''$ (30 \times 50 cm). Egyptian Museum, Cairo. (JE 45626)

A more modest stele for a man named **AMENEMHAT** was brought to completion as a vibrantly painted relief (**FIG. 3-17**). Underneath an inscription inviting food offerings for the deceased Amenemhat is a portrait of his family. Amenemhat sits on a lionlegged bench between his wife Iyi and their son Antef, embraced by both. Next to the trio is an offering table, heaped with meat, topped with onions, and sheltering two loaves of bread standing under the table on the floor. On the far right is Amenemhat and Iyi's daughter, Hapy, completing this touching tableau of family unity, presumably projected into their life after death. The painter of this relief follows an established Egyptian convention of differentiating gender by skin tonality: dark red-brown for men and lighter yellow-ocher for women.

TOWN PLANNING

Although Egyptians used durable materials in the construction of tombs, they built their own dwellings with simple mud bricks, which have either disintegrated over time or been carried away for fertilizer by farmers. Only the foundations of these dwellings now remain.

Archaeologists have unearthed the remains of Kahun, a town built by Senusret II (ruled c. 1842–1837 BCE) for the many officials, priests, and workers who built and maintained his pyramid complex. Parallel streets were laid out on a **grid**, forming rectangular blocks divided into lots for homes and other buildings. The houses of priests, court officials, and their families were large and comfortable, with private living quarters and public rooms grouped around central courtyards. The largest had as many as 70 rooms spread out over half an acre. Workers and their families made do with small, five-room row-houses built back to back along narrow streets.

A New Kingdom workers' village, discovered at Deir el-Medina on the west bank of the Nile near the Valley of the Kings, has provided us with detailed information about the lives of the people who created the royal tombs. Workers lived together here under the rule of the king's chief minister. During a ten-day week, they worked for eight days and had two days off, and also participated in many religious festivals. They lived a good life with their families, were given clothing, sandals, grain, and firewood by the king, and had permission to raise livestock and birds as well as tend a garden. The residents had a council, and the many written records that survive suggest a literate and litigious society that required many scribes. Because the men were away for most of the week working on the tombs, women had a prominent role in the town.

THE NEW KINGDOM, c. 1539–1075 BCE

During the Second Intermediate period (1630–1520 BCE)—another turbulent interruption in the succession of dynasties ruling a unified Egypt—an eastern Mediterranean people called the Hyksos invaded Egypt's northernmost regions. Finally, the kings of the Eighteenth Dynasty (c. 1539–1292 BCE) regained control of the entire Nile region, extending from Nubia in the south to the Mediterranean Sea in the north, and restored political and economic strength. Roughly a century later, one of the same dynasty's most dynamic kings, Thutmose III (r. 1479–1425 BCE), extended Egypt's influence along the eastern Mediterranean coast as far as the region of present-day Syria. His accomplishment was the result of 15 or more military campaigns and his own skill at diplomacy. The heartland of ancient Egypt was now surrounded by a buffer of empire.

Thutmose III was the first ruler to refer to himself as "pharaoh," a term that literally meant "great house." Egyptians used it in the same way that Americans say "the White House" to mean the current U.S. president and his staff. The successors of Thutmose III continued to call themselves pharaohs, and the term ultimately found its way into the Hebrew Bible—and modern usage—as the title for the kings of Egypt.

THE GREAT TEMPLE COMPLEXES

At the height of the New Kingdom, rulers undertook extensive building programs along the entire length of the Nile. Their palaces, forts, and administrative centers disappeared long ago, but remnants of temples and tombs of this great age have endured. Thebes was Egypt's religious center throughout most of the New Kingdom, and worship of the Theban triad of deities—Amun, his wife Mut, and their son Khons—had spread throughout the country. Temples to these and other gods were a major focus of royal patronage, as were tombs and temples erected to glorify the kings themselves.

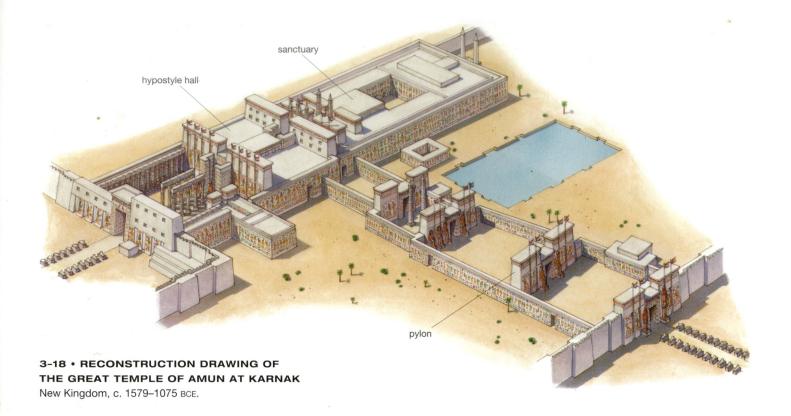

THE NEW KINGDOM TEMPLE PLAN As the home of the god, an Egyptian temple originally took the form of a house—a simple, rectangular, flat-roofed building preceded by a courtyard and gateway. The builders of the New Kingdom enlarged and multiplied these elements. The gateway became a massive pylon with tapering walls; the semipublic courtyard was surrounded by columns (a peristyle court); the temple itself included an outer hypostyle hall (a vast hall filled with columns) and an inner offering hall and sanctuary. The design was symmetrical and axial—that is, all its separate elements are symmetrically arranged along a dominant center line, creating a processional path from the outside straight into the sanctuary. The rooms became smaller, darker, and more exclusive as they neared the sanctuary, where the cult image of the god was housed. Only the pharaoh and the priests entered these inner rooms.

Two temple districts consecrated primarily to the worship of Amun, Mut, and Khons arose within the area of Thebes—a huge complex at Karnak to the north and, joined to it by an avenue of sphinxes, a more compact temple at Luxor to the south.

KARNAK Karnak was a long-standing sacred site, where temples were built and rebuilt for over 1,500 years. During the nearly 500 years of the New Kingdom, successive kings renovated and expanded the complex of the **GREAT TEMPLE OF AMUN** until it covered about 60 acres, an area as large as a dozen football fields (**FIG. 3-18**).

Access to the heart of the temple, a sanctuary containing the statue of Amun, was from the west (on the left side of the reconstruction drawing) through a principal courtyard, a hypostyle hall, and a number of smaller halls and courts. Pylons set off each of these separate elements. Between the reigns of Thutmose I (Eighteenth Dynasty, r. c. 1493-1482 BCE), and Ramses II (Nineteenth Dynasty, r. c. 1279–1213 BCE), this area of the complex underwent a great deal of construction and renewal. The greater part of the pylons leading to the sanctuary and the halls and courts behind them were renovated or newly built and embellished with colorful pictorial wall reliefs. A sacred lake was also added to the south of the complex, where the king and priests might undergo ritual purification before entering the temple. Thutmose III erected a court and festival temple to his own glory behind the sanctuary of Amun. His great-grandson Amenhotep III (r. 1390-1353 BCE) placed a large stone statue of the god Khepri, the scarab (beetle) symbolic of the rising sun, rebirth, and everlasting life, next to the sacred lake.

In the sanctuary of Amun, priests washed the god's statue every morning and clothed it in a new garment. Because the god was thought to derive nourishment from the spirit of food, his statue was provided with tempting meals twice a day, which the priests then removed and ate themselves. Ordinary people entered the temple precinct only as far as the forecourts of the hypostyle halls, where they found themselves surrounded by inscriptions and images of kings and the god on columns and walls. During religious festivals, they lined the waterways, along which statues of the gods were carried in ceremonial boats, and were permitted to submit petitions to the priests for requests they wished the gods to grant.

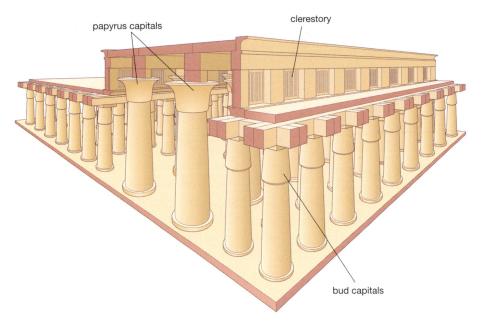

3-19 • RECONSTRUCTION DRAWING OF THE HYPOSTYLE HALL, GREAT TEMPLE OF AMUN AT KARNAK

Nineteenth Dynasty, c. 1292-1190 BCE.

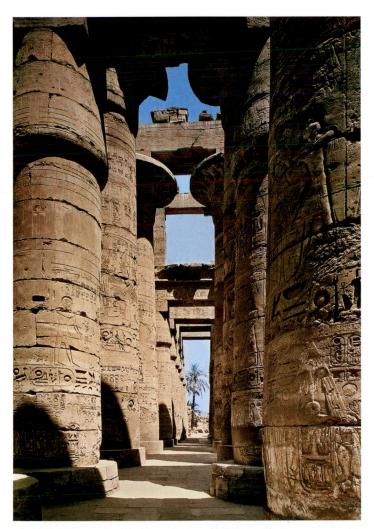

3-20 • COLUMNS WITH PAPYRIFORM AND BUD CAPITALS, HYPOSTYLE HALL, GREAT TEMPLE OF AMUN AT KARNAK

THE GREAT HALL AT KARNAK One of the most prominent features of the complex at Karnak is the enormous hypostyle hall set between two pylons at the end of the main forecourt. Erected in the reigns of the Nineteenth-Dynasty rulers Sety I (r. c. 1290-1279 BCE) and his son Ramses II (r. c. 1279-1213 BCE), and called the "Temple of the Spirit of Sety, Beloved of Ptah in the House of Amun," it may have been used for royal coronation ceremonies. Ramses II referred to it as "the place where the common people extol the name of his majesty." The hall was 340 feet wide and 170 feet long. Its 134 closely spaced columns supported a roof of flat stones, the center section of which rose some 30 feet higher than the broad sides (FIGS. 3-19, 3-20). The columns supporting this higher part of the roof are 69 feet tall and 12 feet in diameter, with massive papyrus capitals. On each side, smaller columns with bud capitals seem to march off forever into the darkness. In each of the side walls of the higher center sec-

tion, a long row of window openings created a clerestory. These openings were filled with stone grillwork, so they cannot have provided much light, but they did permit a cooling flow of air through the hall. Despite the dimness of the interior, artists covered nearly every inch of the columns, walls, and cross-beams with painted pictorial reliefs and inscriptions.

HATSHEPSUT

Across the Nile from Karnak and Luxor lay Deir el-Bahri and the Valleys of the Kings and Queens. These valleys on the west bank of the Nile held the royal necropolis, including the tomb of the pharaoh Hatshepsut. The dynamic Hatshepsut (Eighteenth Dynasty, r. c. 1473–1458 BCE) is a notable figure in a period otherwise dominated by male warrior-kings. Besides Hatshepsut, very few women ruled Egypt—they included the little-known Sobekneferu and Tausret, and much later, the well-known Cleopatra VII.

The daughter of Thutmose I, Hatshepsut married her half-brother, who then reigned for 14 years as Thutmose II. When he died in c. 1473, she became regent for his underage son—Thutmose III—born to one of his concubines. Within a few years, Hatshepsut had herself declared "king" by the priests of Amun, a maneuver that made her co-ruler with Thutmose III for 20 years.

There was no artistic formula for a female pharaoh in Egyptian art, yet Hatshepsut had to be portrayed in her new role. What happened reveals something fundamentally important about the art of ancient Egypt. She was represented as a male king (FIG. 3-21), wearing a kilt and linen headdress, occasionally even a king's false beard. The formula for portraying kings was not adapted to suit one individual; she was adapted to conform to convention. There

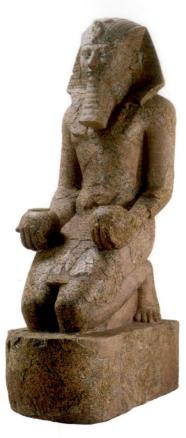

3-21 • HATSHEPSUT KNEELING

From Deir el-Bahri. Eighteenth Dynasty, c. 1473–1458 BCE. Red granite, height 8'6'' (2.59 m). Metropolitan Museum of Art, New York.

could hardly be a more powerful manifestation of the premium on tradition in Egyptian royal art.

At the height of the New Kingdom, rulers undertook extensive personal building programs, and Hatshepsut is responsible for one of the most spectacular: her **FUNERARY TEMPLE** located at Deir el-Bahri, about a mile away from her actual tomb in the Valley of the Kings (**FIG. 3-22**). This imposing complex was designed for funeral rites and commemorative ceremonies and is much larger and more prominent than the tomb itself, reversing the scale relationship we saw in the Old Kingdom pyramid complexes.

3-22 • FUNERARY TEMPLE OF HATSHEPSUT, DEIR EL-BAHRI

Eighteenth Dynasty, c. 1473–1458 $_{\rm BCE.}$ (At the far left, ramp and base of the funerary temple of Mentuhotep III. Eleventh Dynasty, r. c. 2009–1997 $_{\rm BCE.}$)

View the Closer Look for the funerary temple of Hatshepsut on myartslab.com

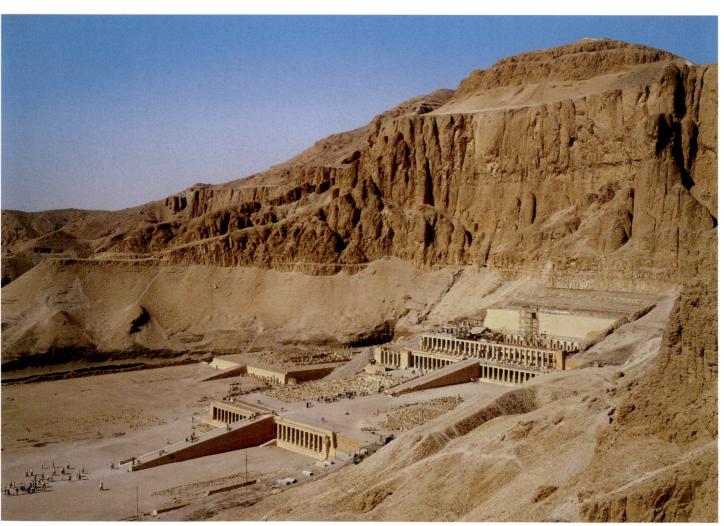

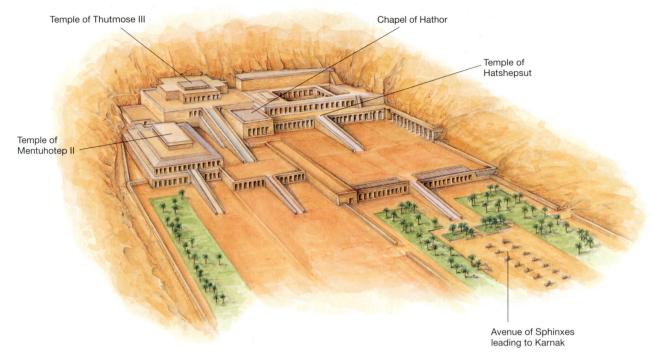

3-23 • SCHEMATIC DRAWING OF THE FUNERARY TEMPLE OF HATSHEPSUT Deir el-Bahri.

Magnificently sited and sensitively reflecting the natural threepart layering in the rise of the landscape—from flat desert, through a sloping hillside, to the crescendo of sheer stone cliffs—Hatshepsut's temple was constructed on an axial plan (FIG. 3-23). A causeway lined with sphinxes once ran from a valley temple on the Nile to the huge open space of the first court, where rare myrrh trees were planted in the temple's garden terraces. From there, visitors ascended a long, straight ramp to a second court where shrines to Anubis and Hathor occupy the ends of the columned porticos. On the temple's uppermost court, colossal royal statues fronted another colonnade (a row of columns supporting a lintel or a series of arches), and behind this lay a large hypostyle hall with chapels dedicated to Hatshepsut, her father, and the gods Amun and Ra-Horakhty—a powerful form of the sun god Ra combined with Horus. Centered in the hall's back wall was the entrance to the innermost sanctuary, a small chamber cut deep into the cliff.

THE TOMB OF RAMOSE

The traditional art of pictorial relief, employing a representational system that had dominated Egyptian figural art since the time of Narmer, reached a high degree of aesthetic refinement and technical sophistication during the reign of Amenhotep III (Eighteenth Dynasty, r. c. 1390–1353 BCE), especially in the reliefs carved for the unfinished tomb of Ramose near Thebes (**FIG. 3–24**).

As mayor of Thebes and vizier (principal royal advisor or minister) to both Amenhotep III and Amenhotep IV (r. 1353–c. 1336 BCE), Ramose was second only to the pharaoh in power and prestige. Soon after his ascent to political prominence, he

began construction of an elaborate Theban tomb comprised of four rooms, including an imposing hypostyle hall 82 feet wide. Walls were covered with paintings or with shallow pictorial relief carvings, celebrating the accomplishments, affiliations, and lineage of Ramose and his wife Merytptah, or visualizing the funeral rites that would take place after their death. But the tomb was not used by Ramose. Work on it ceased in the fourth year of Amenhotep IV's reign, when, renamed Akhenaten, he relocated the court from Thebes to the new city of Akhetaten. Presumably Ramose moved with the court to the new capital, but neither his name nor a new tomb has been discovered there.

The tomb was abandoned in various stages of completion. The reliefs were never painted, and some walls preserve only the preliminary sketches that would have guided sculptors. But the works that were executed are among the most sophisticated relief carvings in the history of art. On one wall, Ramose and his wife Merytptah appear, hosting a banquet for their family. All are portrayed at the same moment of youthful perfection, even though they represent two successive generations. Sophisticated carvers lavished their considerable technical virtuosity on the portrayal of these untroubled and majestic couples, creating clear textural differentiation of skin, hair, clothes, and jewelry. The easy elegance of linear fluidity is not easy to obtain in this medium, and the convincing sense of three-dimensionality in forms and their placement is managed within an extraordinarily shallow depth of relief. In the detail of Ramose's brother May and sister-in-law Werener in FIG. 3-24, the traditional ancient Egyptian marital embrace (see FIGS. 3-9, 3-17) takes on a new tenderness, recalling—especially within

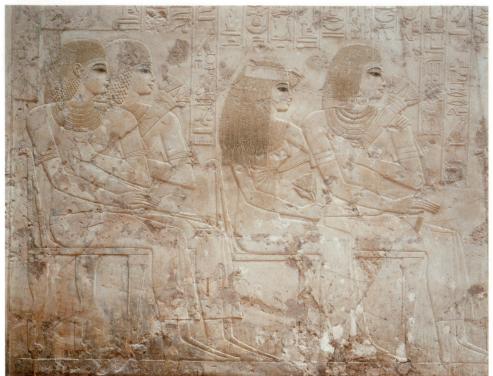

3-24 • RAMOSE'S BROTHER MAY AND HIS WIFE WERENER

Tomb of Ramose, Thebes. Eighteenth Dynasty, c. 1375–1365 BCE.

the eternal stillness of a tomb—the words of a New Kingdom love poem:

While unhurried days come and go, Let us turn to each other in quiet affection, Walk in peace to the edge of old age. And I shall be with you each unhurried day, A woman given her one wish: to see For a lifetime the face of her lord.

(Love Songs of the New Kingdom, trans. Foster, p. 18)

The conceptual conventions of Egyptian royal art are rendered in these carvings with such warmth and refinement that they become almost believable. Our rational awareness of their artificiality is momentarily eclipsed by their sheer beauty. But within this refined world of stable convention, something very jarring took place during the reign of Amenhotep III's successor, Amenhotep IV.

AKHENATEN AND THE ART OF THE AMARNA PERIOD

Amenhotep IV was surely the most unusual ruler in the history of ancient Egypt. During his 17-year reign (c. 1353–1336 BCE), he radically transformed the political, spiritual, and cultural life of the country. He founded a new religion honoring a single supreme god, the life-giving sun deity Aten (represented by the sun's disk), and changed his own name in about 1348 BCE to Akhenaten ("One Who Is Effective on Behalf of the Aten"). Abandoning Thebes, the capital of Egypt since the beginning of his dynasty and a city firmly in the grip of the priests of Amun, Akhenaten built a new capital much farther north, calling it Akhetaten ("Horizon of

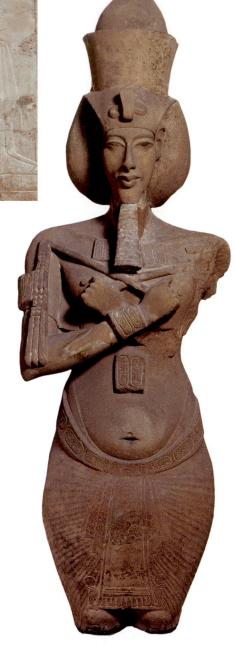

3-25 • COLOSSAL FIGURE OF AKHENATEN

From the temple known as the Gempaaten, built early in Akhenaten's reign just southeast of the Temple of Karnak. Sandstone with traces of polychromy, height of remaining portion about 13' (4 m). Egyptian Museum, Cairo. (JE 49528)

Read the document related to Akhenaten on myartslab.com

the Aten"). Using the modern name for this site, Tell el-Amarna, historians refer to Akhenaten's reign as the Amarna period.

THE NEW AMARNA STYLE Akhenaten's reign not only saw the creation of a new capital and the rise of a new religious focus; it also led to radical changes in royal artistic conventions. In portraits of the king, artists subjected his representation to startling stylizations, even physical distortions. This new royal figure style can be seen in a colossal statue of Akhenaten, about 16 feet tall, created for a new temple to the Aten that he built near the temple complex of Karnak, openly challenging the state gods (FIG. 3-25). This portrait was placed in one of the porticos of a huge courtyard (c. 426 by 394 feet), oriented to the movement of the sun.

The sculpture's strange, softly swelling forms suggest androgyny to modern viewers. The sagging stomach and inflated thighs contrast with spindly arms, protruding clavicles, and an attenuated neck, on which sits a strikingly stylized head. Facial features are exaggerated, often distorted. Slit-like eyes turn slightly downward, and the bulbous, sensuous lips are flanked by dimples that evoke the expression of ephemeral human emotion. Such stark deviations from convention are disquieting, especially since Akhenaten holds the flail and shepherd's crook, traditional symbols of the pharoah's super-human sovereignty.

The new Amarna style characterizes not only official royal portraits, but also pictorial relief sculpture portraying the family life of Akhenaten and Queen Nefertiti. In one panel the king and queen sit on cushioned stools playing with their nude daughters (FIG. 3-26), whose elongated shaved heads conform to the newly minted figure type. The royal couple receive the blessings of the Aten, whose rays end in hands that penetrate the open pavilion to offer ankhs before their nostrils, giving them the "breath of life." The king holds one child and lovingly pats her head, while she

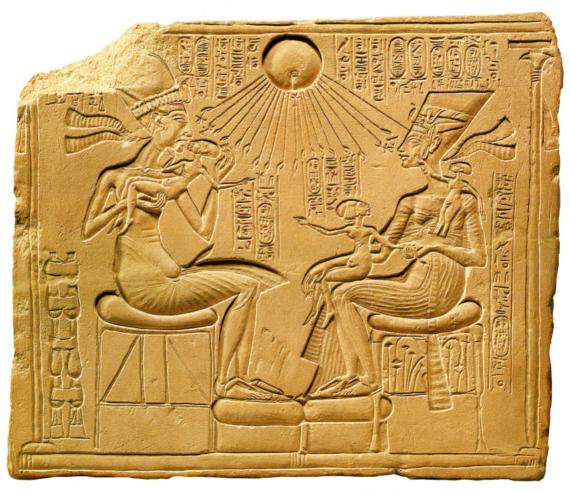

3-26 • AKHENATEN AND HIS FAMILY

From Akhetaten (present-day Tell el-Amarna). Eighteenth Dynasty, c. 1353–1336 BCE. Painted limestone relief, $12\frac{1}{4}$ " \times 15 $\frac{1}{4}$ " (31.1 \times 38.7 cm). Staatliche Museen zu Berlin, Preussischer Kulturbesitz, Ägyptisches Museum. (14145)

Egyptian relief sculptors often employed the **sunken relief** technique seen here. In ordinary reliefs, the background is carved back so that the figures project out from the finished surface. In sunken relief, the original flat surface of the stone is reserved as background, and the outlines of the figures are deeply incised, permitting the development of three-dimensional forms within them.

View the Closer Look for Akhenaten and his Family on myartslab.com

pulls herself forward to kiss him. The youngest of the three perches on Nefertiti's shoulder, trying to attract her mother's attention by stroking her cheek, while the oldest sits on the queen's lap, tugging at her mother's hand and pointing to her father. What a striking contrast with the relief from Ramose's tomb! Rather than composed serenity, this artist has conveyed the fidgety behavior of children and the loving involvement of their parents in a manner not even hinted at in earlier royal portraiture.

THE PORTRAIT OF TIY Akhenaten's goals were actively supported not only by Nefertiti but also by his mother, QUEEN TIY (FIG. 3-27). She had been the chief wife of the king's father, Amenhotep III, and had played a significant role in affairs of state during his reign. Queen Tiy's personality seems to emerge from a miniature portrait head that reveals the exquisite bone structure of her dark-skinned face, with its arched brows, uptilted eyes, and full lips. Originally, this portrait included a funerary silver headdress covered with gold cobras and gold jewelry. But after her son came to power and established his new religion, the portrait was altered. A brown cap covered with blue glass beads was placed over the original headdress.

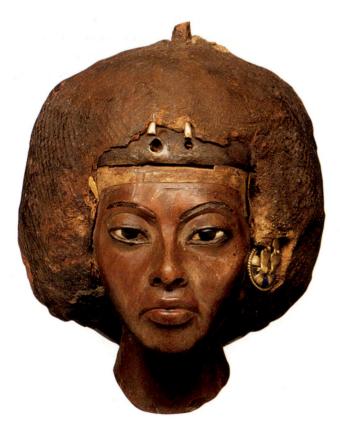

3-27 • QUEEN TIY

From Kom Medinet el-Ghurab (near el-Lahun). Eighteenth Dynasty, c. 1352 BCE. Wood (perhaps yew and acacia), ebony, glass, silver, gold, lapis lazuli, cloth, clay, and wax, height $3\frac{3}{4}$ " (9.4 cm). Staatliche Museen zu Berlin, Preussischer Kulturbesitz, Ägyptisches Museum. (21834)

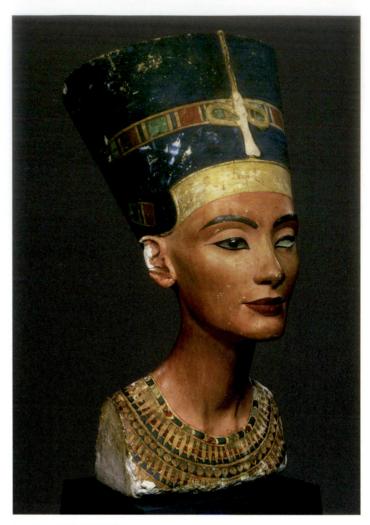

3-28 • NEFERTITIFrom Akhetaten (modern Tell el-Amarna). Eighteenth Dynasty, c. 1353–1336 BCE. Painted limestone, height 20" (51 cm). Staatliche Museen zu Berlin, Preussischer Kulturbesitz, Ägyptisches Museum. (21300)

THE HEAD OF NEFERTITI The famous head of NEFERTITI (FIG. 3-28) was discovered in 1912, along with drawings and other items related to commissions for the royal family, in the Akhetaten studio of the sculptor Thutmose. It may have served as a model for full-length sculptures or paintings of the queen. In 2007, analysis of this famous work using a CT scan revealed the existence of a delicately carved limestone sculpture underneath the modeled stucco that forms its outer surface. The faces of the queen in the two likenesses differs slightly. The sculptor seems to have smoothed out in stucco some of the facial irregularities in the underlying limestone carving—including a bump in Nefertiti's nose and creases around her mouth—and increased the prominence of her cheekbones, probably to bring the queen's face into conformity with contemporary notions of beauty, much in the way we would retouch a photographic image.

The proportions of Nefertiti's refined, regular features, long neck, and heavy-lidded eyes appear almost too ideal to be human, but are eerily consistent with standards of beauty in our own culture. Part of the appeal of this portrait bust, aside from its stunning beauty, may be the artist's dramatic use of color. The hues of the blue headdress and its striped band are repeated in the rich red, blue, green, and gold of the jeweled necklace. The queen's brows, eyelids, cheeks, and lips are heightened with color, as they no doubt were heightened with cosmetics in real life.

GLASS Glassmaking could only be practiced by artists working for the king, and Akhenaten's new capital had its own glassmaking workshops (see "Glassmaking," page 76). A bottle produced there and meant to hold scented oil was fashioned in the shape of a fish that has been identified as a bolti, a species that carries its eggs in its mouth and spits out its offspring when they hatch (see Fig. 3–33). The bolti was a common symbol for birth and regeneration, complementing the self-generation that Akhenaten attributed to the sun disk Aten.

THE RETURN TO TRADITION: TUTANKHAMUN AND RAMSES II

Akhenaten's new religion and revolutionary reconception of pharaonic art outlived him by only a few years. The priesthood of Amun quickly regained its former power, and his young son Tutankhaten (Eighteenth Dynasty, r. c. 1332–1322 BCE) returned to traditional religious beliefs, changing his name to Tutankhamun—"Living Image of Amun"—and moving the court back to Thebes. He died at age 19, and was buried in the Valley of the Kings.

Although some had doubted the royal lineage of the young Tutankhaten, recent DNA testing of a series of royal mummies from this period confirmed that he was the son of Akhenaten and one of his sisters. And his death at such a young age seems not to have been the result of royal intrigue and assassination, but poor health and serious injury. The DNA analysis documented his

struggles with malaria, and CT scans revealed a badly broken and seriously infected leg, as well as a series of birth defects that have been ascribed to royal inbreeding.

TUTANKHAMUN'S TOMB The sealed inner chamber of Tutankhamun's tomb was never plundered, and when it was found in 1922 its incredible riches were just as they had been left since his interment. His mummified body, crowned with a spectacular mask preserving his royal likeness (see FIG. 3-1), lay inside three nested coffins that identified him with Osiris, the god of the dead. The innermost coffin, in the shape of a mummy, is the richest of the three (FIG. 3-29). Made of over 240 pounds (110.4 kg) of gold, its surface is decorated with colored glass and semiprecious gemstones, as well as finely incised linear designs and hieroglyphic inscriptions. The king holds a crook and a flail, symbols that were associated with Osiris and had become a traditional part of the royal regalia. A nemes headcloth with projecting cobra and vulture covers his head, and a blue braided beard is attached to his chin. Nekhbet and Wadjet, vulture and cobra goddesses of Upper and Lower Egypt, spread their wings across his body. The king's features as reproduced on the coffin and masks are those of a very young man, and the unusually full lips, thin-bridged nose, and pierced earlobes suggest the continuing vitality of some Amarna stylizations.

RAMSES II AND ABU SIMBEL By Egyptian standards Tutankhamun was a rather minor king. Ramses II, on the other hand, was both powerful and long-lived. Under Ramses II (Nineteenth Dynasty, r. c. 1279–1213 BCE), Egypt was a mighty empire. He was a bold leader and an effective political strategist. Although he did not win every battle, he was an effective master of royal propaganda, able to turn military defeats into glorious victories. He also triumphed diplomatically by securing a peace

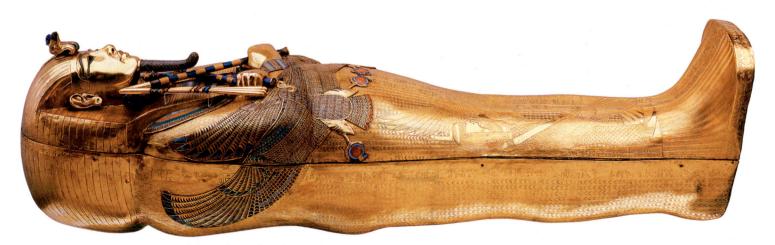

3-29 • INNER COFFIN FROM TUTANKHAMUN'S SARCOPHAGUS

From the tomb of Tutankhamun, Valley of the Kings. Eighteenth Dynasty, c. 1332–1322 BCE. Gold inlaid with glass and semiprecious stones, height 6'% (1.85 m), weight nearly 243 pounds (110.4 kg). Egyptian Museum, Cairo. (JE 60671)

A BROADER LOOK | The Temples of Ramses II at Abu Simbel

Many art objects are subtle, captivating us through their enduring beauty or mysterious complexity. Monuments such as Ramses II's temples at Abu Simbel, however, engage us forcefully across the ages with a sense of raw power born of sheer scale. This king-god of Egypt, ruler of a vast empire, a virile wonder who fathered nearly a hundred children, is self-described in an inscription he had carved into an obelisk (now standing in the heart of Paris): "Son of Ra: Ramses-Meryamun ['Beloved of Amun']. As long as the skies exist, your monuments shall exist, your name shall exist, firm as the skies." So far, this is true.

Abu Simbel was an auspicious site for Ramses II's great temples. It is north of the second cataract of the Nile, in Nubia, the ancient land of Kush, which Ramses ruled and which was the source of his gold, ivory, and exotic animal skins. The monuments were carved directly into the living rock of the sacred

hills. The larger temple is dedicated to Ramses and the Egyptian gods Amun, Ra-Horakhty, and Ptah (FIG. 3–30). A row of four colossal seated statues of the king himself, 65 feet high, dominate the monument, flanked by relatively small statues of family members, including his principal wife Nefertari. Inside the temple, eight 23-foot statues of the god Osiris with the face of the god-king Ramses further proclaim his divinity. The corridor they form leads to seated figures of Ptah, Amun, Ramses II, and Ra. The corridor was oriented so that twice a year the first rays of the rising sun shot through it to illuminate statues of the king and the three gods placed against the back wall (FIG. 3–31).

About 500 feet away, Ramses ordered a smaller temple to be carved into a mountain sacred to Hathor, goddess of fertility, love, joy, and music, and to be dedicated to Hathor and to Nefertari. The two temples were oriented so that their axes crossed in the middle of

the Nile, suggesting that they may have been associated with the annual life-giving flood.

Ironically, rising water nearly destroyed them both. Half-buried in the sand over the ages, the temples were only rediscovered early in the nineteenth century. But in the 1960s, construction of the Aswan High Dam flooded the Abu Simbel site. An international team of experts mobilized to find a way to safeguard Ramses II's temples, deciding in 1963 to cut them out of the rock in blocks (FIG. 3-32) and re-erect them on higher ground, secure from the rising waters of Lake Nasser. The projected cost of \$32 million was financed by UNESCO, with Egypt and the United States each pledging \$12 million. Work began in 1964 and was completed in 1968. Because of this international cooperation and a combination of modern technology and hard labor, Ramses II's temples were saved so they can continue to engage future generations.

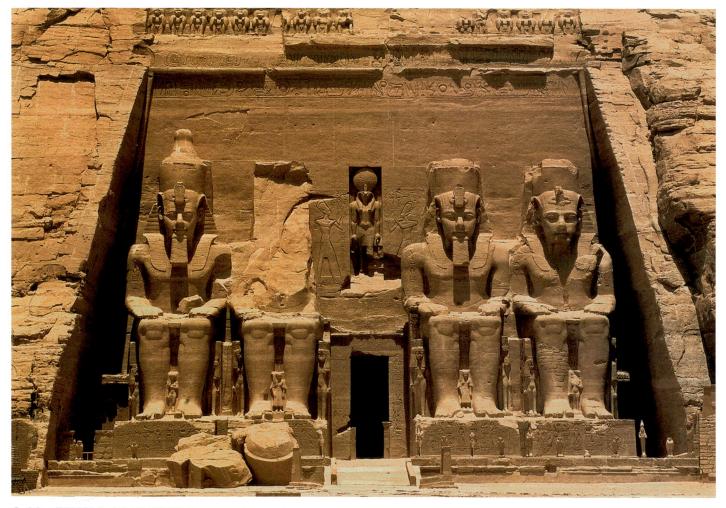

3-30 • TEMPLE OF RAMSES IIAbu Simbel. Nineteenth Dynasty, c. 1279–1213 BCE.

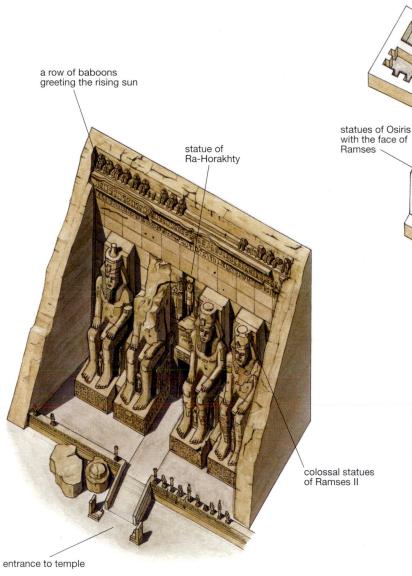

EXTERIOR

3-31 • SCHEMATIC DRAWING OF THE TEMPLE OF RAMSES II

Abu Simbel.

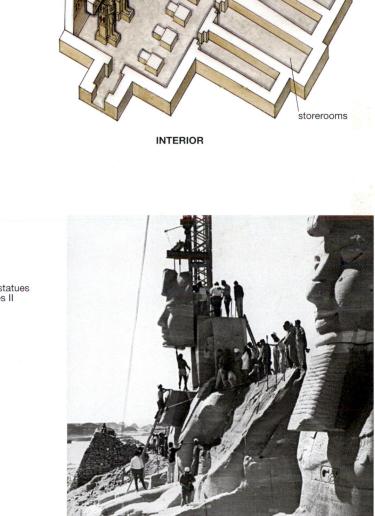

inner sanctuary

vestibule with scenes of Ramses and Nefertari making offerings

3-32 • REMOVAL OF THE FACE OF ONE OF THE COLOSSAL SCULPTURES OF RAMSES II AT ABU SIMBEL IN THE MID 1960S

TECHNIQUE | Glassmaking

No one knows precisely when or where the technique of glassmaking first developed, but the basics of the process are quite clear. Heating a mixture of sand, lime, and sodium carbonate or sodium sulfate to a very high temperature produces glass. The addition of other minerals can make the glass transparent, translucent, or opaque, as well as create a vast range of colors.

The first objects to be made entirely of glass in Egypt were produced with the technique known as core-formed glass. A lump of sandy clay molded into the desired shape was wrapped in strips of cloth, then skewered on a fireproof rod. It was then briefly dipped into a pot of molten glass. When the resulting coating of glass had cooled, the clay core was removed through the opening left by the skewer. To decorate the vessel, glassmakers frequently heated thin rods of colored glass and fused them on and flattened them against the surface in strips. The fish-shaped bottle (Fig. 3-33)—is an example of core-formed glass from the New Kingdom's Amarna period: The body was created from glass tinted with cobalt, and the surface was then decorated with small rods of white and orange glass, achieving the wavy pattern that resembles fish scales by dragging a pointed tool along the surface. Then two slices of a rod of spiraled black and white glass were fused to the surface to create its eyes.

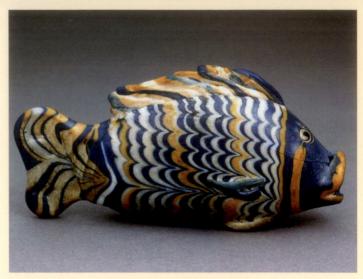

3-33 • FISH-SHAPED PERFUME BOTTLEFrom Akhetaten (present-day Tell el-Amarna). Eighteenth Dynasty, reign of Akhenaten, c. 1353–1336 BCE. Core-formed glass, length 5³/₄" (14.5 cm). British Museum, London. (EA 55193)

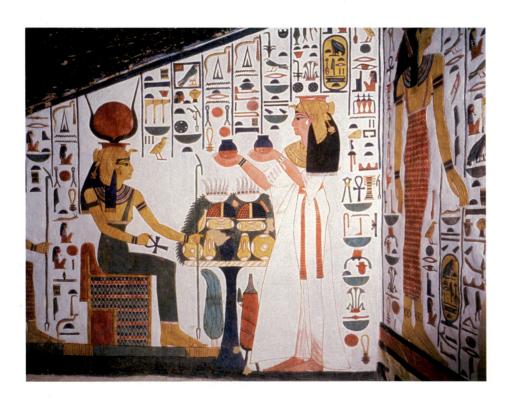

3-34 • QUEEN NEFERTARI MAKING AN OFFERING TO ISIS

Wall painting in the tomb of Nefertari, Valley of the Queens. Nineteenth Dynasty, 1290–1224 BCE.

agreement with the Hittites, a rival power centered in Anatolia (see Chapter 2) that had tried to expand to the west and south at Egypt's expense. Ramses twice reaffirmed that agreement by marrying Hittite princesses.

In the course of a long and prosperous reign, Ramses II initiated building projects on a scale rivaling the Old Kingdom

pyramids at Giza. Today, the most awe-inspiring of his many architectural monuments are found at Karnak and Luxor, and at Abu Simbel in Egypt's southernmost region (see "The Temples of Ramses II at Abu Simbel," page 74). At Abu Simbel, Ramses ordered two large temples to be carved into natural rock, one for himself and the other for his principal wife, Nefertari.

The temples at Abu Simbel were not funerary monuments. Ramses' and Nefertari's tombs are in the Valleys of the Kings and Queens. The walls of Nefertari's tomb are covered with exquisite paintings. In one mural, Nefertari offers jars of perfumed ointment to the goddess Isis (FIG. 3-34). The queen wears the vulture-skin headdress and jeweled collar indicating her royal position, and a long, semitransparent white linen gown. Isis, seated on her throne behind a table heaped with offerings, holds a long scepter in her left hand, the ankh in her right. She wears a headdress surmounted by the horns of Hathor framing a sun disk, clear indications of her divinity.

The artists responsible for decorating the tomb diverged very subtly but distinctively from earlier stylistic conventions. The outline drawing and use of pure colors within the lines reflect traditional practices, but quite new is the slight modeling of the body forms by small changes of **hue** to enhance the appearance of three-dimensionality. The skin color of these women is much darker than that conventionally used for females in earlier periods, and lightly brushed-in shading emphasizes their eyes and lips.

THE BOOKS OF THE DEAD

By the time of the New Kingdom, the Egyptians had come to believe that only a person free from wrongdoing could enjoy an afterlife. The dead were thought to undergo a last judgment consisting of two tests presided over by Osiris, the god of the underworld, and supervised by the jackal-headed god of embalming and cemeteries, Anubis. After the deceased were questioned about their behavior in life, their hearts—which the Egyptians believed to be the seat of the soul—were weighed on a scale against an ostrich feather, the symbol of Ma'at, goddess of truth, order, and justice.

Family members commissioned papyrus scrolls containing magical texts or spells, which the embalmers sometimes placed among the wrappings of the mummified bodies. Early collectors of Egyptian artifacts referred to such scrolls, often beautifully illustrated, as "Books of the Dead." A scene in one that was created for a man named Hunefer (Nineteenth Dynasty) shows three successive stages in his induction into the afterlife (FIG. 3-35). At the left, Anubis leads him by the hand to the spot where he will weigh his heart against the "feather of Truth." Ma'at herself appears atop the balancing arm of the scales wearing the feather as a headdress. To the right of the scales, Ammit, the dreaded "Eater of the Dead"—part crocodile, part lion, and part hippopotamus—watches eagerly for a sign from the ibis-headed god Thoth, who prepares to record the result of the weighing.

But the "Eater" goes hungry. Hunefer passes the test, and Horus, on the right, presents him to the enthroned Osiris, who floats on a lake of natron (see "Preserving the Dead," page 53). Behind the throne, the goddesses Nephthys and Isis support the god's left arm, while in front of him Horus's four sons, each entrusted with the care of one of the deceased's vital organs, stand atop a huge lotus blossom rising up out of the lake. In the top register, Hunefer, finally accepted into the afterlife, kneels before 14 gods of the underworld.

THE THIRD INTERMEDIATE PERIOD, c. 1075–715 BCE

After the end of the New Kingdom, Egypt was ruled by a series of new dynasties, whose leaders continued the traditional patterns of royal patronage and pushed figural conventions in new

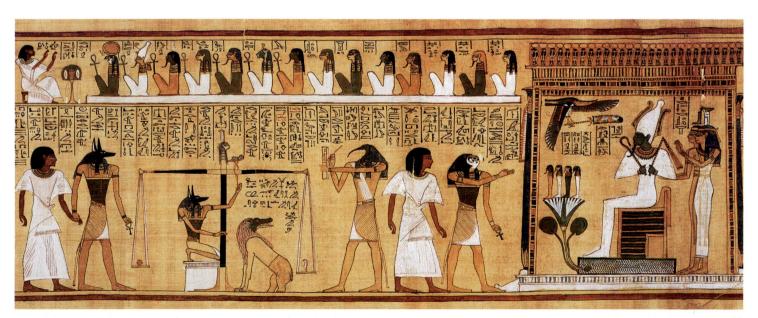

3-35 • JUDGMENT OF HUNEFER BEFORE OSIRIS

Illustration from a Book of the Dead. Nineteenth Dynasty, c. 1285 BCE. Painted papyrus, height 15\%" (39.8 cm). British Museum, London. (EA 9901)

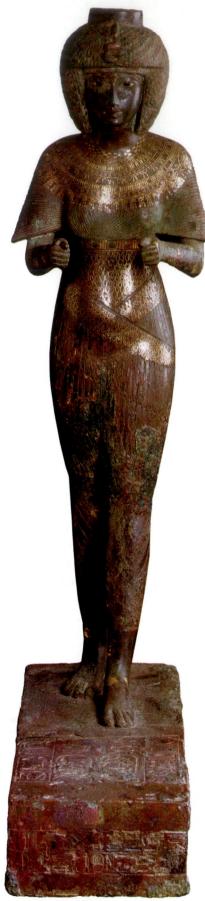

3-36 • KAROMAMAThird Intermediate period, Twenty-Second Dynasty, c. 945–715 BCE. Bronze inlaid with gold, silver, electrum, glass, and copper, height 23½" (59.5 cm). Musée du Louvre, Paris.

and interesting directions. One of the most extraordinary, and certainly one of the largest, surviving examples of ancient Egyptian bronze sculpture dates from this period (**FIG. 3–36**). An inscription on the base identifies the subject as Karomama, divine consort of Amun and member of a community of virgin priestesses selected from the pharaoh's family or retinue who were dedicated to him. Karomama herself was the granddaughter of king Osorkan I (Twenty-First Dynasty, r. c. 985–978 BCE). These priestesses amassed great power, held property, and maintained their own court, often passing on their position to one of their nieces. The *sistra* (ritual rattles) that Karomama once carried in her hands would have immediately identified her as a priestess rather than a princess.

The main body of this statue was cast in bronze and subsequently covered with a thin sheathing of bronze, which was then exquisitely engraved with patterns inlaid with gold, silver, and electrum (a natural alloy of gold and silver). Much of the inlay has disappeared, but we can still make out the elaborately incised drawing of the bird wings that surround Karomama and accentuate the fullness of her figure, conceived to embody a new female ideal. Her slender limbs, ample hips, and more prominent breasts contrast with the uniformly slender female figures of the late New Kingdom (see FIG. 3–34).

LATE EGYPTIAN ART, c. 715-332 BCE

The Late period in Egypt saw the country and its art in the hands and service of foreigners. Nubians, Persians, Macedonians, Greeks, and Romans were all attracted to Egypt's riches and seduced by its art. In the eighth century, Nubians from the powerful kingdom of Kush—ancient Egypt's neighbor to the south—conquered Egypt, establishing capitals at Memphis and Thebes (712–657 BCE) and adopting Egyptian religious practices, artistic conventions, and architectural forms. The sphinx of the Nubian king Taharqo (r. c. 690–664 BCE) expresses royal power in a tradition dating back to the Old Kingdom (see FIG. 3–6), the two cobras on his forehead perhaps representing Taharqo's two kingdoms—Kush and Egypt (FIG. 3–37). The facial features,

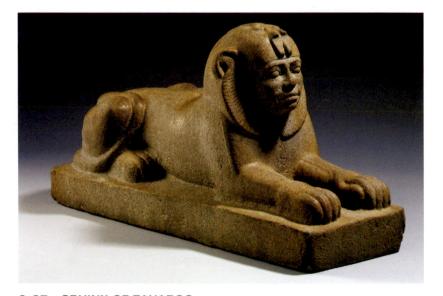

3-37 • SPHINX OF TAHARQO From Temple T, Kawa, Nubia (modern Sudan). Twenty-

From Temple T, Kawa, Nubia (modern Sudan). Twenty-Fifth Dynasty, c. 680 BCE. Granite, height 16" (40.6 cm); length 28\%" (73 cm). British Museum, London.

RECOVERING THE PAST | How Early Art is Dated

After centuries of foreign rule, beginning with the arrival of the Greeks in 332 BCE, the ancient Egyptian language gradually died out. Modern scholars were only able to recover this long-forgotten language through a fragment of a stone stele, dated 196 BCE (FIG. 3–38). Known today as the Rosetta Stone—for the area of the delta where one of Napoleon's officers discovered it in 1799—it contains a decree issued by the priests at Memphis honoring Ptolemy V (r. c. 205–180 BCE) carved in hieroglyphs, demotic (a simplified, cursive form of hieroglyphs), and Greek.

Even with the juxtaposed Greek translation, the two Egyptian texts remained incomprehensible until 1818, when Thomas Young, an English physician interested in ancient Egypt, linked some of the hieroglyphs to specific names in the Greek version. A short time later, French scholar Jean-François Champollion located the names Ptolemy and Cleopatra in both of the Egyptian scripts. With the phonetic symbols for P, T, O, and L in demotic, he was able to build up an "alphabet" of hieroglyphs, and by 1822 he had deciphered the two Egyptian texts.

3-38 • ROSETTA STONE 196 BCE. British Museum, London.

The hieroglyphic signs for the letters P, T, O, and L were Champollion's clues to deciphering the Rosetta Stone.

however, clearly identify him as African, and his specific identity is secured by an inscription engraved into his chest.

In 332 BCE, Macedonian Greeks led by Alexander the Great conquered Egypt, and after Alexander's death in 323 BCE, his

generals divided up his empire. Ptolemy, a Greek, took Egypt, declaring himself king in 305 BCE. The Ptolemaic dynasty ended with the death of Cleopatra VII (r. 51–30 BCE), when the Romans succeeded as Egypt's rulers and made it the breadbasket of Rome.

THINK ABOUT IT

- **3.1** Explain the traditional pictorial conventions for representing the human figure in ancient Egypt using the Palette of Narmer ("A Closer Look," page 52) as an example.
- 3.2 Summarize the religious beliefs of ancient Egypt with regard to the afterlife, and explain how their beliefs inspired traditions in art and architecture, citing specific examples both early and late.
- **3.3** How do depictions of royalty differ from those of more ordinary people in ancient Egyptian art? Focus your answer on one specific representation of each.
- 3.4 Characterize the stylistic transformation that took place during the rule of Akhenaten by comparing FIGURES 3–24 and 3–26.
 Why would there be such a drastic change?

CROSSCURRENTS

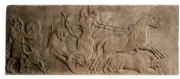

FIG. 2-17

What do these two ancient scenes of hunting express about the wealthy and powerful people who commissioned them? How do the artists make their messages clear? How is location related to meaning?

FIG. 3-12

Study and review on myartslab.com

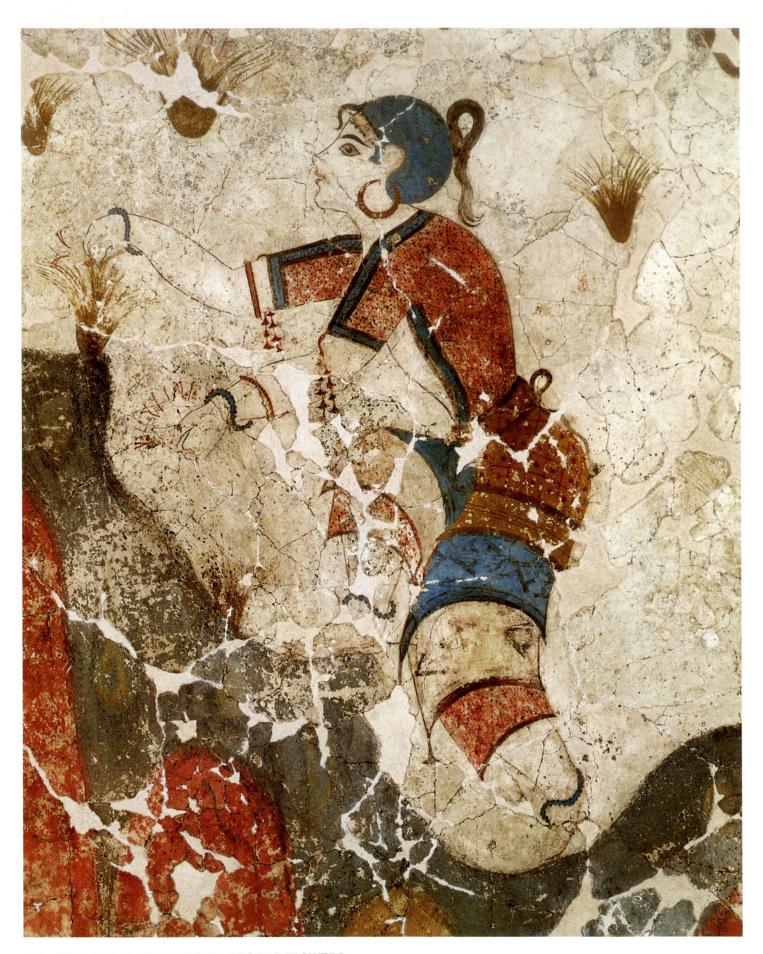

4-1 • GIRL GATHERING SAFFRON CROCUS FLOWERSDetail of wall painting, Room 3 of House Xeste 3, Akrotiri, Thera, Cyclades. Before 1630 BCE. Thera Foundation, Petros M. Nomikos, Greece.

Art of the Ancient Aegean

This elegantly posed and sharply silhouetted girl, reaching to pluck the crocus flowers blooming on the hillside in front of her (FIG. 4-1), offers us a window into life in the ancient Aegean world. The image is from a fresco of c. 1650 BCE found in a house in Akrotiri, a town on the Aegean island of Thera that seems to have been famous for the saffron harvested from its crocuses. Saffron was valued in the Bronze Age Aegean mainly as a yellow dye in textile production, but it also had medicinal properties and was used to alleviate menstrual cramps. The latter use may be referenced in this image, since the fresco was part of the elaborate painted decoration of a room that some scholars believe housed the coming-of-age ceremonies of young women at the onset of menses. The crocus gatherer's shaved head and looped long ponytail are attributes of childhood, but the light blue color of her scalp indicates that her hair is beginning to grow out, suggesting that she is entering adolescence.

The house that contained this painting disappeared suddenly more than 3,600 years ago, when the volcano that formed the island of Thera erupted, spewing pumice that filled and sealed every crevice of Akrotiri—fortunately, after the residents had fled. The rediscovery of the lost town in 1967 was among the most significant archaeological events of the second half of the twentieth century, and excavation of the city is still under way. The opportunity

that Thera affords archaeologists to study works of art and architecture in context has allowed for a deeper understanding of the Bronze Age cultures of the Aegean. As the image of the girl gathering crocuses illustrates, wall paintings may reflect the ritual uses of a room or building, and the meanings of artifacts are better understood by considering both where they are found and how they are grouped with one another.

Before 3000 BCE until about 1100 BCE, several Bronze Age cultures flourished simultaneously across the Aegean: on a cluster of small islands (including Thera) called the Cyclades, on Crete and other islands in the eastern Mediterranean, and on mainland Greece (MAP 4-1). To learn about these cultures, archaeologists have studied shipwrecks, homes, and grave sites, as well as the ruins of architectural complexes. Archaeology—uncovering and interpreting material culture to reconstruct its original context—is our principal means of understanding the Bronze Age culture of the Aegean, since only one of its three written languages has been decoded. In recent years, archaeologists and art historians have collaborated with researchers in such areas of study as the history of trade and the history of climate change to provide an ever-clearer picture of ancient Aegean society. But many sites await excavation, or even discovery. The history of the Aegean Bronze Age is still being written.

LEARN ABOUT IT

- **4.1** Compare and contrast the art and architectural styles developed by three Aegean Bronze Age cultures.
- **4.2** Evaluate how archaeology has recovered, reconstructed, and interpreted ancient Aegean material culture despite the limitations of written documents.
- **4.3** Investigate the relationship between art and social rituals or communal practices in the ancient Aegean cultures.
- **4.4** Assess differences in the designs and use of the large architectural complexes created by the Minoans and the Mycenaeans.

THE BRONZE AGE IN THE AEGEAN

Using metal ores imported from Europe, Arabia, and Anatolia, Aegean peoples created exquisite objects of bronze that were prized for export. This early period when the manufacture of bronze tools and weapons became widespread is known as the Aegean Bronze Age. (See Chapter 1 for the Bronze Age in northern Europe.)

For the ancient Aegean peoples, the sea provided an important link not only between the mainland and the islands, but also to the world beyond. In contrast to the landlocked civilizations of the Near East, and to the Egyptians, who used river transportation, the peoples of the Aegean were seafarers, and their ports welcomed ships from other cultures around the Mediterranean. For this reason shipwrecks offer a rich source of information about the material culture of these ancient societies. For example, the wreck of a trading vessel (probably from the Levant, the Mediterranean coast of the Near East) thought to have sunk in or soon after 1306 BCE and discovered in the vicinity of Ulu Burun, off the southern coast of modern Turkey, carried an extremely varied cargo: metal ingots, bronze weapons and tools, aromatic resins, fruits and spices, jewelry and beads, African ebony, ivory tusks, ostrich eggs, disks of blue glass ready to be melted down for reuse, and ceramics from the Near East, mainland Greece, and Cyprus. Among the gold objects was a scarab associated with Nefertiti, wife of the Egyptian pharaoh Akhenaten. The cargo suggests that this vessel cruised from port to port along the Aegean and eastern Mediterranean seas, loading and unloading goods as it went. It also suggests that the peoples of Egypt and the ancient Near East were important trading partners.

Probably the thorniest problem in Aegean archaeology is that of dating the finds. In the case of the Ulu Burun wreck, the dating of a piece of freshly cut firewood on the ship to 1306 BCE using a technique called dendrochronology that analyzes the spaces between growth rings—allowed unusual precision in pinpointing the moment this ship sunk. But archaeologists are not always able to find such easily datable materials. They usually rely on a relative dating system for the Aegean Bronze Age, based largely on pottery, but assigning specific dates to sites and objects with this system is complicated and controversial. One cataclysmic event has helped: A huge volcanic explosion on the Cycladic island of Thera, as we have seen, devastated Minoan civilization there and on Crete, only 70 miles to the south. Evidence from tree rings from Ireland and California and traces of volcanic ash in ice cores from Greenland put the date of the eruption about 1650-1625 BCE. Sometimes in this book you will find periods cited without attached dates and in other books you may encounter different dates from those given for objects shown here. You should expect dating to change in the future as our knowledge grows and new techniques of dating emerge.

THE CYCLADIC ISLANDS

On the Cycladic islands, late Neolithic and early Bronze Age people developed a thriving culture. They engaged in agriculture, herding, crafts, and trade, using local stone to build fortified towns and hillside burial chambers. Because they left no written records, their artifacts are our principal source of information about them. From about 6000 BCE, Cycladic artists used a coarse, poor-quality local clay to make a variety of ceramic objects, including engaging ceramic figurines of humans and animals, as well as domestic and ceremonial wares. Some 3,000 years later, they began to produce marble sculptures.

The Cyclades, especially the islands of Naxos and Paros, had ample supplies of a fine and durable white marble. Sculptors used this stone to create sleek, abstracted representations of human figures, ranging from a few inches to almost 5 feet tall. They were shaped—perhaps by women—with scrapers made of obsidian and smoothed by polishing stones of emery, both materials easily available on the Cyclades.

These sculptures have been found almost exclusively in graves, and, although there are a few surviving male figures, the

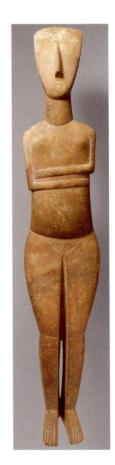

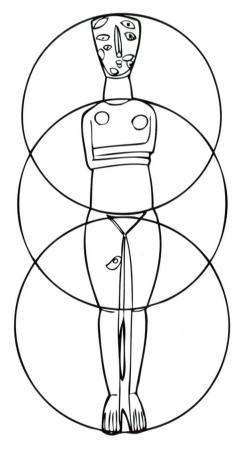

4-2 • FIGURE OF A WOMAN WITH A DRAWING SHOWING EVIDENCE OF ORIGINAL PAINTING AND OUTLINING DESIGN SCHEME

Cyclades. c. 2600–2400 BCE. Marble, height 24³/₄" (62.8 cm). Figure: Metropolitan Museum of Art, New York. Gift of Christos G. Bastis (68.148). Drawing: Elizabeth Hendrix.

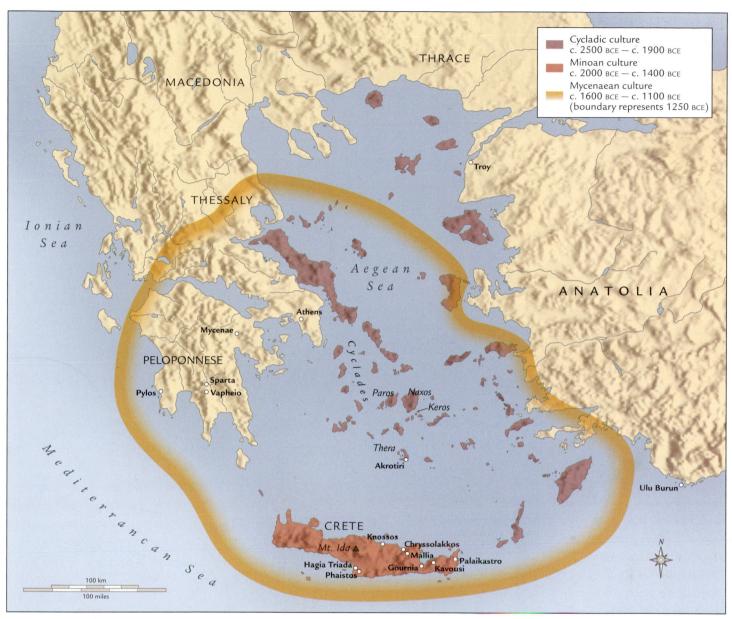

MAP 4-1 • THE ANCIENT AEGEAN WORLD

The three main cultures in the ancient Aegean were the Cycladic, in the Cyclades; the Minoan, on Thera and Crete; and the Helladic, including the Mycenaean, on mainland Greece but also encompassing the regions that had been the center of the two earlier cultures.

overwhelming majority represent nude women and conform to a consistent representational convention (FIG. 4-2). They are presented in extended poses of strict symmetry, with arms folded just under gently protruding breasts, as if they were clutching their abdomens. Necks are long, heads tilted back, and faces are featureless except for a prominent, elongated nose. All body parts are pared down to essentials, and some joints and junctures are indicated with incised lines. The sculptors carefully designed these figures, laying them out with a compass in conformity to three evenly spaced and equally sized circles—the first delineated by the upper arch of the head and the waist, the second by the sloping shoulders and the line of the knees, and the third beginning with the curving limit of the paired feet and meeting the bottom of the upper circle at the waist.

For us, these elegant, pure stylizations recall the modern work of sculptors like Brancusi (see FIGS. 32-27, 32-28), but originally their smooth marble surfaces were enlivened by painted motifs in blue, red, and more rarely green paint, emphasizing their surfaces rather than their three-dimensional shapes. Today, evidence of such painting is extremely faint, but many patterns have been recovered using controlled lighting and microscopic investigation. Unlike the forms themselves, the painted features are often asymmetrical in organization. In the example illustrated here, wide-open eyes appear on forehead, cheeks, and thigh, as well as on either side of the nose.

Art historians have proposed a variety of explanations for the meaning of these painted motifs. The angled lines on some figures' bodies could bear witness to the way Cycladic peoples decorated their own bodies—whether permanently with tattoos or scarification, or temporarily with body paint, applied either during their lifetimes or to prepare their bodies for burial. The staring eyes, which seem to demand the viewer's return gaze, may have been a way of connecting these sculpted images to those who owned or used them. And eyes on locations other than faces may aim to draw viewers' attention—perhaps even healing powers—to a particular area of the body. Some have associated eyes on bellies with pregnancy.

Art historian Gail Hoffman has argued that patterns of vertical red lines painted on the faces of some figures (FIG. 4-3) were related to Cycladic rituals of mourning their dead. Perhaps these sculptures were used in relation to a succession of key moments throughout their owners' lifetimes—such as puberty, marriage, and death—and were continually repainted with motifs associated with each ritual, before finally following their owners into their graves at death. Since there is no written evidence from Cycladic culture, and since our knowledge is hindered by the absence of any information on the archaeological contexts of many works, it is difficult to be certain, but these sculptures were clearly important to Bronze Age Cycladic peoples and seem to have taken on meaning in relationship to their use.

Although some Cycladic islands retained their distinctive artistic traditions, by the Middle and Later Bronze Age, the art and culture of the Cyclades as a whole was subsumed by Minoan and, later, Mycenaean culture.

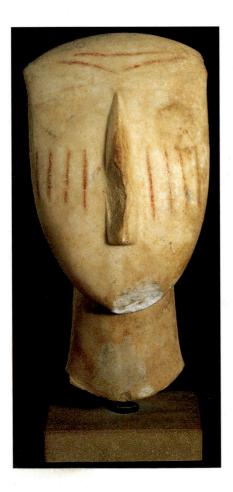

4-3 • HEAD
WITH REMAINS
OF PAINTED
DECORATION
Cyclades. c. 2500–
2200 BCE. Marble and red pigment, height
911/16" (24.6 cm).
National Museum,
Copenhagen. (4697)

THE MINOAN CIVILIZATION ON CRETE

As early as the Neolithic period, there was large-scale migration to and permanent settlement on Crete, the largest of the Aegean islands (155 miles long and 36 miles wide). By the Bronze Age, Crete was economically self-sufficient, producing its own grains, olives and other fruits, cattle, and sheep. With many safe harbors and a convenient location, Crete became a wealthy sea power, trading with mainland Greece, Egypt, the Near East, and Anatolia, thus acquiring the ores necessary for producing bronze.

Between about 1900 BCE and 1375 BCE, a distinctive culture flourished on Crete. The British archaeologist Sir Arthur Evans (see "Pioneers of Aegean Archaeology," opposite) named it Minoan after the legend of Minos, a king who had ruled from the capital, Knossos. According to this legend, a half-man, half-bull monster called the Minotaur—son of the wife of King Minos and a bull belonging to the sea god Poseidon—lived at Knossos in a maze called the Labyrinth. To satisfy the Minotaur's appetite for human flesh, King Minos ordered the mainland kingdom of Athens to send a yearly tribute of 14 young men and women, a practice that ended when the Athenian hero Theseus killed the beast.

Minoan chronology is divided into two main periods, the "Old Palace" period, from about 1900 to 1700 BCE, and the "New Palace" period, from around 1700 to 1450 BCE.

THE OLD PALACE PERIOD, c. 1900-1700 BCE

Minoan civilization remained very much a mystery until 1900 CE, when Sir Arthur Evans began uncovering the buried ruins of the architectural complex at Knossos, on Crete's north coast, that had been occupied in the Neolithic period, then built over with a succession of Bronze Age structures.

ARCHITECTURAL COMPLEXES Like nineteenth-century excavators before him, Evans called these great architectural complexes "palaces." He believed they were occupied by a succession of kings. While some scholars continue to believe that Evans's "palaces" actually were the residences and administrative centers of hereditary rulers, the evidence has suggested to others that Minoan society was not ruled by kings drawn from a royal family, but by a confederation of aristocrats or aristocratic families who established a fluid and evolving power hierarchy. In this light, some scholars interpret these elaborate complexes not primarily as residences, but as sites of periodic religious ceremony or ritual, perhaps enacted by a community that gathered within the courtyards that are their core architectural feature.

The walls of early Minoan buildings were made of rubble and mud bricks faced with cut and finished local stone, our first evidence of **dressed stone** used as a building material in the Aegean. Columns and other interior elements were made of wood. Both in large complexes and in the surrounding towns, timber appears to have been used for framing and bracing walls. Its strength and

RECOVERING THE PAST | Pioneers of Aegean Archaeology

Some see Heinrich Schliemann (1822-1890) as the founder of the modern study of Aegean civilization. Schliemann was the son of an impoverished German minister and a largely self-educated polyglot. He worked hard, grew rich, and retired in 1863 to pursue his lifelong dream of becoming an archaeologist, inspired by the Greek poet Homer's epic tales, the Iliad and the Odyssey. In 1869, he began conducting fieldwork in Greece and Turkey. Scholars of that time considered Homer's stories pure fiction, but by studying the descriptions of geography in the Iliad, Schliemann located a multilayered site at Hissarlik, in present-day Turkey, whose sixth level up from the bedrock is now generally accepted as the closest chronological approximation of Homer's Troy. After his success in Anatolia, Schliemann pursued his hunch that the grave sites of Homer's Greek royal family would be found inside the citadel at Mycenae. But the graves he found were too early to contain the bodies of Atreus, Agamemnon, and their relatives—a fact only established through recent scholarship, after Schliemann's death.

The uncovering of what Schliemann had considered the palace of the legendary King Minos fell to a British archaeologist, Sir Arthur Evans (1851–1941), who led the excavation at Knossos between 1900 and 1905. Evans gave the name Minoan—after legendary King Minos—to Bronze Age culture on Crete. He also made a first attempt to establish an absolute chronology for Minoan art, basing his conjectures on datable Egyptian artifacts found in the ruins on Crete and on Minoan artifacts found in Egypt. Later scholars have revised and refined both his dating and his interpretations of what he found at Knossos.

Evans was not the only pioneering archaeologist drawn to excavate on Crete. Boston-born Harriet Boyd Hawes (1871–1945), after graduating from Smith College in 1892 with a major in Classics and after a subsequent year of post-graduate study in Athens, traveled to Crete to find a site where she could begin a career in archaeology. She was in Knossos in 1900 to observe Evans's early work and was soon supervising her own excavations, first at Kavousi, and then at Gournia, where she directed work from 1901 until 1904. She is famous for the timely and thorough publication of her findings, accomplished while she was not only supervising these Bronze Age digs, but also pursuing her career as a beloved teacher of the liberal arts, first at Smith and later at Wellesley College.

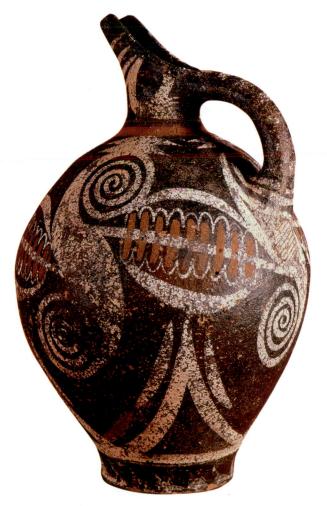

4-4 • KAMARES WARE JUG

From Phaistos, Crete. Old Palace period, c. 2000–1900 BCE. Ceramic, height $10^5\!\%''$ (27 cm). Archaeological Museum, Iraklion, Crete.

flexibility would have minimized damage from the earthquakes common to the area. Nevertheless, an earthquake in c. 1700 BCE severely damaged buildings at several sites, including Knossos and Phaistos.

CERAMIC ARTS During the Old Palace period, Minoans developed elegant new types of ceramics, spurred in part by the introduction of the potter's wheel early in the second millennium BCE. One type is called Kamares ware, after the cave on Mount Ida overlooking the architectural complex at Phaistos, in southern Crete, where it was first discovered. The hallmarks of this select ceramic ware—so sought-after that it was exported as far away as Egypt and Syria—were its extreme thinness, its use of color, and its graceful, stylized, painted decoration. An example from about 2000–1900 BCE has a globular body and a "beaked" pouring spout (FIG. 4-4). Created from brown, red, and creamy white pigments on a black body, the bold, curving forms—derived from plant life—that decorate this jug seem to swell with its bulging contours.

THE NEW PALACE PERIOD, c. 1700-1450 BCE

The early architectural complex at Knossos, erected about 1900 BCE, formed the core of an elaborate new one built after a terrible earthquake shook Crete in c. 1700 BCE. This rebuilding, at Knossos and elsewhere, belonged to the period termed "New Palace" by scholars, many of whom consider it the highest point of Minoan civilization. In its heyday, the Knossos complex covered six acres (FIG. 4–5).

Damaged structures were repaired and enlarged, and the resulting new complexes shared a number of features. Multistoried,

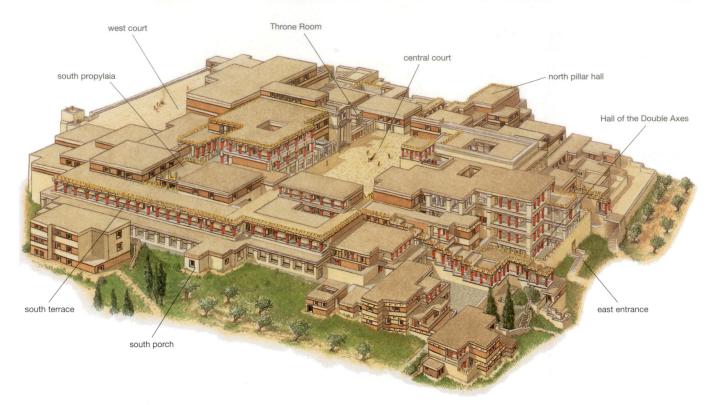

4-5 • RECONSTRUCTION DRAWING OF THE "PALACE" COMPLEX, KNOSSOS, CRETE As it would have appeared during the New Palace period. Site occupied since the Neolithic period; the Minoan complex of the Old Palace period (c. 1900-1700 BCE) was rebuilt during New Palace period (c. 1700-1450 BCE) after earthquakes and fires; final destruction c. 1375 BCE.

flat-roofed, and with many columns, they were designed to maximize light and air, as well as to define access and circulation patterns. Daylight and fresh air entered through staggered levels, open stairwells, and strategically placed air shafts and light-wells (FIG. 4-6).

Large, central courtyards—not audience halls or temples were the most prominent components of these rectangular complexes. Suites of rooms were arranged around them. Corridors and staircases led from the central and subsidiary courtyards, through apartments, ritual areas, and storerooms. Walls were coated with plaster, and some were painted with murals. Floors were plaster, or plaster mixed with pebbles, stone, wood, or beaten earth. The residential quarters had many luxuries: sunlit courtyards or lightwells, richly colored murals, and sophisticated plumbing systems.

Workshops clustered around the complexes formed commercial centers. Storeroom walls were lined with enormous clay jars for oil and wine, and in their floors stone-lined pits from earlier structures had been designed for the storage of grain. The huge scale of the centralized management of foodstuffs became apparent when excavators at Knossos found in a single (although more recent) storeroom enough ceramic jars to hold 20,000 gallons of olive oil.

THE LABYRINTH AT KNOSSOS Because double-axe motifs were used in its architectural decoration, the Knossos "palace" was referred to in later Greek legends as the Labyrinth, meaning the "House of the Double Axes" (Greek labrys, "double axe"). The organization of the complex seemed so complicated that the word labyrinth eventually came to mean "maze" and became part of the Minotaur legend.

This complicated layout provided the complex with its own internal security system: a baffling array of doors leading to unfamiliar rooms, stairs, yet more corridors, or even dead ends. Admittance could be denied by blocking corridors, and some rooms were accessible only from upper terraces. Close analysis, however, shows that the builders had laid out a square grid following predetermined principles, and that the apparently confusing layout may partially be the result of earthquake destruction and rebuilding over the centuries.

In typical Minoan fashion, the rebuilt Knossos complex was organized around a large central courtyard (see FIG. 4-5). A few steps led from the central courtyard down into the so-called Throne Room to the west, and a great staircase on the east side descended to the Hall of the Double Axes, an unusually grand example of a Minoan hall. (Evans gave the rooms their misleading but romantic names.) This hall and others were supported by the uniquely Minoan-type wooden columns that became standard in Aegean palace architecture (see FIG. 4-6). The tree trunks from which the columns were made were inverted so that they tapered toward the bottom. The top, supporting massive roof beams and a broad flattened capital, was wider than the bottom.

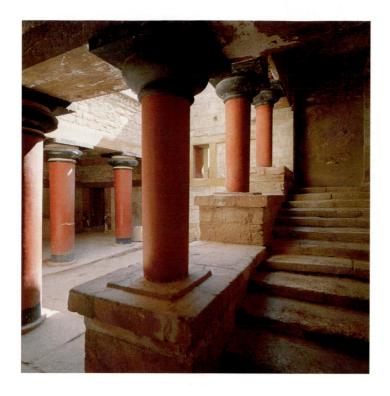

4-6 • EAST WING STAIRWELL "Palace" complex, Knossos, Crete. New Palace period, c. 1700–1450 BCE.

Rooms, following earlier tradition, were arranged around a central space rather than along an axis, as we have seen in Egypt and will see in mainland Greece. During the New Palace period, suites functioned as archives, business centers, and residences. Some must also have had a religious function, though the temples, shrines, and elaborate tombs seen in Egypt are not found in Minoan architecture.

BULL LEAPING AT KNOSSOS Minoan painters worked on a large scale, covering entire walls of rooms with geometric borders, views of nature, and scenes of human activity. Murals can be painted on a still-wet plaster surface (**buon fresco**) or a dry one (**fresco secco**). The wet technique binds pigments to the wall, but forces the painter to work very quickly. On a dry wall, the painter need not hurry, but the pigments tend to flake off over time. Minoans used both techniques.

Minoan wall painting displays elegant drawing, and, like Egyptian painters, Minoan painters filled these linear contours with bright and unshaded fields of pure color. They preferred profile or full-faced views, and they turned natural forms into decorative patterns through stylization. One of the most famous paintings of Knossos depicts one of the most prominent subjects in Minoan art: **BULL LEAPING** (FIG. 4-7). The panel—restored from excavated fragments—is one of a group of paintings with bulls as subjects

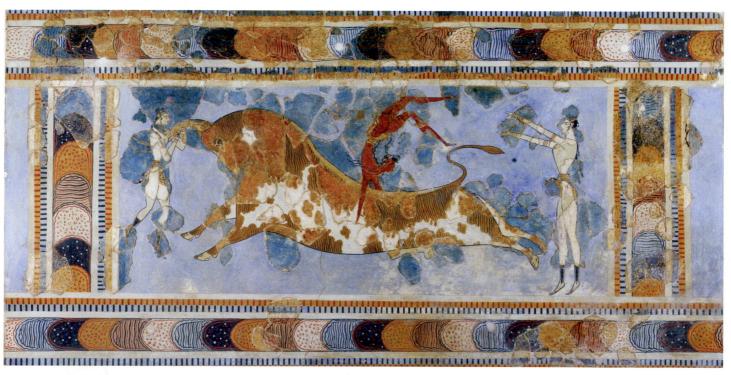

4-7 • BULL LEAPING

Wall painting with areas of modern reconstruction, from the palace complex, Knossos, Crete. Late Minoan period, c. 1450–1375 BCE. Height approx. $24\frac{1}{2}$ " (62.3 cm). Archaeological Museum, Iraklion, Crete.

Careful sifting during excavation preserved many fragments of the paintings that once covered the walls at Knossos. The pieces were painstakingly sorted and cleaned by restorers and reassembled into puzzle pictures; more pieces were missing than found. Areas of color have been used in this reconstruction to fill the gaps, making it obvious which bits are the restored portions, but allowing us to have a sense of the original image.

from a room in the east wing of the complex. The action—perhaps representing an initiation or fertility ritual—shows three scantily clad youths around a gigantic dappled bull, which is charging in the "flying-gallop" pose. The pale-skinned person at the right—her paleness probably identifying her as a woman—is prepared to catch the dark-skinned man in the midst of his leap, and the pale-skinned woman at the left grasps the bull by its horns, perhaps to help steady it, or perhaps preparing to begin her own vault. Framing the action are strips of overlapping shapes, filled with ornament set within striped bands.

STATUETTE OF A MALE FIGURE FROM PALAIKASTRO

Surviving Minoan sculpture consists mainly of small, finely executed work in wood, ivory, precious metals, stone, and ceramic. Faience (colorfully glazed fine ceramic) female figurines holding serpents are among the most characteristic images and may have been associated with water, regenerative power, and protection of the home. But among the most impressive works is an unusually large male figure that has been reconstructed from hundreds of fragments excavated in eastern Crete at Palaikastro between 1987 and 1990 (FIG. 4-8). The blackened state of the remains bears witness to damage in a fire that must have destroyed the building where it was kept since fire damage pervades the archaeological layer in which these fragments were found. The cause or meaning of this fire is a mystery.

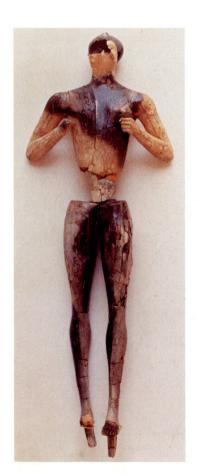

4-8 • STATUETTE OF A MALE FIGURE From Palaikastro, Crete. c. 1500–1475 BCE. Ivory, gold, serpentine, rock crystal, and wood, height 19½" (50 cm). Archaeological Museum, Siteia, Crete.

This statuette is a multimedia work assembled from a variety of mostly precious materials. The majority of the body was carved in exquisite anatomical detail—including renderings of subcutaneous veins, tendons, and bones—from the ivory of two hippopotamus teeth, with a gap in the lower torso for a wooden insert to which was attached a kilt made of gold foil. Miniature gold sandals slipped onto the small, tapering feet. The head was carved of gray serpentine with inset eyes of rock crystal, just as inlaid wooden nipples detail the figure's torso. The ivory and gold may have been imported—perhaps from Egypt—but the style is characteristically Minoan (compare FIG. 4-7). We know very little about the context and virtually nothing about the meaning or use of this figure but the nature of the materials and the large size suggest that it was important. Some have interpreted this as the cult statue of a young god; others have proposed it was a votive effigy for a religious ceremony; but these remain speculations.

STONE RHYTONS Almost certainly of ritual significance are a series of stone **rhytons**—vessels used for pouring liquids—that Minoans carved from steatite (a greenish or brown soapstone) and

4-9 • TWO VIEWS OF THE HARVESTER RHYTONFrom Hagia Triada, Crete. New Palace period, c. 1650–1450 BCE.
Steatite, greatest diameter 4½" (11.3 cm). Archaeological Museum, Iraklion, Crete.

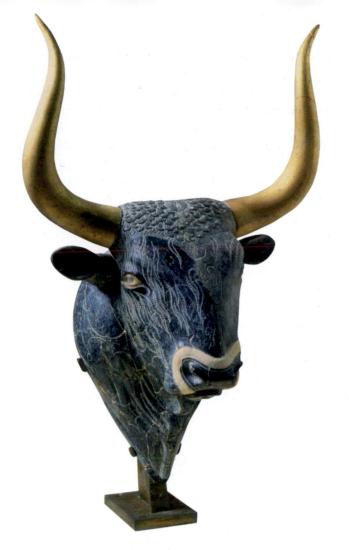

4-10 • BULL'S-HEAD RHYTON

From Knossos, Crete. New Palace period, c. 1550–1450 BCE. Serpentine with shell, rock crystal, and red jasper; the gilt-wood horns are restorations, height 12" (30.5 cm). Archaeological Museum, Iraklion, Crete.

serpentine (usually dull green in color). These have been found in fragments and reconstructed by archaeologists. **THE HAR-VESTER RHYTON** was a cone-shaped vessel (only the upper part is preserved) barely 4½ inches in diameter (**FIG. 4-9**). It may have been covered with gold leaf, sheets of hammered gold (see "Aegean Metalwork," page 90).

A rowdy procession of 27 men has been crowded onto its curving surface. The piece is exceptional for the freedom with which the figures occupy three-dimensional space, overlapping and jostling one another instead of marching in orderly, patterned single file across the surface in the manner of some Near Eastern or Egyptian art. The exuberance of this scene is especially notable in the emotions expressed on the men's faces. They march and chant to the beat of a sistrum—a rattlelike percussion instrument—elevated in the hands of a man whose wide-open mouth seems to signal singing at the top of his lungs. The men have large, bold features and sinewy bodies so trim we can see their ribs. One man stands out from the crowd because of his long hair, scale-covered

ceremonial cloak, and commanding staff. Is he the leader of this enthusiastic band, or is he following along behind them? Archaeologists have proposed a variety of interpretations for the scene—a spring planting or fall harvest festival, a religious procession, a dance, a crowd of warriors, or a gang of forced laborers.

As we have seen, bulls are a recurrent theme in Minoan art, and rhytons were also made in the form of a bull's head (**FIG. 4-10**). The sculptor carved this one from a block of greenish-black serpentine to create an image that approaches animal portraiture. Lightly engraved lines, filled with white powder to make them visible, enliven the animal's coat: short, curly hair on top of the head; longer, shaggy strands on the sides; and circular patterns along the neck suggest its dappled coloring. White bands of shell outline the nostrils, and painted rock crystal and red jasper form the eyes. The horns (here restored) were made of wood covered with gold leaf. This rhyton was filled with liquid through a hole in the bull's neck, and during ritual libations, fluid flowed out from its mouth.

CERAMIC ARTS The ceramic arts, so splendidly realized early on in Kamares ware, continued throughout the New Palace period. Some of the most striking ceramics are characterized as "Marine style," because of the depictions of sea life on their surfaces. In a stoppered bottle of this type known as the **OCTOPUS FLASK**, made about 1500–1450 BCE (**FIG. 4–11**), the painter created a dynamic arrangement of marine life, in

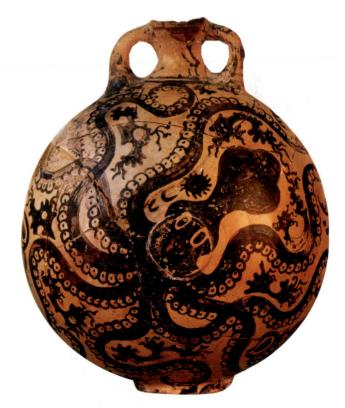

4-11 • OCTOPUS FLASK

From Palaikastro, Crete. New Palace period, c. 1500–1450 BCE. Marine-style ceramic, height 11" (28 cm). Archaeological Museum, Iraklion, Crete.

TECHNIQUE | Aegean Metalwork

Aegean artists created exquisite luxury goods from imported gold. Their techniques included lost-wax casting (see "Lost-Wax Casting," page 418), inlay, filigree, granulation, repoussé, niello, and gilding.

The early Minoan pendant with a pair of gold bees shown here (**FIG. 4–12**) exemplifies early sophistication in **filigree** (delicate decoration with fine wires) and **granulation** (minute granules or balls of precious metal fused to underlying forms), the latter used to enliven the surfaces and to outline or even create three-dimensional shapes.

The Vapheio Cup (see Fig. 4–13) and the funerary mask (see Fig. 4–20) are examples of **repoussé**, in which artists gently pushed up relief forms (perhaps by hammering) from the back of a thin sheet of gold. Experienced goldsmiths may have formed simple designs freehand, or used standard wood forms or punches. For more elaborate decorations they would first have sculpted the entire design in wood or clay and then used this form as a mold for the gold sheet.

The artists who created the Mycenaean dagger blade (see Fig. 4–21) not only inlaid one metal into another, but also employed a special technique called **niello**, still a common method of metal decoration. Powdered nigellum—a black alloy of lead, silver, and copper with sulfur—was rubbed into very fine engraved lines in a silver or gold surface, then fused to the surrounding metal with heat. The resulting lines appear as black drawings.

Gilding—the application of gold to an object made of some other material—was a technically demanding process by which paper-thin sheets of hammered gold called gold leaf (or, if very thin, gold foil) were meticulously affixed to the surface to be gilded. Gold sheets may once have covered the now-bare stone surface of the Harvester Rhyton (see Fig. 4–9) as well as the lost wooden horns of the Bull's-head Rhyton (see Fig. 4–10).

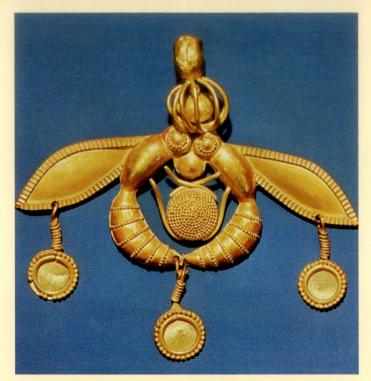

4-12 • PENDANT OF GOLD BEESFrom Chryssolakkos, near Mallia, Crete. Old Palace period, c. 1700–1550 BCE. Gold, height approx. 1¹³/₁₆" (4.6 cm). Archaeological Museum, Iraklion, Crete.

● Watch a video about the process of lost-wax casting on myartslab.com

seeming celebration of Minoan maritime prowess. Like microscopic life teeming in a drop of pond water, sea creatures float around an octopus's tangled tentacles. The decoration on the Kamares ware jug (see FIG. 4–4) had reinforced the solidity of its surface, but here the pottery surface seems to dissolve. The painter captured the grace and energy of natural forms while presenting them as a stylized design in calculated harmony with the vessel's bulging shape.

METALWORK By about 1700 BCE, Aegean metalworkers were producing objects that rivaled those of Near Eastern and Egyptian jewelers, whose techniques they may have learned and adopted. For a pendant in gold found at Chryssolakkos (see "Aegean Metalwork," above), the artist arched a pair of easily recognizable but geometrically stylized bees (or perhaps wasps) around a honeycomb of gold granules, providing their sleek bodies with a single pair of outspread wings. The pendant hangs from a spiderlike filigree form, with what appear to be long legs encircling a tiny gold ball. Small disks dangle from the ends of the wings and the point where the insects' bodies meet.

THE SPREAD OF MINOAN CULTURE

About 1450 BCE, a conquering people from mainland Greece, known as Mycenaeans, arrived in Crete. They occupied the buildings at Knossos and elsewhere until a final catastrophe and the destruction of Knossos about 1375 BCE caused them to abandon the site. But by 1400 BCE, the center of political and cultural power in the Aegean had shifted to mainland Greece.

The skills of Minoan artists, particularly metalsmiths, had made them highly sought after on the mainland. A pair of magnificent gold cups found in a large tomb at Vapheio, on the Greek mainland south of Sparta, were made sometime between 1650 and 1450 BCE, either by Minoan artists or by locals trained in Minoan style and techniques. One side of one cup is shown here (**FIG. 4–13**). The relief designs were executed in repoussé—the technique of pushing up the metal from the back of the sheet. The handles were attached with rivets, and the cup was then lined with sheet gold. In the scenes circling the cups, men are depicted trying to capture bulls in various ways. Here, a scantily clad man has roped a bull's hind leg. The figures dominate the landscape and bulge from the surface with a muscular vitality that belies the cup's

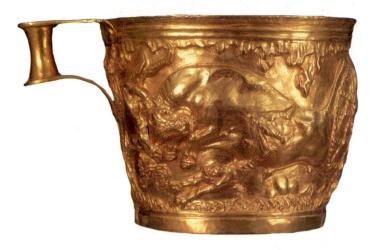

4-13 • VAPHEIO CUP One of two cups found near Sparta, Greece. c. 1650–1450 BCE. Gold, height $4\frac{1}{2}$ " (11.3 cm). National Archaeological Museum, Athens.

small size—it is only 4½ inches tall. The depiction of olive trees could indicate that the scene is set in a sacred grove. Could the cups illustrate exploits in some long-lost heroic tale, or are they commonplace herding scenes?

WALL PAINTING AT AKROTIRI ON THERA Minoan cultural influences seem to have spread to the Cyclades as well as mainland Greece. Thera, for example, was so heavily under Crete's influence in the New Palace period that it was a veritable outpost of Minoan culture. A girl picking crocuses in a fresco in a house at Akrotiri (see FIG. 4-1) wears the typically colorful Minoan flounced skirt with a short-sleeved, open-breasted bodice, large earrings, and bracelets. This wall painting demonstrates the sophisticated decorative sense found in Minoan art, both in color selection and in surface detail. The room in which this painting appears seems to have been dedicated to young women's coming-of-age ceremonies, and its frescos provide the visual context for ritual activity, just like the courtyard of the architectural complexes in Crete.

In another Akrotiri house, an artist has created an imaginative landscape of hills, rocks, and flowers (**FIG. 4-14**), the first pure landscape painting we have encountered in ancient art. A viewer standing in the center of the room is surrounded by orange, rose, and blue rocky hillocks sprouting oversized deep-red lilies. Swallows, sketched by a few deft lines, swoop above and around the flowers. The artist unifies the rhythmic flow of the undulating landscape, the stylized patterning imposed on the natural forms, and the decorative use of bright colors alternating with darker, neutral tones, which were perhaps meant to represent areas of

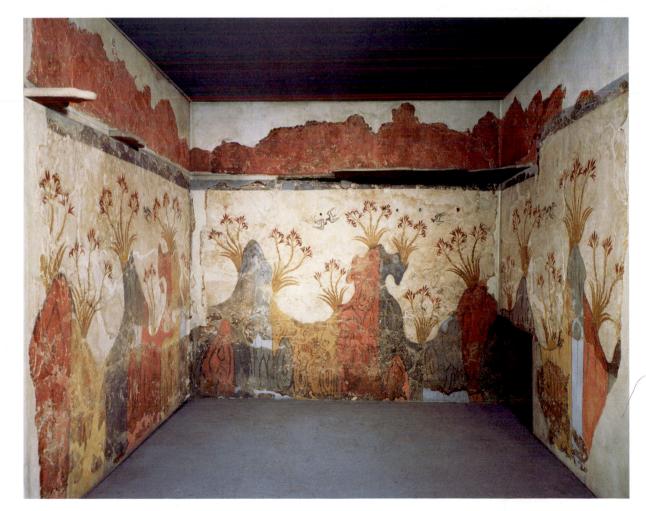

4-14 •
LANDSCAPE
("SPRING
FRESCO")
Wall painting with
areas of modern
reconstruction,
from Akrotiri,
Thera, Cyclades.
Before 1630 BCE.
National
Archaeological
Museum, Athens.

A CLOSER LOOK | The "Flotilla Fresco" from Akrotiri

Detail of the left part of a mural from Room 5 of West House, Akrotiri, Thera.

New Palace period, c. 1650 BCE. Height 145% (44 cm). National Archaeological Museum, Athens.

The depiction of lions chasing deer, perhaps signifying heroism or political power, has a long history in Aegean art. This block of land at the left seems to represent one of two spits of land in Thera that separate the sea from an enclosed area of water within a volcanic caldera at the center of the island. Both the volcanic quality of the painted rocks as well as their division into horizontal registers as bands of color reproduce the actual geological appearance of this terrain.

The arrangement of ships and leaping dolphins in the central part of the mural uses vertical perspective (see Starter Kit, p. xxiii) to indicate recession into depth. In this system, higher placement is given to things that are in the distance, while those placed lower are closer to the viewer.

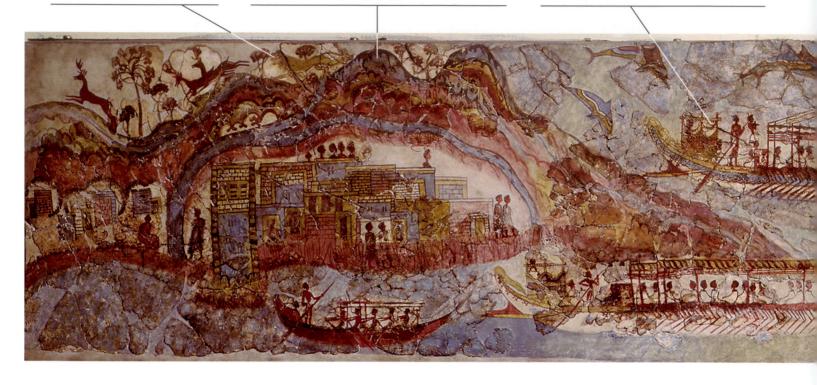

-View the Closer Look for the "Flotilla Fresco" from Akrotiri on myartslab.com

shadow. The colors may seem fanciful to us, but sailors today who know the area well attest to their accuracy, suggesting that these artists recorded the actual colors of Thera's wet rocks in the sunshine, a zestful celebration of the natural world. How different this is from the cool, stable elegance of Egyptian wall painting!

Direct references to the geology of Thera also appear in a long strip of wall painting known as the "Flotilla Fresco" (see "A Closer Look," above) running along the tops of the walls in the room of a house in Akrotiri, a domestic context comparable to that of the fresco of the girl gathering crocuses. This expansive tableau was for years interpreted as a long-distance voyage with a martial flavor, but recently art historian Thomas Strasser has argued convincingly that this is a specific seascape viewed from the eastern interior of the island of Thera itself, looking toward the western opening between two peninsular mountainous landmasses created by a volcanic caldera and at the open sea, populated by festive local ships and the dolphins that leap around them. Rather than serving as the setting for a military expedition, the land and sea of Thera itself may be the principal subject of this painting.

THE MYCENAEAN (HELLADIC) CULTURE

Archaeologists use the term *Helladic* (from *Hellas*, the Greek name for Greece) to designate the Aegean Bronze Age on mainland Greece. The Helladic period extends from about 3000 to 1000 BCE, concurrent with Cycladic and Minoan cultures. In the early part of the Aegean Bronze Age, Greek-speaking peoples, probably from the northwest, moved into the area. They brought with them advanced techniques for metalworking, ceramics, and architectural design, and they displaced the local Neolithic culture. Later in the Aegean Bronze Age, the people of the mainland city of Mycenae rose to power and extended their influence into the Aegean islands as well.

HELLADIC ARCHITECTURE

Mycenaean architecture developed in distinct ways from that of the Minoans. Mycenaeans built fortified strongholds called citadels to protect the palaces of their rulers. These palaces contained a Each of the seven vessels of the fleet on this fresco (only four can be seen in this partial view) is unique, differing in size, decoration (this one has lions painted on its side), and rigging. It has been suggested that this tableau represents a single moment from a nautical festival, perhaps a spring ceremony to kick off a new season of sailing.

Note the difference between the surviving fragments of the original fresco and the modern infill in this restored presentation of a dolphin swimming alongside the ships.

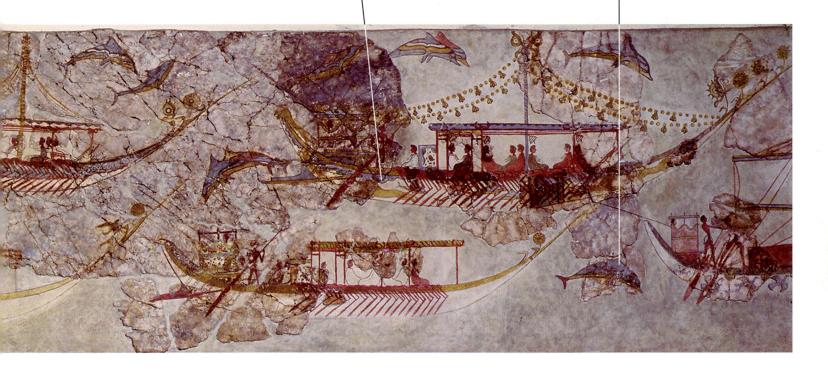

characteristic architectural unit called a **megaron** that was axial in plan, consisting of a large room, entered through a porch with columns, and sometimes a vestibule. The Mycenaeans also buried their dead in magnificent vaulted tombs, round in floor plan and crafted of cut stone.

MYCENAE Later Greek writers called the walled complex of Mycenae (FIGS. 4-15, 4-16) the home of Agamemnon, legendary Greek king and leader of the Greek army that conquered the great city of Troy, as described in Homer's epic poem, the *Iliad*. The site was occupied from the Neolithic period to around 1050 BCE. Even today, the monumental gateway to the citadel at Mycenae is an impressive reminder of the importance of the city. The walls were rebuilt three times—c. 1340 BCE, c. 1250 BCE, and c. 1200 BCE—each time stronger than the last and enclosing more space. The second wall, of c. 1250 BCE, enclosed an earlier grave circle and was pierced by two gates, the monumental "Lion Gate" (see FIG. 4-17) on the west and a smaller secondary, rear gate on the northeast side. The final walls were extended about 1200 BCE

to protect the water supply, an underground cistern. These walls were about 25 feet thick and nearly 30 feet high. Their drywall masonry, using largely unworked boulders, is known as **cyclopean**, because it was believed that only the enormous Cyclops (legendary one-eyed giants) could have moved such massive stones.

As in Near Eastern citadels, the Lion Gate was provided with guardian figures, which stand above the door rather than to the sides in the door jambs. From this gate, the Great Ramp led up the hillside, past the grave circle, to the courtyard for the building occupying the highest point in the center of the city, which may have been the residence of a ruler. From the courtyard one entered a porch, a vestibule, and finally the megaron, which seems to be the intended destination, in contrast to Minoan complexes where the courtyard itself seems to be the destination. The great room of a typical megaron had a central hearth surrounded by four large columns that supported the ceiling. The roof above the hearth was probably raised to admit light and air and permit smoke to escape (see FIGS. 4–18, 4–19). Some architectural historians think that the megaron eventually came to be associated with royalty. The later

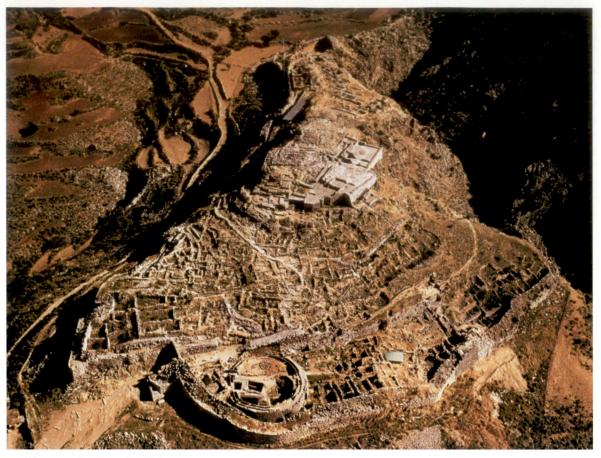

4–15 • CITADEL AT MYCENAEPeloponnese, Greece. Aerial view. Site occupied c. 1600–1200 BCE; walls built c. 1340, 1250, 1200 BCE, creating a progressively larger enclosure.

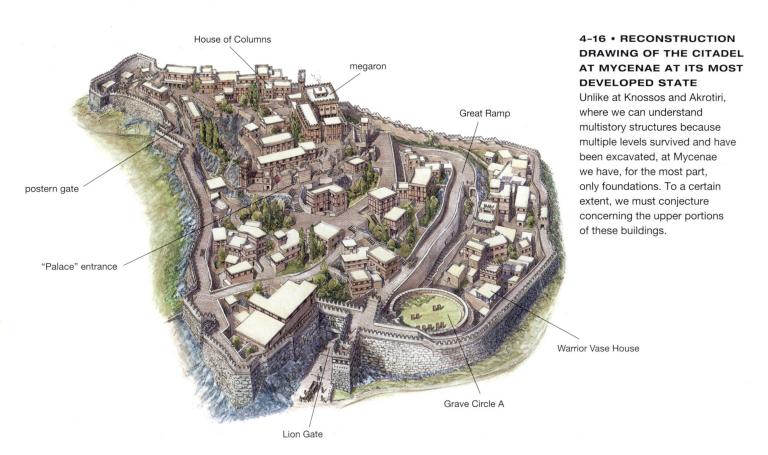

A BROADER LOOK | The Lion Gate

One of the most imposing survivals from the Helladic Age is the gate to the city of Mycenae. The gate is today a simple opening, but its importance is indicated by the very material of the flanking walls, a conglomerate stone that can be polished to glistening multicolors. A corbeled relieving **arch** above the lintel forms a triangle filled with a limestone panel bearing a grand heraldic composition—guardian beasts flanking a single Minoan column that swells upward to a large, bulbous capital.

The archival photograph (**FIG. 4–17**) shows a group posing jauntily outside the gate. Visible is Heinrich Schliemann (standing at the left of the gate) and his wife and partner in archaeology, Sophia (sitting at the right). Schliemann had already "discovered" Troy,

and when he turned his attention to Mycenae in 1876, he unearthed graves containing rich treasures, including gold masks. The grave circle he excavated lay just inside the Lion Gate (see Fig. 4–16).

The Lion Gate has been the subject of much speculation in recent years. What are the animals? What does the architectural feature mean? How is the imagery to be interpreted? The beasts supporting and defending the column are magnificent, supple creatures rearing up on hind legs. Their faces must once have been turned toward the visitor, but today only the attachment holes indicate the presence of their heads.

What were they—lions or lionesses? One scholar points out that since the beasts have

neither teats nor penises, it is impossible to say. The beasts do not even have to be felines. They could have had eagle heads, which would make them griffins, in which case should they not also have wings? They could have had human heads, and that would turn them into sphinxes. Pausanias, a Greek traveler who visited Mycenae in the second century CE, described a gate guarded by lions. Did he see the now-missing heads? And since mixedmedia sculpture-ivory and gold, marble and wood-was common in the ancient Aegean, one could imagine heads created from other materials—perhaps gold. Such heads would have gleamed and glowered out at the visitor. And if the stone sculpture was painted, as most was, the gold would not have seemed out of place.

A metaphor for power, the lions rest their feet on Minoan-style altars. Between them stands the mysterious Minoan column, also on the altar base. Clearly the Mycenaeans are borrowing symbolic vocabulary from Crete. But what does this composition mean? Scholars do not agree. Is it a temple? A palace? The entire city? Or the god of the place? The column and capital support a lintel or architrave, which in turn supports the butt ends of logs forming rafters of the horizontal roof, so the most likely theory is that the structure is the symbol of a palace or a temple. But some scholars suggest that by extension it becomes the symbol of a king or a deity. If so, the imagery of the Lion Gate, with its combination of guardian beasts and divine or royal palace, signifies the legitimate power of the ruler of Mycenae.

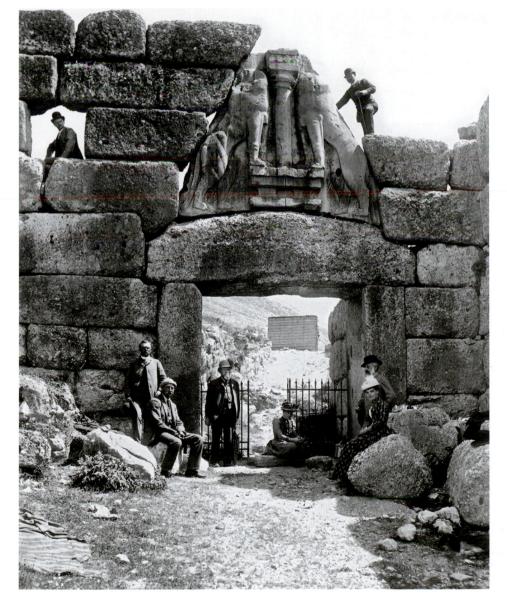

4-17 • LION GATE, MYCENAE

c. 1250 BCE. Historic photo showing Heinrich and Sophia Schliemann.

Greeks adapted its form when building temples, which they saw as earthly palaces for their gods.

PYLOS The rulers of Mycenae fortified their city, but the people of Pylos, in the extreme southwest of the Peloponnese, perhaps felt that their more remote and defensible location made them less vulnerable to attack. This seems not to have been the case, for within a century of its construction in c. 1340 BCE, the palace at Pylos was destroyed by fires, apparently set during the violent upheavals that brought about the collapse of Mycenae itself.

The architectural complex at Pylos was built on a raised site

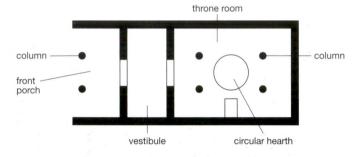

4-18 • PLAN OF THE MEGARON OF THE PYLOS PALACE c. 1300–1200 BCE.

without fortifications, and it was organized around a special area that included an archive, storerooms, workshops, and a megaron (FIG. 4-18) with a formal throne room that may also have been used to host feasting rituals involving elite members of the community. Including a porch and vestibule facing the courtyard, the Pylos megaron was a magnificent display of architectural and decorative skill. The reconstruction in FIGURE 4-19 shows how it might have looked. Every inch was painted—floors, ceilings, beams, and door frames with brightly colored abstract designs, and walls with paintings of large mythical animals and highly stylized plant and landscape forms. Flanking the throne (on the back wall of the reconstruction) are monumental paintings of lions and griffins. A circular hearth sits in the middle, set into a floor finished with plaster painted with imitations of stone and tile patterns. There was a spot in the megaron where priests and priestesses poured libations to a deity from a ceremonial rhyton, fostering communication between the people of Pylos and their god(s).

Clay tablets found in the ruins of the palace include an inventory of its elegant furnishings. The listing on one tablet reads: "One ebony chair with golden back decorated with birds; and a footstool decorated with ivory pomegranates. One ebony chair with ivory back carved with a pair of finials and with a man's figure and heifers; one footstool, ebony inlaid with ivory and pomegranates."

4-19 • RECONSTRUCTION DRAWING OF THE MEGARON (GREAT ROOM) OF THE PYLOS PALACE

c. 1300–1200 BCE. Watercolor by Piet de Jong.

English artist Piet de Jong (1887-1967) began his career as an architect, but his service in the post-World War I reconstruction of Greece inspired him to focus his talents on recording and reconstructing Greek archaeological excavations. In 1922, Arthur Evans called him to work on the reconstructions at Knossos. and Piet de Jong spent the rest of his life creating fanciful but archaeologically informed visions of the original appearance of some of the greatest twentiethcentury discoveries of ancient Greece and the Aegean during a long association with the British School of Archaeology in Athens.

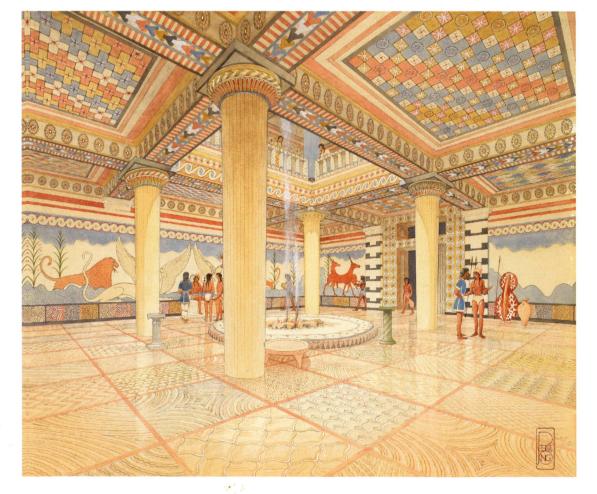

RECOVERING THE PAST | The "Mask of Agamemnon"

One of Heinrich Schliemann's most amazing and famous discoveries in the shaft graves in Mycenae was a solid gold mask placed over the face of a body he claimed was the legendary Agamemnon, uncovered on November 30, 1876. But Schliemann's identification of the mask with this king of Homeric legend has been disproven, and even the authenticity of the mask itself has been called into question over the last 30 years.

Doubts are rooted in a series of stylistic features that separate this mask (Fig. 4–20) from the other four excavated by Schliemann in Grave Circle A—the treatment of the eyes and eyebrows, the cut-out separation of the ears from the flap of gold around the face, and most strikingly the beard and handlebar mustache that have suspicious parallels with nineteenth-century fashion in facial hair. Suspicions founded on such anomalies are reinforced by Schliemann's own history of deceit and embellishment when characterizing his life and discoveries, not to mention his freewheeling excavation practices, when judged against current archaeological standards.

Some specialists have claimed a middle ground between genuine or fake for the mask, suggesting that the artifact itself may be authentic, but that Schliemann quickly subjected it to an overzealous restoration to make the face of "Agamemnon" seem more heroic and noble—at least to viewers in his own day—than the faces of the four other Mycenaean funerary masks. But another scholar has argued that, in fact, this particular mask is not the one Schliemann associated with Agamemnon, undercutting some of the principal arguments for questioning its authenticity in the first place.

The resolution of these questions awaits a full scientific study to determine the nature of the alloy (gold was regularly mixed with small amounts of other metals to make it stronger) from which this mask was made, as well as a microscopic analysis of its technique and the appearance of its surface.

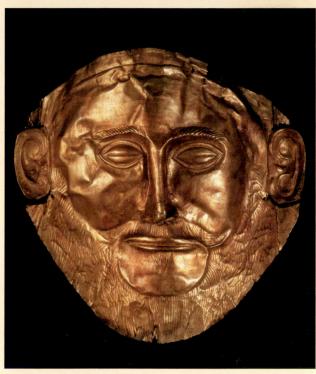

4-20 • "MASK OF AGAMEMNON"
Funerary mask, from Shaft Grave v, Grave Circle A, Mycenae, Greece. c. 1600–1550 BCE. Gold, height approx. 12" (35 cm).
National Archaeological Museum, Athens.

MYCENAEAN TOMBS

SHAFT GRAVES Tombs were given much greater prominence in the Helladic culture of the mainland than they were by the Minoans, and ultimately they became the most architecturally sophisticated monuments of the entire Aegean Bronze Age. The earliest burials were in **shaft graves**, vertical pits 20 to 25 feet deep. In Mycenae, the graves of important people were enclosed in a circle of standing stone slabs. In these graves, the ruling families laid out their dead in opulent dress and jewelry and surrounded them with ceremonial weapons (see Fig. 4–21), gold and silver wares, and other articles indicative of their status, wealth, and power.

Among the 30 pounds of gold objects archaeologist Heinrich Schliemann found in the shaft graves of Mycenae were five funerary masks, and he identified one of these golden treasures as the face of Agamemnon, commander-in-chief of the Greek forces in Homer's account of the Trojan War (see "The Mask of Agamemnon," above). We now know these masks have nothing to do with the heroes of the Trojan War since the Mycenae graves are about 300 years older than Schliemann believed, and the burial practices they display were different from those described by Homer.

Also found in these shaft graves were bronze **DAGGER BLADES** (**FIG. 4-21**) decorated with inlaid scenes, further attesting to the wealth of the bellicose Mycenaean ruling elite. To form the

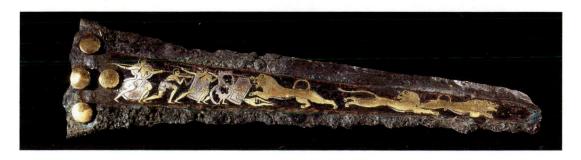

4-21 • DAGGER BLADE WITH LION HUNT
From Shaft Grave iv, Grave
Circle A, Mycenae, Greece.
c. 1550–1500 BCE. Bronze inlaid with gold, silver, and niello, length 9%" (23.8 cm). National Archaeological Museum, Athens.

decoration of daggers like this, Mycenaean artists cut shapes out of different-colored metals (copper, silver, and gold), inlaid them in the bronze blade, and then added fine details in niello (see "Aegean Metalwork," page 90). In Homer's *Iliad*, the poet describes similar decoration on Agamemnon's armor and Achilles' shield. The blade shown here depicts four lunging hunters—Minoan in style—attacking a charging lion who has already downed one of their companions who lies under the lion's front legs. Two other lions retreat in full flight. Like the bull in the Minoan fresco (see FIG. 4–7), these fleeing animals stretch out in the "flying–gallop" pose to indicate speed and energy.

THOLOS TOMBS By about 1600 BCE, members of the elite class on the mainland had begun building large above-ground burial places commonly referred to as **tholos** tombs (popularly known as **beehive tombs** because of their rounded, conical shape). More than 100 such tombs have been found, nine of them in the vicinity of Mycenae. Possibly the most impressive is the so-called **TREASURY OF ATREUS** (FIGS. 4-22, 4-23), which dates from about 1300 to 1200 BCE.

A walled passageway through the earthen mound covering the tomb, about 114 feet long and 20 feet wide and open to the sky, led to the entrance, which was 34 feet high, with a door

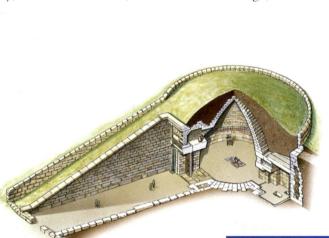

4-22 • CUTAWAY DRAWING OF THOLOS, THE SO-CALLED TREASURY OF ATREUS

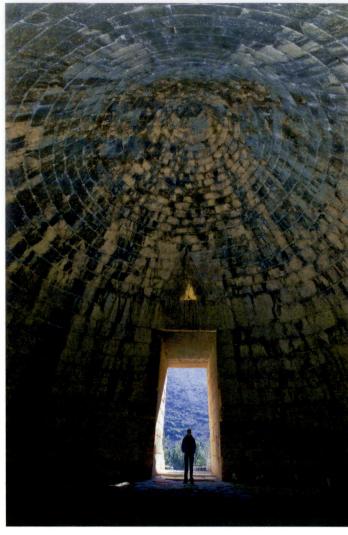

4-24 • CORBEL VAULT, INTERIOR OF THOLOS, THE SO-CALLED TREASURY OF ATREUS Limestone vault, height approx. 43' (13 m), diameter 47'6" (14.48 m).

Watch an architectural simulation of the corbel vault on myartslab.com

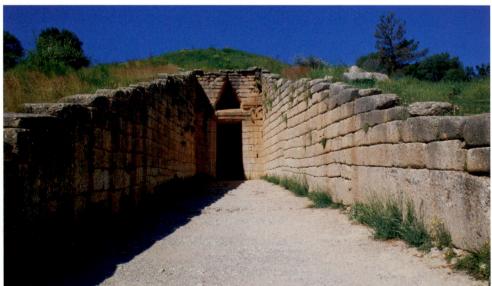

4-23 • EXTERIOR VIEW OF THOLOS, THE SO-CALLED TREASURY OF ATREUS Mycenae, Greece. c. 1300–1200 BCE.

16½ feet high, faced with bronze plaques. On either side of the entrance were columns created from a green stone found near Sparta, and carved with decoration. The section above the lintel had smaller engaged columns on each side, and the relieving triangle was disguised behind a red-and-green engraved marble panel. The main tomb chamber (**FIG. 4-24**) is a circular room 47½ feet in diameter and 43 feet high. It is roofed with a **corbeled vault** built up in regular **courses**, or layers, of **ashlar**—precisely cut blocks of stone—smoothly leaning inward and carefully calculated to meet in a single capstone (topmost stone that joins sides and completes structure) at the peak. Covered with earth, the tomb became a conical hill. It was a remarkable engineering feat.

CERAMIC ARTS

In the final phase of the Helladic Bronze Age, Mycenaean potters created highly refined ceramics. A large **krater**—a bowl for mixing water and wine, used both in feasts and as grave markers—is an example of the technically sophisticated wares being produced on the Greek mainland between 1300 and 1100 BCE. Decorations could be highly stylized, like the scene of marching men on the **WARRIOR KRATER** (**FIG. 4-25**). On the side shown here, a woman at the far left bids farewell to a group of helmeted men marching off to the right, with lances and large shields. The vibrant energy of the Harvester Rhyton or the Vapheio Cup has changed to the regular rhythm inspired by the tramping feet of disciplined warriors. The only indication of the woman's emotions is the gesture of an arm raised to her head, a symbol of mourning. The men are seemingly interchangeable parts in a rigidly disciplined war machine.

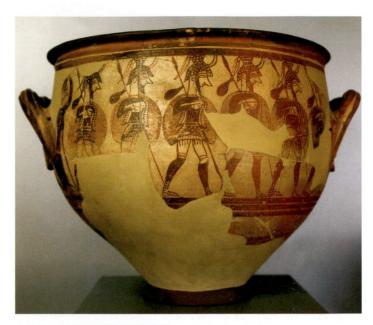

4-25 • WARRIOR KRATERFrom Mycenae, Greece. c. 1300–1100 BCE. Ceramic, height 16" (41 cm). National Archaeological Museum, Athens.

The succeeding centuries, between about 1100 and 900 BCE, were a time of transformation in the Aegean, marked by less political, economic, and artistic complexity and control. A new culture was forming, one that looked back upon the exploits of the Helladic warrior-kings as the glories of a heroic age, while setting the stage for a new Greek civilization.

THINK ABOUT IT

- 4.1 Choose a picture or sculpture of a human figure from two of the ancient Aegean cultures examined in this chapter. Characterize how the artist represents the human form and how that representation could be related to the cultural significance of the works in their original context.
- 4.2 Assess the methods of two archaeologists whose work is discussed in this chapter. How have they recovered, reconstructed, and interpreted the material culture of the Aegean Bronze Age?
- **4.3** What explanations have art historians proposed for the use and cultural significance of the elegant figures of women that have been excavated in the Cyclades?
- 4.4 Compare the plans of the architectural complexes at Knossos and Mycenae. How have the arrangements of the buildings aided archaeologists in speculating on the way in which these complexes were related to their cultural context and ritual or political use?

CROSSCURRENTS

FIG. 3-34

between these two works of ancient painting. Attend to the distinct modes of representing human figures as well as to the ways those figures are related to their surroundings. Is there a possible relationship between the architectural context and the style of presentation?

Discuss the differences in style

FIG. 4-1

Study and review on myartslab.com

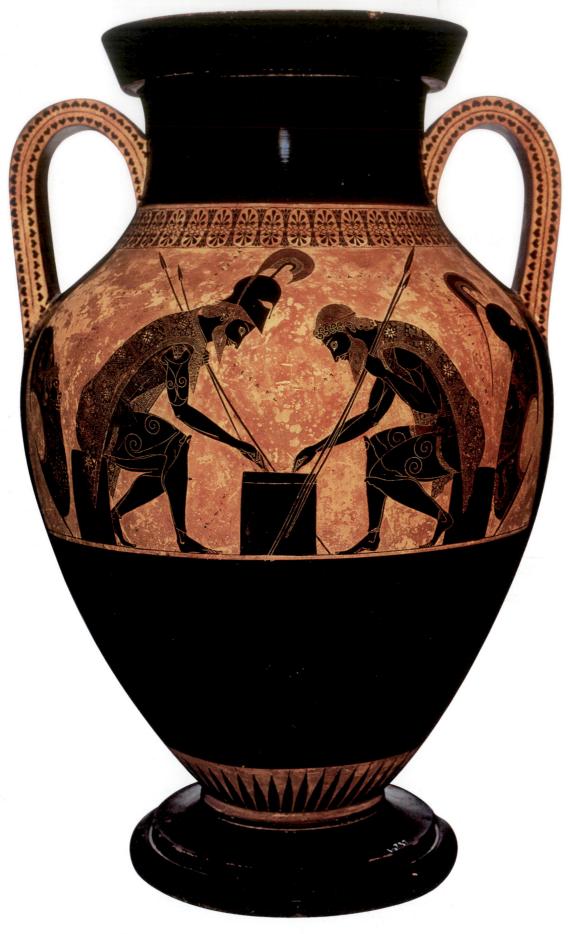

5-1 • Exekias (potter and painter) AJAX AND ACHILLES PLAYING A GAME c. 540–530 BCE. Black-figure painting on a ceramic amphora, height of amphora 2' (61 cm). Vatican Museums, Rome.

Art of Ancient Greece

This elegantly contoured amphora was conceived and created to be more than the all-purpose storage jar signaled by its shape, substance, and size (FIG. 5-1). A strip around the belly of its bulging form was reserved by Exekias—the midsixth-century BCE Athenian artist who signed it proudly as both potter and painter—for the presentation of a narrative episode from the Trojan War, one of the signal stories of the ancient Greeks' mythical conception of their past. Two heroic warriors, Achilles and Ajax, sit across from each other, supporting themselves on their spears as they lean in toward the block between them that serves as a makeshift board for their game of dice. Ajax, to the right, calls out "three" the spoken word written out diagonally on the pot's surface as if issuing from his mouth. Achilles counters with "four," the winning number, his victory presaged by the visual prominence of the boldly silhouetted helmet perched on his head. (Ajax's headgear has been set casually aside on his shield, leaning behind him.) Ancient Greek viewers, however, would have perceived the tragic irony of Achilles' victory. When these two warriors returned from this playful diversion into the serious contest of battle, Achilles would be killed. Soon afterwards, the grieving Ajax would take his own life in despair.

The poignant narrative encounter portrayed on this amphora is also a masterful compositional design. Crisscrossing diagonals and compressed overlapping of spears, bodies, and table describe spatial complexity as well as surface pattern. The varying textures of hair, armor, and clothing are dazzlingly evoked by the alternation between expanses of unarticulated surface and the finely incised lines of dense pattern. Careful contours convey a sense of three-dimensional human form. And the arrangement coordinates with the very shape of the vessel itself, its curving outline matched by the warriors' bending backs, the line of its handles continued in the tilt of the leaning shields.

There is no hint here of gods or kings. Focus rests on the private diversions of heroic warriors as well as on the identity and personal style of the artist who portrayed them. Supremely self-aware and self-confident, the ancient Greeks developed a concept of human supremacy and responsibility that required a new visual expression. Their art was centered in the material world, but it also conformed to strict ideals of beauty and mathematical concepts of design, paralleling the Greek philosophers' search for the human values of truth, virtue, and harmony, qualities that imbue both subject and style in this celebrated work.

LEARN ABOUT IT

- 5.1 Trace the emergence of a distinctive Classical style and approach to art and architecture during the early centuries of Greek civilization and assess the ways Hellenistic sculptors departed from its norms.
- 5.2 Explore the principal themes and subject matter of ancient Greek art, rooted in the lives—both heroic and ordinary—of the people who lived in this time and place as well as the mythological tales that were significant to them.
- **5.3** Explore the nature and meaning of the High Classical style in relation to the historical and cultural situation in Greece during the fifth century BCE.
- **5.4** Understand the differences between and assess the uses of the three orders used in temple architecture.

THE EMERGENCE OF GREEK CIVILIZATION

Ancient Greece was a mountainous land of spectacular natural beauty. Olive trees and grapevines grew on the steep hillsides, producing oil and wine, but there was little good farmland. In towns, skilled artisans produced metal and ceramic wares to trade abroad for grain and raw materials. Greek merchant ships carried pots, olive oil, and bronzes from Athens, Corinth, and Aegina around the Mediterranean Sea, extending the Greek cultural orbit from mainland Greece south to the Peloponnese, north to Macedonia, and east to the Aegean islands and the coast of Asia Minor (MAP 5-1). Greek colonies in Italy, Sicily, and Asia Minor rapidly became powerful independent commercial and cultural centers themselves, but they remained tied to the homeland by common language, heritage, religion, and art.

Within a remarkably brief time, Greek artists developed focused and distinctive ideals of human beauty and architectural design that continue to exert a profound influence today. From about 900 BCE until about 100 BCE, they concentrated on a new, rather narrow range of subjects and produced an impressive body of work with focused stylistic aspirations in a variety of media. Greek artists were restless. They continually sought to change and improve existing artistic trends and fashions, effecting striking stylistic evolution over the course of a few centuries. This is in stark contrast to the situation we discovered in ancient Egypt, where a desire for permanence and continuity maintained stable artistic conventions for nearly 3,000 years.

HISTORICAL BACKGROUND

In the ninth and eighth centuries BCE, long after Mycenaean dominance in the Aegean had come to an end, the Greeks began to form independently governed city-states. Each city-state was an autonomous region with a city—Athens, Corinth, Sparta—as its political, economic, religious, and cultural center. Each had its own form of government and economy, and each managed its own domestic and foreign affairs. The power of these city-states initially depended at least as much on their manufacturing and commercial skills as on their military might.

Among the emerging city-states, Corinth, located on major land and sea trade routes, was one of the oldest and most powerful. By the sixth century BCE, Athens rose to commercial and cultural preeminence. Soon it had also established a representative government in which every community had its own assembly and magistrates. All citizens participated in the assembly and all had an equal right to own private property, to exercise freedom of speech, to vote and hold public office, and to serve in the army or navy. Citizenship, however, was open only to Athenian men. The census of 309 BCE in Athens listed 21,000 citizens, 10,000 foreign residents, and 400,000 others—that is, women, children, and slaves.

RELIGIOUS BELIEFS AND SACRED PLACES

According to ancient Greek legend, the creation of the world involved a battle between the earth gods, called Titans, and the sky gods. The victors were the sky gods, whose home was believed to be atop Mount Olympos in the northeast corner of the Greek mainland. The Greeks saw their gods as immortal and endowed with supernatural powers, but more than peoples of the ancient Near East and the Egyptians, they also visualized them in human form and attributed to them human weaknesses and emotions. Among the most important deities were the supreme god and goddess, Zeus and Hera, and their offspring (see "Greek and Roman Deities," page 104).

Many sites throughout Greece, called **sanctuaries**, were thought to be sacred to one or more gods. The earliest sanctuaries included outdoor altars or shrines and a sacred natural element such as a tree, a rock, or a spring. As more buildings were added, a sanctuary might become a palatial home for the gods, with one or more temples, several treasuries for storing valuable offerings, various monuments and statues, housing for priests and visitors, an outdoor dancefloor or permanent theater for ritual performances and literary competitions, and a stadium for athletic events. The Sanctuary of Zeus near Olympia, in the western Peloponnese, housed an extensive athletic facility with training rooms and arenas for track-and-field events. It was here that athletic competitions, prototypes of today's Olympic Games, were held.

Greek sanctuaries (see FIGS. 5-5, 5-6) are quite different from the religious complexes of the ancient Egyptians (see, for example, the Temple of Amun at Karnak, FIG. 3-18). Egyptian builders dramatized the power of gods or god-rulers by organizing their temples along straight, processional ways. The Greeks, in contrast, treated each building and monument as an independent element to be integrated with the natural features of the site, in an irregular arrangement that emphasized the exterior of each building as a discrete sculptural form on display.

GREEK ART c. 900-c. 600 BCE

Around the mid eleventh century BCE, a new culture began to form on the Greek mainland. Athens began to develop as a major center of ceramic production, creating both sculpture and vessels decorated with organized abstract designs. In this Geometric period, the Greeks, as we now call them, were beginning to create their own architectural forms and were trading actively with their neighbors to the east. By c. 700 BCE, in a phase called the Orientalizing period, they began to incorporate exotic foreign motifs into their native art.

THE GEOMETRIC PERIOD

What we call the Geometric period flourished in Greece between 900 and 700 BCE, especially in the decoration of ceramic vessels with linear motifs, such as spirals, diamonds, and cross-hatching. This abstract vocabulary is strikingly different from the stylized

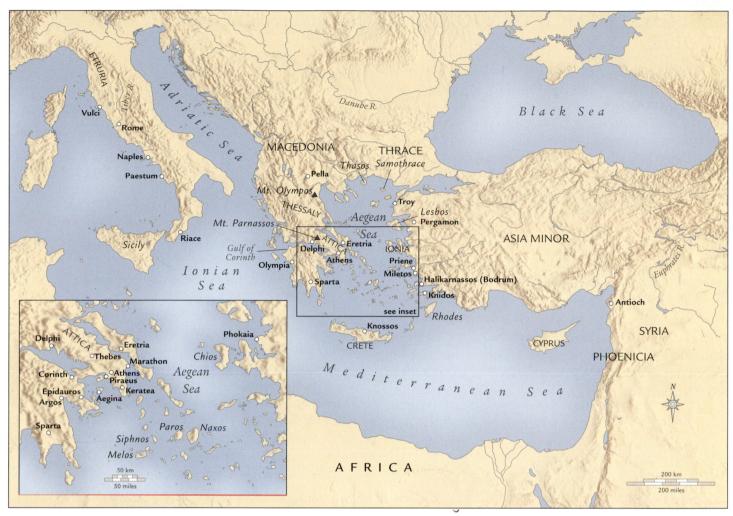

MAP 5-1 • ANCIENT GREECE

The cultural heartland of ancient Greece consisted of the Greek mainland, the islands of the Aegean, and the west coast of Asia Minor, but colonies on the Italic peninsula and the island of Sicily extended Greek cultural influence farther west into the Mediterranean.

plants, birds, and sea creatures that had characterized Minoan pots (see FIGS. 4–4, 4–11).

Large funerary vessels were developed at this time for use as grave markers, many of which have been uncovered at the ancient cemetery of Athens just outside the Dipylon Gate, once the main western entrance into the city. The krater illustrated here (**FIG. 5-2**) seems to provide a detailed pictorial record of funerary rituals associated with the important person whose death is commemorated by this work. On the top register, the body of the deceased

5-2 • Attributed to the Hirschfeld Workshop **FUNERARY KRATER** From the Dipylon Cemetery, Athens. c. 750–735 BCE. Ceramic, height 425/8" (108 cm). Metropolitan Museum of Art, New York. Rogers Fund, 1914. (14.130.14)

View the Closer Look for the funerary krater on myartslab.com

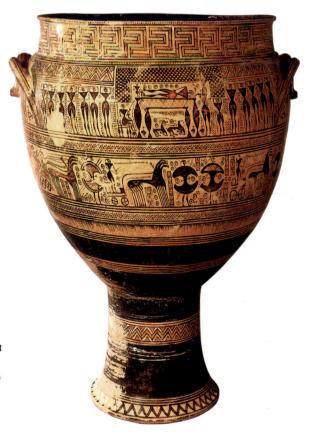

ART AND ITS CONTEXTS | Greek and Roman Deities

(The Roman form of the name is given after the Greek name.)

The Five Children of Earth and Sky

Zeus (Jupiter), supreme Olympian deity. Mature, bearded man, often holding scepter or lightning bolt; sometimes represented as an eagle. **Hera** (Juno), goddess of marriage. Sister/wife of Zeus. Mature woman; cow and peacock are sacred to her.

Hestia (Vesta), goddess of the hearth. Sister of Zeus. Her sacred flame burned in communal hearths.

Poseidon (Neptune), god of the sea. Holds a three-pronged spear (trident). **Hades** (Pluto), god of the underworld, the dead, and wealth.

The Seven Sky Gods, Offspring of the First Five

Ares (Mars), god of war. Son of Zeus and Hera.

Hephaistos (Vulcan), god of the forge, fire, and metal handcrafts. Son of Hera (in some myths, also of Zeus); husband of Aphrodite.

Apollo (Phoebus), god of the sun, light, truth, music, archery, and healing. Sometimes identified with Helios (the Sun), who rides a chariot across the daytime sky. Son of Zeus and Leto (a descendant of Earth); brother of Artemis.

Artemis (Diana), goddess of the hunt, wild animals, and the moon. Sometimes identified with Selene (the Moon), who rides a chariot or oxcart across the night sky. Daughter of Zeus and Leto; sister of Apollo. Carries bow and arrows and is accompanied by hunting dogs.

Athena (Minerva), goddess of wisdom, war, victory, and the city. Also goddess of handcrafts and other artistic skills. Daughter of Zeus; sprang fully grown from his head. Wears helmet and carries shield and spear. **Aphrodite** (Venus), goddess of love. Daughter of Zeus and the water

nymph Dione; alternatively, born of sea foam; wife of Hephaistos.

Hermes (Mercury), messenger of the gods, god of fertility and luck, guide of the dead to the underworld, and god of thieves and commerce. Son of Zeus and Maia, the daughter of Atlas, a Titan who supports the sky on his shoulders. Wears winged sandals and hat; carries caduceus, a wand with two snakes entwined around it.

Other Important Deities

Demeter (Ceres), goddess of grain and agriculture. Daughter of Kronos and Rhea, sister of Zeus and Hera.

Persephone (Proserpina), goddess of fertility and queen of the underworld. Wife of Hades; daughter of Demeter.

Dionysos (Bacchus), god of wine, the grape harvest, and inspiration. His female followers are called **maenads** (Bacchantes).

Eros (Cupid), god of love. In some myths, the son of Aphrodite. Shown as an infant or young boy, sometimes winged, carrying bow and arrows.

Pan (Faunus), protector of shepherds, god of the wilderness and of music. Half-man, half-goat, he carries panpipes.

Nike (Victory), goddess of victory. Often shown winged and flying.

is depicted laying on its side atop a funeral bier, perhaps awaiting the relatively new Greek practice of cremation. Male and female figures stand on each side of the body, their arms raised and both hands placed on top of their heads in a gesture of anguish, as if these mourners were literally tearing their hair out with grief. In the register underneath, horse-drawn chariots and footsoldiers, who look like walking shields with tiny antlike heads and muscular legs, move in solemn procession.

The geometric shapes used to represent human figures on this pot—triangles for torsos; more triangles for the heads in profile; round dots for eyes; long, thin rectangles for arms; tiny waists; and long legs with bulging thigh and calf muscles—are what has given the Geometric style its name. Figures are shown in either full-frontal or full-profile views that emphasize flat patterns and crisp outlines. Any sense of the illusion of three-dimensional forms occupying real space has been avoided. But the artist has captured a deep sense of human loss by exploiting the stylized solemnity and strong rhythmic accents of the carefully arranged elements.

5-3 • MAN AND CENTAUR

Perhaps from Olympia. c. 750 BCE. Bronze, height $4^{5}/_{16}$ " (11.1 cm). Metropolitan Museum of Art, New York. Gift of J. Pierpont Morgan, 1917. (17.190.2072)

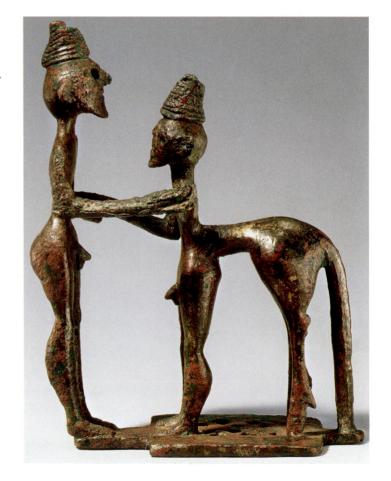

Egyptian funerary art reflected the strong belief that the dead, in the afterworld, could continue to engage in activities they enjoyed while alive. For the Greeks, the deceased entered a place of mystery and obscurity that living humans could not define precisely, and their funerary art, in contrast, focused on the emotional reactions of the survivors. The scene of human mourning on this pot contains no supernatural beings, nor any identifiable reference to an afterlife, only poignant evocations of the sentiments and rituals of those left behind on earth.

Greek artists of the Geometric period also produced figurines of wood, ivory, clay, and cast bronze. These small statues of humans and animals are similar in appearance to those painted on pots. A tiny bronze of this type, depicting a MAN AND CENTAUR—a mythical creature, part man and part horse (FIG. 5-3)—dates to about the same time as the funerary krater. Although there were wise and good centaurs in Greek lore, this work takes up the theme of battling man and centaur, prominent throughout the history of Greek art (see FIG. 5-38). The two figures confront each other after the man—perhaps Herakles—has stabbed the centaur; the spearhead is visible on the centaur's left side. Like the painter of the contemporary funerary krater, the sculptor has distilled the body parts of these figures to elemental geometric shapes, arranging them in a composition of solid forms and open, or negative, spaces that makes the piece interesting from multiple viewpoints. Most such sculptures have been found in sanctuaries, suggesting that they may have served as votive offerings to the gods.

THE ORIENTALIZING PERIOD

By the seventh century BCE, painters in major pottery centers in Greece had moved away from the dense linear decoration of the Geometric style, preferring more open compositions built around large motifs—real and imaginary animals, abstract plant forms, and human figures. The source of these motifs can be traced to the arts of the Near East, Asia Minor, and Egypt. Greek painters did not simply copy the work of Eastern artists, however. Instead, they drew on work in a variety of media—including sculpture, metalwork, and textiles—to invent an entirely new approach to painting vessels.

The Orientalizing style (c. 700–600 BCE) began in Corinth, a port city where luxury wares from the Near East and Egypt inspired artists. The new style is evident in a Corinthian **olpe**, or wide-mouthed pitcher, dating to about 650–625 BCE (**FIG. 5-4**). Silhouetted creatures—lions, panthers, goats, deer, bulls, boars, and swans—stride in horizontal bands against a light background with stylized flower forms called **rosettes** filling the spaces around them. An early example of the **black-figure** technique (see "Black-Figure and Red-Figure," page 118), dark shapes define the silhouettes of the animals against a background of very pale buff, the natural color of the Corinthian clay. The artist incised fine details inside the silhouetted shapes with a sharp tool and added touches of white and red slip to enliven the design.

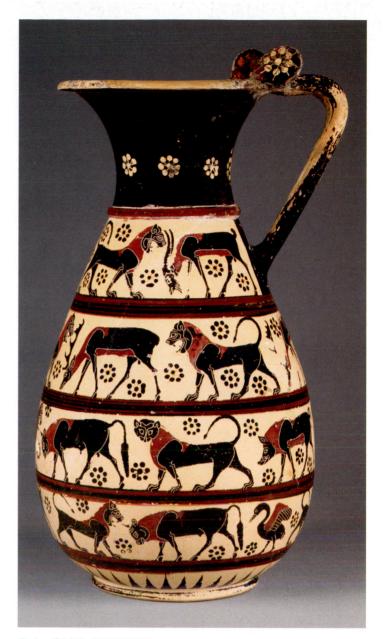

5-4 • OLPE (PITCHER)
Corinth. c. 650–625 BCE. Ceramic with black-figure de

Corinth. c. 650–625 BCE. Ceramic with black-figure decoration, height 12% (32.8 cm). J. Paul Getty Museum, Malibu.

THE ARCHAIC PERIOD, c. 600–480 BCE

The Archaic period does not deserve its name. "Archaic" means "antiquated" or "old-fashioned," even "primitive," and the term was chosen by art historians who wanted to stress what they perceived as a contrast between the undeveloped art of this time and the subsequent Classical period, once thought to be the most admirable and highly developed phase of Greek art. But the Archaic period was a time of great new achievement in Greece. In literature, Sappho wrote her inspired poetry on the island of Lesbos, while on another island the legendary storyteller, Aesop, crafted his animal fables. Artists and architects shared in the growing prosperity

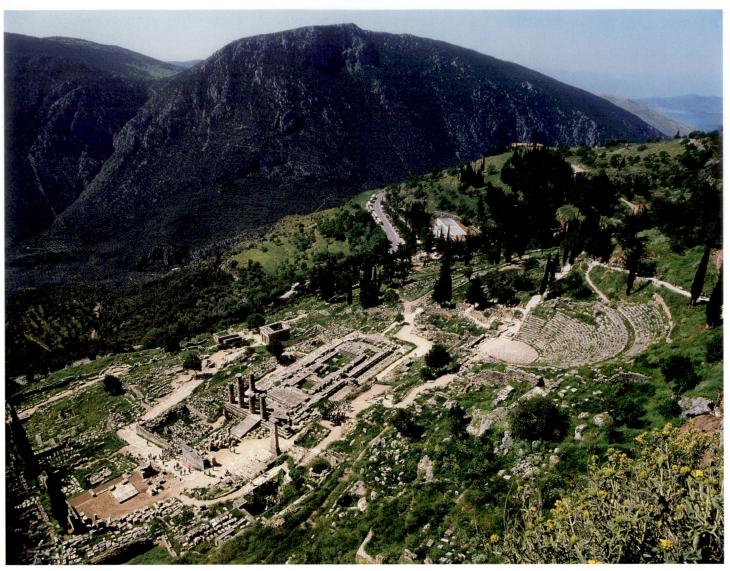

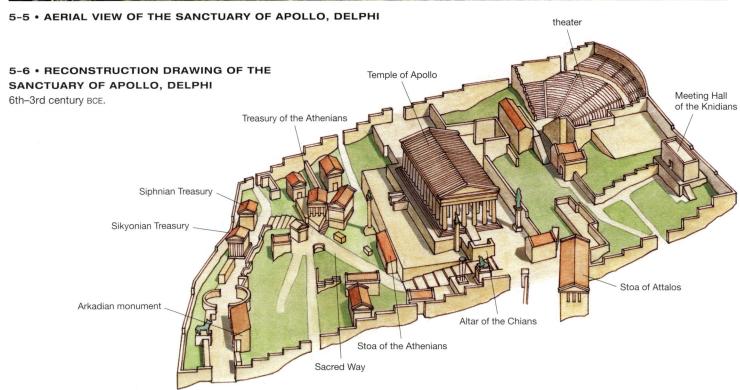

as city councils and wealthy individuals sponsored the creation of extraordinary sculpture and fine ceramics and commissioned elaborate civic and religious buildings in cities and sanctuaries.

THE SANCTUARY AT DELPHI

According to Greek myth, Zeus was said to have released two eagles from opposite ends of the earth and they met exactly at the rugged mountain site of Apollo's sanctuary (FIG. 5-5). From very early times, the sanctuary at Delphi was renowned as an oracle, a place where the god Apollo was believed to communicate with humans by means of cryptic messages delivered through a human intermediary, or medium (the Pythia). The Greeks and their leaders routinely sought advice at oracles, and attributed many twists of fate to misinterpretations of the Pythia's statements. Even foreign rulers journeyed to request help at Delphi.

Delphi was the site of the Pythian Games which, like the Olympian Games, attracted participants from all over Greece. The principal events were the athletic contests and the music, dance, and poetry competitions in honor of Apollo. As at Olympia, hundreds of statues dedicated to the victors of the competitions, as well as mythological figures, filled the sanctuary grounds. The sanctuary of Apollo was significantly developed during the Archaic period and included the main temple, performance and athletic areas, treasuries, and other buildings and monuments, which made full use of limited space on the hillside (**FIG. 5-6**).

After visitors had climbed the steep path up the lower slopes of Mount Parnassos, they entered the sanctuary by a ceremonial gate in the southeast corner. From there they zigzagged up the Sacred Way, so named because it was the route of religious processions during festivals. Moving past the numerous treasuries and memorials built by the city-states, they arrived at the long colonnade of the Temple of Apollo, rebuilt in c. 530 BCE on the site of an earlier temple. Below the temple was a **stoa**, a columned pavilion open on three sides, built by the people of Athens. There visitors rested, talked, or watched ceremonial dancing. At the top of the sanctuary hill was a stadium area for athletic contests.

TREASURY OF THE SIPHNIANS Sanctuaries also included treasuries built by the citizens of Greek city-states to house and protect their offerings. The small but luxurious **TREASURY OF THE SIPHNIANS** (**FIG. 5-7**) was built in the sanctuary of Apollo at Delphi by the residents of the island of Siphnos in the Cyclades, between about 530 and 525 BCE. It survives today only in fragments housed in the museum at Delphi. Instead of columns, the builders used two stately **caryatids**—columns carved in the form of clothed women in finely pleated, flowing garments, raised on **pedestals** and balancing elaborately carved capitals on their heads. The capitals support a tall **entablature** conforming to the **Ionic order**, which features a plain, or three-panel, **architrave** and a continuous carved **frieze**, set off by richly carved moldings (see "The Greek Orders," page 110).

Both the continuous frieze and the **pediments** of the Siphnian Treasury were originally filled with relief sculpture. A surviving section of the frieze from the building's north side, which shows a scene from the legendary **BATTLE BETWEEN THE GODS AND THE GIANTS**, is notable for its complex representation of space (**FIG. 5-8**). To give a sense of three-dimensional recession, the sculptors overlapped the figures—sometimes three deep—varying

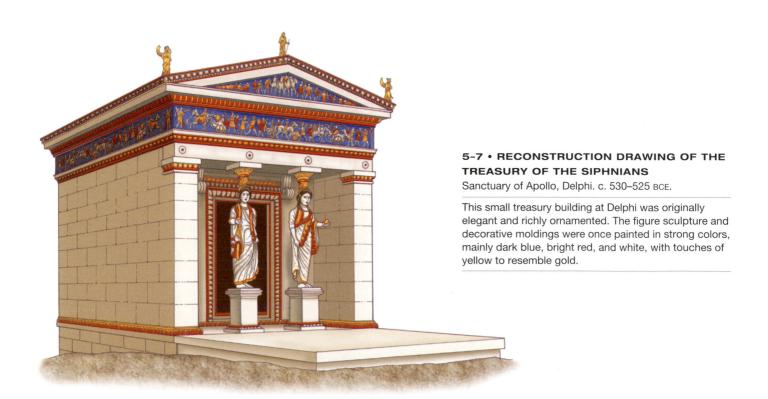

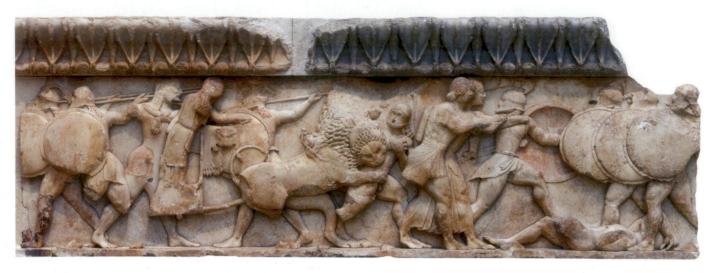

5-8 • BATTLE BETWEEN THE GODS AND THE GIANTS

Fragments of the north frieze of the Treasury of the Siphnians, Sanctuary of Apollo, Delphi. c. 530–525 BCE. Marble, height 26" (66 cm). Archaeological Museum, Delphi.

the depth of the relief to allow viewers to grasp their placement within space. Originally such sculptures were painted with bright color to enhance the lifelike effect.

TEMPLES

For centuries ancient Greeks had worshiped at sanctuaries where an outdoor altar stood within an enclosed sacred area called a **temenos** reserved for worship. Sometimes temples sheltering a statue of a god were incorporated into these sanctuaries, often later additions to an established sanctuary. A number of standardized temple plans evolved, ranging from simple, one-room structures with columned **porches** (covered, open space in front of an entrance) to buildings with double porches (front and back), surrounded entirely by columns. Builders also experimented with the design of temple **elevations**—the arrangement, proportions, and appearance of the columns and the lintels, which now grew into elaborate entablatures. Two elevation designs emerged during the Archaic period: the **Doric order** and the Ionic order. The **Corinthian order**, a variant of the Ionic order, would develop later (see "The Greek Orders," page 110).

A particularly well-preserved Archaic Doric temple, built around 550 BCE, still stands at the former Greek colony of Poseidonia (Roman Paestum) about 50 miles south of the modern city of Naples, Italy (FIG. 5-9). Dedicated to Hera, the wife of Zeus, it is known today as Hera I to distinguish it from a second, adjacent temple to Hera built about a century later. A row of columns called the peristyle surrounded the main room, the cella. The columns of Hera I are especially robust—only about four times as high as their maximum diameter—and topped with a widely flaring capital and a broad, blocky abacus, creating an impression of great stability and permanence. As the column shafts rise, they

swell in the middle and contract again toward the top, a refinement known as **entasis**, giving them a sense of energy and lift. Hera I has an uneven number of columns—nine—across the short ends of the peristyle, with a column instead of a space at the center of the two ends. The entrance to the **pronaos** (enclosed vestibule) has three columns in antis (between flanking wall piers), and a row of columns runs down the center of the wide cella to help support the ceiling and roof. The unusual two-aisle, two-door arrangement leading to the small room at the end of the cella proper suggests that the temple had two presiding deities: either Hera and Poseidon (patron of the city), or Hera and Zeus, or perhaps Hera in her two manifestations (as warrior and protector of the city and as mother and protector of children).

THE TEMPLE OF APHAIA ON AEGINA A fully developed and somewhat sleeker Doric temple—part of a sanctuary dedicated to a local goddess named Aphaia-was built on the island of Aegina during the first quarter of the fifth century BCE (FIG. 5-10). Spectacularly sited on a hill overlooking the sea, the temple is reasonably well preserved, in spite of the loss of pediments, roof, and sections of its colonnade. Enough evidence remains to form a reliable reconstruction of its original appearance (FIG. 5-11). The plan combines six columns on the façades with 12 on the sides, and the cella—whose roof was supported by superimposed colonnades—could be entered from porches on both short sides. The slight swelling of the columns (entasis) seen at Poseidonia is evident here as well, and the outside triglyphs are pushed to the ends of frieze, out of alignment with the column underneath them, to avoid the awkwardness of half a metope (rectangular panel with a relief or painting) at the corner.

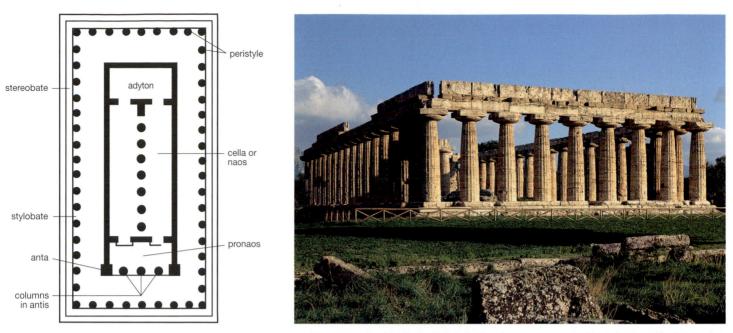

5-9 • PLAN (A) AND EXTERIOR VIEW (B) OF THE TEMPLE OF HERA I, POSEIDONIA (ROMAN PAESTUM) Southern Italy. c. 550–540 BCE.

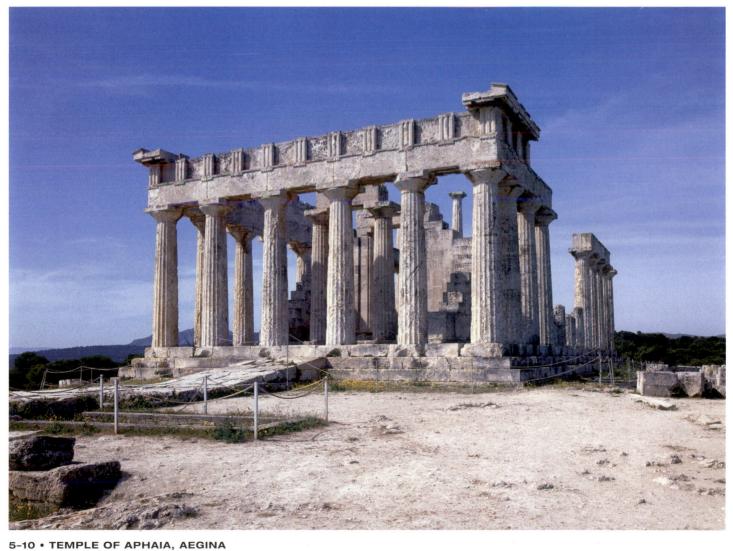

View from the east. c. 500 or c. 475 BCE. Column height about 17' (5.18 m).

ELEMENTS OF ARCHITECTURE | The Greek Orders

Each of the three Classical Greek architectural **orders**—Doric, lonic, and Corinthian—constitutes a system of interdependent parts whose proportions are based on mathematical ratios. No element of an order could be changed without producing a corresponding change in other elements.

The basic components are the **column** and the entablature, which function as post and lintel in the structural system. All three types of columns have a **shaft** and a **capital**; lonic and Corinthian also have a base. The shafts are formed of stacked round sections, or **drums**, which are joined inside by metal pegs. In Greek temple architecture, columns stand on the **stylobate**, the "floor" of the temple, which rests on top of a set of steps that form the temple's base, known as the **stereobate**.

In the Doric order, shafts sit directly on the stylobate, without a base. They are **fluted**, or channeled, with sharp edges. The height of the substantial columns ranges from five-and-a-half to seven times the diameter of the base. A necking at the top of the shaft provides a

transition to the capital itself, composed of the rounded **echinus**, and the tabletlike abacus. The entablature includes the architrave, the distinctive frieze of alternating **triglyphs** and **metopes**, and the **cornice**, the topmost, projecting horizontal element. The roofline may have decorative waterspouts and terminal decorative elements called **acroteria**.

The lonic order has more elongated proportions than the Doric, the height of a column being about nine times the diameter of its base. The flutes on the columns are deeper and are separated by flat surfaces called **fillets**. The capital has a distinctive spiral scrolled **volute**; the entablature has a three-panel architrave, continuous sculptured or decorated frieze, and richer decorative moldings.

The Corinthian order, a variant of the lonic order originally developed by the Greeks for use in interiors, was eventually used on temple exteriors as well. Its elaborate capitals are sheathed with stylized acanthus leaves that rise from a convex band called the astragal.

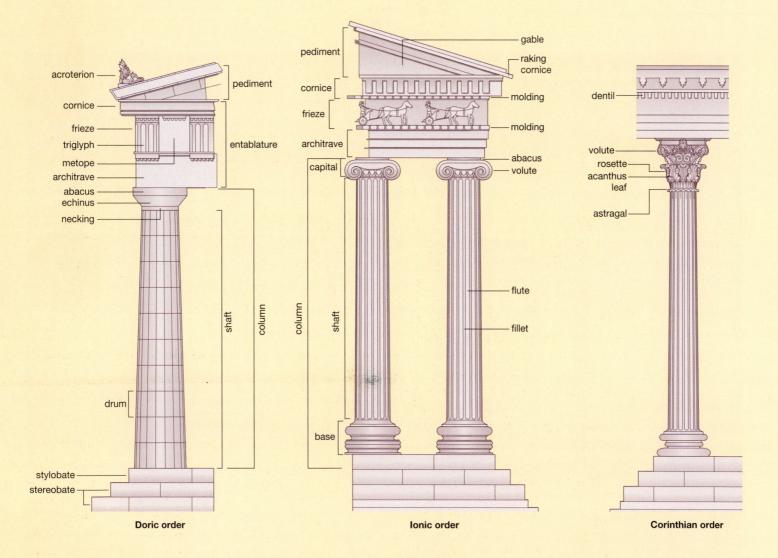

● Watch an architectural simulation about the Greek orders on myartslab.com

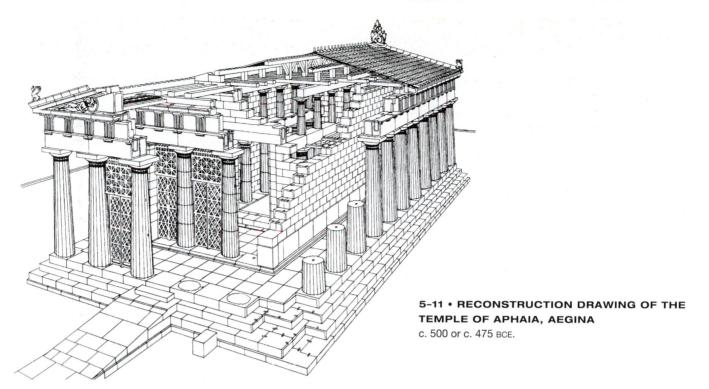

Like most Greek temples, this building was neither isolated nor situated in open space, but set in relation to an outside altar where religious ceremonies were focused. By enclosing the temple within a walled precinct or temenos, the designer could control the viewer's initial experience of the temple. As the viewer entered the sacred space through a gatehouse—the propylon—the temple would be seen at an oblique angle (FIG. 5-12). Unlike ancient Egyptian temples, where long processional approaches led visitors directly to the flat entrance façade of a building (see FIGS. 3-18, 3-22), the Greek architect revealed from the outset the full shape of a closed, compact, sculptural mass, inviting viewers not to enter seeking something within, but rather to walk around the exterior, exploring the rich sculptural embellishment on pediments and frieze. Cult ceremonies, after all, took place outside the temples.

Modern viewers, however, will not find exterior sculpture at Aegina. Nothing remains from the metopes, and substantial surviving portions of the two pediments were purchased in the early nineteenth century by the future Ludwig I of Bavaria and are now exhibited in Munich. The triangular pediments in Greek temples created challenging compositional problems for sculptors intent on fitting figures into the tapering spaces at the outside corners, since the scale of figures could not change, only their poses. The west pediment from Aegina (FIG. 5-13)—traditionally dated about 500-490 BCE, before its eastern counterpart—represents a creative solution that became a design standard, appearing with variations throughout the fifth century BCE. The subject of the pediment, rendered in fully three-dimensional figures, is the participation of local warriors in the military expedition against Troy. Fallen warriors fill the angles at both ends of the pediment base, while others crouch and lunge, rising in height toward an image of Athena as warrior goddess-who can fill the elevated pointed space at the center

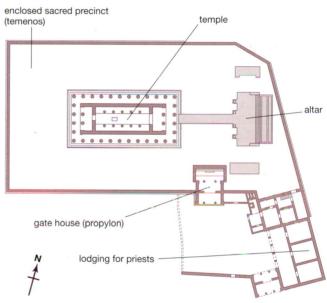

5-12 • PLAN OF COMPLEX OF THE TEMPLE OF APHAIA, AEGINA

c. 500 or c. 475 BCE.

peak since she is allowed to be represented larger (hierarchic scale) than the humans who flank her.

Among the best-preserved fragments from the west pediment is the **DYING WARRIOR** from the far right corner (**FIG. 5-14**). This tragic but noble figure struggles to rise up, supported on bent leg and elbow, in order to extract an arrow from his chest, even though his death seems certain. This figure originally would have been painted and fitted with authentic bronze accessories, heightening the sense of reality (see "Color in Greek Sculpture," page 113).

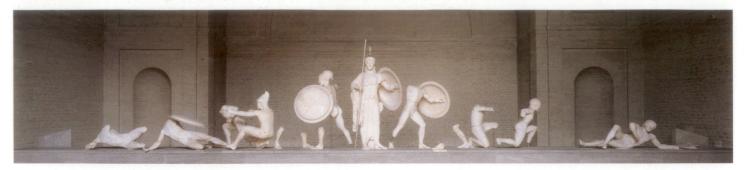

5-13 • WEST PEDIMENT OF THE TEMPLE OF APHAIA, AEGINA

c. 500-490 or 470s BCE. Width about 49' (15 m). Surviving fragments as assembled in the Staatliche Antikensammlungen und Glyptothek, Munich (early restorations removed).

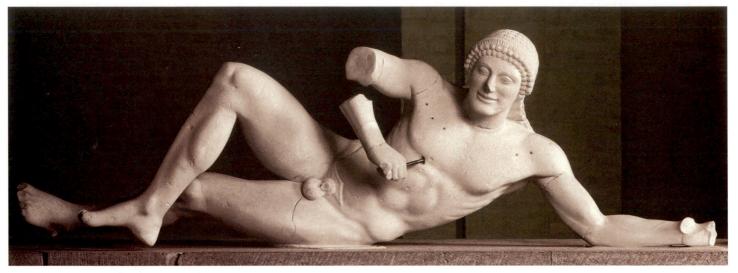

5-14 • DYING WARRIOR

From the right corner of the west pediment of the Temple of Aphaia, Aegina. c. 500–490 or 470s BCE. Marble, length 5'6" (1.68 m). Staatliche Antikensammlungen und Glyptothek, Munich.

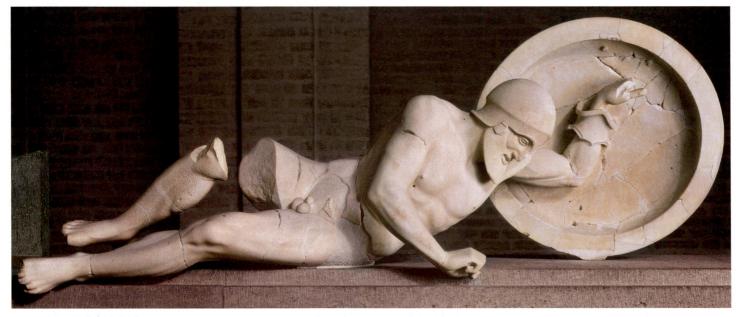

5-15 • DYING WARRIOR

From the left corner of the east pediment of the Temple of Aphaia, Aegina. c. 490–480 or 470s BCE. Marble, length 6' (1.83 m). Staatliche Antikensammlungen und Glyptothek, Munich.

TECHNIQUE | Color in Greek Sculpture

For many modern viewers, it comes as a real surprise, even a shock, that the stone sculptures of ancient Greece did not always have stark white, pure marble surfaces, comparable in appearance to-and consistent in taste with—the more recent, but still classicizing sculptures of Michelangelo or Canova (see Figs. 21-10 and 30-14). But they were originally painted with brilliant colors. A close examination of Greek sculpture and architecture has long revealed evidence of polychromy, even to the unaided eye, but our understanding of the original appearance of these works has been greatly enhanced recently. Since the 1980s, German scholar Vinzenz Brinkmann has used extensive visual and scientific analysis to evaluate the traces of painting that remain on ancient Greek sculpture, employing tools such as ultraviolet and x-ray fluorescence, microscopy, and pigment analysis. Based on this research, he and his colleague Ulrike Koch-Brinkmann have fashioned reconstructions that allow us to imagine the exuberant effect these works would have had when they were new.

Illustrated here is their painted reconstruction of a kneeling archer from about 500 (or during the 470s) BCE that once formed part of the west pediment of the Temple of Aphaia at Aegina (FIGS. 5-16, 5-17). To begin with they have replaced features of the sculpture—ringlet hair extensions, a bow, a quiver, and arrows-probably made of bronze or lead and attached to the stone after it was carved, using the holes still evident in the current state of the figure's hip and head. Most stunning, however, is the diamond-shaped patterns that were painted on his leggings and sleeves, using pigments derived from malachite, azurite, arsenic, cinnabar and charcoal. And the surfaces of such figures were not simply colored in. Artists created a sophisticated integration of three-dimensional form, color, and design. The patterning applied to this archer's leggings actually changes in size and shape in relation to the body beneath it, stretching out on expansive thighs and constricting on tapering ankles. Ancient authors indicate that sculpture was painted to make figures more lifelike, and these recent reconstructions certainly back them up.

5-16 • Vinzenz Brinkmann and Ulrike Koch-Brinkmann RECONSTRUCTION OF ARCHER

From the west pediment of the Temple of Aphaia, Aegina. 2004 ce. Staatliche Antikensammlungen und Glyptothek, Munich.

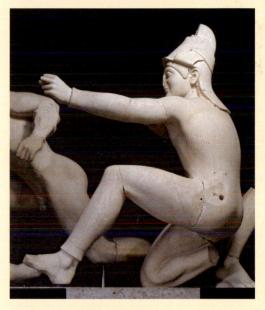

5-17 • ARCHER ("PARIS")

From the west pediment of the Temple of Aphaia, Aegina. c. 500–490 or 470s BCE. Marble. Staatliche Antikensammlungen und Glyptothek, Munich.

A similar figure appeared on the east pediment (FIG. 5-15), traditionally seen as postdating the west pediment by a decade or so. The sculptor of this dying warrior also exploited the difficult framework of the pediment corner, only here, instead of an uplifted frontal form in profile, we see a twisted body capable of turning in space. The figure is more precariously balanced on his shield, clearly about to collapse. There is an increased sense of softness in the portrayal of human flesh and a greater sophistication in tailoring bodily posture not only to the tapering shape of the pediment, but also to the expression of the warrior's own emotional

involvement in the agony and vulnerability of his predicament, which in turn inspires a sense of pathos or empathy in the viewer.

For decades, art historians have taught that over the course of a decade, two successive sets of sculptures on Aegina allow us to trace the transition from Archaic toward Early Classical art. Very recently, however, Andrew Stewart has reviewed the archaeological evidence on the Athenian Akropolis and Aegina and reached a very different conclusion. He questions the traditional dating of key works from the transition between Archaic and Early Classical art—notably the Aegina pediment sculpture and the Kritios Boy

(see FIG. 5–26)—placing them after the Persian invasion of 580–579 BCE, and raising the question of whether Greek victory over this outside enemy might have been a factor in the stylistic change. In the case of the Aegina temple, this re-dating becomes especially interesting. Instead of assuming that the difference in style between the western and eastern pediments represents a time gap separating their production, Stewart proposes that both ensembles were produced concurrently during the 470s by two workshops, one conservative and one progressive.

FREE-STANDING SCULPTURE

In addition to statues designed for temple exteriors, sculptors of the Archaic period created a new type of large, free-standing statue made of wood, **terra cotta** (clay fired over low heat, sometimes unglazed), limestone, or white marble from the islands of Paros and Naxos. These free-standing figures were brightly painted and sometimes bore inscriptions indicating that individual men or women had commissioned them for a commemorative purpose. They have been found marking graves and in sanctuaries, where they lined the sacred way from the entrance to the main temple.

A female statue of this type is called a **kore** (plural, *koraî*), Greek for "young woman," and a male statue is called a **kouros** (plural, *kouroi*), Greek for "young man." Archaic *korai*, always clothed, probably represented deities, priestesses, and nymphs (young female immortals who served as attendants to gods). *Kouroi*, nearly always nude, have been variously identified as gods, warriors, and victorious athletes. Because the Greeks associated young, athletic males with fertility and family continuity, the *kouroi* figures may have symbolized ancestors.

METROPOLITAN KOUROS A kouros dated about 600 BCE (FIG. 5-18) recalls the pose and proportions of Egyptian sculpture. As with Egyptian figures such as the statue of Menkaure (see FIG. 3-9), this young Greek stands rigidly upright, arms at his sides, fists clenched, and one leg slightly in front of the other. However, the Greek artist has cut away all stone from around the body to make the human form free-standing. Archaic kouroi are also much less lifelike than their Egyptian forebears. Anatomy is delineated with linear ridges and grooves that form regular, symmetrical patterns. The head is ovoid and schematized, and the wiglike hair evenly knotted into tufts and tied back with a narrow ribbon. The eyes are relatively large and wide open, and the mouth forms a conventional closed-lip expression known as the Archaic smile. In Egyptian sculpture, male figures usually wore clothing associated with their status, such as the headdresses, necklaces, and kilts that identified them as kings. The total nudity of the Greek kouroi is unusual in ancient Mediterranean cultures, but it is acceptable even valued—in the case of young men. Not so with women.

5-18 • METROPOLITAN KOUROS

Attica, Greece. c. 600-590 BCE. Marble, height 6'4%'' (1.95 m). Metropolitan Museum of Art, New York. Fletcher Fund, 1932. (32.11.1)

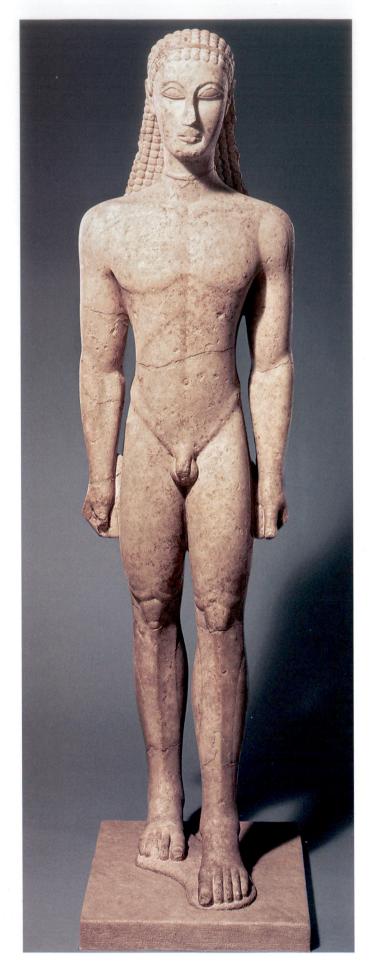

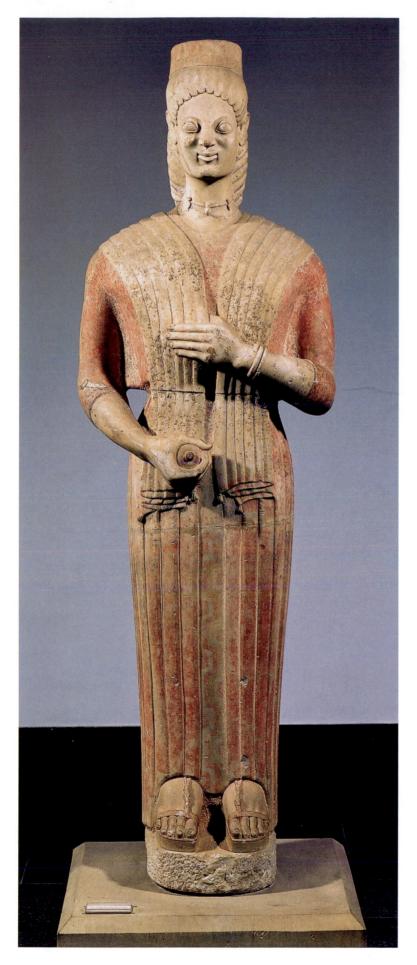

BERLIN KORE Early Archaic korai are as severe and stylized as the male figures. The BERLIN KORE, a funerary statue found in a cemetery at Keratea and dated about 570–560 BCE, stands more than 6 feet tall (FIG. 5–19). The erect, full-bodied figure takes an immobile pose—accentuated by a bulky crown and thick-soled clogs. The thick robe and tasseled cloak over her shoulders fall in regularly spaced, symmetrically disposed, parallel folds like the fluting on a Greek column. This drapery masks her body but mimics its curving contours. Traces of red—perhaps the red clay used to make thin sheets of gold adhere—indicate that the robe was once painted or gilded. The figure holds a pomegranate in her right hand, a symbol of Persephone, who was abducted by Hades, the god of the underworld, and whose annual return brought the springtime.

ANAVYSOS KOUROS The powerful, rounded, athletic body of a *kouros* from Anavysos, dated about 530 BCE, documents the increasing interest of artists and their patrons in a more lifelike rendering of the human figure (FIG. 5-20). The pose, wiglike hair, and Archaic smile echo the earlier style, but the massive torso and limbs have carefully rendered, bulging muscularity, suggesting heroic strength. The statue, a grave monument to a fallen war hero, has been associated with a base inscribed: "Stop and grieve at the tomb of the dead Kroisos, slain by wild Ares [god of war] in the front rank of battle." However, there is no evidence that the figure was meant to preserve the likeness of Kroisos or anyone else. He is a symbolic type, not a specific individual.

"PEPLOS" KORE The kore in **FIGURE 5-21** is dated about the same time as the Anavysos Kouros, though she is a votive rather than a funerary statue. Like the *kouros*, she has rounded body forms, but unlike him, she is clothed. She has the same motionless, vertical pose of the Berlin Kore (see FIG. 5-19), but her bare arms and head convey a sense of soft flesh covering a real bone structure, and her smile and hair are considerably less stylized. The original painted colors on both body and clothing must have made her seem even more lifelike, and she also once wore a metal crown and jewelry.

The name we use for this figure is based on an assessment of her clothing as a young girl's peplos—a draped rectangle of cloth pinned at the shoulders and belted to give a bloused effect—but it has recently been argued that this *kore* is actually not wearing a peplos but a sheathlike garment,

5-19 • BERLIN KORE

From the cemetery at Keratea, near Athens. c. 570–560 BCE. Marble with remnants of red paint, height 6'3" (1.9 m). Staatliche Museen zu Berlin, Antikensammlung, Preussischer Kulturbesitz, Berlin.

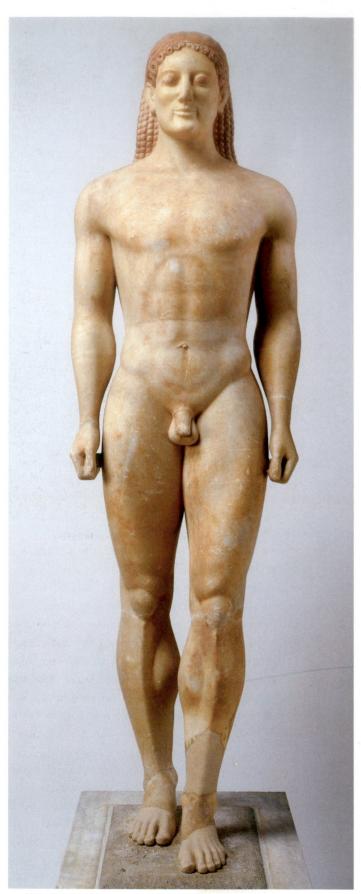

5-20 • ANAVYSOS KOUROSFrom the cemetery at Anavysos, near Athens. c. 530 BCE. Marble with remnants of paint, height 6'4" (1.93 m). National Archaeological Museum, Athens.

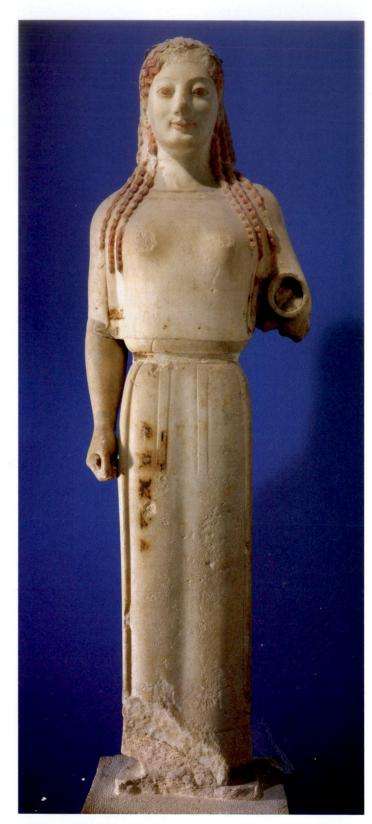

5–21 • "PEPLOS" KORE From the Akropolis, Athens. c. 530 BCE. Marble, height 4^\prime (1.21 m). Akropolis Museum, Athens.

originally painted with a frieze of animals, identifying her not as a young girl but a goddess, perhaps Athena or Artemis. Her missing left forearm—which was made of a separate piece of marble fitted into the still-visible socket—would have extended forward horizontally, and may have held an attribute that provided the key to her identity.

PAINTED POTS

Greek potters created beautiful vessels whose standardized shapes were tailored to specific utilitarian functions (FIG. 5-22). Occasionally, these potters actually signed their work, as did the artists who painted scenes on the pots. Greek ceramic painters became highly accomplished at accommodating their pictures to the often awkward fields on utilitarian shapes, and they usually showcased not isolated figures but scenes of human interaction evoking a story.

BLACK-FIGURE VESSELS During the Archaic period, Athens became the dominant center for pottery manufacture and trade in Greece, and Athenian painters adopted Corinthian black-figure techniques (see FIG. 5–4), which became the principal mode of decoration throughout Greece in the sixth century BCE. At first, Athenian vase painters retained the horizontal banded composition that was characteristic of the Geometric period. Over time, however, they decreased the number of bands and increased the size of figures until a single narrative scene dominates each side of the vessel.

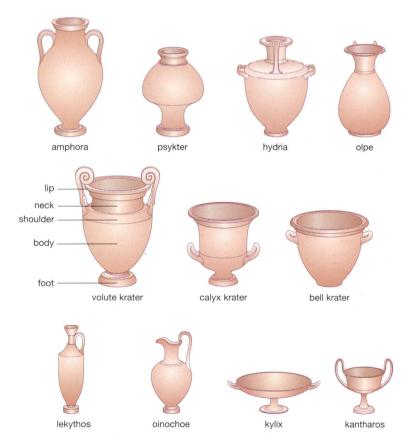

5-22 • SOME STANDARD SHAPES OF GREEK VESSELS

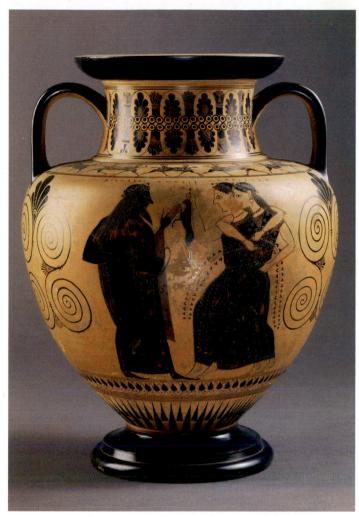

5-23 • Amasis Painter DIONYSOS WITH MAENADS
 c. 540 BCE. Black-figure decoration on an amphora. Ceramic, height of amphora 13" (33.3 cm). Bibliothèque Nationale, Paris.

THE AMASIS PAINTER A mid-sixth-century BCE amphora—a large, all-purpose storage jar—with bands of decoration above and below a central figural composition illustrates this development (**FIG. 5-23**). The painting on this amphora has been attributed to an artist we call the Amasis Painter, since this distinctive style was first recognized on vessels signed by a prolific potter named Amasis.

Two maenads (female worshipers of the wine god Dionysos), intertwined with arms around each other's shoulders, skip forward to present their offerings—a long-eared rabbit and a small deer—to the god. (Amasis signed his work just above the rabbit.) The maenad holding the deer wears the skin of a spotted panther (or leopard), its head still attached, draped over her shoulders and secured with a belt at her waist. The god, an imposing, richly dressed figure, clasps a large **kantharos** (wine cup). This encounter between humans and a god appears to be a joyful, celebratory occasion rather than one of reverence or fear. The Amasis Painter favored strong shapes and patterns over conventions for making figures appear to occupy real space. He emphasized fine details, such as the large, delicate petal and spiral designs below

TECHNIQUE | Black-Figure and Red-Figure

The two predominant techniques for painting on Greek ceramic vessels were black-figure (Fig. 5–24) and red-figure (Fig. 5–25). Both involved applying slip (a mixture of clay and water) to the surface of a pot and carefully manipulating the firing process in a kiln (a closed oven) to control the amount of oxygen reaching the ceramics. This firing process involved three stages. In the first stage, oxygen was allowed into the kiln, which "fixed" the whole vessel in one overall shade of red depending on the composition of the clay. Then, in the second (reduction) stage, the oxygen in the kiln was cut back (reduced) to a minimum, turning the vessel black, and the temperature was raised to the point at which the slip partially vitrified (became glasslike). Finally, in the third stage, oxygen was allowed back into the kiln, turning the unslipped areas back to a shade of red. The areas where slip had been applied, however, were sealed against the oxygen and remained black.

In the black-figure technique, artists silhouetted the forms—figures, objects, or abstract motifs—with slip against the unpainted clay of the background. Then, using a sharp tool (a stylus), they cut through the slip to the body of the vessel, **incising** linear details within the silhouetted.

background. Then, using a sharp tool (a stylus), they cut through the stothe body of the vessel, incising linear details within the silhouetted

5-24 • Lysippides Painter HERAKLES DRIVING A BULL TO SACRIFICE

c. 525–520 BCE. Black-figure decoration on an amphora. Ceramic, height of amphora $20^{15}/_{16}$ " (53.2 cm). Museum of Fine Arts, Boston. Henry Lillie Pierce Fund (99.538)

shape by revealing the unpainted clay underneath. The characteristic color contrast only appeared in firing. Sometimes touches of white and reddish-purple gloss—made of metallic pigments mixed with slip—enhanced the decorative effect.

In the red-figure technique, the approach was reversed. Artists painted not the shapes of the forms themselves but the background around forms (negative space), reserving unpainted areas for silhouetted forms. Instead of engraving details, painters drew on the reserved areas with a fine brush dipped in liquid slip. The result was a lustrous black vessel with light-colored figures delineated in fluid black lines.

The contrasting effects obtained by these two techniques are illustrated here in details of two sides of a single amphora of about 525 BCE, both portraying the same figural composition, one painted by an artist using black-figure, and the other painted by an innovative proponent of red-figure technique. The sharp precision and flattened decorative richness characterizing black-figure contrasts strikingly here with the increased fluidity and greater sense of three-dimensionality facilitated by the development of the red-figure technique.

5-25 • Andokides Painter HERAKLES DRIVING A BULL TO SACRIFICE

c. 525–520 BCE. Red-figure decoration on an amphora. Ceramic, height of amphora $20^{15}\!/_6"$ (53.2 cm). Museum of Fine Arts, Boston. Henry Lillie Pierce Fund (99.538)

each handle, the figures' meticulously arranged hair, and the bold patterns on their clothing.

EXEKIAS Perhaps the most famous of all Athenian black-figure painters, Exekias, signed many of his vessels as both potter and painter. He took his subjects from Greek mythology, which he and his patrons probably considered to be history. On the body of

an amphora we have already seen at the beginning of this chapter, he portrayed Trojan War heroes Ajax and Achilles in a rare moment of relaxation playing dice (see FIG. 5–1). This is an episode not included in any literary source, but for Greeks familiar with the story, this anecdotal portrayal of friendly play would have been a poignant reminder that before the end of the war, the heroes would be parted by death, Achilles in battle and Ajax by suicide.

A CLOSER LOOK | The Death of Sarpedon

by Euphronios (painter) and Euxitheos (potter).
c. 515 BCE. Red-figure decoration on a calyx krater. Ceramic, height of krater 18" (45.7 cm).
Museo Nazionale di Villa Giulia, Rome.

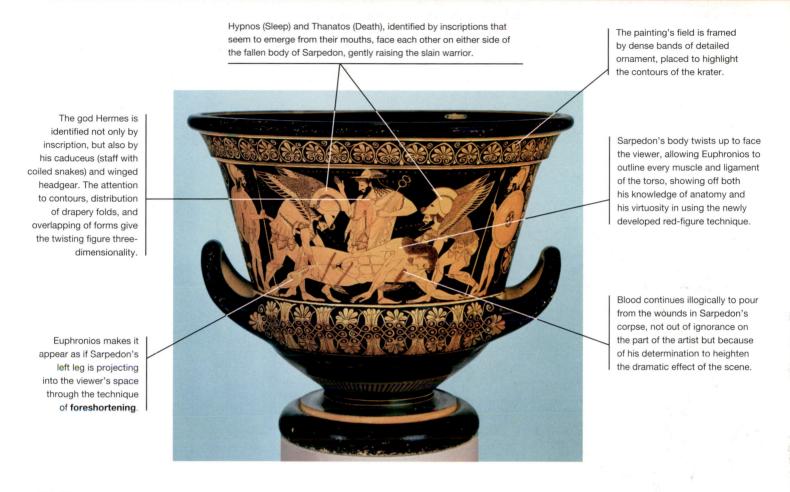

View the Closer Look for the krater showing the death of Sarpedon on myartslab.com

Knowing the story was critical to engaging with such paintings, and artists often included identifying labels beside the characters to guide viewers to the narrative source so they could delight in the painters' rich renderings of familiar narrative situations.

RED-FIGURE VESSELS In the last third of the sixth century BCE, while many painters were still creating handsome blackfigure wares, some turned away from this meticulous process to a new, more fluid technique called **red-figure** (see "Black-Figure and Red-Figure," opposite). In this mode of decoration, red figures stand out against a black background, the opposite of blackfigure painting. The greater freedom and flexibility that resulted from painting rather than engraving details led ceramic painters to adopt the red-figure technique widely in a relatively short time. It allowed them to create livelier human figures with a more developed sense of bodily form—qualities that were increasingly demanded of Greek artists in several media.

EUPHRONIOS One of the best-known red-figure artists was Euphronios. His rendering of the death of Sarpedon, about 515 BCE (see "A Closer Look," above), is painted on a krater—called a **calyx krater** because its handles curve up like a flower's calyx. Such a vessel was used as a punchbowl during a **symposium**, a social gathering of rich and powerful men. According to Homer's *Iliad*, Sarpedon, a son of Zeus and a mortal woman, was killed by the Greek warrior Patroclus while fighting for the Trojans. Euphronios captures the scene in which the warrior is being carried off to the underworld, the land of the dead.

Euphronios has created a balanced composition of verticals and horizontals that take the shape of the vessel into account. The bands of decoration above and below the scene echo the long horizontal of the dead fighter's body, which seems to levitate in the gentle grasp of its bearers, and the inward-curving lines of the handles mirror the arching backs and extended wings of Hypnos (Sleep) and Thanatos (Death). The upright figures of the

ART AND ITS CONTEXTS | Classic and Classical

Our words "classic" and "classical" come from the Latin word *classis*, referring to the division of people into classes based on wealth. "Classic" has come to mean "first class" or "the standard of excellence." Greek artists in the fifth century BCE sought to create ideal images based on strict mathematical proportions, which we call "Classical." Since Roman artists were inspired by the Greeks, "Classical" often refers to the

cultures of ancient Greece and Rome. By extension, the word may also mean "in the style of ancient Greece and Rome," whenever or wherever that style is used. In the most general usage, a "classic" is something—perhaps a literary work, an automobile, a film, even a soft drink—thought to be of lasting quality and universal esteem.

lance-bearers on each side and Hermes in the center counterbalance the horizontal and diagonal elements of the composition. While conveying a sense of the mass and energy of human subjects, Euphronios also portrayed the elaborate details of their clothing, musculature, and facial features with the fine tip of a brush. And he created the impression of real space around the figures by gently foreshortening Sarpedon's left leg that appears to be coming toward the viewer's own space. Such formal features, as well as a palpable sense of pathos in the face of Sarpedon's fate, seem to connect Euphronios' work with the dying warriors of the pediments from Aegina (see FIGS. 5-14, 5-15).

THE EARLY CLASSICAL PERIOD, c. 480–450 BCE

Over the brief span of 160 years, between c. 480 and 323 BCE, the Greeks established an ideal of beauty that has endured in the Western world to this day. Scholars have associated Greek Classical art with three general concepts: humanism, rationalism, and idealism (see "Classic and Classical," above). The ancient Greeks believed the words of their philosophers and followed these injunctions in their art: "Man is the measure of all things," that is, seek an ideal based on the human form; "Know thyself," seek the inner significance of forms; and "Nothing in excess," reproduce only essential forms. In their embrace of humanism, the Greeks even imagined their gods as perfect human beings. But the Greeks valued human reason over human emotion. They saw all aspects of life, including the arts, as having meaning and pattern. Nothing happens by accident. It is not surprising that great Greek artists and architects were not only practitioners but theoreticians as well. In the fifth century BCE, the sculptor Polykleitos (see "'The Canon' of Polykleitos," page 134) and the architect Iktinos both wrote books on the theory underlying their practice.

Art historians usually divide the Classical into three phases, based on the formal qualities of the art: the Early Classical period (c. 480–450 BCE); the High Classical period (c. 450–400 BCE); and the Late Classical period (c. 400–323 BCE). The Early Classical period begins with the defeat of the Persians in 480–479 BCE by an alliance of city-states led by Athens and Sparta. The expanding Persian Empire had posed a formidable threat to the independence

of the city-states, and the two sides had been locked in battle for decades until the Greek alliance was able to repulse a Persian invasion and score a decisive victory. Some scholars have argued that their success against the Persians gave the Greeks a self-confidence that accelerated artistic development, inspiring artists to seek new and more effective ways to express their cities' accomplishments. In any case, the period that followed the Persian Wars, extending to about 450 BCE, saw the emergence of a new stylistic direction, away from elegant stylizations and toward a sense of greater faithfulness to the natural appearance of human beings and their world.

MARBLE SCULPTURE

In the remarkably short time of only a few generations, Greek sculptors had moved far from the stiff bearing and rigid frontality of the Archaic kouroi to more relaxed poses in lifelike figures such as the so-called KRITIOS BOY of about 480 BCE (FIG. 5-26). The softly rounded body forms, broad facial features, and calm expression give the figure an air of self-confident seriousness. His weight rests on his left, engaged leg, while his right, relaxed leg bends slightly at the knee, and a noticeable curve in his spine counters the slight shifting of his hips and a subtle drop of one of his shoulders. We see here the beginnings of contrapposto, the convention (later developed in full by High Classical sculptors such as Polykleitos) of presenting standing figures with opposing alternations of tension and relaxation around a central axis that will dominate Classical art. The slight turn of the head invites the spectator to follow his gaze and move around the figure, admiring the small marble statue from every angle.

BRONZE SCULPTURE

The development of the technique of hollow-casting bronze in the lost-wax process gave Greek sculptors the potential to create more complex action poses with outstretched arms and legs. These were very difficult to create in marble, since unbalanced figures might topple over and extended appendages might break off due to their pendulous weight. Bronze figures were easier to balance, and the metal's greater tensile strength made complicated poses and gestures technically possible.

The painted underside of an Athenian **kylix** (broad, flat drinking cup) portrays work in a late Archaic foundry for casting life-size

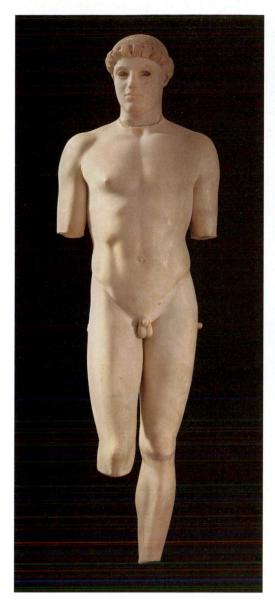

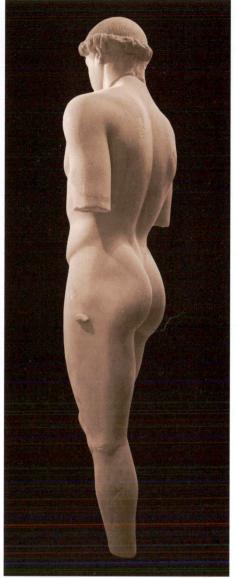

5-26 • KRITIOS BOY
From the Akropolis, Athens. c. 475 BCE.
Marble, height 3'10" (1.17 m). Akropolis
Museum, Athens.

The damaged figure, excavated from the debris on the Athenian Akropolis, was thought by its finders to be by the Greek sculptor Kritios, whose work they knew only from Roman copies.

figures (FIG. 5-27), providing clear evidence that the Greeks were creating large bronze statues in active poses as early as the first decades of the fifth century BCE. The walls of the workshop are filled with hanging tools and other foundry paraphernalia including several sketches—a horse, human heads, and human figures in different poses. One worker, wearing what looks like a modern-day construction helmet, squats to tend the furnace on the left, perhaps aided by an assistant who peeks from behind. The man in the center, possibly the supervisor, leans on a staff, while a third worker assembles a leaping figure that is braced against a molded support. The unattached head lies between his feet.

5-27 • Foundry Painter
A BRONZE FOUNDRY
490-480 BCE. Red-figure
decoration on a kylix
from Vulci, Italy. Ceramic,
diameter of kylix 12" (31 cm).
Staatliche Museen zu Berlin,
Preussischer Kulturbesitz,
Antikensammlung.

The Foundry Painter has masterfully organized this workshop scene within the flaring space that extends upward from the foot of the vessel and along its curving underside to the lip, thereby using a circle as the groundline for his composition.

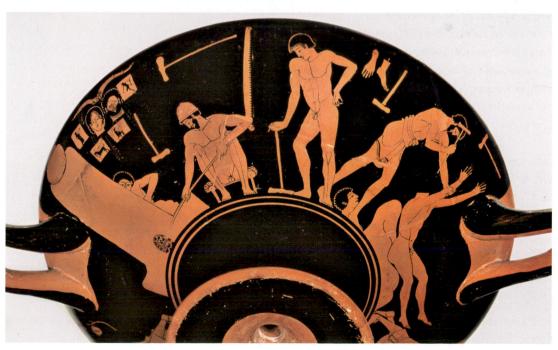

THE CHARIOTEER A spectacular and rare life-size bronze, the CHARIOTEER (FIG. 5-28), cast about 470 BCE, documents the skills of Early Classical bronze-casters. It was found in the sanctuary of Apollo at Delphi, together with fragments of a bronze chariot and horses, all buried during an earth-quake in 373 BCE that may have saved them from the fate of most ancient bronzes, which were melted down so the material could be recycled and made into a new work. According to its inscription, the sculptural group commemorated a victory in the Pythian Games of 478 or 474 BCE, though it was the team of horses and the owner—not the charioteer—who were being celebrated.

The face of this handsome youth is highly idealized, but there is a lifelike quality to the way his head turns slightly to one side, and the glittering, onyx eyes and fine copper eyelashes enhance his intense, focused expression. He stands at attention, sheathed in a long robe with folds falling naturally under their own weight, varying in width and depth, yet seemingly capable of swaying and rippling with the charioteer's movement. The feet, with their closely observed toes, toenails, and swelling veins over the instep, are so realistic that they seem to have been cast from molds made from the feet of a living person.

THE RIACE WARRIORS Shipwreck as well as earthquake has protected ancient bronzes from recycling. As recently as 1972, divers recovered a pair of heavily corroded, larger-than-life-size bronze figures of warriors from the seabed off the coast of Riace, Italy, dating from about 460–450 BCE (see "The Riace Warriors," page 127).

The **WARRIOR** in **FIG. 5-29** reveals a striking balance between the idealized smoothness of "perfected" anatomy conforming to Early Classical standards and the reproduction of details observed from nature, such as the swelling veins in the backs of the hands. Contrapposto is further developed here than in the Kritios Boy, with a more pronounced counterbalance between tension (right leg and left arm) and relaxation (left leg and right arm), raising the prospect of a shift and

5-28 • CHARIOTEER

From the Sanctuary of Apollo, Delphi. c. 470 BCE. Bronze, copper (lips and lashes), silver (hand), onyx (eyes), height 5'11" (1.8 m). Archaeological Museum, Delphi.

The setting of a work of art affects the impression it makes. Today, the *Charioteer* is exhibited on a low base in the peaceful surroundings of a museum, isolated from other works and spotlighted for close examination. Its effect would have been very different in its original outdoor location, standing in a horse-drawn chariot atop a tall monument. Viewers in ancient times, tired from the steep climb to the sanctuary and jostled by crowds of fellow pilgrims, could have absorbed only its overall effect, not the fine details of the face, robe, and body visible to today's viewers.

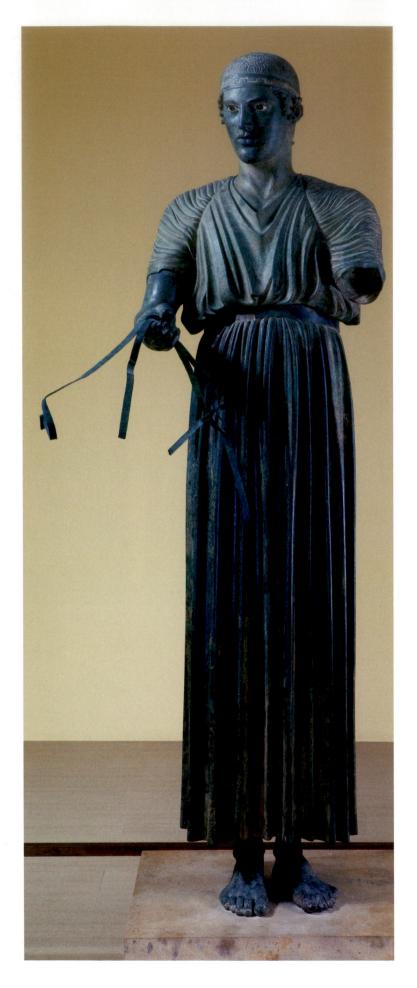

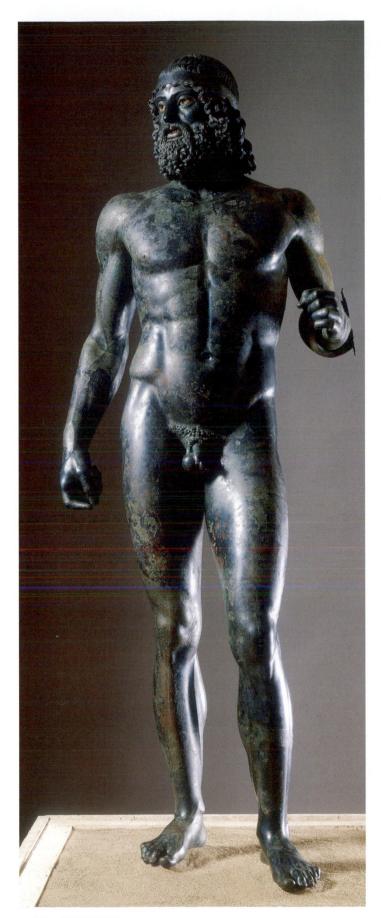

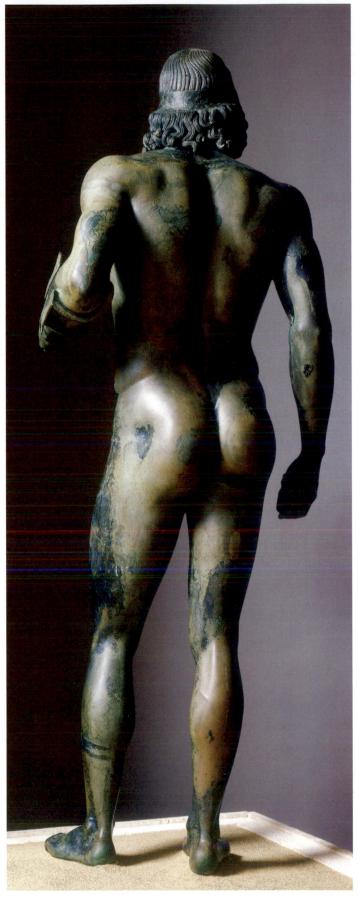

5–29 • WARRIORFound in the sea off Riace, Italy. c. 460–450 BCE. Bronze with bone and glass eyes, silver teeth, and copper lips and nipples, height 6'9" (2.05 m). National Archeological Museum, Reggio Calabria, Italy.

A BROADER LOOK | The Tomb of the Diver

Although ancient Greek commentators describe elaborate monumental wall paintings and discuss the output and careers of illustrious painters from the fifth and fourth centuries BCE, almost nothing of this art has survived. We rely heavily on ceramics to fill gaps in our knowledge of Greek painting, assuming that the decoration of these more modest utilitarian vessels reflects the glorious painting tradition documented in texts. There are also tantalizing survivals in provincial Greek sites. Principal among them are the well-preserved Early Classical wall paintings of c. 480-470 BCE in the Tomb of the Diver, discovered in 1968 just south of the Greek colony of Poseidonia (Roman Paestum) in southern Italy.

The paintings cover travertine slabs that formed the four walls and roof of a tomb submerged into the natural rock (FIG. 5–30), approximately 7 feet long, 3½ feet wide, and 2½ feet deep. Painted in buon fresco (waterbased pigments applied to wet plaster) on a white ground in earthy browns, yellows, and blacks, with accents of blue, the scenes on the walls surrounded the occupant of this tomb with a group of reclining men, assembled for a symposium—lively, elite male gatherings that focused on wine, music, games, and love making. Many of the most

distinguished of surviving Greek ceramic vessels were made for use in these playfully competitive drinking parties, and they are highlighted in the tomb paintings. On one short side (visible in the reconstruction drawing). a striding nude youth has filled the oinochoe (wine jug) in his right hand with the mixture of wine and water that was served from large kraters (punch bowls, like that portrayed on the table behind him) as the featured beverage of the symposium. He extends his arm toward a group of revelers reclining along one of the long walls (Fig. 5-31), each of whom has a kylix (wide, shallow, footed drinking cup), waiting to be filled. The man at the left reclines alone, raising his kylix to salute a couple just arriving—or perhaps toasting their departure on the other short side. Behind him, the two couples on the long frieze-in each case a bearded, mature man paired with a youthful companion—are already engaged in the party. The young man in the middle pairing is slinging his upraised kylix, presumably to propel the dregs of his wine toward a target, a popular symposium game. His partner turns in the opposite direction to ogle at the amorous pair at the right, who have abandoned their cups on the table in front of them and turned to embrace, gazing into each other's eyes as the erotic action heats up.

The significance of these paintings in relationship to a young man's tomb is not absolutely clear. Perhaps they are indicative of the deceased's elevated social status, since only wealthy aristocrats participated in such gatherings. The symposium could also represent funerary feasting or a vision of the pleasures that awaits the deceased in a world beyond death.

The transition between this world and the next certainly seems to be the theme of the spare but energetic painting on the roof of the tomb, where a naked boy is caught in mid dive, poised to plunge into the water portrayed as a blue mound underneath him (FIG. 5-32). Whereas the scene of the symposium accords with an ancient Greek pictorial tradition. especially prominent on ceramic vessels made for use by its male participants, this diver finds his closest parallels in Etruscan tomb painting (see FIG. 6-6), flourishing at this time farther north in Italy. Since the scene was located directly over the body of the man entombed here, it is likely that it mirrors his own plunge from life into death. And since it combines Greek and Etruscan traditions, perhaps this tomb was made for an Etruscan citizen of Poseidonia, whose tomb was commissioned from a Greek artist working in this flourishing provincial center.

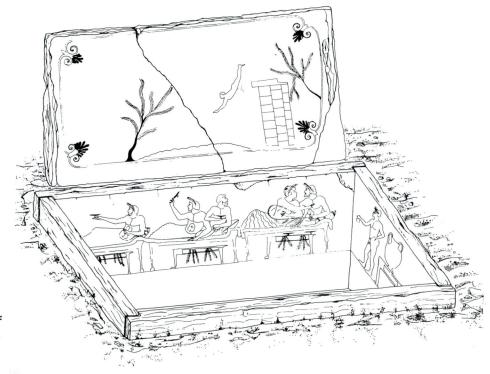

5-30 • RECONSTRUCTION DRAWING OF THE TOMB OF THE DIVER, POSEIDONIA (ROMAN PAESTUM)

c. 480 BCE.

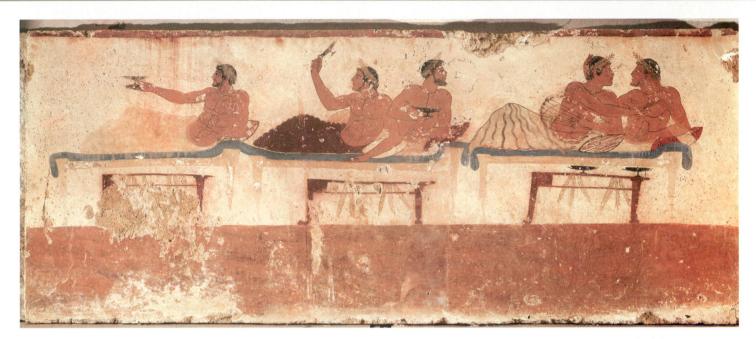

5-31 • A SYMPOSIUM SCENEFrom the Tomb of the Diver, Poseidonia (Roman Paestum). c. 480 BCE. Fresco on travertine slab, height 31" (78 cm). Paestum Museum.

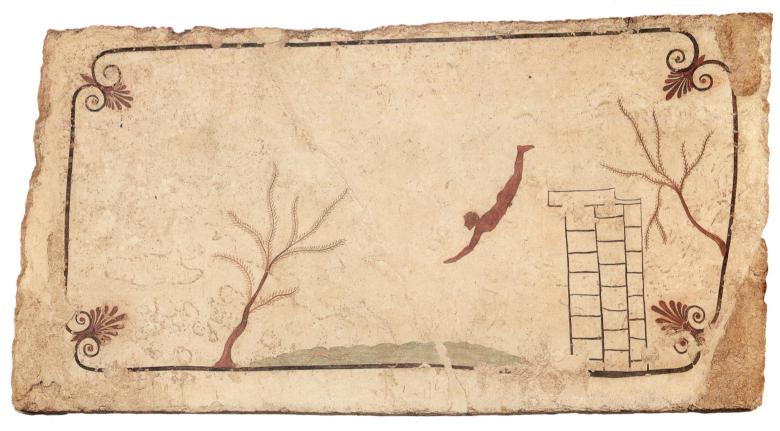

5-32 • A DIVERFrom the Tomb of the Diver, Poseidonia (Roman Paestum). c. 480 BCE. Fresco on travertine slab, height 3'4" (1.02 m). Paestum Museum.

with it the possibility of movement and life. The lifelike quality of this bronze is further heightened by inserted eyeballs of bone and colored glass, copper inlays on lips and nipples, silver plating on the teeth that peek between parted lips, and attached eyelashes and eyebrows of separately cast strands of bronze. This accommodation of the intense study of the human figure to an idealism that belies the irregularity of nature will be continued by artists in the High Classical period.

CERAMIC PAINTING

Greek potters and painters continued to work with the red-figure technique throughout the fifth century BCE, refining their ability to create supple, rounded figures, posed in ever more complicated and dynamic compositions. One of the most prolific Early Classical artists was Douris, whose signature appears on over 40

surviving pots decorated with scenes from everyday life as well as mythological subjects. His conspicuous skill in composing complex figural scenes that respond to the complicated and irregular pictorial fields of a variety of vessel types is evident in a frieze of frisky satyrs that he painted c. 480 BCE around the perimeter of a **psykter** (**FIG. 5-33**). This strangely shaped pot was a wine cooler, made to float in a krater (see "A Closer Look," page 119) filled with chilled water, its extended bottom serving as a keel to keep it from tipping over.

Like the krater, the psykter was a vessel meant for use in exclusive male drinking parties know as symposia, and the decoration was chosen with this context in mind. The acrobatic virtuosity of the satyrs is matched by the artist's own virtuosity in composing them as an interlocking set of diagonal gestures that alternately challenge and correspond with the bulging form around which they are painted. The playful interaction of satyrs with their kylixes must have amused the tipsy revelers, especially when this pot was gently bobbing within the krater, making the satyrs seem to be walking around in circles on top of the wine. One satyr cups his kylix to his buttocks, juxtaposing convex and concave shapes. Another, balanced in a precarious handstand, seems to be observing his own reflection within the wine of his kylix.

But Douris was also capable of more lyrical compositions, as seen in the painting he placed within a kylix (FIG. 5-34), similar in shape to those used as props by the satyrs on the psykter. This tondo (circular painting) was an intimate picture. It became visible only to the user of the cup when he tilted up the kylix to drink from it; otherwise, sitting on a table, the painting would have been obscured by the dark wine pool within it. A languidly posed and elegantly draped youth stands behind an altar pouring wine from an oinochoe (wine jug) into the kylix of a more dignified, bearded older man. Euphronios' tentative essay in foreshortening Sarpedon's bent leg on his krater (see "A Closer Look," page 119) blossoms in the work of Douris to become full-scale formal projection as the graceful youth on this kylix bends his arm from the background to project his frontal oinochoe over the laterally held kylix of his seated companion.

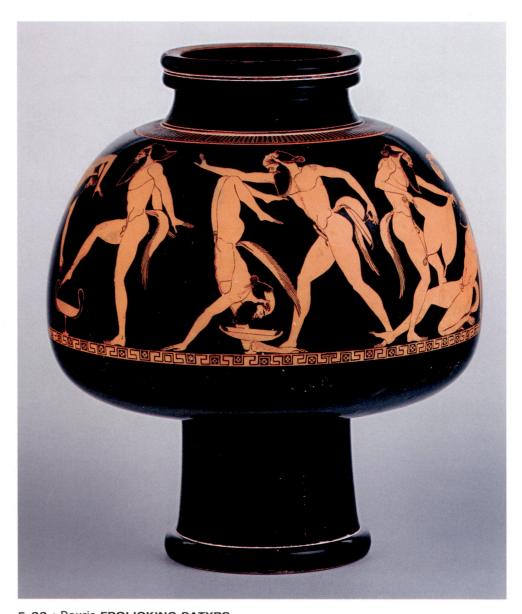

5–33 • Douris **FROLICKING SATYRS** c. 480 BCE. Red-figure decoration on a psykter. Ceramic, height 11⁵/₁₆" (28.7 cm). British Museum, London.

RECOVERING THE PAST | The Riace Warriors

In 1972, a scuba diver in the Ionian Sea near the beach resort of Riace, Italy, found what appeared to be a human elbow and upper arm protruding from sand about 25 feet beneath the sea. Taking a closer look, he discovered that the arm was made of metal, not flesh, and was part of a large statue. He quickly uncovered a second statue nearby, and underwater salvagers soon raised the statues: bronze warriors more than 6 feet tall, complete in every respect, except for swords, shields, and one helmet.

After centuries underwater, however, the bronze *Warriors* were corroded and covered with accretions. The clay cores from the casting

process were still inside, adding to the deterioration by absorbing lime and sea salts. Conservators first removed all the exterior corrosion and lime encrustations using surgeon's scalpels, pneumatic drills, and high-technology equipment such as sonar (sound-wave) probes and micro-sanders. Then they painstakingly removed the clay core through existing holes in the heads and feet using hooks, scoops, jets of distilled water, and concentrated solutions of peroxide. Finally, they cleaned the figures thoroughly by soaking them in solvents, and they sealed them with a fixative specially designed for use on metals before exhibiting them in 1980.

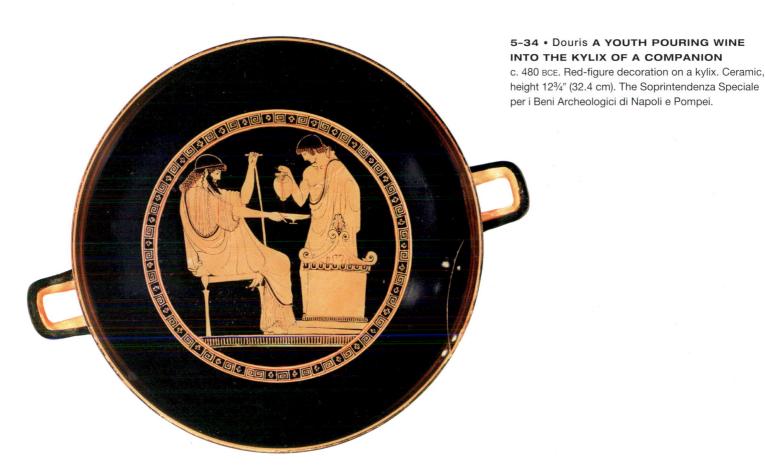

For the well-educated reveler using this cup at a symposium, there were several possible readings for the scene he was observing. This could be the legendary Athenian king Kekrops, who appears, identified by inscription, in the scene Douris painted on the underside of the kylix. Also on the bottom of the cup are Zeus and the young Trojan prince Ganymede, whom the supreme god abducted to Olympus to serve as his cup-bearer. Or, since the symposia themselves were the site of amorous interactions between older and younger men, the user of this cup might have found his own situation mirrored in what he was observing while he drank.

THE HIGH CLASSICAL PERIOD, c. 450–400 BCE

The High Classical period of Greek art lasted only a half-century, 450–400 BCE. The use of the word "high" to qualify the art of this time reflects the value judgments of art historians who have considered this period a pinnacle of artistic refinement, producing works that set a standard of unsurpassed excellence. Some have even referred to this half-century as Greece's "Golden Age," although these decades were also marked by turmoil and destruction. Without a common enemy, Sparta and Athens turned on each other in a series of conflicts known as the Peloponnesian War. Sparta dominated the Peloponnese peninsula and much of the rest of

mainland Greece, while Athens controlled the Aegean and became the wealthy and influential center of a maritime empire. Today we remember Athens more for its cultural and intellectual brilliance and its experiments with democratic government, which reached its zenith in the fifth century BCE under the charismatic leader Perikles (c. 495-429 BCE), than for the imperialistic tendencies of its considerable commercial power.

Except for a few brief interludes. Perikles dominated Athenian politics and culture from 462 BCE until his death in 429 BCE. Although comedy writers of the time sometimes mocked him. calling him "Zeus" and "The Olympian" because of his haughty personality, he was a dynamic, charismatic political and military leader. He was also a great patron of the arts, supporting the use of Athenian wealth for the adornment of the city, and encouraging artists to promote a public image of peace, prosperity, and power. Perikles said of his city and its accomplishments: "Future generations will marvel at us, as the present age marvels at us now." It was a prophecy he himself helped fulfill.

THE AKROPOLIS

Athens originated as a Neolithic akropolis, or "city on top of a hill" (akro means "high" and polis means "city"), that later served as a fortress and sanctuary. As the city grew, the Akropolis became the religious and ceremonial center devoted primarily to the goddess Athena, the city's patron and protector.

After Persian troops destroyed the Akropolis in 480 BCE, the Athenians vowed to keep it in ruins as a memorial, but Perikles convinced them to rebuild it, arguing that this project honored the gods, especially Athena, who had helped the Greeks defeat the Persians. Perikles intended to create a visual expression of Athenian values and civic pride that would bolster the city's status as the capital of the empire he was instrumental in building. He chose his close friend Pheidias, a renowned sculptor, to supervise the rebuilding and assembled under him the most talented artists in Athens.

The cost and labor involved in this undertaking were staggering. Large quantities of gold, ivory, and exotic woods had to be imported. Some 22,000 tons of marble were transported 10 miles from mountain quarries to city workshops. Perikles was severely criticized by his political opponents for this extravagance, but it never cost him popular support. In fact, many working-class Athenians—laborers, carpenters, masons, sculptors, and the farmers and merchants who kept them supplied and fed-benefited from his expenditures.

Work on the AKROPOLIS continued throughout the fifth century BCE (FIG. 5-35). Visitors in 400 BCE would have climbed

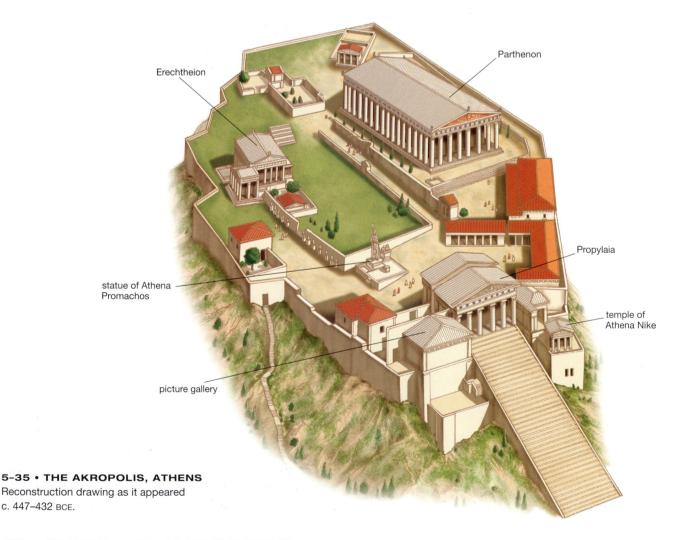

c. 447-432 BCE.

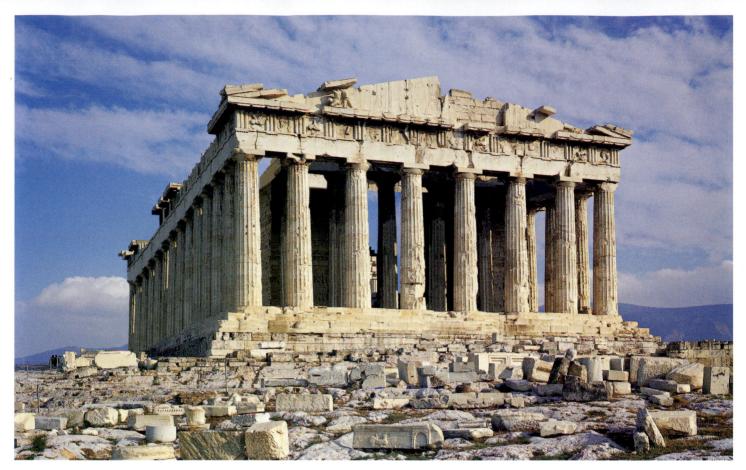

5-36 • Kallikrates and Iktinos VIEW (A) AND PLAN (B) OF THE PARTHENON

Akropolis, Athens. 447–432 $_{\mbox{\footnotesize BCE}}.$ Pentelic marble. Photograph: view from the northwest.

Explore the architectural panoramas of the Parthenon on myartslab.com

a steep ramp on the west side of the hill (in the foreground of FIGURE 5-35) to the sanctuary entrance, perhaps pausing to admire the small temple dedicated to Athena Nike (Athena as goddess of victory in war), poised on a projection of rock above the ramp. After passing through an impressive porticoed gatehouse called the Propylaia, they would have seen a huge bronze figure of Athena Promachos (the Defender), designed and executed by Pheidias between about 465 and 455 BCE. Sailors entering the Athenian port of Piraeus, about 10 miles away, could see the sun reflected off her helmet and spear tip. Behind this statue was a walled precinct that enclosed the Erechtheion, a temple dedicated to several deities, and to its right was the largest building on the Akropolis—the Parthenon, a temple dedicated to Athena Parthenos (the Virgin). Visitors approached the temple from its northwest corner, instantly grasping the imposing width and depth of this building, isolated like a work of sculpture elevated on a pedestal.

THE PARTHENON

Sometime around 490 BCE, Athenians had begun work on a temple to Athena Parthenos that was still unfinished when the Persians sacked the Akropolis a decade later. In 447 BCE Perikles

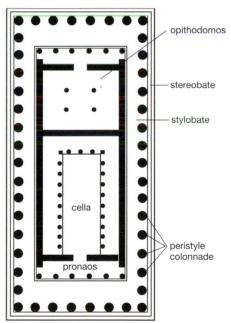

commissioned the architects Kallikrates and Iktinos to design a larger temple using the existing foundation and stone elements. The finest white marble was used throughout—even on the roof, in place of the more usual terra-cotta tiles (FIG. 5–36). The planning and execution of the Parthenon (dedicated in 438 BCE) required extraordinary mathematical and mechanical skills and would have been impossible without a large contingent of distinguished architects and builders, as well as talented sculptors and painters. The

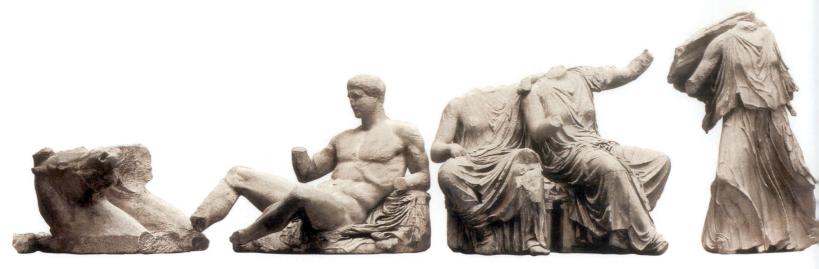

5--37 \bullet Photographic mock-up of the east pediment of the parthenon (using photographs of the extant marble sculpture)

c. 447–432 BCE. The gap in the center represents the space that would have been occupied by the missing sculpture. The pediment is over 90 feet (27.45 m) long; the central space of about 40 feet (12.2 m) is missing.

result is as much a testament to Pheidias' administrative skills as his artistic vision, since he supervised the entire project.

One key to the Parthenon's sense of harmony and balance is an attention to proportions—especially the ratio of 4:9, expressing the relationship of breadth to length and the relationship of column diameter to space between columns. Also important are subtle refinements of design, deviations from absolute regularity to create a harmonious effect when the building was actually viewed. For example, since long, straight horizontal lines seem to sag when seen from a distance, base and entablature curve slightly upward to correct this optical distortion. The columns have a gentle swelling (entasis) and tilt inward slightly from bottom to top; the corners are strengthened visually by reducing the space between columns at those points. These subtle refinements in the arrangement of seemingly regular elements give the Parthenon a buoyant organic appearance and assure that it will not look like a heavy, lifeless stone box. The significance of their achievement was clear to its builders—Iktinos even wrote a book on the proportions of this masterpiece.

The sculptural decoration of the Parthenon reflects Pheidias' unifying aesthetic vision, but it also conveys a number of political and ideological themes: the triumph of the democratic Greek city-states over imperial Persia, the preeminence of Athens thanks to the favor of Athena, and the triumph of an enlightened Greek civilization over despotism and barbarism.

THE PEDIMENTS As with most temples, sculpture in the round filled both pediments of the Parthenon, set on the deep shelf of the cornice and secured to the wall with metal pins. Unfortunately, much has been damaged or lost over the centuries (also see "Who Owns the Art?" page 133). Using the locations of the pinholes and weathering marks on the cornice, and also drawings

made by French artist Jacques Carrey (1649–1726) on a visit to Athens in 1674, scholars have been able to determine the placement of surviving statues and infer the poses of missing ones. We know the subjects from the descriptions of the second century CE Greek writer Pausanias. The west pediment sculpture, facing the entrance to the Akropolis, presented the contest Athena won over the sea god Poseidon for rule over the Athenians. The east pediment figures, above the entrance to the cella, portrayed the birth of Athena, fully grown and clad in armor, from the brow of her father, Zeus.

The statues from the east pediment are the best preserved of the two groups (FIG. 5-37). Flanking the missing central figures—probably Zeus seated on a throne with the newborn adult Athena standing at his side—were groups of goddesses and a single male figure. In the left corner was the sun god Helios in his horse-drawn chariot rising from the sea, while at the right the moon goddess Selene descends in her chariot to the sea, the head of her tired horse hanging over the cornice. The reclining male nude, whose relaxed pose fits so easily into the left pediment, has been identified as either Herakles with his lion's skin or Dionysos (god of wine) lying on a panther skin. The two seated women may be the earth and grain goddesses Demeter and Persephone. The running female figure just to the left of center is Iris, messenger of the gods, already spreading the news of Athena's birth.

The three interlocked female figures on the right side who seem to be awakening from a deep sleep, two sitting upright and one reclining, are probably Hestia (a sister of Zeus and the goddess of the hearth), Dione (one of Zeus's many consorts), and her daughter, Aphrodite. The sculptor, whether Pheidias or a follower, expertly rendered the female form beneath the fall of draperies, which both cover and reveal their bodies while uniting the three figures into a single mass.

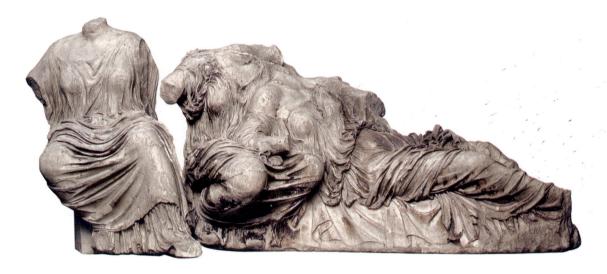

THE DORIC FRIEZE The all-marble Parthenon had two sculptured friezes, one above the outer peristyle and another atop the cella wall inside. The Doric frieze on the exterior had 92 metope reliefs depicting legendary battles, symbolized by combat between two representative figures: a centaur against a Lapith (a legendary people of pre-Hellenic times); a god against a Titan; a Greek

against a Trojan; a Greek against an Amazon (one of the mythical tribe of female warriors sometimes said to be the daughters of the war god Ares). Each of these mythic struggles represented for the Greeks the triumph of reason over unbridled animal passion.

Among the best-preserved metope reliefs are several depicting the battle between Lapiths and centaurs from the south side of the

Parthenon. The panel shown here (FIG. 5-38) presents a pause within the fluid struggle, a timeless image standing for an extended historical episode. Forms are reduced to their most characteristic essentials, and so dramatic is the chiasmic (X-shaped) composition that we easily accept its visual contradictions. The Lapith is caught at an instant of total equilibrium. What could be a grueling tug-of-war between a man and a man-beast has been transformed into an athletic ballet, choreographed to show off the Lapith warrior's flexed muscles and graceful movements against the implausible backdrop of his carefully draped cloak.

5-38 • LAPITH FIGHTING A CENTAUR

Metope relief from the Doric frieze on the south side of the Parthenon. c. 447–432 BCE. Marble, height 56" (1.42 m). British Museum, London.

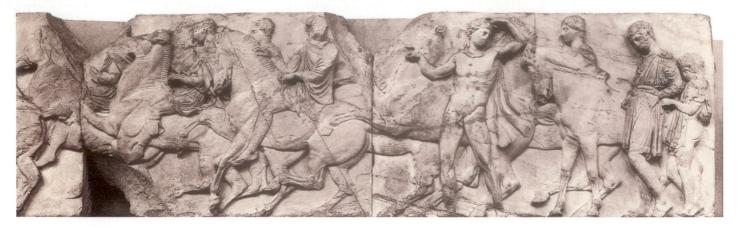

5-39 • HORSEMENDetail of the Procession, from the lonic frieze on the north side of the Parthenon. c. 447–432 BCE. Marble, height 41¾" (106 cm). British Museum, London.

THE PROCESSIONAL FRIEZE Enclosed within the Parthenon's Doric peristyle, a continuous, 525-foot-long Ionic frieze ran along the exterior wall of the cella. Since the eighteenth century, its subject has been seen as a procession celebrating the festival that took place in Athens every four years, when the women of the city wove a new wool peplos and carried it to the Akropolis to clothe an ancient wooden cult statue of Athena. Both the skilled riders in the procession (**FIG. 5–39**), and the graceful but physically sturdy young walkers (**FIG. 5–40**), are representative types, ideal inhabitants of a successful city-state. The underlying message of

the frieze as a whole is that the Athenians are a healthy, vigorous people, united in a democratic civic body looked upon with favor by the gods. The people are inseparable from and symbolic of the city itself.

A more recent interpretation by art historian Joan Connelly, however, has challenged the traditional reading of the frieze as an ideal rendering of a contemporary event. She argues that—consistent with what we know of temple decoration elsewhere—what is portrayed is not contemporary but mythological history—the legendary Athenian king Erechtheus, who, following the advice

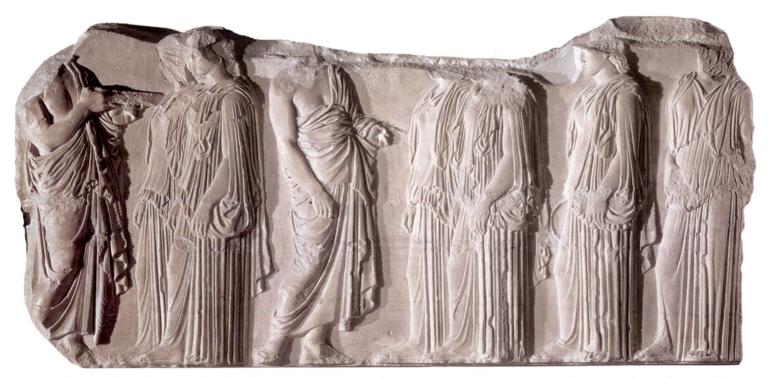

5-40 • YOUNG WOMEN AND MENDetail of the Procession, from the Ionic frieze on the east side of the Parthenon. c. 447–432 BCE. Marble, height 3'6" (1.08 m). Musée du Louvre, Paris.

ART AND ITS CONTEXTS | Who Owns the Art? The Elgin Marbles and the Euphronios Krater

At the beginning of the nineteenth century, Thomas Bruce, the British Earl of Elgin and ambassador to Constantinople, acquired much of the surviving sculpture from the Parthenon, which was at that time being used for military purposes. He shipped it back to London in 1801 to decorate a lavish mansion for himself and his wife; but by the time he returned to England, his wife had left him and the ancient treasures were at the center of a financial dispute and had to be sold. Referred to as the Elgin Marbles, most of the sculpture is now in the British Museum, including all the elements seen in FIGURE 5–37. The Greek government has tried unsuccessfully to have the Elgin Marbles returned.

Recently, another Greek treasure has been in the news. In 1972, a krater, painted by Euphronios and depicting the death of the

warrior Sarpedon during the Trojan War, had been purchased by the Metropolitan Museum of Art in New York (see "A Closer Look," page 119). Museum officials were told that it had come from a private collection, and it became the centerpiece of the museum's galleries of Greek vessels. But in 1995, Italian and Swiss investigators raided a warehouse in Geneva, Switzerland, where they found documents showing that the krater had been stolen from an Etruscan tomb near Rome. The Italian government demanded its return. The controversy was only resolved in 2006. The krater, along with other objects known to have been stolen from other Italian sites, were returned, and the Metropolitan Museum will display pieces "of equal beauty" under long-term loan agreements with Italy.

of the oracle at Delphi, sacrificed one of his own daughters to save the city of Athens from an external enemy. This theme, also incorporating a procession, would have had obvious resonance with the recent Athenian victory over the Persians.

As with the metope relief of a Lapith fighting a centaur (see FIG. 5–38), viewers of the processional frieze easily accept its disproportions, spatial compression and incongruities, and such implausible compositional features as men and women standing as tall as rearing horses. Carefully planned rhythmic variations contribute to the effectiveness of the frieze. Horses plunge ahead at full gallop; women proceed with a slow, stately step, while men pause to look back at the progress of those behind them.

In executing the frieze, the sculptors took into account the spectators' low viewpoint and the dim lighting inside the peristyle. They carved the top of the frieze band in higher relief than the lower part, thus tilting the figures out to catch the reflected light from the pavement, permitting a clearer reading of the action. The subtleties in the sculpture may not have been as evident to Athenians in the fifth century BCE as they are now: the frieze, seen at the top of a high wall and between columns, was originally completely painted. Figures in red and ocher, accented with glittering gold and real metal details, were set against a contrasting background of dark blue.

STATUE OF ATHENA PARTHENOS After having explored the considerable richness of sculpture on the exterior of the Parthenon, with permission, viewers could have climbed the east steps to look into the cella, where they would have seen Pheidias' colossal gold and ivory statue of Athena—outfitted in armor and holding a shield in one hand and a winged Nike (Victory) in the other—which was installed in the temple and dedicated 438 BCE (FIG. 5-41). The original has completely vanished, but descriptions and later copies allow us a clear sense of its appearance and its imposing size, looming nearly 40 feet tall.

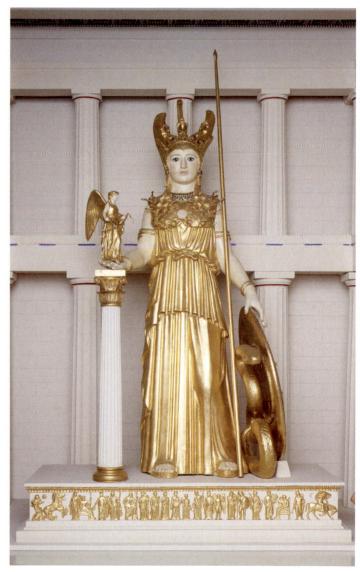

5-41 • RE-CREATION OF PHEIDIAS' HUGE GOLD AND IVORY FIGURE OF ATHENA

Royal Ontario Museum, Toronto.

TECHNIQUE | "The Canon" of Polykleitos

Just as Greek architects defined and followed a set of standards for ideal temple design, Greek sculptors sought an ideal for representing the human body. Studying actual human beings closely and selecting those human attributes they considered most desirable—such as regular facial features, smooth skin, and particular body proportions—sculptors combined them into a single ideal of physical perfection.

The best-known theorist of the High Classical period was the sculptor Polykleitos of Argos. About 450 BCE, balancing careful observation with generalizing **idealization**, he developed a set of rules for constructing what he considered the ideal human figure, which he set down in a treatise called "The Canon" (*kanon* is Greek for "measure," "rule," or "law"). To illustrate his theory, Polykleitos created a bronze statue of a standing man carrying a spear—perhaps the hero Achilles. Neither the treatise nor the original statue has survived, but both were widely discussed in the writings of his contemporaries, and later Roman artists made marble copies of the *Spear Bearer* (*Doryphoros*). By studying these copies, scholars have tried to determine the set of measurements that defined ideal human proportions in Polykleitos' canon.

The canon included a system of ratios between a basic unit and the length of various body parts. Some studies suggest that this basic unit may have been the length of the figure's index finger or the width of its hand across the knuckles; others suggest that it was the height of the head from chin to hairline. The canon also included guidelines for symmetria ("commensurability"), by which Polykleitos meant the relationship of body parts to one another. In the Spear Bearer, he explored not only proportions, but also the diagonally counterbalanced relationships between weight-bearing and relaxed legs and arms around a central axis, referred to as contrapposto.

The Roman marble copy of the **SPEAR BEARER** (Fig. 5–42) shows a male athlete, perfectly balanced, with the whole weight of the upper body supported over the straight (engaged) right leg. The left leg is bent at the knee, with the left foot poised on the ball of the foot, suggesting the weight shift of preceding and succeeding movement. The pattern of tension and relaxation is reversed in the arrangement of the arms, with the right relaxed on the engaged side, and the left bent to support the weight of the (missing) spear. The pronounced tilt of the *Spear Bearer*'s hipline accommodates the raising of the left foot onto its ball, and the head is turned toward the same side as the engaged leg. Hints of this dynamically balanced body pose—characteristic of High Classical standing figure sculpture—had already appeared in the Kritios Boy (see Fig. 5–26) and it was developed further in the Riace *Warrior* (see Fig. 5–29).

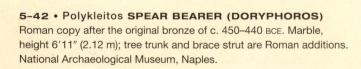

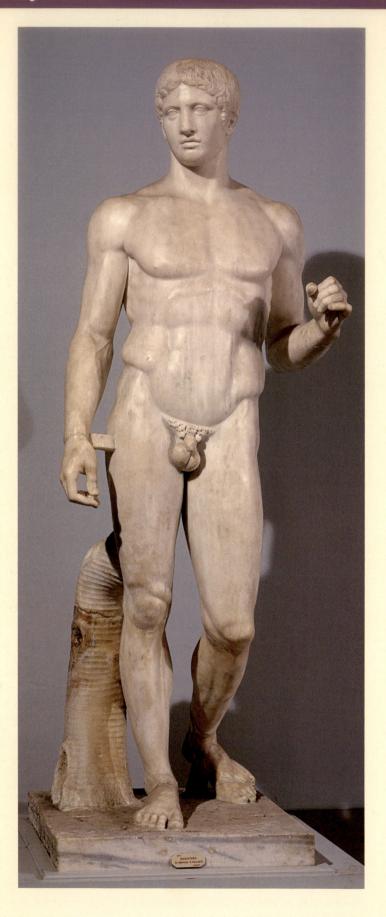

THE PROPYLAIA AND THE ERECHTHEION

Upon completion of the Parthenon, work began in 437 on the monumental gatehouse, the Propylaia (FIG. 5-43), that had been part of the original design of the Akropolis complex. The Propylaia had no sculptural decoration, but its north wing was originally a dining hall that later became the earliest known museum (meaning "home of the Muses"), a gallery built specifically to house a collection of paintings for public view.

Construction of the **ERECHTHEION** (FIG. 5-44), the second important temple erected on the Akropolis under Perikles' building program, began in the 430s BCE and ended in 406 BCE, just before the fall of Athens to Sparta. The asymmetrical plan reflects the building's multiple functions in housing several shrines,

and also conformed to the sharply sloping terrain on which it is located. The Erechtheion stands on the site of the mythical contest between the sea god Poseidon and Athena for patronage over Athens. During this contest, Poseidon struck a rock with his trident (three-pronged harpoon), bringing forth a spout of water, but Athena gave an olive tree to Athens and won the contest. The Athenians enclosed what they believed to be this sacred rock, bearing the marks of the trident, in the Erechtheion's north porch. The Erechtheion also housed the venerable wooden cult statue of Athena that was the center of the Panathenaic festival.

The north and east porches of the Erechtheion have come to epitomize the Ionic order, serving as an important model for European architects since the eighteenth century. Taller and more

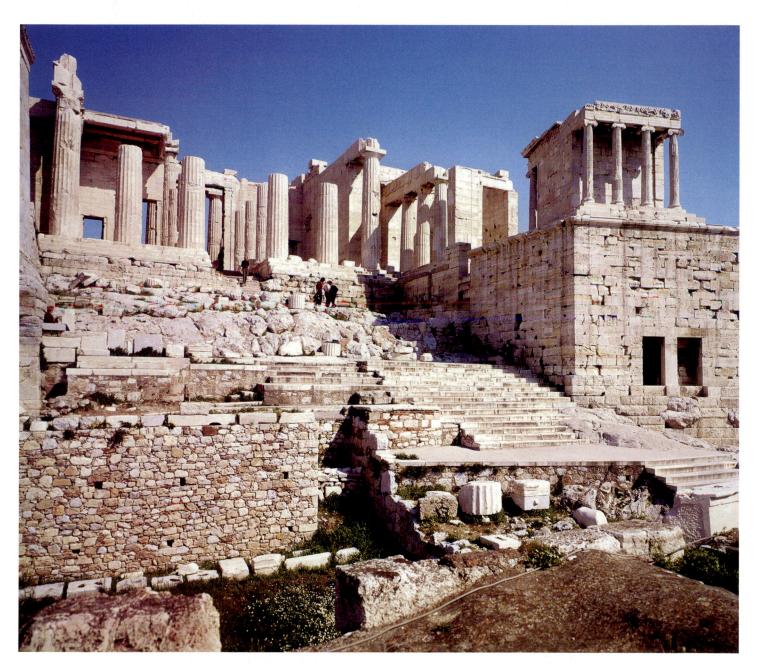

5-43 • THE MONUMENTAL ENTRANCE TO THE AKROPOLIS, ATHENS

The Propylaia (Mnesikles) with the Temple of Athena Nike (Kallikrates) on the bastion at the right. c. 437-423 BCE.

5-44 • ERECHTHEION

Akropolis, Athens. 430s–406 $_{\rm BCE}$. View from the east. Porch of the Maidens at left; the north porch can be seen through the columns of the east wall.

slender in proportion that the Doric, the Ionic order also has richer and more elaborately carved decoration (see "The Greek Orders," page 110). The columns rise from molded bases and end in volute (spiral) capitals; the frieze is continuous.

The **PORCH OF THE MAIDENS** (**FIG. 5–45**), on the south side facing the Parthenon, is even more famous. Raised on a high base, its six stately caryatids support an Ionic entablature made up of bands of carved molding. In a pose characteristic of Classical figures, each caryatid's weight is supported on one engaged leg, while the free leg, bent at the knee, rests on the ball of the foot. The three caryatids on the left have their right legs engaged, and the three on the right have their left legs engaged, creating a sense of closure, symmetry, and rhythm.

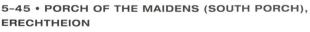

Akropolis, Athens. Porch c. 420-410 BCE.

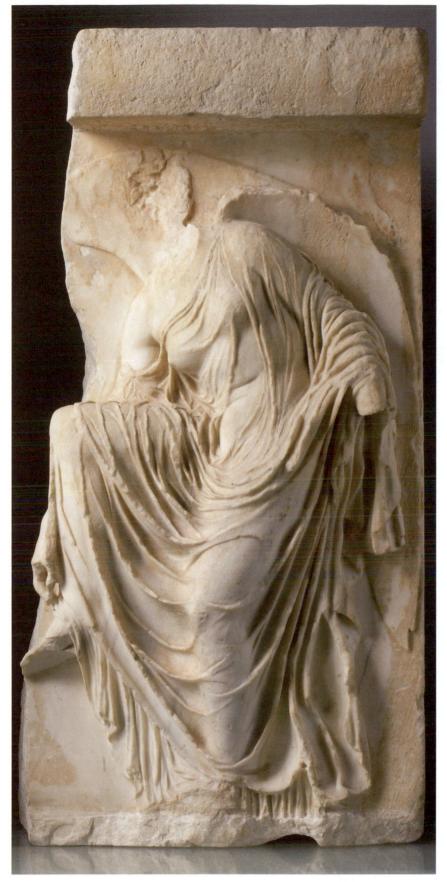

5-46 • NIKE (VICTORY) ADJUSTING HER SANDALFragment of relief decoration from the parapet (now destroyed), Temple of Athena Nike, Akropolis, Athens. Last quarter of the 5th century (perhaps 410–405) BCE.
Marble, height 3'6" (1.06 m). Akropolis Museum, Athens.

THE TEMPLE OF ATHENA NIKE

The Ionic Temple of Athena Nike (victory in war), located south of the Propylaia, was designed and built about 425 BCE, probably by Kallikrates (see FIG. 5–43). Reduced to rubble during the Turkish occupation of Greece in the seventeenth century CE, the temple has since been rebuilt. Its diminutive size—about 27 by 19 feet—and refined Ionic decoration are in marked contrast to the weightier Doric Propylaia adjacent to it.

Between 410 and 405 BCE, this temple was surrounded by a parapet or low wall faced with sculptured panels depicting Athena presiding over the preparation of a celebration by winged Nikes (victory figures). The parapet no longer exists, but some panels have survived, including the celebrated NIKE (VICTORY) ADJUSTING HER SANDAL (FIG. 5-46). The figure bends forward gracefully, allowing her chiton (tunic) to slip off one shoulder. Her large overlapping wings effectively balance her unstable pose. Unlike the decorative swirls of heavy fabric covering the Parthenon goddesses, or the weighty, pleated robes of the Erechtheion caryatids, the textile covering this Nike appears delicate and light, clinging to her body like wet silk, one of the most discreetly erotic images in ancient art.

THE ATHENIAN AGORA

In Athens, as in most cities of ancient Greece, commercial, civic, and social life revolved around the marketplace, or agora. The Athenian Agora, at the foot of the Akropolis, began as an open space where farmers and artisans displayed their wares. Over time, public and private structures were erected on both sides of the Panathenaic Way, a ceremonial road used during an important festival in honor of Athena (FIG. 5-47). A stone drainage system was installed to prevent flooding, and a large fountain house was built to provide water for surrounding homes, administrative buildings, and shops (see "Women at a Fountain House," page 139). By 400 BCE, the Agora contained several religious and administrative structures and even a small racetrack. The Agora also had the city mint, its military headquarters, and two buildings devoted to court business.

In design, the stoa, a distinctively Greek structure found nearly everywhere people gathered, ranged from a simple roof held up by columns to a substantial, sometimes architecturally impressive, building with two stories and shops along one side.

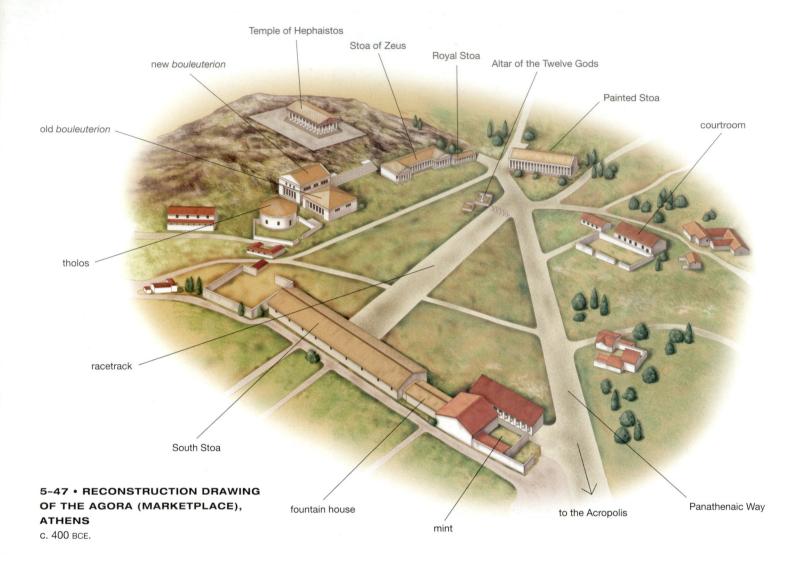

Stoas offered protection from the sun and rain, and provided a place for strolling and talking business, politics, or philosophy. While city business could be, and often was, conducted in the stoas, agora districts also came to include buildings with specific administrative functions.

In the Athenian Agora, the 500-member boule, or council, met in a building called the bouleuterion. This structure, built before 450 BCE but probably after the Persian destruction of Athens in 480 BCE, has a simple rectangular plan with a vestibule and large meeting room. Near the end of the fifth century BCE, a new bouleuterion was constructed to the west of the old one. This too had a rectangular plan. The interior, however, may have had permanent tiered seating arranged in an ascending semicircle around a ground-level **podium**, or raised platform.

Nearby was a small, round building with six columns supporting a conical roof, a type of structure known as a tholos. Built about 465 BCE, this tholos was the meeting place of the 50-member executive committee of the boule. The committee members dined there at the city's expense, and a few of them always spent the night there in order to be available for any pressing business that might arise.

Private houses surrounded the Agora. Compared with the often grand public buildings, houses of the fifth century BCE in Athens were rarely more than simple rectangular structures of stucco-faced mud brick with wooden posts and lintels supporting roofs of terra-cotta tiles. Rooms were small and included a dayroom in which women could sew, weave, and do other chores, a dining room with couches for reclining around a table, a kitchen, bedrooms, and occasionally an indoor bathroom. Where space was not at a premium, houses sometimes opened onto small courtyards or porches.

CITY PLANS

In older Greek cities such as Athens, buildings and streets developed in conformance to the needs of their inhabitants and the requirements of the terrain. As early as the eighth century BCE, however, builders in some western Greek settlements began to use a mathematical concept of urban development based on the **orthogonal** (or grid) plan. New cities or rebuilt sections of old cities were laid out on straight, evenly spaced parallel streets that intersected at right angles to create rectangular blocks. These blocks were then subdivided into identical building plots.

ART AND ITS CONTEXTS | Women at a Fountain House

Since most women in ancient Greece were confined to their homes, their daily trip to the communal well or fountain house in the agora was an important event. The Archaic ceramic artist known as the Priam Painter has recorded a vignette from this aspect of Greek city life on a black-figure hydria (water jug) (FIG. 5–48). In the shade of a Doriccolumned porch, three women fill hydriae just like the one on which they are painted. A fourth balances her empty jug on her head as she waits, while a fifth woman, without a jug, seems to be waving a greeting to someone. The building is designed like a stoa, open on one side, but having animal-head spigots on three walls. The Doric columns support a Doric entablature with an architrave above the colonnade and a colorful frieze—here black-and-white blocks replace carved metopes.

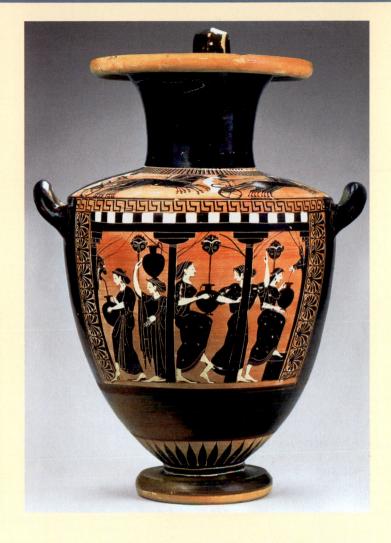

5–48 • Priam Painter WOMEN AT A FOUNTAIN HOUSE 520–510 BCE. Black-figure decoration on a hydria. Ceramic, height of hydria 20%" (53 cm). Museum of Fine Arts, Boston. William Francis Warden Fund. (61.195)

During the Classical period, Hippodamos of Miletos, a major urban planner of the fifth century BCE, held views on the reasoned perfectibility of urban design akin to those of the Athenian philosophers (such as Socrates) and artists (such as Polykleitos). He believed the ideal city should be limited to 10,000 citizens divided into three classes—artists, farmers, and soldiers—and three zones—sacred, public, and private. The basic Hippodamian plot was a square 600 feet on each side, divided into quarters. Each quarter was subdivided into six rectangular building plots measuring 100 by 150 feet, a scheme still widely used in American and European cities and suburbs.

STELE SCULPTURE

Upright stone slabs called stelai (singular, stele) were used in Greek cemeteries as gravestones, carved in low relief with an image (actual or allegorical) of the person(s) to be remembered. Instead of the proud warriors or athletes used in the Archaic period, however, Classical stelae place figures in personal or domestic contexts

that often feature women and children. A touching mid-fifth-century BCE example found on the island of Paros portrays a young girl, seemingly bidding farewell to her pet birds, one of which she kisses on the beak (FIG. 5-49). She wears a loose peplos, which parts at the side to disclose the tender flesh underneath and clings elsewhere over her body to reveal its three-dimensional form. The extraordinary carving recalls the contemporary reliefs of the Parthenon frieze, and like them, this stele would have been painted with color to provide details such as the straps of the girl's sandals or the feathers on her beloved birds.

Another, somewhat later, stele commemorates the relationship between a couple, identified by name across an upper frieze resting on two Doric pilasters (FIG. 5–50). The husband Ktesilaos stands casually with crossed legs and joined hands, gazing at his wife Theano, who sits before him on a bench, pulling at her gauzy wrap with her right hand in a gesture that is often associated with Greek brides. Presumably this was a tombstone for a joint grave, since both names are inscribed on it, but we do not know which of

the two might have died first, leaving behind a mate to mourn and memorialize by commissioning this stele. The air of introspective melancholy here, as well as the softness and delicacy of both flesh and fabric, seem to point forward out of the High Classical period and into the increased sense of narrative and delicacy that was to characterize the fourth century BCE.

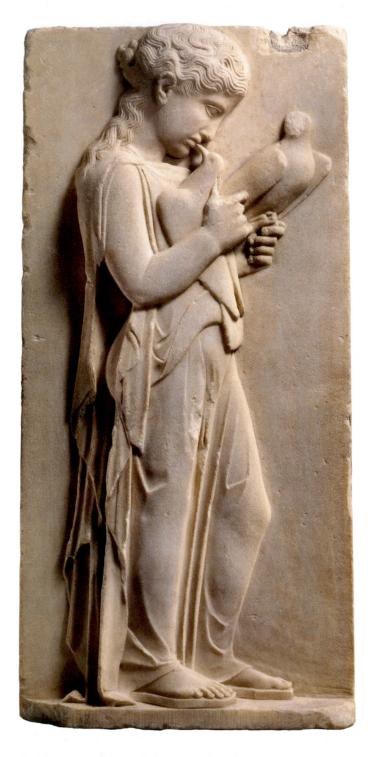

5-49 • GRAVE STELE OF A LITTLE GIRL c. 450–440 BCE. Marble, height $31\frac{1}{2}$ " (80 cm). Metropolitan Museum of Art, New York.

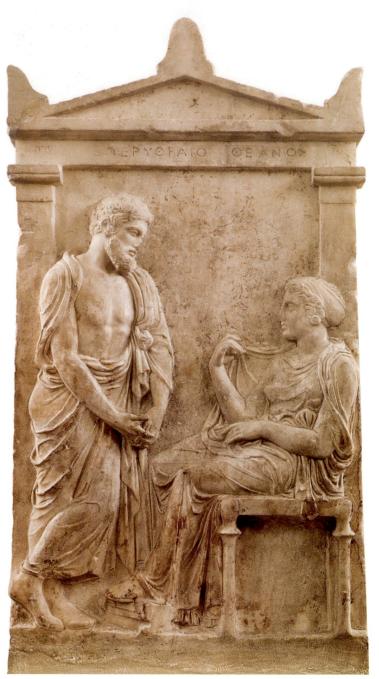

5–50 • GRAVE STELE OF KTESILAOS AND THEANO c. 400 BCE. Marble, height 36% (93 cm). National Archaeological Museum, Athens.

PAINTING

The Painted Stoa built on the north side of the Athenian Agora (see FIG. 5–47) about 460 BCE is known to have been decorated with paintings (hence its name) by the most famous artists of the time, including Polygnotos of Thasos (active c. 475–450 BCE). His contemporaries praised his talent for creating the illusion of spatial recession in landscapes, rendering female figures clothed in transparent draperies, and conveying through facial expressions the full range of human emotions. Ancient writers described his painting, as well as other famous works, enthusiastically, but nothing survives for us to see.

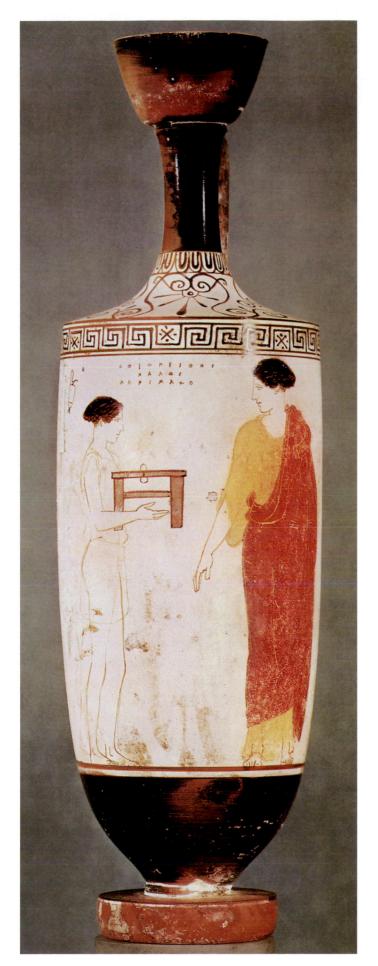

5–51 • Style of the Achilles Painter **WOMAN AND MAID** c. 450–440 BCE. White-ground lekythos. Ceramic, with additional painting in tempera, height 15½" (38.4 cm). Museum of Fine Arts, Boston. Francis Bartlett Donation of 1912. (13.201)

White-ground ceramic painting, however, may echo the style of lost contemporary wall and panel painting. In this technique, painters first applied refined white slip as the ground on which they painted designs with liquid slip. High Classical white-ground painting became a specialty of Athenian potters. Artists enhanced the fired vessel with a full range of colors using paints made by mixing tints with white clay, and also using tempera, an opaque, water-based medium mixed with glue or egg white. This fragile decoration deteriorated easily, and for that reason seems to have been favored for funerary, votive, and other non-utilitarian vessels.

Tall, slender, one-handled white-ground **lekythoi** were used to pour libations during religious rituals. Some convey grief and loss, with scenes of departing figures bidding farewell. Others depict grave stelai draped with garlands. Still others envision the deceased returned to the prime of life and engaged in a seemingly everyday activity. A white-ground lekythos, dated about 450–440 BCE, shows a young servant girl carrying a stool for a small chest of valuables to a well-dressed woman of regal bearing, the dead person whom the vessel memorializes (**FIG. 5–51**). As on the stele of Ktesilaos and Theano (see FIG. **5–50**), the scene portrayed here contains no overt signs of grief, but a quiet sadness pervades it. The two figures seem to inhabit different worlds, their glances somehow failing to meet.

THE LATE CLASSICAL PERIOD, c. 400–323 BCE

After the Spartans defeated Athens in 404 BCE, they set up a pro-Spartan government so oppressive that within a year the Athenians rebelled against it, killed its leader, Kritias, and restored democracy. Athens recovered its independence and its economy revived, but it never regained its dominant political and military status. It did, however, retain its reputation as a center of artistic and intellectual life. In 387 BCE, the great philosopher-teacher Plato founded a school just outside Athens, as his student Aristotle did later. Among Aristotle's students was young Alexander of Macedon, known to history as Alexander the Great.

In 359 BCE, a crafty and energetic warrior, Philip II, had come to the throne of Macedon. In 338, he defeated Athens and rapidly conquered the other Greek cities. When he was assassinated two years later, his kingdom passed to his 20-year-old son, Alexander, who consolidated his power and led a united Greece in a war of revenge and conquest against the Persians. In 334 BCE, he crushed the Persian army and conquered Syria and Phoenicia. By 331, he had occupied Egypt and founded the seaport he named Alexandria. The Egyptian priests of Amun recognized him as the son

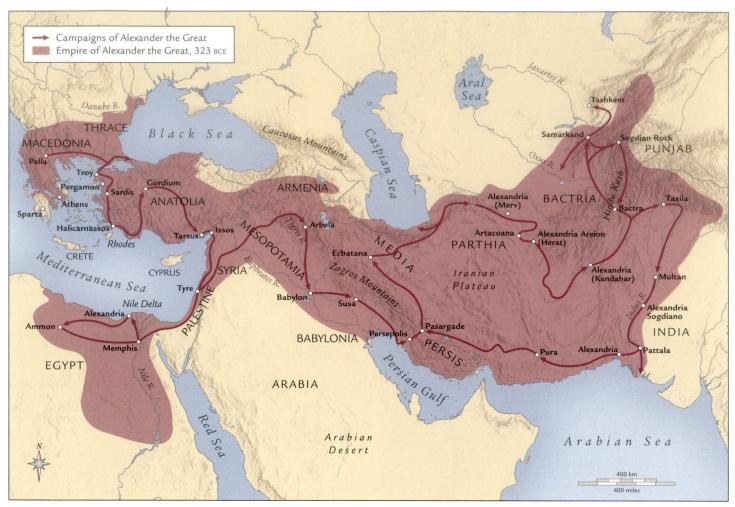

MAP 5-2 • HELLENISTIC GREECE

Alexander the Great created a Greek empire that extended from the Greek mainland and Egypt across Asia Minor and as far east as India.

of a god, an idea he readily adopted. That same year, he reached the Persian capital of Persepolis and continued east until reaching present-day Pakistan in 326 BCE; his troops then refused to go any farther (MAP 5-2). On the way home in 323 BCE, Alexander died of a fever. He was only 33 years old.

Changing political conditions never seriously dampened the Greeks' artistic creativity. Indeed, artists experimented widely with new subjects and styles. Although they maintained a Classical approach to composition and form, they relaxed its conventions, supported by a sophisticated new group of patrons drawn from the courts of Philip and Alexander, wealthy aristocrats in Asia Minor, and foreign aristocrats eager to import Greek works and, sometimes, Greek artists.

SCULPTURE

Throughout the fifth century BCE, sculptors had accepted and worked within standards for the ideal proportions and forms of the human figure, as established by Pheidias and Polykleitos at mid century. But fourth-century BCE artists began to challenge and modify those standards. On mainland Greece, in particular,

a new canon of proportions associated with the sculptor Lysippos emerged for male figures—now eight or more "heads" tall rather than the six-and-a-half or seven-head height of earlier works. The calm, noble detachment characteristic of High Classical figures gave way to more sensitively rendered expressions of wistful introspection, dreaminess, even fleeting anxiety or lightheartedness.

PRAXITELES According to the Greek traveler Pausanias, writing in the second century CE, the Late Classical sculptor Praxiteles (active in Athens from about 370 to 335 BCE or later) carved a "Hermes of stone who carries the infant Dionysos" for the Temple of Hera at Olympia. In 1875, just such a statue depicting the messenger god Hermes teasing the baby Dionysos with a bunch of grapes was discovered in the ruins of this temple (**FIG. 5-52**). Initially accepted as an original work of Praxiteles because of its high quality, recent studies hold that it is probably an excellent Roman or Hellenistic copy.

The sculpture highlights the differences between the fourth- and fifth-century BCE Classical styles. Hermes has a smaller head and a more sensual and sinuous body than Polykleitos' *Spear*

Bearer (see "The Canon' of Polykleitos," page 134). His off-balance, S-curving pose, requires him to lean on a post—a clear contrast with the balanced posture of Polykleitos' work. Praxiteles also created a sensuous play of contrasting textures over the figure's surface, juxtaposing the gleam of smooth flesh with crumpled draperies and rough locks of hair. Praxiteles humanizes his subject with a hint of narrative—two gods, one a loving adult and the other a playful child, caught in a moment of absorbed companionship.

Around 350 BCE, Praxiteles created a daring statue of Aphrodite for the city of Knidos in Asia Minor. Although artists of the fifth century BCE had begun to hint boldly at the naked female body beneath tissue–thin drapery as in the panel showing a Nike adjusting her sandal (see FIG. 5–46)—this Aphrodite was apparently the first statue by a well–known Greek sculptor to depict a fully nude woman, and it set a new standard (FIG. 5–53). Although nudity among athletic young men was admired in Greek society, nudity among women was seen as a sign of low character. The acceptance of nudity in statues of Aphrodite may be related to the gradual merging of the Greeks' concept of this goddess with some of the characteristics of the Phoenician goddess Astarte (the Babylonian Ishtar), who was nearly always shown nude in Near Eastern art.

In the version of Praxiteles' statue seen here (actually a composite of two Roman copies), the goddess is preparing to take a bath, with a water jug and her discarded clothing at her side. Her hand is caught in a gesture of modesty that only calls attention to her nudity. Her strong and well-toned body leans forward slightly, with one projecting knee in a seductive pose that emphasizes the swelling forms of her thighs and abdomen. According to an old legend, the sculpture was so realistic that Aphrodite herself journeyed to Knidos to see it and cried out in shock, "Where did Praxiteles see me naked?" The Knidians were so proud of their Aphrodite that they placed it in an open shrine where people could view it from every side. Hellenistic and Roman copies probably numbered in the hundreds, and nearly 50 survive in various collections today.

5-52 • Praxiteles or his followers HERMES AND THE INFANT DIONYSOS

Probably a Hellenistic or Roman copy after a Late Classical 4th–century BCE original. Marble, with remnants of red paint on the lips and hair, height 7'1" (2.15 m). Archaeological Museum, Olympia.

Discovered in the rubble of the ruined Temple of Hera at Olympia in 1875, this statue is now widely accepted as an outstanding Roman or Hellenistic copy. Support for this conclusion comes from certain elements typical of Roman sculpture: Hermes' sandals, which recent studies suggest are not accurate for a fourth-century BCE date; the supporting element of crumpled fabric covering a tree stump; and the use of a reinforcing strut, or brace, between Hermes' hip and the tree stump.

5-53 • Praxiteles APHRODITE OF KNIDOS

Composite of two similar Roman copies after the original marble of c. 350 BCE. Marble, height 6'8" (2.04 m). Vatican Museums, Museo Pio Clementino, Gabinetto delle Maschere, Rome.

The head of this figure is from one Roman copy, the body from another. Seventeenth- and eighteenth-century ce restorers added the nose, the neck, the right forearm and hand, most of the left arm, and the feet and parts of the legs. This kind of restoration would rarely be undertaken today, but it was frequently done and considered quite acceptable in the past, when archaeologists were trying to put together a body of work documenting the appearance of lost Greek statues.

5-54 • Lysippos MAN SCRAPING HIMSELF (APOXYOMENOS)

Roman copy after the original bronze of c. 350–325 BCE. Marble, height 6'9'' (2.06 m). Vatican Museums, Museo Pio Clementino, Gabinetto dell'Apoxyomenos, Rome.

LYSIPPOS Compared to Praxiteles, more details of Lysippos' life are known, and, although none of his original works has survived, there are many copies of the sculpture he produced between c. 350 and 310 BCE. He claimed to be entirely self-taught and asserted that "nature" was his only model, but he must have received some technical training in the vicinity of his home, near Corinth. He expressed great admiration for Polykleitos, but his own figures reflect a different ideal and different proportions. For his famous portrayal of a MAN SCRAPING HIMSELF (APOXYOMENOS), known today only from Roman copies (FIG. 5-54), he chose a typical Classical subject—a nude male athlete. But instead of a figure actively engaged in his sport, striding, or standing at ease, Lysippos depicted a young man after his workout, methodically removing oil and dirt from his body with a scraping tool called a strigil.

This tall and slender figure with a relatively small head, makes a telling comparison with Polykleitos' *Spear Bearer* (see "The Canon' of Polykleitos," page 134). Not only does it reflect a different canon of proportions, but the legs are in a wider stance to counterbalance the outstretched arms, and there is a pronounced curve to the posture. The *Spear Bearer* is contained within fairly simple, compact contours and oriented toward a center-front viewer. In contrast, the arms of the *Man Scraping Himself* break free into the surrounding space, inviting the viewer to move around the statue to absorb its full aspect. Roman authors, who may have been describing the bronze original rather than a marble copy, remarked on the subtle modeling of the statue's elongated body and the spatial extension of its pose.

When Lysippos was summoned to create a portrait of Alexander the Great, he portrayed Alexander as a full-length standing figure with an upraised arm holding a scepter, the same way he posed Zeus. Based on description and later copies, we know Lysippos idealized the ruler as a ruggedly handsome, heavy-featured young man with a large Adam's apple and short, tousled hair. According to the Roman historian Plutarch, Lysippos presented Alexander in a meditative pose, perhaps contemplating grave decisions, waiting to receive divine advice.

THE ART OF THE GOLDSMITH

The detailed, small-scale work of Greek goldsmiths followed the same stylistic trends and achieved the same high standards of technique and execution characterizing other arts. A specialty of Greek goldsmiths was the design of earrings in the form of tiny works of sculpture. They were often placed on the ears of marble statues of goddesses, but they adorned the ears of living women as well. **EARRINGS** dated about 330–300 BCE depict the abducted youth Ganymede caught in the grasp of an eagle (Zeus) (**FIG. 5–55**), a technical *tour-de-force*. Slightly more than 2 inches high, they were hollow-cast using the lost-wax process, no doubt to make them light on the ear. Despite their small size, they capture the drama of their subject, evoking swift movement through space.

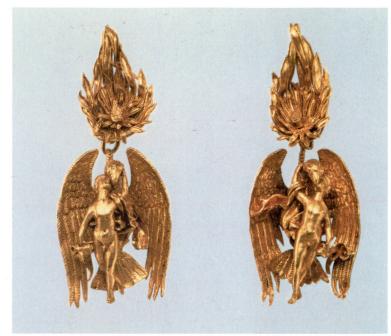

5–55 • EARRINGS c. 330–300 BCE. Hollow-cast gold, height 2%" (6 cm). Metropolitan Museum of Art, New York. Harris Brisbane Dick Fund, 1937. (37.11.9–10)

PAINTING AND MOSAICS

Roman observers such as Pliny the Elder praised Greek painters for their skill in capturing the appearance of the real world. Roman patrons also admired Greek murals, and they commissioned copies, in fresco or **mosaic**, to decorate their homes. (Mosaics—created from **tesserae**, small cubes of colored stone or marble—provide a permanent waterproof surface that the Romans used for floors in important rooms.) A first-century CE Roman mosaic, **ALEXANDER THE GREAT CONFRONTS DARIUS III AT THE BATTLE**OF ISSOS (FIG. 5-56), for example, replicates a Greek painting of about 310 BCE. Pliny the Elder mentions a painting of this subject by Philoxenos of Eretria, but a new theory claims the original as a work of Helen of Egypt.

Such copies document a growing taste for dramatic narrative subjects in late fourth-century BCE Greek painting. Certainly the scene here is one of violent action, where diagonal disruption and radical foreshortening draw the viewer in and elicit an emotional response. Astride a rearing horse at the left, his hair blowing free and his neck bare, Alexander challenges the helmeted and armored Persian leader, who stretches out his arm in a gesture of defeat and apprehension as his charioteer whisks him back toward safety within the Persian ranks. The mosaicist has created an illusion of solid figures through modeling, mimicking the play of light on three-dimensional surfaces by highlights and shading.

The interest of fourth-century BCE artists in creating believable illusions of the real world was the subject of anecdotes repeated by later writers. One popular legend involved a floral designer named Glykera—widely praised for her artistry in weaving blossoms and greenery into wreaths, swags, and garlands for religious processions

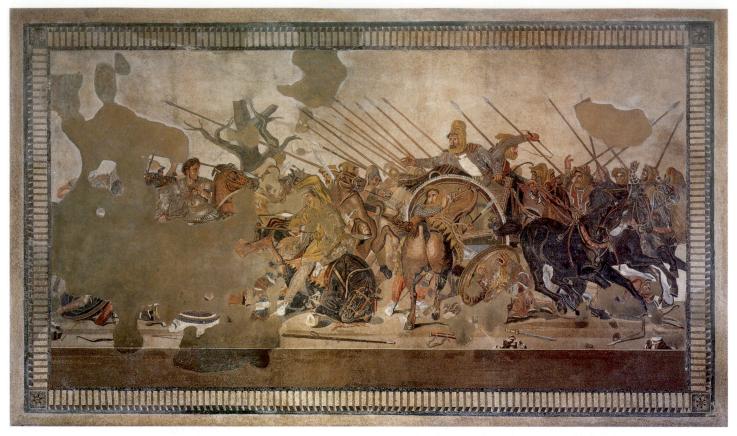

5-56 • ALEXANDER THE GREAT CONFRONTS DARIUS III AT THE BATTLE OF ISSOS

Floor mosaic, Pompeii, Italy. 1st-century BCE Roman copy of a Greek wall painting of c. 310 BCE, perhaps by Philoxenos of Eretria or Helen of Egypt. Entire panel $8^{\prime}10^{\prime\prime}\times17^{\prime}$ (2.7 \times 5.2 m). Museo Archeologico Nazionale, Naples.

and festivals—and Pausias—the foremost painter of his day. Pausias challenged Glykera to a contest, claiming that he could paint a picture of one of her complex works that would appear as lifelike to the spectator as her real one. According to the legend, he succeeded. It is not surprising, although perhaps unfair, that the opulent floral borders so popular in later Greek painting and mosaics are described as "Pausian" rather than "Glykeran."

A Pausian design frames a mosaic floor from a palace at Pella (Macedonia), dated about 300 BCE (FIG. 5–57). The floor features a series of hunting scenes, such as the *Stag Hunt* seen here, prominently signed by an artist named Gnosis. The blossoms, leaves, spiraling tendrils, and twisting, undulating stems that frame this scene, echo the linear patterns formed by the

5-57 • Gnosis STAG HUNT

Detail of mosaic floor decoration from Pella, Macedonia (in present-day Greece). 300 BCE. Pebbles, central panel $10'7'/2'' \times 10'5''$ (3.24 \times 3.17 m). Signed at top: "Gnosis made it." Archaeological Museum, Pella.

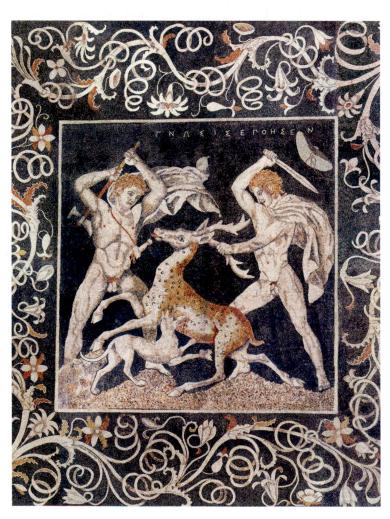

hunters, the dog, and the struggling stag. The human and animal figures are modeled in light and shade, and the dog's front legs are expertly foreshortened to create the illusion that the animal is turning at a sharp angle into the picture. The work is all the more impressive because it was not made with uniformly cut marble in different colors, but with a carefully selected assortment of natural pebbles.

THE HELLENISTIC PERIOD, 323–31/30 BCE

When Alexander died unexpectedly at age 33 in 323 BCE, he left a vast empire with no administrative structure and no accepted successor. Almost immediately his generals turned against one another, local leaders fought to regain their lost autonomy, and the empire began to break apart. By the early third century BCE, three of Alexander's generals—Antigonus, Ptolemy, and Seleucus—had carved out kingdoms. The Antigonids controlled Macedonia and mainland Greece; the Ptolemies ruled Egypt; and the Seleucids controlled Asia Minor, Mesopotamia, and Persia.

Over the course of the second and first centuries BCE, these kingdoms succumbed to the growing empire centered in Rome. Ptolemaic Egypt endured the longest, and its capital Alexandria, flourished as a prosperous seaport and great center of learning and the arts. Its library is estimated to have contained 700,000 papyrus and parchment scrolls. The Battle of Actium in 31 BCE and the death in 30 BCE of Egypt's last Ptolemaic ruler, the remarkable Cleopatra, marks the end of the Hellenistic period.

Alexander's lasting legacy was the spread of Greek culture far beyond its original borders, but artists of the Hellenistic period developed visions discernibly distinct from those of their Classical Greek predecessors. Where earlier artists sought to codify a generalized artistic ideal, Hellenistic artists shifted focus to the individual and the specific. They turned increasingly away from the heroic to the everyday, from gods to mortals, from aloof serenity to individual emotion, and from decorous drama to emotional melodrama. Their works appeal to the senses through luscious or lustrous surface treatments and to our hearts as well as our intellects through expressive subjects and poses. Although such tendencies are already evident during the fourth century BCE, they become more pronounced in Hellenistic art.

THE CORINTHIAN ORDER IN HELLENISTIC ARCHITECTURE

In the architecture of the Hellenistic period, a variant of the Ionic order that had previously been reserved for interiors—called Corinthian by the Romans and featuring elaborate foliate capitals—challenged the dominant Doric and Ionic orders (see "The Greek Orders," page 110). In Corinthian capitals, curly acanthus leaves and coiled flower spikes surround a basket-shaped core. Above the capitals, the Corinthian entablature, like the Ionic, has a stepped-out architrave and a continuous frieze, but it includes additional bands of carved moldings.

The Corinthian **TEMPLE OF OLYMPIAN ZEUS**, located in the lower city of Athens at the foot of the Akropolis, was designed by the Roman architect Cossutius in the second century BCE (**FIG. 5–58**) on the foundations of an earlier Doric temple, but it was not completed until three centuries later, under the patronage of the Roman emperor Hadrian. Viewed through these huge columns—55 feet 5 inches tall—the Parthenon seems modest in comparison. But the new temple followed long-established

View from the southeast with the Akropolis in the distance. Building and rebuilding phases: foundation c. 520–510 BCE, using the Doric order; temple designed by Cossutius begun 175 BCE; left unfinished 164 BC; completed 132 CE using Cossutius' design. Height of columns 55'5" (16.89 m).

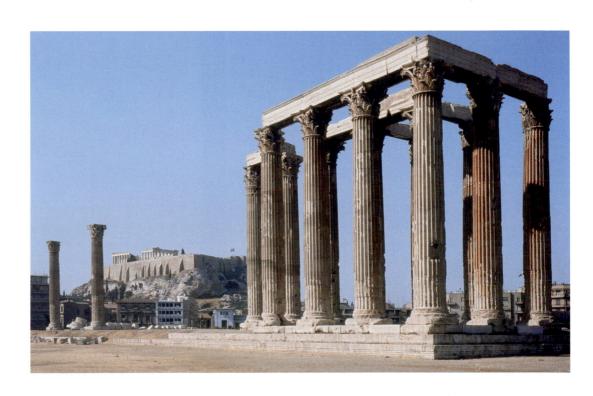

ART AND ITS CONTEXTS | Greek Theaters

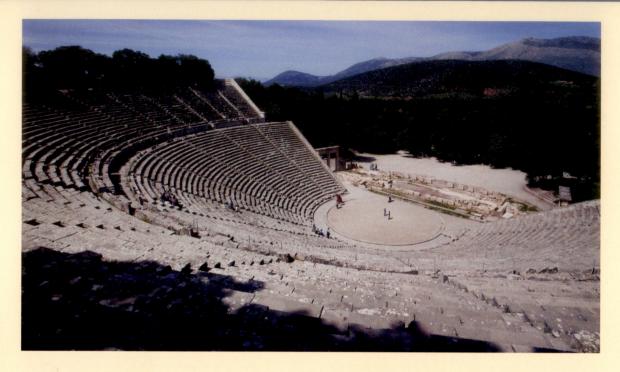

5-59 • OVERALL
VIEW (A) AND
RECONSTRUCTION
DRAWING (B) OF
THE THEATER,
EPIDAUROS
Pelopopose Greece

Peloponnese, Greece. Fourth century BCE and later.

In ancient Greece, the theater was more than mere entertainment: It was a vehicle for the communal expression of religious beliefs through music, poetry, and dance. In very early times, theater performances took place on the hard-packed dirt or stone-surfaced pavement of an outdoor threshing floor—the same type of floor later incorporated into religious sanctuaries. Whenever feasible, dramas were also presented facing a steep hill that served as elevated seating for the audience. Eventually such sites were made into permanent open-air auditoriums. At first, tiers of seats were simply cut into the side of the hill. Later, builders improved them with stone.

During the fifth century BCE, the plays were usually tragedies in verse based on popular myths, and were performed at festivals dedicated to Dionysos; the three great Greek tragedians—Aeschylus, Sophocles, and Euripides—created works that would define tragedy for centuries. Because they were used continuously and frequently modified over many centuries, early theaters have not survived in their original form.

The theater at Epidauros (**FIG. 5–59**), built in the second half of the fourth century BCE, is characteristic. A semicircle of tiered seats built into the hillside overlooked the circular performance area, called the orchestra, at the center of which was an altar to Dionysos. Rising behind the orchestra was a two-tiered stage structure made up of the vertical *skene* (scene)—an architectural backdrop for performances that also screened the backstage area from view—and the *proskenion* (**proscenium**), a raised platform in front of the *skene* that was

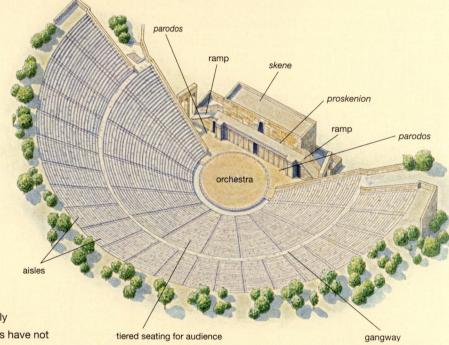

increasingly used over time as an extension of the orchestra. Ramps connecting the *proskenion* with lateral passageways provided access for performers. Steps gave the audience access to the 55 rows of seats and divided the seating area into uniform wedge-shaped sections. The tiers of seats above the wide corridor, or gangway, were added at a much later date. This design provided uninterrupted sight lines and good acoustics, and allowed for the efficient entrance and exit of the 12,000 spectators. No better design has ever been created.

conventions. It was an enclosed rectangular building surrounded by a screen of columns standing on a three-stepped base. It is, quite simply, a Greek temple grown very large.

SCULPTURE

Hellenistic sculptors produced an enormous variety of work in a wide range of materials, techniques, and styles. The period was marked by two broad and conflicting trends. One trend emulated earlier Classical models; sculptors selected aspects of favored works of the fourth century BCE and incorporated them into their own work. The other (sometimes called anti-Classical or Baroque) abandoned Classical strictures and experimented freely with new forms and subjects. This style was especially strong in Pergamon and other eastern centers of Greek culture.

PERGAMON Pergamon—capital of a breakaway state within the Seleucid realm established in the early third century BCE—quickly became a leading center of the arts and the hub of an experimental sculptural style that had far-reaching influence throughout the Hellenistic period. This radical style characterizes a monument com-

memorating the victory in 230 BCE of Attalos I (ruled 241–197 BCE) over the Gauls, a Celtic people (see "The Celts," page 150). The monument extols the dignity and heroism of the defeated enemies and, by extension, the power and virtue of the Pergamenes.

The bronze figures of Gauls mounted on the pedestal of this monument are known today only from Roman copies in marble. One captures the slow demise of a wounded Celtic soldier-trumpeter (FIG. 5–60), whose lime-spiked hair, mustache, and twisted neck ring or torc (reputedly the only thing the Gauls wore into battle) identify him as a barbarian (a label the ancient Greeks used for all foreigners, whom they considered uncivilized). But the sculpture also depicts his dignity and heroism in defeat, inspiring in viewers both admiration and pity for this fallen warrior. Fatally injured, he struggles to rise, but the slight bowing of his supporting right arm and his unseeing, downcast gaze indicate that he is on the point of death. This kind of deliberate attempt to elicit a specific emotional response in the viewer is known as expressionism, and it was to become a characteristic of Hellenistic art.

The sculptural style and approach seen in the monument to the defeated Gauls became more pronounced and dramatic in later

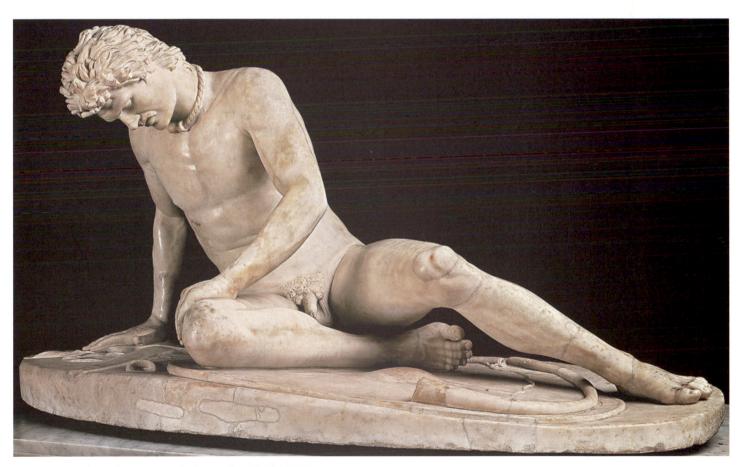

5-60 • EPIGONOS (?) DYING GALLIC TRUMPETER

Roman copy (found in Julius Caesar's garden in Rome) after the original bronze of c. 220 BCE. Marble, height $36\frac{1}{2}$ " (93 cm). Museo Capitolino, Rome.

Pliny the Elder described a work like the *Dying Gallic Trumpeter*, attributing it to an artist named Epigonos. Recent research indicates that Epigonos probably knew the early fifth-century BCE sculpture of the Temple of Aphaia on Aegina, which included the *Dying Warriors* (see FIGS. 5–14, 5–15), and could have had it in mind when he created his own works.

ART AND ITS CONTEXTS | The Celts

During the first millennium BCE, Celtic peoples inhabited most of central and western Europe. The Celtic Gauls portrayed in the Hellenistic Pergamene victory monument (see FIG. 5–60) moved into Asia Minor from Thrace during the third century BCE. The ancient Greeks referred to these neighbors, like all outsiders, as barbarians. Pushed out by migrating people, attacked and defeated by challenged kingdoms like that at Pergamon, and then by the Roman armies of Julius Caesar, the Celts were pushed into the northwesternmost parts of the continent—Ireland, Cornwall, and Brittany. Their wooden sculpture and dwellings and their colorful woven textiles have disintegrated, but spectacular funerary goods such as jewelry, weapons, and tableware survive.

This golden **TORC**, dating sometime between the third and first centuries BCE (**FIG. 5–61**), was excavated in 1866 from a Celtic tomb in

northern France, but it is strikingly similar to the neck ring worn by the dying trumpeter illustrated in FIGURE 5–60. Torcs were worn by noblemen and were sometimes awarded to warriors for heroic performance in combat. Like all Celtic jewelry, the decorative design of this work consists not of natural forms but of completely abstract ornament, in this case created by the careful twisting and wrapping of strands of pure gold, resolved securely by the definitive bulges of two knobs. In Celtic hands, pattern becomes an integral part of the object itself, not an applied decoration. In stark contrast to the culture of the ancient Greeks, where the human figure was at the heart of all artistic development, here it is abstract, non-representational form and its continual refinement that is the central artistic preoccupation.

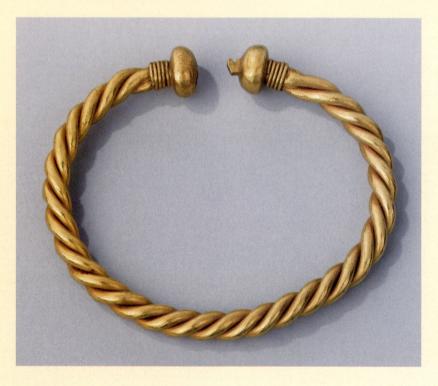

5-61 • TORC Found at Soucy, France. Celtic Gaul, 3rd–1st century BCE. Gold, height $5'' \times$ length 5%'' (12.7 \times 14.5 cm). Musée Nationale du Moyen-Âge, Paris.

works, culminating in the sculptured frieze wrapped around the base of a Great Altar on a mountainside at Pergamon (FIG. 5-62). Now reconstructed inside a Berlin museum, the original altar was enclosed within a single-story Ionic colonnade raised on a high podium reached by a monumental staircase 68 feet wide and nearly 30 feet deep. The sculptural frieze, over 7 feet in height, probably executed during the reign of Eumenes II (197–159 BCE), depicts the battle between the gods and the giants, a mythical struggle that the Greeks saw as a metaphor for their conflicts with outsiders, all of whom they labeled barbarians. In this case it evokes the Pergamenes' victory over the Gauls.

The Greek gods fight here not only with giants, but also with monsters with snakes for legs emerging from the bowels of the earth. In this detail (**FIG. 5-63**), the goddess Athena at the left has

grabbed the hair of a winged male monster and forced him to his knees. Inscriptions along the base of the sculpture identify him as Alkyoneos, a son of the earth goddess Ge. Ge rises from the ground on the right in fear as she reaches toward Athena, pleading for her son's life. At the far right, a winged Nike rushes to crown Athena with a victor's wreath.

The figures in the Pergamon frieze not only fill the space along the base of the altar, they also break out of their architectural boundaries and invade the spectators' space, crawling out onto the steps that visitors climbed on their way to the altar. Many consider this theatrical and complex interaction of space and form to be a benchmark of the Hellenistic style, just as they consider the balanced restraint of the Parthenon sculpture to be the epitome of the High Classical style. Where fifth-century BCE artists sought

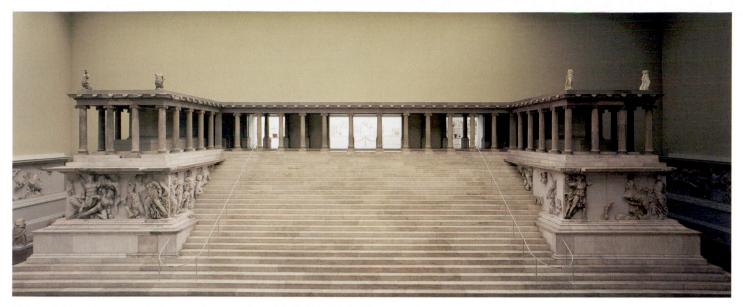

5-62 • RECONSTRUCTED WEST FRONT OF THE ALTAR FROM PERGAMON (IN MODERN TURKEY)

c. 175–150 BCE. Marble, height of figure 7'7" (2.3 m). Staatliche Museen, Berlin.

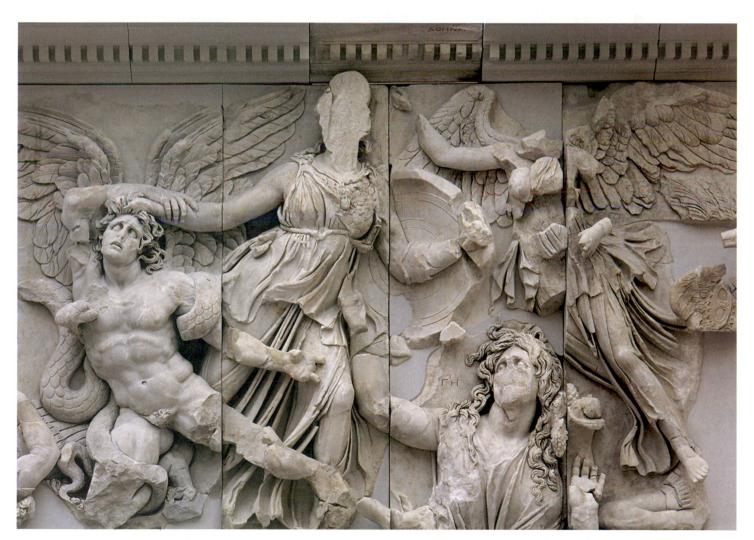

5-63 • ATHENA ATTACKING THE GIANTS

Detail of the frieze from the east front of the altar from Pergamon. c. 175–150 BCE. Marble, frieze height 7'7" (2.3 m). Staatliche Museen, Berlin.

horizontal and vertical equilibrium and control, the Pergamene artists sought to balance opposing forces in three-dimensional space along dynamic diagonals. Classical preference for smooth, evenly illuminated surfaces has been replaced by dramatic contrasts of light and shade playing over complex forms carved with

deeply undercut high relief. The composure and stability admired in the Classical style have given way to extreme expressions of pain, stress, wild anger, fear, and despair. Whereas the Classical artist asked only for an intellectual commitment, the Hellenistic artist demanded that the viewer also empathize.

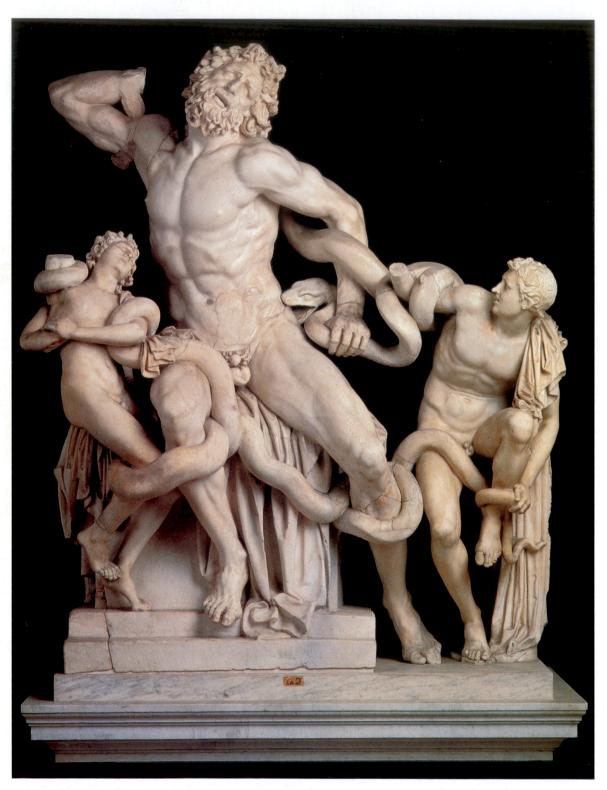

5-64 • Hagesandros, Polydoros, and Athenodoros of Rhodes **LAOCOÖN AND HIS SONS** Original of 1st century BCE, or a Roman copy, adaptation, or original of the 1st century CE. Marble, height 8' (2.44 m). Musei Vaticani, Museo Pio Clementino, Cortile Ottagono, Rome.

THE LAOCOÖN Pergamene artists may have inspired the work of Hagesandros, Polydoros, and Athenodoros, three sculptors on the island of Rhodes named by Pliny the Elder as the creators of the famed **LAOCOÖN AND HIS SONS** (FIG. 5-64). This work has been assumed by many art historians to be a Hellenistic original from the first century BCE, although others argue that it is a brilliant copy, a creative adaptation, or a Hellenistic-style invention, commissioned by an admiring Roman patron in the first century CE.

This complex sculptural composition illustrates an episode from the Trojan War when the priest Laocoön warned the Trojans not to bring within their walls the giant wooden horse left behind by the Greeks. The gods who supported the Greeks retaliated by sending serpents from the sea to destroy Laocoön and his sons as they walked along the shore. The struggling figures, anguished faces, intricate diagonal movements, and skillful unification of diverse forces in a complex composition all suggest a strong relationship between Rhodian and Pergamene sculptors. Although sculpted in the round, the Laocoön was composed to be seen frontally and from close range, and the three figures resemble the relief sculpture on the altar from Pergamon.

THE NIKE OF SAMOTHRACE This winged figure of Victory (FIG. 5-65) is even more theatrical than the Laocoön. In its original setting—in a hill-side niche high above the theater in the Sanctuary of the Great Gods at Samothrace, perhaps drenched with spray from a fountain—this huge goddess must have reminded visitors of the god in Greek plays who descends from heaven to determine the outcome of the drama. The forward momentum of the

5-65 • NIKE (VICTORY) OF SAMOTHRACESanctuary of the Great Gods, Samothrace. c. 180 BCE (?). Marble, height 8'1" (2.45 m). Musée du Louvre, Paris.

The wind-whipped costume and raised wings of this Nike indicate that she has just alighted on the prow of the stone ship that formed the original base of the statue. The work probably commemorated an important naval victory, perhaps the Rhodian triumph over the Seleucid king Antiochus III in 190 BCE. The Nike (lacking its head and arms) and a fragment of its stone ship base were discovered in the ruins of the Sanctuary of the Great Gods by a French explorer in 1863 (additional fragments were discovered later). Soon after, the sculpture entered the collection of the Louvre Museum in Paris.

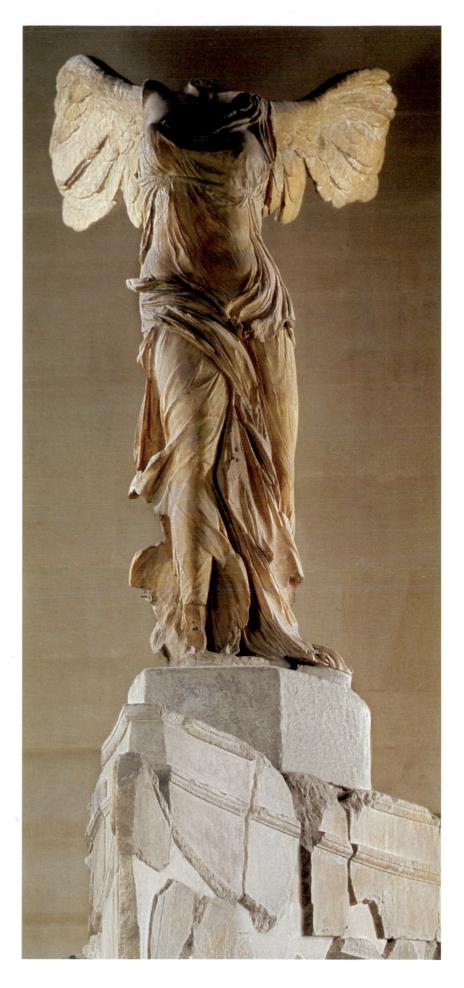

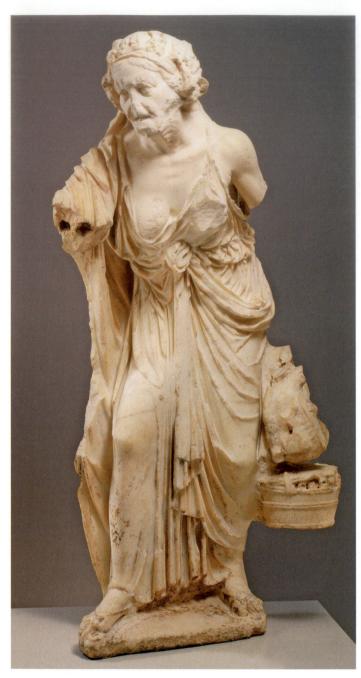

5-66 • OLD WOMAN

Roman 1st century CE copy of a Greek work of the 2nd century BCE. Marble, height $49\frac{1}{2}$ " (1.25 m).

Metropolitan Museum of Art, New York. Rogers Fund, 1909. (09.39)

5-67 • Alexandros from Antioch-on-the-Orontes **APHRODITE OF MELOS (ALSO CALLED VENUS DE MILO)**

c. 150-100 BCE. Marble, height 6'8" (2.04 m). Musée du Louvre, Paris.

The original appearance of this famous statue's missing arms has been much debated. When it was dug up in a field on the Cycladean island of Milos in 1820, some broken pieces (now lost) found with it indicated that the figure was holding out an apple in its right hand. Many judged these fragments to be part of a later restoration, not part of the original statue. Another theory is that Aphrodite was admiring herself in the highly polished shield of the war god Ares, an image that was popular in the second century BCE. This theoretical "restoration" would explain the pronounced S-curve of the pose and the otherwise unnatural forward projection of the knee.

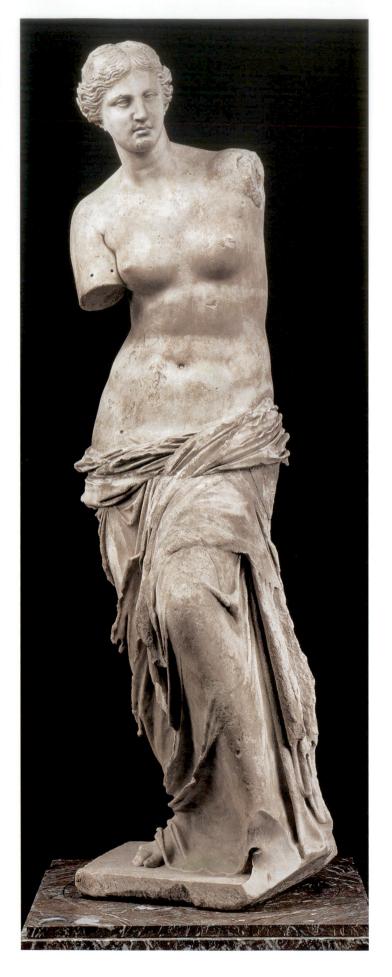

Nike's heavy body is balanced by the powerful backward thrust of her enormous wings. The large, open movements of the figure, the strong contrasts of light and dark on the deeply sculpted forms, and the contrasting textures of feathers, fabric, and skin typify the finest Hellenistic art.

OLD WOMAN The Hellenistic world was varied and multicultural, and some artists turned from generalizing idealism to an attempt to portray the world as they saw it, including representations of people from every level of society, unusual types as well as ordinary individuals. Traditionally, this figure of an aged woman (FIG. 5-66) has been seen as a seller on her way to the agora, carrying three chickens and a basket of produce. Despite the bunched and untidy disposition of her dress, however, it is elegant in design and made of fine fabric, and her hair is not in total disarray. These characteristics, along with the woman's sagging lower jaw, unfocused stare, and lack of concern for her exposed breasts, have led to a more recent interpretation that sees her as an aging, dissolute follower of Dionysos on her way to a religious festival, carrying offerings and wearing on her head the ivy wreath associated with the cult of this god of wine. Either way, she is the antithesis of the Nike of Samothrace. Yet in formal terms, both sculptures stretch out assertively into the space around them, both demand an emotional response from the viewer, and both display technical virtuosity in the rendering of forms and textures.

APHRODITE OF MELOS Not all Hellenistic artists followed the descriptive and expressionist tendencies of the artists of Pergamon and Rhodes. Some turned to the past, creating an eclectic style by reexamining and borrowing elements from earlier Classical styles and combining them in new ways. Many looked back to Praxiteles and Lysippos for their models. This was the case with Alexandros son of Menides, the sculptor of an *Aphrodite* (better known as the **VENUS DE MILO**) (FIG. 5-67) found on the island of Melos by French excavators in the early nineteenth century. The dreamy gaze recalls Praxiteles' work (see FIG. 5-53), and the figure has the heavier proportions of High Classical sculpture, but the twisting stance and the strong projection of the knee are typical of Hellenistic art, as is the rich three-dimensionality of the drapery. The juxtaposition of soft flesh and crisp drapery, seemingly in the process of slipping off the figure, adds a note of erotic tension.

By the end of the first century BCE, the influence of Greek painting, sculpture, and architecture had spread to the artistic communities of the emerging Roman Empire. Roman patrons and artists maintained their enthusiasm for Greek art into Early Christian and Byzantine times. Indeed, so strong was the urge to emulate the work of great Greek artists that, as we have seen throughout this chapter, much of our knowledge of Greek achievements comes from Roman replicas of Greek artworks and descriptions of Greek art by Roman writers.

THINK ABOUT IT

- 5.1 Discuss the development of a characteristically Greek approach to the representation of the male nude by comparing the Anavysos Kouros (FIG. 5–20), the Kritios Boy (FIG. 5–26), the Spear Bearer (FIG. 5–42), and Hermes and the Infant Dionysos (FIG. 5–52). What changes and what remains constant?
- 5.2 Choose a work from this chapter that illustrates a scene from a Greek myth or a scene from daily life in ancient Greece. Discuss the nature of the story or event, the particular aspect chosen for illustration by the artist, and the potential meaning of the episode in relation to its cultural context.
- What ideals are embodied in the term "High Classicism" and what are the value judgments that underlie this art-historical category? Select one sculpture and one building discussed in the chapter, and explain why these works are regarded as High Classical.
- **5.4** Distinguish the attributes of the Doric and Ionic orders, focusing your discussion on a specific building representing each.

CROSSCURRENTS

What is the common theme found in the heroic subjects depicted on these two very different works? What does the specific function and location of each indicate about the importance of that theme in each culture?

FIG. 2-8

FIG. 5-38

Study and review on myartslab.com

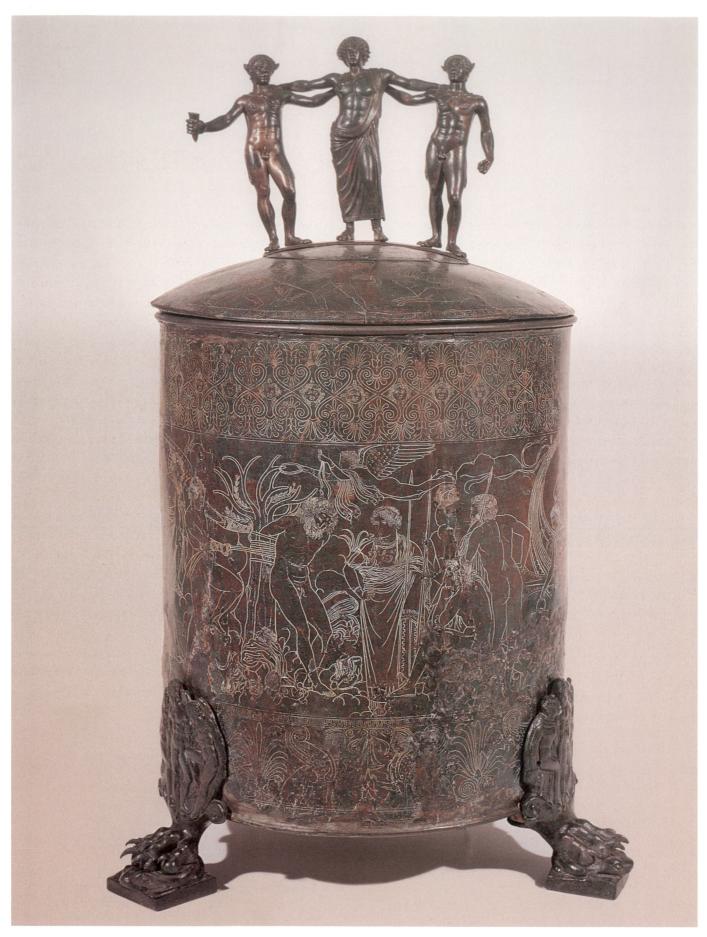

6-1 • Novios Plautios THE FICORONI CISTA 350–300 BCE. Bronze, height 2'61/4" (78.6 cm). Museo Nazionale di Villa Giulia, Rome.

Etruscan and Roman Art

Long before the Romans ruled the entire Italic peninsula as the center of an expanding empire, the Etruscans created a thriving culture in northern and central Italy. Etruscan artists were known throughout the Mediterranean world for their special sophistication in casting and engraving on bronze. Some of their most extraordinary works were created for domestic use, including a group of surviving **cistae**—cylindrical containers used by wealthy women as cases for toiletry articles such as mirrors, cosmetics, and perfume.

This exquisitely wrought and richly decorated example—THE FICORONI CISTA, named after an eighteenth-century owner—was made in the second half of the fourth century BCE and excavated in Palestrina (FIG. 6-1). It was commissioned by an Etruscan woman named Dindia Macolnia as a gift for her daughter, perhaps on the occasion of her marriage. The artist Novios Plautios signed the precisely engraved drawings around the cylinder, accomplished while the hammered bronze sheet from which it was constructed was still flat. First he incised lines within the metal and then filled them with a white substance to make them stand out. The cista's legs and handle—created by the figural group of Dionysus between two satyrs—were cast as separate pieces, attached during the assembly process.

The natural poses and individualization of these figures—both incised and cast—recalls the relaxed but lively

naturalism of Etruscan wall paintings, but the Classicizing idealization of bodies and poses seems to come directly from contemporary Greek art. Furthermore, the use of broad foliate and ornamental bands to frame the frieze of figural narrative running around the cylinder matches the practice of famous Greek ceramic painters like Euphronios (see "A Closer Look," page 119). As with Greek pots, the most popular subjects for cistae were Greek myths. Here Novios has engraved sequential scenes drawn from an episode in the story of the Argonauts' quest for the Golden Fleece. The sailors sought water in the land of King Amykos, but the hostile king would only give them water from his spring if they beat him in a boxing match. After the immortal Pollux defeated Amykos, the Argonauts tied the king to a tree, the episode highlighted on the side of the cista seen here.

Novios Plautios probably based this scene on a monumental, mid-fourth-century BCE Greek painting of the Argonauts by Kydias that seems to have been in Rome at this time—perhaps explaining why the artist tells us in his incised signature that he executed this work in Rome. The combination of cultural components coming together in the creation of this cista—Greek stylistic sources in the work of an Etruscan artist living in Rome—will continue as Roman art develops out of the native heritage of Etruria and the emulation of the imported Classical heritage of the Greeks.

LEARN ABOUT IT

- **6.1** Explore the various ways Romans embellished the walls and floors of their houses with illusionistic painting in fresco and mosaic.
- **6.2** Trace the development and use of portraiture as a major artistic theme for the ancient Romans.
- **6.3** Examine the ways that Etruscan funerary art celebrates the vitality of human existence.
- **6.4** Investigate how knowledge of Roman advances in structural technology furthers our understanding of Roman civic architecture.

((• Listen to the chapter audio on myartslab.com

THE ETRUSCANS

At the end of the Bronze Age (about 1000 BCE), a central European people known as the Villanovans occupied the northern and western regions of the boot-shaped Italian peninsula, while the central area was home to people who spoke a closely related group of Italic languages, Latin among them. Beginning in the eighth century BCE, Greeks established colonies on the Italian mainland and in Sicily. From the seventh century BCE, people known as Etruscans, probably related to the Villanovans, gained control of the north and much of today's central Italy, an area known as Etruria. They reached the height of their power in the sixth century BCE, when they expanded into the Po River valley to the north and the Campania region to the south (MAP 6-1).

Etruscan wealth came from fertile soil and an abundance of metal ore. Besides being farmers and metalworkers, the Etruscans were also sailors and merchants, and they exploited their resources in trade with the Greeks and with other people of the eastern Mediterranean. Etruscan artists knew and drew inspiration from Greek and Near Eastern art, assimilating such influences to create a distinctive Etruscan style.

ETRUSCAN ARCHITECTURE

In architecture, the Etruscans established patterns of building that would be adopted later by the Romans. Cities were laid out on grid plans, like cities in Egypt and Greece, but more regularly. Two main streets—one usually running north—south and the other east—west—divided the city into quarters, with the town's business district centered at their intersection. We know something about Etruscan domestic architecture within these quarters, because they created house-shaped funerary urns and also decorated the interiors of tombs to resemble houses. Dwellings were designed around a central courtyard (or atrium) that was open to the sky, with a pool or cistern fed by rainwater.

Walls with protective gates and towers surrounded Etruscan cities. The third- to second-century BCE city gate of Perugia, called the **PORTA AUGUSTA**, is one of the few surviving examples of Etruscan monumental architecture (**FIG. 6-2**). A tunnel-like passageway between two huge towers, this gate is significant for anticipating the Roman use of the round arch, which is here extended to create a semicircular barrel vault over the passageway (see "The Roman Arch," page 170, and "Roman Vaulting," page 187). A square frame surmounted by a horizontal decorative element resembling an entablature sets off the entrance arch, which is accentuated by a molding. The decorative section is filled with a row of circular panels, or **roundels**, alternating with rectangular, columnlike upright strips called **pilasters** in an effect reminiscent of the Greek Doric frieze.

ETRUSCAN TEMPLES

The Etruscans incorporated Greek deities and heroes into their pantheon and, like the ancient Mesopotamians, used divination

6-2 • PORTA AUGUSTAPerugia, Italy. 3rd–2nd century BCE.

to predict future events. Beyond this and their burial practices (as revealed by the findings in their tombs), we know little about their religious beliefs. Our knowledge of the appearance of Etruscan temples comes from a few excavated foundations, from ceramic votive models, and from the later writings of the Roman architect Vitruvius, who compiled, sometime between 33 and 23 BCE, descriptions of the nature of Etruscan architecture (see "Roman Writers on Art," page 167).

Etruscans built their temples with mud-brick walls; columns and entablatures were made of wood or a quarried volcanic rock (tufo) that hardens upon exposure to air. Vitruvius indicates that like the Greeks, Etruscan builders also used the post-and-lintel structure and gable roofs, with bases, column shafts, and capitals recalling the Doric or Ionic order, and entablatures resembling a Doric frieze (**FIG. 6-3**). Vitruvius used the term "**Tuscan order**" to describe the characteristic Etruscan variation of Doric, with an unfluted shaft and simplified base, capital, and entablature (see "Roman Architectural Orders," page 161).

Like the Greeks, the Etruscans built rectangular temples on a high platform, but often imbedded them within urban settings. Rather than surrounding temples uniformly on all sides with a stepped stereobate and peristyle colonnade, as was the practice in

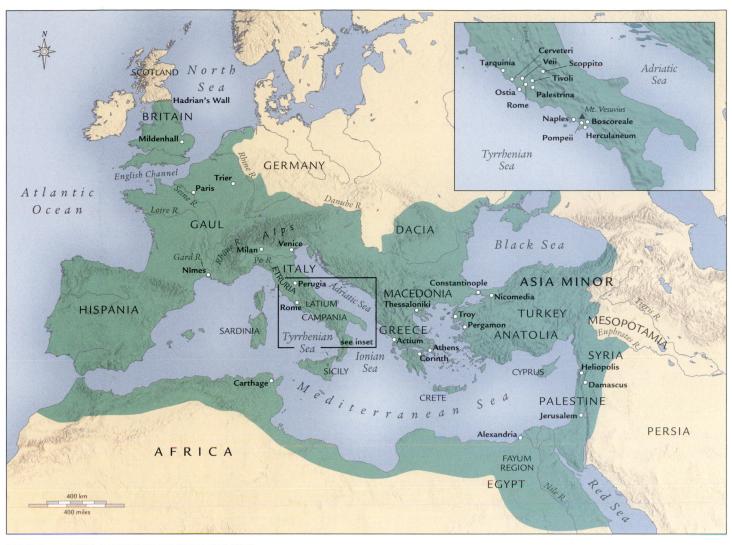

MAP 6-1 • THE ANCIENT ROMAN WORLD

This map shows the Roman Empire at its greatest extent, which was reached in 106 cF under the emperor Trajan.

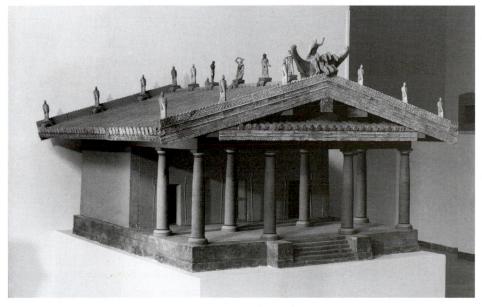

6-3 • MODEL (A) AND PLAN (B) OF AN ETRUSCAN TEMPLE Based on descriptions by Vitruvius.

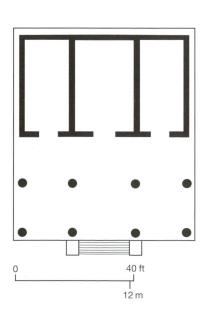

Greece (see FIGS. 5–10, 5–36), Etruscans built a single flight of stairs leading to a columned porch on one short side. An approach to siting and orientation also constitutes an important difference from Greek temples, which were built toward the center of an enclosed sacred precinct (see FIGS. 5–12, 5–36), rather than on the edge of a courtyard or public square. Also, there was an almost even division in Etruscan temples between porch and interior space, which was often divided into three rooms, presumably for cult statues (see FIG. 6–3B).

Although Etruscan temples were simple in form, they were embellished with dazzling displays of painting and terra-cotta sculpture. The temple roof, rather than the pediment, served as a base for large statue groups. Etruscan artists excelled at the imposing technical challenge of making huge terra-cotta figures for placement on temples. A splendid example is a life-size figure of **APOLLO** (FIG. 6-4). To make such large clay sculptures, artists had to know how to construct figures so that they did not collapse under their own weight while the raw clay was still wet. They also had to regulate the kiln temperature during the long firing process. The names of some Etruscan terra-cotta artists have come down to us, including that of a sculptor from Veii (near Rome) called Vulca, in whose workshop this figure of Apollo may have been created.

Dating from about 510–500 BCE and originally part of a four-figure scene depicting one of the labors of Hercules, this boldly striding Apollo comes from the temple dedicated to Minerva and other gods in the sanctuary of Portonaccio at Veii. Four figures on the temple's ridgepole (horizontal beam at the peak of the roof) depicted Apollo and Hercules fighting for possession of a deer sacred to Diana, while she and Mercury looked on.

Apollo's well-developed body and his "Archaic smile" clearly demonstrate that Etruscan sculptors were familiar with the *kouroi* of their Archaic Greek counterparts. But a comparison of the Apollo and a figure such as the Greek Anavysos Kouros (see FIG. 5–20) reveals telling differences. Unlike the Greek *kouros*, the body of the Etruscan Apollo is partially concealed by a rippling robe that cascades in knife-edged pleats to his knees. The forward-moving pose of the Etruscan statue also has a dynamic vigor that is avoided in the balanced, rigid stance of the Greek figure. This sense of energy expressed in purposeful movement is a defining characteristic of Etruscan sculpture and painting.

TOMB CHAMBERS

Like the Egyptians, the Etruscans seem to have conceived tombs as homes for the dead. The Etruscan cemetery of La Banditaccia at Cerveteri, in fact, was laid out as a small town, with "streets" running between the grave mounds. The tomb chambers were partially or entirely excavated below the ground, and some were hewn out of bedrock. They were roofed over, sometimes with corbel vaulting, and covered with dirt and stones.

Etruscan painters had a remarkable ability to envision their subjects inhabiting a bright, tangible world just beyond the tomb. Vividly colored scenes of playing, feasting, dancing, hunting,

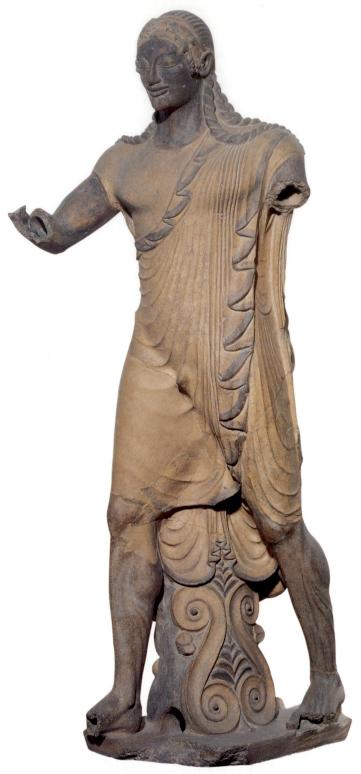

6-4 • Master Sculptor Vulca (?) **APOLLO**From the temple of Minerva, Portonaccio, Veii. c. 510–500 BCE. Painted terra cotta, height 5'10" (1.8 m). Museo Nazionale di Villa Giulia, Rome.

fishing, and other leisure activities decorated the walls. In a late sixth-century BCE tomb from Tarquinia, wall paintings show two boys spending a day in the country, surrounded by the graceful flights of brightly colored birds (**FIG. 6-6**). The boy to the left is climbing a hillside to the promontory of a cliff, soon to put aside

ELEMENTS OF ARCHITECTURE | Roman Architectural Orders

The Etruscans and Romans adapted Greek architectural orders (see "The Greek Orders," page 110) to their own tastes, often using them as applied decoration on walls. The Etruscans developed the Tuscan order by modifying the Doric order, adding a base under the shaft, which was often left unfluted. This system was subsequently adopted by the Romans. Later, the Romans created the **Composite order (Fig. 6–5)** by combining the volutes of Greek Ionic capitals with the acanthus leaves from the Corinthian order. In this diagram, the two Roman orders are shown on pedestals, which consist of a **plinth**, a **dado**, and a cornice.

6-5 • FAÇADE OF LIBRARY OF CELSUS, EPHESUS Modern Turkey. Detail showing capital, architrave, frieze, and cornice, conforming to the Composite order. 135 ce. Marble.

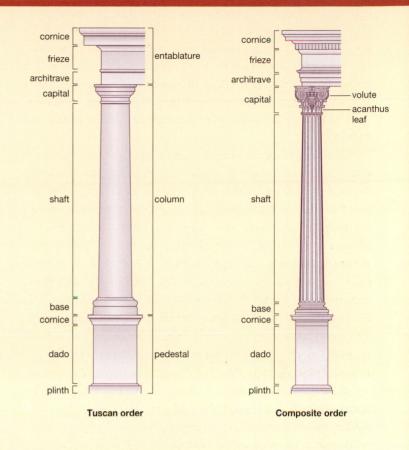

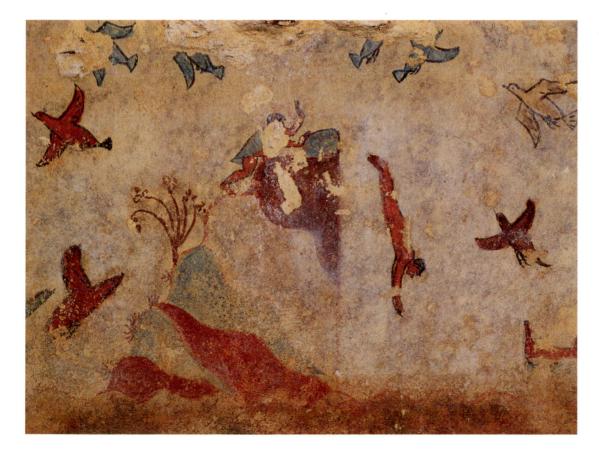

6-6 • BOYS CLIMBING ROCKS AND DIVING, TOMB OF HUNTING AND FISHING Tarquinia, Italy. Late 6th century BCE.

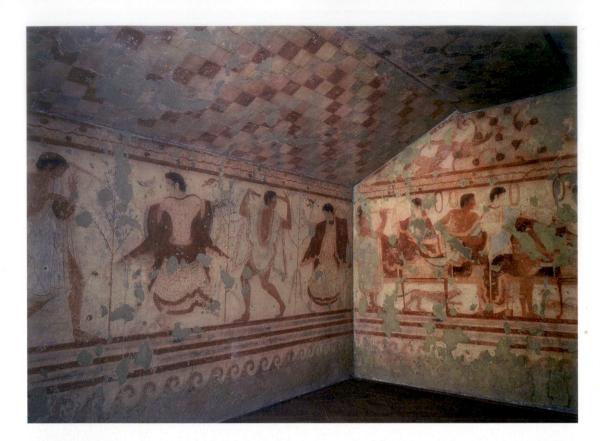

6-7 • DANCERS AND DINERS, TOMB OF THE TRICLINIUM
Tarquinia, Italy. c. 480–470 BCE.

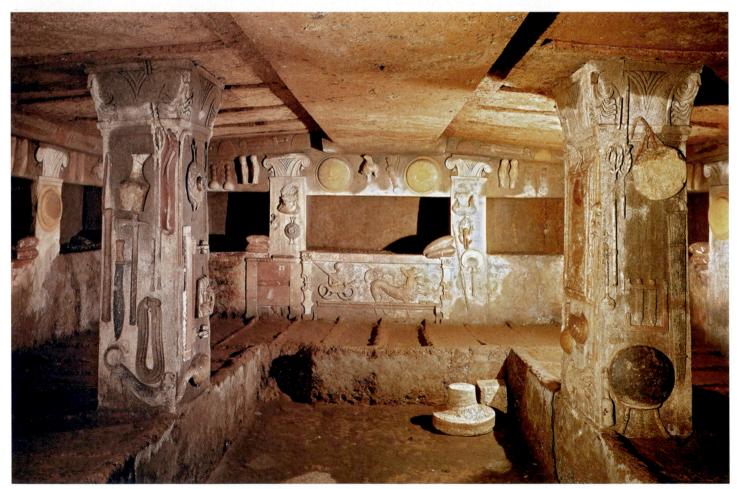

6-8 • BURIAL CHAMBER, TOMB OF THE RELIEFS Cerveteri, Italy. 3rd century BCE.

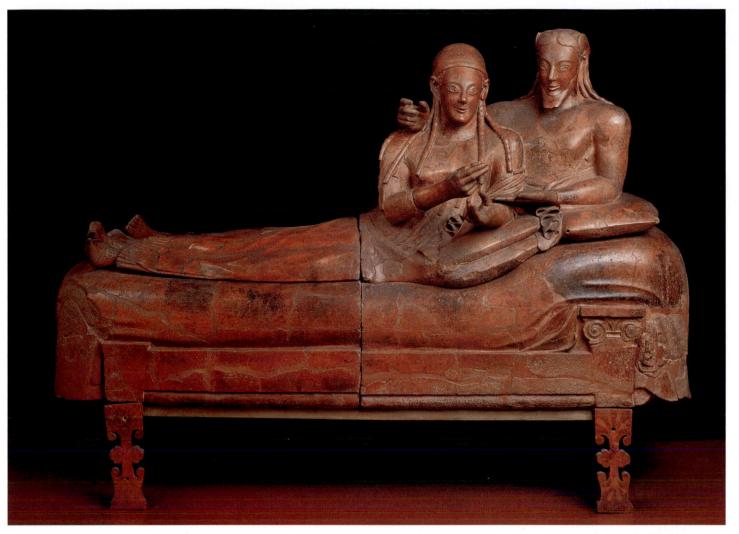

6-9 • RECLINING COUPLE ON A SARCOPHAGUS FROM CERVETERI

c. 520 BCE. Terra cotta, length 6'7" (2.06 m). Museo Nazionale di Villa Giulia, Rome.

Portrait sarcophagi like this one evolved from earlier terra-cotta cinerary urns with sculpted heads of the deceased whose ashes they held.

his clothes and follow his naked companion, caught by the artist in mid-dive, plunging toward the water below. Such charming scenes of carefree diversions, removed from the routine demands of daily life, seem to promise a pleasurable post-mortem existence to the occupant of this tomb. But this diver could also symbolize the deceased's own plunge from life into death (see "The Tomb of the Diver," page 124).

In a painted frieze in the **TOMB OF THE TRICLINIUM**, somewhat later but also from Tarquinia, the diversions are more mature in focus as young men and women frolic to the music of the lyre and double flute within a room whose ceiling is enlivened with colorful geometric decoration (**FIG. 6-7**). These dancers line the side walls, composed within a carefully arranged setting of stylized trees and birds, while at the end of the room couples recline on couches enjoying a banquet as cats prowl underneath the table looking for scraps. The immediacy of this wall painting is striking.

Dancers and diners—women as well as men—are engaging in the joyful customs and diversions of human life as we know it.

Some tombs were carved out of the rock to resemble rooms in a house. The **TOMB OF THE RELIEFS**, for example, seems to have a flat ceiling supported by square stone posts (**FIG. 6-8**). Its walls were plastered and painted, and it was fully furnished. Couches were carved from stone, and other fittings were formed of stucco, a slow-drying type of plaster that can be easily molded and carved. Simulated pots, jugs, robes, axes, and other items were molded and carved to look like real objects hanging on hooks. Could the animal rendered in low relief at the bottom of the post just left of center be the family pet?

The remains of the deceased were placed in urns or sarcophagi (coffins) made of clay or stone. On the terra-cotta **SARCOPHA-GUS FROM CERVETERI**, dating from about 520 BCE (**FIG. 6-9**), a husband and wife are shown reclining comfortably on a dining

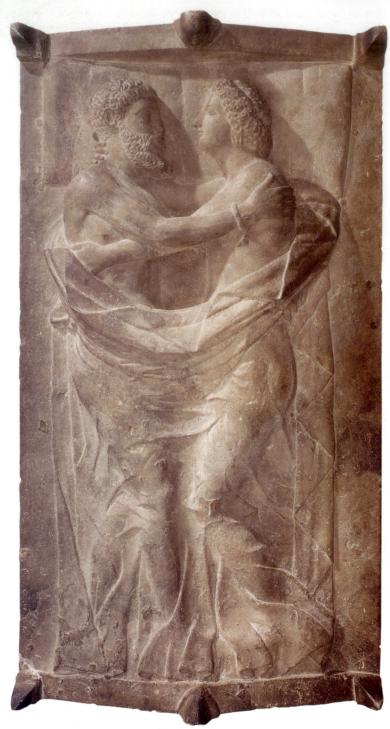

6-10 • MARRIED COUPLE (LARTH TETNIES AND THANCHVIL TARNAI) EMBRACING

Lid of a sarcophagus. c. 350–300 BCE. Marble, length 7^{\prime} (2.13 m). Museum of Fine Arts, Boston. Museum purchase with funds donated by contribution and the Benjamin Pierce Cheney Fund (86.145a-b)

couch. The smooth, lifelike forms of their upper bodies are vertical and square-shouldered, but their hips and extended legs seem to sink into the softness of the couch. Rather than a somber memorial to the dead, we encounter two lively individuals with alert eyes and warm smiles. The man once raised a drinking vessel, addressing the viewer with the lively and engaging gesture of a genial host, perhaps offering an invitation to dine with them for eternity

or to join them in the sort of convivial festivities recorded in the paintings on the walls of Etruscan tombs.

The lid of another Etruscan sarcophagus—slightly later in date and carved of marble rather than molded in clay—also portrays a reclining Etruscan couple, but during a more private moment (FIG. 6-10). Dressed only in their jewelry and just partially sheathed by the light covering that clings to the forms of their bodies, this loving pair has been caught for eternity in a tender embrace, absorbed with each other rather than looking out to engage the viewer. The sculptor of this relief was clearly influenced by Greek Classicism in the rendering of human forms, but the human intimacy that is captured here is far removed from the cool, idealized detachment characterizing Greek funerary stelai (see FIG. 5-50).

WORKS IN BRONZE

The Etruscans developed special sophistication in casting and engraving on bronze. Some of the most extraordinary works were created for domestic use, including a group of surviving cistae—cylindrical containers used by wealthy women as cases for toiletry articles such as mirrors. The richly decorated Ficoroni Cista, dated to the second half of the fourth century BCE and found in Palestrina (see FIG. 6–1), was made by Novios Plautios for a woman named Dindia Macolnia, who gave it to her daughter.

Since Etruscan bronze artists went to work for Roman patrons after Etruscan lands became part of the Roman Republic, distinguishing between Etruscan and early Roman art is often difficult. A head that was once part of a bronze statue of a man may be an example of an important Roman commission from an Etruscan artist (FIG. 6-12). Since it is over life size, this head may have been part of a commemorative work honoring a great man, and the downturned tilt of the head, as well as the flexing of the neck, have led many to propose that it was part of an equestrian figure. Traditionally dated to about 300 BCE, this rendering of a strong, broad face with heavy brows, hawk nose, firmly set lips, and clear-eyed expression is scrupulously detailed. The commanding, deep-set eyes are created with ivory inlay, within which float irises created of glass paste within a ring of bronze. The lifelike effect is further enhanced by added eyelashes of separately cut pieces of bronze. This work is often associated with a set of male virtues that would continue to be revered by the Romans:

stern seriousness, strength of character, the age-worn appearance of a life well lived, and the wisdom and sense of purpose it confers.

Etruscan art and architectural forms left an indelible stamp on the art and architecture of early Rome that was rivaled only by the influence of Greece. By 88 BCE, when the Etruscans were granted Roman citizenship, their art had already been absorbed into that of Rome.

RECOVERING THE PAST | The Capitoline She-Wolf

This ferocious she-wolf has been considered an outstanding example of Etruscan bronze sculpture (Fig. 6–11), lauded for its technical sophistication and expressive intensity and traditionally dated to c. 500–470 BCE. She confronts us with a vicious snarl, her tense body, thin flanks, and protruding ribs, contrasting with her pendulous, milk-filled teats. Since she currently suckles two chubby human boys—Renaissance additions of the fifteenth century—the ensemble evokes the story of the twins Romulus and Remus, legendary founders of Rome, who were nursed back to health by a she-wolf after having been left to die on the banks of the Tiber. But is this famous animal actually Etruscan in origin?

Now in Rome's Museo Capitolino, the bronze she-wolf was restored and cleaned during 1997–2000, under the supervision of archaeologist

Anna Maria Carruba, who has mounted a serious challenge to its Etruscan pedigree. She argues, in fact, that it dates not from antiquity, but from the Middle Ages. Technical as well as stylistic evidence supports her conclusions, specifically the fact that this unusual work, created by the lost-wax process, was formed in the medieval technique of single-pour casting, whereas all surviving Etruscan and Roman bronzes were assembled from separate pieces soldered together. Carruba's proposal of a date of c. 800 cE for the she-wolf has certainly caught the attention of specialists in ancient art, many of whom have revised their assessment of the work. Others are waiting for the full publication of the scientific evidence before removing the Capitoline She-Wolf from the Etruscan canon.

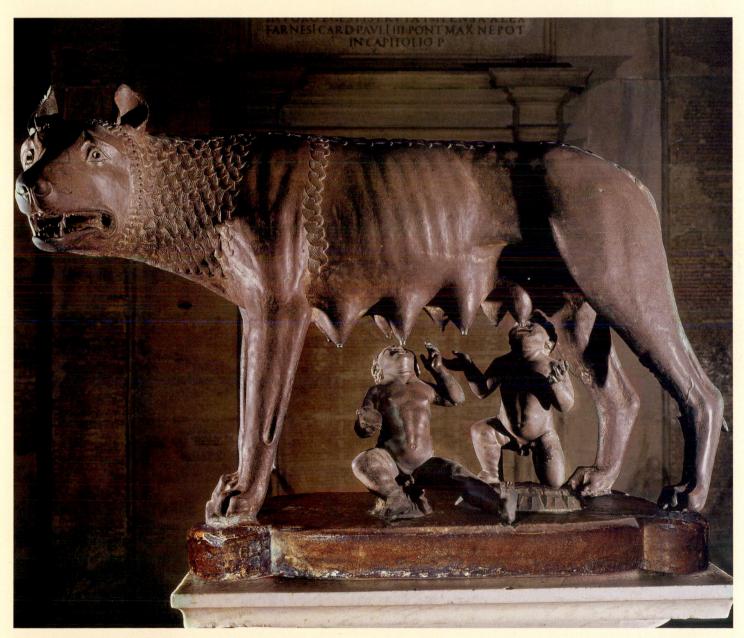

6-11 • CAPITOLINE SHE-WOLF

c. 500 BCE or c. 800 CE? (Boys underneath, 15th century CE). Bronze, height 331/2" (85 cm). Museo Capitolino, Rome.

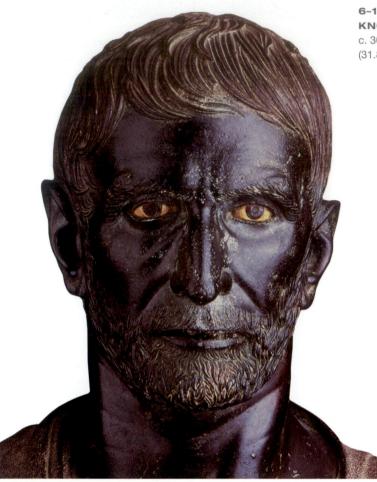

6-12 • HEAD OF A MAN (TRADITIONALLY KNOWN AS "BRUTUS")

c. 300 BCE. Bronze, eyes of painted ivory, height $12\frac{1}{2}$ " (31.8 cm). Palazzo dei Conservatori, Rome.

THE ROMANS

At the same time that the Etruscan civilization was flourishing, the Latin-speaking inhabitants of Rome began to develop into a formidable power. For a time, kings of Etruscan lineage ruled them, but in 509 BCE the Romans overthrew them and formed a republic centered in Rome. The Etruscans themselves were absorbed by the Roman Republic at the end of the third century BCE, by which time Rome had steadily expanded its territory in many directions. The Romans unified what is now Italy and, after defeating their rival, the North African city-state of Carthage, they established an empire that encompassed the entire Mediterranean region (see MAP 6-1).

At its greatest extent, in the early second century CE, the Roman Empire reached from the Euphrates River, in southwest Asia, to Scotland. It ringed the Mediterranean Sea—mare nostrum, or "our sea," the Romans called it. Those who were conquered by the Romans gradually assimilated Roman legal, administrative, and cultural structures that endured for some five centuries—and in the eastern Mediterranean until the fifteenth century CE—and left a lasting mark on the civilizations that emerged in Europe.

The Romans themselves assimilated Greek gods, myths, and religious beliefs and practices into their state religion. During the

imperial period, they also deified some of their emperors posthumously. Worship of ancient gods mingled with homage to past rulers; oaths of allegiance to the living ruler made the official religion a political duty. Religious worship became increasingly ritualized, perfunctory, and distant from the everyday life of most people.

Many Romans adopted the so-called mystery religions of the people they had conquered. Worship of Isis and Osiris from Egypt, Cybele (the Great Mother) from Anatolia, the hero-god Mithras from Persia, and the single, all-powerful God of Judaism and Christianity from Palestine challenged the Roman establishment. These unauthorized religions flourished alongside the state religion, with its Olympian deities and deified emperors, despite occasional government efforts to suppress them.

THE REPUBLIC, 509-27 BCE

Early Rome was governed by kings and an advisory body of leading citizens called the Senate. The population was divided into two classes: a wealthy and powerful upper class, the patricians, and a lower class, the plebeians. In 509 BCE, Romans overthrew the last Etruscan king and established the Roman Republic as an oligarchy, a government by aristocrats, that would last about 450 years.

ART AND ITS CONTEXTS | Roman Writers on Art

Only one book devoted specifically to the arts survives from antiquity. All our other written sources consist of digressions and insertions in works on other subjects. That one book, the *Ten Books on Architecture* by Vitruvius (c. 80–c. 15 BCE), however, is invaluable. Written for Augustus in the first century BCE, it is a practical handbook for builders that discusses such things as laying out cities, siting buildings, and using the Greek architectural orders. Vitruvius argued for appropriateness and rationality in architecture, and he also made significant contributions to art theory, including studies on proportion.

Pliny the Elder (c. 23–79 cE) wrote a vast encyclopedia of "facts, histories, and observations" known as *Naturalis Historia* (*The Natural History*) that often included discussions of art and architecture. Pliny occasionally used works of art to make his points—for example, citing

sculpture within his essays on stone and metals. Pliny's scientific turn of mind led to his death, for he was overcome while observing the eruption of Mount Vesuvius that buried Pompeii. His nephew, Pliny the Younger (c. 61–113 cE), a voluminous letter writer, added to our knowledge of Roman domestic architecture with his meticulous descriptions of villas and gardens.

Valuable bits of information can also be found in books by travelers and historians. Pausanias, a second-century ce Greek traveler, wrote descriptions that are basic sources on Greek art and artists. Flavius Josephus (c. 37–100 ce), a historian of the Flavians, wrote in his *Jewish Wars* a description of the triumph of Titus that includes the treasures looted from the Temple in Jerusalem (see Fig. 6–37).

As a result of its stable form of government, and especially of its encouragement of military conquest, by 275 BCE Rome controlled the entire Italian peninsula. By 146 BCE, Rome had defeated its great rival, Carthage, on the north coast of Africa, and taken control of the western Mediterranean. By the mid second century BCE, Rome had taken Macedonia and Greece, and by 44 BCE, it had conquered most of Gaul (present-day France) as well as the eastern Mediterranean (see MAP 6-1). Egypt remained independent until Octavian defeated Mark Antony and Cleopatra at the Battle of Actium in 31 BCE.

During the Republic, Roman art was rooted in its Etruscan heritage, but territorial expansion brought wider exposure to the arts of other cultures. Like the Etruscans, the Romans admired Greek art. As Horace wrote (*Epistulae* ii, 1): "Captive Greece conquered her savage conquerors and brought the arts to rustic Latium." The Romans used Greek designs and Greek orders in their architecture, imported Greek art, and employed Greek artists. In 146 BCE, for example, they stripped the Greek city of Corinth of its art treasures and shipped them back to Rome.

PORTRAIT SCULPTURE

Portrait sculptors of the Republican period sought to create lifelike images based on careful observation of their subjects, objectives that were related to the Romans' veneration of their ancestors and the making and public displaying of death masks of deceased relatives (see "Roman Portraiture," page 168).

Perhaps growing out of this early tradition of maintaining images of ancestors as death masks, a new Roman artistic ideal emerged during the Republican period in relation to portrait sculpture, an ideal quite different from the one we encountered in Greek Classicism. Instead of generalizing a human face, smoothed of its imperfections and caught in a moment of detached abstraction, this new Roman idealization emphasized—rather than

suppressed—the hallmarks of advanced age and the distinguishing aspects of individual likenesses. This mode is most prominent in portraits of Roman patricians (FIG. 6-13), whose time-worn faces

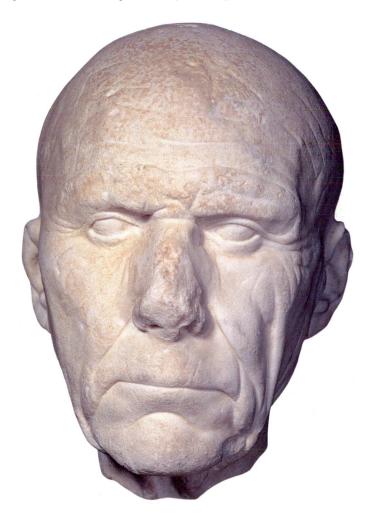

6-13 • PORTRAIT HEAD OF AN ELDER FROM SCOPPITO1st century BCE. Marble, height 11" (28 cm). Museo Nazionale, Chieti.

ART AND ITS CONTEXTS | Roman Portraiture

The strong emphasis on portraiture in Roman art may stem from the early practice of creating likenesses—in some cases actual wax death masks—of revered figures and distinguished ancestors for display on public occasions, most notably funerals. Contemporary historians have left colorful evocations of this distinctively Roman custom. Polybius, a Greek exiled to Rome in the middle of the second century BCE, wrote home with the following description:

... after the interment [of the illustrious man] and the performance of the usual ceremonies, they place the image of the departed in the most conspicuous position in the house, enclosed in a wooden shrine. This image is a mask reproducing with remarkable fidelity both the features and the complexion of the deceased. On the occasion of public sacrifices, they display these images, and decorate them with much care, and when any distinguished member of the family dies they take them to the funeral, putting them on men who seem to bear the closest resemblance to the original in stature and carriage.... There could not easily be a more ennobling spectacle for a young man who aspires to fame and virtue. For who would not be inspired by the sight of the images of men renowned for their excellence, all together and as if alive and breathing?... By this means, by the constant renewal of the good report of brave men, the celebrity of those who performed noble deeds is rendered immortal, while at the same time the fame of those who did good services to their country becomes known to the people and a heritage for future generations. (The Histories, 7.53, 54, trans. W.R. Paton, Loeb Library ed.)

Growing out of this heritage, Roman Republican portraiture is frequently associated with the notion of **verism**—an interest in the faithful reproduction of the immediate visual and tactile appearance of subjects. Since we find in these portrait busts the same sorts of individualizing physiognomic features that allow us to differentiate among the people we know in our own world, it is easy to assume that they are exact likenesses of their subjects as they appeared during their lifetime. Of course, this is impossible to verify, but our strong desire to believe it must realize the intentions of the artists who made these portraits and the patrons for whom they were made.

A life-size marble statue of a Roman PATRICIAN (FIG. 6-14), dating from the period of the Emperor Augustus, reflects the practices documented much earlier by Polybius and links the man portrayed with a revered tradition and its laudatory associations. The large marble format emulates a Greek notion of sculpture, and its use here signals not only this man's wealth but also his sophisticated artistic tastes, characteristics he shared with the emperor himself. His toga, however, is not Greek but indigenous and signifies his respectability as a Roman citizen of some standing. The busts of ancestors that he holds in his hands document his distinguished lineage in the privileged upper class (laws regulated which members of society could own such collections) and the statue as a whole proclaims his adherence to the family tradition by having his own portrait created.

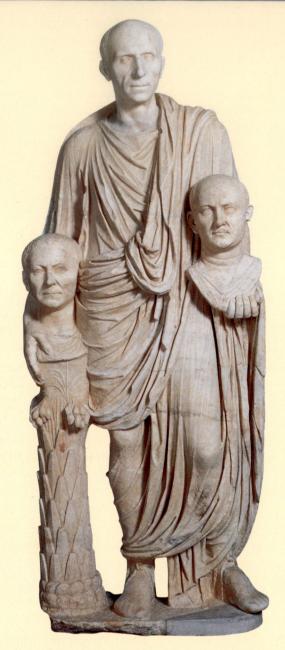

6-14 • PATRICIAN CARRYING PORTRAIT BUSTS OF TWO ANCESTORS (KNOWN AS THE BARBERINI TOGATUS)

End of 1st century BCE or beginning of 1st century CE. Marble, height 5'5" (1.65 m). Palazzo de Conservatori, Rome.

The head of this standing figure, though ancient Roman in origin, is a later replacement and not original to this statue. The separation of head and body in this work is understandable since in many instances the bodies of full-length portraits were produced in advance, waiting in the sculptor's workshop for a patron to commission a head with his or her own likeness that could be attached to it. Presumably the busts carried by this patrician were likewise only blocked out until they could be carved with the faces of the commissioner's ancestors. These faces share a striking family resemblance, and the stylistic difference reproduced in the two distinct bust formats reveals that these men lived in successive generations. They could be the father and grandfather of the man who carries them.

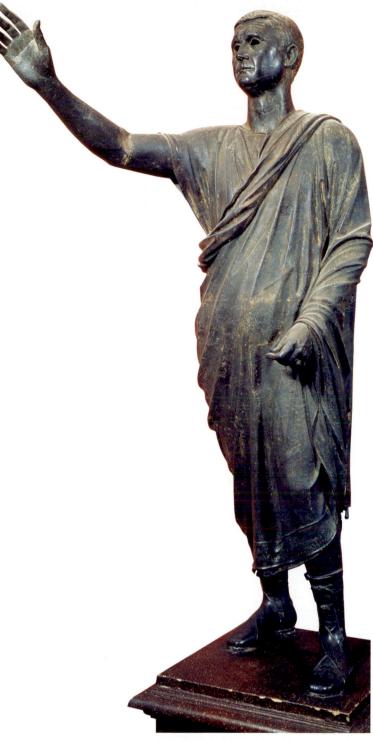

6-15 • AULUS METELLUS (THE ORATOR)Found near Perugia. c. 80 BCE. Bronze, height 5'11" (1.8 m). Museo Archeologico Nazionale, Florence.

embody the wisdom and experience that come with old age. Frequently we take these portraits of wrinkled elders at face value, as highly realistic and faithful descriptions of actual human beings—contrasting Roman realism with Greek idealism—but there is good reason to think that these portraits actually conform to a

particularly Roman type of idealization that underscores the effects of aging on the human face.

THE ORATOR The life-size bronze portrait of AULUS METELLUS—the Roman official's name is inscribed on the hem of his garment in Etruscan letters (FIG. 6-15)—dates to about 80 BCE. The statue, known from early times as *The Orator*, depicts a man addressing a gathering, his arm outstretched and slightly raised, a pose expressive of rhetorical persuasiveness. The orator wears sturdy laced leather boots and a folded and draped toga, the characteristic garment of a Roman senator. Perhaps the statue was mounted on an inscribed base in a public space by officials grateful for Aulus' benefactions on behalf of their city.

THE DENARIUS OF JULIUS CAESAR The propaganda value of portraits was not lost on Roman leaders. In 44 BCE, Julius Caesar issued a DENARIUS (a widely circulated coin) bearing his portrait (FIG. 6-16) conforming to the Roman ideal of advanced age. He was the first Roman leader to place his own image on a coin, initiating a practice that would be adopted by his successors, but at the time when this coin was minted, it smacked of the sort of megalomaniacal behavior that would ultimately lead to his assassination. Perhaps it is for this reason that Caesar underscores his age, and thus his old-fashioned respectability, in this portrait, which reads as a mark of his traditionalism as a senator. But the inscription placed around his head—CAESAR DICT PERPETUO, or "Caesar, dictator forever"—certainly contradicts the ideal embodied in the portrait.

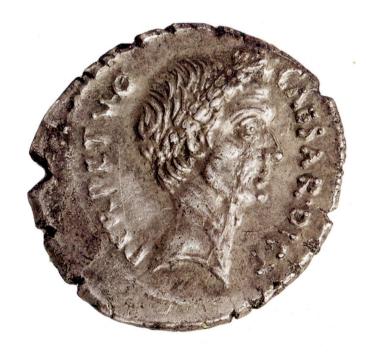

6-16 • DENARIUS WITH PORTRAIT OF JULIUS CAESAR 44 BCE. Silver, diameter approximately 3/4" (1.9 cm). American Numismatic Society, New York.

ELEMENTS OF ARCHITECTURE | The Roman Arch

The round arch was not an Etruscan or Roman invention, but the Etruscans and Romans were the first to make widespread use of it (see FIG. 6–2)—both as an effective structural idea and an elegant design motif.

Round arches displace most of their weight, or downward thrust (see arrows on diagram), along their curving sides, transmitting that weight to adjacent supporting uprights (door or window jambs, columns, or piers). From there, the thrust goes to, and is supported by, the ground. To create an arch, brick or cut stones are formed into a curve by fitting together wedge-shaped pieces, called voussoirs, until they meet and are locked together at the top center by the final piece, called the keystone. These voussoirs exert an outward as well as a downward thrust, so arches may require added support, called buttressing, from adjacent masonry elements.

Until the keystone is in place and the mortar between the bricks or stones dries, an arch is held in place by wooden scaffolding called **centering**. The points from which the curves of the arch rise are called **springings**, and their support is often reinforced by **impost blocks**. The wall areas adjacent to the curves of the arch are **spandrels**. In a succession of arches, called an **arcade**, the space encompassed by each arch and its supports is called a **bay**.

A stunning example of the early Roman use of the round arch is a bridge known as the **PONT DU GARD** (FIG. 6-17), part of an aqueduct located near Nîmes, in southern France. An ample water supply was essential for a city, and the Roman invention to supply this water was the aqueduct, built with arcades—a linear series of arches. This aqueduct brought water from springs 30 miles to the north using a simple gravity flow, and it provided 100 gallons a day for every person in Nîmes. Each arch buttresses its neighbors and the huge arcade ends solidly in the hillsides. The structure conveys the balance, proportions, and rhythmic harmony of a great work of art, and although it harmonizes with its natural setting, it also makes a powerful statement about Rome's ability to control nature in order to provide for its cities. Both structure and function are marks of Roman civilization.

spandrel spandrel extrados voussoirs intrados impost pier pier bay

6-17 • PONT DU GARD

Nîmes, France. Late 1st century BCE. Height above river 160' (49 m), width of road bed on lower arcade 20' (6 m).

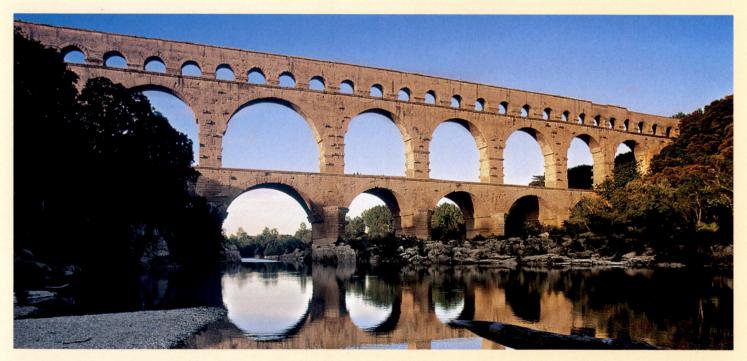

Watch an architectural simulation about the arch on myartslab.com

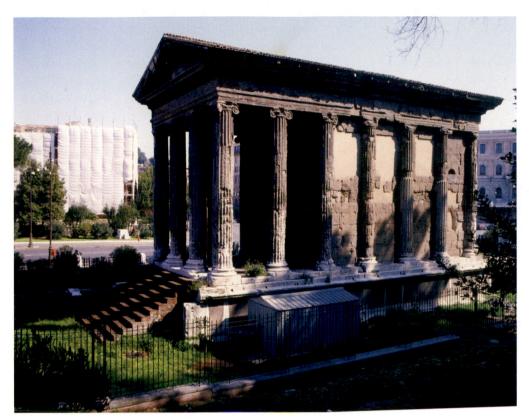

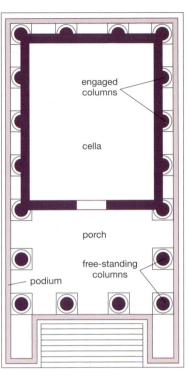

6-18 • EXTERIOR VIEW (A) AND PLAN (B) OF A TEMPLE, PERHAPS DEDICATED TO PORTUNUS Forum Boarium (Cattle Market), Rome. Late 2nd century BCE.

ROMAN TEMPLES

Architecture during the Roman Republic reflected both Etruscan and Greek practices. Like the Etruscans, the Romans built urban temples in commercial centers as well as in special sanctuaries. An early example is a small rectangular temple standing on a raised platform, or podium, beside the Tiber River in Rome (FIG. 6-18), probably from the second century BCE and perhaps dedicated to Portunus, the god of harbors and ports. This temple uses the Etruscan system of a rectangular cella and a front porch at one end reached by a broad, inviting flight of steps, but the Roman architects have adopted the Greek Ionic order, with full columns on the porch and half-columns engaged (set into the wall) around the exterior walls of the cella (see FIG. 6-18B) and a continuous frieze in the entablature. The overall effect resembles a Greek temple, but there are two major differences. First, Roman architects liberated the form of the column from its post-and-lintel structural roots and engaged it onto the surface of the wall as a decorative feature. Second, while a Greek temple encourages viewers to walk around the building and explore its uniformly articulated sculptural mass, Roman temples are defined in relation to interior spaces, which visitors are invited to enter through one opening along the longitudinal axis of a symmetrical plan.

By the first century BCE, nearly a million people lived in Rome, which had evolved into the capital of a formidable commercial and political power with a growing overseas empire. As long as

Republican Rome was essentially a large city-state, its form of government—an oligarchy under the control of a Senate—remained feasible. But as the empire around it grew larger and larger, a government of competing senators and military commanders could not enforce taxation and maintain order in what was becoming a vast and complicated territorial expanse. As governance of the Republic began to fail, power became concentrated in fewer and fewer leaders, until it was ruled by one man, an emperor, rather than by the Senate.

THE EARLY EMPIRE, 27 BCE-96 CE

The first Roman emperor was born Octavian in 63 BCE. When he was only 18 years old, his brilliant great-uncle, Julius Caesar, adopted him as son and heir, recognizing in him qualities that would make him a worthy successor. Shortly after Julius Caesar refused the Senate's offer of the imperial crown, early in 44 BCE, he was murdered by a group of conspirators, and the 19-year-old Octavian stepped up. Over the next 17 spectacular years, as general, politician, statesman, and public-relations genius, Octavian vanquished warring internal factions and brought peace to fractious provinces. By 27 BCE, the Senate had conferred on him the title of Augustus (meaning "exalted," "sacred"). Assisted by his astute and pragmatic second wife, Livia, Augustus led the state and the empire for 45 years. He established efficient rule and laid the

foundation for an extended period of stability, domestic peace, and economic prosperity known as the *Pax Romana* ("Roman Peace"), which lasted over 200 years (27 BCE to 180 CE). In 12 BCE he was given the title Pontifex Maximus ("High Priest"), becoming the empire's highest religious official as well as its political leader.

Conquering and maintaining a vast empire required not only the inspired leadership and tactics of Augustus, but also careful planning, massive logistical support, and great administrative skill. Some of Rome's most enduring contributions to Western civilization reflect these qualities—its system of law, its governmental and administrative structures, and its sophisticated civil engineering and architecture.

To facilitate the development and administration of the empire, as well as to make city life comfortable and attractive to its citizens, the Roman state undertook building programs of unprecedented scale and complexity, mandating the construction of central administrative and legal centers (forums and basilicas), recreational facilities (racetracks, stadiums), temples, markets, theaters, public baths, aqueducts, middle-class housing, and even entire new towns. To accomplish these tasks without sacrificing beauty, efficiency, and human well-being, Roman builders and architects developed rational plans using easily worked but durable materials and highly sophisticated engineering methods.

To move their armies about efficiently, to speed communications between Rome and the farthest reaches of the empire, and to promote commerce, the Romans built a vast and complex network of roads and bridges. Many modern European highways still follow the lines laid down by Roman engineers, some Roman bridges are still in use, and Roman-era foundations underlie the streets of many cities.

ART IN THE AGE OF AUGUSTUS

Roman artists of the Augustan age created a new style—a new Roman form of idealism that, though still grounded in the appearance of the everyday world, is heavily influenced by a revival of Greek Classical ideals. They enriched the art of portraiture in both official images and representations of private individuals, they recorded contemporary historical events on public monuments, and they contributed unabashedly to Roman imperial propaganda.

AUGUSTUS OF PRIMAPORTA In the sculpture known as **AUGUSTUS OF PRIMAPORTA** (FIG. 6-19)—because it was discovered in Livia's villa at Primaporta, near Rome (see FIG. 6-32)—we see the emperor as he wanted to be seen and remembered. This work demonstrates the creative combination of earlier sculptural traditions that is a hallmark of Augustan art. In its idealization of a specific ruler and his prowess, the sculpture also illustrates the way Roman emperors would continue to use portraiture for propaganda that not only expressed their authority directly, but rooted it in powerfully traditional stories and styles.

The sculptor of this larger-than-life marble statue adapted the standard pose of a Roman orator (see FIG. 6-15) by melding it with the contrapposto and canonical proportions developed by the Greek High Classical sculptor Polykleitos, as exemplified by his *Spear Bearer* (see "'The Canon' of Polykleitos," page 134). Like the heroic Greek figure, Augustus' portrait captures him in the physical prime of youth, far removed from the image of advanced age idealized in the coin portrait of Julius Caesar. Although Augustus lived almost to age 76, in his portraits he is always a vigorous ruler, eternally young. But like Caesar, and unlike the *Spear Bearer*, Augustus' face is rendered with the kind of details that make this portrait an easily recognizable likeness.

To this combination of Greek and Roman traditions, the sculptor of the Augustus of Primaporta added mythological and historical imagery that exalts Augustus' family and celebrates his accomplishments. Cupid, son of the goddess Venus, rides a dolphin next to the emperor's right leg, a reference to the claim of the emperor's family, the Julians, to descent from the goddess Venus through her human son Aeneas. Augustus' anatomically conceived cuirass (torso armor) is also covered with figural imagery. Midtorso is a scene representing Augustus' 20 BCE diplomatic victory over the Parthians; a Parthian (on the right) returns a Roman military standard to a figure variously identified as a Roman soldier or the goddess Roma. Looming above this scene at the top of the cuirass is a celestial deity who holds an arched canopy, implying that the peace signified by the scene below has cosmic implications. The personification of the earth at the bottom of the cuirass holds an overflowing cornucopia, representing the prosperity brought by Augustan peace.

Another Augustan monument that synthesizes Roman traditions and Greek Classical influence to express the peace and prosperity that Augustus brought to Rome is the Ara Pacis Augustae (see "The Ara Pacis Augustae," page 174). The processional friezes on the exterior sides of the enclosure wall clearly reflect Classical Greek works like the Ionic frieze of the Parthenon (see FIG. 5–40), with their three-dimensional figures wrapped in revealing draperies that also create rhythmic patterns of rippling folds. But unlike the Greek sculptors of the Parthenon, the Roman sculptors of the Ara Pacis depicted actual individuals participating in a specific event at a known time. The Classical style may evoke the general notion of a Golden Age, but the historical references and identifiable figures in the Ara Pacis procession associate that Golden Age specifically with Augustus and his dynasty.

THE JULIO-CLAUDIANS

After his death in 14 CE, Augustus was deified by decree of the Roman Senate and succeeded by his stepson Tiberius (r. 14–37 CE). In acknowledgment of the lineage of both—Augustus from Julius Caesar and Tiberius from his father, Tiberius Claudius Nero, Livia's first husband—the dynasty is known as the Julio-Claudian (14–68 CE). It ended with the death of Nero in 68 CE.

An exquisite large onyx **cameo** (a gemstone carved in low relief) known as the **GEMMA AUGUSTEA** glorifies Augustus as triumphant over barbarians (a label for foreigners that the Romans

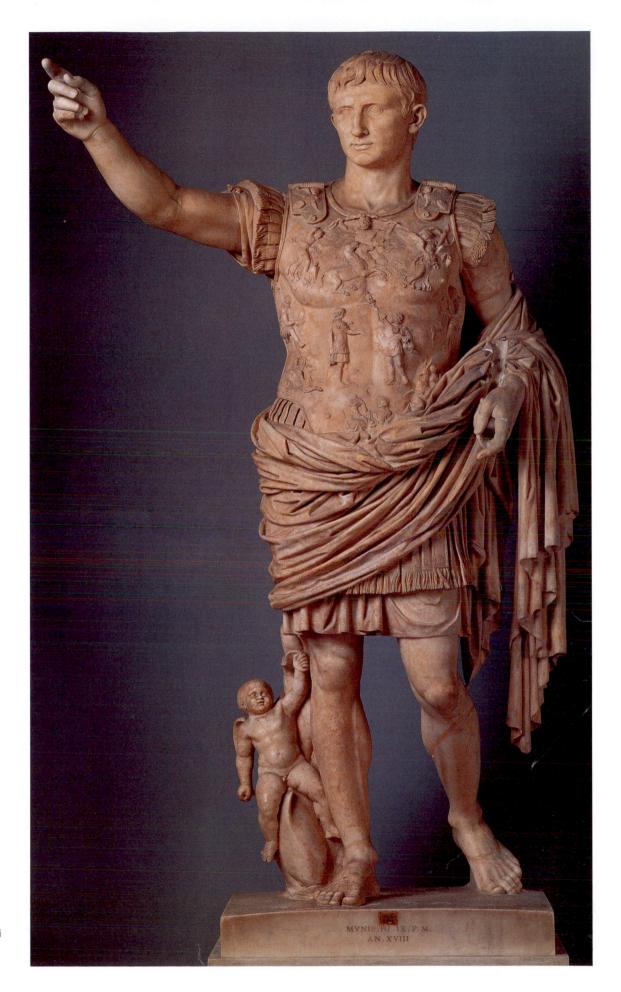

6-19 • AUGUSTUS OF PRIMAPORTA

Early 1st century CE.
Perhaps a copy of a
bronze statue of c. 20 BCE.
Marble, originally colored,
height 6'8" (2.03 m). Musei
Vaticani, Braccio Nuovo,
Rome.

A BROADER LOOK | The Ara Pacis Augustae

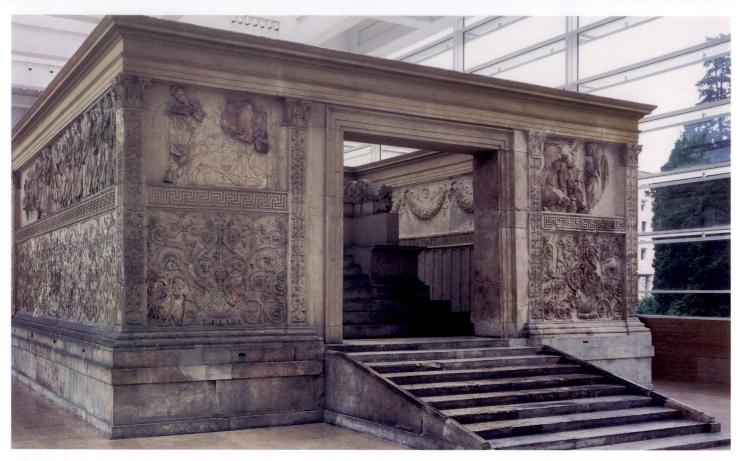

6-20 • ARA PACIS AUGUSTAE (ALTAR OF AUGUSTAN PEACE)

Rome. 13–9 BCE. View of west side. Marble, approx. $34'5'' \times 38'$ (10.5×11.6 m).

This monument was begun when Augustus was 50 (in 13 BCE) and was dedicated on Livia's 50th birthday (9 BCE).

One of the most extraordinary surviving Roman moreuments from the time of Augustus is the ARA PACIS AUGUSTAE, or Altar of Augustan Peace (FIG. 6–20), begun in 13 BCE and dedicated in 9 BCE, on the occasion of Augustus' triumphal return to the capital after three years spent establishing Roman rule in Gaul and Hispania. In its original location in the Campus Martius (Plain of Mars), the Ara Pacis was aligned with a giant sundial, marked out on the pavement with lines and bronze inscriptions, using as its pointer an Egyptian obelisk that Augustus had earlier brought from Heliopolis to signify Roman dominion over this ancient land.

The Ara Pacis itself consists of a walled rectangular enclosure surrounding an openair altar, emulating Greek custom (FIG. 6-21). Made entirely of marble panels carved with elaborate sculpture, the monument presented powerful propaganda, uniting portraiture and allegory, religion and politics, the private and the public. On the inner walls, foliate garlands

are suspended in swags from ox skulls. The skulls symbolize sacrificial offerings at the altar during annual commemorations, and the garlands—including fruits and flowers from every season—signify the continuing peace and prosperity that Augustus brought to the Roman world.

On the exterior, this theme of natural prosperity continues in lower reliefs of lavish, scrolling acanthus populated by animals. Above them, decorative allegory gives way to figural tableaux. On the front and back are framed allegorical scenes evoking the mythical history of Rome and the divine ancestry of Augustus. The longer sides portray two continuous processions, seemingly representing actual historical events rather than myth or allegory. Perhaps they document Augustus' triumphal return, or they could memorialize the dedication and first sacrifice performed by Augustus on the completed altar itself. In any event, the arrangement of the

participants is emblematic of the fundamental dualism characterizing Roman rule under Augustus. On one side march members of the Senate, a stately line of male elders. But on the other is Augustus' imperial family (FIG. 6-22) men, women, and notably, children, who stand in the foreground as Augustus' hopes for dynastic succession. Whereas most of the adults maintain their focus on the ceremonial event, the imperial children are allowed to fidget, look at their cousins, or reach up to find comfort in holding the hands or tugging at the garments of the adults around them, one of whom puts her finger to her mouth in a shushing gesture, perhaps seeking to mitigate their distracting behavior. The lifelike aura brought by such anecdotal details underlines the earthborn reality of the ideology embodied here. Rome is now subject to the imperial rule of the family of Augustus, and this stable system will bring continuing peace and prosperity since his successors have already been born.

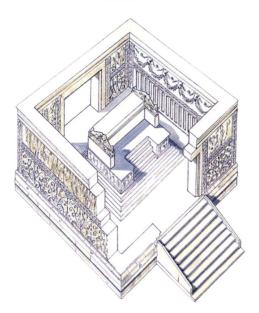

The Ara Pacis did not survive from antiquity in the form we see today. The monument eventually fell into disuse, ultimately into ruin. Remains were first discovered in 1568, but complete excavation took place only in 1937–1938, under the supervision of archaeologist Giuseppe Moretti, sponsored by dictator Benito Mussolini, who was fueled by his own ideological objectives. Once the monument had been unearthed, Mussolini had it reconstructed and commissioned a special building to house it, close to the **Mausoleum** (monumental tomb) of Augustus, all in preparation for celebrating the 2,000th anniversary of Augustus' birth and associating

the Roman imperial past with Mussolini's fascist state. The dictator even planned his own burial within Augustus' mausoleum.

More recently, the City of Rome commissioned American architect Richard Meier to design a new setting for the Ara Pacis, this time within a sleek, white box with huge walls of glass that allow natural light to flood the exhibition space (seen in Fig. 6–20). Many Italian critics decried the Modernist design of Meier's building—completed in 2006—but this recent urban renewal project focused on the Ara Pacis has certainly revived interest in one of the most precious remains of Augustan Rome.

6-21 • RECONSTRUCTION DRAWING
OF THE ARA PACIS AUGUSTAE

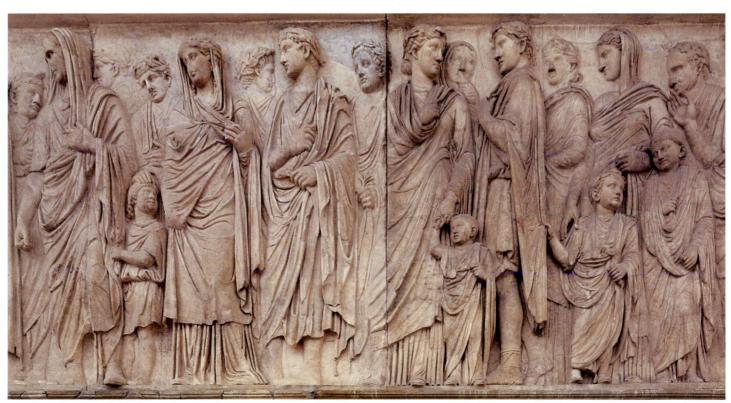

6-22 • IMPERIAL PROCESSION

Detail of a relief on the south side of the Ara Pacis. Height 5'2" (1.6 m).

The figures in this frieze represent members of Augustus' extended family, and scholars have proposed some specific, if tentative, identifications. The middle-aged man with the shrouded head at the far left is generally accepted to be a posthumous portrait of Marcus Agrippa, who would have been Augustus' successor had he not predeceased him in 12 BCE. The bored but well-behaved youngster pulling at Agrippa's robe—and being restrained gently by the hand of the man behind him—is probably Agrippa's son Gaius Caesar. The heavily swathed woman next to Agrippa on the right may be Augustus' wife, Livia, followed perhaps by Tiberius, who would become the next emperor. Behind Tiberius could be Antonia, the niece of Augustus, looking back at her husband, Drusus, Livia's younger son. She may grasp the hand of Germanicus, one of her younger children. The depiction of children and real women in an official relief was new to the Augustan period and reflects Augustus' desire to promote private family life as well as to emphasize his potential heirs and thus the continuity of his dynasty.

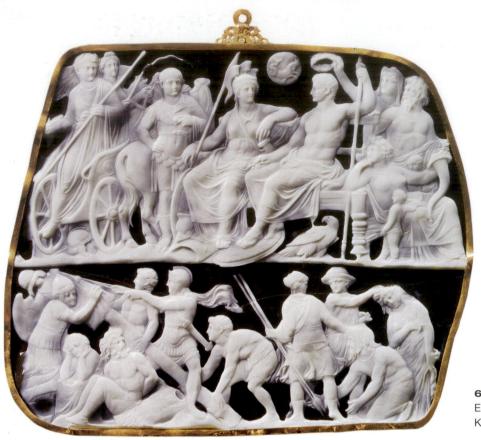

6-23 • GEMMA AUGUSTEAEarly 1st century ce. Onyx, 7½" × 9" (19 × 23 cm). Kunsthistorisches Museum, Vienna.

adopted from the Greeks) and as the deified emperor (FIG. 6-23). The emperor, crowned with a victor's wreath, sits at the center right of the upper register. He has assumed the pose and identity of Jupiter, the king of the gods; an eagle, sacred to Jupiter, stands at his feet. Sitting next to him is a personification of Rome that seems to have Livia's features. The sea goat in the roundel between them may represent Capricorn, the emperor's zodiac sign.

Tiberius, as the adopted son of Augustus, steps out of a chariot at far left, returning victorious from the German front, prepared to assume the imperial throne as Augustus' chosen heir. Below this realm of godlike rulers, Roman soldiers are raising a post or standard on which armor captured from the defeated enemy is displayed as a trophy. The cowering, shackled barbarians on the bottom right wait to be tied to it. The artist of the Gemma Augustea brilliantly combines idealized, heroic figures based on Classical Greek art with recognizable Roman portraits, the dramatic action of Hellenistic art with Roman attention to descriptive detail and historical specificity.

ROMAN CITIES AND THE ROMAN HOME

In good times and bad, individual Romans—like people everywhere at any time—tried to live a decent or even comfortable life with adequate shelter, food, and clothing. The Romans loved to have contact with the natural world. The middle classes enjoyed their gardens, wealthy city dwellers maintained rural estates, and Roman emperors had country villas that were both functioning

farms and places of recreation. Wealthy Romans even brought nature indoors by commissioning artists to paint landscapes on the interior walls of their homes. Through the efforts of the modern archaeologists who have excavated them, Roman cities and towns, houses, apartments, and country villas still evoke for us the ancient Roman way of life with amazing clarity.

ROMAN CITIES Roman architects who designed new cities or who expanded and rebuilt existing ones based the urban plan on the layout of Roman army camps. Like Etruscan towns, they were designed as a grid with two bisecting main streets crossing at right angles to divide the layout into quarters. The **forum** and other public buildings were generally located at this intersection, where the commander's headquarters was placed in a military camp.

Much of the housing in a Roman city consisted of brick apartment blocks called *insulae*. These apartment buildings had internal courtyards, multiple floors joined by narrow staircases, and occasionally overhanging balconies. City dwellers—then as now—were social creatures who spent much of their lives in public markets, squares, theaters, baths, and neighborhood bars. The city dweller returned to the *insulae* to sleep, perhaps to eat. Even women enjoyed a public life outside the home—a marked contrast to the circumscribed lives of Greek women.

The affluent southern Italian city of Pompeii, a thriving center of between 10,000 and 20,000 inhabitants, gives a vivid picture of Roman city life. In 79 ce Mount Vesuvius erupted, burying the

city under more than 20 feet of volcanic ash and preserving it until its rediscovery and excavation, beginning in the eighteenth century (FIGS. 6-24, 6-25). Temples and government buildings surrounded a main square, or forum; shops and houses lined mostly straight, paved streets; and a protective wall enclosed the heart of

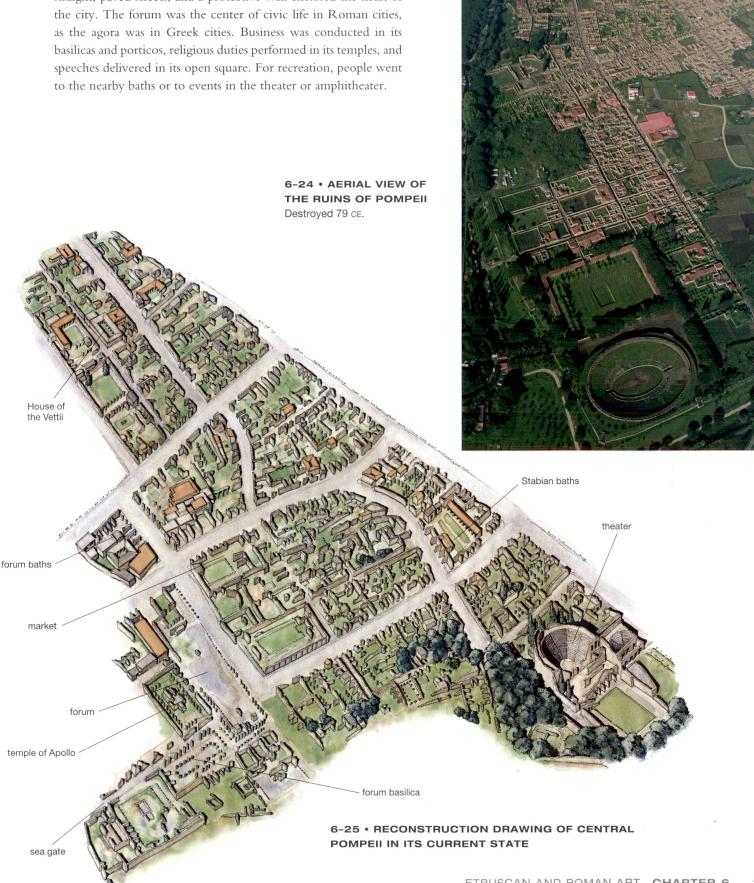

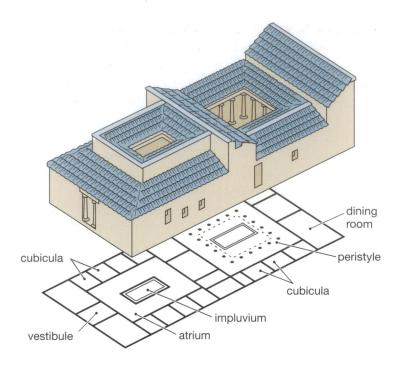

6-26 • PLAN AND RECONSTRUCTION DRAWING
OF THE HOUSE OF THE SILVER WEDDING

Pompeii. 1st century CE.

ROMAN HOUSES Wealthy city dwellers lived in private houses with enclosed gardens and were often fronted by shops facing the street. The Romans emphasized the interior rather than the exterior in such gracious domestic architecture.

A Roman house usually consisted of small rooms laid out around one or two open courts, the atrium and the peristyle (FIG. 6-26). People entered the house from the street through a vestibule and stepped into the atrium, a large space with an impluvium (pool for catching rainwater). The peristyle was a planted courtyard, farther into the house, enclosed by columns. Off the peristyle was the formal reception room or office called the tablinum, and here the head of the household conferred with clients. Portrait busts of the family's ancestors might be displayed in the tablinum or in the atrium. The private areas—such as the family dining and sitting rooms, as well as bedrooms (cubicula)—and service areas—such as the kitchen and servants' quarters—could be arranged around the peristyle or the atrium. In Pompeii, where the mild southern climate permitted gardens to flourish year-round, the peristyle was often turned into an outdoor living room with painted walls, fountains, and sculpture, as in the mid first-century CE remodeling of the second-century BCE HOUSE OF THE VETTII (FIG. 6-27). Since Roman houses were designed in relation to a

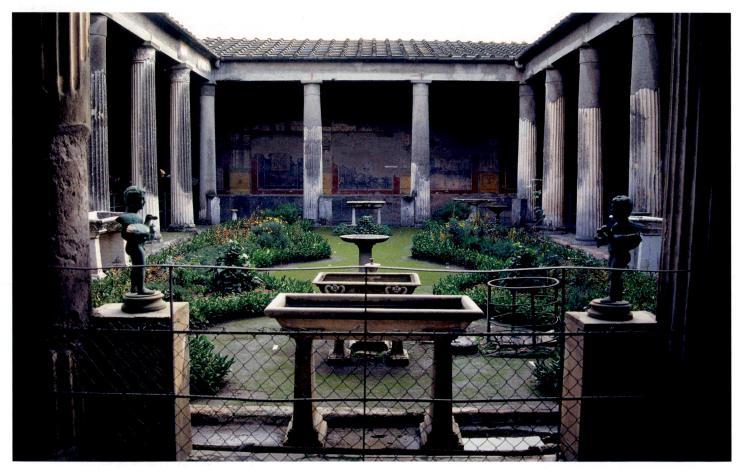

6-27 • PERISTYLE GARDEN, HOUSE OF THE VETTII Pompeii. Rebuilt 62-79 ce.

long axis that runs from the entrance straight through the atrium and into the peristyle, visitors were greeted at the door of the house with a deep vista, showcasing the lavish residence of their host and its beautifully designed and planted gardens extending into the distance.

Little was known about these gardens until archaeologist Wilhelmina Jashemski (1910–2007) excavated the peristyle in the House of G. Polybius in Pompeii, beginning in 1973. Earlier archaeologists had usually ignored, or unwittingly destroyed, evidence of gardens, but Jashemski developed a new way to find and analyze the layout and the plants cultivated in them. Workers first removed layers of debris and volcanic material to expose the level of the soil as it was before the eruption in 79 ce. They then collected samples of pollen, seeds, and other organic material and carefully injected plaster into underground root cavities. When the surrounding earth was removed, the roots, now in plaster, enabled botanists to identify the types of plants and trees cultivated in the garden and to estimate their size.

The garden in the house of Polybius was surrounded on three sides by a portico, which protected a large cistern on one side that

supplied the house and garden with water. Young lemon trees in pots lined the fourth side of the garden, and nail holes in the wall above the pots indicated that the trees had been espaliered—pruned and trained to grow flat against a support—a practice still in use today. Fig, cherry, and pear trees filled the garden space, and traces of a fruit-picking ladder, wide at the bottom and narrow at the top to fit among the branches, was found on the site.

An aqueduct built during the reign of Augustus eliminated Pompeii's dependence on wells and rainwater basins and allowed residents to add pools, fountains, and flowering plants that needed heavy watering to their gardens. In contrast to earlier, unordered plantings, formal gardens with low, clipped borders and plantings of ivy, ornamental boxwood, laurel, myrtle, acanthus, and rosemary—all mentioned by writers of the time—became fashionable. There is also evidence of topiary work, the clipping of shrubs and hedges into fanciful shapes, sculpture, and fountains. The peristyle garden of the House of the Vettii, for example, had more than a dozen fountain statues jetting water into marble basins (see FIG. 6–27). In the most elegant peristyles, mosaic decorations covered the floors, walls, and fountains.

dining room kitchen "Ixion Room" impluvium atrium entrance garden peristyle courtyard 10 meters 30 feet

WALL PAINTING

The interior walls of Roman houses were plain, smooth plaster surfaces with few architectural moldings or projections. On these invitingly blank fields, artists painted decorations. Some used mosaic, but most employed pigment suspended in a water-based solution of lime and soap, sometimes with a little wax. After such paintings were finished, they were polished with a special metal, glass, or stone burnisher and then buffed with a cloth. Many fine wall paintings in a series of developing styles (see, "August Mau's Four Styles of Pompeian Painting," page 182) have come to light through excavations, first in Pompeii and other communities surrounding Mount Vesuvius, near Naples, and more recently in and around Rome.

HOUSE OF THE VETTII Some of the finest surviving Roman wall paintings are found in the Pompeian House of the Vettii, whose peristyle garden we have already explored (see Fig. 6-27). The house was built in conformity to the axial house plan—with entrance leading through atrium to peristyle garden (Fig. 6-28)—by two

6-28 • PLAN OF THE HOUSE OF THE VETTII

Pompeii. Rebuilt 62-79 ce.

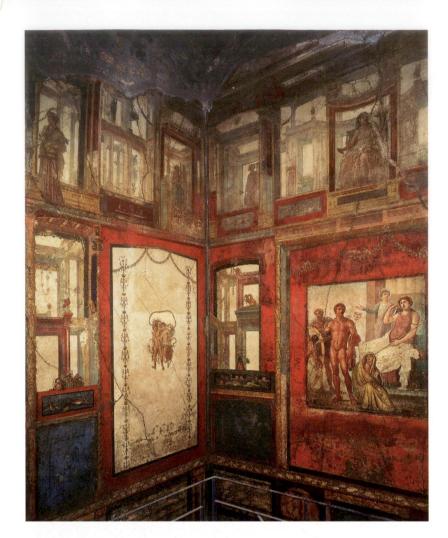

6-29 • WALL PAINTING IN THE "IXION ROOM," HOUSE OF THE VETTII

Pompeii. Rebuilt 62-79 ce.

brothers, wealthy freed slaves A. Vettius Conviva and A. Vettius Restitutus. Between its damage during an earthquake in 62 CE and the eruption of Vesuvius in 79 CE, the walls of the house were repainted, and this spectacular Fourth–Style decoration was uncovered in a splendid state of preservation during excavations at the end of the nineteenth century.

A complex combination of painted fantasies fills the walls of a reception room off the peristyle garden (FIG. 6-29). At the base of the walls is a lavish frieze of simulated colored-marble revetment, imitating the actual stone veneers that are found in some Roman residences. Above this "marble" dado are broad areas of pure red or white, onto which are painted pictures resembling framed panel paintings, swags of floral garlands, or unframed figural vignettes. The framed picture here illustrates a Greek mythological scene from the story of Ixion, who was bound by Zeus to a spinning wheel in punishment for attempting to seduce Hera. Between these pictorial fields, and along a long strip above them that runs around the entire room, are fantastic architectural vistas with multicolored columns and undulating

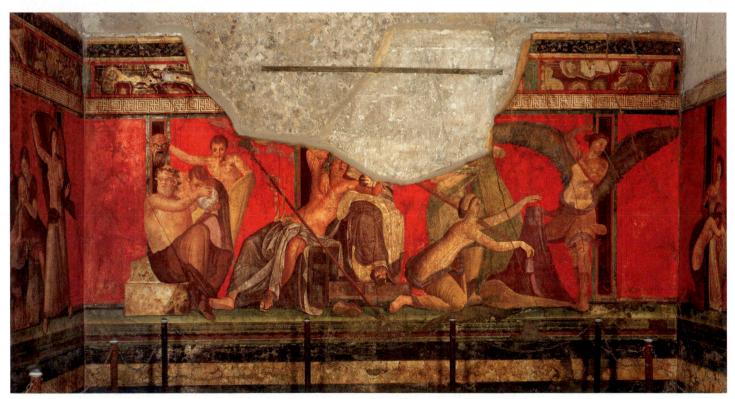

6-30 • INITIATION RITES OF THE CULT OF BACCHUS (?), VILLA OF THE MYSTERIES Pompeii. Wall painting. c. 60–50 BCE.

entablatures that recede into fictive space through the use of fanciful linear perspective. The fact that this fictive architecture is occupied here and there by volumetric figures only enhances the sense of three-dimensional spatial definition.

VILLAS Villas were the country houses of wealthy Romans, and their plans, though resembling town houses, were often more expansive and irregular. The eruption of Vesuvius in 79 CE preserved not only the houses along the city streets within Pompeii, but also the so-called **VILLA OF THE MYSTERIES** just outside the city walls. Here a series of elaborate figural murals from the mid first century BCE (**FIG. 6-30**) seem to portray the initiation rites of a mystery religion, probably the cult of Bacchus, which were often performed in private homes as well as in special buildings or temples. Perhaps this room in this villa was a shrine or meeting place for such a cult to this god of vegetation, fertility,

and wine. Bacchus (or Dionysus) was one of the most important deities in Pompeii.

The entirely painted architectural setting consists of a simulated marble dado (similar to that which we saw in the House of the Vettii) and, around the top of the wall, an elegant frieze supported by painted pilaster strips. The figural scenes take place on a shallow "stage" along the top of the dado, with a background of a brilliant, deep red—now known as Pompeian red—that, as we have already seen, was very popular with Roman painters. The tableau unfolds around the entire room, perhaps depicting a succession of events that culminate in the acceptance of an initiate into the cult.

The walls of a room from another villa, this one at Boscoreale, farther removed from Pompeii and dating slightly later, open onto a fantastic urban panorama (**FIG. 6–31**). Surfaces seem to dissolve behind an inner frame of columns and lintels, opening onto a maze

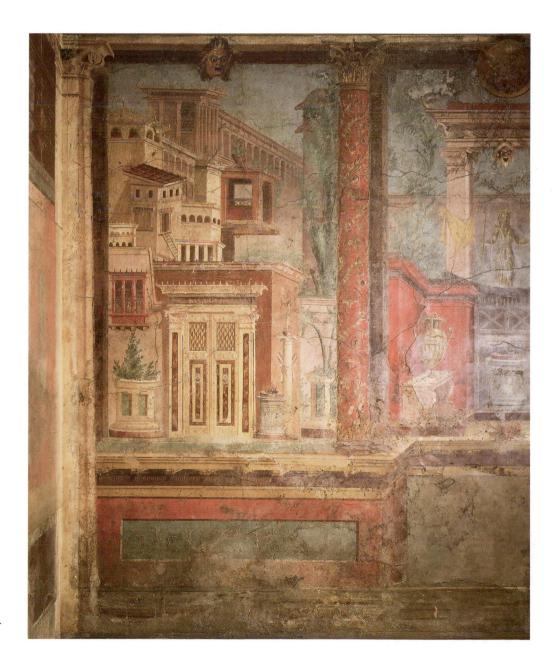

6-31 • CITYSCAPE, HOUSE OF PUBLIUS FANNIUS SYNISTOR
Boscoreale. Detail of a wall painting from a bedroom. c. 50–30 BCE.
Metropolitan Museum of Art, New York.
Rogers Fund, 1903. (03.14.13)

ART AND ITS CONTEXTS | August Mau's Four Styles of Pompeian Painting

In the 1870s, German art historian August Mau (1840–1909), in an early analysis of Pompeian wall painting proposed a schematic organizing system that is still used by many today to categorize its stylistic development. In the earliest wall paintings from Pompeii, artists covered the walls with illusionistic paintings of thin slabs of colored marble and projecting architectural moldings. Mau referred to this as First-Style wall painting (c. 300–100 BCE). By about 100 BCE, painters began to extend the space of a room visually with scenes of figures on a shallow platform or with landscapes or cityscapes (see FIGS. 6–30, 6–31)—Mau's Second Style (c. 100–20 BCE). Starting in

the late first century BCE, Third-Style wall painting replaced vistas with solid planes of color, decorated with slender, whimsical architectural and floral details and small, delicate vignettes (c. 20 BCE-c. 50 CE). In the final phase of Pompeian wall painting, the Fourth Style (c. 50-79 CE) united all three earlier styles into compositions of enormous complexity (see FIG. 6-29), where some wall surfaces seem to recede or even disappear behind a maze of floating architectural forms, while other flat areas of color become the support for simulated paintings of narrative scenes or still lifes (compositions of inanimate objects) (e.g., see FIG. 6-32).

of complicated architectural forms, like the painted scenic backdrops of a stage. Indeed, the theater may have inspired this kind of decoration, as the theatrical masks hanging from the lintels seem to suggest. By using a kind of **intuitive perspective**, the artists have created a general impression of real space beyond the wall. In

intuitive perspective, the architectural details follow diagonal lines that the eye interprets as parallel lines receding into the distance, and objects meant to be perceived as far away from the surface plane of the wall are shown gradually smaller and smaller than those intended to appear in the foreground.

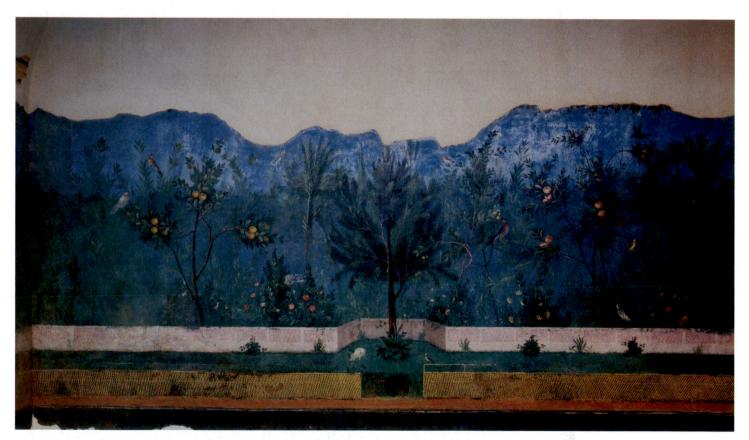

6-32 • GARDEN VISTA, VILLA OF LIVIA AT PRIMAPORTANear Rome. Late 1st century BCE. Museo Nazionale Romano, Rome.

Like the garlands and curling vine scrolls on the Ara Pacis Augustae (see Fig. 6–20), the lush fertility of nature seems to celebrate the vitality and prosperity of Rome under Augustan peace.

ART AND ITS CONTEXTS | A Painter at Work

This fresco—portraying a painter absorbed in her art—once decorated the walls of a house in Pompeii (FIG. 6–33). Like women in Egypt and Crete, Roman women were far freer and more worldly than their Greek counterparts. Many received a formal education and became physicians, writers, shopkeepers, even overseers in such male-dominated businesses as shipbuilding. But we have little information about the role women played in the visual arts, making the testimony of this picture all the more precious.

The painter sits within a room that opens behind her to the outdoors, holding her palette in her left hand, a sign of her profession. She is dressed in a long robe, covered by an ample mantle, and her hair is pulled back by a gold headband; but lighting and composition highlight two other aspects of her body: her centralized face, which focuses intently on the subject of her painting—a sculptured rendering of the bearded fertility god Priapus appearing in the shadows of the right background—and her right arm, which extends downward so she can dip her brush into a paintbox that rests precariously on a rounded column drum next to her folding stool. A small child steadies the panel on which she paints, and two elegantly posed and richly dressed women—perhaps her patrons—stand next to a pier behind her. The art she is practicing reflects well on her social position. Pliny the Elder claimed that "Among artists, glory is given only to those who paint panel paintings" (Natural History 35.118). Wall paintings, he claimed, are of lesser value because they cannot be removed in case of fire. In this fresco, however, fixed positioning facilitated survival. When Mount Vesuvius erupted in 79 ce, it was wall paintings like this one that were preserved for rediscovery by eighteenth-century archaeologists.

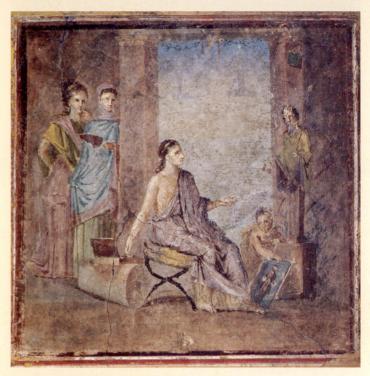

6-33 • A PAINTER AT WORK

From the House of the Surgeon, Pompeii. 1st century BCE–1st century CE. Fresco, 17% × 17% (45.5 × 45.3 cm). Museo Archeologico Nazionale, Naples.

This painting of a female artist at work was conceived as a simulated panel painting, positioned on the yellow wall of a small room (compare the red wall in Fig. 6–29). It was revered so highly by the archaeologists who discovered it in 1771 that it was cut out of the wall to be exhibited as a framed picture in a museum, a practice that would be anathema today but was far from unusual in the eighteenth century.

Close to Rome, the late first-century BCE paintings on the dining-room walls of Livia's villa at Primaporta, exemplify yet another approach to creating a sense of expanded space with murals (FIG. 6-32). Instead of rendering a stage set or opening onto an expansive architectural vista, the artists here "dissolved" wall surfaces by creating the illusion of being on a porch or pavilion looking out over a low wall into an orchard of flowering shrubs and heavily laden fruit trees populated by a variety of wonderfully observed birds—an idealized view of the carefully cultivated natural world. Here the painters used atmospheric perspective, where the world becomes progressively less distinct as it recedes into the distance.

ROMAN REALISM IN DETAILS: STILL LIFES AND PORTRAITS In addition to cityscapes, landscapes and figural tableaux, other subjects that appeared in Roman art included exquisitely rendered genre scenes (see "A Painter at Work," above), still lifes,

and portraits. A still-life panel from Herculaneum, a community in the vicinity of Mount Vesuvius near Pompeii, depicts everyday domestic objects—still-green peaches just picked from the tree and a glass jar half-filled with water (**FIG. 6-34**). The items have been carefully arranged on two stepped shelves to give the composition clarity and balance. A strong, clear light floods the picture from left to right, casting shadows, picking up highlights, and enhancing the illusion of solid objects in real space.

Few Pompeian paintings are more arresting than a double portrait of a young husband and wife (FIG. 6-35), who look out from their simulated spatial world beyond the wall into the viewers' space within the room. The swarthy, wispy-bearded man addresses us with a direct stare, holding a scroll in his left hand, a conventional attribute of educational achievement seen frequently in Roman portraits. Though his wife overlaps him to stake her claim to the foreground, her gaze out at us is less direct. She also holds fashionable attributes of literacy—the stylus she elevates in front of

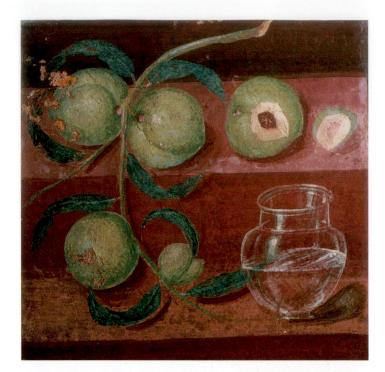

6-34 • STILL LIFE, HOUSE OF THE STAGS (CERVI) Herculaneum. Detail of a wall painting. Before 79 cE. Approx. $1'2'' \times 1'\frac{1}{2}''$ (35.5 \times 31.7 cm). Museo Archeologico Nazionale, Naples.

her chin and the folding writing tablet on which she would have used the stylus to inscribe words into a wax infill. This picture is comparable to a modern studio portrait photograph—perhaps a wedding picture—with its careful lighting and retouching, conventional poses and accoutrements. But the attention to physiognomic detail—note the differences in the spacing of their eyes and the shapes of their noses, ears, and lips—makes it quite clear that we are in the presence of actual human likenesses.

THE FLAVIANS

The Julio-Claudian dynasty ended with the suicide of Nero in 68 CE, which led to a brief period of civil war. Eventually an astute general, Vespasian, seized control of the government in 69 CE, founding a new dynasty known as the Flavian—practical military men who inspired confidence and ruled for the rest of the first century, restoring the imperial finances and stabilizing the frontiers. They replaced the Julio-Claudian fashion for classicizing imperial portraiture with a return to the ideal of time-worn faces, enhancing the effects of old age.

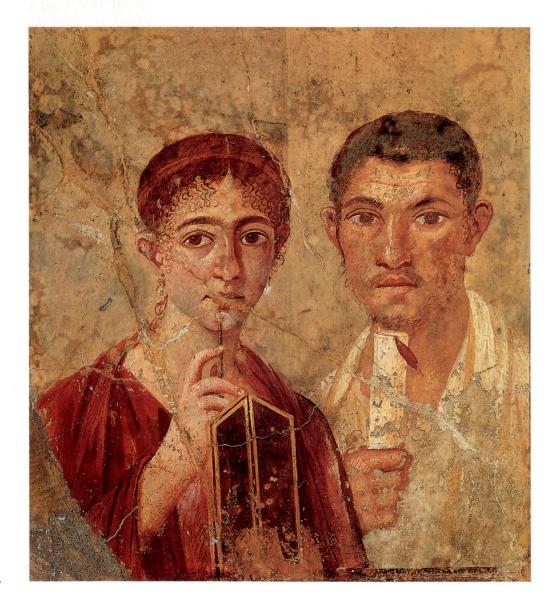

6-35 • PORTRAIT OF A MARRIED COUPLE

Wall painting from Pompeii. Mid 1st century ce. Height 25½" (64.8 cm). Museo Archeologico Nazionale, Naples.

THE ARCH OF TITUS When Domitian assumed the throne in 81 CE, he immediately commissioned a triumphal arch to honor the capture of Jerusalem in 70 CE by his brother and deified predecessor, Titus. Part architecture, part sculpture, and distinctly Roman, free-standing triumphal archs commemorate a triumph, or formal victory celebration, during which a victorious general or emperor paraded through Rome with his troops, captives, and booty. Constructed of concrete and faced with marble, THE ARCH OF TITUS (FIG. 6–36) is essentially a free-standing gateway

whose passage is covered by a barrel vault and which served as a giant base, 50 feet tall, for a lost bronze statue of the emperor in a four-horse chariot, a typical triumphal symbol. Applied to the faces of the arch are columns in the Composite order supporting an entablature. The inscription on the uppermost, or attic, story declares that the Senate and the Roman people erected the monument to honor Titus.

Titus' capture of Jerusalem ended a fierce campaign to crush a revolt of the Jews in Palestine. The Romans sacked and destroyed

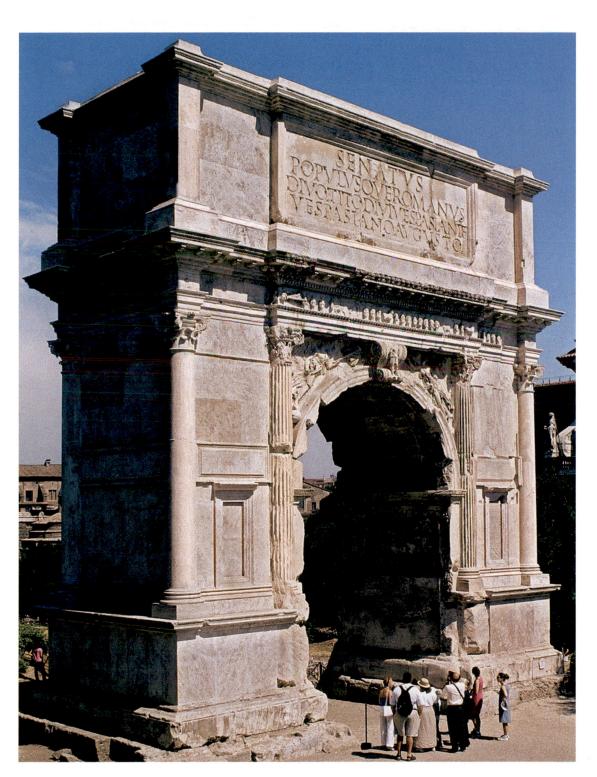

6-36 • THE ARCH OF TITUS

Rome. c. 81 cE (restored 1822–1824). Concrete and white marble, height 50' (15 m).

The dedication inscribed across the tall attic story above the arch opening reads: "The Senate and the Roman people to the Deified Titus Vespasian Augustus, son of the Deified Vespasian." The perfectly sized and spaced Roman capital letters meant to be read from a distance and cut with sharp terminals (serifs) to catch the light established a standard that calligraphers and font designers still follow.

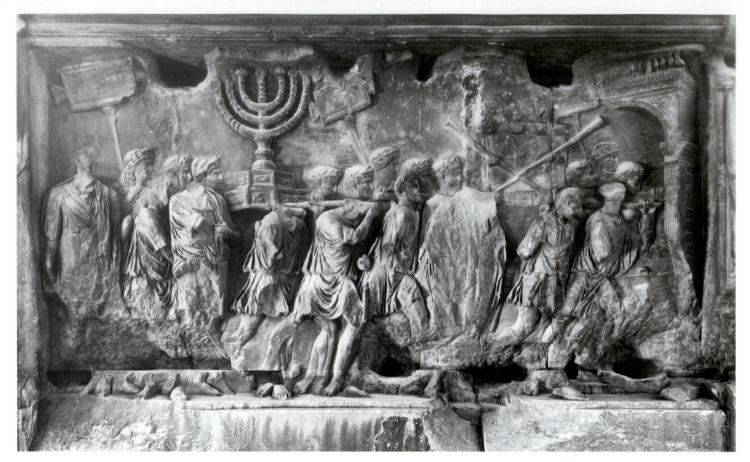

6-37 • SPOILS FROM THE TEMPLE IN JERUSALEMRelief in the passageway of the Arch of Titus. Marble, height 6'8" (2.03 m).

the Temple in Jerusalem, carried off its sacred treasures, then displayed them in a triumphal procession in Rome (FIG. 6-37). A relief on the inside walls of the arch, capturing the drama of the occasion, depicts Titus' soldiers flaunting this booty as they carry it through the streets of Rome. The soldiers are headed toward the right and through an arch, turned obliquely to project into the viewers' own space, thus allowing living spectators a sense of the press of a boisterous, disorderly crowd. They might expect at any moment to hear soldiers and onlookers shouting and chanting.

The mood of the procession depicted in this relief contrasts with the relaxed but formal solemnity of the procession portrayed on the Ara Pacis (see FIG. 6-22), but like the sculptors of the Ara Pacis, the sculptors of the Arch of Titus showed the spatial relationships among figures by varying the depth of the relief to render nearer elements in higher relief than those more distant. A menorah (seven-branched lampholder) from the Temple in Jerusalem dominates the scene, rendered as if seen from the low point of view of a spectator at the event.

THE FLAVIAN AMPHITHEATER Romans were huge sports fans, and the Flavian emperors catered to their tastes by building splendid facilities. Construction of the **FLAVIAN AMPHITHE-ATER**, Rome's greatest arena (**FIGS. 6-38, 6-39**), began under

Vespasian in 70 CE and was completed under Titus, who dedicated it in 80 CE. The Flavian Amphitheater came to be known as the "Colosseum," because a gigantic statue of Nero called the *Colossus* stood next to it. "Colosseum" is a most appropriate description of this enormous entertainment center. Its outer wall stands 159 feet high. It is an oval, measuring 615 by 510 feet, with a floor 280 by 175 feet. This floor was laid over a foundation of service rooms and tunnels that provided an area for the athletes, performers, animals, and equipment. The floor was covered by sand, *arena* in Latin, hence the English term "arena" for a building of this type.

Roman audiences watched a variety of athletic events, blood sports, and spectacles, including animal hunts, fights to the death between gladiators or between gladiators and wild animals, performances of trained animals and acrobats, and even mock sea battles, for which the arena would be flooded. The opening performances in 80 CE lasted 100 days, during which time it was claimed that 9,000 wild animals and 2,000 gladiators died for the amusement of the spectators.

The amphitheater is such a remarkable piece of planning—with easy access, perfect sight lines, and effective crowd control—that stadiums today still use this efficient plan. Some 50,000 spectators could move easily through the 76 entrance doors to the

ELEMENTS OF ARCHITECTURE | Roman Vaulting

The Romans became experts in devising methods of covering large, open architectural spaces with concrete and masonry, using barrel vaults, groin vaults, or domes.

A **barrel vault** is constructed in the same manner as the round arch (see "The Roman Arch," page 170). In a sense, it is a series of connected arches extended in sequence along a line. The outward pressure exerted by the curving sides of the barrel vault requires buttressing within or outside the supporting walls.

When two barrel-vaulted spaces intersect each other at the same level, the result is a **groin**vault. Both the weight and outward thrust of the groin vault are concentrated on four corner piers; only the piers require buttressing, so the walls on all four sides can be opened. The Romans used the groin vault to construct some of their grandest interior spaces.

A third type of vault brought to technical perfection by the Romans is the **dome**. The rim of the dome is supported on a circular wall, as in the Pantheon (see FIGS. 6–49, 6–50, 6–52). This wall is called a drum when it is raised on top of a main structure. Sometimes a circular opening, called an **oculus**, is left at the top.

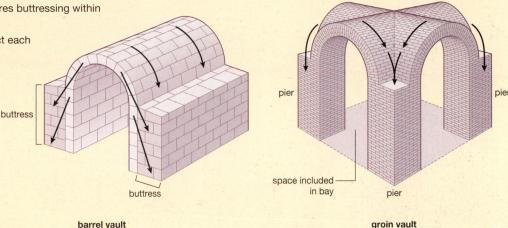

● Watch an architectural simulation about the groin vault on myartslab.com

three levels of seats—laid over barrel-vaulted access corridors and entrance tunnels—and the standing area at the top. Each spectator had an uninterrupted view of the events below, and the walls on the top level supported a huge awning that could shade the seats. Sailors, who had experience in handling ropes, pulleys, and large expanses of canvas, worked the apparatus that extended the awning.

The curving, outer wall of the Colosseum consists of three levels of arcades surmounted by a wall-like attic (top) story. Each

arch is framed by engaged columns. Entablature-like friezes mark the divisions between levels. Each level also uses a different architectural order, increasing in complexity from bottom to top: the plain Tuscan order on the ground level, Ionic on the second level, Corinthian on the third, and Corinthian pilasters on the fourth. The attic story is broken by small, square windows, which originally alternated with gilded-bronze shield-shaped ornaments called **cartouches**, supported on brackets that are still in place.

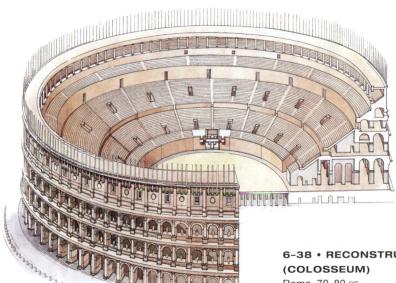

6-38 • RECONSTRUCTION DRAWING OF THE FLAVIAN AMPHITHEATER (COLOSSEUM)

Rome. 70-80 CE.

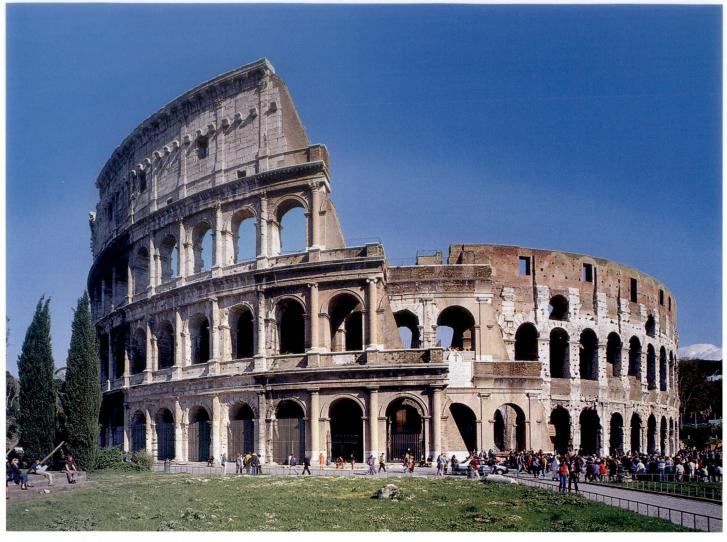

 $\textbf{6-39} \bullet \textbf{OUTER}$ WALL OF THE FLAVIAN AMPHITHEATER Rome. 70–80 ce.

All these elements are purely decorative. As we saw in the Etruscan Porta Augusta (see FIG. 6-2), the addition of post-and-lintel decoration to arched structures was an Etruscan innovation. The systematic use of the orders in a logical succession from sturdy Tuscan to lighter Ionic to decorative Corinthian follows a tradition inherited from Hellenistic architecture. This orderly, dignified, and visually satisfying way of organizing the façades of large buildings is still popular. Unfortunately, much of the Colosseum was dismantled in the Middle Ages as a source of marble, metal fittings, and materials for buildings such as churches.

PORTRAIT SCULPTURE Roman patrons continued to expect recognizable likenesses in their portraits, but this did not preclude idealization. A portrait sculpture of a **YOUNG FLAVIAN WOMAN** (FIG. 6–40) is idealized in a manner similar to the *Augustus of Primaporta* (see FIG. 6–19). Her well-observed, recognizable features—a strong nose and jaw, heavy brows, deep-set eyes, and a long neck—contrast with the smoothly rendered flesh and soft, sensual lips.

Her hair is piled high in an extraordinary mass of ringlets following the latest court fashion. Executing the head required skillful chiseling and **drillwork**, a technique for rapidly cutting deep grooves with straight sides, used here to render the holes in the center of the curls. The overall effect, especially from a distance, is quite lifelike, as the play of natural light over the subtly sculpted marble surfaces simulates the textures of real skin and hair.

A contemporary bust of an older woman (**FIG. 6-41**) presents a strikingly different image of its subject. Although she also wears her hair in the latest fashion, it is less elaborate and less painstakingly confected and carved than that of her younger counterpart. The work emphasizes not the fresh sheen of an unblemished face, but a visage clearly marked by the passage of time during a life well lived. We may regard this portrait as less idealized and more naturalistic, but for a Roman viewer, it conformed to an ideal of age and accomplishment by showcasing signs of aging facial features, cherished since the Republican period as reflections of virtue and venerability.

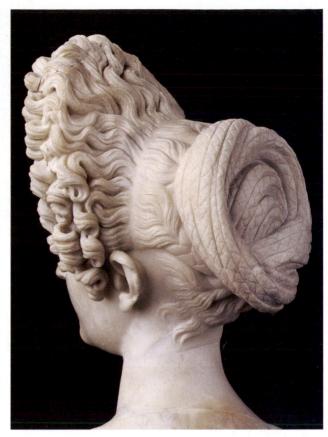

6-40 • YOUNG FLAVIAN WOMAN c. 90 CE. Marble, height 25" (65.5 cm). Museo Capitolino, Rome.

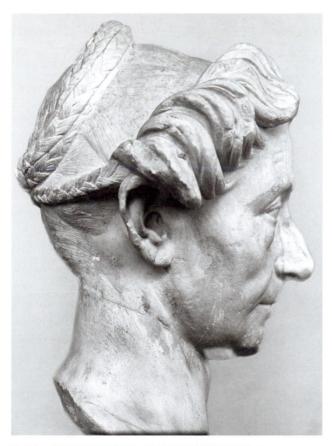

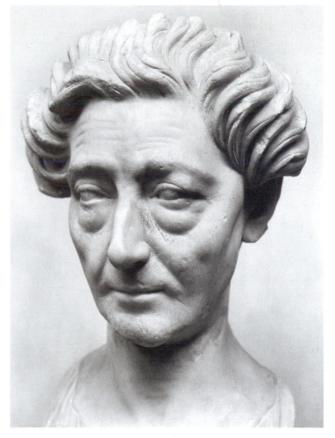

6-41 • MIDDLE-AGED FLAVIAN WOMAN
Late 1st century ce. Marble, height 9½" (24.1 cm). Musei Vaticani, Museo Gregoriano Profano, ex-Lateranese, Rome.

THE HIGH IMPERIAL ART OF TRAJAN AND HADRIAN

Domitian, the last Flavian emperor, was assassinated in 96 CE and succeeded by a senator, Nerva (r. 96–98 CE), who designated as his successor Trajan, a general born in Spain who had commanded Roman troops in Germany. For nearly a century, the empire was under the control of brilliant administrators. Instead of depending on the vagaries of fate (or genetics) to produce intelligent heirs, the emperors Nerva (r. 96–98 CE), Trajan (r. 98–117 CE), Hadrian (r. 117–138 CE), and Antoninus Pius (r. 138–161 CE)—but not his successor, Marcus Aurelius (r. 161–180 CE)—each selected an able administrator to follow him, thus "adopting" his successor. Italy and the provinces flourished, and official and private patronage of the arts increased.

Under Trajan, the empire reached its greatest territorial expanse. By 106 CE, he had conquered Dacia, roughly present-day Romania (see MAP 6-1), and his successor, Hadrian, consolidated the empire's borders and imposed far-reaching social, governmental,

and military reforms. Hadrian was well educated and widely traveled, and his admiration for Greek culture spurred new building programs and classicizing works of art throughout the empire. Unfortunately, Marcus Aurelius broke the tradition of adoption and left his son, Commodus, to inherit the throne. Within 12 years, Commodus (r. 180–192 CE) had destroyed the stable government his predecessors had so carefully built.

IMPERIAL ARCHITECTURE

The Romans believed their rule extended to the ends of the Western world, but the city of Rome remained the nerve center of the empire. During his long and peaceful reign, Augustus had paved the city's old Republican Forum, restored its temples and basilicas, and followed Julius Caesar's example by building an Imperial Forum. These projects marked the beginning of a continuing effort to transform the capital into a magnificent monument to imperial rule. Such grand structures as the Imperial Forums, the Colosseum, the Circus Maximus (a track for chariot races), the Pantheon, and aqueducts stood amid the temples, baths, warehouses, and homes

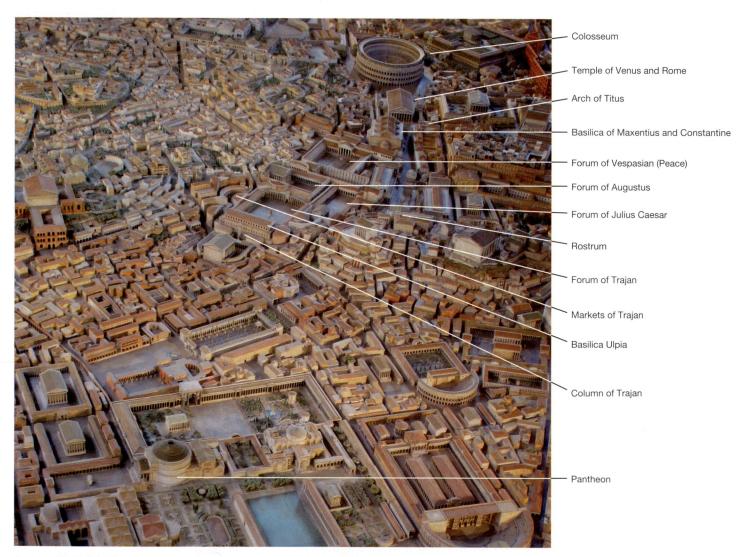

6-42 • MODEL OF IMPERIAL ROME IN c. 324 CE

in the city center as expressions of successive emperors' beneficence and their desire to leave their mark on, and preserve their memory in, the capital. A model of Rome's city center makes apparent the dense building plan (FIG. 6-42).

THE FORUM OF TRAJAN The last and largest Imperial Forum was built by Trajan about 110–113 CE and finished under Hadrian about 117 CE on a large piece of property next to the earlier forums of Augustus and Julius Caesar (FIG. 6-43). For this major undertaking, Trajan chose a Greek architect, Apollodorus of Damascus, who was experienced as a military engineer. A straight, central axis leads from the Forum of Augustus through a triple-arched gate surmounted by a bronze chariot group into a large, colonnaded square with a statue of Trajan on horseback at its center. Closing off the courtyard at the north end was the BASILICA ULPIA (FIG. 6-44), dedicated in c. 112 CE, and named for the family to which Trajan belonged.

A **basilica** was a large, rectangular building with an extensive interior space, adaptable for a variety of administrative governmental functions. The Basilica Ulpia was a court of law, but other basilicas served as imperial audience chambers, army drill halls, and schools. The Basilica Ulpia was a particularly grand interior space, 385 feet long (not including the apses) and 182 feet wide. A large central area (the **nave**) was flanked by double colonnaded aisles surmounted by open galleries or by a clerestory, an upper nave wall with windows. The timber truss roof

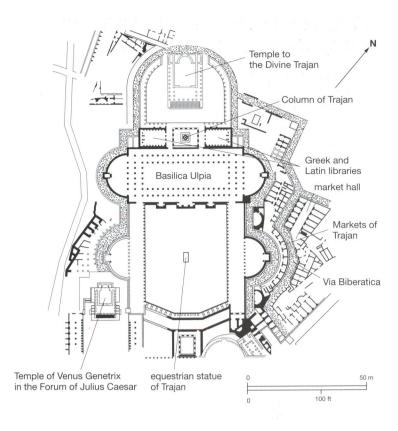

6-43 • PLAN OF TRAJAN'S FORUM AND MARKET c. 110–113 ce.

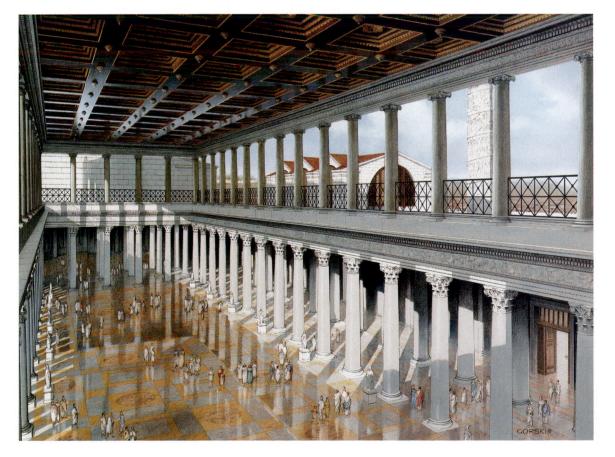

6-44 • Gilbert
Gorski RESTORED
PERSPECTIVE VIEW
OF THE CENTRAL
HALL, BASILICA
ULPIA

Rome. As it was c. 112 ce.

Trajan's architect was Apollodorus of Damascus. The building may have had clerestory windows instead of the gallery shown in this drawing. The Column of Trajan can be seen through the upper colonnade at right.

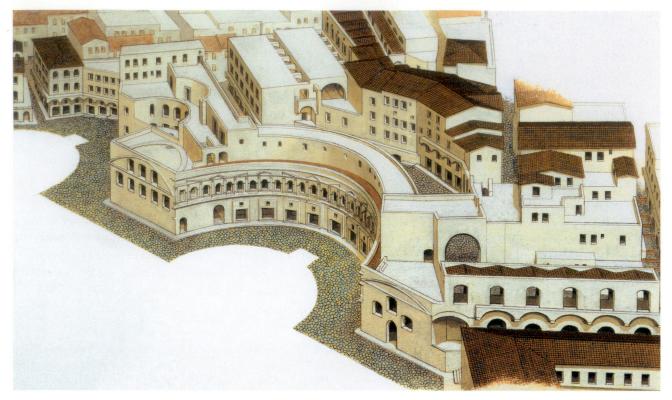

6-45 • RECONSTRUCTION DRAWING OF TRAJAN'S MARKET Rome. As it was 100–112 ce.

had a span of about 80 feet. The two **apses**, rounded extensions at each end of the building, provided imposing settings for judges when the court was in session.

During the site preparation for Trajan's forum, part of a commercial district had to be razed and excavated. To make up for the loss, Trajan ordered the construction of a handsome public market (**FIGS. 6-45, 6-46**). The market, comparable in size to a large modern shopping mall, had more than 150 individual shops

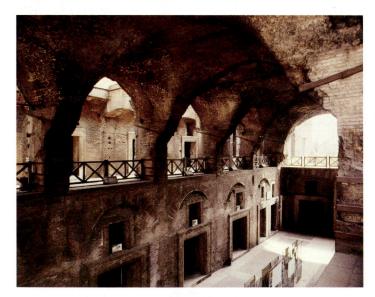

6-46 • MAIN HALL, TRAJAN'S MARKET Rome. 100-112 ce.

on several levels and included a large groin-vaulted main hall. In compliance with a building code that was put into effect after a disastrous fire in 64 ce, the market, like most Roman buildings of the time, was constructed of concrete (see "Concrete," page 194) faced with brick, with only occasional detailing in stone and wood.

Behind the Basilica Ulpia stood twin libraries built to house the emperor's collections of Latin and Greek manuscripts. These buildings flanked an open court, the location of the great spiral column that became Trajan's tomb when Hadrian placed a golden urn containing his predecessor's ashes in its base. The column commemorated Trajan's victory over the Dacians and was erected either c. 113 CE, at about the same time as the Basilica Ulpia, or by Hadrian after Trajan's death in 117 CE.

THE COLUMN OF TRAJAN The relief decoration on the **COLUMN OF TRAJAN** spirals upward in a band that would stretch almost 625 feet if laid out straight. Like a giant, unfurled version of the scrolls housed in the libraries next to it, the column presents a continuous pictorial narrative of the Dacian campaigns of 102–103 and 105–106 CE (**FIG. 6-47**). The remarkable sculpture includes more than 2,500 individual figures linked by landscape and architecture, and punctuated by the recurring figure of Trajan. The narrative band slowly expands from about 3 feet in height at the bottom, near the viewer, to 4 feet at the top of the column, where it is farther from view. The natural and architectural elements in the scenes have been kept small so the important figures can occupy as much space as possible.

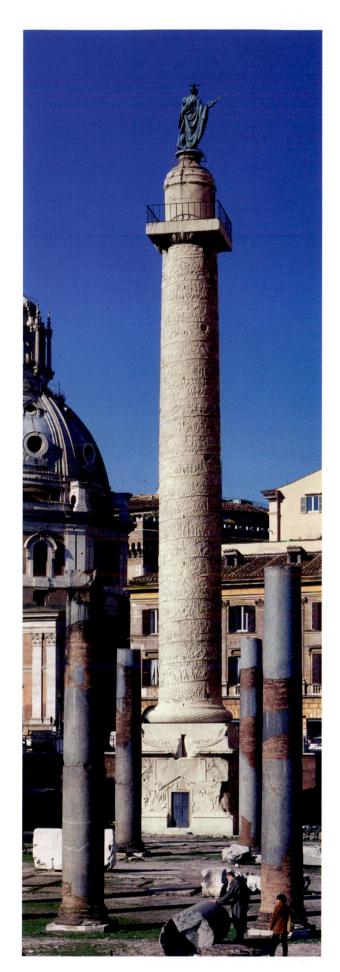

6-47 • COLUMN OF TRAJAN

Rome. 113–116 ce, or after 117 ce. Marble, overall height with base 125' (38 m); column alone 97'8" (29.77 m); length of relief 625' (190.5 m).

The height of the column may have recorded the depth of the excavation required to build the Forum of Trajan. The gilded bronze statue of Trajan that once stood on the top was replaced in 1588 cE with the statue of St. Peter seen today.

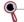

View the Closer Look for the Column of Trajan on myartslab.com

The scene at the beginning of the spiral, at the bottom of the column, shows Trajan's army crossing the Danube River on a pontoon bridge to launch the first Dacian campaign of 101 CE (FIG. 6-48). Soldiers construct battlefield headquarters in Dacia from which the men on the frontiers will receive orders, food, and weapons. In this spectacular piece of imperial ideology or propaganda, Trajan is portrayed as a strong, stable, and efficient commander of a well-run army, and his barbarian enemies are shown as worthy opponents of Rome.

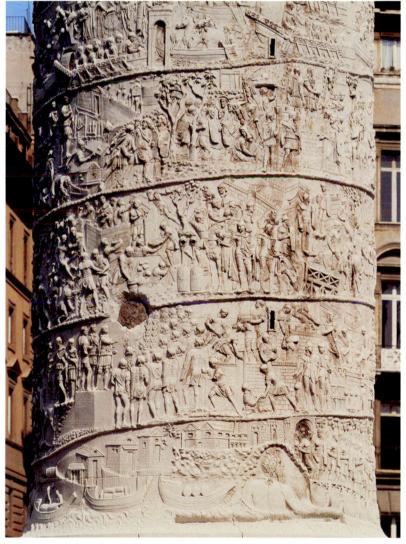

6-48 • ROMANS CROSSING THE DANUBE AND BUILDING A FORT

Detail of the lowest part of the Column of Trajan. 113–116 $^{\circ}$ CE, or after 117 CE. Marble, height of the spiral band approx. 36" (91 cm).

ELEMENTS OF ARCHITECTURE | Concrete

The Romans were pragmatic builders, and their practicality extended from recognizing and exploiting undeveloped potential in construction methods and physical materials to organizing large-scale building works. Their exploitation of the arch and the vault is typical of their adapt-and-improve approach (see "The Roman Arch," page 170, and "Roman Vaulting," page 187). But their innovative use of concrete, beginning in the first century BCE, was a technological breakthrough of the greatest importance in the history of architecture.

In contrast to stone—which was expensive and difficult to quarry and transport—the components of concrete were cheap, relatively light, and easily transported. Building stone structures required highly skilled masons, but a large, semiskilled workforce directed by a few experienced supervisors could construct brick-faced concrete buildings.

Roman concrete consisted of powdered lime, a volcanic sand called *pozzolana*, and various types of rubble, such as small rocks and broken pottery. Mixing these materials in water caused a chemical reaction that blended them, and they hardened as they dried into a strong, solid mass. At first, concrete was used mainly for poured foundations, but with technical advances it became indispensable for the construction of walls, arches, and vaults for ever-larger buildings, such as the Flavian

Amphitheater (see Fig. 6–38) and the Markets of Trajan (see Fig. 6–46). In the earliest concrete wall construction, workers filled a framework of rough stones with concrete. Soon they developed a technique known as opus reticulatum, in which the framework is a diagonal web of smallish bricks set in a cross pattern. Concrete-based construction freed the Romans from the limits of right-angle forms and comparatively short spans. With this new freedom, Roman builders pushed the established limits of architecture, creating some very large and highly original spaces by pouring concrete over wooden frameworks to mold it into complex curving shapes.

Concrete's one weakness was that it absorbed moisture and would eventually deteriorate if unprotected, so builders covered exposed surfaces with a veneer, or facing, of finer materials—such as marble, stone, stucco, or painted plaster—to protect it. An essential difference between Greek and Roman architecture is that Greek builders reveal the building material itself and accept the design limitations of post-and-lintel construction, whereas Roman buildings expose only an externally applied surface covering. The sophisticated structural underpinnings that allow huge spaces molded by three-dimensional curves are set behind them, hidden from view.

Watch an architectural simulation about the Roman use of concrete on myartslab.com

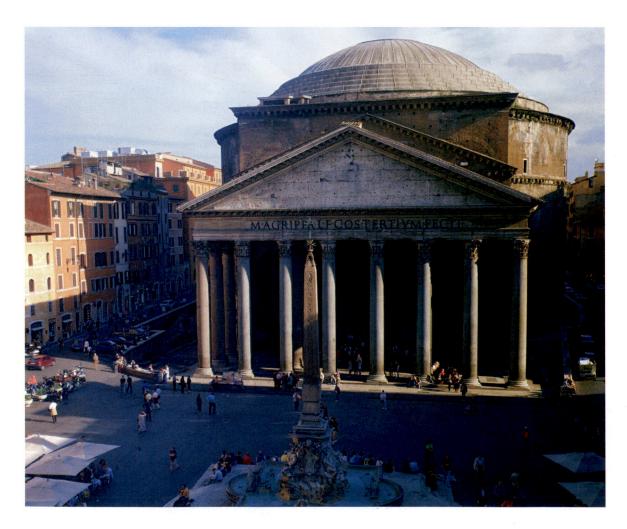

6-49 • PANTHEON

Rome, c. 110-128 ce.

Today a huge fountain dominates the square in front of the Pantheon. Built in 1578 by Giacomo della Porta, it now supports an Egyptian obelisk placed there in 1711 by Pope Clement XI.

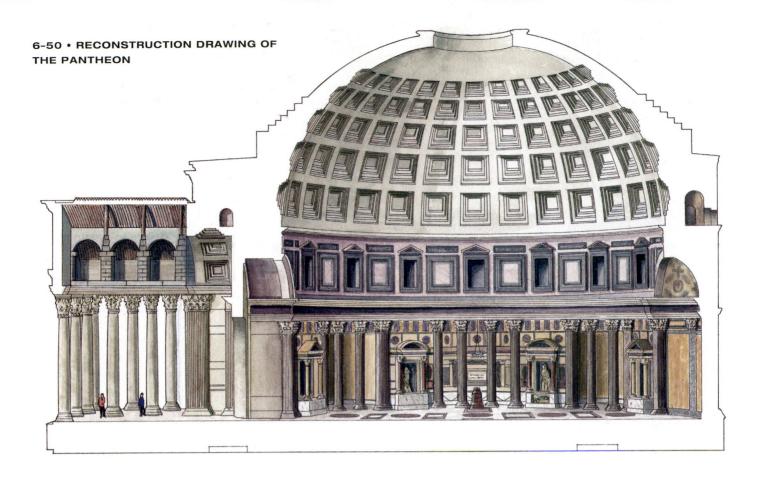

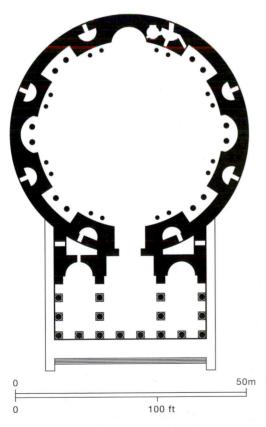

6-51 • PLAN OF THE PANTHEON

THE PANTHEON Perhaps the most remarkable ancient building surviving in Rome—and one of the marvels of world architecture in any age—is a temple to Mars, Venus, and the divine Julius Caesar known as the PANTHEON (FIG. 6-49). Although this magnificent monument was designed and constructed during the reigns of emperors Trajan and Hadrian, the long inscription on the architrave states that it was built by "Marcus Agrippa, son of Lucius, who was consul three times." Agrippa, the son-in-law and valued advisor of Augustus, sponsored a building on this site in 27–25 BCE. After a fire in 80 CE, Domitian either restored the Pantheon or built a new temple, which burned again after being struck by lightning in 110 CE. Although there has been a strong scholarly consensus that it was Hadrian who reconstructed the building in its current state in 118–128 CE, a recent study of the brick stamps has argued convincingly that the Pantheon was begun soon after 110 under Trajan, but only completed during the reign of his successor, Hadrian. This spectacular and influential design may represent another work of Apollodorus of Damascus.

The current setting of the temple gives little suggestion of its original appearance. Centuries of dirt and street construction hide its podium and stairs. Attachment holes in the pediment indicate the placement of bronze sculpture, perhaps an eagle within a wreath, the imperial Jupiter. Today we can see the sides of the rotunda flanking the entrance porch, but when the Pantheon was constructed, the façade of this porch—resembling the façades of typical, rectangular temples—was literally all viewers could see of the building. Since their approach was controlled by an enclosed courtyard (see FIG. 6–42), the actual circular shape of the Pantheon was concealed. Viewers were therefore surprised to pass through the rectilinear and restricted aisles of the portico and the huge main door to encounter the gaping space of the giant **rotunda** (circular room) surmounted by a vast, bowl-shaped dome, 143 feet in diameter and 143 feet from the floor at its summit (**FIGS. 6–50, 6–51**). Even without the controlled

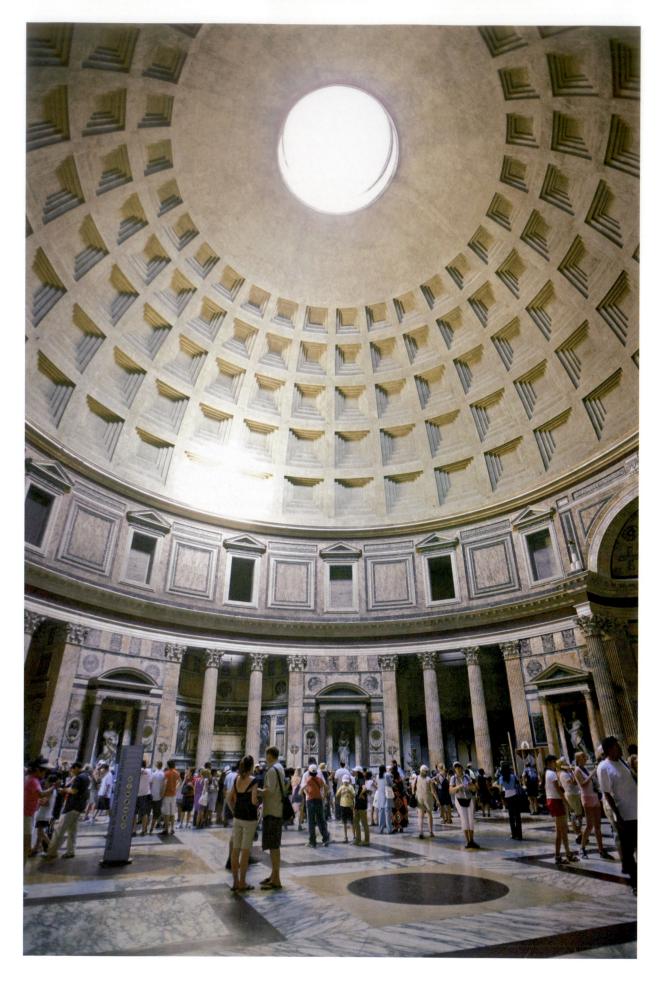

6-52 • DOME OF THE PANTHEON

With light from the oculus on its coffered ceiling. c. 110-128 cE. Brick, concrete, marble veneer, diameter of dome 143' (43.5 m).

Explore the architectural panoramas of the Pantheon on myartslab.com

courtyard approach, encountering this glorious space today is still an overwhelming experience—for many of us, one that is repeated on successive visits to the rotunda.

Standing at the center of this hemispherical temple (**FIG. 6-52**), the visitor feels isolated from the outside world and intensely aware of the shape and tangibility of the luminous space itself. Our eyes are drawn upward over the patterns made by the sunken panels, or **coffers**, in the dome's ceiling to the light entering the 29-footwide oculus, or round central opening, which illuminates a brilliant circle against the surface of the dome. This disk of light moves around this microcosm throughout the day like a sun. Clouds can be seen traveling across the opening on some days; on others, rain

falls in and then drains off through conduits on the floor planned by the original engineer. Occasionally a bird flies in.

The simple shape of the Pantheon's dome belies its sophisticated design and engineering (see FIG. 6-52). Marble veneer and two tiers of richly colored architectural detail conceal the internal brick arches and concrete structure of the 20-foot-thick walls of the rotunda. More than half of the original decoration—a wealth of columns, pilasters, and entablatures—survives. The simple repetition of square against circle, established on a large scale by juxtaposing the rectilinear portico against the circular rotunda, is found throughout the building's ornamentation. The wall is punctuated by seven exedrae (niches)—rectangular alternating with semicircular—that originally held statues of gods. The square, boxlike coffers inside the dome, which help lighten the weight of the masonry, may once have contained gilded bronze rosettes or stars suggesting the heavens. In 609 CE, Pope Boniface IV rededicated the Pantheon as the Christian church of St. Mary of the Martyrs, thus ensuring its survival through the Middle Ages and down to our day.

HADRIAN'S VILLA AT TIVOLI To imagine imperial Roman life at its most luxurious, one must go to Tivoli, a little more than 20 miles from Rome. HADRIAN'S VILLA, or country resiprivate suite (libraries) dence, was not a single building but an architectural complex of many buildings, lakes, and gardens spread over half a square mile maritime theate (FIG. 6-53). Each section had its own inner logic, and each took advantage of natural land formations and attractive views. Hadrian Poikile stadium Piazza d'Oro triclinium vestibule great baths Piazza d'Oro 25 m 50 ft 0 250 m academy 500 ft

6-53 • PLAN OF HADRIAN'S VILLA Tivoli. c. 125-135 ce.

6-54 • THE CANAL (REFLECTING POOL), HADRIAN'S VILLA Tivoli. c. 125–135 ce.

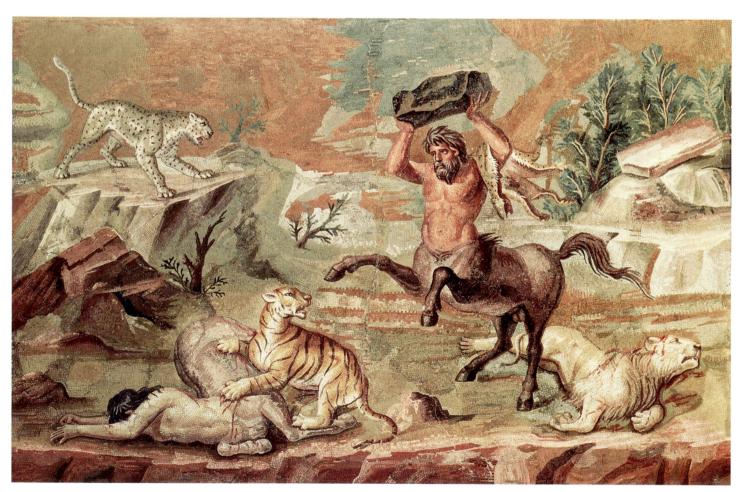

6-55 • BATTLE OF CENTAURS AND WILD BEASTS

From Hadrian's Villa, Tivoli. c. 125 ce. Mosaic, $23'' \times 36''$ (58.4 \times 91.4 cm). Staatliche Museen zu Berlin, Preussischer Kulturbesitz, Antikensammlung, Berlin.

This floor mosaic may be a copy of a much-admired scene of a fight between centaurs and wild animals painted by the late fifth-century BCE Greek artist Zeuxis.

TECHNIQUE | Roman Mosaics

Mosaics were used widely in Hellenistic times and became enormously popular for decorating homes in the Roman period. Mosaic designs were created with pebbles (see Fig. 5–57), or with small, regularly shaped pieces of colored stone and marble, called *tesserae*. The stones were pressed into a kind of soft cement called grout. When the stones were firmly set, the spaces between them were also filled with grout. After the surface dried, it was cleaned and polished. Since the natural stones produced only a narrow range of colors, glass *tesserae* were also used to extend the palette as early as the third century BCE.

Mosaic production was made more efficient by the use of emblemata (the plural of *emblema*, "central design"). These small, intricate mosaic compositions were created in the artist's workshop in square or rectangular trays. They could be made in advance, carried to a work site, and inserted into a floor decorated with an easily produced geometric pattern.

Some skilled mosaicists even copied well-known paintings, often by famous Greek artists. Employing a technique in which very small tesserae, in a wide range of colors, were laid down in irregular, curving lines, they effectively imitated painted brushstrokes. One example is The Unswept Floor (Fig. 6–56). Herakleitos, a second-century ce Greek mosaicist living in Rome, made this copy of an original work by the renowned second-century BCE artist Sosos. Pliny the Elder, in his Natural History, mentions a mosaic of an unswept floor and another of doves that Sosos made in Pergamon. (For another Roman mosaic copy of a Greek painting, see Fig. 5–56.)

A dining room would be a logical location for a floor mosaic of this theme, with table scraps re-created in meticulous detail, even to the shadows they cast, and a mouse foraging among them. Guests reclining on their banquet couches would certainly have been amused by the pictures on the floor, but they could also have shown off their knowledge of the notable Greek precedents for the mosaic beneath their feet.

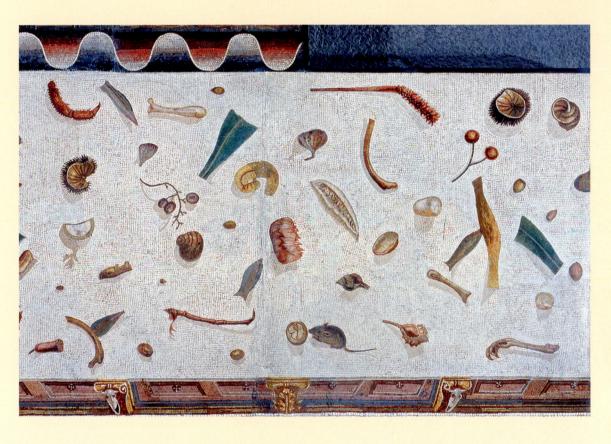

6-56 • THE
UNSWEPT FLOOR
Mosaic variant of a

2nd-century BCE painting by Sosos of Pergamon. 2nd century CE. Signed by Herakleitos. Musei Vaticani, Museo Gregoriano Profano, Rome.

instructed his architects to re-create his favorite places throughout the empire so he could pretend to enjoy the Athenian Grove of Academe, the Painted Stoa from the Athenian Agora, and buildings of the Ptolemaic capital of Alexandria in Egypt.

Landscapes with pools, fountains, and gardens turned the villa into a place of sensuous delight. An area with a long reflecting pool, called **THE CANAL**, was framed by a colonnade with alternating semicircular and straight entablatures (**FIG. 6-54**). Copies of famous Greek statues—sometimes even originals—filled the spaces

between columns. So great was Hadrian's love of Greek sculpture that he even had the caryatids of the Erechtheion (see FIG. 5–45) replicated for his pleasure palace.

The individual buildings were not large, but they were extremely complex and imaginatively designed, exploiting fully the flexibility offered by concrete vaulted construction. Walls and floors had veneers of marble and travertine or of exquisite mosaics and paintings. A panel from one of the floor mosaics (**FIG. 6–55**) demonstrates the extraordinary artistry of Hadrian's mosaicists (see

"Roman Mosaics," page 199). In a rocky landscape with only a few bits of greenery, a desperate male centaur raises a large boulder over his head to crush a tiger that has attacked and severely wounded a female centaur. Two other felines apparently took part in the attack—the white leopard on the rocks to the left and the dead lion at the feet of the male centaur. The artist rendered the figures with three-dimensional shading, foreshortening, and a great sensitivity to a range of figure types, including human torsos and powerful animals in a variety of poses.

IMPERIAL PORTRAITS

Imperial portraits were objects of propaganda, proclaiming the accomplishments and pretensions of emperors. Marcus Aurelius, like Hadrian, was a successful military commander who was equally proud of his intellectual attainments. In a lucky error—or twist of fortune—a gilded-bronze equestrian statue of the emperor, dressed as a military commander in a tunic and short, heavy cloak (FIG. 6-57), came mistakenly to be revered during the Middle Ages as a statue of Constantine, the first Christian emperor, and

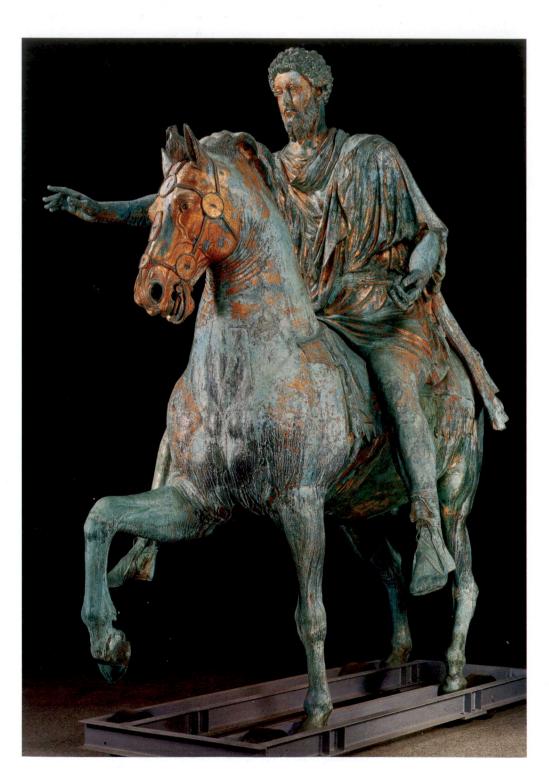

6-57 • EQUESTRIAN STATUE OF MARCUS AURELIUS

c. 176 cE. Bronze, originally gilded, height of statue 11'6" (3.5 m). Museo Capitolino, Rome.

Between 1187 and 1538, this statue stood in the piazza fronting the palace and church of St. John Lateran in Rome. In January 1538, Pope Paul III had it moved to the Capitoline Hill, and Michelangelo made it the centerpiece of his newly redesigned Capitoline Piazza. After being removed from its base for cleaning and restoration during the 1980s, it was taken inside the Capitoline Museum to protect it from air pollution, and a copy has replaced it in the piazza.

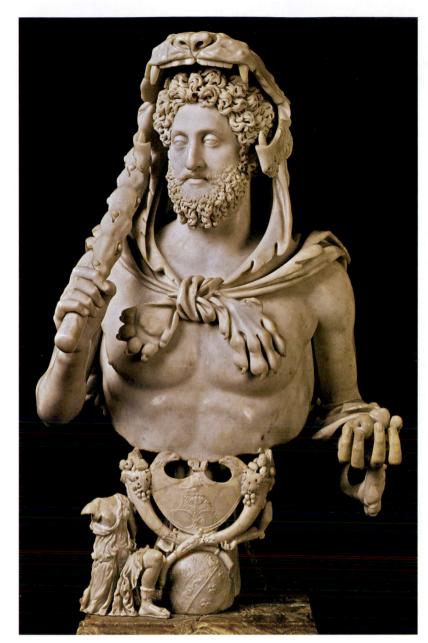

6–58 • COMMODUS AS HERCULES From the Esquiline Hill, Rome. c. 191–192 ce. Marble, height $46\frac{1}{2}$ " (118 cm). Palazzo dei Conservatori, Rome.

consequently the sculpture escaped being melted down. The raised foreleg of his horse once trampled a crouching barbarian.

Marcus Aurelius' head, with its thick, curly hair and full beard (a fashion initiated by Hadrian), resembles traditional "philosopher" portraits from the Greek world. The emperor wears no armor and carries no weapons; like Egyptian kings, he conquers effortlessly by divine will. And like his illustrious predecessor Augustus, he reaches out to those around him in a rhetorical gesture of address. It is difficult to create an equestrian portrait in which the rider stands out as the dominant figure without making the horse look too small. The sculptor of this statue found a balance acceptable to viewers of the time and, in doing so, created a model for later artists.

Marcus Aurelius was succeeded as emperor by his son Commodus, a man without political skill, administrative competence, or intellectual distinction. During his unfortunate reign (180-192 cE), he devoted himself to luxury and frivolous pursuits, claiming at various times to be the reincarnation of Hercules and the incarnation of the god Jupiter. When he proposed to assume the consulship dressed and armed as a gladiator, his associates, including his mistress, arranged to have him strangled in his bath by a wrestling partner. In a spectacular marble bust, the emperor poses as HERCU-LES (FIG. 6-58), adorned with references to the hero's legendary labors: Hercules' club, the skin and head of the Nemean lion, and the golden apples from the Garden of the Hesperides. Commodus' likeness emphasizes his family resemblance to his more illustrious and powerful father (see FIG. 6-57), but it also captures his vanity, through the grand pretensions of his costume and the Classical associations of his body type. The sculptor's sensitive modeling and expert drillwork exploit the play of light and shadow on the figure to bring out the textures of the hair, beard, facial features, and drapery, and to capture the illusion of life and movement.

FUNERARY SCULPTURE During the second and third centuries, a shift from cremation to inhumation created a growing demand for sarcophagi in which to bury the bodies of the deceased. Wealthy Romans commissioned thousands of massive and elaborate marble sarcophagi, encrusted with sculptural relief, created in large production workshops throughout the Roman Empire.

In 1885, nine particularly impressive sarcophagi were discovered in private underground burial chambers built for use by a powerful, aristocratic Roman family—the Calpurnii Pisones. One of these sarcophagi, from c. 190 CE, portrays the *Indian Triumph of Dionysus* (see "A Closer Look," page 202). This is a popular theme in late second-century CE sarcophagi, but here the carved relief

is of especially high quality—complex but highly legible at the same time. The mythological composition owes a debt to imperial ceremony: Dionysus, at far left in a chariot, receives from a personification of Victory standing behind him a laurel crown, identical to the headdress worn by Roman emperors during triumphal processions. Also derived from state ceremony is the display of booty and captives carried by the elephants at the center of the composition. But religion, rather than statecraft, is the real theme here. The set of sarcophagi to which this belongs proclaims the family's adherence to a mystery cult of Dionysus that focused on themes of decay and renewal, death and rebirth. The triumph of the deceased over death is the central message here, not one particular episode in the life of Dionysus himself.

A CLOSER LOOK | Sarcophagus with the Indian Triumph of Dionysus

c. 190 ce. Marble, $47\%''\times92\%z''\times35^{13}\%''$ (120.7 \times 234.9 \times 90.96 cm). Walters Art Museum, Baltimore.

Semele, mortal mother of the god Dionysus, gives birth prematurely and then dies. Once grown, Dionysus would travel to the underworld and bring his mother to paradise. Semele's death therefore suggests the promise of eternal life through her son.

These hooked sticks are identical to the *ankusha* still used by *mahouts* (elephant drivers) in India today.

As part of their worship, followers of Dionysiac mystery religions re-created the triumphant return of the god from India by parading in the streets after dark. A dancing maenad beats her tambourine here, suggesting the sounds and movements that would accompany such ritual re-enactments.

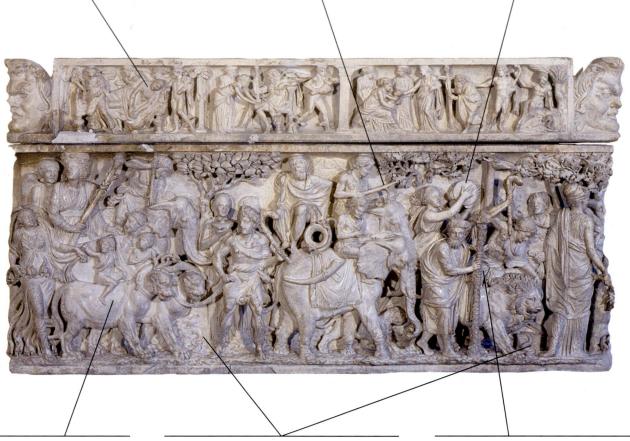

The presence of exotic animals such as elephants, a lion, a giraffe, and panthers, identifies this scene as Dionysus' triumphant return from India.

Snakes were not only used in the rites of Dionysiac mystery religions; they were powerful symbols of rebirth and phallic fertility, making them especially appropriate in the context of a sarcophagus. Three snakes appear along the ground-line of the sculptural frieze.

The aged god Silenus leans on a *thyrsos* staff, composed of a giant fennel wound with ivy and topped with a pinecone, symbolizing fertility. Dionysus, with whom such staffs were associated, also carries one here as his triumphal scepter.

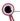

View the Closer Look for the sarcophagus with the Indian Triumph of Dionysus on myartslab.com

THE LATE EMPIRE, THIRD AND FOURTH CENTURIES CE

The comfortable life suggested by the wall paintings in Roman houses and villas was, within a century, to be challenged by hard times. The reign of Commodus marked the beginning of a period of political and economic decline. Barbarian groups had already begun moving into the empire in the time of Marcus Aurelius.

Now they pressed on Rome's frontiers. Many crossed the borders and settled within them, disrupting provincial governments. As perceived threats spread throughout the empire, imperial rule became increasingly authoritarian. Eventually the army controlled the government, and the Imperial Guards set up and deposed rulers almost at will, often selecting candidates from among poorly educated, power-hungry provincial leaders in their own ranks.

THE SEVERAN DYNASTY

Despite the pressures brought by political and economic change, the arts continued to flourish under the Severan emperors (193–235 CE) who succeeded Commodus. Septimius Severus (r. 193–211 CE), who was born in Africa, and his Syrian wife, Julia Domna, restored public buildings, commissioned official portraits, and revitalized the old cattle market in Rome into a well-planned center of bustling commerce. Their sons, Geta and Caracalla, succeeded Septimius Severus as co-emperors in 211 CE, but Caracalla murdered Geta in 212 CE and then ruled alone until he in turn was murdered in 217 CE.

PORTRAITS OF CARACALLA The Emperor Caracalla appears in his portraits as a fierce and courageous ruler, capable of confronting Rome's enemies and safeguarding the security of the Roman Empire. In the example shown here (**FIG. 6–59**), the sculptor has enhanced the intensity of the emperor's expression by producing strong contrasts of light and dark with careful chiseling and drillwork. Even the marble eyes have been drilled and

engraved to catch the light in a way that makes them dominate his expression. The contrast between this style and that of the portraits of Augustus is a telling reflection of the changing character of imperial rule. Augustus envisioned himself as the suave initiator of a Golden Age of peace and prosperity; Caracalla presents himself as a no-nonsense ruler of iron-fisted determination, with a militaristic, close-cropped haircut and a glare of fierce intensity.

THE BATHS OF CARACALLA The year before his death in 211 CE, Septimius Severus had begun a popular public-works project: the construction of magnificent new public baths on the southeast side of Rome as a new recreational and educational center. Caracalla completed and inaugurated the baths today known by his name, in 216–217 CE. The impressive brick and concrete structure was hidden under a sheath of colorful marble and mosaic. The builders used soaring groin and barrel vaults, which allow the maximum space with the fewest possible supports. The groin vaults also made possible large windows in every

bay. Windows were important, since the baths depended on natural light and could only be open during daylight hours.

The **BATHS OF CARACALLA** (FIG. 6-60) were laid out on a strictly symmetrical plan. The bathing facilities were grouped in the center of the main building to make efficient use of the below-ground furnaces that heated them and to allow bathers to move comfortably from hot to cold pools and then finish with a swim. Many other facilities—exercise rooms, shops, latrines, and dressing rooms—were housed on each side of the bathing block. The bath buildings alone covered 5 acres. The entire complex, which included gardens, a stadium, libraries, a painting gallery, auditoriums, and huge water reservoirs, covered an area of 50 acres.

6-59 • CARACALLAEarly 3rd century CE. Marble, height 14½" (36.2 cm).
Metropolitan Museum of Art, New York. Samuel D. Lee Fund, 1940. (40.11.1A)

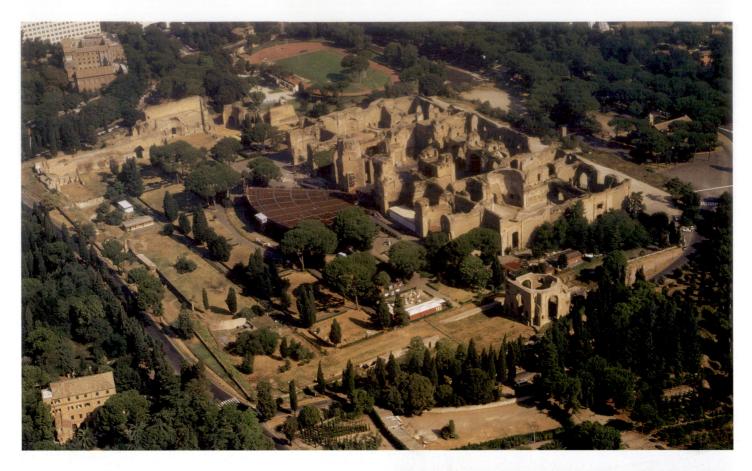

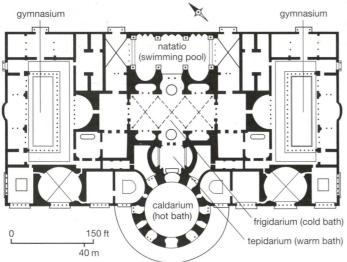

6-60 • AERIAL VIEW (A) AND PLAN (B) OF THE BATHS OF CARACALLA

Rome. c. 211-217 CE.

Explore the architectural panoramas of the Baths of Caracalla on myartslab.com

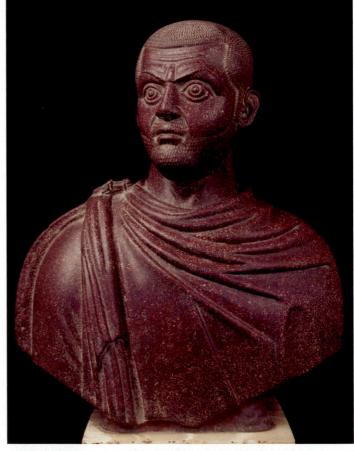

6-61 • PORTRAIT OF A TETRARCH (GALERIUS?)Early 4th century ce. Porphyry, 2′5½" (65 cm). Egyptian Museum, Cairo.

THE SOLDIER EMPERORS

Following the assassination of the last Severan emperor by one of his military commanders in 235 CE, Rome was plunged into a period of anarchy that lasted for 50 years. A series of soldier emperors attempted to rule the empire, but real order was only restored by Diocletian (r. 284–305 CE), also a military commander. This brilliant politician and general reversed the empire's declining fortunes, but he also initiated an increasingly autocratic form of rule, and the social structure of the empire became increasingly rigid.

To divide up the task of defending and administering the Roman world and to assure an orderly succession, in 286 CE Diocletian divided the empire in two parts. According to his plan, he would rule in the East with the title of "Augustus," while another Augustus, Maximian, would rule in the West. Then, in 293 CE, he devised a form of government called a tetrarchy, or "rule of four," in which each Augustus designated a subordinate and heir, who held the title of "Caesar." And the Roman Empire, now divided into four quadrants, would be ruled by four individuals.

TETRARCHIC PORTRAITURE Diocletian's political restructuring is paralleled by the introduction of a radically new, hard style of geometricized abstraction, especially notable in portraits of the tetrarchs themselves. A powerful bust of a tetrarch, startlingly alert with searing eyes (FIG. 6-61), embodies this stylistic shift toward the antithesis of the suave Classicism seen in the portrait of Commodus as Hercules (see FIG. 6-58). There is no clear sense of likeness. Who this individual is seems to be less significant than the powerful position he holds. Some art historians have interpreted this change in style as a conscious embodiment of Diocletian's new concept of government, while others have pointed to parallels with the provincial art of Diocletian's Dalmatian homeland or with the Neoplatonic aesthetics of idealized abstrac-

6-62 • THE TETRARCHS

c. 300 cE. Porphyry, height of figures 51" (129 cm). Installed at the corner of the façade of the Cathedral of St. Mark, Venice.

This particular sculpture may have been made in Egypt and moved to Constantinople after 330 cc. Christian crusaders who looted Constantinople in 1204 cc took the statue to Venice and installed it at the Cathedral of St. Mark, where it is today.

tion promoted by Plotinus, a third-century CE philosopher who was widely read in the late Roman world. In any event, these riveting works represent not a degeneration of the Classical tradition but its conscious replacement by a different aesthetic viewpoint—militaristic, severe, and abstract rather than suave, slick, and classicizing.

This new mode is famously represented by an actual sculptural group of **THE TETRARCHS** (**FIG. 6–62**). The four figures are nearly identical, except that the senior Augusti have beards while

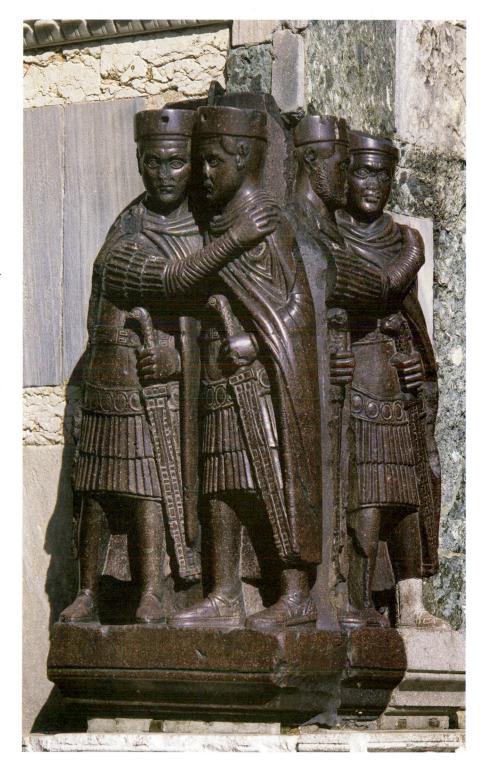

their juniors, the Caesars, are clean-shaven. Dressed in military garb and clasping swords at their sides, they embrace each other in a show of imperial unity, proclaiming an alliance rooted in strength and vigilance. The sculpture is made of porphyry, an extremely hard, purple stone from Egypt that was reserved for imperial use (see FIG. 6–61).

THE BASILICA AT TRIER The tetrarchs ruled the empire from administrative headquarters in Milan (Italy), Trier (Germany), Thessaloniki (Greece), and Nicomedia (Turkey). Imposing architecture was created to house the government in these new capital cities. In Trier, for example, Constantius Chlorus (Caesar, 293–

305; Augustus, 305–306 CE) and his son Constantine fortified the city with walls and a monumental gate that still stand. They built public amenities, such as baths, and a palace with a huge **AUDI-ENCE HALL**, later used as a Christian church (**FIGS. 6-63, 6-64**). This early fourth-century basilica's large size and simple plan and structure exemplify the architecture of the tetrarchs: no-nonsense, imposing buildings that would impress their subjects. The audience hall is a large rectangular building, 190 by 95 feet, with a strong directional focus given by a single apse opposite the door. Brick walls, originally stuccoed on the outside and covered with marble veneer inside, are pierced by two rows of arched windows. A flat roof, nearly 100 feet above the floor, covers both

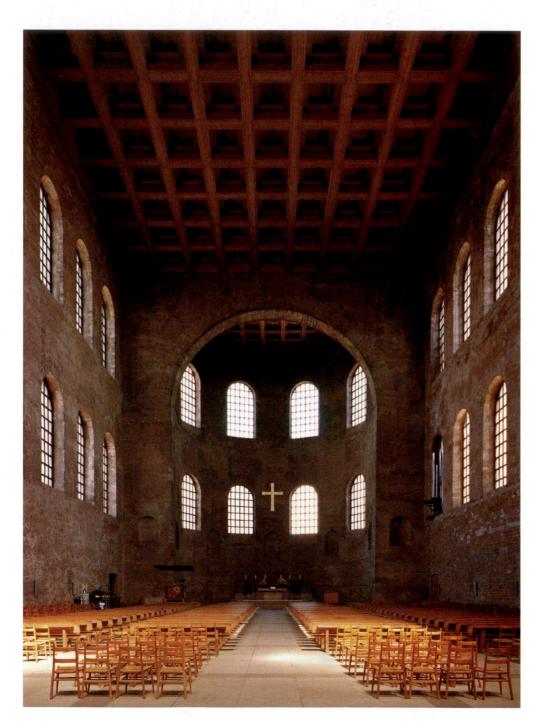

6-63 • AUDIENCE HALL OF CONSTANTIUS CHLORUS (NOW KNOWN AS THE BASILICA)

Trier, Germany. View of the nave. Early 4th century ce. Height of room 100′ (30.5 m).

Only the left wall and apse survive from the original Roman building. The hall became part of the bishop's palace during the medieval period.

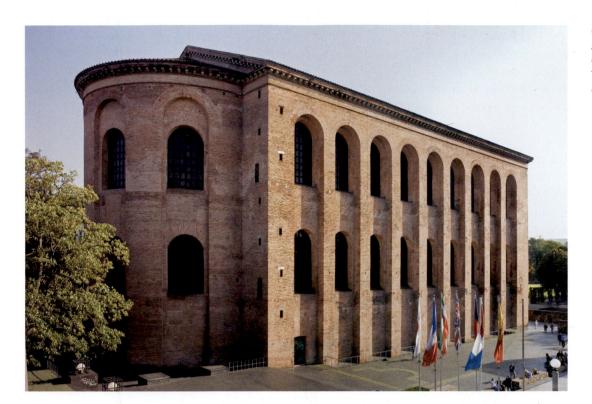

6-64 • EXTERIOR OF AUDIENCE HALL OF CONSTANTIUS CHLORUS Trier, Germany. Early 4th century ce.

the nave and the apse. In a concession to the northern climate, the building was centrally heated with hot air flowing under the floor, a technique also used in Roman baths. The windows of the apse create an interesting optical effect. Slightly smaller than the windows in straight side walls, they create the illusion of greater distance, so that the tetrarch enthroned in the apse would appear larger than life and the hall would seem longer than it actually is.

CONSTANTINE THE GREAT

In 305 CE, Diocletian abdicated and forced his fellow Augustus, Maximian, to do so too. The orderly succession he had planned for failed to occur, and a struggle for position and advantage followed almost immediately. Two main contenders appeared in the Western Empire: Maximian's son Maxentius, and Constantine, son of Tetrarch Constantius Chlorus. Constantine emerged victorious in 312, defeating Maxentius at the Battle of the Milvian Bridge at the entrance to Rome.

According to Christian tradition, Constantine had a vision the night before the battle in which he saw a flaming cross in the sky and heard these words: "In this sign you shall conquer." The next morning he ordered that his army's shields and standards be inscribed with the monogram XP (the Greek letters *chi* and *rho*, standing for *Christos*). The victorious Constantine then showed his gratitude by ending the persecution of Christians and recognizing Christianity as a lawful religion. He may have been influenced in that decision by his mother, Helena, a devout Christian—later canonized. Whatever his motivation, in 313 CE, together with Licinius, who ruled the Eastern Empire, Constantine issued the Edict of Milan, a model of religious toleration.

The Edict granted freedom to all religious groups, not just Christians. Constantine, however, remained the Pontifex Maximus of Rome's state religion and also reaffirmed his devotion to the military's favorite god, Mithras, and to the Invincible Sun, Sol Invictus, a manifestation of Helios Apollo, the sun god. In 324 CE, Constantine defeated Licinius, his last rival, and ruled as sole emperor until his death in 337. He made the port city of Byzantium the new capital of the Roman Empire after his last visit to Rome in 325, and renamed the city after himself—Constantinople (present-day Istanbul, in Turkey). Rome, which had already ceased to be the seat of government in the West, further declined in importance.

THE ARCH OF CONSTANTINE In Rome, next to the Colosseum, the Senate erected a triumphal arch to commemorate Constantine's victory over Maxentius (FIG. 6-65), a huge, triple arch that dwarfs the nearby Arch of Titus (see FIG. 6-36). Its three barrel-vaulted passageways are flanked by columns on high pedestals and surmounted by a large attic story with elaborate sculptural decoration and a laudatory inscription: "To the Emperor Constantine from the Senate and the Roman People. Since through divine inspiration and great wisdom he has delivered the state from the tyrant and his party by his army and noble arms, [we] dedicate this arch, decorated with triumphal insignia." The "triumphal insignia" were in part appropriated from earlier monuments made for Constantine's illustrious predecessors-Trajan, Hadrian, and Marcus Aurelius. The reused items visually transferred the old Roman virtues of strength, courage, and piety associated with these earlier exemplary emperors to Constantine

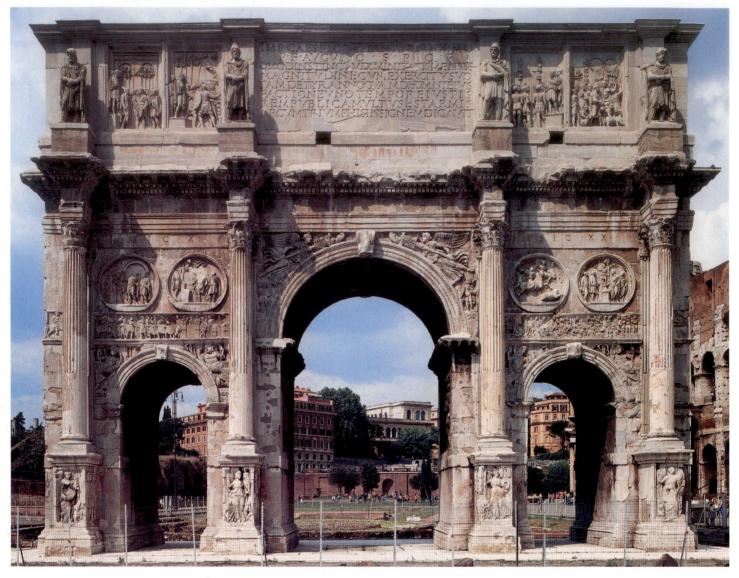

6-65 • ARCH OF CONSTANTINE

Rome. 312–315 CE (dedicated July 25, 315). $69' \times 85'$ (21 \times 26 m).

This massive, triple-arched monument to Emperor Constantine's victory over Maxentius in 312 ce is a wonder of recycled sculpture. On the attic story, flanking the inscription over the central arch, are relief panels taken from a monument celebrating the victory of Marcus Aurelius over the Germans in 174 ce. On the attached piers framing these panels are large statues of prisoners made to celebrate Trajan's victory over the Dacians in the early second century ce. On the inner walls of the central arch and on the attic of the short sides (neither seen here) are reliefs also commemorating Trajan's conquest of Dacia. Over each of the side arches is a pair of large tondi (circular compositions) taken from a monument to Hadrian (see Fig. 6–66). The rest of the decoration is early fourth century ce, contemporary with the arch.

himself. New reliefs were made for the arch to recount the story of Constantine's victory and to symbolize his own power and generosity. They run in strips underneath the reused Hadrianic tondi (a tondo is a circular composition) (FIG. 6-66).

Although the new Constantinian reliefs reflect the long-standing Roman predilection for depicting important events with recognizable detail, they nevertheless represent a significant change in style, approach, and subject matter (see lower figural frieze in FIG. 6–65). In this scene of Constantine addressing the Roman people in the Roman Forum, the Constantinian reliefs are

easily distinguished from the reused Hadrianic tondi mounted just above them because of the faithfulness of the new reliefs to the avant-garde tetrarchic style we have already encountered in portraiture. The forceful, blocky, mostly frontal figures are compressed into the foreground plane. The participants to the sides, below the enthroned Constantine (his head is missing), almost congeal into a uniformly patterned mass that isolates the new emperor and connects him visually with the seated statues of his illustrious predecessors flanking him on the dais. This two-dimensional, hierarchical approach with its emphasis on authority and power

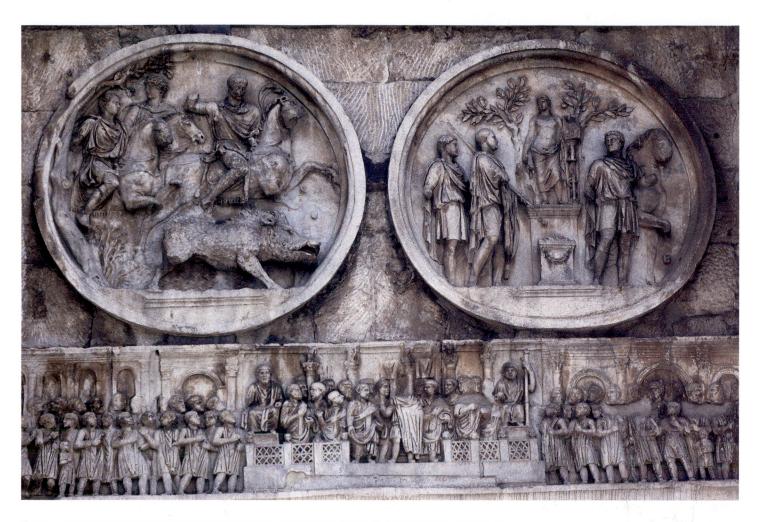

6-66 • HADRIAN/CONSTANTINE HUNTING BOAR AND SACRIFICING TO APOLLO; CONSTANTINE ADDRESSING THE ROMAN PEOPLE IN THE ROMAN FORUM

Tondi made for a monument to Hadrian and reused on the Arch of Constantine. c. 130–138 ce. Marble, diameter 6'6" (2 m). Frieze by Constantinian sculptors 312–315 ce. Marble, height 3'4" (1 m).

The two tondi were originally part of a lost monument erected by the emperor Hadrian (r. 117–138 ce). The boar hunt demonstrates his courage and physical prowess, and his sacrificial offering to Apollo shows his piety and gratitude to the gods for their support. The classicizing heads, form-enhancing drapery, and graceful poses of the figures betray a debt to the style of Late Classical Greek art. In the fourth century ce, Constantine appropriated these tondi, had Hadrian's head recarved with his own or his father's features, and incorporated them into his own triumphal arch (see Fig. 6–65) so that the power and piety of this predecessor could reflect on him and his reign. In a strip of relief underneath the tondi, sculptors from his own time portrayed a ceremony performed by Constantine during his celebration of the victory over his rival, Maxentius, at the Battle of the Milvian Bridge (312 ce). Rather than the Hellenizing mode popular during Hadrian's reign, the Constantinian sculptors employ the blocky and abstract stylizations that became fashionable during the Tetrarchy.

rather than on individualized outward form is far removed from the classicizing illusionism of earlier imperial reliefs. It is one of the Roman styles that will be adopted by the emerging Christian Church.

THE BASILICA NOVA Constantine's rival Maxentius, who controlled Rome throughout his short reign (r. 306–312), ordered the repair of older buildings there and had new ones built. His most impressive undertaking was a huge new basilica, just southeast of the Imperial Forums, called the **BASILICA NOVA**, or New Basilica (**FIG. 6-67**). Now known as the Basilica of Maxentius

and Constantine, this was the last important imperial government building erected in Rome. Like all basilicas, it functioned as an administrative center and provided a magnificent setting for the emperor when he appeared as supreme judge.

Earlier basilicas, such as Trajan's Basilica Ulpia (see FIG. 6–44), had been columnar halls, but Maxentius ordered his engineers to create the kind of large, unbroken, vaulted space found in public baths. The central hall was covered with groin vaults, and the side aisles were covered with lower barrel vaults that acted as buttresses, or projecting supports, for the central vault and allowed generous window openings in the clerestory areas over the side walls.

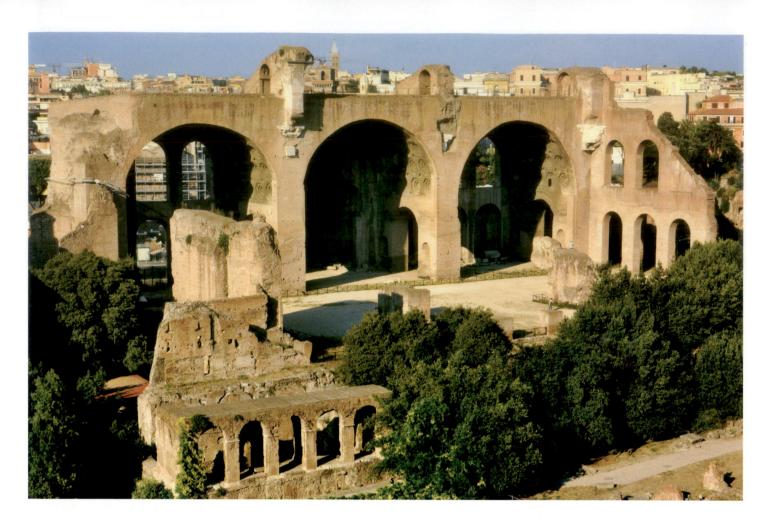

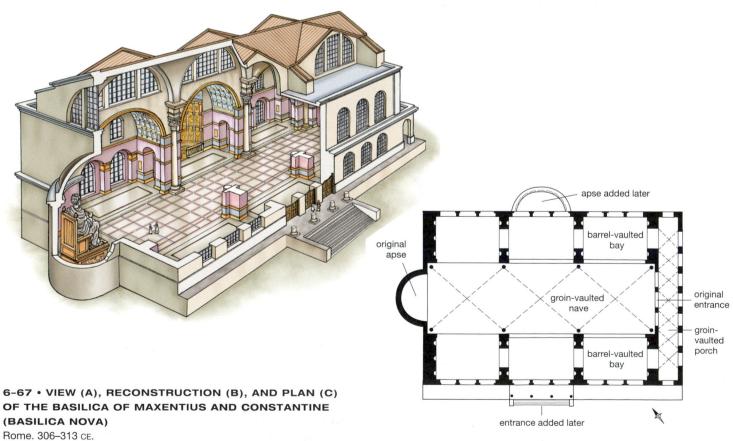

6-68 • CONSTANTINE THE GREAT

From the Basilica of Maxentius and Constantine, Rome. 325–326 ce.

Marble, height of head 8'6'' (2.6 m). Palazzo dei Conservatori, Rome.

Three of these brick-and-concrete barrel vaults still loom over the streets of present-day Rome (see FIG. 6-67A). The basilica originally measured 300 by 215 feet and the vaults of the central nave rose to a height of 114 feet. A groin-vaulted porch extended across the short side and sheltered a triple entrance to the central hall. At the opposite end of the long axis of the hall was an apse of the same width, which acted as a focal point for the building (see FIGS. 6-67B, 6-67C). Such directional focus along a central axis from entrance to apse was adopted by Christians for use in basilican churches.

Constantine, seeking to impress the people of Rome with visible symbols of his authority, put his own stamp on projects Maxentius had started, including this one. He may have changed the orientation of the Basilica Nova by adding an imposing new entrance in the center of the long side facing the Via Sacra and a giant apse facing it across the three aisles. He also commissioned a colossal, 30-foot statue of himself to be placed inside within an apse (FIG. 6-68). Sculptors used white marble for the head, chest, arms, and legs, and sheets of bronze for the drapery, all supported on a wooden frame. This statue became a permanent stand-in for the emperor, representing him whenever the conduct of business legally required his presence. The head combines features of traditional Roman portraiture with some of the abstract qualities evident in images of the tetrarchs (see FIG. 6-61). The defining characteristics of Constantine's face—his heavy jaw, hooked nose, and jutting chin—have been incorporated into a stylized, symmetrical pattern in which other features, such as his eyes, eyebrows, and hair, have been simplified into repeated geometric arcs. The result is a work that projects imperial power and dignity with no hint of human frailty or imperfection.

ROMAN ART AFTER CONSTANTINE

Although Constantine was baptized only on his deathbed in 337, Christianity had become the official religion of the empire by the end of the fourth century, and non-Christians had become targets of persecution. This religious shift, however, did not diminish Roman interest in the artistic traditions of their pagan Classical past. A large silver **PLATTER** dating from the mid fourth century CE (**FIG. 6-69**) proves that artists working for Christian patrons continued to use pagan themes, allowing them the opportunity to create elaborate figural compositions displaying the nude or lightly draped human body in complex,

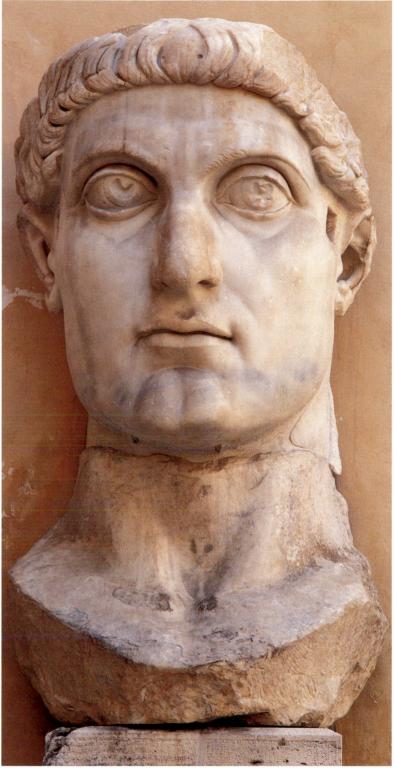

dynamic poses. The platter was found in a cache of silver tableware near Mildenhall, England, including spoons engraved with Christian symbols. The original owner of the hoard was likely to have been a wealthy Roman Christian, living in the provinces. Such opulent items were often hidden or buried to protect them from theft and looting, a sign of the breakdown of the Roman peace, especially in provincial areas (see "The Mildenhall Treasure," page 212).

RECOVERING THE PAST | The Mildenhall Treasure

In 1942, a farmer plowing a field outside the town of Mildenhall in Suffolk, England, located near the site of an ancient Roman villa, accidentally made one of the greatest archaeological finds of the twentieth century. In total he unearthed 34 pieces of Roman silver dating from the fourth century ce. The find was not made public until four years later, since the farmer and his associates claimed they were unaware of how valuable it was, both materially and historically. When word of the discovery leaked out, however, the silver was confiscated by the government to determine if it was a "Treasure Trove"—gold or silver objects that have been intentionally hidden (rather than, for example, included in a burial) and that by law belong not to the finder, but to the Crown. The silver found at Mildenhall was deemed a "Treasure Trove" and is now one of the great glories of the British Museum in London.

This is the official story of the discovery at Mildenhall. But there are

those who do not believe it. None of the silver in the hoard showed any sign of having been dented by a plow, and some believe that the quality and style of the objects are inconsistent with a provincial Roman context, especially so far in the hinterlands in England. Could the treasure have been looted from Italy during World War II, brought back to England (Mildenhall is not far from an American airfield), and buried to set up a staged discovery? The farmer who discovered the hoard and his associates, some argue, changed their story several times over the course of its history. Most scholars do believe the official story—that the silver was buried quickly for safekeeping by wealthy provincial Romans in Britain who felt threatened by a possible invasion or attack, and was forgotten (perhaps its owners were killed in the expected turmoil) until its accidental discovery in 1942. But when the history of art is founded on undocumented archaeological finds, there is usually room for doubt.

Q-

View the Closer Look for a platter from the Mildenhall Treasure on myartslab.com

The Bacchic revelers on this platter whirl, leap, and sway in a dance to the piping of satyrs around a circular central medallion. In the centerpiece, the head of the sea god Oceanus is ringed by nude females frolicking in the waves with fantastic sea creatures. In the outer circle, the figure of Bacchus is the one stable element. With a bunch of grapes in his right hand, a krater at his feet, and one foot on the haunches of his panther, he listens to a male follower begging for another drink. Only a few figures away, the pitifully drunken hero Hercules has lost his lionskin mantle and collapsed in a stupor into the supporting arms of two satyrs. The detail, clarity, and liveliness of this platter reflect the work of a virtuoso artist. Deeply engraved lines emphasize the contours of the subtly modeled bodies, echoing the technique of undercutting used to add depth to figures in stone and marble reliefs and suggesting a connection between silverworking and relief sculpture.

Not all Romans, however, converted to Christianity. Among the champions of paganism were the Roman patricians Quintus Aurelius Symmachus and Virius Nicomachus Flavianus. A famous ivory diptych (FIG. 6-70) attests to the close relationship between their families, perhaps through marriage, as well as to their firmly held beliefs. A diptych was a pair of panels attached with hinges, not unlike the modest object held by the woman in FIG. 6-35, but in this case made of a very precious material and

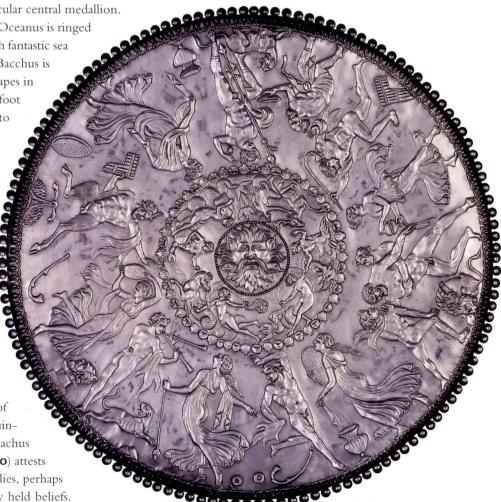

6-69 • PLATTER

From Mildenhall, England. Mid 4th century CE. Silver, diameter approx. 24" (61 cm). British Museum, London.

6-70 • PRIESTESS OF BACCHUS (?)

Right panel of the diptych of Symmachus and Nicomachus. c. 390–401 cE. Ivory, $11\frac{3}{4}$ " \times $4\frac{3}{4}$ " (29.9 \times 12 cm). Victoria & Albert Museum, London.

carved with reliefs on the exterior sides. On the interior of a diptych there were shallow, traylike recessions filled with wax, into which messages could be written with a stylus and sent with a servant as a letter to a friend or acquaintance, who could then smooth out the wax surface, incise a reply with his or her own stylus, and send the diptych back to its owner with the servant. Here one family's name is inscribed at the top of each panel. On the panel inscribed "Symmachorum" (illustrated here), a stately, elegantly attired priestess burns incense at a beautifully decorated altar. On her head is a wreath of ivy, sacred to Bacchus. She is assisted by a small child, and the event takes place out of doors under an oak tree, sacred to Jupiter. Like the silversmiths, Roman ivory carvers of the fourth century CE were highly skillful, and their work was widely admired. For conservative patrons like the Nicomachus and Symmachus families, they imitated the Augustan style effortlessly. The exquisite rendering of the drapery and foliage recalls the reliefs of the Ara Pacis (see FIG. 6–22).

Classical subject matter remained attractive to artists and patrons throughout the late Roman period. Even such great Christian thinkers as the fourth-century CE bishop Gregory of Nazianzus spoke out in support of the right of the people to appreciate and enjoy their Classical heritage, so long as they were not seduced by it to return to pagan practices. As a result, stories of the ancient gods and heroes entered the secular realm as lively, visually delightful, even erotic decorative elements. As Roman authority gave way to local rule by powerful "barbarian" tribes in much of the West, many people continued to appreciate Classical learning and to treasure Greek and Roman art. In the East, Classical traditions and styles were cultivated to become an enduring element of Byzantine art.

THINK ABOUT IT

- 6.1 Characterize the salient stylistic features of the murals that survive from Roman houses in Pompeii, discussing specific examples from this chapter.
- **6.2** Explain how the Roman interest in portraits grew out of early funeral rituals and developed into a powerful aspect of imperial self-fashioning.
- 6.3 Describe and evaluate the subjects used in Etruscan tomb paintings and sarcophagi. How do Etruscan practices relate to what we have discovered about tombs in other ancient cultures?
- 6.4 Identify two key structural advances made by Roman builders and discuss their use in one large civic building. Why do you think the ancient Romans built on such a large scale?

CROSSCURRENTS

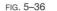

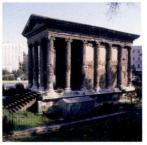

FIG. 6-18A

Greek and Roman temples have features in common, but they are fundamentally different in important respects. Evaluate the significant similarities and dissimilarities by comparing these two buildings.

√ Study and review on myartslab.com

Glossary

abacus (p. 108) The flat slab at the top of a **capital**, directly under the **entablature**.

abbey church (p. 239) An abbey is a monastic religious community headed by an abbot or abbess. An abbey church often has an especially large **choir** to provide space for the monks or nuns.

absolute dating (p. 12) A method, especially in archaeology, of assigning a precise historical date at which, or span of years during which, an object was made. Based on known and recorded events in the region, as well as technically extracted physical evidence (such as carbon-14 disintegration). See also radiometric dating, relative dating.

abstract (p. 7) Of art that does not attempt to describe the appearance of visible forms but rather to transform them into stylized patterns or to alter them in conformity to ideals.

academy (p. 926) An institution established for the training of artists. Academies date from the Renaissance and after; they were particularly powerful, staterun institutions in the seventeenth and eighteenth centuries. In general, academies replaced guilds as the venues where students learned the craft of art and were educated in art theory. Academies helped the recognition of artists as trained specialists, rather than craftsmakers, and promoted their social status. An academician is an academy-trained artist.

acanthus (p. 110) A Mediterranean plant whose leaves are reproduced in Classical architectural ornament used on **moldings**, **friezes**, and **capitals**.

acroterion (pl. acroteria) (p. 110) An ornament at the corner or peak of a roof.

Action painting (p. 1074) Using broad gestures to drip or pour paint onto a pictorial surface. Associated with mid-twentieth-century American Abstract Expressionists, such as Jackson Pollock.

adobe (p. 399) Sun-baked blocks made of clay mixed with straw. Also: buildings made with this material.

aedicula (p. 609) A decorative architectural frame, usually found around a niche, door, or window. An aedicula is made up of a **pediment** and **entablature** supported by **columns** or **pilasters**.

aerial perspective (p. 626) See under perspective. agora (p. 137) An open space in a Greek town used as a central gathering place or market. Compare forum.

aisle (p. 225) Passage or open corridor of a church, hall, or other building that parallels the main space, usually on both sides, and is delineated by a row, or **arcade**, of **column**s or **piers**. Called side aisles when they flank the **nave** of a church.

akropolis (p. 128) The citadel of an ancient Greek city, located at its highest point and housing temples, a treasury, and sometimes a royal palace. The most famous is the Akropolis in Athens.

album (p. 796) A book consisting of a series of paintings or prints (album leaves) mounted into book form.

allegory (p. 627) In a work of art, an image (or images) that symbolizes an idea, concept, or principle, often moral or religious.

alloy (p. 23) A mixture of metals; different metals melted together.

altarpiece (p. xxxii) A painted or carved panel or ensemble of panels placed at the back of or behind and above an altar. Contains religious imagery (often specific to the place of worship for which it was made) that viewers can look at during liturgical ceremonies (especially the **Eucharist**) or personal devotions.

amalaka (p. 302) In Hindu architecture, the circular or square-shaped element on top of a spire (shikhara), often crowned with a finial, symbolizing the cosmos. ambulatory (p. 224) The passage (walkway) around

ambulatory (p. 224) The passage (walkway) around the apse in a church, especially a basilica, or around the central space in a central-plan building.

amphora (*pl.* **amphorae**) (p. 101) An ancient Greek or Roman jar for storing oil or wine, with an egg-shaped body and two curved handles.

animal style or interlace (p. 433) Decoration made of interwoven animals or serpents, often found in early medieval Northern European art.

ankh (p. 51) A looped cross signifying life, used by ancient Egyptians.

appropriation (p. xx) The practice of some Postmodern artists of adopting images in their entirety from other works of art or from visual culture for use in their own art. The act of recontextualizing the appropriated image allows the artist to critique both it and the time and place in which it was created.

apse (p. 192) A large semicircular or polygonal (and usually **vaulted**) recess on an end wall of a building. In a Christian church, it often contains the altar. "Apsidal" is the adjective describing the condition of having such a space.

arabesque (p. 267) European term for a type of linear surface decoration based on foliage and calligraphic forms, thought by Europeans to be typical of Islamic art and usually characterized by flowing lines and swirling shapes.

arcade (p. 170) A series of **arch**es, carried by **columns** or **piers** and supporting a common wall or **lintel**. In a **blind arcade**, the arches and supports are **engaged** and have a purely decorative function.

arch (p. 95) In architecture, a curved structural element that spans an open space. Built from wedgeshaped stone blocks called voussoirs placed together and held at the top by a trapezoidal keystone. It forms an effective space-spanning and weight-bearing unit, but requires buttresses at each side to contain the outward thrust caused by the weight of the structure. Corbeled arch: an arch or vault formed by courses of stones, each of which projects beyond the lower course until the space is enclosed; usually finished with a capstone. Horseshoe arch: an arch of more than a half-circle; typical of western Islamic architecture. Round arch: an arch that displaces most of its weight, or downward thrust along its curving sides, transmitting that weight to adjacent supporting uprights (door or window jambs, columns, or piers). Ogival arch: a sharply pointed arch created by S-curves. Relieving arch: an arch built into a heavy wall just above a post-andlintel structure (such as a gate, door, or window) to help support the wall above by transferring the load to the side walls. Transverse arch: an arch that connects the wall piers on both sides of an interior space, up and over a stone vault.

Archaic smile (p. 114) The curved lips of an ancient Greek statues in the period c. 600–480 BCE, usually interpreted as a way of animating facial features.

architrave (p. 107) The bottom element in an entablature, beneath the frieze and the cornice. archivolt (p. 478) A band of molding framing an arch, or a series of stone blocks that form an arch resting directly on flanking columns or piers.

ashlar (p. 99) A highly finished, precisely cut block of stone. When laid in even **courses**, ashlar masonry creates a uniform face with fine joints. Often used as a facing on the visible exterior of a building, especially as a veneer for the **facade**. Also called **dressed stone**.

assemblage (p. 1026) Artwork created by gathering and manipulating two- and/or three-dimensional found objects.

astragal (p. 110) A thin convex decorative **molding**, often found on a Classical **entablature**, and usually decorated with a continuous row of beadlike circles.

atelier (p. 946) The studio or workshop of a master artist or craftsmaker, often including junior associates and apprentices.

atmospheric perspective (p. 183) See under perspective.

atrial cross (p. 943) A cross placed in the **atrium** of a church. In Colonial America, used to mark a gathering and teaching place.

atrium (p. 158) An unroofed interior courtyard or room in a Roman house, sometimes having a pool or garden, sometimes surrounded by **columns**. Also: the open courtyard in front of a Christian church; or an entrance area in modern architecture.

automatism (p. 1057) A technique in which artists abandon the usual intellectual control over their brushes or pencils to allow the subconscious to create the artwork without rational interference.

avant-garde (p. 972) Term derived from the French military word meaning "before the group," or "vanguard." Avant-garde denotes those artists or concepts of a strikingly new, experimental, or radical nature for their time.

axis (p. xxiv) In pictures, an implied line around which elements are composed or arranged. In buildings, a dominant line around which parts of the structure are organized and along which human movement or attention is concentrated.

axis mundi (p. 300) A concept of an "axis of the world," which marks sacred sites and denotes a link between the human and celestial realms. For example, in Buddhist art, the axis mundi can be marked by monumental free-standing decorative pillars.

baldachin (p. 472) A canopy (whether suspended from the ceiling, projecting from a wall, or supported by columns) placed over an honorific or sacred space such as a throne or church altar.

bar tracery (p. 510) See under tracery.

barbarian (p. 149) A term used by the ancient Greeks and Romans to label all foreigners outside their cultural orbit (e.g., Celts, Goths, Vikings). The word derives from an imitation of what the "barblings" of their language sounded like to those who could not understand it.

barrel vault (p. 187) See under vault.

bas-relief (p. 325) Another term for low relief ("bas" is the French word for "low"). See under relief sculpture.

basilica (p. 191) A large rectangular building. Often built with a clerestory, side aisles separated from the center nave by colonnades, and an apse at one or both ends. Originally Roman centers for administration, later adapted to Christian church use.

bay (p. 170) A unit of space defined by architectural elements such as **columns**, **piers**, and walls.

beehive tomb (p. 98) A **corbel-vaulted** tomb, conical in shape like a beehive, and covered by an earthen mound.

Benday dots (p. 1095) In modern printing and typesetting, the individual dots that, together with many others, make up lettering and images. Often machine-or computer-generated, the dots are very small and closely spaced to give the effect of density and richness of tone.

bilum (p. 865) Netted bags made mainly by women throughout the central highlands of New Guinea. The bags can be used for everyday purposes or even to carry the bones of the recently deceased as a sign of mourning.

biomorphic (p. 1058) Denoting the biologically or organically inspired shapes and forms that were routinely included in abstracted Modern art in the early twentieth century.

black-figure (p. 105) A technique of ancient Greek **ceramic** decoration in which black figures are painted on a red clay ground. Compare **red-figure**.

blackware (p. 855) A **ceramic** technique that produces pottery with a primarily black surface with **matte** and glossy patterns on the surface.

blind arcade (p. 780) See under arcade.

bodhisattva (p. 311) In Buddhism, a being who has attained enlightenment but chooses to remain in this world in order to help others advance spiritually. Also defined as a potential Buddha.

Book of Hours (p. 549) A prayer book for private use, containing a calendar, services for the canonical hours, and sometimes special prayers.

boss (p. 556) A decorative knoblike element that can be found in many places, e.g. at the intersection of a Gothic **rib vault** or as a buttonlike projection on metalwork.

bracket, bracketing (p. 341) An architectural element that projects from a wall to support a horizontal part of a building, such as beams or the eaves of a roof.

buon fresco (p. 87) See under fresco.

burin (p. 592) A metal instrument used in engraving to cut lines into the metal plate. The sharp end of the burin is trimmed to give a diamond-shaped cutting point, while the other end is finished with a wooden handle that fits into the engraver's palm.

buttress, buttressing (p. 170) A projecting support built against an external wall, usually to counteract the lateral thrust of a vault or arch within. In Gothic church architecture, a flying buttress is an arched bridge above the aisle roof that extends from the upper nave wall, where the lateral thrust of the main vault is greatest, down to a solid pier.

cairn (p. 17) A pile of stones or earth and stones that served both as a prehistoric burial site and as a marker for underground tombs.

calligraphy (p. 275) Handwriting as an art form. calyx krater (p. 119) See under krater.

calotype (p. 969) The first photographic process utilizing negatives and paper positives; invented by William Henry Fox Talbot in the late 1830s.

came (*pl.* **cames**) (p. 501) A lead strip used in the making of leaded or **stained-glass** windows. Cames have an indented groove on the sides into which individual pieces of glass are fitted to make the overall design.

cameo (p. 172) Gemstone, clay, glass, or shell having layers of color, carved in low relief (see under **relief** sculpture) to create an image and ground of different colors.

camera obscura (p. 750) An early cameralike device used in the Renaissance and later for recording images from the real world. It consists of a dark box (or room) with a hole in one side (sometimes fitted with a lens). The camera obscura operates when bright light shines through the hole, casting an upside-down image of an object outside onto the inside wall of the box.

canon of proportions (p. 64) A set of ideal mathematical ratios in art based on measurements, as in the proportional relationships between the basic elements of the human body.

canopic jar (p. 53) In ancient Egyptian culture, a special jar used to store the major organs of a body before embalming.

capital (p. 110) The sculpted block that tops a **column**. According to the **conventions** of the orders, capitals include different decorative elements (see **order**). A *historiated capital* is one displaying a figural composition and/or narrative scenes.

capriccio (*pl. capricci*) (p. 915) A painting or print of a fantastic, imaginary landscape, usually with architecture.

capstone (p. 17) The final, topmost stone in a **corbeled arch** or **vault**, which joins the sides and completes the structure.

cartoon (p. 501) A full-scale drawing of a design that will be executed in another **medium**, such as wall painting, **tapestry**, or **stained glass**.

cartouche (p. 187) A frame for a **hieroglyphic** inscription formed by a rope design surrounding an oval space. Used to signify a sacred or honored name. Also: in architecture, a decorative device or plaque, usually with a plain center used for inscriptions or epitaphs.

caryatid (p. 107) A sculpture of a draped female figure acting as a **column** supporting an **entablature**.

cassone (pl. cassoni) (p. 616) An Italian dowry chest often highly decorated with carvings, paintings, inlaid designs, and gilt embellishments.

catacomb (p. 215) An underground cemetery consisting of tunnels on different levels, having niches for urns and **sarcophagi** and often incorporating rooms (**cubicula**).

cathedral (p. 220) The principal Christian church in a diocese, the bishop's administrative center and housing his throne (*cathedra*).

celadon (p. 358) A high-fired, transparent **glaze** of pale bluish-green hue whose principal coloring agent is an oxide of iron. In China and Korea, such glazes were typically applied over a pale gray **stoneware** body, though Chinese potters sometimes applied them over **porcelain** bodies during the Ming (1368–1644) and Qing (1644–1911) dynasties. Chinese potters invented celadon glazes and initiated the continuous production of celadon-glazed wares as early as the third century CE.

cella (p. 108) The principal interior room at the center of a Greek or Roman temple within which the cult statue was usually housed. Also called the **naos**.

celt (p. 383) A smooth, oblong stone or metal object, shaped like an axe-head.

cenotaph (p. 771) A funerary monument commemorating an individual or group buried elsewhere.

centering (p. 170) A temporary structure that supports a masonry **arch**, **vault**, or **dome** during construction until the mortar is fully dried and the masonry is self-sustaining.

central-plan building (p. 225) Any structure designed with a primary central space surrounded by symmetrical areas on each side, e.g., a **rotunda**.

ceramics (p. 20) A general term covering all types of wares made from fired clay.

chacmool (p. 396) In Maya sculpture, a half-reclining figure probably representing an offering bearer.

chaitya (p. 305) A type of Buddhist temple found in India. Built in the form of a hall or **basilica**, a *chaitya* hall is highly decorated with sculpture and usually is carved from a cave or natural rock location. It houses a sacred shrine or **stupa** for worship.

chamfer (p. 780) The slanted surface produced when an angle is trimmed or beveled, common in building and metalwork.

chasing (p. 432) Ornamentation made on metal by incising or hammering the surface.

château (pl. **châteaux**) (p. 693) A French country house or residential castle. A *château fort* is a military castle incorporating defensive works such as towers and battlements.

chattri (p. 780) In Indian architecture, a decorative pavilion with an umbrella-shaped **dome**.

chevron (p. 357) A decorative or heraldic motif of repeated Vs; a zigzag pattern.

chiaroscuro (p. 636) An Italian word designating the contrast of dark and light in a painting, drawing, or print. Chiaroscuro creates spatial depth and volumetric forms through gradations in the intensity of light and shadow.

choir (p. 225) The part of a church reserved for the clergy, monks, or nuns, either between the **transept** crossing and the **apse** or extending farther into the **nave**; separated from the rest of the church by screens or walls and fitted with stalls (seats).

cista (*pl.* **cistae**) (p. 157) Cylindrical containers used in antiquity by wealthy women as a case for toiletry articles such as a mirror.

clerestory (p. 57) In a **basilica**, the topmost zone of a wall with windows, extending above the **aisle** roofs. Provides direct light into the **nave**.

cloisonné (p. 257) An enameling technique in which artists affix wires or strips to a metal surface to delineate designs and create compartments (cloisons) that they subsequently fill with enamel.

cloister (p. 448) An enclosed space, open to the sky, especially within a monastery, surrounded by an **arcade**d walkway, often having a fountain and garden. Since the most important monastic buildings (e.g., dormitory, refectory, church) open off the cloister, it represents the center of the monastic world.

codex (pl. codices) (p. 245) A book, or a group of manuscript pages (folios), held together by stitching or other binding along one edge.

coffer (p. 197) A recessed decorative panel used to decorate ceilings or **vaults**. The use of coffers is called coffering.

coiling (p. 848) A technique in basketry. In coiled baskets a spiraling coil, braid, or rope of material is held in place by stitching or interweaving to create a permanent shape.

collage (p. 1025) A composition made of cut and pasted scraps of materials, sometimes with lines or forms added by the artist.

colonnade (p. 69) A row of **columns**, supporting a straight **lintel** (as in a **porch** or **portico**) or a series of **arches** (an **arcade**).

colophon (p. 438) The data placed at the end of a book listing the book's author, publisher, illuminator, and other information related to its production. In East Asian **handscrolls**, the inscriptions which follow the painting are also called colophons.

column (p. 110) An architectural element used for support and/or decoration. Consists of a rounded or polygonal vertical **shaft** placed on a **base** and topped by a decorative **capital**. In Classical architecture, columns are built in accordance with the rules of one of the architectural **orders**. They can be free-standing or attached to a background wall (**engaged**).

combine (p. 1087) Combination of painting and sculpture using nontraditional art materials.

complementary color (p. 995) The primary and secondary colors across from each other on the color wheel (red and green, blue and orange, yellow and purple). When juxtaposed, the intensity of both colors increases. When mixed together, they negate each other to make a neutral gray-brown.

Composite order (p. 161) See under order. composite pose or image (p. 10) Combining different viewpoints within a single representation. composition (p. xxi) The overall arrangement,

organizing design, or structure of a work of art. **conch** (p. 236) A halfdome.

connoisseur (p. 289) A French word meaning "an expert," and signifying the study and evaluation of art based primarily on formal, visual, and stylistic analysis. A connoisseur studies the style and technique of an object to assess its relative quality and identify its maker through visual comparison with other works of secure authorship. See also Formalism.

continuous narrative (p. 245) See under narrative image.

contrapposto (p. 120) Italian term meaning "set against," used to describe the Classical convention of representing human figures with opposing alternations of tension and relaxation on either side of a central axis to imbue figures with a sense of the potential for movement.

convention (p. 31) A traditional way of representing forms

corbel, corbeling (p. 19) An early roofing and arching technique in which each **course** of stone projects slightly beyond the previous layer (a corbel) until the uppermost corbels meet; see also under **arch**. Also: **bracket**s that project from a wall.

corbeled vault (p. 99) See under vault.

Corinthian order (p. 108) See under order.

cornice (p. 110) The uppermost section of a Classical **entablature**. More generally, a horizontally projecting element found at the top of a building wall or **pedestal**. A *raking comice* is formed by the junction of two slanted cornices, most often found in **pediments**.

course (p. 99) A horizontal layer of stone used in building.

crenellation, crenellated (p. 44) Alternating high and low sections of a wall, giving a notched appearance and creating permanent defensive shields on top of fortified buildings.

crocket (p. 587) A stylized leaf used as decoration along the outer angle of spires, pinnacles, gables, and around **capital**s in Gothic architecture.

cruciform (p. 228) Of anything that is cross-shaped, as in the cruciform plan of a church.

cubiculum (pl. cubicula) (p. 220) A small private room for burials in a **catacomb**.

cuneiform (p. 28) An early form of writing with wedge-shaped marks impressed into wet clay with a **stylus**, primarily used by ancient Mesopotamians.

curtain wall (p. 1045) A wall in a building that does not support any of the weight of the structure.

cyclopean (p. 93) A method of construction using huge blocks of rough-hewn stone. Any large-scale, monumental building project that impresses by sheer size. Named after the Cyclopes (sing. Cyclops), one-eyed giants of legendary strength in Greek myths.

cylinder seal (p. 35) A small cylindrical stone decorated with **incised** patterns. When rolled across soft clay or wax, the resulting raised pattern or design served in Mesopotamian and Indus Valley cultures as an identifying signature.

dado (pl. dadoes) (p. 161) The lower part of a wall, differentiated in some way (by a **molding** or different coloring or paneling) from the upper section.

daguerreotype (p. 969) An early photographic process that makes a positive print on a light-sensitized copperplate; invented and marketed in 1839 by Louis-Jacques-Mandé Daguerre.

dendrochronology (p. XXVIII) The dating of wood based on the patterns of the tree's growth rings.

dentils (p. 110) A row of projecting rectangular blocks forming a **molding** or running beneath a **cornice** in Classical architecture.

desert varnish (p. 406) A naturally occurring coating that turns rock faces into dark surfaces. Artists would draw images by scraping through the dark surface and revealing the color of the underlying rock. Extensively used in southwest North America.

diptych (p. 212) Two panels of equal size (usually decorated with paintings or reliefs) hinged together.

dogu (p. 362) Small human figurines made in Japan during the Jomon period. Shaped from clay, the figures have exaggerated expressions and are in contorted poses. They were probably used in religious rituals.

dolmen (p. 17) A prehistoric structure made up of two or more large upright stones supporting a large, flat, horizontal slab or slabs.

dome (p. 187) A rounded vault, usually over a circular space. Consists of curved masonry and can vary in shape from hemispherical to bulbous to ovoidal. May use a supporting vertical wall (drum), from which the vault springs, and may be crowned by an open space (oculus) and/or an exterior lantern. When a dome is built over a square space, an intermediate element is required to make the transition to a circular drum. There are two systems. A dome on pendentives incorporates arched, sloping intermediate sections of wall that carry the weight and thrust of the dome to heavily buttressed supporting piers. A dome on squinches uses an arch built into the wall (squinch) in the upper corners of the space to carry the weight of the dome across the corners of the square space below. A halfdome or conch may cover a semicircular space.

domino construction (p. 1045) System of building construction introduced by the architect Le Corbusier in which reinforced concrete floor slabs are floated on six free-standing posts placed as if at the positions of the six dots on a domino playing piece.

Doric order (p. 108) See order.

dressed stone (p. 84) Another term for ashlar.

drillwork (p. 188) The technique of using a drill for the creation of certain effects in sculpture.

drum (p. 110) The circular wall that supports a **dome**. Also: a segment of the circular **shaft** of a **column**.

drypoint (p. 748) An **intaglio** printmaking process by which a metal (usually copper) plate is directly inscribed with a pointed instrument (**stylus**). The resulting design of scratched lines is inked, wiped, and printed. Also: the print made by this process.

earthenware (p. 20) A low-fired, opaque ceramic ware, employing humble clays that are naturally heat-resistant and remain porous after firing unless glazed. Earthenware occurs in a range of earth-toned colors, from white and tan to gray and black, with tan predominating.

earthwork (p. 1102) Usually very large-scale, outdoor artwork that is produced by altering the natural environment.

echinus (p. 110) A cushionlike circular element found below the **abacus** of a Doric **capital**. Also: a similarly shaped **molding** (usually with egg-and-dart motifs) underneath the **volutes** of an Ionic capital.

electronic spin resonance (p. 12) Method that uses magnetic field and microwave irradiation to date material such as tooth enamel and its surrounding soil.

elevation (p. 108) The arrangement, proportions, and details of any vertical side or face of a building. Also: an architectural drawing showing an exterior or interior wall of a building.

embroidery (p. 397) Stitches applied in a decorative pattern on top of an already-woven fabric ground.

en plein air (p. 987) French term (meaning "in the open air") describing the Impressionist practice of painting outdoors so artists could have direct access to the fleeting effects of light and atmosphere while working.

enamel (p. 255) Powdered, then molten, glass applied to a metal surface, and used by artists to create designs. After firing, the glass forms an opaque or transparent substance that fuses to the metal background. Also: an object created by the enameling technique. See also *cloisonné*.

encaustic (p. 246) A painting **medium** using pigments mixed with hot wax.

engaged (p. 171) Of an architectural feature, usually a **column**, attached to a wall.

engraving (p. 592) An **intaglio** printmaking process of inscribing an image, design, or letters onto a metal or wood surface from which a print is made. An engraving is usually drawn with a sharp implement (**burin**) directly onto the surface of the plate. Also: the print made from this process.

entablature (p. 107) In the Classical **orders**, the horizontal elements above the **columns** and **capitals**. The entablature consists of, from bottom to top, an **architrave**, a **frieze**, and a **cornice**.

entasis (p. 108) A slight swelling of the **shaft** of a Greek **column**. The optical illusion of entasis makes the column appear from afar to be straight.

esquisse (p. 946) French for "sketch." A quickly executed drawing or painting conveying the overall idea for a finished painting.

etching (p. 748) An intaglio printmaking process in which a metal plate is coated with acid-resistant resin and then inscribed with a stylus in a design, revealing the plate below. The plate is then immersed in acid, and the exposed metal of the design is eaten away by the acid. The resin is removed, leaving the design etched permanently into the metal and the plate ready to be inked, wiped, and printed.

Eucharist (p. 220) The central rite of the Christian Church, from the Greek word for "thanksgiving." Also known as the Mass or Holy Communion, it reenacts Christ's sacrifice on the cross and commemorates the Last Supper. According to traditional Catholic Christian belief, consecrated bread and wine become the body and blood of Christ; in Protestant belief, bread and wine symbolize the body and blood.

exedra (pl. **exedrae**) (p. 197) In architecture, a semicircular niche. On a small scale, often used as decoration, whereas larger exedrae can form interior spaces (such as an **apse**).

expressionism (p. 149) Artistic styles in which aspects of works of art are exaggerated to evoke subjective emotions rather than to portray objective reality or elicit a rational response.

façade (p. 52) The face or front wall of a building.

faience (p. 88) Type of ceramic covered with colorful, opaque glazes that form a smooth, impermeable surface. First developed in ancient Egypt.

fang ding (p. 334) A square or rectangular bronze vessel with four legs. The fang ding was used for ritual offerings in ancient China during the Shang dynasty.

fête galante (p. 910) A subject in painting depicting well-dressed people at leisure in a park or country setting. It is most often associated with eighteenth-century French Rococo painting.

filigree (p. 90) Delicate, lacelike ornamental work. fillet (p. 110) The flat ridge between the carved-out flutes of a column shaft.

finial (p. 780) A knoblike architectural decoration usually found at the top point of a spire, pinnacle, canopy, or gable. Also found on furniture. Also the ornamental top of a staff.

flutes (p. 110) In architecture, evenly spaced, rounded parallel vertical grooves incised on **shafts** of **columns** or on columnar elements such as **pilasters**.

flying buttress (p. 503) See under buttress.

flying gallop (p. 88) A non-naturalistic pose in which animals are depicted hovering above the ground with legs fully extended backwards and forwards to signify that they are running.

foreshortening (p. xxiii) The illusion created on a flat surface by which figures and objects appear to recede or project sharply into space. Accomplished according to the rules of **perspective**.

formal analysis (p. xxi) An exploration of the visual character that artists bring to their works through the expressive use of elements such as line, form, color, and light, and through its overall structure or composition.

Formalism (p. 1073) An approach to the understanding, appreciation, and valuation of art based almost solely on considerations of form. The Formalist's approach tends to regard an artwork as independent of its time and place of making.

forum (p. 176) A Roman town center; site of temples and administrative buildings and used as a market or gathering area for the citizens.

fresco (p. 81) A painting technique in which water-based pigments are applied to a plaster surface. If the plaster is painted when wet, the color is absorbed by the plaster, becoming a permanent part of the wall (*buon fresco*). *Fresco secco* is created by painting on dried plaster, and the color may eventually flake off. Murals made by both these techniques are called frescos.

frieze (p. 107) The middle element of an entablature, between the architrave and the cornice. Usually decorated with sculpture, painting, or moldings. Also: any continuous flat band with relief sculpture or painted decoration.

frottage (p. 1057) A design produced by laying a piece of paper over a textured surface and rubbing with charcoal or other soft **medium**.

fusuma (p. 820) Sliding doors covered with paper, used in traditional Japanese construction. *Fusuma* are often highly decorated with paintings and colored backgrounds.

gallery (p. 236) A roofed passageway with one or both of its long sides open to the air. In church architecture, the story found above the side **aisles** of a church or across the width at the end of the **nave** or **transepts**, usually open to and overlooking the area below. Also: a building or hall in which art is displayed or sold.

garbhagriha (p. 302) From the Sanskrit word meaning "womb chamber," a small room or shrine in a Hindu temple containing a holy image.

genre painting (p. 714) A term used to loosely categorize paintings depicting scenes of everyday life, including (among others) domestic interiors, parties, inn scenes, and street scenes.

geoglyph (p. 399) Earthen design on a colossal scale, often created in a landscape as if to be seen from an aerial viewpoint.

gesso (p. 546) A ground made from glue, gypsum, and/or chalk, used as the ground of a wood panel or the priming layer of a canvas. Provides a smooth surface for painting.

gilding (p. 90) The application of paper-thin gold leaf or gold pigment to an object made from another **medium** (for example, a sculpture or painting). Usually used as a decorative finishing detail.

giornata (pl. giornate) (p. 539) Adopted from the Italian term meaning "a day's work," a giomata is the section of a fresco plastered and painted in a single day. glazing (p. 600) In ceramics, an outermost layer of vitreous liquid (glaze) that, upon firing, renders the ware waterproof and forms a decorative surface. In painting, a technique used with oil media in which a transparent layer of paint (glaze) is laid over another, usually lighter, painted or glazed area. In architecture, the process of filling openings in a building with windows of clear or stained glass.

gold leaf (p. 47) Paper-thin sheets of hammered gold that are used in gilding. In some cases (such as Byzantine icons), also used as a ground for paintings. *gopura* (p. 775) The towering gateway to an Indian Hindu temple complex.

Grand Manner (p. 923) An elevated style of painting popular in the eighteenth century in which the artist looked to the ancients and to the Renaissance for inspiration; for portraits as well as history painting, the artist would adopt the poses, compositions, and attitudes of Renaissance and antique models.

Grand Tour (p. 913) Popular during the eighteenth and nineteenth centuries, an extended tour of cultural sites in France and Italy intended to finish the education of a young upper-class person primarily from Britain or North America.

granulation (p. 90) A technique of decoration in which metal granules, or tiny metal balls, are fused onto a metal surface.

graphic arts (p. 698) A term referring to those arts that are drawn or printed and that utilize paper as the primary support.

grattage (p. 1057) A pattern created by scraping off layers of paint from a canvas laid over a textured surface. Compare **frottage**.

grid (p. 65) A system of regularly spaced horizontally and vertically crossed lines that gives regularity to an architectural plan or in the composition of a work of art. Also: in painting, a grid is used to allow designs to be enlarged or transferred easily.

grisaille (p. 540) A style of monochromatic painting in shades of gray. Also: a painting made in this style.

groin vault (p. 187) See under vault.

grozing (p. 501) Chipping away at the edges of a piece of glass to achieve the precise shape needed for inclusion in the composition of a **stained-glass** window.

guild (p. 419) An association of artists or craftsmakers. Medieval and Renaissance guilds had great economic power, as they controlled the marketing of their members' products and provided economic protection, political solidarity, and training in the craft to its members. The painters' guild was usually dedicated to St. Luke, their patron saint.

hall church (p. 521) A church with **nave** and **aisles** of the same height, giving the impression of a large, open hall.

halo (p. 215) A circle of light that surrounds and frames the heads of emperors and holy figures to signify their power and/or sanctity. Also known as a nimbus.

handscroll (p. 343) A long, narrow, horizontal painting or text (or combination thereof) common in Chinese and Japanese art and of a size intended for individual use. A handscroll is stored wrapped tightly around a wooden pin and is unrolled for viewing or reading.

hanging scroll (p. 796) In Chinese and Japanese art, a vertical painting or text mounted within sections of silk. At the top is a semicircular rod; at the bottom is a round dowel. Hanging scrolls are kept rolled and tied except for special occasions, when they are hung for display, contemplation, or commemoration.

haniwa (p. 362) Pottery forms, including cylinders, buildings, and human figures, that were placed on top of Japanese tombs or burial mounds during the Kofun period (300–552 ce).

Happening (p. 1087) An art form developed by Allan Kaprow in the 1960s, incorporating performance, theater, and visual images. A Happening was organized without a specific narrative or intent; with audience participation, the event proceeded according to chance and individual improvisation.

hemicycle (p. 512) A semicircular interior space or structure.

henge (p. 17) A circular area enclosed by stones or wood posts set up by Neolithic peoples. It is usually bounded by a ditch and raised embankment.

hierarchic scale (p. 27) The use of differences in size to indicate relative importance. For example, with human figures, the larger the figure, the greater her or his importance.

hieratic (p. 484) Highly stylized, severe, and detached, often in relation to a strict religious tradition.

hieroglyph (p. 52) Picture writing; words and ideas rendered in the form of pictorial symbols.

high relief (p. 307) See under relief sculpture. historiated capital (p. 484) See under capital.

historicism (p. 965) The strong consciousness of and attention to the institutions, themes, styles, and forms of the past, made accessible by historical research, textual study, and archaeology.

history paintings (p. 926) Paintings based on historical, mythological, or biblical narratives. Once considered the noblest form of art, history paintings generally convey a high moral or intellectual idea and are often painted in a grand pictorial style.

horizon line (p. 569) A horizontal "line" formed by the implied meeting point of earth and sky. In **linear perspective**, the **vanishing point** or points are located on this "line."

horseshoe arch (p. 272) See under arch.

hue (p. 77) Pure color. The saturation or intensity of the hue depends on the purity of the color. Its value depends on its lightness or darkness.

hydria (p. 139) A large ancient Greek or Roman jar with three handles (horizontal ones at both sides and one vertical at the back), used for storing water.

hypostyle hall (p. 66) A large interior room characterized by many closely spaced **columns** that support its roof.

icon (p. 246) An image representing a sacred figure or event in the Byzantine (later the Orthodox) Church. Icons are venerated by the faithful, who believe their prayers are transmitted through them to God.

iconic image (p. 215) A picture that expresses or embodies an intangible concept or idea.

iconoclasm (p. 248) The banning and/or destruction of images, especially icons and religious art. Iconoclasm in eighth- and ninth-century Byzantium and sixteenth-and seventeenth-century Protestant territories arose from differing beliefs about the power, meaning, function, and purpose of imagery in religion.

iconography (p. xxv) Identifying and studying the subject matter and conventional symbols in works of art

iconology (p. xxvii) Interpreting works of art as embodiments of cultural situation by placing them within broad social, political, religious, and intellectual contexts.

iconophile (p. 247) From the Greek for "lover of images." In periods of **iconoclasm**, iconophiles advocate the continued use of sacred images.

idealization (p. 134) A process in art through which artists strive to make their forms and figures attain perfection, based on pervading cultural values and/or their own personal ideals.

illumination (p. 431) A painting on paper or parchment used as an illustration and/or decoration in a **manuscript** or **album**. Usually richly colored, often supplemented by gold and other precious materials. The artists are referred to as illuminators. Also: the technique of decorating manuscripts with such paintings.

impasto (p. 749) Thick applications of pigment that give a painting a palpable surface texture.

impluvium (p. 178) A pool under a roof opening that collected rainwater in the **atrium** of a Roman house.

impost block (p. 170) A block of masonry imposed between the top of a **pier** or above the **capital** of a **column** in order to provide extra support at the springing of an **arch**.

incising (p. 118) A technique in which a design or inscription is cut into a hard surface with a sharp instrument. Such a surface is said to be incised.

ink painting (p. 812) A monochromatic style of painting developed in China, using black ink with gray washes.

inlay (p. 30) To set pieces of a material or materials into a surface to form a design. Also: material used in or decoration formed by this technique.

installation, installation art (p. 1051)

Contemporary art created for a specific site, especially a gallery or outdoor area, that creates a complete and controlled environment.

intaglio (p. 592) A technique in which the design is carved out of the surface of an object, such as an engraved seal stone. In the **graphic arts**, intaglio includes **engraving**, **etching**, and **drypoint**—all processes in which ink transfers to paper from incised, ink-filled lines cut into a metal plate.

intarsia (p. 618) Technique of inlay decoration using variously colored woods.

intuitive perspective (p. 182) See under perspective. lonic order (p. 107) See under order.

iwan (p. 277) In Islamic architecture, a large, vaulted chamber with a monumental arched opening on one side.

jamb (p. 478) In architecture, the vertical element found on both sides of an opening in a wall, and supporting an **arch** or **lintel**.

Japonisme (p. 996) A style in French and American nineteenth-century art that was highly influenced by Japanese art, especially prints.

jasperware (p. 919) A fine-grained, unglazed, white **ceramic** developed in the eighteenth century by Josiah Wedgwood, often with raised designs remaining white above a background surface colored by metallic oxides.

Jataka tales (p. 303) In Buddhism, stories associated with the previous lives of Shakyamuni, the historical Buddha.

joggled voussoirs (p. 268) Interlocking voussoirs in an arch or lintel, often of contrasting materials for colorful effect.

joined-block sculpture (p. 373) Large-scale wooden sculpture constructed by a method developed in Japan. The entire work is made from smaller hollow blocks, each individually carved, and assembled when complete. The joined-block technique allowed production of larger sculpture, as the multiple joints alleviate the problems of drying and cracking found with sculpture carved from a single block.

kantharos (p. 117) A type of ancient Greek goblet with two large handles and a wide mouth.

keep (p. 477) The innermost and strongest structure or central tower of a medieval castle, sometimes used as living quarters, as well as for defense. Also called a donjon.

kente (p. 892) A woven cloth made by the Ashanti peoples of West Africa. *Kente* cloth is woven in long, narrow pieces featuring complex and colorful patterns, which are then sewn together.

key block (p. 828) The master block in the production of a colored woodblock print, which requires different blocks for each color. The key block is a flat piece of wood upon which the outlines for the entire design of the print were first drawn on its surface and then all but these outlines were carved away with a knife. These outlines serve as a guide for the accurate registration or alignment of the other blocks needed to add colors to specific parts of a print.

keystone (p. 170) The topmost **voussoir** at the center of an **arch**, and the last block to be placed. The pressure of this block holds the arch together. Often of a larger size and/or decorated.

kiln (p. 20) An oven designed to produce enough heat for the baking, or firing, of clay, for the melting of the glass used in **enamel** work, and for the fixing of vitreous paint on **stained glass**.

kiva (p. 405) A subterranean, circular room used as a ceremonial center in some Native American cultures.

kondo (p. 366) The main hall inside a Japanese Buddhist temple where the images of Buddha are housed.

korambo (p. 865) A ceremonial or spirit house in Pacific cultures, reserved for the men of a village and used as a meeting place as well as to hide religious artifacts from the uninitiated.

kore (pl. kourai) (p. 114) An Archaic Greek statue of a young woman.

koru (p. 872) A design depicting a curling stalk with a bulb at the end that resembles a young tree fern; often found in Maori art.

kouros (pl. kouroi) (p. 114) An Archaic Greek statue of a young man or boy.

kowhaiwhai (p. 872) Painted curvilinear patterns often found in Maori art.

krater (p. 99) An ancient Greek vessel for mixing wine and water, with many subtypes that each have a distinctive shape. *Calyx krater*: a bell-shaped vessel with handles near the base that resembles a flower calyx. *Volute krater*: a krater with handles shaped like scrolls.

Kufic (p. 275) An ornamental, angular Arabic script. **kylix** (p. 120) A shallow ancient Greek cup, used for drinking, with a wide mouth and small handles near the rim.

lacquer (p. 824) A type of hard, glossy surface varnish, originally developed for use on objects in East Asian cultures, made from the sap of the Asian sumac or from shellac, a resinous secretion from the lac insect. Lacquer can be layered and manipulated or combined with pigments and other materials for various decorative effects.

lakshana (p. 306) The 32 marks of the historical Buddha. The *lakshana* include, among others, the Buddha's golden body, his long arms, the wheel impressed on his palms and the soles of his feet, and his elongated earlobes.

lamassu (p. 42) Supernatural guardian-protector of ancient Near Eastern palaces and throne rooms, often represented sculpturally as a combination of the bearded head of a man, powerful body of a lion or bull, wings of an eagle, and the horned headdress of a god, usually possessing five legs.

lancet (p. 505) A tall, narrow window crowned by a sharply pointed arch, typically found in Gothic architecture.

lantern (p. 464) A turretlike structure situated on a roof, vault, or dome, with windows that allow light into the space below.

lekythos (pl. lekythoi) (p. 141) A slim ancient Greek oil vase with one handle and a narrow mouth.

linear perspective (p. 595) See under perspective. linga shrine (p. 315) A place of worship centered on an object or representation in the form of a phallus (the lingam), which symbolizes the power of the Hindu god Shiva.

lintel (p. 18) A horizontal element of any material carried by two or more vertical supports to form an opening.

literati painting (p. 793) A style of painting that reflects the taste of the educated class of East Asian intellectuals and scholars. Characteristics include an appreciation for the antique, small scale, and an intimate connection between maker and audience.

lithography (p. 953) Process of making a print (lithograph) from a design drawn on a flat stone block with greasy crayon. Ink is applied to the wet stone and adheres only to the greasy areas of the design.

loggia (p. 534) Italian term for a **gallery**. Often used as a corridor between buildings or around a courtyard, a loggia usually features an **arcade** or **colonnade**.

longitudinal-plan building (p. 225) Any structure designed with a rectangular shape and a longitudinal axis. In a cross-shaped building, the main arm of the building would be longer than any arms that cross it. For example, a **basilica**.

lost-wax casting (p. 36) A method of casting metal, such as bronze. A wax mold is covered with clay and plaster, then fired, thus melting the wax and leaving a hollow form. Molten metal is then poured into the hollow space and slowly cooled. When the hardened clay and plaster exterior shell is removed, a solid metal form remains to be smoothed and polished.

low relief (p. 40) See under relief sculpture.

lunette (p. 221) A semicircular wall area, framed by an **arch** over a door or window. Can be either plain or decorated.

lusterware (p. 277) Pottery decorated with metallic glazes.

madrasa (p. 277) An Islamic institution of higher learning, where teaching is focused on theology and law.

maenad (p. 104) In ancient Greece, a female devotee of the wine god Dionysos who participated in orgiastic rituals. Often depicted with swirling drapery to indicate wild movement or dance. Also called a Bacchante, after Bacchus, the Roman equivalent of Dionysos.

majolica (p. 573) Pottery painted with a tin **glaze** that, when fired, gives a lustrous and colorful surface.

mandala (p. 302) An image of the cosmos represented by an arrangement of circles or concentric geometric shapes containing diagrams or images. Used for meditation and contemplation by Buddhists.

mandapa (p. 302) In a Hindu temple, an open hall dedicated to ritual worship.

mandorla (p. 479) Light encircling, or emanating from, the entire figure of a sacred person.

manuscript (p. 244) A hand-written book or document.

maqsura (p. 272) An enclosure in a Muslim mosque, near the *mihrab*, designated for dignitaries. martyrium (pl. martyria) (p. 238) A church, chapel, or shrine built over the grave of a Christian martyr.

mastaba (p. 53) A flat-topped, one-story structure with slanted walls built over an ancient Egyptian underground tomb.

matte (p. 573) Of a smooth surface that is without shine or luster.

mausoleum (p. 175) A monumental building used as a tomb. Named after the tomb of King Mausolos erected at Halikarnassos around 350 BCE.

medallion (p. 222) Any round ornament or decoration. Also: a large medal.

medium (pl. media) (p. xxi) The material from which a work of art is made.

megalith (adj. megalithic) (p. 16) A large stone used in some prehistoric architecture.

megaron (p. 93) The main hall of a Mycenaean palace or grand house.

memento mori (p. 909) From Latin for "remember that you must die." An object, such as a skull or extinguished candle, typically found in a *vanitas* image, symbolizing the transience of life.

menorah (p. 186) A Jewish lampstand with seven or nine branches; the nine-branched menorah is used during the celebration of Hanukkah. Representations of the seven-branched menorah, once used in the Temple of Jerusalem, became a symbol of Judaism.

metope (p. 110) The carved or painted rectangular panel between the **triglyphs** of a Doric **frieze**.

mihrab (p. 265) A recess or niche that distinguishes the wall oriented toward Mecca (*qibla*) in a **mosque**.

millefiori (p. 434) A glassmaking technique in which rods of differently colored glass are fused in a long bundle that is subsequently sliced to produce disks or beads with small-scale, multicolor patterns. The term derives from the Italian for "a thousand flowers."

minaret (p. 274) A tower on or near a mosque from which Muslims are called to prayer five times a day.

minbar (p. 265) A high platform or pulpit in a mosque.

miniature (p. 245) Anything small. In painting, miniatures may be illustrations within **album**s or **manuscripts** or intimate portraits.

mirador (p. 280) In Spanish and Islamic palace architecture, a very large window or room with windows, and sometimes balconies, providing views to interior courtyards or the exterior landscape.

mithuna (p. 305) The amorous male and female couples in Buddhist sculpture, usually found at the entrance to a sacred building. The *mithuna* symbolizes the harmony and fertility of life.

moai (p. 875) Statues found in Polynesia, carved from tufa, a yellowish brown volcanic stone, and depicting the human form. Nearly 1,000 of these statues have been found on the island of Rapa Nui but their significance has been a matter of speculation.

modeling (p. xxi) In painting, the process of creating the illusion of three-dimensionality on a two-dimensional surface by use of light and shade. In sculpture, the process of molding a three-dimensional form out of a malleable substance.

module (p. 346) A segment or portion of a repeated design. Also: a basic building block.

molding (p. 319) A shaped or sculpted strip with varying contours and patterns. Used as decoration on architecture, furniture, frames, and other objects.

mortise-and-tenon (p. 18) A method of joining two elements. A projecting pin (tenon) on one element fits snugly into a hole designed for it (mortise) on the other.

mosaic (p. 145) Image formed by arranging small colored stone or glass pieces (**tesserae**) and affixing them to a hard, stable surface.

mosque (p. 265) A building used for communal Islamic worship.

Mozarabic (p. 439) Of an eclectic style practiced in Christian medieval Spain when much of the Iberian peninsula was ruled by Islamic dynasties.

mudra (p. 307) A symbolic hand gesture in Buddhist art that denotes certain behaviors, actions, or feelings.

mullion (p. 510) A slender straight or curving bar that divides a window into subsidiary sections to create tracery.

muqarna (p. 280) In Islamic architecture, one of the nichelike components, often stacked in tiers to mark the transition between flat and rounded surfaces and often found on the vault of a dome.

naos (p. 236) The principal room in a temple or church. In ancient architecture, the **cella**. In a Byzantine church, the **nave** and **sanctuary**.

narrative image (p. 215) A picture that recounts an event drawn from a story, either factual (e.g. biographical) or fictional. In **continuous narrative**, multiple scenes from the same story appear within a single compositional frame.

narthex (p. 220) The vestibule or entrance porch of a church.

nave (p. 191) The central space of a church, two or three stories high and usually flanked by **aisles**.

necropolis (p. 53) A large cemetery or burial area; literally a "city of the dead."

nemes headdress (p. 51) The royal headdress of ancient Egypt.

niello (p. 90) A metal technique in which a black sulfur **alloy** is rubbed into fine lines engraved into metal (usually gold or silver). When heated, the alloy becomes fused with the surrounding metal and provides contrasting detail.

oculus (pl. oculi) (p. 187) In architecture, a circular opening. Usually found either as windows or at the apex of a dome. When at the top of a dome, an oculus is either open to the sky or covered by a decorative exterior lantern.

odalisque (p. 952) Turkish word for "harem slave girl" or "concubine."

oil painting (p. 575) Any painting executed with pigments suspended in a **medium** of oil. Oil paint has particular properties that allow for greater ease of working: among others, a slow drying time (which allows for corrections), and a great range of relative opaqueness of paint layers (which permits a high degree of detail and luminescence).

oinochoe (p. 126) An ancient Greek jug used for wine.

olpe (p. 105) Any ancient Greek vessel without a spout.

one-point perspective (p. 259) See under perspective.

orant (p. 220) Of a standing figure represented praying with outstretched and upraised arms.

oratory (p. 228) A small chapel.

order (p. 110) A system of proportions in Classical architecture that includes every aspect of the building's plan, elevation, and decorative system. Composite: a combination of the Ionic and the Corinthian orders. The capital combines acanthus leaves with volute scrolls. Corinthian: the most ornate of the orders, the Corinthian includes a base, a fluted column shaft with a capital elaborately decorated with acanthus leaf carvings. Its entablature consists of an architrave decorated with moldings, a frieze often containing relief sculpture, and a cornice with dentils. Doric: the column shaft of the Doric order can be fluted or smooth-surfaced and has no base. The Doric capital consists of an undecorated echinus and abacus. The Doric entablature has a plain architrave, a frieze with metopes and triglyphs, and a simple cornice. Ionic: the column of the Ionic order has a base, a fluted shaft, and a capital decorated with volutes. The Ionic entablature consists of an architrave of three panels and moldings,

a frieze usually containing sculpted relief ornament, and a cornice with dentils. *Tuscan*: a variation of Doric characterized by a smooth-surfaced column shaft with a base, a plain architrave, and an undecorated frieze. *Colossal* or *giant*: any of the above built on a large scale, rising through two or more stories in height and often raised from the ground on a **pedestal**.

Orientalism (p. 968) A fascination with Middle Eastern cultures that inspired eclectic nineteenth-century European fantasies of exotic life that often formed the subject of paintings.

orthogonal (p. 138) Any line running back into the represented space of a picture perpendicular to the imagined picture plane. In linear perspective, all orthogonals converge at a single vanishing point in the picture and are the basis for a grid that maps out the internal space of the image. An orthogonal plan is any plan for a building or city that is based exclusively on right angles, such as the grid plan of many major cities.

pagoda (p. 347) An East Asian reliquary tower built with successively smaller, repeated stories. Each story is usually marked by an elaborate projecting roof.

painterly (p. 253) A style of painting which emphasizes the techniques and surface effects of brushwork (also color, light, and shade).

palace complex (p. 41) A group of buildings used for living and governing by a ruler and his or her supporters, usually fortified.

palazzo (p. 602) Italian term for palace, used for any large urban dwelling.

palette (p. 183) A hand-held support used by artists for arranging colors and mixing paint during the process of painting. Also: the choice of a range of colors used by an artist in a particular work, as typical of his or her style. In ancient Egypt, a flat stone used to grind and prepare makeup.

panel painting (p. xxxiii) Any painting executed on a wood support, usually planed to provide a smooth surface. A panel can consist of several boards joined together.

parchment (p. 245) A writing surface made from treated skins of animals. Very fine parchment is known as **vellum**.

parterre (p. 761) An ornamental, highly regimented flowerbed; especially as an element of the ornate gardens of a seventeenth-century palace or **château**.

passage grave (p. 17) A prehistoric tomb under a cairn, reached by a long, narrow, slab-lined access passageway or passageways.

pastel (p. 914) Dry pigment, chalk, and gum in stick or crayon form. Also: a work of art made with pastels. pedestal (p. 107) A platform or base supporting a sculpture or other monument. Also: the block found below the base of a Classical column (or colonnade), serving to raise the entire element off the ground.

pediment (p. 107) A triangular gable found over major architectural elements such as Classical Greek porticos, windows, or doors. Formed by an entablature and the ends of a sloping roof or a raking cornice. A similar architectural element is often used decoratively above a door or window, sometimes with a curved upper molding. A broken pediment is a variation on the traditional pediment, with an open space at the center of the topmost angle and/or the horizontal cornice.

pendant (also **pendent**) (p. 640) One of a pair of artworks meant to be seen in relation to each other as a set.

pendentive (p. 236) The concave triangular section of a **vault** that forms the transition between a square or polygonal space and the circular base of a **dome**.

Performance art (p. 1087) A contemporary artwork based on a live, sometimes theatrical performance by the artist.

peristyle (p. 66) In Greek architecture, a surrounding **colonnade**. A peristyle building is surrounded on the exterior by a colonnade. Also: a peristyle court is an open colonnaded courtyard, often having a pool and garden.

perspective (p. xix) A system for representing three-dimensional space on a two-dimensional surface. Atmospheric or aerial perspective: a method of rendering the effect of spatial distance by subtle variations in color and clarity of representation. Intuitive perspective: a method of giving the impression of recession by visual instinct, not by the use of an overall system or program. Oblique perspective: an intuitive spatial system in which a building or room is placed with one corner in the picture plane, and the other parts of the structure recede to an imaginary vanishing point on its other side. Oblique perspective is not a comprehensive, mathematical system. One-point and multiple-point perspective (also called linear, scientific, or mathematical perspective): a method of creating the illusion of threedimensional space on a two-dimensional surface by delineating a horizon line and multiple orthogonal lines. These recede to meet at one or more points on the horizon (vanishing point), giving the appearance of spatial depth. Called scientific or mathematical because its use requires some knowledge of geometry and mathematics, as well as optics. Reverse perspective: a Byzantine perspective theory in which the orthogonals or rays of sight do not converge on a vanishing point in the picture, but are thought to originate in the viewer's eve in front of the picture. Thus, in reverse perspective the image is constructed with orthogonals that diverge, giving a slightly tipped aspect to objects.

photomontage (p. 1039) A photographic work created from many smaller photographs arranged (and often overlapping) in a composition, which is then rephotographed.

pictograph (p. 337) A highly stylized depiction serving as a symbol for a person or object. Also: a type of writing utilizing such symbols.

picture plane (p. 575) The theoretical plane corresponding with the actual surface of a painting, separating the spatial world evoked in the painting from the spatial world occupied by the viewer.

picturesque (p. 919) Of the taste for the familiar, the pleasant, and the agreeable, popular in the eighteenth and nineteenth centuries in Europe. Originally used to describe the "picturelike" qualities of some landscape scenes. When contrasted with the sublime, the picturesque stood for the interesting but ordinary domestic landscape.

piece-mold casting (p. 334) A casting technique in which the mold consists of several sections that are connected during the pouring of molten metal, usually bronze. After the cast form has hardened, the pieces of the mold are disassembled, leaving the completed object.

pier (p. 270) A masonry support made up of many stones, or rubble and concrete (in contrast to a column **shaft** which is formed from a single stone or a series of **drums**), often square or rectangular in plan, and capable of carrying very heavy architectural loads.

pietà (p. 230) A devotional subject in Christian religious art. After the Crucifixion the body of Jesus was laid across the lap of his grieving mother, Mary. When other mourners are present, the subject is called the Lamentation.

pietra serena (p. 602) A gray Tuscan sandstone used in Florentine architecture.

pilaster (p. 158) An **engaged** columnlike element that is rectangular in format and used for decoration in architecture.

pilgrimage church (p. 239) A church that attracts visitors wishing to venerate **relic**s as well as attend religious services.

pinnacle (p. 503) In Gothic architecture, a steep pyramid decorating the top of another element such as a **buttress**. Also: the highest point.

plate tracery (p. 505) See under tracery.

plein air (p. 989) See under en plein air.

plinth (p. 161) The slablike base or **pedestal** of a **column**, statue, wall, building, or piece of furniture.

pluralism (p. 1107) A social structure or goal that allows members of diverse ethnic, racial, or other groups to exist peacefully within the society while continuing to practice the customs of their own divergent cultures. Also: an adjective describing the state of having a variety of valid contemporary styles available at the same time to artists.

podium (p. 138) A raised platform that acts as the foundation for a building, or as a platform for a speaker. poesia (pl. poesie) (p. 656) Italian Renaissance paintings based on Classical themes, often with erotic overtones, notably in the mid-sixteenth-century works of the Venetian painter Titian.

polychromy (p. 524) Multicolored decoration applied to any part of a building, sculpture, or piece of furniture. This can be accomplished with paint or by the use of multicolored materials.

polyptych (p. 566) An **altarpiece** constructed from multiple panels, sometimes with hinges to allow for movable wings.

porcelain (p. 20) A type of extremely hard and fine white **ceramic** first made by Chinese potters in the eighth century CE. Made from a mixture of kaolin and petuntse, porcelain is fired at a very high temperature, and the final product has a translucent surface.

porch (p. 108) The covered entrance on the exterior of a building. With a row of **columns** or **colonnade**, also called a **portico**.

portal (p. 40) A grand entrance, door, or gate, usually to an important public building, and often decorated with sculpture.

portico (p. 63) In architecture, a projecting roof or porch supported by **columns**, often marking an entrance. See also **porch**.

post-and-lintel (p. 19) An architectural system of construction with two or more vertical elements (posts) supporting a horizontal element (**lintel**).

potassium-argon dating (p. 12) Archaeological method of radiometric dating that measures the decay of a radioactive potassium isotope into a stable isotope of argon, and inert gas.

potsherd (p. 20) A broken piece of **ceramic** ware. *poupou* (p. 873) In Pacific cultures, a house panel, often carved with designs.

Prairie Style (p. 1046) Style developed by a group of Midwestern architects who worked together using the aesthetic of the prairie and indigenous prairie plants for landscape design to create mostly domestic homes and small public buildings.

predella (p. 550) The base of an **altarpiece**, often decorated with small scenes that are related in subject to that of the main panel or panels.

primitivism (p. 1022) The borrowing of subjects or forms, usually from non-European or prehistoric sources by Western artists, in an attempt to infuse their work with the expressive qualities they attributed to other cultures, especially colonized cultures.

pronaos (p. 108) The enclosed vestibule of a Greek or Roman temple, found in front of the **cella** and marked by a row of **columns** at the entrance.

proscenium (p. 148) The stage of an ancient Greek or Roman theater. In a modern theater, the area of the stage in front of the curtain. Also: the framing **arch** that separates a stage from the audience.

psalter (p. 256) In Jewish and Christian scripture, a book of the Psalms (songs) attributed to King David.

psykter (p. 126) An ancient Greek vessel with an extended base to allow it to float in a larger **krater**; used to chill wine.

putto (pl. putti) (p. 224) A plump, naked little boy, often winged. In Classical art, called a cupid; in Christian art, a cherub.

pylon (p. 66) A massive gateway formed by a pair of tapering walls of oblong shape. Erected by ancient Egyptians to mark the entrance to a temple complex.

qibla (p. 274) The **mosque** wall oriented toward Mecca; indicated by the *mihrab*.

quatrefoil (p. 508) A four-lobed decorative pattern common in Gothic art and architecture.

quillwork (p. 847) A Native American technique in which the quills of porcupines and bird feathers are dyed and attached to materials in patterns.

radiometric dating (p. 12) Archaeological method of absolute dating by measuring the degree to which radioactive materials have degenerated over time. For dating organic (plant or animal) materials, one radiometric method measures a carbon isotope called radiocarbon, or carbon-14.

raigo (p. 378) A painted image that depicts the Amida Buddha and other Buddhist deities welcoming the soul of a dying believer to paradise.

raku (p. 823) A type of *ceramic* made by hand, coated with a thick, dark *glaze*, and fired at a low heat. The resulting vessels are irregularly shaped and glazed and are highly prized for use in the Japanese tea ceremony.

readymade (p. 1038) An object from popular or material culture presented without further manipulation as an artwork by the artist.

red-figure (p. 119) A technique of ancient Greek **ceramic** decoration characterized by red clay-colored figures on a black background. The figures are reserved against a painted ground and details are drawn, not engraved; compare **black-figure**.

register (p. 30) A device used in systems of spatial definition. In painting, a register indicates the use of differing groundlines to differentiate layers of space within an image. In **relief sculpture**, the placement of self-contained bands of reliefs in a vertical arrangement.

registration marks (p. 828) In Japanese woodblock prints, two marks carved on the blocks to indicate proper alignment of the paper during the printing process. In multicolor printing, which used a separate block for each color, these marks were essential for achieving the proper position or registration of the colors.

relative dating (p. 12) Archaeological process of determining relative chronological relationships among excavated objects. Compare **absolute dating**.

relic (p. 239) Venerated object or body part associated with a holy figure, such as a saint, and usually housed in a **reliquary**.

relief sculpture (p. 5) A three-dimensional image or design whose flat background surface is carved away to a certain depth, setting off the figure. Called *high* or *low* (*bas-*) *relief* depending upon the extent of projection of the image from the background. Called *sunken relief* when the image is carved below the original surface of the background, which is not cut away.

reliquary (p. 366) A container, often elaborate and made of precious materials, used as a repository for sacred relics.

repoussé (p. 90) A technique of pushing or hammering metal from the back to create a protruding image. Elaborate reliefs are created by pressing or hammering metal sheets against carved wooden forms.

rhyton (p. 88) A vessel in the shape of a figure or an animal, used for drinking or pouring liquids on special occasions.

rib vault (p. 499) See under vault.

ridgepole (p. 16) A longitudinal timber at the apex of a roof that supports the upper ends of the rafters.

roof comb (p. 392) In a Maya building, a masonry wall along the apex of a roof that is built above the level of the roof proper. Roof combs support the highly decorated false **façades** that rise above the height of the building at the front.

rose window (p. 505) A round window, often filled with stained glass set into tracery patterns in the form of wheel spokes, found in the **façade**s of the **naves** and **transepts** of large Gothic churches.

rosette (p. 105) A round or oval ornament resembling a rose.

rotunda (p. 195) Any building (or part thereof) constructed in a circular (or sometimes polygonal) shape, usually producing a large open space crowned by a **dome**.

round arch (p. 170) See under arch.

roundel (p. 158) Any ornamental element with a circular format, often placed as a decoration on the exterior of a building.

rune stone (p. 442) In early medieval northern Europe, a stone used as a commemorative monument and carved or inscribed with runes, a writing system used by early Germanic peoples.

rustication (p. 602) In architecture, the rough, irregular, and unfinished effect deliberately given to the exterior facing of a stone edifice. Rusticated stones are often large and used for decorative emphasis around doors or windows, or across the entire lower floors of a building.

sacra conversazione (p. 630) Italian for "holy conversation." Refers to a type of religious painting developed in fifteenth-century Florence in which a central image of the Virgin and Child is flanked by standing saints of comparable size who stand within the same spatial setting and often acknowledge each other's presence.

salon (p. 907) A large room for entertaining guests or a periodic social or intellectual gathering, often of prominent people, held in such a room. Also: a hall or **gallery** for exhibiting works of art.

sanctuary (p. 102) A sacred or holy enclosure used for worship. In ancient Greece and Rome, consisted of one or more temples and an altar. In Christian architecture, the space around the altar in a church called the chancel or presbytery.

sarcophagus (pl. sarcophagi) (p. 49) A stone coffin. Often rectangular and decorated with **relief** sculpture.

scarab (p. 51) In ancient Egypt, a stylized dung beetle associated with the sun and the god Amun.

scarification (p. 409) Ornamental decoration applied to the surface of the body by cutting the skin for cultural and/or aesthetic reasons.

school of artists or painting (p. 285) An arthistorical term describing a group of artists, usually working at the same time and sharing similar styles, influences, and ideals. The artists in a particular school may not necessarily be directly associated with one another, unlike those in a workshop or atelier.

scriptorium (pl. scriptoria) (p. 244) A room in a monastery for writing or copying manuscripts.

scroll painting (p. 347) A painting executed on a flexible support with rollers at each end. The rollers permit the horizontal scroll to be unrolled as it is studied or the vertical scroll to be hung for contemplation or decoration.

sculpture in the round (p. 5) Three-dimensional sculpture that is carved free of any background or block. Compare **relief sculpture**.

serdab (p. 53) In ancient Egyptian tombs, the small room in which the ka statue was placed.

sfumato (p. 636) Italian term meaning "smoky," soft, and mellow. In painting, the effect of haze in an image. Resembling the color of the atmosphere at dusk, *sfumato* gives a smoky effect.

sgraffito (p. 604) Decoration made by incising or cutting away a surface layer of material to reveal a different color beneath.

shaft (p. 110) The main vertical section of a **column** between the **capital** and the base, usually circular in cross section.

shaft grave (p. 97) A deep pit used for burial.

shikhara (p. 302) In the architecture of northern India, a conical (or pyramidal) spire found atop a Hindu temple and often crowned with an *amalaka*.

shoin (p. 821) A term used to describe the various features found in the most formal room of upper-class Japanese residential architecture.

shoji (p. 821) A standing Japanese screen covered in translucent rice paper and used in interiors.

siapo (p. 876) A type of **tapa** cloth found in Samoa and still used as an important gift for ceremonial occasions.

silkscreen printing (p. 1092) A technique of printing in which paint or ink is pressed through a stencil and specially prepared cloth to reproduce a design in multiple copies.

sinopia (pl. **sinopie**) (p. 539) Italian word taken from Sinope, the ancient city in Asia Minor that was famous for its red-brick pigment. In **fresco** paintings, a full-sized, preliminary sketch done in this color on the first rough coat of plaster or *arriccio*.

site-specific (p. 1102) Of a work commissioned and/or designed for a particular location.

slip (p. 118) A mixture of clay and water applied to a **ceramic** object as a final decorative coat. Also: a solution that binds different parts of a vessel together, such as the handle and the main body.

spandrel (p. 170) The area of wall adjoining the exterior curve of an **arch** between its **springing** and the **keystone**, or the area between two arches, as in an **arcade**.

spolia (p. 471) Fragments of older architecture or sculpture reused in a secondary context. Latin for "hide stripped from an animal."

springing (p. 170) The point at which the curve of an **arch** or **vault** meets with and rises from its support.

squinch (p. 238) An **arch** or **lintel** built across the upper corners of a square space, allowing a circular or polygonal **dome** to be securely set above the walls.

stained glass (p. 287) Glass stained with color while molten, using metallic oxides. Stained glass is most often used in windows, for which small pieces of different colors are precisely cut and assembled into a design, held together by lead cames. Additional details may be added with vitreous paint.

stave church (p. 443) A Scandinavian wooden structure with four huge timbers (staves) at its core.

stele (pl. **stelai**), also **stela** (pl. **stelae**) (p. 27) A stone slab placed vertically and decorated with inscriptions or reliefs. Used as a grave marker or commemorative monument.

stereobate (p. 110) In Classical architecture, the foundation upon which a temple stands.

still life (pl. still lifes) (p. xxvii) A type of painting that has as its subject inanimate objects (such as food and dishes) or fruit and flowers taken out of their natural contexts.

stoa (p. 107) In Greek architecture, a long roofed walkway, usually having **columns** on one long side and a wall on the other.

stoneware (p. 20) A high-fired, vitrified, but opaque ceramic ware that is fired in the range of 1,100 to 1,200 degrees Celsius. At that temperature, particles of silica in the clay bodies fuse together so that the finished vessels are impervious to liquids, even without glaze. Stoneware pieces are glazed to enhance their aesthetic appeal and to aid in keeping them clean. Stoneware occurs in a range of earth-toned colors, from white and tan to gray and black, with light gray predominating. Chinese potters were the first in the world to produce stoneware, which they were able to make as early as the Shang dynasty.

stringcourse (p. 503) A continuous horizontal band, such as a **molding**, decorating the face of a wall.

stucco (p. 72) A mixture of lime, sand, and other ingredients made into a material that can easily be molded or modeled. When dry, it produces a durable surface used for covering walls or for architectural sculpture and decoration.

stupa (p. 302) In Buddhist architecture, a bell-shaped or pyramidal religious monument, made of piled earth or stone, and containing sacred **relics**.

style (p. xxviii) A particular manner, form, or character of representation, construction, or expression that is typical of an individual artist or of a certain place or period.

stylobate (p. 110) In Classical architecture, the stone foundation on which a temple **colonnade** stands.

stylus (p. 28) An instrument with a pointed end (used for writing and printmaking), which makes a delicate line or scratch. Also: a special writing tool for **cuneiform** writing with one pointed end and one triangular.

sublime (p. 955) Of a concept, thing, or state of greatness or vastness with high spiritual, moral, intellectual, or emotional value; or something aweinspiring. The sublime was a goal to which many nineteenth-century artists aspired in their artworks.

sunken relief (p. 71) See under relief sculpture. symposium (p. 119) An elite gathering of wealthy and powerful men in ancient Greece that focused principally on wine, music, poetry, conversation, games, and love making.

syncretism (p. 220) A process whereby artists assimilate and combine images and ideas from different cultural traditions, beliefs, and practices, giving them new meanings.

taotie (p. 334) A mask with a dragon or animal-like face common as a decorative motif in Chinese art.

tapa (p. 876) A type of cloth used for various purposes in Pacific cultures, made from tree bark stripped and beaten, and often bearing subtle designs from the mallets used to work the bark.

tapestry (p. 292) Multicolored decorative weaving to be hung on a wall or placed on furniture. Pictorial or decorative motifs are woven directly into the supporting fabric, completely concealing it.

tatami (p. 821) Mats of woven straw used in Japanese houses as a floor covering.

temenos (p. 108) An enclosed sacred area reserved for worship in ancient Greece.

tempera (p. 141) A painting **medium** made by blending egg yolks with water, pigments, and occasionally other materials, such as glue.

tenebrism (p. 723) The use of strong *chiaroscuro* and artificially illuminated areas to create a dramatic contrast of light and dark in a painting.

terra cotta (p. 114) A **medium** made from clay fired over a low heat and sometimes left unglazed. Also: the orange-brown color typical of this medium.

tessera (pl. **tesserae**) (p. 145) A small piece of stone, glass, or other object that is pieced together with many others to create a **mosaic**.

thatch (p. 16) Plant material such as reeds or straw tied over a framework of poles to make a roof, shelter, or small building.

thermo-luminescence dating (p. 12) A method of radiometric dating that measures the irradiation of the crystal structure of material such as flint or pottery and the soil in which it is found, determined by luminescence produced when a sample is heated.

tholos (p. 98) A small, round building. Sometimes built underground, e.g. as a Mycenaean tomb.

thrust (p. 170) The outward pressure caused by the weight of a **vault** and supported by **buttressing**. See also under **arch**.

tondo (pl. tondi) (p. 126) A painting or relief sculpture of circular shape.

torana (p. 302) In Indian architecture, an ornamented gateway arch in a temple, usually leading to the **stupa**.

torc (p. 149) A circular neck ring worn by Celtic warriors.

toron (p. 422) In West African **mosque** architecture, the wooden beams that project from the walls. Torons are used as support for the scaffolding erected annually for the replastering of the building.

tracery (p. 503) Stonework or woodwork forming a pattern in the open space of windows or applied to wall surfaces. In *plate tracery*, a series of openings are cut through the wall. In *bar tracery*, mullions divide the space into segments to form decorative patterns.

transept (p. 225) The arm of a **cruciform** church perpendicular to the **nave**. The point where the nave and transept intersect is called the crossing. Beyond the crossing lies the **sanctuary**, whether **apse**, **choir**, or chevet.

transverse arch (p. 463) See under arch.

trefoil (p. 298) An ornamental design made up of three rounded lobes placed adjacent to one another.

triforium (p. 505) The element of the interior elevation of a church found directly below the **clerestory** and consisting of a series of arched openings in front of a passageway within the thickness of the wall.

triglyph (p. 110) Rectangular block between the **metope**s of a Doric **frieze**. Identified by the three carved vertical grooves, which approximate the appearance of the end of wooden beams.

triptych (p. 566) An artwork made up of three panels. The panels may be hinged together in such a way that the side segments (wings) fold over the central area.

trompe l'oeil (p. 618) A manner of representation in which artists faithfully describe the appearance of natural space and forms with the express intention of fooling the eye of the viewer, who may be convinced momentarily that the subject actually exists as three-dimensional reality.

trumeau (p. 478) A **column**, **pier**, or post found at the center of a large **portal** or doorway, supporting the **lintel**.

tugra (p. 288) A calligraphic imperial monogram used in Ottoman courts.

tukutuku (p. 872) Lattice panels created by women from the Maori culture and used in architecture.

Tuscan order (p. 158) See under order.

twining (p. 848) A basketry technique in which short rods are sewn together vertically. The panels are then joined together to form a container or other object.

tympanum (p. 478) In medieval and later architecture, the area over a door enclosed by an **arch** and a **lintel**, often decorated with sculpture or mosaic.

ukiyo-e (p. 828) A Japanese term for a type of popular art that was favored from the sixteenth century, particularly in the form of color **woodblock prints**. *Ukiyo-e* prints often depicted the world of the common people in Japan, such as courtesans and actors, as well as landscapes and myths.

undercutting (p. 212) A technique in sculpture by which the material is cut back under the edges so that the remaining form projects strongly forward, casting deep shadows.

underglaze (p. 800) Color or decoration applied to a **ceramic** piece before glazing.

upeti (p. 876) In Pacific cultures, a carved wooden design tablet, used to create patterns in cloth by dragging the fabric across it.

uranium-thorium dating (p. 12) Technique used to date prehistoric cave paintings by measuring the decay of uranium into thorium in the deposits of calcium carbinate that cover the surfaces of cave walls, to determine the minimum age of the paintings under the crust.

urna (p. 306) In Buddhist art, the curl of hair on the forehead that is a characteristic mark of a buddha. The *urna* is a symbol of divine wisdom.

ushnisha (p. 306) In Asian art, a round turban or tiara symbolizing royalty and, when worn by a buddha, enlightenment.

vanishing point (p. 610) In a perspective system, the point on the horizon line at which orthogonals meet. A complex system can have multiple vanishing points.

vanitas (p. XXVIII) An image, especially popular in Europe during the seventeenth century, in which all the objects symbolize the transience of life. Vanitas paintings are usually of still lifes or genre subjects.

vault (p. 17) An arched masonry structure that spans an interior space. Barrel or tunnel vault: an elongated or continuous semicircular vault, shaped like a half-cylinder. Corbeled vault: a vault made by projecting courses of stone; see also under corbel. Groin or cross vault: a vault created by the intersection of two barrel vaults of equal size which creates four side compartments of identical size and shape. Quadrant vault: a half-barrel vault. Rib vault: a groin vault with ribs (extra masonry) demarcating the junctions. Ribs may function to reinforce the groins or may be purely decorative.

veduta (pl. vedute) (p. 915) Italian for "vista" or "view." Paintings, drawings, or prints, often of expansive city scenes or of harbors.

vellum (p. 245) A fine animal skin prepared for writing and painting. See also **parchment**.

verism (p. 168) Style in which artists concern themselves with describing the exterior likeness of an object or person, usually by rendering its visible details in a finely executed, meticulous manner.

vihara (p. 305) From the Sanskrit term meaning "for wanderers." A vihara is, in general, a Buddhist monastery in India. It also signifies monks' cells and gathering places in such a monastery.

volute (p. 110) A spiral scroll, as seen on an Ionic capital.

votive figure (p. 31) An image created as a devotional offering to a deity.

voussoir (p. 170) Wedge-shaped stone block used to build an **arch**. The topmost voussoir is called a **keystone**. See also **joggled voussoirs**.

warp (p. 292) The vertical threads in a weaver's loom. Warp threads make up a fixed framework that provides the structure for the entire piece of cloth, and are thus often thicker than weft threads.

wattle and daub (p. 16) A wall construction method combining upright branches, woven with twigs (wattles) and plastered or filled with clay or mud (daub).

weft (p. 292) The horizontal threads in a woven piece of cloth. Weft threads are woven at right angles to and through the warp threads to make up the bulk of the decorative pattern. In carpets, the weft is often completely covered or formed by the rows of trimmed knots that form the carpet's soft surface.

westwork (p. 446) The monumental, west-facing entrance section of a Carolingian, Ottonian, or Romanesque church. The exterior consists of multiple stories between two towers; the interior includes an entrance vestibule, a chapel, and a series of galleries overlooking the nave.

white-ground (p. 141) A type of ancient Greek pottery in which the background color of the object was painted with a slip that turns white in the firing process. Figures and details were added by painting on or incising into this slip. White-ground wares were popular in the Classical period as funerary objects.

woodblock print (p. 591) A print made from one or more carved wooden blocks. In Japan, woodblock prints were made using multiple blocks carved in relief, usually with a block for each color in the finished print. See also woodcut.

woodcut (p. 592) A type of print made by carving a design into a wooden block. The ink is applied to the block with a roller. As the ink touches only on the surface areas and lines remaining between the carvedaway parts of the block, it is these areas that make the print when paper is pressed against the inked block, leaving the carvedaway parts of the design to appear blank. Also: the process by which the woodcut is made.

yaksha, yakshi (p. 301) The male (yaksha) and female (yakshi) nature spirits that act as agents of the Hindu gods. Their sculpted images are often found on Hindu temples and other sacred places, particularly at the entrances.

yamato-e (p. 374) A native style of Japanese painting developed during the twelfth and thirteenth centuries, distinguished from Japanese painting styles that emulate Chinese traditions.

ziggurat (p. 28) In ancient Mesopotamia, a tall stepped tower of earthen materials, often supporting a shrine.

Bibliography

Susan V. Craig, updated by Carrie L. McDade

This bibliography is composed of books in English that are suggested "further reading" titles. Most are available in good libraries, whether college, university, or public. Recently published works have been emphasized so that the research information would be current. There are three classifications of listings: general surveys and art history reference tools, including journals and Internet directories; surveys of large periods that encompass multiple chapters (ancient art in the Western tradition, European medieval art, European Renaissance through eighteenth-century art, modern art in the West, Asian art, and African and Oceanic art, and art of the Americas); and books for individual Chapters 1 through 33.

General Art History Surveys and Reference Tools

- Adams, Laurie Schneider. Art Across Time. 4th ed. New York: McGraw-Hill, 2011.
- Barnet, Sylvan. A Short Guide to Writing about Art. 10th ed. Upper Saddle River, NJ: Pearson/Prentice Hall, 2010.
- Bony, Anne. Design: History, Main Trends, Main Figures. Edinburgh: Chambers, 2005.
- Boström, Antonia. *Encyclopedia of Sculpture*. 3 vols. New York: Fitzroy Dearborn, 2004.
- Broude, Norma, and Mary D. Garrard, eds. Feminism and Ant History: Questioning the Litany. Icon Editions. New York: Harper & Row, 1982.
- Chadwick, Whitney. Women, Art, and Society. 4th ed. New York: Thames & Hudson, 2007.
- Chilvers, Ian, ed. The Oxford Dictionary of Art. 4th ed. New York: Oxford Univ. Press, 2009.
- Curl, James Stevens. A Dictionary of Architecture and Landscape Architecture. 2nd ed. Oxford: Oxford Univ. Press, 2006.
- Davies, Penelope J.E., et al. *Janson's History of Art: The Western Tradition*. 8th ed. Upper Saddle River, NJ: Prentice Hall, 2010.
- The Dictionary of Art. Ed. Jane Turner. 34 vols. New York: Grove's Dictionaries, 1996.
- Frank, Patrick, Duane Preble, and Sarah Preble. Prebles' Artforms. 10th ed. Upper Saddle River, NJ: Pearson/ Prentice Hall, 2011.
- Gaze, Delia, ed. *Dictionary of Women Artists*. 2 vols. London: Fitzroy Dearborn, 1997.
- Griffiths, Antony. Prints and Printmaking: An Introduction to the History and Techniques. 2nd ed. London: British Museum Press, 1996.
- Hadden, Peggy. The Quotable Artist. New York: Allworth Press, 2002.
- Hall, James. Dictionary of Subjects and Symbols in Art. 2nd ed. Boulder, CO: Westview Press, 2008.
- Holt, Elizabeth Gilmore, ed. *A Documentary History of Art.* 3 vols. New Haven: Yale Univ. Press, 1986.
- Honour, Hugh, and John Fleming. *The Visual Arts: A History*. 7th ed. rev. Upper Saddle River, NJ: Pearson/Prentice Hall, 2010.
- Johnson, Paul. Art: A New History. New York: HarperCollins, 2003.
- Kemp, Martin, ed. The Oxford History of Western Art. Oxford: Oxford Univ. Press, 2000.
- Kleiner, Fred S. *Gardner's Art through the Ages*. Enhanced 13th ed. Belmont, CA: Thomson/Wadsworth, 2011.
- Kostof, Spiro. A History of Architecture: Settings and Rituals. 2nd ed. Revised Greg Castillo. New York: Oxford Univ. Press, 1995.
- Mackenzie, Lynn. Non-Western Art: A Brief Guide. 2nd ed. Upper Saddle River, NJ: Pearson/Prentice Hall, 2001.
- Marmor, Max, and Alex Ross, eds. Guide to the Literature of Art History 2. Chicago: American Library Association, 2005.
- Onians, John, ed. *Atlas of World Art.* New York: Oxford Univ. Press, 2004.

- Sayre, Henry M. Writing about Art. 6th ed. Upper Saddle River, NJ: Pearson/Prentice Hall, 2009.
- Sed-Rajna, Gabrielle. *Jewish Art*. Trans. Sara Friedman and Mira Reich. New York: Abrams, 1997.
- Slatkin, Wendy. Women Artists in History: From Antiquity to the Present. 4th ed. Upper Saddle River, NJ: Pearson/ Prentice Hall, 2001.
- Sutton, Ian. Western Architecture: From Ancient Greece to the Present. World of Art. New York: Thames & Hudson, 1999.
- Trachtenberg, Marvin, and Isabelle Hyman. Architecture, from Prehistory to Postmodernity. 2nd ed. Upper Saddle River, NJ: Pearson/Prentice Hall, 2002.
- Watkin, David. A History of Western Architecture. 4th ed. New York: Watson-Guptill, 2005.

Art History Journals: A Select List of Current Titles

- African Arts. Quarterly. Los Angeles: Univ. of California at Los Angeles, James S. Coleman African Studies Center, 1967–.
- American Art: The Journal of the Smithsonian American Art Museum. 3/year. Chicago: Univ. of Chicago Press, 1987–.
- American Indian Art Magazine. Quarterly. Scottsdale, AZ: American Indian Art Inc., 1975—.
- American Journal of Archaeology. Quarterly. Boston: Archaeological Institute of America, 1885—.
- Antiquity: A Periodical of Archaeology. Quarterly. Cambridge: Antiquity Publications Ltd., 1927—.
- Apollo: The International Magazine of the Arts. Monthly. London: Apollo Magazine Ltd., 1925—.
- Architectural History. Annually. Farnham, UK: Society of Architectural Historians of Great Britain, 1958–.
- Archives of American Art Journal. Quarterly. Washington, DC: Archives of American Art, Smithsonian Institution, 1960—
- Archives of Asian Art. Annually. New York: Asia Society, 1945-.
- Ars Orientalis: The Arts of Asia, Southeast Asia, and Islam. Annually. Ann Arbor: Univ. of Michigan Dept. of Art History, 1954–.
- Art Bulletin. Quarterly. New York: College Art Association, 1913—
- Art History: Journal of the Association of Art Historians. 5/year. Oxford: Blackwell Publishing Ltd., 1978–.
- Art in America. Monthly. New York: Brant Publications Inc., 1913—.
- Art Journal. Quarterly. New York: College Art Association, 1960-.
- An Nexus. Quarterly. Bogota, Colombia: Arte en Colombia Ltda, 1976–.
- Art Papers Magazine. Bimonthly. Atlanta: Atlanta Art Papers Inc., 1976–.
- Artforum International. 10/year. New York: Artforum International Magazine Inc., 1962–.
- Artnews. 11/year. New York: Artnews LLC, 1902–. Bulletin of the Metropolitan Museum of Art. Quarterly. New
- York: Metropolitan Museum of Art, 1905—. Burlington Magazine. Monthly. London: Burlington Magazine Publications Ltd., 1903—.
- Dumbarton Oaks Papers. Annually. Locust Valley, NY: J.J. Augustin Inc., 1940–.
- Flash Art International. Bimonthly. Trevi, Italy: Giancarlo Politi Editore, 1980-.
- Gesta. Semiannually. New York: International Center of Medieval Art, 1963–.
- History of Photography. Quarterly. Abingdon, UK: Taylor & Francis Ltd., 1976–.
- International Review of African American Art. Quarterly. Hampton, VA: International Review of African American Art, 1976—.
- Journal of Design History. Quarterly. Oxford: Oxford Univ. Press, 1988–.

- Journal of Egyptian Archaeology. Annually. London: Egypt Exploration Society, 1914—.
- Journal of Hellenic Studies. Annually. London: Society for the Promotion of Hellenic Studies, 1880–.
- Journal of Roman Archaeology. Annually. Portsmouth, RI: Journal of Roman Archaeology LLC, 1988–.
- Journal of the Society of Architectural Historians. Quarterly. Chicago: Society of Architectural Historians, 1940-.
- Journal of the Warburg and Courtauld Institutes. Annually. London: Warburg Institute, 1937–.
- Leonardo: Art, Science, and Technology. 6/year. Cambridge, MA: MIT Press, 1968–.
- Marg. Quarterly. Mumbai, India: Scientific Publishers, 1946–.
- Master Drawings. Quarterly. New York: Master Drawings Association, 1963—
- October. Cambridge, MA: MIT Press, 1976-.
- Oxford Art Journal. 3/year. Oxford: Oxford Univ. Press, 1978-.
- Parkett. 3/year. Zürich, Switzerland: Parkett Verlag AG, 1984-.
- Print Quarterly. Quarterly. London: Print Quarterly Publications, 1984–.
- Simiolus: Netherlands Quarterly for the History of Art. Quarterly. Apeldoorn, Netherlands: Stichting voor Nederlandse Kunsthistorische Publicaties, 1966–.
- Woman's Art Journal. Semiannually. Philadelphia: Old City Publishing Inc., 1980–.

Internet Directories for Art History Information: A Selected List

ARCHITECTURE AND BUILDING,

http://www.library.unlv.edu/arch/rsrcc/webresources/
A directory of architecture websites collected by Jeanne
Brown at the Univ. of Nevada at Las Vegas. Topical lists include architecture, building and construction, design, history,
housing, planning, preservation, and landscape architecture.
Most entries include a brief annotation and the last date the
link was accessed by the compiler.

ART HISTORY RESOURCES ON THE WEB, http://witcombe.sbc.edu/ARTHLinks.html

Authored by Professor Christopher L.C.E. Witcombe of Sweet Briar College in Virginia, since 1995, the site includes an impressive number of links for various art-historical eras as well as links to research resources, museums, and galleries. The content is frequently updated.

ART IN FLUX: A DIRECTORY OF RESOURCES FOR RESEARCH IN CONTEMPORARY ART,

http://www.boisestate.edu/art/artinflux/intro.html Cheryl K. Shurtleff of Boise State Univ. in Idaho has authored this directory, which includes sites selected according to their relevance to the study of national or international contemporary art and artists. The subsections include artists,

ARTCYCLOPEDIA: THE GUIDE TO GREAT ART ON THE INTERNET,

http://www.artcyclopedia.com

museums, theory, reference, and links.

With more than 2,100 art sites and 75,000 links, this is one of the most comprehensive Web directories for artists and art topics. The primary search is by artist's name but access is also available by title of artwork, artistic movement, museums and galleries, nationality, period, and medium.

MOTHER OF ALL ART AND ART HISTORY LINKS PAGES.

http://umich.edu/~motherha

Maintained by the Dept. of the History of Art at the Univ. of Michigan, this directory covers art history departments, art museums, fine arts schools and departments, as well as links to research resources. Each entry includes annotations.

VOICE OF THE SHUTTLE.

http://vos.ucsb.edu

Sponsored by Univ. of California, Santa Barbara, this directory includes more than 70 pages of links to humanities and humanities-related resources on the Internet. The structured guide includes specific subsections on architecture, on art (modern and contemporary), and on art history. Links usually include a one-sentence explanation and the resource is frequently updated with new information.

ARTBABBLE,

http://www.artbabble.org/

An online community created by staff at the Indianapolis Museum of Art to showcase art-based video content, including interviews with artists and curators, original documentaries, and art installation videos. Partners and contributors to the project include Art21, Los Angeles County Museum of Art, The Museum of Modern Art, The New York Public Library, San Francisco Museum of Modern Art, and Smithsonian American Art Museum.

YAHOO! ARTS>ART HISTORY,

http://dir.vahoo.com/Arts/Art History/

Another extensive directory of art links organized into subdivisions with one of the most extensive being "Periods and Movements." Links include the name of the site as well as a few words of explanation.

Ancient Art in the Western Tradition, General

- Amiet, Pierre. Art in the Ancient World: A Handbook of Styles and Forms. New York: Rizzoli, 1981.
- Beard, Mary, and John Henderson. Classical Art: From Greece to Rome. Oxford History of Art. Oxford: Oxford Univ. Press, 2001.
- Boardman, John. Oxford History of Classical Art. New York: Oxford Univ. Press, 2001.
- Chitham, Robert. The Classical Orders of Architecture. 2nd ed. Boston: Elsevier/Architectural Press, 2005.

 Ehrich, Robert W. ed. Chronologies in Old World Archaeology.
- Ehrich, Robert W., ed. Chronologies in Old World Archaeology.
 3rd ed. 2 vols. Chicago: Univ. of Chicago Press, 1992.
- Gerster, Georg. The Past from Above: Aerial Photographs of Archaeological Sites. Ed. Charlotte Trümpler. Trans. Stewart Spencer. Los Angeles: J. Paul Getty Museum, 2005.
- Groenewegen-Frankfort, H.A., and Bernard Ashmole. Art of the Ancient World: Painting, Pottery, Sculpture, Architecture from Egypt, Mesopotamia, Crete, Greece, and Rome. Library of Art History. Upper Saddle River, NJ: Prentice Hall, 1972.
- Haywood, John. The Penguin Historical Atlas of Ancient Civilizations. New York: Penguin, 2005.
- Milleker, Elizabeth J., ed. The Year One: Art of the Ancient World East and West. New York: Metropolitan Museum of Art, 2000.
- Nagle, D. Brendan. The Ancient World: A Social and Cultural History. 7th ed. Upper Saddle River, NJ: Pearson/ Prentice Hall, 2010.
- Saggs, H.W.F. Civilization before Greece and Rome. New Haven: Yale Univ. Press, 1989.
- Smith, William Stevenson. Interconnections in the Ancient Near East: A Study of the Relationships between the Arts of Egypt, the Aegean, and Western Asia. New Haven: Yale Univ. Press, 1965.
- Tadgell, Christopher. Imperial Form: From Achaemenid Iran to Augustan Rome. New York: Whitney Library of Design, 1998.
- Origins: Egypt, West Asia, and the Aegean. New York: Whitney Library of Design, 1998.
- Trigger, Bruce G. Understanding Early Civilizations: A Comparative Study. New York: Cambridge Univ. Press, 2003
- Woodford, Susan. The Art of Greece and Rome. 2nd ed. New York: Cambridge Univ. Press, 2004. Electa/Rizzoli. 1986.
- Upton, Dell. Architecture in the United States. Oxford History of Art. Oxford: Oxford Univ. Press, 1998.
- Wood, Paul, ed. Varieties of Modernism. Art of the 20th Century. New Haven: Yale Univ. Press, 2004.
- Woodham, Jonathan M. Twentieth-Century Design. Oxford History of Art. Oxford: Oxford Univ. Press, 1997.

Introduction

- Acton, Mary. Learning to Look at Paintings. 2nd ed. New York: Routledge, 2009.
- Arnold, Dana. Art History: A Very Short Introduction. Oxford and New York: Oxford Univ. Press, 2004.
- Baxandall, Michael. Patterns of Intention: On the Historical Explanation of Pictures. New Haven: Yale Univ. Press, 1985.

- Clearwater, Bonnie. *The Rothko Book*. London: Tate Publishing, 2006.
- Decoteau, Pamela Hibbs. Clara Peeters, 1594–ca. 1640 and the Development of Still-Life Painting in Northern Europe. Lingen: Luca Verlag, 1992.
- Geertz, Clifford. "Art as a Cultural System." Modern Language Notes 91 (1976): 1473–1499.
- Hochstrasser, Julie Berger. Still Life and Trade in the Dutch Golden Age. New Haven: Yale Univ. Press, 2007.
- Holstein, Jonathan. The Pieced Quilt: An American Design Tradition. New York: Galahad Books, 1973.
- Jolly, Penny Howell. "Rogier van der Weyden's Escorial and Philadelphia Crucifixions and Their Relation to Fra Angelico at San Marco." Oud Holland 95 (1981): 113–126.
- Mainardi, Patricia. "Quilts: The Great American Art." The Feminist Art Journal 2/1 (1973): 1, 18–23.
- Miller, Angela L., et al. American Encounters: Art, History, and Cultural Identity. Upper Saddle River, NJ: Pearson/ Prentice Hall. 2008.
- Minor, Vernon Hyde. Art History's History. Upper Saddle River, NJ: Pearson/Prentice Hall, 2001.
- Nelson, Robert S., and Richard Shiff, eds. Critical Terms for Art History. 2nd ed. Chicago: Univ. of Chicago Press, 2003.
- Panofsky, Erwin. Studies in Iconology: Humanistic Themes in the Art of the Renaissance. New York: Oxford Univ. Press, 1939.
- ______. Meaning in the Visual Arts. Phoenix ed. Chicago: Univ. of Chicago Press, 1982.
- Preziosi, Donald, ed. The Art of Art History: A Critical Anthology. 2nd ed. Oxford and New York: Oxford Univ. Press, 2009.
- Rothko, Mark. Writings on Art. Ed. Miguel López-Remiro. New Haven: Yale Univ. Press, 2006.
- . The Artist's Reality: Philosophies of Art. Ed.
 Christopher Rothko, New Haven: Yale Univ. Press, 2004.
- Schapiro, Meyer. "The Apples of Cézanne: An Essay on the Meaning of Still Life." *An News Annual* 34 (1968): 34–53. Reprinted in *Modern Art 19th & 20th Centuries: Selected Papers* 2, London: Chatto & Windus, 1978.
- Sowers, Robert. Rethinking the Forms of Visual Expression. Berkeley: Univ. of California Press, 1990.
- Taylor, Joshua. Learning to Look: A Handbook for the Visual Arts. 2nd ed. Chicago: Chicago Univ. Press, 1981.
- Tucker, Mark. "Rogier van der Weyden's 'Philadelphia Crucifixion." Burlington Magazine 139 (1997): 676–683.
- Wang, Fangyu, et al., eds. Master of the Lotus Garden: The Life and Art of Bada Shanren (1626–1705). New Haven: Yale Univ. Press, 1990.

Chapter 1 Prehistoric Art

- Aujoulat, Norbert. Lascaux: Movement, Space, and Time. New York: Abrams, 2005.
- Bahn, Paul G. The Cambridge Illustrated History of Prehistoric Art. Cambridge Illustrated History. Cambridge: Cambridge Univ. Press, 1998.
- Bataille, Georges. The Cradle of Humanity: Prehistoric Art and Culture. Ed. Stuart Kendall. Trans. Michelle Kendall and Stuart Kendall. New York: Zone Books, 2005.
- Berghaus, Gunter. New Perspectives on Prehistoric Art. Westport, CT: Praeger, 2004.
- Chippindale, Christopher. Stonehenge Complete. 3rd ed. New York: Thames & Hudson, 2004.
- Clottes, Jean. Chauvet Cave: The Art of Earliest Times. Salt Lake City: Univ. of Utah Press, 2003.
- World Rock Art. Trans. Guy Bennett. Los Angeles: Getty Conservation Institute, 2002.
- ——, and J. David Lewis-Williams. The Shamans of Prehistory: Trance and Magic in the Painted Caves. Trans. Sophie Hawkes. New York: Abrams, 1998.
- Connah, Graham. African Civilizations: An Archaeological Perspective. 2nd ed. Cambridge: Cambridge Univ. Press, 2001.
- Coulson, David, and Alec Campbell. African Rock Art: Painting and Engravings on Stone. New York: Abrams, 2001.
- Cunliffe, Barry W., ed. The Oxford Illustrated History of Prehistoric Europe. New York: Oxford Univ. Press, 2001. Forte, Maurizio, and Alberto Siliotti. Virtual Archaeology: Re-
- Creating Ancient Worlds. New York: Abrams, 1997.
 Freeman, Leslie G. Altamira Revisited and Other Essays on
 Early Art. Chicago: Institute for Prehistoric Investigation,
- 1987.
 Garlake, Peter S. The Hunter's Vision: The Prehistoric Art of Zimbabwe. Seattle: Univ. of Washington Press, 1995.
- Gowlett, John A.J. Ascent to Civilization: The Archaeology of Early Humans. 2nd ed. New York: McGraw-Hill, 1993.

- Guthrie, R. Dale. *The Nature of Paleolithic Art.* Chicago: Univ. of Chicago Press, 2005.
- Jope, E.M. Early Celtic Art in the British Isles. 2 vols. New York: Oxford Univ. Press, 2000.
- Kenrick, Douglas M. Jomon of Japan: The World's Oldest Pottery. New York: Kegan Paul, 1995.
- Leakey, Richard E., and Roger Lewin. Origins Reconsidered: In Search of What Makes Us Human. New York: Doubleday, 1992.
- Le Quellec, Jean-Loïc. Rock Art in Africa: Mythology and Legend. Trans. Paul Bahn. Paris: Flammarion, 2004.
- Leroi-Gourhan, André. The Dawn of European Art: An Introduction to Paleolithic Cave Painting. Trans. Sara Champion. Cambridge: Cambridge Univ. Press, 1982.
- Lewis-Williams, J. David. The Mind in the Cave: Consciousness and the Origins of Art. New York: Thames & Hudson, 2002.
- O'Kelly, Michael J. Newgrange: Archaeology, Art, and Legend. New Aspects of Antiquity. London: Thames & Hudson, 1982.
- Price, T. Douglas. *Images of the Past*. 5th ed. Boston: McGraw-Hill. 2008.
- Renfrew, Colin, ed. The Megalithic Monuments of Western Europe. London: Thames & Hudson, 1983.
- Sandars, N.K. *Prehistoric Art in Europe*. 2nd ed. Pelican History of Art. New Haven: Yale Univ. Press, 1992.
- Sura Ramos, Pedro A. *The Cave of Altamira*. Gen. Ed. Antonio Beltran. New York: Abrams, 1999.
- Sieveking, Ann. *The Cave Artists*. Ancient People and Places, vol. 93. London: Thames & Hudson, 1979.
- White, Randall. Prehistoric Art: The Symbolic Journey of Mankind. New York: Abrams, 2003.

Chapter 2 Art of the Ancient Near East

- Akurgal, Ekrem. Ancient Civilizations and Ruins of Turkey: From Prehistoric Times until the End of the Roman Empire. 5th ed. London: Kegan Paul, 2002.
- Aruz, Joan, et al., eds. Beyond Babylon: Art, Trade, and Diplomacy in the Second Millennium B.C. New Haven: Yale Univ. Press, and Metropolitan Museum of Art, 2008.
- ——, ed. Art of the First Cities: The Third Millennium

 B.C. from the Mediterranean to the Indus. New York:

 Metropolitan Museum of Art, 2003.
- Bahrani, Zainab. The Graven Image: Representation in Babylonia and Assyria. Archaeology, Culture, and Society Series. Philadelphia: Univ. of Pennsylvania Press, 2003.
- Boardman, John. Persia and the West: An Archaeological Investigation of the Genesis of Achaemenid Art. New York: Thames & Hudson, 2000.
- Bottero, Jean. Everyday Life in Ancient Mesopotamia. Trans. Antonia Nevill. Baltimore, MD: Johns Hopkins Univ. Press, 2001.
- Charvat, Petr. Mesopotamia before History. Rev. & updated ed. New York: Routledge, 2002.
- Crawford, Harriet. Sumer and the Sumerians. 2nd ed. New York: Cambridge Univ. Press, 2004.
- Curtis, John, and Nigel Tallis, eds. Forgotten Empire: The World of Ancient Persia. Berkeley: Univ. of California Press. 2005.
- Ferrier, R.W., ed. *The Arts of Persia*. New Haven: Yale Univ. Press, 1989.
- Frankfort, Henri. *The Art and Architecture of the Ancient Orient*. 5th ed. Pelican History of Art. New Haven: Yale Univ. Press, 1996.
- Haywood, John. Ancient Civilizations of the Near East and Mediterranean. London: Cassell, 1997.
- Meyers, Eric M., ed. The Oxford Encyclopedia of Archaeology in the Near East. 5 vols. New York: Oxford Univ. Press, 1907
- Moorey, P.R.S. Idols of the People: Miniature Images of Clay in the Ancient Near East. The Schweich Lectures of the British Academy, 2001. New York: Oxford Univ. Press, 2003.
- Polk, Milbry, and Angela M.H. Schuster. The Looting of the Iraq Museum, Baghdad: The Lost Legacy of Ancient Mesopotamia. New York: Abrams, 2005.
- Reade, Julian: Assyrian Sculpture. Cambridge, MA: Harvard Univ. Press, 1999.
- Roaf, Michael. Cultural Atlas of Mesopotamia and the Ancient Near East. New York: Facts on File, 1990.
- Roux, Georges. Ancient Iraq. 3rd ed. London: Penguin, 1992. Winter, Irene. "Sex, Rhetoric, and the Public Monument: The Alluring Body of the Male Ruler." In Sexuality in Ancient Art, eds Natalie Kampen and Bettina A. Bergmann. Cambridge: Cambridge Univ. Press, 1996: 11–26.
- Zettler, Richard L., and Lee Horne, ed. Treasures from the Royal Tombs of Ur. Philadelphia: Univ. of Pennsylvania, Museum of Archaeology and Anthropology, 1998.

Chapter 3 Art of Ancient Egypt

- Arnold, Dieter. Temples of the Last Pharaohs. New York: Oxford Univ. Press, 1999.
- Baines, John, and Jaromír Málek. Cultural Atlas of Ancient Egypt. Rev. ed. New York: Facts on File, 2000.
- Brier, Bob. Egyptian Mummies: Unraveling the Secrets of an Ancient Art. New York: Morrow, 1994.
- Egyptian Art in the Age of the Pyramids. New York: Metropolitan Museum of Art, 1999.
- The Egyptian Book of the Dead: The Book of Going Forth by Day: Being the Papyrus of Ani (Royal Scribe of the Divine Offerings). 2nd rev. ed. Trans. Raymond O. Faulkner. San Francisco: Chronicle, 2008.
- Freed, Rita E., Sue D'Auria, and Yvonne J. Markowitz.

 Pharaohs of the Sun: Akhenaten, Neferitit, Tutankhamen.

 Boston: Museum of Fine Arts in assoc. with Bulfinch
 Press/Little, Brown, 1999.
- Hawass, Zahi A. Tutankhamun and the Golden Age of the Pharaohs. Washington, DC: National Geographic, 2005.
 Johnson, Paul. The Civilization of Ancient Egypt. Updated ed. New York: HarperCollins, 1999.
- Kozloff, Arielle P. Egypt's Dazzling Sun: Amenhotep III and His World. Cleveland: Cleveland Museum of Art, 1992. Lehner. Mark. The Counter Pyramids. New York: Thames
- Lehner, Mark. *The Complete Pyramids*. New York: Thames & Hudson, 2008.
- Love Songs of the New Kingdom. Trans. John L. Foster. New York: Scribner, 1974; Austin: Univ. of Texas Press, 1992. Málek, Jaromir. Egypt: 4,000 Years of Art. London: Phaidon Press, 2003.
- Pemberton, Delia. *Ancient Egypt*. Architectural Guides for Travelers. San Francisco: Chronicle, 1992.
- Robins, Gay. The Art of Ancient Egypt. Rev. ed. Cambridge, MA: Harvard Univ. Press, 2008.
- Roehrig, Catharine H., Renee Dreyfus, and Cathleen A. Keller. Hatshepsut, from Queen to Pharaoh. New York: Metropolitan Museum of Art, 2005.
- Russmann, Edna R. Egyptian Sculpture: Cairo and Luxor. Austin: Univ. of Texas Press, 1989.
- Smith, Craig B. How the Great Pyramid Was Built. Washington, DC: Smithsonian Books, 2004.
- Smith, William Stevenson. The Art and Architecture of Ancient Egypt. 3rd ed. Revised William Kelly Simpson. Pelican History of Art. New Haven: Yale Univ. Press, 1998.
- Strouhal, Eugen. Life of the Ancient Egyptians. Trans. Deryck Viney. Norman: Univ. of Oklahoma Press, 1992.
- Strudwick, Nigel, and Helen Strudwick. Thebes in Egypt: A Guide to the Tombs and Temples of Ancient Luxor. Ithaca, NY: Cornell Univ. Press, 1999.
- Thomas, Thelma K. Late Antique Egyptian Funerary Sculpture: Images for this World and for the Next. Princeton, NJ: Princeton Univ. Press, 2000.
- Tiradritti, Francesco. Ancient Egypt: Art, Architecture and History. Trans. Phil Goddard. London: British Museum Press, 2002.
- The Treasures of Ancient Egypt: From the Egyptian Museum in Cairo. New York: Rizzoli, 2003.
- Wilkinson, Richard H. The Complete Temples of Ancient Egypt. New York: Thames & Hudson, 2000.
- —. Reading Egyptian Art: A Hieroglyphic Guide to Ancient Egyptian Painting and Sculpture. London: Thames & Hudson, 1992.
- Winstone, H.V.F. Howard Carter and the Discovery of the Tomb of Tutankhamen. Rev. ed. Manchester: Barzan, 2006.
- Ziegler, Cristiane, ed. The Pharaohs. New York: Rizzoli, 2002.Zivie-Coche, Christiane. Sphinx: History of a Monument. Trans.David Lorton. Ithaca, NY: Cornell Univ. Press, 2002.

Chapter 4 Art of the Ancient Aegean

- Castleden, Rodney. The Knossos Labyrinth: A New View of the "Palace of Minos" at Knossos. London: Routledge, 1990.
 ——. Mycenaeans. New York: Routledge, 2005.
- Demargne, Pierre. The Birth of Greek Art. Trans. Stuart Gilbert and James Emmons. Arts of Mankind, vol. 6. New York: Golden. 1964.
- Doumas, Christos. *The Wall-Paintings of Thera*. 2nd ed. Trans. Alex Doumas. Athens: Kapon Editions, 1999 Fitton, J. Lesley. *Cycladic Art*. 2nd ed. London: British
- Museum Press, 1999.
 Getz-Gentle, Pat. Personal Styles in Early Cycladic Sculpture.
 Madison: Univ. of Wisconsin Press, 2001.
- Hamilakis, Yannis. ed. Labyrinth Revisited: Rethinking "Minoan" Archaeology. Oxford: Oxbow, 2002.
- Hendrix, Elizabeth. "Painted Ladies of the Early Bronze Age," *The Metropolitan Museum of Art Bulletin* New Series, 55/3 (Winter 1997–1998): 4–15.
- Higgins, Reynold A. Minoan and Mycenean Art. New. ed. World of Art. New York: Thames & Hudson, 1997.

- Hitchcock, Louise. Minoan Architecture: A Contextual Analysis. Studies in Mediterranean Archaeology and Literature, Pocket-Book, 155. Jonsered: P. Åströms Förlag, 2000.
- Hoffman, Gail L. "Painted Ladies: Early Cycladic II Mourning Figures?" American Journal of Archaeology 106/4 (October 2002): 525–550.
- Immerwahr, Sara Anderson. Aegean Painting in the Bronze Age. University Park: Pennsylvania State Univ. Press, 1990.
- Preziosi, Donald, and Louise Hitchcock. Aegean Art and Architecture. Oxford History of Art. Oxford: Oxford Univ. Press, 1999.
- Shelmerdine, Cynthia W., ed. The Cambridge Companion to the Aegean Bronze Age. New York: Cambridge Univ. Press, 2008.
- Strasser, Thomas F. "Location and Perspective in the Theran Flotilla Fresco," *Journal of Mediterranean Archaeology* 23/1 (2010): 3–26.

Chapter 5 Art of Ancient Greece

- Barletta, Barbara A. *The Origins of the Greek Architectural Orders*. New York: Cambridge Univ. Press, 2001.
- Beard, Mary. *The Parthenon*. Cambridge, MA: Harvard Univ. Press, 2003.
- Belozerskaya, Marina, and Kenneth D.S. Lapatin. *Ancient Greece: Art, Architecture, and History*. Los Angeles: J. Paul Getty Museum, 2004.
- Boardman, John. Early Greek Vase Painting: 11th–6th Centuries B.C.: A Handbook. World of Art. London: Thames & Hudson, 1998.
- Greek Sculpture: The Archaic Period: A Handbook. World of Art. London: Thames & Hudson, 1991.
- Greek Sculpture: The Classical Period: A Handbook. London: Thames & Hudson, 1985.
- Greek Sculpture: The Late Classical Period and Sculpture in Colonies and Overseas. World of Art. New York: Thames & Hudson, 1995.
- The History of Greek Vases: Potters, Painters, and Pictures. New York: Thames & Hudson, 2001.
- Burn, Lucilla. Hellenistic Art: From Alexander the Great to Augustus. Los Angeles: J. Paul Getty Museum, 2004.
- Clark, Andrew J., Maya Elston, and Mary Louise Hart. Understanding Greek Vases: A Guide to Terms, Styles, and Techniques. Los Angeles: J. Paul Getty Museum, 2002.
- De Grummond, Nancy T. and Brunilde S. Ridgway. From Pergamon to Sperlonga: Sculpture in Context. Berkeley: Univ. of California Press, 2000.
- Donohue, A.A. *Greek Sculpture and the Problem of Description*. New York: Cambridge Univ. Press, 2005.
- Fullerton, Mark D. Greek Art. Cambridge: Cambridge Univ. Press, 2000.
- Hard, Robin. The Routledge Handbook of Greek Mythology: Based on H.J. Rose's "Handbook of Greek Mythology." 7th ed. London: Routledge, 2008.
- Hurwit, Jeffrey M. The Acropolis in the Age of Pericles. New York: Cambridge Univ. Press, 2004.
- Karakasi, Katerina. Archaic Korai. Los Angeles: J. Paul Getty Museum, 2003.
- Lawrence, A.W. Greek Architecture. 5th ed. Revised R.A. Tomlinson. Pelican History of Art. New Haven: Yale Univ. Press, 1996.
- Martin, Roland. Greek Architecture: Architecture of Crete, Greece, and the Greek World. History of World Architecture. New York: Electa/Rizzoli, 1988.
- Neils, Jenifer. The British Museum Concise Introduction to Ancient Greece. Ann Arbor: Univ. of Michigan. 2008
- Osborne, Robin. Archaic and Classical Greek Art. Oxford History of Art. Oxford: Oxford Univ. Press, 1998. Palagia, Olga, ed. Greek Sculpture: Function, Materials, and
- Palagia, Olga, ed. Greek Sculpture: Function, Materials, and Techniques in the Archaic and Classical Periods. New York: Cambridge Univ. Press, 2006.
- ——, and J.J. Pollitt, eds. Personal Styles in Greek Sculpture. Yale Classical Studies, vol. 30. Cambridge: Cambridge Univ. Press, 1996.
- Pedley, John Griffiths. Greek Art and Archaeology. 5th ed. Upper Saddle River, NJ: Pearson/Prentice Hall, 2012.
- Pollitt, J.J. Art and Experience in Classical Greece. Cambridge: Cambridge Univ. Press, 1972; reprinted 1999.
- The Art of Ancient Greece: Sources and Documents.
 2nd ed. rev. Cambridge: Cambridge Univ. Press, 2001.
 Ridgway, Brunilde Sismondo. The Archaic Style in Greek
- Sculpture. 2nd ed. Chicago: Ares, 1993.
- NJ: Princeton Univ. Press, 1981.
- Fourth Century Styles in Greek Sculpture. Wisconsin Studies in Classics. Madison: Univ. of Wisconsin Press, 1997.

- ——. Hellenistic Sculpture 1: The Styles of ca. 331–200 B.C. Wisconsin Studies in Classics. Madison: Univ. of Wisconsin Press, 1990.
- Stafford, Emma J. Life, Myth, and Art in Ancient Greece. Los Angeles: J. Paul Getty Museum, 2004.
- Stewart, Andrew F. Greek Sculpture: An Exploration, 2 vols. New Haven: Yale Univ. Press, 1990.
- Whitley, James. *The Archaeology of Ancient Greece*. New York: Cambridge Univ. Press, 2001.

Chapter 6 Etruscan and Roman Art

- Bianchi Bandinelli, Ranuccio. Rome: The Centre of Power: Roman Art to A.D. 200. Trans. Peter Green. Arts of Mankind, 15. London: Thames & Hudson, 1971.
- ——. Rome: The Late Empire: Roman Art A.D. 200–400. Trans. Peter Green. Arts of Mankind, 17. New York: Braziller, 1971.
- Borrelli, Federica. The Etruscans: Art, Architecture, and History. Ed. Stefano Peccatori and Stefano Zuffi. Trans. Thomas Michael Hartmann. Los Angeles: J. Paul Getty Museum. 2004.
- Brendel, Otto J. Prolegomena to the Study of Roman Art. New Haven: Yale Univ. Press, 1979.
- . Etruscan Art. 2nd ed. Pelican History of Art. New Haven: Yale Univ. Press, 1995.
- Conlin, Diane Atnally. The Artists of the Ara Pacis: The Process of Hellenization in Roman Relief Sculpture. Studies in the History of Greece & Rome. Chapel Hill: Univ. of North Carolina Press. 1997.
- Cornell, Tim, and John Matthews. Atlas of the Roman World. New York: Facts on File, 1982.
- D'Ambra, Eve. Roman Art. Cambridge: Cambridge Univ. Press, 1998.
- Elsner, Jas. Imperial Rome and Christian Triumph: The Art of the Roman Empire A.D. 100–450. Oxford History of Art. Oxford: Oxford Univ. Press, 1998.
- Gabucci, Ada. Ancient Rome: Art, Architecture, and History. Eds. Stefano Peccatori and Stephano Zuffi. Trans. T.M. Hartman. Los Angeles: J. Paul Getty Museum, 2002.
- Haynes, Sybille. Etruscan Civilization: A Cultural History. Los Angeles: J. Paul Getty Museum, 2000.
- Holloway, R. Ross. Constantine & Rome. New Haven: Yale Univ. Press, 2004.
- Kleiner, Fred. S. A History of Roman Art. Belmont, CA: Thomson/Wadsworth, 2007.
- MacDonald, William L. The Architecture of the Roman Empire: An Introductory Study. Rev. ed. 2 vols. Yale Publications in the History of Art, 17, 35. New Haven: Yale Univ. Press. 1982.
- —. The Pantheon: Design, Meaning, and Progeny. New foreword by John Pinto. Cambridge, MA: Harvard Univ. Press, 2002.
- Mattusch, Carol C. Pompeii and the Roman Villa: Art and Culture around the Bay of Naples. Washington, DC: National Gallery of Art, 2008.
- Mazzoleni, Donatella. *Domus: Wall Painting in the Roman House*. Los Angeles: J. Paul Getty Museum, 2004.
- Packer, James E. The Forum of Trajan in Rome: A Study of the Monuments in Brief. Berkeley: Univ. of California Press, 2001.
- Pollitt, J.J. The Art of Rome, c. 753 B.C.—337 A.D.: Sources and Documents. Upper Saddle River, NJ: Pearson/Prentice Hall, 1966.
- Polybius. *The Histories*. Trans. W.R. Paton. 6 vols. Loeb Classical Library. Cambridge, MA: Harvard Univ. Press, 2000
- Ramage, Nancy H., and Andrew Ramage. Roman Art: Romulus to Constantine. 5th ed. Upper Saddle River, NJ: Pearson/Prentice Hall, 2009.
- Spivey, Nigel. Etruscan Art. World of Art. New York: Thames & Hudson, 1997.
- Stamper, John W. The Architecture of Roman Temples: The Republic to the Middle Empire. New York: Cambridge Univ. Press, 2005.
- Stewart, Peter. Statues in Roman Society: Representation and Response. Oxford Studies in Ancient Culture and Representation. New York: Oxford Univ. Press, 2003
- Strong, Donald. *Roman Art*. 2nd ed. rev. & annotated. Ed. Roger Ling. Pelican History of Art. New Haven: Yale Univ. Press, 1995.
- Ward-Perkins, J.B. Roman Architecture. History of World Architecture. New York: Electa/Rizzoli, 1988.
 ————. Roman Imperial Architecture. Pelican History of Art.
- New Haven: Yale Univ. Press, 1981. Wilson Jones, Mark. *Principles of Roman Architecture*. New
- Wilson Jones, Mark. Principles of Roman Architecture. Ne Haven: Yale Univ. Press, 2000.

Credits

Introduction

Intro-1 © 2010 Digital Image, The Museum of Modern Art, New York/Scala Florence © 2005 Kate Rothko Prizel & Christopher Rothko/Artists Rights Society (ARS), New York; Intro-2 object no 1997.007.0697; Intro-3 © Achim Bednorz, Cologne; page xxx A British Library Board/Robana; page xxx A detail British Library Board/Robana; page xxx C © Studio Fotografico Quattrone Florence; page xxx D Robana Picture Library/The British Library Board; page xxx D detail British Library Board/Robana; Intro-4 essione del Ministero per il Beni e le Attività Culturali, photo INDEX/Tosi: Intro-5 © 2007 Image copyright The Metropolitan Museum of Art/Art Resource, NY/Scala, Florence; Intro-5 A Closer Look a Ashmolean Museum, Oxford, England, U.K; Intro-5 A Closer look b Princeton University Art Museum. Museum Purchase in memory of Ellen B. Elliott. Fowler McCormick, Class of 1922. Fund 2008-345. Photo: © UAM/Bruce M. White, 2008; Intro-6 © 2004. Photo The Philadelphia Museum of Art/Scala, Florence; Intro-7 Kunsthistorisches Museum, Vienna; Intro-8 © Studio Fotografico Quattrone, Florence; Intro-9 © 2009 Photo Scala, Florence courtesy of the Ministero Beni e. Att. Culturali; Intro-10 © 2004. Photo The Philadelphia Museum of Art/Scala, Florence.

Chapter 1

1.1 Scala, Florence/BPK, Bildagentur fuer Kunst, Kultur und Geschichte, Berlin; 1.2 © Tom Till; 1.3 © 2009 Photo Werner Forman Archive/Scala, Florence; 1.4 Image courtesy of Christopher Henshilwood; 1.5 Jack Unruh/National Geographic Stock; 1.6 K.H. Augustin, Esslingen/Ulmer Museum; 1.7 akg-images/Erich Lessing; 1.8 The Art Archive/Moravian Museum Brno/Alfredo Dagli Orti; 1.9 Sisse Brimberg/National Geographic Image Collection; 1.10 French Ministry of Culture and Communication, Regional Direction for Cultural Affairs—Rhône-Alpes region—Regional department of archaeology Slide no 10; 1.11 akg-images; 1.12 Yvonne Vertut; 1.13 Sisse Brimberg/National Geographic Stock; 1.14 Yvonne Vertut; 1.15 John Swogger; 1.16 akg-images/Erich Lessing; 1.17 The Art Archive/ Museum of Anatolian Civilizations Ankara/Gianni Dagli Orti; page 15 Reconstruction by John Gordon Swogger, originally published as figure 5.8 in Ian Hodder's The Leopard's Tale, Thames & Hudson; 1.18 Souvatzi, S. 2009. A Social Archaeology of Households in Neolithic Greece. An Anthropological Approach, fig. 4.8b. Cambridge University Press. After Theocharis 1973 (Theocharis, D.R. Neolithic Greece. National Bank of Greece, 1973); 1.19 © National Monuments Service. Dept of Arts, Heritage, and the Gaeltacht, Ireland; 1.20 Aerofilms/English Heritage Photo Library; 1.21 Peter Adams/The Image Bank/Getty; 1.22 Courtesy Antiquity magazine; 1.23 English Heritage Photo Library; 1.24 © Sakamoto Photo Research Laboratory/Corbis; 1.25 Catherine Perlès; 1.26a & 1.26b akg-images/ Erich Lessing; 1.27 The Department of Antiquities of Jordan(DoA);

Chapter 2

2.1 Photo Josse, Paris; 2.2 World Tourism Organization: Iraq; 2.3 & 2.4a © 2008. Photo Scala, Florence/BPK, Bildagentur fuer Kunst, Kultur und Geschichte, Berlin; 2.4b Photo Scala, Florence; 2.5 Courtesy of the Oriental Institute of the University of Chicago; 2.9 BaghdadMuseum.org; 2.6 Courtesy of the Penn Museum, imag #191209; 2.7 Courtesy of the Penn Museum, image # 160104; 2.8 Courtesy of the Penn Museum, image #150888; 2.10a Courtesy of the Penn Museum, image #10872; 2.10b Courtesy of the Penn Museum, image #10872; 2.11 Courtesy of the Penn Museum image #150424; 2.12 © 1990 Photo Scala, Florence; 2.13 Michael S. Yamashita/CORBIS: 2.14 D. Arnaudet/Louvre, Paris, France/ Réunion des Musées Nationaux; 2.15 RMN/Hervé Lewandowski; 2.16 Art Archive/Dagli Orti; 2.17 © The Trustees of the British Museum. All rights reserved; 2.18 Courtesy of the Oriental Institute of the University of Chicago; page 42 © The Trustees of the British Museum. All rights reserved; 2.19 World Tourism Organization: Iraq; 2.20 © The Trustees of the British Museum. All rights reserved; 2.21 Courtesy of the Oriental Institute of the University of Chicago; 2.22 © 2012 Photo Scala, Florence/BPK, Bildagentur fuer Kunst, Kultur und Geschichte, Berlin; 2.23 Kurt and Rosalia Scholz/SuperStock; 2.24 Gérard Degeorge/CORBIS; 2.29b Courtesy of the Penn Museum, image #10872

1.28 & 1.29 akg-images/Erich Lessing; 1.30 Giraudon/The Bridgeman Art Library.

Chapter 3

3.1 Photo: Jürgen Liepe; page 52, both akg-images/Erich Lessing; 3.3 Iberfoto/Alinari Archives; 3.4 National Geographic/SuperStock; 3.5 Maltings © Dorling Kindersley; 3.6 © Roger Wood/Corbis; 3.7 Werner Forman Archive; 3.8 Araldo de Luca/The Egyptian Museum, Cairo; 3.9 Photograph © 2013 Museum of Fine Arts, Boston; 3.10 RMN-Grand Palais (Musée du Louvre)/Franck Raux; 3.11 Courtesy of the Oriental Institute of the University of Chicago; 3.12 & 3.14 Yvonne Vertut; 3.15 © 2009 White Image/Scala, Florence; 3.16 © The Trustees of the British Museum. All rights reserved; 3.17 Photo: Jürgen Liepe: page 64 © The Trustees of the British Museum. All rights reserved; 3.20 Yvonne Vertut; 3.21 The Metropolitan Museu of Art/Scala, Florence/Art Resource NY; 3.22 Kurt and Rosalia Scholz/SuperStock; 3.23 Dorling Kindersley; 3.24 Photo Scala, Florence: 3.25 Araldo de Luca/IKONA: 3.26 & 3.27 Photo Scala Florence/BPK, Bildagentur fuer Kunst, Kultur und Geschichte, Berlin; 3.28 © 2012 Photo Scala, Florence/BPK, Bildagentur fuer Kunst Kultur und Geschichte, Berlin; 3.29 Araldo de Luca Studio; 3.30 The Art Archive/Gianni Dagli Orti; 3.32 Terrence Spencer/Time & Life Pictures/Getty Images; 3.33 © The Trustees of the British Museum All rights reserved; 3.34 The Getty Conservation Institute. © The J. Paul Getty Trust 2010. All rights reserved. Photo by Guillermo Aldana; 3.35 © The Trustees of the British Museum. All rights reserved; 3.36 RMN/Hervé Lewandowski; 3.37 & 3.38a © The Trustees of the British Museum. All rights reserved.

Chapter 4

4.1 Ch. Doumas, The Wall Paintings of Thera, Idryma Theras-Petros M. Nomikos, Athens 1992; 4.2a © 2009 Image copyright The Metropolitan Museum of Art/Art Resource/Scala, Florence; 4.3 © Copenhagen National Museum #4697; 4.4 © Craig & Marie Mauzy, Athens; 4.5 McRae Books Srl; 4.6 Roger Wood/Corbis; 4.7 © Craig & Maric Mauzy, Athens; 4.8 British School at Athens by permission of the Management Committee (courtesy of the Department of Classics, University of Columbia, USA, photo © L.H. Sackett); 4.9a & 4.9b Craig & Marie Mauzy, Athens; 4.10 akg-images/Nimatallah; 4.11 © Craig & Marie Mauzy, Athens; 4.12 Studio Kontos, Photostock; 4.13 © Craig & Marie Mauzy, Athens; 4.14 Studio Kontos Photostock; page 92-93 akg-images/Nimatallah; 4.15 Studio Kontos Photostock; 4.17 Deutsches Archaologisches Institut, Athens; 4.19 University of Cincinnati, Department of Classics (courtesy Professor C.W.Blegen); 4.20 © Craig & Marie Mauzy, Athens; 4.21 The Art Archive/National Archaeological Museum Athens/Gianni Dagli Orti; 4.23 & 4.24 © Craig & Marie Mauzy, Athens; 4.25 © Craig & Marie Mauzy, Athens.

Chapter 5

5.1 Photo: Vatican Museums; 5.2 & 5.3 © 2012 Image copyright The Metropolitan Museum of Art/Art Resource/Scala, Florence; 5.4 The J. Paul Getty Museum, Villa Collection, Malibu, California; 5.5 The Art Archive/Gianni Dagli Orti; 5.6 Dorling Kindersley; 5.8 © Craig & Marie Mauzy, Athens; 5.9b Fotografica Foglia, Naples; 5.10 © Craig & Marie Mauzy, Athens; 5.11 Courtesy of Laurence King Publishing, John Griffiths Pedley, Greek Art and Archaeology 4th edition © 2007; 5.13 Staatliche Antikensammlungen, Munich; 5.14, 5.15, 5.16, & 5.17 Staatliche Antikensammlungen, Munich/Studio Koppermann; 5.18 Image © The Metropolitan Museum of Art/Art Resource/ Scala, Florence; 5.19 Photo Scala, Florence/BPK, Bildagentur fuer Kunst, Kultur und Geschichte, Berlin; 5.20 © Craig & Marie Mauzy, Athens; 5.21 © Craig & Marie Mauzy, Athens/Acropolis Museum Athens, Greece; 5.23 Bibliothèque Nationale de France; 5.24 & 5.25 Photograph © 2013 Museum of Fine Arts, Boston; page 119 © 2012 Photo Scala, Florence—courtesy of the Ministero Beni e Att. Culturali; 5.26a © Craig & Marie Mauzy, Athens; 5.26b Studio Kontos Photostock; 5.27 Photo Scala, Florence/BPK, Bildagentur fuer Kunst, Kultur und Geschichte, Berlin; 5.28 © Craig & Marie Mauzy, Athens/Archaeological Museum, Delphi; 5.29a & 5.29b akg-images Nimatallah; 5.30 © Aaron M. Levin, Baltimore; 5.31 Photo Scala. Florence—courtesy of the Ministero Beni e Att. Culturali; 5.32 Photo Scala, Florence/Fotografica Foglia—courtesy of the Ministero Beni e Att. Culturali; 5.33 © The Trustees of the British Museum. All rights reserved; 5.34 Courtesy Ministero per i Beni e le Attivita Culturali; 5.36a © Craig & Marie Mauzy, Athens; 5.37a, 5.37b, 5.37c, 5.38, & 5.39 © The Trustees of the British Museum. All rights reserved; 5.40 Giraudon/The Bridgeman Art Library; 5.41 With permission of

the Royal Ontario Museum © ROM; 5.42 akg-images/Nimatallah; 5.43 & 5.44 Studio Kontos Photostock; 5.45 Borisb17/Shutterstock; 5.46 C Craig & Marie Mauzy, Athens/Akropolis Museum, Athens 5.48 Photograph © 2013 Museum of Fine Arts, Boston; 5.49 © 2007 Image copyright The Metropolitan Museum of Art/Scala, Florence; 5.50 Photo Scala, Florence; 5.51 Photograph © 2013 Museum of Fine Arts, Boston; 5.52 © Craig & Marie Mauzy, Athens/ Archaeological Museum, Olympia; 5.53 akg-images/Nimatallah; 5.54 Photo: Vatican Museums; 5.55 Image © The Metropolitan Museum of Art/Art Resource/Scala, Florence; 5.56 © 2011 Photo Scala, Florence-courtesy of the Ministero Beni e Att. Culturali: 5.57 & 5.58 Studio Kontos Photostock; 5.59a © Craig & Marie Mauzy, Athens; 5.60 © Araldo de Luca/CORBIS; 5.61 © RMN/Jean-Gilles Berizzi; 5.62 Photo Scala, Florence/BPK, Bildagentur fuer Kunst, Kultur und Geschichte, Berlin: 5.63 © 2011 Photo Scala, Florence/ BPK, Bildagentur fuer Kunst, Kultur und Geschichte, Berlin; 5.64 Photo Scala, Florence; 5.65 RMN/Gérard Blot/Christian Jean; 5.66 Image copyright The Metropolitan Museum of Art/Art Resource/ Scala, Florence; 5.67 RMN/Hervé Lewandowski

Chapter 6

6.1 © Vincenzo Pirozzi, Rome; 6.2 Maurizio Bellu/IKONA; 6.3a Courtesy of Penelope Davies; 6.4 © Vincenzo Pirozzi, Rome; 6.5 The Art Archive/Gianni Dagli Orti; 6.6 © 1990 Photo Scala, Florence. Courtesy of the Ministero Beni e Att. Culturali; 6.7 akg-images/De Agostini Picture Library; 6.8 Photo Scala, Florence—courtesy of the Ministero Beni e Att. Culturali; 6.9 Araldo de Luca/CORBIS; 6.10 Photograph © 2013 Museum of Fine Arts, Boston; 6.11 © 2012 Photo Scala, Florence; 6.12 © Araldo de Luca/CORBIS; 6.13 Canali Photobank; 6.14 Araldo de Luca; 6.15 Canali Photobank, Milan, Italy; 6.16 American Numismatic Society of New York; 6.17 © Jon Arnold Images/DanitaDelimont.com: 6.18a © Vincenzo Pirozzi. Rome: 6.19 Araldo de Luca/CORBIS; 6.20 Andrea Jemolo/IKONA; 6.21 Andrea Jemolo/IKONA; 6.23 Kunsthistorisches Museum, Vienna, Austria; 6.24 George Gerster/Photo Researchers; 6.25 Dorling Kindersley; 6.26 Canali Photobank; 6.27 Alberti/Index Ricerca Iconografica; 6.29 Canali Photobank; 6.30 Photo Scala, Florence/Luciano Romano-courtesy of the Ministero Beni e Att. Culturali; 6.31 Image copyright The Metropolitan Museum of Art/Art Resource/ Scala, Florence: 6.32 © Vincenzo Pirozzi, Rome: 6.33 © 2003, Photo Scala, Florence/Fotografica Foglia. Courtesy of the Minstero Beni e Att. Culturali; 6.34 akg-images/Erich Lessing; 6.35 © 2012 Photo Scala, Florence/Fotografica Foglia—courtesy of the Ministero Beni e Att. Culturali; 6.36 A. Vasari/Index Ricerca Iconografica; 6.37 © Achim Bednorz, Cologne; 6.39 Canali Photobank; 6.40a&b Araldo de Luca/Index Ricerca Iconografica; 6.41a&b Musei Vaticani/IKONA; 6.42 Index/Vasari; 6.44 Dr. James E. Packer; 6.45 akg-images/Peter Connolly; 6.46 Scala, Florence-courtesy of the Ministero Beni e Att. Culturali; 6.47 © Vincenzo Pirozzi, Rome; 6.48 Photo Scala, Florence—courtesy of the Ministero Beni e Att. Culturali; 6.49 © Vincenzo Pirozzi, Rome; 6.51 After William L. MacDonald, The Architecture of the Roman Empire I: An Introductory Study. New Haven and London: Yale University Press. 1965, fig. 9; 6.52 ALIMDI.NET/ Birgit Koch; 6.54 © Vincenzo Pirozzi, Rome; 6.55 Photo Scala, Florence/BPK, Bildagentur fuer Kunst, Kultur und Geschichte, Berlin; 6.56 Photo: Vatican Museums; 6.57 Canali Photobank/Museo Capitolino; 6.58 © Araldo de Luca/CORBIS; page 202 Photo © The Walters Art Museum, Baltimore; 6.59 The Metropolitan Museum of Art/Art Resource/Scala, Florence; 6.60a © Alinari Archives/ CORBIS; 6.61 Araldo de Luca; 6.63 © Achim Bednorz, Cologne; 6.62 © Cameraphoto Arte, Venice; 6.64 © Achim Bednorz, Cologne; 6.65 Araldo de Luca/Index Ricerca Iconografica; 6.66 Vasari, Roma/ IKONA; 6.67a ALIMDI.NET/Raimund Kutter; 6.68 © Vincenzo Pirozzi, Rome; 6.69 © The Trustees of the British Museum. All rights reserved; 6.70 V&A Images

Index

Figures in italics refer to illustrations and captions

Altamira, Spain: cave paintings 8-9, 11, 11 Altar of Augustan Peace see Ara Pacis Augustae arches, Roman Amarna period 70-71 structural 170, 170 Akhenaten and His Family (relief) 71,71-2 triumphal 185, 185-6, 207-9, 208, 209 A colossal figure of Akhenaten 70, 71 architectural orders abacus 108, 110 fish-shaped perfume bottle 73, 76, 76 Composite order (Roman) 161, 161, 185 Abraham 32 head of Nefertiti 72, 72-3 Corinthian 108, 110, 110, 147 abstract art/abstraction xxvi, xxix, 7 portrait of Queen Tiy 72, 72 Doric 108, 110, 110 Abu Simbel, Egypt: Temples of Ramses II 74, 74, Amasis Painter: Dionysos with Maenads 117, 117-18 Ionic 107, 107, 110, 110, 135-6, 171 75, 76, 77 Amazons 131 Tuscan (Etruscan) 158, 161, 161 acanthus leaves (Corinthian order) 110, 110 Amenemhat, stele of 65, 65 architectural plans xvii, xvii Achaemenids 44, 47 Amenhotep III, of Egypt 66, 69, 72 architecture xxvi, xxvii, xx Achilles 98, 100, 101, 118 Amenhotep IV see Akhenaten Assyrian 38, 41, 41–3 Achilles Painter (style of): Woman and Maid 141, Amorites 28 Babylonian 44, 44, 45 141 amphitheaters, Roman 177, 186-8, 187, 188 Egyptian: funerary 53-5, 54, 55, 68, 68-9, 69; acroteria 110, 110 amphoras 117 temples 50, 51, 57, 58, 65-7, 66, 67, 68, Actium, Battle of (31 BCE) 147, 167 Ajax and Achilles Playing a Game (Exekias) 100, 68-9, 69, 74, 74, 75, 76, 102 adyton 109 Etruscan 158, 158, 159, 160, 161 Aegean cultures 23, 81, 82 Dionysos with Maenads (Amasis Painter) 117, Greek 106, 107, 107, 108, 109, 110, 111, 111 Cycladic 82-4 (Archaic), 128, 128-30, 129, 135, 135-6, map 83 Herakles Driving a Bull to Sacrifice (Andokides 136, 137-8 (Classical) Minoan 84-92 Painter) 118, 118 Hellenistic 147, 147, 149 Mycenaean (Helladic) 92-9 Herakles Driving a Bull to Sacrifice (Lysippides Hittite 38, 40 Aegina, island of 102 Painter) 118, 118 megalithic 16-20, 18 Temple of Aphaia 108, 109, 111, 111, 112, 113, Amun (god) 51, 66, 69, 73, 74 Minoan 84, 85-7, 86, 87 113-14 Amykos, King 157 Neolithic 13, 13-20, 15, 16, 18, 20 Aeschylus 148 Anatolia 37, see also Turkey Paleolithic 4-5, 5 Aesop 105 Anavysos Kouros 115, 116, 160 Persian 45, 46 Agamemnon 85, 93, 97, 98 Andokides Painter: Herakles Driving a Bull to Roman 161, 161, 186-8, 187, 188, 190-92, 192, "Mask of Agamemnon" 97, 97 Sacrifice 118, 118 203, 204, and see below Agora, Athenian 137-8, 138 Angelico Fra Roman basilicas 191, 191-2, 206, 206-7, 207, Agrippa, Marcus 175, 195 Annunciation xxxii 209, 210, 211 Mocking of Christ with the Virgin Mary and St. Roman houses and villas 178, 178-9, 179, 181, 'Ain Ghazal, Jordan: human figures 21, 23, 23 Ajax and Achilles Playing a Game (Exekias) 100, 101 Dominic xxxii, xxxii 197, 197, 198, 199-200 Akhenaten (Amenhotep IV) 69, 70, 70, 71, 73 ankh 51 Roman temples 171, 171, 194, 195, 195, 196, Akhenaten and His Family (relief) 71,71-2 Antigonids 147 197 Akhetaten (Egypt) 69, 70-71, 73 Antoninus Pius, Emperor 190 Sumerian ziggurats 28, 29, 37, 37 Akkad/Akkadians 27, 28, 35, 37 Anu (god) 28 see also building methods and techniques; Disk of Enheduanna 35, 35-6 Anubis (god) 51, 69, 77 tombs Head of a Man (Akkadian Ruler) 36, 36 Apadana (audience hall), Persepolis 45, 46 architraves 107, 110 Stele of Naram-Sin 26, 27, 34, 36 Aphrodite (goddess) 104, 130 Ares (god) 104, 131 Akropolis, The (Athens) 128, 128-9 Aphrodite of Knidos (Praxiteles) 143, 144 Argonauts, the 157 Athena Parthenos (Pheidias) 133, 133 Aphrodite of Melos (Alexandros) 154, 155 Aristotle 141 Athena Promachos (Pheidias) 129 Apollo (god) 104, 107 Arnhem Land, Australia: Rainbow Serpent rock Erechtheion 129, 135-6, 136 Apollo (?Vulca) 160, 160 2, 2 Parthenon (Kallikrates and Iktinos) 129, 129-30; Apollodorus of Damascus art sculptures 34, 130, 130-33, 131, 132 Trajan's Forum, Rome 191, 191 abstract xxvi, xix, 7 Porch of the Maidens 136, 136 see also Pantheon, Rome basic properties xiv-xv The Propylaia 129, 135, 135 Apoxyomenos (Lysippos) see Man Scraping Himself characteristics and definitions xviii-xxi Temple of Athena Nike 129, 135, 137, 137 appropriation xx conventions 31, 51 Akrotiri (Thera) 81 aqueducts, Roman 170, 170, 179 art history xxi-xxviii "Flotilla Fresco" 92, 92-3 Ara Pacis Augustae 172, 174, 174-5, 175 case study xxviii-xxxiii Girl Gathering Saffron Crocus Flowers (fresco) 80, Arch of Constantine, Rome 207-9, 208, 209 Artemis (goddess) 104 Arch of Titus, Rome 185, 185-6 ashlar masonry 99 Landscape ("Spring Fresco") 91, 91-2 archaeology 81 Assurbanipal, King of the Assyrians 42-3, 43 Alexander the Great 47, 79, 141-2, 142, 145, 147 Archaic period 105-20, 139; see Greece, ancient Assurnasirpal II, of Assyria 38, 40, 41 Alexander the Great Confronts Darius III at the Battle architectural relief sculpture 107-8, 108 Assyria/Assyrians 38, 44 of Issos (?Philoxenos of Eretria or Helen of architecture 106, 107, 107, 108, 109, 111, 11 architecture 38, 41, 41-3 Egypt) 145, 146 sculpture 112, 113, 113-15, 114-16 lamassus 42, 43

vases 117, 117-20, 118, 119

"Archaic smile" 114, 160

relief sculpture 40, 41, 42, 43, 43

Alexandria, Egypt 147

Bradley, Richard 24 ceramics/pottery xvi, 20 astragal 110, 110 Aswan High Dam, Egypt 50, 74 Breuil, Abbé Henri 8 Cycladic 82 Brinkmann, Vinzenz and Koch-Brinkmann, Aten (god) 70, 71, 73 Egyptian 20, 50 Athena (goddess) 104, 135 Ulrike: reconstruction of Greek sculpture Greek vases 100, 101, 102-4, 103, 105, 105, 117, 117-20, 118, 119, 139, 139 (Archaic), Athena Attacking the Giants (Pergamon frieze) 150, 113, 113 Bronze Age 23-4 126, 126-7, 127, 141, 141 (Classical) 151 Aegean cultures 81-4, 92 Athena Parthenos (Pheidias) 133, 133 Jomon (Japan) pottery 21, 21 Minoan 85, 85, 88, 89, 89-90 Athena Promachos (Pheidias) 129 bronzes 23, 24 Mycenaean 99, 99 Athens 102, 107, 117, 120, 127-8, 130, 138, 141 Akkadian head of a ruler 36, 36 Neolithic 20-21, 21, 22, 22 Egyptian statue 78, 78 Agora and stoas 137-8, 138, 140 Etruscan 156, 157, 164, 165, 165, 166 Paleolithic figurine 7, 7 Panathenaic festival 132, 135 Temple of Olympian Zeus 147, 147, 149 Greek 104, 105 (Geometric), 120-22, 122, 123, see also terra cottas Ceres (goddess) 104 see also Akropolis, The 126 (Classical) Hellenistic 149 Cernavodă, Romania: figurines 21, 22, 22 Atreus 85 Mycenaean dagger blade 97, 97-8 "Treasury of Atreus," Mycenae 98, 98-9 Cerveteri, Italy Attalus I, of Pergamon 149 Roman 169, 169, 200, 200-1 Etruscan tombs 160, 162, 163 Augustus, Emperor (Octavian) 167, 168, 171-2, "Brutus"/Head of a Man 164, 166 Sarcophagus 163, 163-4 174, 175, 190, 203 building methods and techniques Champollion, Jean-François 79 Augustus of Primaporta 172, 173 ashlar masonry 99 Charioteer, The (Greek bronze) 122, 122 Aulus Metellus (Roman bronze) 169, 169 barrel vaults 187, 187 Charpentier, Marguérite-Louise xxxvii Aurelius, Emperor Marcus 190, 202 concrete (Roman) 194 Mme. Charpentier and Her Children (Renoir) xxiv, corbeled vaults 17, 17, 19, 98, 99 equestrian statue 200, 200-1 xxv, xxv, xxvii cyclopean masonry 93 Chauvet Cave paintings, Vallon-Pont-d'Arc, France Australia: Rainbow Serpent Rock, Arnhem Land dressed stone 84 9,9-10 2, 2 Austria: Woman from Willendorf 6, 6-7 drywall masonry 93 China: potter's wheel 20 glazed bricks 44 Christianity 39, 166, 207, 211, 212, 213 Chryssolakkos, Crete: bee pendant 90, 90 mortise-and-tenon 18 В post-and-lintel 17, 18, 19, 158 cistae, Etruscan 156, 157, 164 Babylon 28, 37, 44, 44 ridgepoles 16 city-states Ishtar Gate 44, 45 thatch 16 Greek 102, 120 voussoirs 170,170 Mesopotamian 28, 37 palace of Nebuchadnezzar II 44 "classic"/"classical" 120 Babylonians wattle and daub 16 wood-post framing 19, 20, 20 religion/gods 28, 39 Classical period (Greece) 120-27 (early), 127-41 (high), 141-7 (late) Stele of Hammurabi 37, 39, 39 Bull Leaping fresco (Knossos) 87, 87-8 Bacchus (god) 104, 181 Bull's-head Rhyton (Minoan) 89, 89 Cleopatra VII, of Egypt 67, 79, 147, 167 see also Dionysos/Dionysus buon fresco 87 clerestories 57 Bada Shanren see Zhu Da Butcher (Egyptian) 60, 60-61 Code of Hammurabi 39, 39 color xxi, xxiii Baghdad: Iraq National Museum 34 "barbarians" 149 attributes of xiv C Barberini Togatus (Roman sculpture) 168, 168 Colosseum, Rome 186-8, 187, 188 Caesar, Julius 171, 172, 190 basilicas 191 columns Basilica at Trier 206, 206-7 denarius 169, 169 Greek 108, 110, 110 Basilica Nova/Basilica of Maxentius and cairns, Neolithic 17 Minoan 84 Commodus, Emperor 190, 202 Constantine, Rome 209, 210, 211 calyx kraters 117 Basilica Ulpia, Rome 191, 191-2 The Death of Sarpedon (Euphronios and Commodus as Hercules 201, 201, 205 Bastet (goddess) 51 Euxitheos) 119, 119-20, 130 Composite order 161, 161, 185 Baths of Caracalla, Rome 203, 204 "Canon" of Polykleitos 134, 142 composite poses 10, 53 canopic jars, Egyptian 53 composition xv, xxi, xxiv-xxv Battle between the Gods and the Giants (frieze) 107-8, 108 Capitoline She-Wolf (?Etruscan bronze) 165, 165 concrete, Roman 194, 199 Connelly, Joan 132 Battle of Centaurs and Wild Beasts (Roman mosaic) capstones 17 198, 199-200 Caracalla, Emperor 203 Constantine, Emperor ("the Great") 200, 207, 211 Battle of Issos, The (?Philoxenos of Eretria or Helen Baths of Caracalla 203, 204 Head 211, 211 of Egypt) 145, 146 portraits 203, 203 Constantinople 207 Hagia Sophia xvii Bee Pendant (Minoan) 90, 90 Carnarvon, George Herbert, 5th Earl of 49 Carrey, Jacques 130 Constantius Chlorus, Tetrarch 206 beehive tombs see tholos tombs bell krater 117 Carruba, Anna Maria 165 content xvi Carter, Howard 49 contrapposto 120, 122 Beni Hasan, Egypt: rock-cut tombs 62, 62-3, 63 conventions, artistic 31, 51 Berlin Kore 115, 115 Carthage 167 black-figure vases, Greek 100, 101, 105, 105, 117, Carthusians xxxii-xxxiii copper artifacts, Neolithic 23 corbeled vaults 17, 17, 19, 98, 99 117-19, 118, 119, 139, 139 cartoons xxvi Corinth, Greece 102, 167 caryatids 107, 136, 136 Blombos Cave, South Africa: engraved ocher 4, Catalhöyük, Turkey 13 olpe 105, 105 Boat and sea battle (prehistoric rock carving) 24-5, houses 13-15, 15 Corinthian order 108, 110, 110, 147 Cossutius: Temple of Olympian Zeus 147, 147, wall painting 14, 15 cave art, Paleolithic 149 Bohuslän, Sweden: Bronze Age rock carvings 24-5, 25 paintings xxxiv, 1, 8-11, 9, 10, 11 crenellations 44 sculptures 1, 11-12, 12 Crete 81, 82, 85 Boniface IV, Pope 197 see Knossos; Minoan civilization Books of the Dead, Egyptian 77, 77 cella 108, 109 Celts 19, 150 Crucifixion Triptych with Donors and Saints (van der Boscoreale, Italy: House of Publius Fannius

goldwork 150, 150

Synistor 181, 181-2

Weyden) xxx-xxxi, xxxi

Crucifixion with the Virgin and St. John the Evangelist (van der Weyden) xxviii-xxx, xxix, xxxii, xxxiii, xxxiii cultural context xxvii-xxviii cuneiform writing 28, 30, 33 Cupid (god) 104 Cybele (Great Mother) 166 Cycladic islands 81, 82 sculpture 82, 82-4, 84 cyclopean masonry 93 cylinder seals, Sumerian 34-5, 35 Cyrus II ("the Great"), of Persia 44

D dagger blade, Mycenaean 97, 97-8 Darius I, of Persia 44-5, 47, 47 Darius II, of Persia 47 Darius and Xerxes Receiving Tribute (relief) 45, 47, 47 dating methods 12 dendrochronology xxviii, 82 electron spin resonance 12 potassium-argon 12 radiometric 12 thermo-luminescence 12 uranium-thorium 1, 12 Death of Sarpedon, The (Euphronios and Euxitheos) 119, 119-20, 133 Deir el-Bahri, Egypt 67 funerary temple of Hatshepsut 68, 68-9, 69 Deir el-Medina, Egypt 65 Babylonian 39 Egyptian 50-51, 65, 66, 70 Greek 104 Roman 104 Sumerian 28, 36 de Jong, Piet: Pylos Palace 96 Delphi, Greece Sanctuary of Apollo 106, 107, 122 Treasury of the Siphnians 107, 107-8, 108 Demeter (goddess) 104 denarius (of Julius Caesar) 169, 169 dendrochronology xxviii, 82 Diana (goddess) 104 Diocletian, Emperor 205 Dionysos/Dionysus (god) 104, 117, 130, 142, 143, 148, 155, 201, 202 Dionysos with Maenads (Amasis Painter) 117, 117-18 Dionysus see Dionysos diptych, Roman 212-13, 213 Dipylon Krater 103, 103-4 Disk of Enheduanna 35, 35-6 Djoser's Complex, Saqqara, Egypt 53-5, 54, 55 dolmens 17 Dolní Věstonice, Czech Republic 7, 7 kilns 20 dome construction 187, 187, 195, 197 Domitian, Emperor 185, 195 Doni Tondo (Michelangelo) xxiii Doric order 108, 110, 110 Doryphoros (Polykleitos) see Spear Bearer

Durrington Walls, England 20, 20 Dying Gallic Trumpeter (?Epigonos) 149, 149 Dying Warrior (from Temple of Aphaia) 111, 112,

E

earthenware 20 echinus 110, 110 Edict of Milan (313) 207 Education of the Virgin, The (La Tour) xxii Egypt, ancient 38, 50, 50, 78, 79, 82, 141, 147, 167 artistic conventions 51, 65 Books of the Dead 77, 77 canopic jars 53 dynasties and kingdoms 56, 62, 65, 77 funerary stelai 63, 63-5, 64, 65, 105 glassmaking 73, 76, 76 god-kings 50-51 goldwork 48, 49, 72, 73, 73 Great Sphinx, Giza 57, 58, 62 hieroglyphs 51, 52, 79, 79 mastabas 53, 55, 55, 61 Middle Kingdom 62-5 mummification 53 necropolises 53, 62 New Kingdom 65-77 Old Kingdom 56-61 pharaohs 65 pictorial relief sculpture 63, 63-4, 64, 71, 71-2 poetry 70 pottery 20, 50 pyramids 55, 56, 56-7, 57 rock-cut tombs 62, 62-3 sculpture 57-61, 59, 60, 70, 67-8, 68, 70, 71, 74, 74, 78, 78-9; portraits 62, 62, 72, 72-3 symbols 51 temples 50, 51, 57, 58, 65-7, 66, 67, 68, 68-9, 69, 74, 74, 75, 76, 102 Third Intermediate Period 77-8 tomb paintings 62-3, 63 76, 77 tomb reliefs 61, 61, 69-70, 70 tombs 50, 53-5, 54, 69, see also mastabas; pyramids; rock-cut tombs (above) town planning 65 Elamites 34, 36 electron spin resonance dating method 12 "Elgin Marbles" 34, 133 Durrington Walls, Wiltshire 20, 20 "Mildenhall Treasure" 211-12, 212 Stonehenge, Wiltshire 15, 17-20, 18, 19 Enheduanna 35-6 Disk of Enheduanna 35, 35-6 Enkidu 28 entablature 107, 110, 110 entasis 108 ephemeral arts xvii Ephesus, Turkey: Library of Celsus (façade) 161 Epic of Gilgamesh 28, 32

Epidauros, Greece: theater 148, 148

Etruscans 124, 158, 166, 167

architecture 158, 158, 159, 160

sarcophagi 163, 163-4, 164

bronzes 156, 157, 164, 165, 165, 166

Eros (god) 104

34

Epigonos (?): Dying Gallic Trumpeter 149, 149

Erechtheion, Akropolis, Athens 129, 135-6, 136

Eshnunna (Tell Asmar, Iraq): votive figures 31, 31,

sculpture 160, 160 tombs 133, 160, 161, 162, 163 Euphrates, River 28, 29, 40, 44 Euphronios and Euxitheos: The Death of Sarpedon 119, 119-20, 133 Euripides 148 Evans, Sir Arthur 84, 85, 96 Ajax and Achilles Playing a Game 100, 101, 118-19 expressionism xvi, 149

F

Faunus (god) 104 Feminist Art Journal, The xxi Fertile Crescent 28, 29 Ficoroni Cista, The (Novios Plautios) 156, 157, filigree 90 fish-shaped perfume bottle, Egyptian 73, 76, 76 Flavians 184, 186, 188, 189 Florence, Italy: Monastery of San Marco frescos (Fra Angelico) xxxii, xxxii "Flotilla Fresco" (Minoan) 92, 92-3 foreshortening xxiii form (in art) xiv and space xv and texture xv formal analysis xxi-xxv Foundry Painter: A Bronze Foundry 120-21, 121 Paleolithic cave paintings xxxiv, 1, 8, 9-11, 9, 10, 11 Paleolithic sculpture 7, 7, 11-12, 12 see also Gaul/Gauls Franchthi Cave, Greece: pottery 21, 21 Freeman, Leslie G. 8 frescos xvi, xxxii, xxxii, 87 Greek 124, 124, 125 Minoan 87, 87-8, 91, 91-2, 92-3 Roman 179-84, 180-84 friezes 107, 110, 110 Athena Attacking the Giants (Pergamon) 150, Battle Between the Gods and the Giants (Siphnian Treasury) 107-8, 108 Parthenon 131, 131-3, 132 Frolicking Satyrs (Douris) 126, 126

G

Gamble, Clive 6-7 Ganymede 127, 145 Gaul/Gauls 149, 150, 167 Gemma Augustea (Roman cameo) 172, 176, 176 Geometric period (Greece) 102-5 Geshtinanna (goddess) 37 gilding 90 Gilgamesh 28, 32 Girl Gathering Saffron Crocus Flowers (fresco) 80, 81,91 Girsu (Telloh, Iraq) 37 votive statues 37, 38 Giza, Egypt Great Sphinx 57, 58 pyramids 55, 56, 56-7, 57 glassmaking, Egyptian 73, 76, 76 Glykera 145-6 Gnosis: Stag Hunt 146, 146-7

Douris 126

drawing(s) xvi

lamassus 42, 43

Frolicking Satyrs 126, 126

A Youth Pouring Wine into the Kylix of a

Companion 126-7, 127

Dur Sharrukin (Khorsabad, Iraq) 41

palace of Sargon II 41, 41-2

goldwork	Hattusha (Turkey) 37	Iliad (Homer) 85, 93, 97-8, 119
Celtic 150, 150	Lion Gate 38, 40	illumination, manuscript xvi, xxii
Egyptian 48, 49, 72, 73, 73	Hawes, Harriet Boyd 85	illusionism xvi, 145–6
Greek 145, 145 Minoan 88, 89, 90, 90–91, 91	Head of a Man (Akkadian Ruler) 36, 36	
	Head of a Man ("Brutus") 164, 166	Imhotep: Djoser's Complex, Saqqara, Egypt 53–5,
Mycenaean 97, 97		54, 55
Neolithic 23, 24	Head of Constantine 211, 211	Inanna (goddess) 28, 30, 36
Persian 47	Helen of Egypt (?): Alexander the Great Confronts	Indian Triumph of Dionysus (Roman sarcophagus)
Gournia, Crete 85	Darius III at the Battle of Issos 145, 146	201, 202
granulation 90	Helena, St. 207	insulae 176
graphic arts xvi–xvii	Helladic culture 92; see Mycenaean culture	Ionic order 107, 107, 110, 110, 135-6, 171
Great Altar, Pergamon 150, <i>151</i> , 152	Hellenistic period 147	Ireland
Great Sphinx, Giza, Egypt 57, 58, 62	architecture 147, 147, 148	Knowth passage grave 17
Great Temple of Amun, Karnak, Egypt 66, 66–7, 67	map 142	Newgrange passage grave 17, 17
Greece, ancient 102	mosaics 145–7, 146	Ishtar (goddess) 28
Archaic period 105–20	sculpture 143, 143, 149, 149–50, 152, 153, 153,	Ishtar Gate, Babylon 44, 45
architecture 106, 107, 107, 108, 109, 110, 111,	<i>154</i> , 155	Isimila Korongo, Tanzania: Paleolithic hand-axe
111 (Archaic), 128, 128–30, 129, 135,	henges 17, see Stonehenge	4, 4
135–6, 136, 137–8 (Classical), see also	Hephaistos (god) 104	Isis 76, 166
architectural orders	Hera (goddess) 102, 104, 108, 180	isometric drawings xvii, xvii
bronzes 104, 105	Herakleitos: The Unswept Floor 199, 199	Istanbul: Hagia Sophia <i>xvii</i>
Classical period 105, 120-47	Herakles/Hercules 201	ivories
deities 102, 104	Commodus as Hercules 201, 201	Minoan statuette 88, 88
Geometric period 102–5, 117	Herakles Driving a Bull to Sacrifice (Andokides	Paleolithic figures 5, 5–6, 7, 7
goldwork 145, <i>145</i>	Painter), 118, 118	Priestess of Bacchus (Roman diptych) 212-13, 213
grave stelai 139–40, 140	Herakles Driving a Bull to Sacrifice (Lysippides	Ixion 180
map 103	Painter) 118, 118	
Neolithic pottery 21, 21	Herculaneum: still life 183, 184	
Neolithic stone-foundation house 16, 16	Hercules see Herakles	J
		Y N. 1:1: // 24 24
Neolithic wattle-and-daub walls 19	Hermes (god) 104, 119	Japan: Neolithic (Jomon) pottery 21, 21
Orientalizing period 105	Hermes and the Infant Dionysos (Praxiteles) 142–3, 143	Jashemski, Wilhelmina 179
painting 124, 125, 140, 145-6, see also vases (below)	Herodotus 50, 53	Jerusalem: looting of the Temple 167, 185, 185-6
philosophers 120	Hestia (goddess) 104, 130	jewelry
relief sculpture 107–8, 108 (Archaic), 131, 131–	Hierakonpolis, Egypt	Celtic torc 150, <i>150</i>
	Narmer Palette 51–3, 52	
3, 132, 137, 137, 139–40, 140 (Classical)		Greek earrings 145, 145
sanctuaries 102, 106, 107	tomb paintings 50	Minoan pendant 90, 90
sculpture 104, 104, 105, 111, 112, 113, 113–15,	hierarchic scale 27, 52	Neolithic 23
114, 115, 116, 117 (Archaic), 120–22, 121,	hieroglyphs, Egyptian 51, 52, 79, 79	Jews 44, 167, 185
122, 123, 126, 130, 130–31, 133, 133, 134,	Hippodamus of Miletos 139	Johnson, John G.: Collection xxx
134, 142–3, 143, 144, 145 (Classical)	Hissarlik, Turkey 85	Jolly, Penny Howell xxxii, xxxiii
	Hittites 37–8, 76	
symposia 124, <i>125</i> , 127		Jomon pottery (Japan) 21, 21
theater 148, 148	Hoffman, Gail 84	Josephus, Flavius: Jewish Wars 167
urban planning 138–9	Hohlenstein-Stadel, Germany: Lion-Human 5,	Judaism 166
vases 100, 101, 102-4, 103, 105, 105, 117,	5-6	Judgment of Hunefer before Osiris (Book of the
117-20, 118, 119, 139, 139 (Archaic), 126,	Holstein, Jonathan xx	Dead) 77, 77
126–7, <i>127</i> , 141, <i>141</i> (Classical)	Holy Family, The (Michelangelo) xxiii	Julio-Claudians 172, 184
see also Hellenistic period	Homer	Junayd: Humay and Humayun xxiii
Gudea, ruler of Lagash 37, 38	Iliad 85, 93, 97–8, 119	Juno (goddess) 104
Guti, the 37	Odyssey 85	Jupiter (god) 104
	Homo sapiens sapiens 2, 3–4, 8	
	Horace: Epistulae 167	
Н	Horus (god) 51, <i>51</i> , 53, 77	K
TT 1 . 104		1 52 (4
Hades 104	hues xiv	ka 53, 61
Hadrian, Emperor 147, 190, 191, 195	humanism 120	Kalhu (Nimrud, Iraq) 38
Hadrian's Villa, Tivoli 197, 197, 198, 199–200	Humay and Humayun (Junayd) xxiii	palace of Assurnasirpal II 40, 41, 42
Hagesandros, Polydoros, and Athenodoros of		
	Hunefer 77, 77	Kallikrates
	Hunefer 77, 77	Kallikrates Parthenon 129 129–30
Rhodes: Laocoön and His Sons 152, 153	huyuk 29	Parthenon 129, 129-30
Hagia Sophia, Istanbul xvii	huyuk 29 hydria 117	Parthenon <i>129</i> , 129–30 Temple of Athena Nike 129, <i>135</i> , 137, <i>137</i>
Hagia Sophia, Istanbul <i>xvii</i> Hall of Bulls, Lascaux Caves, France <i>10</i> , 10–11	huyuk 29 hydria 117 Woman at a Fountain House (Priam Painter) 139,	Parthenon <i>129</i> , 129–30 Temple of Athena Nike 129, <i>135</i> , 137, <i>137</i> Kamares ware 85, <i>85</i> , 90
Hagia Sophia, Istanbul <i>xvii</i> Hall of Bulls, Lascaux Caves, France <i>10</i> , 10–11 Hammurabi, King 28, 37	huyuk 29 hydria 117 Woman at a Fountain House (Priam Painter) 139, 139	Parthenon 129, 129–30 Temple of Athena Nike 129, 135, 137, 137 Kamares ware 85, 85, 90 kantharos 117, 117
Hagia Sophia, Istanbul <i>xvii</i> Hall of Bulls, Lascaux Caves, France <i>10</i> , 10–11	huyuk 29 hydria 117 Woman at a Fountain House (Priam Painter) 139,	Parthenon <i>129</i> , 129–30 Temple of Athena Nike 129, <i>135</i> , 137, <i>137</i> Kamares ware 85, <i>85</i> , 90
Hagia Sophia, Istanbul <i>xvii</i> Hall of Bulls, Lascaux Caves, France <i>10</i> , 10–11 Hammurabi, King 28, 37	huyuk 29 hydria 117 Woman at a Fountain House (Priam Painter) 139, 139	Parthenon 129, 129–30 Temple of Athena Nike 129, 135, 137, 137 Kamares ware 85, 85, 90 kantharos 117, 117
Hagia Sophia, Istanbul <i>xvii</i> Hall of Bulls, Lascaux Caves, France <i>10</i> , 10–11 Hammurabi, King 28, 37 Code/Stele of Hammurabi 34, 37, <i>39</i> hand-axes, Paleolithic 3, <i>4</i>	huyuk 29 hydria 117 Woman at a Fountain House (Priam Painter) 139, 139 Hyksos, the 65	Parthenon 129, 129–30 Temple of Athena Nike 129, 135, 137, 137 Kamares ware 85, 85, 90 kantharos 117, 117 Karnak, Egypt 71, 76 Great Temple of Amun 66, 66–7, 67
Hagia Sophia, Istanbul <i>xvii</i> Hall of Bulls, Lascaux Caves, France <i>10</i> , 10–11 Hammurabi, King 28, 37 Code/Stele of Hammurabi 34, 37, <i>39</i> hand-axes, Paleolithic 3, <i>4</i> handscrolls xvi	huyuk 29 hydria 117 Woman at a Fountain House (Priam Painter) 139, 139 Hyksos, the 65	Parthenon 129, 129–30 Temple of Athena Nike 129, 135, 137, 137 Kamares ware 85, 85, 90 kantharos 117, 117 Karnak, Egypt 71, 76 Great Temple of Amun 66, 66–7, 67 Karomama (Egyptian bronze) 78, 78
Hagia Sophia, Istanbul <i>xvii</i> Hall of Bulls, Lascaux Caves, France <i>10</i> , 10–11 Hammurabi, King 28, 37 Code/Stele of Hammurabi 34, 37, <i>39</i> hand-axes, Paleolithic 3, <i>4</i> handscrolls xvi Hanging Gardens of Babylon <i>44</i>	huyuk 29 hydria 117 Woman at a Fountain House (Priam Painter) 139, 139 Hyksos, the 65	Parthenon 129, 129–30 Temple of Athena Nike 129, 135, 137, 137 Kamares ware 85, 85, 90 kantharos 117, 117 Karnak, Egypt 71, 76 Great Temple of Amun 66, 66–7, 67 Karomama (Egyptian bronze) 78, 78 Kavousi, Crete 85
Hagia Sophia, Istanbul <i>xvii</i> Hall of Bulls, Lascaux Caves, France <i>10</i> , 10–11 Hammurabi, King 28, 37 Code/Stele of Hammurabi 34, 37, <i>39</i> hand-axes, Paleolithic 3, <i>4</i> handscrolls xvi Hanging Gardens of Babylon <i>44</i> hanging scrolls xvi	huyuk 29 hydria 117 Woman at a Fountain House (Priam Painter) 139, 139 Hyksos, the 65 hypostyle halls 66, 66, 67, 67	Parthenon 129, 129–30 Temple of Athena Nike 129, 135, 137, 137 Kamares ware 85, 85, 90 kantharos 117, 117 Karnak, Egypt 71, 76 Great Temple of Amun 66, 66–7, 67 Karomama (Egyptian bronze) 78, 78 Kavousi, Crete 85 keystones 170, 170
Hagia Sophia, Istanbul xvii Hall of Bulls, Lascaux Caves, France 10, 10–11 Hammurabi, King 28, 37 Code/Stele of Hammurabi 34, 37, 39 hand-axes, Paleolithic 3, 4 handscrolls xvi Hanging Gardens of Babylon 44 hanging scrolls xvi Harvester Rhyton (Minoan) 88, 88–9, 99	huyuk 29 hydria 117 Woman at a Fountain House (Priam Painter) 139, 139 Hyksos, the 65 hypostyle halls 66, 66, 67, 67 l iconography xxv, xxvi, xxvii	Parthenon 129, 129–30 Temple of Athena Nike 129, 135, 137, 137 Kamares ware 85, 85, 90 kantharos 117, 117 Karnak, Egypt 71, 76 Great Temple of Amun 66, 66–7, 67 Karomama (Egyptian bronze) 78, 78 Kavousi, Crete 85 keystones 170, 170 Khafre, Egyptian king
Hagia Sophia, Istanbul xvii Hall of Bulls, Lascaux Caves, France 10, 10–11 Hammurabi, King 28, 37 Code/Stele of Hammurabi 34, 37, 39 hand-axes, Paleolithic 3, 4 handscrolls xvi Hanging Gardens of Babylon 44 hanging scrolls xvi Harvester Rhyton (Minoan) 88, 88–9, 99 Hathor (god) 69, 77	huyuk 29 hydria 117 Woman at a Fountain House (Priam Painter) 139, 139 Hyksos, the 65 hypostyle halls 66, 66, 67, 67 I iconography xxv, xxvi, xxvii iconology xxvii	Parthenon 129, 129–30 Temple of Athena Nike 129, 135, 137, 137 Kamares ware 85, 85, 90 kantharos 117, 117 Karnak, Egypt 71, 76 Great Temple of Amun 66, 66–7, 67 Karomama (Egyptian bronze) 78, 78 Kavousi, Crete 85 keystones 170, 170
Hagia Sophia, Istanbul xvii Hall of Bulls, Lascaux Caves, France 10, 10–11 Hammurabi, King 28, 37 Code/Stele of Hammurabi 34, 37, 39 hand-axes, Paleolithic 3, 4 handscrolls xvi Hanging Gardens of Babylon 44 hanging scrolls xvi Harvester Rhyton (Minoan) 88, 88–9, 99	huyuk 29 hydria 117 Woman at a Fountain House (Priam Painter) 139, 139 Hyksos, the 65 hypostyle halls 66, 66, 67, 67 l iconography xxv, xxvi, xxvii	Parthenon 129, 129–30 Temple of Athena Nike 129, 135, 137, 137 Kamares ware 85, 85, 90 kantharos 117, 117 Karnak, Egypt 71, 76 Great Temple of Amun 66, 66–7, 67 Karomama (Egyptian bronze) 78, 78 Kavousi, Crete 85 keystones 170, 170 Khafre, Egyptian king
Hagia Sophia, Istanbul xvii Hall of Bulls, Lascaux Caves, France 10, 10–11 Hammurabi, King 28, 37 Code/Stele of Hammurabi 34, 37, 39 hand-axes, Paleolithic 3, 4 handscrolls xvi Hanging Gardens of Babylon 44 hanging scrolls xvi Harvester Rhyton (Minoan) 88, 88–9, 99 Hathor (god) 69, 77	huyuk 29 hydria 117 Woman at a Fountain House (Priam Painter) 139, 139 Hyksos, the 65 hypostyle halls 66, 66, 67, 67 I iconography xxv, xxvi, xxvii iconology xxvii	Parthenon 129, 129–30 Temple of Athena Nike 129, 135, 137, 137 Kamares ware 85, 85, 90 kantharos 117, 117 Karnak, Egypt 71, 76 Great Temple of Amun 66, 66–7, 67 Karomama (Egyptian bronze) 78, 78 Kavousi, Crete 85 keystones 170, 170 Khafre, Egyptian king funerary complex 57 Great Sphinx 57, 58, 62
Hagia Sophia, Istanbul xvii Hall of Bulls, Lascaux Caves, France 10, 10–11 Hammurabi, King 28, 37 Code/Stele of Hammurabi 34, 37, 39 hand-axes, Paleolithic 3, 4 handscrolls xvi Hanging Gardens of Babylon 44 hanging scrolls xvi Harvester Rhyton (Minoan) 88, 88–9, 99 Hathor (god) 69, 77 Hatshepsut 67–8 Funerary Temple of Hatshepsut, Deir el-Bahri	huyuk 29 hydria 117 Woman at a Fountain House (Priam Painter) 139, 139 Hyksos, the 65 hypostyle halls 66, 66, 67, 67 I iconography xxv, xxvi, xxvii iconology xxvii idealism 120, 169 idealization xvi, 134	Parthenon 129, 129–30 Temple of Athena Nike 129, 135, 137, 137 Kamares ware 85, 85, 90 kantharos 117, 117 Karnak, Egypt 71, 76 Great Temple of Amun 66, 66–7, 67 Karomama (Egyptian bronze) 78, 78 Kavousi, Crete 85 keystones 170, 170 Khafre, Egyptian king funerary complex 57 Great Sphinx 57, 58, 62 Pyramid (Giza) 55, 56, 56, 57
Hagia Sophia, Istanbul xvii Hall of Bulls, Lascaux Caves, France 10, 10–11 Hammurabi, King 28, 37 Code/Stele of Hammurabi 34, 37, 39 hand-axes, Paleolithic 3, 4 handscrolls xvi Hanging Gardens of Babylon 44 hanging scrolls xvi Harvester Rhyton (Minoan) 88, 88–9, 99 Hathor (god) 69, 77 Hatshepsut 67–8	huyuk 29 hydria 117 Woman at a Fountain House (Priam Painter) 139, 139 Hyksos, the 65 hypostyle halls 66, 66, 67, 67 l iconography xxv, xxvi, xxvii iconology xxvii idealism 120, 169	Parthenon 129, 129–30 Temple of Athena Nike 129, 135, 137, 137 Kamares ware 85, 85, 90 kantharos 117, 117 Karnak, Egypt 71, 76 Great Temple of Amun 66, 66–7, 67 Karomama (Egyptian bronze) 78, 78 Kavousi, Crete 85 keystones 170, 170 Khafre, Egyptian king funerary complex 57 Great Sphinx 57, 58, 62

Khamerernebty II, Queen 59, 59 Khons (god) 65, 66 Khorsabad, Iraq see Dur Sharrukin Khufu, Pyramid of (Giza) 56, 56, 57 Knossos, Crete 84, 85, 90 Bull Leaping fresco 87, 87-8 Labyrinth 84, 86 Palace complex 85-6, 86, 87, 87 Knowles, Martha xix My Sweet Sister Emma (quilt) xix, xix-xx, Knowth, Ireland: passage grave 17 kore (pl. korai) 114 Berlin Kore 115, 115 "Peplos" Kore 115, 116, 117 kouros (pl. kouroi) 114, 120 Anavysos Kouros 115, 116, 160 Metropolitan Kouros 114, 114 kraters 117 Dipylon Krater 103, 103-4 Warrior Krater 99, 99 see also calyx kraters Kritias 141 Kritios Boy 113, 120, 121 Kush, kingdom of 74, 78 Kydias 157 kylixes 117 A Bronze Foundry 120-21, 121 A Youth Pouring Wine into the Kylix of a Companion (Douris) 126-7, 127 L

Labyrinth at Knossos, the 84, 86 Lagash (Iraq) 28, 37 lamassus 42, 43 Laming-Emperaire, Annette 8 Landscape ("Spring Fresco") (Minoan) 91, 91-2 Laocoön and His Sons (Hagesandros et al.) 152, 153 lapis lazuli 30, 33, 34, 35, 35 Lapith Fighting a Centaur (Parthenon relief) 131, 131, 133 Lascaux Cave paintings, Dordogne, France 10, 10-11, 11 La Tour, Georges de: The Education of the Virgin xxii law code: Code of Hammurabi 37, 39, 39 Le Corbusier (Charles-Édouard Jeanneret): Nôtre-Dame-du-Haut, Ronchamp, France lekythoi 117 Woman and Maid (style of Achilles Painter) 141, 141 Lepenski Vir, Serbia: Neolithic houses/shrines 13, 13, 14, 15 Leroi-Gourhan, André 8 Lewis-Williams, David 9 Li Bai xxvi light/lighting xxi, xxii, xxiii Lindisfarne Gospels: Carpet Page xxii implied xxiv linear perspective $x\nu$ linear styles xvi lintels 18 post-and-lintel construction 17, 18, 19, 158 "Lion Gate," Mycenae 93, 95, 95 Lion-Human (Paleolithic sculpture) 5, 5-6 Livia 171, 172, 175, 176 Villa of Livia, Primaporta 182, 183

Lorblanchet, Michel 8
lost-wax casting 36
Ludwig I, of Bavaria 111
Lullubi people 27, 36
Luxor, Egypt 67, 76
lyres, Sumerian 32–3, 33, 34
Lysippides Painter: Herakles Driving a Bull to
Sacrifice 118, 118
Lysippos 145, 155
Man Scraping Himself (Apoxyomenos) 144, 145

M

Ma'at (goddess) 51,77 Madame Charpentier and Her Children (Renoir) xxiv, xxv, xxv, xxvii Madonna of the Goldfinch (Madonna del Cardellino) (Raphael) xxiv, xxiv-xxv, xxvii Magenta, Black, Green, on Orange (No. 3/No. 13) (Rothko) xviii, xix, xxi Mainardi, Patricia xxi mammoth-bone houses, prehistoric 4-5, 5 mammoth ivory sculpture 5, 5-6 Man and Centaur (Greek bronze) 104, 105 Man Scraping Himself (Apoxyomenos) (Lysippos) maps ancient Aegean world 83 ancient Egypt 50 ancient Greece 103 ancient Near East 29 Hellenistic Greece 142 prehistoric Europe 3 Roman Empire 159 marble 82, 114 Marduk (god) 44 Marduk Ziggurat, Babylon 44 Mars (god) 104 "Mask of Agamemnon" 97, 97 Mask of Tutankhamun, Funerary 48, 49 mass xv mastabas 53, 54, 55, 55, 61 Mau, August 182 Maxentius 206, 207, 209, 211 Maximian, Emperor 205 Medes, the 44 Media 44, 45 medium/media xvi, xxi megalithic architecture 16-20, 18 megarons, Mycenaean 93, 96, 96 Meier, Richard 175 Memphis, Egypt 78, 79 Menkaure, King 56 Menkaure and a Queen 59, 59 Pyramid of Menkaure (Giza) 56, 56, 57 Mercury (god) 104 Mesopotamia 28 metalwork Bronze Age 23-4 Neolithic 23, 24 see also bronzes; goldwork; silverwork, Roman metopes 110, 110 reliefs 131, 131, 133 Metropolitan Kouros 114, 114 Mezhirich, Ukraine: Paleolithic dwellings 5 Michelangelo Buonarroti: The Holy Family (Doni Todo) xxiii Middle-aged Flavian Woman (Roman sculpture) 188,

189

Milan, Italy 206 Edict of Milan (313) 207 "Mildenhall Treasure," England 211-12, 212 Milvian Bridge, Battle of (312) 207 Minerva (goddess) 104 Minoan civilization 82, 83, 84, 90 architecture 84, 85-7, 86, 87 ceramics 85, 85, 88, 89, 89-90 goldwork 88, 89, 90, 90-91, 91 ivory figure 88, 88 stone rhytons 88, 88-9, 89 Minos, King 84, 85 Minotaur, the 84 Mithen, Steve 8-9 Mithras 166, 207 Mocking of Christ with the Virgin Mary and St. Dominic (Fra Angelico) xxxii, xxxii modeling xxi, xxiii, xxiv Moretti, Giuseppe 175 Morgan, Jacques de 34 mortise-and-tenon joints 18 mosaics xvi, 199 Battle of Centaurs and Wild Beasts (Hadrian's Villa) 198, 199-200 The Battle of Issos (?Philoxenos of Eretria or Helen of Egypt) 145, 146 Stag Hunt (Gnosis) 146, 146-7 The Unswept Floor (Herakleitos) 199, 199 Moses 39 mummification 53 Muqaiyir, Iraq see Ur Muqi xxviii Museum of Modern Art, New York xix Mussolini, Benito 175 Mut (goddess) 65, 66 Mycenae 85, 93, 94 "Lion Gate" 93, 95, 95 Mycenaean culture 90, 92 bronze dagger blades 97, 97-8 ceramics 99, 99 citadels/palaces 92-3, 94, 96, 96 "Mask of Agamemnon" 97, 97 megarons 93, 96, 96 shaft graves 97 tholos (beehive) tombs 98 "Treasury of Atreus" 98, 98-9

N

see also Mycenae

Nabonidus, Neo-Babylonian ruler 44 Nanna (god) 36, 37 ziggurat (Ur) 37, 37 Napoleon Bonaparte 49, 79 Naram-Sin, Stele of 26, 27, 34, 36 Narmer, Palette of 51-3, 52 Native Americans 34 naturalism xvi Naxos, island of: marble 82, 114 Neanderthals 1, 3 Nebuchadnezzar II, of Babylonia 44 necropolises, Egyptian 53, 62 Nefertari, Queen 74, 76 Queen Nefertari Making an Offering to Isis (tomb painting) 76, 77 Nefertiti, Queen 71, 71, 72, 82 portrait bust 72, 72-3 Nekhbet (goddess) 51,73 nemes headdress 51, 73 Neo-Babylonians 44

Neolithic period 2, 12-13, 23, 50 Palaikastro, Crete 88 Philip II, of Macedon 141, 142 architecture 13, 13-16, 15, 16 Octopus Flask 89, 89-90 Philoxenos of Eretria (?): Alexander the Great statuette of male figure 88, 88 Confronts Darius III at the Battle of Issos 145, ceramics 20-21, 21, 22, 22 copper artifacts 23 Paleolithic period 2 Cycladic sculpture 82, 82-4, 84 cave paintings xxxiv, 1, 8-11, 9, 10, 11 Phoebus (god) 104 goldwork 23, 24 decorated ocher 4, 4 phonograms 30 hand-axes 3, 4 photography xvi, xvii jewelry 23 plaster figures 21, 23, 23 Picking Figs (tomb painting) 63, 63 Homo sapiens sapiens 2, 3-4 sculpture 13, 14, 21, 22, 22 ivory figures 5, 5-6, 7, 7 pictographs 30 tombs 14, 17, 17 map 3 pictorial depth xv wall painting 14, 15 Neanderthals 1, 3 picture plane xv Neoplatonism 205 relief sculpture 5, 11-12, 12 picture space xv rock art 2, 2 Plato 141 Neptune (god) 104 sculpture 5-7, 5-7, 7 Nero, Emperor 172, 184, 186 Pliny the Elder: Natural History 145, 153, 167, Nerva, Emperor 190 tools 1, 2-3, 4 Palette of Narmer 51-3, 52 Netherlands: painting (flowers) xxvi, xxviii Pliny the Younger 167 Newgrange, Ireland: passage grave 17, 17 Pan (god) 104 Plotinus 205 Nicomachus Flavianus, Virius: diptych 212-13, panel painting xvi Plutarch 53, 145 213 Panofsky, Erwin xxv, xxvii Pluto (god) 104 niello decoration 90 Pantheon, Rome 194, 195, 195, 196, 197 Polybius 168 Parnassos, Mount 107 Polygnotos of Thasos 140 Nike (goddess) 104, 133 Polykleitos of Argos 120, 139 Nike (Victory) Adjusting Her Sandal (relief) 137, Paros, island of grave stele of little girl 139, 139 "Canon" 134, 142 Spear Bearer (Doryphoros) 134, 134 Nike (Victory) of Samothrace 153, 153, 155 marble 82, 114 Nile, River/Nile Valley 50, 50, 56, 65, 74 Parthenon see Akropolis Pompeii 167, 176-7, 177, 178 Parthians 172 four styles of painting 182 Nîmes, France: Pont du Gard 170, 170 House of G. Polybius 179 Nimrud, Iraq see Kalhu passage graves, Neolithic (Ireland) 17, 17 Nineveh (Ninua, Iraq) 42, 44 patricians, Roman: portraits 167, 167, 169 House of the Silver Wedding 178 Head of a Man (Akkadian Ruler) 36, 36 Patrician Carrying Portrait Busts of Two Ancestors House of the Surgeon (fresco) 183, 183 House of the Vettii 178, 178, 179, 179-80 palace of Sargon II 42-3, 43 168, 168 nonrepresentational/nonobjective art xvi pattern xxi, xxii Portrait of a Married Couple 183-4, 184 Nôtre-Dame-du-Haut, Ronchamp, France (Le Pausanias 130, 142, 167 Villa of the Mysteries 180, 181 Corbusier) xx, xx Pausias 146 Pont du Gard, Nîmes, France 170, 170 Novios Plautios: The Ficoroni Cista 156, 157 Pavlov, Czech Republic 7 porcelain 20 Nubia/Nubians 50, 58, 62, 65, 74, 78 Pax Romana 172 Porta, Giacomo della: fountain, Rome 194 Sphinx of Taharqo 78, 78-9 Pearson, Mike Parker 19 Portrait of a Married Couple (wall painting) 183-4, Pech-Merle Cave, Dordogne, France: spotted horses and human hands xxxiv, 1, 8 portraiture, Roman 167, 167, 168, 168, 169, 169, pediments 107, 110 204, 205, 205-6, 211, 211 Octopus Flask (Minoan) 89, 89-90 Peeters, Clara: Still Life with Fruit and Flowers xxvi, Poseidon (god) 104, 135 Poseidonia (Paestum), Italy Odyssey (Homer) 85 xxviii oinochoe 117 Pella, Macedonia: floor mosaic 146, 146-7 Temple of Hera I 108, 109 Old Woman (Hellenistic sculpture) 154, 155 Peloponnesian War 127-8 Tomb of the Diver 124, 124, 125 "Peplos" Kore 115, 116, 117 Olduvai Gorge, Tanzania 2 post-and-lintel construction 17, 18, 19, 158 Olorgesailie, Kenya 3 Pergamon, Turkey 149 potassium-argon dating method 12 olpe 105, 105, 117 Great Altar 150, 151, 152 potsherds 20 Olympian Games 102 Perikles 128, 129 pottery 20, see ceramics opithodomos 129 pozzolana 194 period style xvi opus reticulatum 194 peristyle 109 Praxiteles 142, 155 Orator, The (Roman bronze) 169, 169 peristyle courts 66 Aphrodite of Knidos 143, 144 orders, architectural see architectural orders peristyle gardens 178, 178-9 Hermes and the Infant Dionysos 142-3, 143 orthogonal plans (city planning) 138 Prědmosti, Czech Republic 7 Persephone (goddess) 104 orthogonals xxiii Persepolis (Iran) 45, 46, 47, 142 prehistory 1, see Neolithic period; Paleolithic Osiris (god) 51, 73, 74, 75, 77, 166 Persian Empire 44-5, 47, 120 period Persian Wars 120, 128, 130, 141 Priam Painter: Women at a Fountain House 139, perspective xv, xix P atmospheric xv, 183 Priestess of Bacchus (Roman ivory) 212-13, 213 Paestum see Poseidonia divergent xv Primaporta, Italy: Livia's villa 182, 183 Painter at Work, A (Roman fresco) 183, 183 intuitive xv, 182 prints xvi-xvii painterly xvi linear xv pronaos 108, 109 Propylaia, Akropolis, Athens 129, 135, 135 painting xvi vertical xv propylons 111, 111 cave xxxiv, 1, 8-11, 9, 10, 11 Perugia, Italy: Porta Augusta 158, 158 Dutch (flowers) xxvi, xxviii Phaistos 85 Proserpina (goddess) 104 Egyptian (tomb) 62-3, 63 76, 77 Pheidias 142 psykters 117 Etruscan 160, 161, 162, 163 Athena Parthenos 133, 133 Frolicking Satyrs (Douris) 126, 126 Athena Promachos 129 Ptah (god) 51,74 Greek 124, 125, 140, 145-6, see also vases, Parthenon 129-30 Ptolemy, king of Egypt 79, 147 Greek Ptolemy V, of Egypt 79 Minoan 87, 87-8, 91, 91-2, 92-3 Philadelphia, Pennsylvania Philadelphia Museum of Art xxviii, xxx Neolithic (wall) 14, 15 Pylos, Greece 96 Vanna Venturi House xvii Roman 179-84, 180-84 Palace 96, 96

pyramids 55, 57 Roman Empire 171, 205, 212 Sargon I, Akkadian king 35, 36 Sargon II, of Assyria 41 Djoser's step pyramid (Saggara) 54, 54-5 see also Romans; Rome Pyramid of Khafre (Giza) 55, 56, 56, 57 Roman Republic 164, 166-7, 171 palace complex, Dur Sharrukin 41, 41-2, 43 Pyramid of Khufu (Giza) 56, 56, 57 Romans 157, 166 saturation, color xiv Pyramid of Menkaure (Giza) 56, 56, 57 amphitheaters 177, 186-8, 187, 188 scarabs 51, 66, 82 Pythian Games 107, 122 aqueducts 170, 170, 179 Schaden, Otto 49 arches: structural 170, 170; triumphal 185, Schliemann, Heinrich 85, 95, 95, 97 185-6, 207-9, 208, 209 Scraper, The see Man Scraping Himself architectural orders 161, 161 scroll painting xvi sculpture xvi, xvii quilts xix, xix-xxi bronzes 169, 169, 200, 200-1 Quince (Mugua) (Zhu Da) xxvi, xxvii, xxviii cities 176-7 Akkadian 36, 36, 37 Cucladic 82, 82-4, 84 concrete 194 Egyptian 57-61, 59, 60, 62, 62, 70, 67-8, 68, 70, deities 104 R fora 176, 177, 190 71, 72, 72-3, 74, 74, 78, 78-9 houses and villas 178, 178-9, 179, 181, 197, 197, Etruscan 160, 160 Ra (god) 51 198, 199-200 Greek 104, 104, 105, 111, 112, 113, 113-15, Ra-Horakhty (god) 69,74 radiometric dating method 12 ivory diptych 212-13, 213 114, 115, 116, 117 (Archaic), 120-22, 121, Rainbow Serpent rock, Arnhem Land, Australia 2, 2 map 159 122, 123, 126, 130, 130-31, 133, 133, 134, Ramose, tomb of (Thebes) 69-70, 70 mosaics 198, 199, 199-200 134, 142-3, 143, 144, 145 (Classical) Ramses II, Pharaoh 66, 67, 73, 76, 77 painting 183-4, 184, see also wall paintings Hellenistic 149, 149-50, 152, 153, 153, 154, 155 Minoan 88, 88-9, 89 Temples, Abu Simbel 74, 74, 75, 76, 77 peristyle gardens 178, 178-9 Neolithic 13, 14, 21, 22, 22, 23, 23 Raphael (Raffaello Sanzio): Madonna of the Paleolithic 1, 5-7, 5-7, 11-12, 12 portrait sculpture 167, 167, 168, 168, 169, 169, Goldfinch (Madonna del Cardellino) xxiv, xxiv-178, 188, 189, 204, 205, 205-6 Roman 172, 173, 211, 211; portraiture 167, xxv, xxvii 167, 168, 168, 169, 169, 204, 205, 205–6 rationalism 120 relief sculpture 174, 174-5, 175, 186, 186, 192-3, 193, 201, 202, 208, 208-9, 209 Sumerian 30, 30, 31, 31, 34, 34, 37, 38 Ravenna, Italy: San Vitale xvii religions 104, 166, 207, 212 see also relief sculpture realism xvi, 169, 183 Scythians 44 sculpture 172, 173, 211, 211; copies of Greek Realism xvi seals, cylinder (Sumerian) 34-5, 35 red-figure vases, Greek 118, 118, 119, 126, 126-7, statues 143, 143, 144, 145; see also portrait Seated Scribe (Egyptian) 60, 60 127 sculpture (above) regional styles xvi silver 169, 169, 211-12, 212 Seleucids 147, 149 temples 171, 171, 194, 195, 195, 196, 197 Semele 202 registers 30 theater 177, see amphitheaters (above) Senusret II, of Egypt 65 Reinach, Salomon 8 relief sculpture xvii vaulting 187, 187 Senusret III, of Egypt: portrait head 62, 62 wall paintings 179-83, 180-84 Akkadian 26, 27, 35, 35-6 Assyrian 40, 41, 42, 43, 43 see also Roman Republic; Rome Sesklo, Greece: stone-foundation houses 16, 16 Rome 167, 171, 190, 190-91, 202, 205 Sety I, Pharaoh 67 Babylonian 34, 37, 39, 39, 40 Severan emperors 203, 205 Ara Pacis Augustae 172, 174, 174-5, 175 Egyptian 51-3, 52, 61, 61, 71, 71-2; stelai 63, 63-4, 64; tomb 61, 61, 69-70, 70 Arch of Constantine 207-9, 208, 209 Severus, Emperor Septimius 203 Etruscan 161, 162, 163 Arch of Titus 185, 185-6 shading xxi, xxiii Greek 107-8, 108 (Archaic), 131, 131-3, 132, Basilica Nova/Basilica of Maxentius and shaft graves, Mycenaean 97 137, 137, 139-40, 140 (Classical) Constantine 209, 210, 211 shamanism 9 Shamash (god) 39 Basilica Ulpia 191, 191-2 Hellenistic 150, 151, 152 shape xiv Paleolithic 5, 11-12, 12 Baths of Caracalla 203, 204 shipwrecks 82, 122, 127 Persian 45, 47, 47 Colosseum 186-8, 187, 188 Pantheon 194, 195, 195, 196, 197 silverwork, Roman Roman 174, 174-5, 175, 186, 186, 192-3, 193, 201, 202, 208, 208-9, 209 Santa Costanza xvii denarius of Julius Caesar 169, 169 Temple of ?Portunus, Forum Boarium 171, 171 platter 211-12, 212 Sumerian 30-31, 31, 34-5, 35 Trajan's Column 192-3, 193 Socrates 139 religions Akkadian 36 Trajan's Forum 191, 191 Sophocles 148 Christianity 166, 207, 211, 212, 213 Trajan's Market 191, 192, 192 Sosos of Pergamon: The Unswept Floor 199, 199 Ronchamp, France: Nôtre-Dame-du-Haut Egyptian 50-51 space xv Greek 102, 104 (Le Corbusier) xx, xx Spain: cave paintings 1, 8-9, 11, 11 Mesopotamian 28 Rosen, David xxx spandrels 170, 170 Rosetta Stone 34, 79, 79 Sparta/Spartans 102, 120, 127-8, 141 Roman 104, 166, 207 spatial recession xv, xv Sumerian 28, 30, 31 Rothko, Mark xix, xx Magenta, Black, Green, on Orange (No. 3/No. 13) Spear Bearer (Doryphoros) (Polykleitos) 134, 134, Renoir, Auguste Mme. Charpentier and Her Children xxiv, xxv, xxv, xviii, xix, xxi 142 - 3, 145Sphinx, the (Giza) 57, 58 xxvii Russia 44 repoussé work 90, 91 Sphinx of Taharqo (from Nubia) 78, 78-9 Paleolithic settlements 4-5 spotted horses and human hands (cave painting) representational styles xvi rhytons, Minoan 88, 88-9, 89 xxxiv, 1, 8 S Riace Warriors, The (Greek bronzes) 122, 123, 126, "Spring Fresco" (Minoan) 91, 91-2 Sappho 105 Stag Hunt (Gnosis) 146, 146-7 127 stained glass xvi rock art Saqqara, Egypt Djoser's Complex 53-5, 54, 55 Bronze Age carvings 24-5, 25 Paleolithic 2, 2 Tomb of Ti 61, 61 grave stele of Ktesilaos and Theano 139-40, 140

sarcophagi

Etruscan 163, 163-4, 164

Roman 201, 202

grave stele of little girl (from Paros) 139, 140

Stele of Amenemhat 65, 65

Stele of Hammurabi 34, 37, 39, 39

see also cave art

Rollefson, Gary 21

rock-cut tombs, Egyptian 62, 62-3

Thebes, Egypt 51, 65, 66, 78 Stele of Naram-Sin 26, 27, 34, 36 Tomb of Ramose 69-70, 70 Stele of the Sculptor Userwer 63, 63-4, 64 step pyramids, Egyptian 53, 54, 54-5, 55 Thera, island of 81, 82, 91, 92 stereobates 109, 110, 110, 129 see also Akrotiri Stevanović, Mira 16 thermo-luminescence dating method 12 Stewart Andrew 113-14 Theseus 84 still life xxviii tholos tombs, Mycenaean 98, 98-9 Still Life (House of the Stags, Herculaneum) 183, Thomas, Henrietta xix My Sweet Sister Emma (quilt) xix, xix-xx, Still Life with Fruit and Flowers (Peeters) xxvi, xxi Thoth (god) 51 xxviii stoas 137-8, 140 Thutmose I, Pharaoh 66, 67 Thutmose II. Pharaoh 67 Stone Age see Neolithic period; Paleolithic period Thutmose III, Pharaoh 65, 66, 67 Stonehenge, England 15, 17-20, 18, 19 Thutmose (sculptor) 72 stoneware 20 Tiberius, Emperor 172, 175, 176 Minoan rhytons 88, 88-9, 89 Tigris, River 28, 29 Strasser, Thomas 92 Titus, Emperor 167, 185-6 Tivoli, Italy: Hadrian's Villa 197, 197, 198, styles xvi stylobates 109, 110, 110, 128 199-200 stylus 28, 30 Tiy, Queen: portrait 72, 72 tomb paintings and reliefs subject matter identifying xxv, xxvii Egyptian 61, 61, 62-3, 63, 69-70, 70, 76, 77 natural xxvii Etruscan 160, 161, 162, 163 Sumer/Sumerians 28, 37 Greek 124, 125 alabaster vessel 30-31, 31 tombs Egyptian 49, 50, 53-5, 54, 62, 62, see also cylinder seals 34-5, 35 Epic of Gilgamesh 28, 32 mastabas; pyramids inventions 28 Etruscan 153, 160, 161, 162, 163 lyres 32-3, 33, 34 Mycenaean 93, 97-9, 98 metalworking 34 Neolithic 14, 17, 17 religion 28, 30, 31, 37 see also tomb paintings and reliefs tools, prehistoric 1, 2-3, 4 royal burials 32-3 sculpture 30, 30, 31, 31, 34, 34 torcs, Celtic/Gallic 149, 150, 150 votive figures 31, 31, 34, 37, 38 town planning writing 28, 30 Egyptian 65 ziggurats 28, 29, 37, 37 Greek 138-9 Susa (Iran) 34 Roman 176, 177 Trajan, Emperor 190, 191, 192, 193 Symmachus, Quintus Aurelius: diptych 212-13, Trajan's Column, Rome 192-3, 193 symposia 124, 125, 127 Trajan's Forum, Rome 191, 191 Trajan's Market, Rome 191, 192, 192 "Treasury of Atreus" (Mycenaean tomb) 98, T Tarquinia, Italy: Etruscan tombs 160, 161, 162, Treasury of the Siphnians, Delphi 107, 107-8, 163 Trier, Germany: Basilica 206, 206-7, 207 technique xvi Tell Asmar, Iraq: votive figures 31, 31, 34 triglyphs 110, 110 Tell el-Amarna, Egypt see Amarna period trilithons 18 Telloh, Iraq see Girsu Tringham, Ruth 16 tells 29 Troy/Trojan War 85, 93, 100, 101, 111, 119 temenos 108, 111 Tuc d'Audoubert, Le, France: cave sculpture 11-12, 12 temples Egyptian 50, 51, 57, 58, 65-7, 66, 67, 68, 68-9, Tucker, Mark xxviii, xxx, xxxiii 69, 74, 74, 75, 76, 102 Turkey Etruscan 158, 159, 160 Hagia Sophia, Istanbul xvii Greek 106, 107, 108, 109, 111, 111, 113-14, Library of Celsus (façade), Ephesus 161 171 (Archaic), 128, 129, 129-33, 135, 137, see also Çatalhöyük; Pergamon; Troy/Trojan War Roman 171, 171, 194, 195, 195, 196, 197 Tuscan order 158, 161, 161 Ten Commandments, the 39 Tutankhamun 73 tepe 29 funerary mask 48, 49 inner coffin from sarcophagus 73, 73 terra cottas Etruscan 160, 160, 163, 163-4 tomb 49 Greek 114

Tetrarchs 205

Greek 148, 148

theater

portraits 204, 205, 205-6

Roman 177, see amphitheaters, Roman

U

Ukraine 44 mammoth-bone house 4–5, *5* Ulu Burun, Turkey: shipwreck 82 under-drawings xxviii Unswept Floor, The (Herakleitos/Sosos of Pergamon) 199, 199 Ur (Mugaiyir, Iraq) 28, 32 bull's head lyre 32-3, 33 burials 32, 32 cylinder seals 35, 35 Nanna ziggurat 37, 37 uranium-thorium dating method 1, 12 Urnammu, King of Ur 37 Uruk (Warka, Iraq) 28, 30 alabaster vessel 30-31, 31 Anu ziggurat 28, 29 Face of a woman 30, 30, 34, 34 White Temple 28, 29, 30 Userwer, Stele of 63, 63-4, 64 Disk of Enheduanna 35, 35-6

V

Valley of the Kings 49, 50, 67, 73, 77

Valley of the Queens 50, 67 values, color xiv van der Hoof, Gail xx vanishing point xv vanitas paintings xxviii Vapheio Cup (Minoan) 90-91, 91, 99 Varna, Bulgaria: gold and copper artifacts 23, 24 vases, Greek 100, 101, 102-4, 103, 105, 105, 117, 117-20, 118, 119, 139, 139 (Archaic), 126, 126-7, 127, 141, 141 (Classical) vaults barrel 187, 187 corbeled 17, 17, 19, 98, 99 Veii, Italy 160 Venus (goddess) 104 Venus de Milo (Alexandros) 154, 155 "Venus" figures 6 verism 168 Vespasian, Emperor 184 Vesta (goddess) 104 Vesuvius, Mount 167, 176-7 Victory (goddess) 104, see Nike Victory of Samothrace 153, 153, 155 Villanovans 158 Vitelli, Karen 21 Vitruvius 158, 167 volume xv volutes 110, 110 votive figures, Sumerian 31, 31, 34, 37, 38 voussoirs 170, 170 Vulca (?): Apollo 160, 160 Vulcan (god) 104

W

Wadjet (goddess) 51,73
wall paintings xvi
Etruscan 160, 161, 162, 163
Greek 124, 124, 125
Minoan 87,87–8, 91,91–2, 92–3
Neolithic 14,15
Roman 179–84, 180–84
see also cave paintings, prehistoric; tomb
paintings and reliefs
Warka see Uruk
"Warka Head" 30, 30, 34, 34
Warrior Krater (Mycenaean) 99, 99
wattle and daub 16, 19

weapons, bronze 24

Weyden, Rogier van der xxviii, xxxii–xxxiii

Crucifixion Triptych with Donors and Saints xxx–
xxxi, xxxi

Crucifixion with the Virgin and St. John the Evangelist xxviii–xxx, xxix, xxxii, xxxiii, xxxiii

Whitney Museum, New York xx

"Abstract Design in American Quilts" xx Willendorf, Austria: Woman from Willendorf 6, 6–7

Winter, Irene 27

Woman at a Fountain House (Priam Painter) 139, 139

Woman and Maid (style of Achilles Painter) 141, 141

Woman from Brassempouy 7, 7 Woman from Dolní Věstonice 7, 7 Woman from Willendorf 6, 6–7 wood-post framing 19, 20, 20 Woolley, Katherine 32 Woolley, Sir Leonard 32, 32, 35 Worth, Charles Frederick xxvii writing cuneiform 28, 30

X

Egyptian hieroglyphs 51, 52, 79, 79

Xerxes I, of Persia 47, 47

Y

Young, Thomas 79

Young Flavian Woman (Roman sculpture) 188, 189 Youth Pouring Wine into the Kylix of a Companion, A (Douris) 126–7, 127

Z

Zeus (god) 102, 104, 107, 127, 130, 145, 180 Zhu Da (Bada Shanren) xxvii—xxviii *Quince (Mugua) xxvi* ziggurats

Babylonian *44* Sumerian 28, *29*, 347, *347*